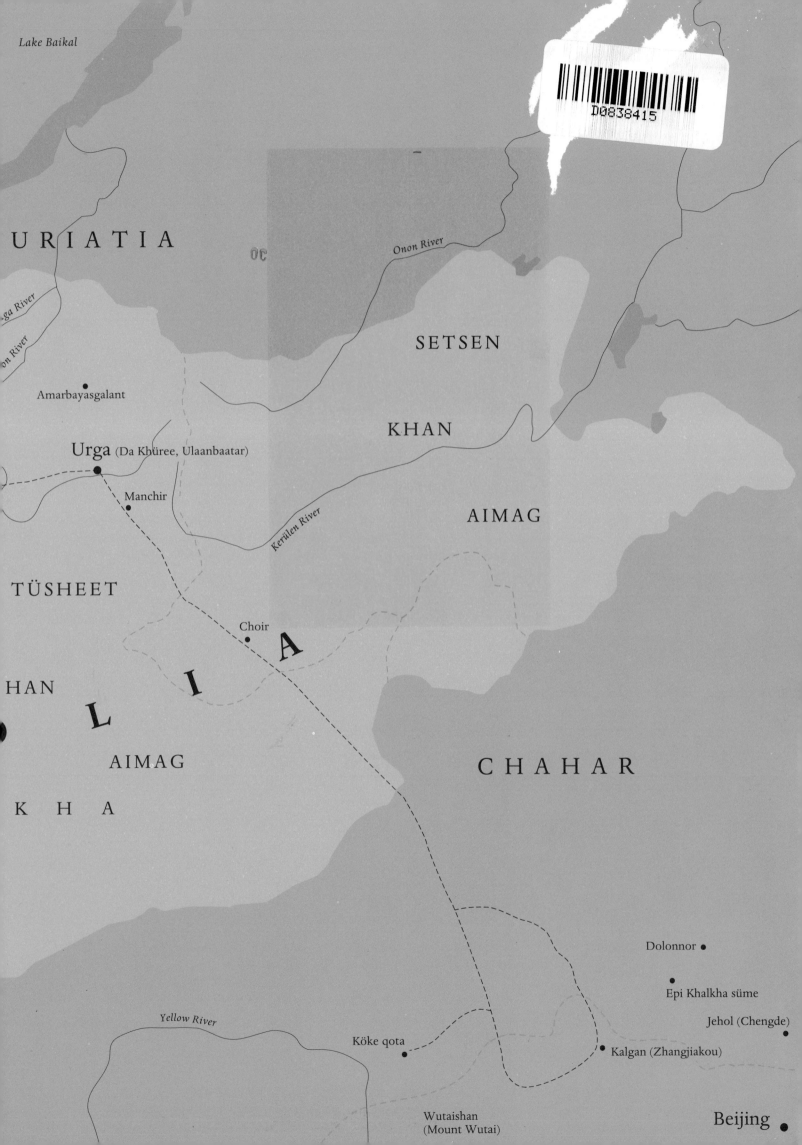

Lake Baikal

URIATIA

ga River

on River

Onon River

SETSEN

KHAN

Amarbayasgalant

Urga (Da Khüree, Ulaanbaatar)

AIMAG

Manchir

Kerülen River

TÜSHEET

Choir

HAN

L I A

AIMAG

CHAHAR

K H A

Dolonnor

Epi Khalkha süme

Jehol (Chengde)

Yellow River

Köke qota

Kalgan (Zhangjiakou)

Wutaishan
(Mount Wutai)

Beijing

Mongolia

THE LEGACY OF CHINGGIS KHAN

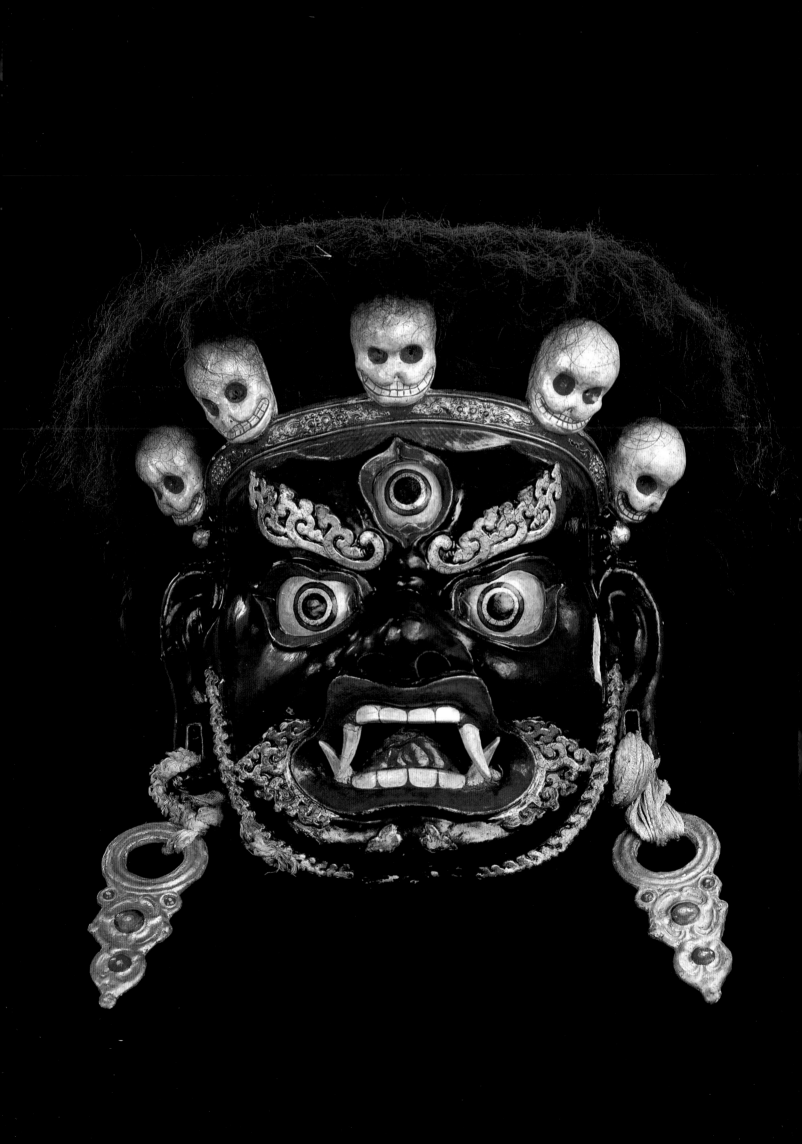

Mongolia

THE LEGACY OF CHINGGIS KHAN

Patricia Berger

Terese Tse Bartholomew

With essays by

James Bosson

Lewis R. Lancaster

Morris Rossabi

Heather Stoddard

Catalogue photographs by

Kazuhiro Tsuruta

THAMES AND HUDSON

in association with

ASIAN ART MUSEUM OF SAN FRANCISCO

Published on the occasion of *Mongolia: The Legacy of Chinggis Khan*, an exhibition organized by the Asian Art Museum of San Francisco in association with the Ministry of Culture, National Museums, and National Library of Mongolia.

Major funding for the exhibition has been provided by the National Endowment for the Humanities, a federal agency; the Henry Luce Foundation; the National Endowment for the Arts, a federal agency; and Joyce and John Clark/Carlson Marketing Group.

Presentation of the exhibition in San Francisco has been made possible by generous contributions from Dr. and Mrs. Bruce Alberts, the L. J. Skaggs and Mary C. Skaggs Foundation, Asian Cultural Council, Elsie R. Carr, Castagnola Family Foundation, Anne and Cameron Dorsey, Edward P. Gerber, Martha M. Hertelendy, and the Soros Foundations.

Additional support provided through an indemnification from the Federal Council on the Arts and the Humanities.

Asian Art Museum of San Francisco
19 July–15 October 1995

Denver Art Museum
11 November 1995–26 February 1996

National Geographic Society, Washington, D.C.
3 April–7 July 1996

Asian Art Museum of San Francisco
Emily J. Sano, Acting Director
Hal Fischer, Project Director, Mongolia Exhibition
Terese Tse Bartholomew, Curator of Indian and Himalayan Art

Fronia W. Simpson, editor
Jessica A. Eber, copy editor
Bret Granato, designer
Susan E. Kelly, typesetter
Produced by Marquand Books, Inc., Seattle

First published in Great Britain in 1995 by Thames and Hudson Ltd, London

First published in the United States of America in hardcover in 1995 by Thames and Hudson Inc., 500 Fifth Avenue, New York, New York 10110

© 1995 by the Asian Art Museum of San Francisco

Library of Congress Catalog Card Number 95-60283

British Library Cataloguing-in-Publication Data
A catalogue record for this book is available from the British Library.

ISBN: 0-500-23705-0

Printed and bound by C & C Offset Printing Co., Hong Kong

Frontispiece: Mahakala mask, cat. no. 37.

Page vi: *Ger* in landscape. Photo: Kazuhiro Tsuruta.

Page xii: Begtse in a 19th-century *tsam* performance.
From Tsultem, *Mongolian Sculpture,* fig. 159.

Page 96: Ganesha, cat. no. 75.

Contents

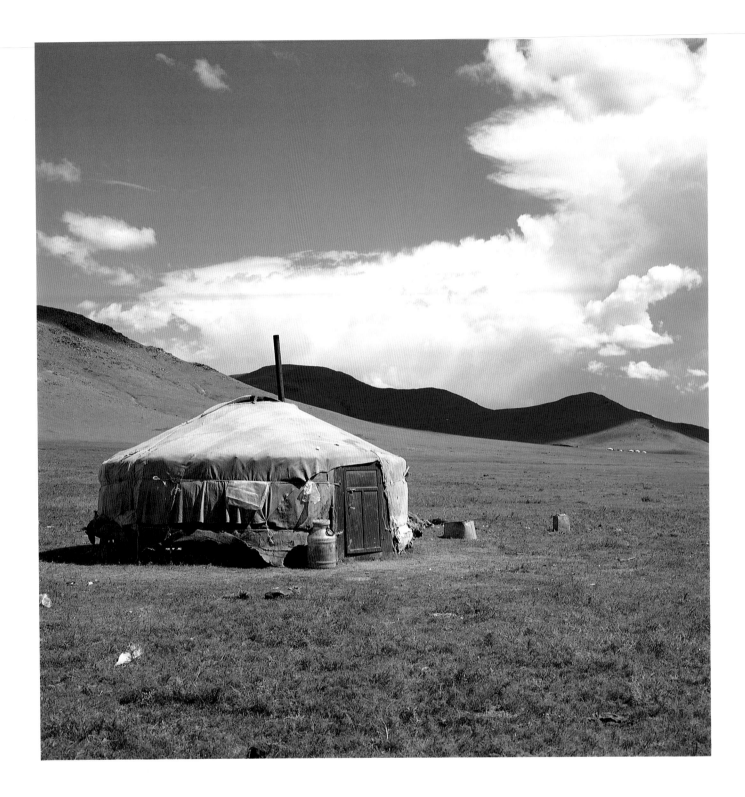

Statements and Acknowledgments

HIS EXCELLENCY NAMBARYN ENKHBAYAR

Minister of Culture, Mongolia

We all live under the same sun and on the same earth, although we differ in history, language, religion, and culture. All of these things together create the tapestry that is mankind's civilization. With a rich and lengthy cultural history, Mongolia and its people are a small part of this tapestry.

The unique nomadic culture of Mongolia has its roots in the first Mongol empire, which was created eight hundred years ago. Over this time we have developed our life and culture and have forged a national identity grounded in our nomadic heritage.

Today, our sacred duty to mankind is to enrich world culture by melding the historical achievements of the Mongolian people with modern civilization. As a people and a culture, the most bitter lesson of our long history was the destruction that took place in the 1930s in the name of proletarian culture. In this brief period of time centuries-old aspects of our national heritage were destroyed. Thanks to sweeping changes enacted in 1990, Mongolia has become a democratic country with a market economy and a strong commitment to human rights.

We are greatly pleased that this exhibition, *Mongolia: The Legacy of Chinggis Khan,* has given our two countries, Mongolia and the United States, the opportunity to establish a closer relationship. Through our work on this exhibition we have learned much about one another.

Mongolia: The Legacy of Chinggis Khan is the first major exhibition from Mongolia's national museums and library to be held in the United States. We hope presentation of this exhibition will mark the beginning of a new chapter in cultural relations between our countries, one that will give impetus to new projects and even closer cooperation.

On behalf of the Mongolian people, I would like to extend my sincere gratitude to the Asian Art Museum of San Francisco and most especially to those members of its staff who have taken an active part in organizing this wonderful exhibition devoted to the historical and cultural achievements of the Mongolian people. In undertaking this project, they have contributed a great deal toward strengthening the bonds of friendship between Mongolia and the United States.

EMILY J. SANO

Acting Director

In 1991, when staff members of the Asian Art Museum made their first exploratory trip to Mongolia, the country had just emerged from the veil of seventy years of Soviet dominance. Eager to embrace democracy and Western-style free enterprise, government officials welcomed the opportunity to share with visitors from the West the spectacular but little-known works of art in their national museums and library. Most significantly, they wanted the world to know about Mongolia and its unique heritage. Thus began a collaborative undertaking between the Asian Art Museum and the Ministry of Culture of Mongolia—an enterprise designed to introduce American audiences to the history of this landlocked and misunderstood country.

Mongolia was converted to Tibetan-style Buddhism twice—first by the example of Khubilai Khan, Chinggis Khan's grandson and unifier of Mongolia and China in the thirteenth century, and again in the sixteenth century, after an apparent lapse of several centuries, when Altan Khan took Buddhist vows and bestowed upon Sonam Gyatsho, leader of the Tibetan Buddhist Gelug order, the title Dalai Lama. The finest works of religious and secular art remaining in Mongolia belong to the period of the second conversion, or the Mongol renaissance, and it is this period that is explored in *Mongolia: The Legacy of Chinggis Khan.*

From the onset, the Asian Art Museum saw *Mongolia: The Legacy of Chinggis Khan* as a sequel to *Wisdom and Compassion: The Sacred Art of Tibet,* an exploration of the Tibetan Buddhist cosmos organized by the Asian Art Museum in 1991. *Mongolia: The Legacy of Chinggis Khan* reveals the profound impact Tibetan Buddhism has had on every aspect of Mongolian life and so furthers our exploration of the ways in which Tibetan Buddhism has influenced Asian life and history. At the same time, this exhibition examines the impact of nomadic life, which not only created a natural link between Mongolia and Tibet but influenced Mongolia's material culture.

Central to the success of this project has been the cooperation extended by our Mongolian colleagues. His Excellency Nambaryn Enkhbayar, Minster of Culture, has supported the project since its inception. His Excellency Puntsag Jasrai, Prime Minister of Mongolia, and His Excellency Luvsandorj Dawagiv, Mongolian Ambassador to the United States, have ensured governmental support of this project at the highest level. To them we extend our deepest appreciation.

Mongolia: The Legacy of Chinggis Khan has benefited from the contributions of a team of talented and committed scholars. Our special thanks go to James Bosson, Lewis R. Lancaster, Morris Rossabi, and Heather Stoddard, who served as consultants to the project and contributors to the catalogue. We also acknowledge Patricia Berger for her outstanding catalogue essays and object entries and for her perseverance in seeing to the completeness and accuracy of the catalogue. At the Denver Art Museum, Director Lewis I. Sharp and members of his staff have worked to guarantee the success of this exhibition. At the National Geographic Society, Dale Petroskey, Vice President, Public Affairs; Nancy Beers, Administrative Director; and Richard McWalters, Technical Director, have been enthusiastic participants in the planning of this project.

We offer our heartfelt thanks to the National Endowment for the Humanities, the Henry Luce Foundation, and the National Endowment for the Arts, for awarding major grants in support of the exhibition and catalogue. *Mongolia: The Legacy of Chinggis Khan* has drawn the interest and commitment of several individuals, each of whom has contributed to the project's success. Asian Art Museum trustees Betty Alberts and Anne Diller, co-chairs of our "Mongolia" committee, along with committee members Elsie Carr, Anne and Cameron Dorsey, Edward Gerber, Virginia Castagnola Hunter, Martha Hertelendy, and Joyce and John Clark created a strong base of local support for this project. The efforts of June Arney Roadman, Marjorie Stern, Pat and Darle Maveety, and Jack and Betty Bogart greatly aided our progress.

The staff of the Asian Art Museum deserves recognition for a show carefully produced and managed. Special thanks are due Terese Tse Bartholomew, who was on the original team that initiated the exhibition. She contributed to the catalogue and supervised the installation and training of docents. In particular, however, the successful management of all aspects of this complex project is due to the tenacity and talents of Hal Fischer, who as project coordinator was the exhibition's engine and linchpin. He not only achieved the essential communication of a myriad of details, negotiating the show across international borders, but he coordinated the efforts of authors, editors, designers, and other staff, and achieved full funding of this costly project several months before the show opened. To Hal we owe our gratitude and hearty congratulations on a job well done.

It is a great honor for the Asian Art Museum to be the organizer of the first major American exhibition from newly democratic Mongolia. With this exhibition and catalogue we celebrate the richness of Mongolian culture and the significant role the Mongolian people have played in the history of Inner Asia.

TERESE TSE BARTHOLOMEW
Curator of Indian and Himalayan Art

HAL FISCHER
Project Director

Mongolia: The Legacy of Chinggis Khan has benefited from the support and encouragement of individuals in the United States, Asia, and Europe. On our planning trips to Mongolia, Dorjiin Enkhtugs, director of the Museum of Theatre in Ulaanbaatar, coordinated efforts and saw to logistical details with great efficiency. Liguu Enhbold, translator for the Ministry of Culture, deftly removed verbal obstacles at every turn. We would also like to thank N. Urtnasan, Director, Department of Cultural Policy, Ministry of Culture, for administrative assistance. Luvsantseren Orgil, Second Secretary, Embassy of Mongolia, facilitated communications between Mongolia and the United States. Gandan Dunbure, Dorjyn Dashbaldan, Ichinkhorloogiin Lkhagvasuren, Nyamjavyn Dugarsuren, and Dr. Renchingiin Otgon, past and present directors of Mongolia's national museums and national library, were generous with their time and unequivocally supportive of our efforts. We also wish to thank Tsambyn Jargalsaikhan, J. Bayasgalant, and especially Dr. Nyam-Osoryn Tsultem, whose publications inspired this exhibition.

At the Denver Art Museum, Dan Jacobs, Assistant Director for Special Projects, and Ronald Otsuka, Curator of Asian Art, have worked to ensure the success of this project. At Explorers Hall, National Geographic Society, Nancy Beers, Administrative Director, and Richard McWalters, Technical Director, have been unceasingly helpful and enthusiastic.

Our special appreciation goes to James Bosson, Lewis R. Lancaster, Morris Rossabi, and Heather Stoddard, who have been most generous with their time and expertise. For their contributions to the project we are grateful to Gilles Béguin, Amy Heller, the Honorable Joseph E. Lake, former United States Ambassador to Mongolia, David Lattimore, Builder Levy, Dr. Evgenii Lubo-Lesnichenko, Luo Wenhua of the Palace Museum, Beijing, Joseph Mellott, David Snellgrove, James Spencer of the Chang Foundation, Taiwan, John B. Taylor, Gary Tepfer, Alaina Teplitz, and Håkan Wahlquist and Sanna Törneman of the Folkens Museum Etnografiska. We also extend our thanks to Fronia W. Simpson, catalogue editor, to Jessica Eber and Susan Kelly for editorial support, and to Ed Marquand, Bret Granato, and Tomarra LeRoy for their design and production efforts. Jamie Camplin, editorial director at Thames and Hudson, has been a welcome voice of expertise throughout the production process.

To Andrea Anderson of the National Endowment for the Humanities, Philip Jelley of the L. J. Skaggs and Mary C. Skaggs Foundation, Sarah Bradley of the Asian Cultural Council, and Ellen Holtzman and Terry Lautz of the Henry Luce Foundation we owe a special debt of thanks. We are especially grateful to Paul Kahn and Dynamic Diagrams for their innovative CD-ROM contribution to the project, and to Scott Harrison, Ronnie Lamb and Amicale Corp., Lobsang Khaidup, Dennis C. Scherzer, and Marc Le Boiteux and the staff of International Art Transport for providing much-needed expertise. Our special thanks go to Patricia Berger, whose scholarship and creativity are evident in the conceptual framework that distinguishes this exhibition and catalogue.

We feel especially fortunate to have had the full cooperation and support of our colleagues at the Asian Art Museum in undertaking a project of considerable complexity. Each of them has contributed to the success of this project. On our second trip to Mongolia, Head Conservator Linda Scheifler Marks, with the assistance of Irit Lev, admirably supervised the preparation of the objects for photography and exhibition. Senior Registrar Marilyn O'Keeffe saw to the safe transport of personnel and objects between Ulaanbaatar and San Francisco. Under the most challenging of circumstances, photographer Kazuhiro Tsuruta once again brought his consummate skills to bear upon an Asian Art Museum publication. Exhibition Intern Kristina Youso handled a myriad of details with efficiency and good humor. Public Programs Coordinator Aislinn Scofield, School Programs Coordinator Molly Schardt, Exhibition Designer Stephen Penkowsky, Principal Preparator Guy Herrington, and members of the preparators crew and conservation staff have worked to ensure the success of the exhibition's presentation in San Francisco.

JOYCE AND JOHN CLARK
Creative Marketing Incentives (CMI)
Division of Carlson Marketing Group

The urge to be a small part of this exhibition began in 1992 on a trip to the Silk Route, sponsored by the Society for Asian Art. A small group from that trip pressed our leader, Dr. William Wu, to take us the following year to Mongolia. We were all curious to see this mysterious and remote land of Chinggis Khan, which for so many centuries had been described in such fierce terms, and also to see firsthand the tremendous contrast between life on the steppe and life in agricultural China.

None of us were prepared for what we experienced in Mongolia. The spectacular landscape was a dramatic backdrop and the detailed and significant work in both sacred and secular art was impressive, but what really moved us was actually seeing people busy reinventing a large part of their cultural heritage, which had been so forcibly interrupted for nearly three-quarters of a century while the country was under heavy Soviet influence. Observing old monks instructing and practicing the formerly forbidden Buddhist rituals; watching the teaching of dance and drama to young students; talking to people who were scouring the country for lost musical instruments; and entering makeshift museums that had been opened to tell the historic tale that had been suppressed for several generations of Mongols—all these experiences, and more, filled our days and nights.

On our return, stories and photographs of the trip were eagerly sought after by clients, co-workers, and friends. The verbal and visual pictures demonstrated what an uplifting experience going to Mongolia had been for us. When we learned that this exhibition was being planned, and having seen a great number of the objects that would be on display in it, the opportunity to sponsor this catalogue with its text and photographs became the answer to our question of how to take our interest in Mongolia to a higher level.

For us, this catalogue serves as a powerful reminder of what we saw and how we felt while in that faraway country. For our clients, co-workers, and friends, as well as for others who have not been exposed to Mongolia, we hope that this exhibition and catalogue create the kind of curiosity and understanding that will encourage them to travel to Mongolia, to see the country whose people, culture, and legacy are celebrated here.

Note to the Reader

Terms from all the languages of Tibeto-Mongolian Buddhism—Mongolian, Tibetan, Sanskrit, and Chinese—are used in this book, a reflection of the cosmopolitanism of Mongolian Buddhism. We have tried to make this Tower of Babel less forbidding in a number of ways. The following system of abbreviations has been developed to signal the use of individual words in these languages: M: = Mongolian; T: = Tibetan; S: = Sanskrit; and C: = Chinese.

Chinese, for example, is transcribed according to the standard Pinyin system in use throughout the People's Republic and in most American newspapers and magazines. (The reader should note a few potentially confusing letters, e.g., *q* = *ch*, *x* = palatalized *sh*, *c* = *ts*.)

We decided to transcribe Sanskrit terms in the text, many of them the names of Buddhist deities, without diacritical marks, sacrificing perfect accuracy for approachability. Exceptions to this rule are in the section on sacred texts, where the Sanskrit titles of books are transcribed complete with diacritics, and several proper names.

Tibetan presents an unusual obstacle to the nonspecialist reader, because the system of classical transcription found in scholarly works on Tibet makes it seem a jumble of unpronounceable consonants. We have thus used spellings in the text, which, while in some cases nonstandard, allow the reader to approximate Central Tibetan pronunciation. Classical transcriptions are provided in the Index.

The transcription of Mongolian is still more complex. We have provided the Mongolian names of deities in classical Mongolian form, and the names of most historic figures and terms still in general use in modern form (thus the Tüsheet Khan instead of the Tüshiyetü Qan). The names of texts are transcribed as they are written, in classical Mongolian, as are personal names when they are part of a translated text.

Mongolian has many sounds that are unfamiliar and difficult for speakers of American English. Classical Mongolian includes a few that require transcription with diacritics, such as *č* (similar to *ch*), *ǰ, ü,* and *ö*. We have used *gh* to transcribe a sound most often rendered in scholarly transcriptions with a Greek *gamma* (γ).

Some Mongolian terms are used so often that we have adopted a hybridized spelling for them, e.g., Chinggis Khan, *khutuktu* (incarnate-lama), *suburgan* (stupa). We have resisted the Persianized Genghis Khan, however.

Most deities are given their Sanskrit names throughout the catalogue, because they are most likely to be familiar to our readers, and because Mongolian Buddhists borrowed many of these terms outright. The Tibetan *dorje* (S: *vajra,* thunderbolt) entered Mongolian in both forms, and so is used in the catalogue in a way that may seem haphazard. *Dorje* (M: *dorji*) is the more ordinary form, but *vajra* (M: *vačir*) is preferred whenever it occurs as an attribute of a deity whose Sanskrit name incorporates *vajra* (e.g., Vajrasattva, Vajradhara, Vajravarahi, etc.).

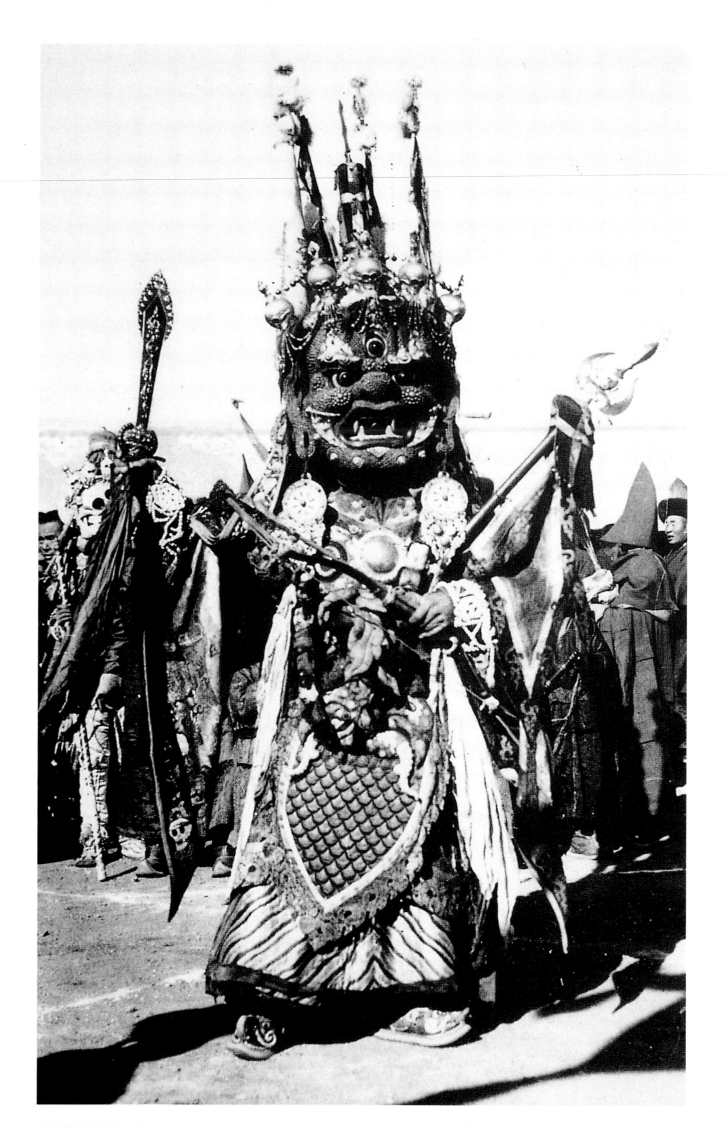

Introduction

PATRICIA BERGER

Since the days of Chinggis Khan, the Mongols have exerted an almost hypnotic fascination over the West, both as the people of Prester John, a virtuous but enigmatic Christian khan with an almost messianic allure, and as the embodiment of the divine forces of Armageddon and harbingers of the Second Coming.[1] The immediacy of Chinggis's empire, which at its height in the early thirteenth century stretched from Korea to the Danube, generated both terror and admiring awe; tales of Chinggis's ruthlessness preceded his armies, and later, when his extraordinary grandson Khubilai ruled a vast, Chinese-based empire, word of his brilliance, sophistication, and virtue reached the West in the writings of intrepid travelers, among whom was the Venetian merchant Marco Polo.

Mongolia: The Legacy of Chinggis Khan reveals what happened in Mongolia more than two centuries after the fall of Khubilai's Yuan dynasty in 1368, when his family's epic deeds continued to fuel the Mongol imagination. While most Mongols continued their nomadic ways uninterrupted, a succession of ambitious khans kept up the dream of recreating Chinggis's world empire. This dream had every appearance of being realized when in 1578 the Mongol Altan Khan (r. 1543–82) gave the Tibetan monk Sonam Gyatsho the title Dalai (Ocean) Lama and was in turn recognized as a reincarnation of Khubilai Khan, reinstating the interdependent, Buddhist-based relationship between Mongolia and Tibet that had first been forged in Khubilai's day and officially ordering the reconversion of Mongolia to Tibetan Buddhism. Cloaking himself in Mongolia's heroic past, Altan Khan assumed a kind of legitimacy that depended not just on inheritance but also on reincarnation. The irony of Altan Khan's accomplishment was that it was the Manchus, and not the Mongols, who were eventually recognized as Khubilai's true heirs and became in the seventeenth century the masters of a vast realm modeled on Khubilai's, which included Mongolia, China, Tibet, and vast tracts of Central Asia. Even so, the Mongolian reconversion to Buddhism fostered a cultural renaissance in Inner Asia that encompassed Mongolia, Tibet, and Manchu-ruled China.

Today Mongolia is divided into two halves, Outer Mongolia (Aru Mongghol), or Khalkha, a sovereign nation that was until recently under the sway of the former Soviet Union; and Inner Mongolia (Öbür Mongghol), now an autonomous region of the People's Republic of China largely settled by ethnic Chinese. This division is an artifact of the forces, both Russian and Chinese, that have shaped Mongolia since its resurgence in the sixteenth century, but it also reflects a pull that the Mongols have long felt between the twin foci of Chinggis's empire, the one in Russia, the other in China. *Mongolia: The Legacy of Chinggis Khan* is made up entirely of works of art drawn from the state museums and Central Library of (Outer) Mongolia, which gives it a particular bias. For Outer Mongolia was the heartland of the Mongol renaissance; its khans, lamas, and artists gave it form, imbued it with a rich, historic significance and symbolism, and made Mongolia's Buddhist church one of the most powerful in Inner Asia.

The internationalist political model that Mongolia pursued during its resurgence in the late sixteenth, seventeenth, and eighteenth centuries also inspired a renaissance of the arts, and this is the story this exhibition recounts. Perhaps unique among world cultures, Mongolia's chosen leader, Öndür Gegen or Zanabazar (1635–1723), a direct descendant of Chinggis and an incarnate Buddhist lama who defined and embodied the Mongolian renaissance and masterminded Outer Mongolia's submission to the Manchus, is also remembered as its greatest artist. While living a traditional, nomadic life, Zanabazar was indoctrinated into the tenets of Tibetan Buddhism by the Panchen and Dalai Lamas of Tibet and learned the art of bronze casting, probably

from Nepalese artists working in Tibet's great monasteries. About a century after Altan Khan conferred the title Dalai Lama on Sonam Gyatsho, Zanabazar began to make splendid, sophisticated works of art, all of them intended for use in Buddhist ritual, and simultaneously built the church that dominated Mongolian life well into modern times.

Mongolia: The Legacy of Chinggis Khan presents a survey of the arts of the Mongol renaissance and its aftermath, some of them secular and decorative, others made for use in sacred ritual, some manufactured in Khalkha, others imported from China or Inner Mongolia. The exhibition culminates with ten gilt bronze sculptures attributed to Zanabazar's own hand and a number of pieces by his immediate school, made up of artist-monks closely associated with him and the monasteries he founded in Khalkha. This extraordinary selection of work poses a pair of questions that can be answered only in part—what were the sources of the cultural renaissance Zanabazar has come to personify in the Mongol mind, and how should this complex legacy be defined and assessed? Clearer perhaps are the motivations of Zanabazar and his contemporaries, among which were a heartfelt desire for Mongol unity and the creation of a new, authentically Mongol era reformulated according to the tenets of Tibetan Buddhism; these can be read in the structure of lineage, reincarnation, and cultural rebirth inherited from Chinggis, Khubilai, Altan Khan, and others, which they worked to distill and sustain.

THE MANY FACETS OF THE MONGOL RESURGENCE

We have attempted in this catalogue to present as broad a view of Mongolian life as possible, because Mongolia's renaissance, while primarily played out in a Buddhist context, was born of a complex mix, partly native and non-Buddhist, partly Tibetan, Chinese, and Central Asian. Even today many Mongols still live as pastoral nomads, leading their herds of sheep, goats, horses, camels, and yaks from summer to winter pasturage, but in centuries past they had little choice, for the harsh steppe and desert of Outer Mongolia provide little opportunity for sedentary agriculture. Their daily lives are the subject of James Bosson's essay "Who Are the Mongols, and Why?" Taking a linguist's perspective, he shows how the Mongols emerged as a people and how their language reflects their truest concerns. Their vocabulary for the horse, without which their lives would be impossible, is more precise than any other in the world. He also details how the Mongols have created a rich and varied culture from raw materials that seem limited and impoverished from a modern, materialistic, Western point of view, and how, by working in harmony with the seasons, Mongols have managed to avoid the subterfuges and alienation of urban life.

The nomadic life has naturally had an impact on the art of Mongolia, both limiting it in terms of scale and promoting finesse and a high regard for detail. Most of the monasteries in Khalkha were at least seminomadic; permanent temples were designed in a Chinese or Tibetan style, but monks lived in encampments of felt *ger* (yurts) provided by their own families, just as every other Mongol did, high or low, and they often migrated with the seasons, returning to their monasteries to stage seasonal rituals.

Like many other nomads, the Mongols have concentrated their personal wealth in jewelry and other portable, precious objects. But even as Mongol women adorned themselves with massive, architectonic headdresses that proclaimed their status, wealth, and tribal affiliation, contact with China and Tibet moved the Mongolian people to build immense monastic establishments on the steppe, such as Erdeni Zuu, founded by Zanabazar's great-grandfather, Abadai Khan, and Da Khüree (Urga or modern Ulaanbaatar), Zanabazar's own partly nomadic monastery, and to fill them with sometimes colossal images of Buddhist deities.

In "Mongolia: From Chinggis Khan to Independence" Morris Rossabi recounts the evolution of the Mongols from scattered, nomadic herders into a powerful confederation, which, under the charismatic leadership of Chinggis, his sons, and grandsons, came close to conquering the entire known world. Here we see the growth of the Mongols' empire, which flowered most impressively in the thirteenth century under Khubilai Khan in China and then rapidly waned, but continued well into the sixteenth century in Russia and the Near East. Rossabi contrasts the historic Western view of the Mongols as monstrous barbarians with the true sophistication of their communications systems, their strategies of warfare and overlordship, their promotion and assimilation of culture throughout their vast empire, and their devotion to Tibetan-style Buddhism. He describes the details of Mongolia's political resurgence in the sixteenth and seventeenth centuries, the confluence of purpose that led to the choice of the boy Zanabazar as Khalkha's first incarnate Buddhist ruler, his installation as the First Jebtsundamba Khutuktu (M: Bogdo Gegen) of Urga by the Great Fifth Dalai Lama, and his subsequent career through seven more incarnations.

My essay "After Xanadu" lays out some of the symbolic underpinnings of the Mongol resurgence and cultural renaissance, describing how Mongol leaders of the sixteenth and seventeenth centuries borrowed from and reinterpreted the legacy of Chinggis and Khubilai, how they utilized Tibetan ideas of incarnation and rebirth to legitimize their claims to power, and how their ideas were translated into visual form. Zanabazar's reuse of the classic Nepalese style first adopted by Khubilai Khan to demonstrate his empire's solidarity with the powerful Buddhist institutions of Tibet

suggests that the protagonists of the Mongol resurgence were thoughtful, self-conscious, and sensitive to historic facts and to the power of myth. Similarly, Zanabazar's promotion of the rites of the Dalai Lama's reformist Gelug order, in particular the millenarian Maitreya Festival, which enacts the arrival on earth of the Future Buddha, was part of a program designed to encourage the dawn of a new age of Mongol greatness. At the same time, he and other pundits of Outer and Inner Mongolia, in cooperation with the Buddhist Manchu emperors of China, worked to integrate native Mongolian shamanist figures into the infinitely accommodating Buddhist pantheon, which eventually came to include the spirits of Khalkha's sacred mountains and even the avowedly non-Buddhist Chinggis Khan.

Terese Tse Bartholomew follows with an essay on Mongolian style, analyzing the hitherto undifferentiated (and still huge) body of painting, silk appliqué, and metalwork that can be found in the monasteries and museums of Mongolia today. She separates metalwork according to technique (cast or repoussé) and style into three major schools—Outer Mongolian, Inner Mongolian, and Sino-Tibetan or Tibeto-Chinese (i.e., made in China for use in a Tibetan-style Buddhist context). Bartholomew shows that although the main source of inspiration for Outer Mongolian artists, such as Zanabazar, came from exposure to the classic traditions of the Nepalese Newari metalworkers, who were refurbishing Tibet's monasteries under the inspirational Great Fifth Dalai Lama, the Outer Mongolian church was open to influences (and gifts) from all sides and was part of a spiritual realm that can be called Greater Tibet. Thus some of the finest works in Outer Mongolian collections today were actually made at the order of the Manchu Chinese court and sent as gifts to Zanabazar and his seven successors, the powerful, incarnate line of the Jebtsundamba Khutuktus of Urga, while in the nineteenth century, the lightweight, often colossal repoussé metalwork of Inner Mongolian Dolonnor, the seat of the great Inner Mongolian incarnate-lama, the Jangjya Khutuktu, was shipped all over Southern and Northern Mongolia, China, and Tibet.

Nowhere does Mongol internationalism demonstrate itself so clearly as in the complex evolution of its written language. Buddhist doctrine was transmitted in Mongolia largely but not exclusively in Tibetan, and the scripts used to write the Mongolian language have been borrowed, notably from Central Asian Uighur, a Turkic language, or, in modern times, Russian Cyrillic. James Bosson provides us with a history of Mongolian script and its myriad forms, tracing its development from the earliest extant stone inscriptions through the Cyrillic alphabet of the Soviet era, now officially discarded in favor of traditional Uighur-derived script. He also discusses some of the more creative experiments in Mongolian script, the cumbersome square script invented by

Phagspa, Buddhist preceptor to Khubilai Khan, and Zanabazar's own Soyombo, neither of which had very wide currency. However, both Phagspa's and Zanabazar's efforts show that the Mongols have perceived their dependence on imported writing systems as an inhibition to complete cultural independence. The recent move toward script reform is only the latest in a historic series of efforts to liberate the national language and make it a symbol of Mongol identity.

THE CATALOGUE

The 115 works included in *Mongolia: The Legacy of Chinggis Khan* are mostly but not entirely Buddhist, chosen with an eye toward illuminating the Buddhist character of the Mongol resurgence, as well as its secular context. We have arranged them into six sections, each with a short, prefatory essay. The first section covers the nomadic arts and includes objects generally used in everyday life—saddles, serving vessels, and jewelry—but even here, the line of distinction between secular and sacred is blurred, for one of the saddles, the most sumptuous, belonged to a high lama, who, like everyone else, rode on horseback.

The other five sections reveal, from the outside in, the multilayered, complex structure of Mongolian Buddhism, beginning with the concept of reincarnation and the outward signs of lineage and authority assumed by Outer Mongolia's greatest incarnate-lamas, the Jebtsundamba Khutuktus of Urga. A section on Buddhist public festivals, filled with the brilliant masks used in the sacred *tsam* dance and the ritual paraphernalia of the Maitreya Festival, illustrates the special ritual emphasis Mongolian Buddhism placed on the pacification and conversion of local deities and on Mongol hopes for a new, utopian Buddhist age. A selection of Buddhist manuscripts with sumptuous covers, drawn from the collection of the State Central Library, includes volumes in Tibetan and Mongolian made in Mongolia, as well as multilingual books sent as gifts from the Manchu court. Lewis Lancaster provides an introduction to this section, discussing the dissemination of the Buddhist canon and the particular importance in daily monastic life of the *Astasahasrika Prajnaparamita*. The huge pantheon of Tibeto-Mongolian Buddhism appears in paintings, silk appliqués, cast and repoussé metal sculpture, wood carving, and papier-mâché, which Mongol Buddhists encountered in monasteries and used in their private devotional practices. Heather Stoddard describes a sacred world of infinite complexity and flexibility, showing how different orders of Tibetan Buddhism emphasized different groups of deities and how the Mongols tamed their own shamanist spirits through conversion and integration. Both the catalogue and the exhibition are brought to a close with the works of the subtlest of all exponents of Mongolian Buddhist art, Zanabazar, who provided the monaster-

ies he built with works of the rarest insight, true to the tradition he inherited, yet perfectly fresh, designed to encourage and lead the devoted in their personal searches for Buddhist enlightenment.

SOURCES FOR A HISTORY OF MONGOLIAN ART

What little art remains from the classic period of Mongolian history, when Chinggis and his offspring ruled most of Asia, shows how broadly international Mongol tastes were, accommodating local styles in every corner of the empire. This phenomenon has been amply studied in the old Mongol domains of the Near East, where miniature painters elegantly depicted Mongol princes and their wives enjoying the pleasures of their gardens, and in India, whose Moghul rulers, descendants of the latter-day Turko-Mongol conqueror Tamerlane, created a new, sumptuous, courtly style. In Chinese-controlled Inner Mongolia, the remains of a series of ancient, nomadic cultures—the Xiongnu, Xianbei, Khitan, and Jurchen—all precursors of the Mongols, have been found in abundance and were recently presented in the traveling exhibition *Empires beyond the Great Wall: The Heritage of Genghis Khan*. In notable contrast to their predecessors on the Inner Asian steppe, the Mongols appear in that exhibition as a group of consumers rather than as artists in their own right, purchasing luxury goods from their neighbors and making very little of their own.

The Mongol transformation of Chinese art in the Yuan dynasty, beginning with Khubilai Khan, has been documented by Heather [Karmay] Stoddard, whose *Early Sino-Tibetan Art*, published in 1975, was the first systematic survey in the West of artistic exchanges between the Mongol court and Tibet's great monasteries. She showed that the art the Mongol court officially subsidized, including illustrated printings of the Buddhist canon and large-scale monuments like the Juyong Gate north of Beijing, was again the work of hired hands—Nepalese, Tibetan, and Chinese—and that it was intended to reach a multiethnic audience, truly imperial in scope. The Himalayan transformation of Buddhist art during the Yuan was part of a larger, politically motivated strategy Khubilai and his successors employed to maintain control over Tibet and China's hinterlands, while finally remaining aloof from the Chinese Buddhist church.

Sherman Lee and Wai-kam Ho struck a similar note with the exhibition *Chinese Art under the Mongols: The Yuan Dynasty*, held at the Cleveland Museum of Art in 1968, which showed clearly that even if the Mongols were not artists during their Chinese years, neither were they merely passive consumers of Chinese art. Instead, they used the ceramics, lacquers, and other crafts whose makers they patronized for their own purposes of dynastic promotion and preservation, and their particular tastes ultimately widened the gap between themselves and those they ruled. The degree to which China's Mongol rulers alienated the Confucian elite, who in turn produced paintings and poetry expressing their disillusionment and withdrawal, is another strand in the story of Yuan art, one that has been recently softened by studies of appreciative connoisseurship and collecting of Chinese paintings among members of the Mongol imperial clan.[2]

The fall of the Yuan and the Mongol retrenchment north of the Great Wall after 1368 was a cataclysmic event; despite efforts to rebuild a capital at Bars qota in Inner Mongolia, the empire's glory days in East Asia were clearly over. The massive dislocation this retreat created also ended Mongolia's relationship with the Buddhist church in Tibet, and most of the luxurious works of art commissioned by the Mongol khans were dispersed and ultimately lost. From this period through the beginnings of the Mongol resurgence in the mid-sixteenth century, Mongolia temporarily receded from East Asian consciousness.

This dislocation has made it difficult to reconstruct the foundation upon which Mongolia's cultural renaissance was built. Although traditional histories—Mongol, Tibetan, and Chinese—are full of reports of Anige, Khubilai's prodigious and prolific Nepalese artist and an originator of the Sino-Tibetan style, it was only recently that any extant works were attributed to his hand, and most of our insight into Mongol Buddhist art has been based on woodblock-printed sutras, an occasional monument in stone, and examples of twelfth- and thirteenth-century Nepalese art, the acknowledged source of the Yuan dynastic style. The true Buddhist imperial symbols—Khubilai's Mahakala, made by Anige to fend off the Southern Song, and Phagspa's golden Mahakala, returned to the Chahar Mongol khan Ligdan in the seventeenth century and later ensconced in Mukden as the palladium of the Manchus—have all disappeared.

There is no lack of art in Mongolia today (and in Russian collections) from the period of the Mongol renaissance, the sixteenth through the eighteenth centuries, but what remains has, like the Mongolian people themselves, gone through many dislocations, including the raids of the Zunghar Galdan in the late seventeenth century and, in the 1930s, the complete obliteration of Buddhism, when, by government order, monasteries were systematically burnt to the ground. With the execution of tens of thousands of monks and the loss of most monastic records, these purges also wiped out witnesses to the way things were, leaving the Mongolian people without a cultural memory. One of Mongolia's leading art historians, the painter N. Tsultem, recently told us that the history of Mongolian art has to be completely rewritten, if not re-created, a difficult, almost impossible task when the provenance of most works of art has been lost and when their sources, iconographic and stylistic, are so complex.

So what does this leave us with? The unflagging records

of the Chinese court through the Qing dynasty report on interchanges with the Jebtsundamba Khutuktus of Urga and other great prelates of Mongolian and Tibetan Buddhism, as do the records of Tibet's great monasteries, the regular goal of devout Mongol monks, and the biographies of notable lamas, among them the Jangjya Khutuktu Rolpay Dorje, who presided over the monasteries of Dolonnor in Inner Mongolia. Mongolia's own histories, such as *Erdeni-yin tobči,* written by Saghang Sečen in about 1662, the mid-nineteenth-century record of the Jebtsundamba Khutuktus translated by Charles Bawden, and Dharmatala's *Rosary of White Lotuses,* which documents the history of Buddhism in Mongolia up to the late nineteenth century, all contain fragmentary references to Zanabazar's artistic career, which happily can often be connected to his extant works.

Firsthand accounts of the early travelers who journeyed through Mongolia abound, from the medieval monks William of Rubruck and Giovanni dal Piano del Carpine, and the merchant Marco Polo, to the nineteenth-century Russian Mongolist Aleksei Pozdneyev, whose eyewitness reporting of the waning years of Mongolia's Buddhist-dominated state, interspersed with learned retellings from traditional histories, is a mine of art-historical information. Journals of diplomats and adventurers, such as the Russian ambassador Iwan Korostovetz and the American eccentric Beatrix Bulstrode, who rode into Mongolia in full Victorian rig, are valuable for their insights into Mongolian personalities, and, in Bulstrode's case, for her occasional misinterpretations of Mongolian customs. In our century, the Swedish explorer Sven Hedin and his team, and the American Owen Lattimore also traveled extensively throughout Mongolia, recording everything from geological data to the details of daily life. Hedin brought a vast amount of art, mostly Inner Mongolian, back to Sweden with him; it is now housed in the Folkens Museum in Stockholm. Another major collection of Mongolian art was brought back to Denmark by the Henning Haslund-Christensen expeditions of 1936–39 and is in the Nationalmuseet in Copenhagen, which has recently republished a catalogue of its Mongolian costumes.[3]

Since breaking away from the Soviet Union in 1990, Mongolia has actively worked to reconstitute its cultural heritage, through cataloguing, publication, conservation of works of art and architectural monuments, and through international exhibitions. A number of exhibitions in Europe and Japan have preceded this one and made our path clearer, notably the comprehensive German *Die Mongolen,* with hundreds of objects borrowed from Mongolia's state museums and an authoritative two-volume catalogue covering a myriad of topics, and the Musée Guimet's *Trésors de Mongolie,* which concentrated on the work of Zanabazar, placing him in the wider context of Tibetan Buddhist art. The time has clearly come for Mongolia to abandon decades of isolation and present itself once again on the world stage.

THE MONGOL MYTH

On 18 November 1797 Samuel Taylor Coleridge lay slumped in an opium-inspired reverie in an English village thousands of miles from Mongolia. When he awoke, his head was filled with a poetic vision of "Kubla Khan," which he feverishly transcribed, only to be interrupted by the famous but mysterious "person from Porlock," who had come to discuss business. The poem Coleridge left us is an elliptical, apocalyptic fragment that presents in visionary shards an image of the great Khubilai as a failed genius, a ruler whose imperial plan is about to be brought to an unsettling end.[4] Coleridge's "Kubla Khan" is so well known—it is one of the poems that ushered in the modern age—that its image of the Mongol khan has overriden all others in the Western mind.

"Kubla Khan" is the record of a dream-state, but it was a well-informed dream, for Coleridge was extremely learned and was one of the most sophisticated religious thinkers of his day, deeply involved in the controversy that swirled in Germany and England over the nature of the Bible—was it revealed truth or lyricized mythology? His Khubilai is thus transposed into a generalized Oriental setting, with biblical, Edenic overtones, where he experiences the last, chaotic days of his empire.

None of this is historic fact, for Khubilai, as we will see in the course of this volume, presided not over the end of the Mongol empire but over its birth. From the Western perspective, however, Coleridge's "Kubla Khan" rang true, because it was tinged with a residue of historic memory. During the medieval crusades, as European Christianity faced off against the Muslim conquerors of Jerusalem and Armageddon seemed nigh, the Mongols appeared at the Danube and threatened to bring the world to an end. Multinational armies were mounted against them and obliterated, the Catholic pope dispatched emissaries to attempt an alliance with them against the forces of Islam, but to no avail. Small wonder that this seemingly invincible, intractable force grew in the Western mind to mythic proportions. They were the innocent arm of God, brought to destroy a world drowning in sin, then Gog and Magog, the "final flick of the dragon's tail,"[5] and finally, with the death in 1241 of Ögödei Khan, Chinggis's son and successor, and the ensuing Mongol retreat to their Asian heartland, they were imagined as the denizens of an enlightened kingdom which bore some resemblance to a preadamite utopia. It is an extraordinary coincidence that just as Coleridge was placing them at the center of his own vision of the apocalypse (and the dawning of a new age), the Mongols had also creatively reconstructed their own past in the hopes of fulfilling a Buddhist (if not a Christian) utopian dream.

This is the burden of myth the Western viewer brings, consciously or not, to an encounter with the Mongols. *Mongolia: The Legacy of Chinggis Khan* presents a singular oppor-

tunity for each of us to compare the myths we have inherited with the ones that inspired them.

NOTES

1. Devin DeWeese, "The Influence of the Mongols on the Religious Consciousness of Thirteenth-Century Europe," *Mongolian Studies* 5 (1977–78), 41–78.

2. Marsha Weidner, "Painting and Patronage at the Mongol Court of China" (Ph.D. diss., University of California, Berkeley, 1982); "Aspects of Painting and Patronage at the Mongol Court, 1260–1368," in Chu-tsing Li, ed., *Artists and Patrons: Some Social and Economic Aspects of Chinese Art* (Seattle: University of Washington Press, 1989), pp. 37–59.

3. Henny Harald Hansen, *Mongol Costumes: Researches on the Garments Collected by the First and Second Danish Central Asian Expeditions under the Leadership of Henning Haslund-Christensen, 1936–37 and 1938–39* (repr.; London: Thames and Hudson, 1993).

4. The literature on this poem is vast. For two very different analyses, see E. S. Shaffer, *"Kubla Khan" and the Fall of Jerusalem: The Mythological School in Biblical Criticism and Secular Literature, 1770–1880* (Cambridge: Cambridge University Press, 1975); John Livingston Lowes, *The Road to Xanadu: A Study in the Ways of the Imagination* (Princeton, N.J.: Princeton University Press, 1927).

5. DeWeese, "The Influence of the Mongols on the Religious Consciousness of Thirteenth-Century Europe," p. 43.

Who Are the Mongols, and Why?

JAMES BOSSON

THE PEOPLE AND THE LAND

Stretching across the Eurasian continent from Manchuria to Hungary in a practically unbroken continuum is a wide band of steppelands and semidesert. This geographical region varies in altitude from six-thousand-foot-high plateaus to nearly sea level. Imposing mountain ranges are found in portions of this landscape, but there are passable corridors throughout the terrain (fig. 1). This geography has various names across the vast area it covers. Some have entered the international vocabulary, such as *grasslands* and the Russian word *steppe* or the Hungarian *puszta;* others, though used in a wider area, have not, such as the Mongolian *keger* or the Qazaq *dala.*

One of the outstanding characteristics of these plains is the facility with which a traveler can cover long distances. And the traveler is, in fact, often forced to cover long distances to get from one source of water to another, or from one good source of pasturage to another. But to utilize this terrain in a rational way requires more than pedestrian movement if one is not to succumb between one water source and the next. Yet the perfect means of conveyance for this terrain is known to have existed here since prehistoric times—the horse. This beautiful, strong, versatile, and supple conveyance makes life on the plains economically viable; the immobility of a settled agricultural life is not a possibility.

From the earliest times, various peoples have moved throughout this area, developing one of the most exemplary forms of pastoral nomadism on earth. The early history of these peoples is known mainly from archaeological finds. Historical accounts have been preserved only when their activities—commercial or military—encroached on surrounding sedentary cultures that were able to compile records of these contacts, describing the organization, mores, and some names connected with the nomads. These

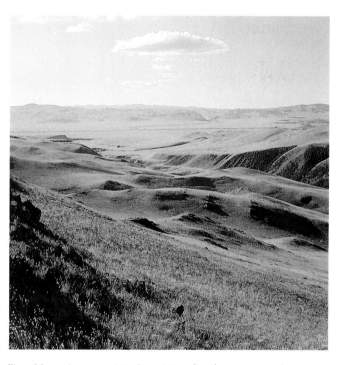

Fig. 1. Mountainous terrain in Outer Mongolia. Photo: Gary Tepfer.

records seldom contained a detailed description of the nomads but dealt only with actions and features that were either an advantage or an irritant or danger to the sedentary groups. This is particularly true of the Chinese records.

As a result, we have the names of peoples who invaded the territories to the south and west of the Central and Inner Asian steppe, but we do not know in most cases who these people were ethnically or what languages they spoke. A well-known example is the existence of the powerful state of the Xiongnu-Huns, which spread over the vast area of Inner Asia from North China to Central Europe and lasted for over five centuries, from about the first century B.C. to the fifth century A.D. Yet we know little of the ethnic origin of

the Huns. Information taken from the extremes of their geographic and temporal borders, not surprisingly, can seem quite contradictory. A number of reported names and titles can be convincingly construed as Turkic words, yet the evidence is not conclusive. Even the only example connected to a context is ambiguous. This is the famous so-called Xiongnu Distich (a two-line verse) from the early fourth century, which was recorded in the Chinese historical text *Zhoushu*.[1] Here the Xiongnu (or Hunnic?) text is presented in ten Chinese characters that represent a phonetic transcription of the verse, and a terse Chinese translation. On the basis of this translation and a reconstruction of the phonetic value of the ten characters, several leading Turkologists have presented their own—and divergent—suggestions for the original text in Old Turkic. However, other linguists, in a tour de force, have presented almost equally convincing readings in other, totally unrelated languages. It is widely held that the Xiongnu-Huns were a Turkic people, and this makes good sense in many respects. Yet another group of the Xiongnu, called the Xianbei, are considered to be Mongols (or proto-Mongols).

The answer to the mystery is that we are dealing with nomadic societies. They were not national and linguistic units, and they were not tied to the ground within specific borders. They were not states in the sense that we are used to in sedentary societies. They were confederations, and these confederations were made up of a changing composition of clans, which either had allied themselves with a dominant nuclear clan or clans or had been defeated in warfare and were then incorporated into the body of the confederation. They were not necessarily linguistically identical, but they were culturally identical insofar as they were nomads and had an economic, social, and military organization that was compatible with that of their conquerors. One of these features was that their military organization consisted of units of tens, hundreds, thousands, and ten thousands, and the leaders of each of these units had taken an oath of allegiance that tied them through the chain of command to their khan. Upon conquest the khan and his top commanders were eliminated and a new oath was administered that effectively tied the clan-army to the khan of the victorious clan or confederation. Thus, in one sweep, his army grew by geometric progression. The new troops were all trained equestrians and archers, they had their own mounts and weapons, and they were all trained in essentially the same tactics as the soldiers of the conquering army. No blood baths, no prison camps, no huge expenditures were required, and it was to the advantage of the new troops to belong to a victorious army that promised rich shares in future booty. In the nomadic tradition, the wives, children, and livestock of the soldiers slowly followed the army and joined them for the long winter encampment. With this support, the ever-growing armies could advance in any direction without needing long and costly supply lines, and the soldiers were, for a large portion of the year, surrounded by their families, thus avoiding the restlessness that longing for their loved ones could cause.

Another reason for the adaptability of the nomadic troops was the lack of a romantic and emotional devotion to a specific spot of ground and a set line of borders. Certainly they had an attachment to the area of their birth, but their sense of nationalism was movable and expandable. In fact, these peoples had no linguistic suffix that identified a national geographic entity. When such terms were later applied to their nations, the suffixes were all borrowed from other cultures and languages, for example, Qazakh*stan*, Türkmeni*stan*, Mongol*ia*, and Türk*iye*. Their state terms, such as *il* or *ulus*, meant only "confederation" and did not tie them to any one locality.

It is little wonder, then, that scholars who have studied the early history of Inner Asia have felt a frustration and a sense of moving through a morass, where things slid out from under them and where they had difficulty pinning identities to specific places and peoples. These confederations were often not homogeneous; they were always shifting. As one might expect, many of these confederations carried names that included numerals, such as *Toquz Oghuz*, "The Nine Oghuz"; *On Uighur*, "The Ten Uighur"; *Naiman*, "Eight"; *Tümed*, "Ten Thousand." It is exactly this suppleness and mobility that allowed exceptional nomadic rulers to suddenly spring on an unsuspecting sedentary world and paralyze it by the unexpectedness of their explosive expansion.

The people we have come to know as the Mongols did not, of course, appear from nowhere. Most likely they had already appeared in recorded history many times, but under names that we cannot unequivocally identify with them. The Xianbei who are mentioned in Chinese histories toward the later part of the Xiongnu era are widely assumed to be Mongols making one of their first appearances on the historical scene. It is also not impossible that the Mohe, who were mentioned around the Three Kingdoms period (5th–9th centuries A.D.), when the Korean state was formed, were the first group to carry the ethnonym *Mongol*.

It is, however, most likely that the Khitan confederation that conquered North China and established the Liao dynasty (916–1125) was a Mongol-dominated confederation. And, with that in mind, it is not quite as difficult to account for the sudden rise of Mongol power under the leader Temüjin, who later was given the title Chinggis Khan.[2]

In the middle of the twelfth century the Mongqal were established as a clan group. For this we have historical sources, and for the first time we can go back to native sources, not foreign ones with ambiguous transcriptions of names.[3] It was this clan that Temüjin inherited from his

father. At the time, the clan was much reduced. It was at the bottom of its fortunes and can only be described as a handful of people. From these humble beginnings, and with great difficulty, Temüjin was able to start consolidating and spreading his power, until in 1206 at a nomadic congress by the Onon River, not only was he confirmed as khan with the title Chinggis, but the whole confederation adopted the name *Mongqal,* which has become fixed as the name of the Mongol language and the Mongol people. It has even come to designate one of the most populous races of the world—the Mongoloid race.

Chinggis Khan forged his confederation in the traditional pattern of nomadic confederations, and it came to contain clans from other linguistic groups and backgrounds, but the designations *Mongol* and *Mongolian language* remained fixed even after the small number of Mongols were far outnumbered in the body of the confederation by Turkic peoples. The confederation eventually stretched far enough over the northwestern route to lend its name to the Moghul empire in India.

One term from this period has become the only Mongolian loanword to be fully acclimatized in the English language: *horde.* Batu, one of the grandsons of Chinggis Khan, inherited the fiefdom of the southern Russian steppe, where he established his command encampment called Altan Hordu, which in Western languages became known as the Golden Horde. In Mongolian this simply meant "Central Palace," in which the term *golden* was a word connected with the color designations of the points of the compass, in this case, "the center." This system of designating the points of the compass with colors was widely used in Central and East Asia. Hence we have geographical names such as "the Red Sea," "the Black Sea," and so forth. The term for "palace" became identified with the troops commanded from there—in English it became *horde, hordes;* in Turkish, *ordu* (army); and in the Indian subcontinent it became the name of the army language, *Urdu.*

The linguistic origin of the word *Mongol* is not at all clear. In the Mongolian language itself there is no apparent etymology for the word. A number of attempts have been made to identify it. Some are based on folk etymology, and some merely fanciful. One suggested etymology, including the Tungusic plural suffix, *-l,* ties the name to the Amur River, which geographically is not at all impossible for the early period. This would also tie the name to a possible origin of the ethnonym *Manchu,* without implying any blood relationship between the two peoples.[4]

INNER AND OUTER MONGOLIA

Part of the difficulty in studying this region of the world stems from the place names used to describe geographic regions. In many contexts the designations *Inner Mongolia* and *Outer Mongolia* are used, and as they often confuse the general reader, it would not be out of place to give an explanation of them here.

Of the vast empire that Chinggis Khan and his descendants bequeathed to their people, the steppe-dominated heartland—stretching from the Khailar River in the east to the Ili River in the west, from the Great Wall in the south to Lake Baikal in the north—could be termed Mongolia proper. It was here that the greater part of the Mongolian soldiery returned as the empire deflated. Yet even back on their home ground, the Mongols were not at peace. In general, the balance of power was maintained by continual wars between the Eastern and the Western Mongols. (Only once, for a period in the latter part of the fifteenth century, a descendant of Chinggis Khan, Batu Möngke, under the title Dayan Khan, restored the Chinggisid khanship over a confederation including all the Mongols.) By the late sixteenth and early seventeenth centuries, the Ming dynasty had declined in power and was threatened from the northeast by a new confederation, which was growing steadily stronger and more menacing. These were the Manchus, under the leadership of Nurhaci, whose power was considerably increased by the expert cavalry of Southern Mongol clans, which either had allied themselves with the Manchus or had been conquered by them and incorporated into their confederation. This union led to their conquest of Beijing and the downfall of the Ming dynasty, whereupon the Manchu rulers founded the Qing dynasty in 1644. Subsequent Manchu warfare throughout North China and Southern Mongolia resulted in the defeat and the forced alliance of all the Mongols adjacent to the Great Wall and up to the southern Gobi Desert. This in effect stretched the borders of the Qing dynasty to the Gobi.

The Mongols of Northern Mongolia were now faced with alternately fighting Qing troops from the south and Western Mongol troops from the west. As a defensive device, all these Eastern Mongols formed a new alliance, which they named Khalkha (Qalqa). This means "shield" and symbolized their struggle against Qing encroachment from the south.

Thus it was from this time that a distinction was made between the Southern Mongols, who were by now Qing subjects and within the borders of the Qing empire, and the Mongols of the Khalkha confederation, who were outside that border. This separation is reflected in the terms *Inner* (within the wall) and *Outer* (outside the wall) *Mongolia.* The Mongols themselves also made this distinction but used the terms *Öbür Mongghol* and *Aru Mongghol,* which mean literally "Southern (or front) Mongolia" and "Northern (or back) Mongolia."

By 1691 the Khalkha Mongols were so pressed by their

two enemies that they submitted to Qing rule. The terms *Öbür Mongghol* and *Aru Mongghol,* however, persisted and are still in use today, although *Outer Mongolia* is no longer an official term (even though that part of Mongolia again fell outside the border in 1911). After more than four decades of being called *Bügüde Nayiramdaqu Mongghol Arad Ulus,* "The Mongolian People's Republic," the country now simply has the name *Mongghol Ulus,* "Mongolia," or "The Republic of Mongolia."

THE MONGOLIAN LANGUAGE AND ITS SPEAKERS

After the great expansion of the Mongol empire and its sub-sequent collapse, the majority of the Mongols returned to the Inner Asian region that one may identify as Greater Mongolia. Here they settled back into their normal pastoral life, with far fewer military actions. One of the consequences of the mobile nomadic life is the frequent contact with speakers of other dialects; as a result, most of the Mongols are able to speak to each other with functional intelligibility.

The Mongolian language is considered to belong to the Altaic language family, of which the other main branches are the Turkic and the Manchu-Tungusic languages. Some level of Old Korean is probably also related, and the relationship may even reach as far as some strain of Old Japanese, in the opinion of some linguists.[5] There are a few small dialects on the fringes of the Mongolian linguistic area, separated from the main linguistic community, which one might think of as island dialects.[6] But on the whole, there are four main dialects (fig. 2).

> 1. The Western, or Oirat, dialects are spoken in the far western districts of the Mongolian Republic; in the Alashan, Qinghai, and Xinjiang regions of the People's Republic of China; and in Kalmuckia, between the Caucasus and the lower reaches of the Volga. Special scripts are used for these dialects.
> 2. The Buriat dialect is spoken in Buriatia, within the borders of Russia, to the west, east, and south of Lake Baikal. Buriat has developed into a separate literary language with its own grammar, for which two distinct scripts have been developed.
> 3. The Khalkha dialect is the main dialect of the Mongolian Republic and the dialect on which the official language of the republic is based. Culturally, this has been the most influential of all the Mongol dialects.
> 4. The Inner Mongolian dialects, or the main non-Oirat dialects of Inner Mongolia, within the borders of the People's Republic of China, have many features in common that make them distinct from the other main dialects, but the speakers of these are fully able to communicate with the speakers of, for example, the Khalkha

Fig. 2. Territories of the tribes and peoples of Mongolia.

dialect. Until today the literary vehicle of these dialects has been the traditional (also called classical) Mongolian vertical script, which, due to its ancient orthography, supersedes or blurs dialect differences and thus serves as a perfect linguistic-cultural unifier of the Mongolian language.

The different dialect regions of Mongolia are also defined by some material and stylistic differences that are clearly discernible in some of the objects in this exhibition (see cat. nos. 1–3 and 7–13).[7]

THE NOMADIC PASTORAL LIFE OF THE MONGOLS

Daily life for the Mongols, like that of most other peoples, has naturally changed with the passage of time. The life-style described here has very little to do with the daily life of, say, an office worker or a rock-band singer (and they do exist) today in Mongolia's capital, Ulaanbaatar. Yet the description is still valid for the majority of the Mongol population, who live close to their animals and close to the steppe. Traditional life has been preserved owing partially to the landlocked situation of Mongolia—which has also resulted in Mongolia's having the world's most typical continental climate (i.e., a climate typified by an extreme diurnal and

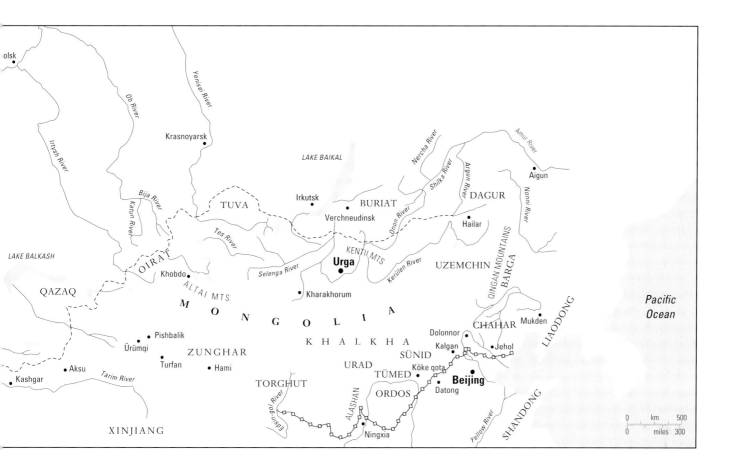

annual range of temperature; it is not unknown for temperatures to go from 70–80° F in the daytime to below freezing at night)—and partially to Mongolia's long political and commercial isolation from the rest of the world. Thus, no matter how modern and metropolitan the daily life of the above-mentioned rock star may be, it is not unlikely that he is a first- or perhaps second-generation city dweller, and that he owns a number of horses and sheep, perhaps also a felt yurt (*ger* in Mongolian), which remain in the care of his family out on the steppe, where he returns for vacations and holidays.

Sources for traditional life in Mongolia prior to the time of Chinggis Khan are few. Much of what we know about the period of empire building comes from the oldest extant Mongolian history, *The Secret History of the Mongols,* which was composed in 1240. From a slightly later period we have the reports and travel descriptions of Europeans who visited Mongolia on diplomatic and religious missions. These include the accounts of John of Plano Carpine (Giovanni dal Piano del Carpine; known in Latin as Plano Carpini), a Franciscan monk of Italian origin sent by Pope Innocentius IV on a journey that took two years, 1246–48, and another Franciscan monk known as William of Rubruck, probably a native of Flanders, who was sent by the French king Louis IX (known as Saint Louis) on a mission that lasted from 1253 to 1255. The manuscript of William's report, addressed to his king, was first published in London by Richard Hakluyt three centuries later, in 1598.[8] The most famous of these travelers' accounts, of course, is that of the Venetian Marco Polo, who traveled east for personal and commercial reasons.

These reports, valuable or, rather, invaluable as they are, necessarily view the nomadic society from an outside, sedentary perspective. William of Rubruck, for example, paid great attention to the artificial and newly founded capital of the Mongol empire, Kharakhorum, but he also noticed many aspects of nomadic life on his journey to and from the capital. Among other things, he described the predominantly dairy-based diet of the Mongols. He found the milk product he called *cosmos* particularly pleasing. This can be none other than the beverage we call koumiss, prepared by fermenting mare's or cow's milk. Yet his use of this particular term shows that his interpreters used a Turkic language, because *cosmos* obviously represents the Turkic word *qïmïz,* rather than the Mongolian word *airag.* He also mentions a taste for *cara cosmos,* the distilled product of *cosmos,* akin to vodka.

During the eighteenth and nineteenth centuries a series of travelers and naturalists published books that contained detailed descriptions of Mongolia and the Mongols. Since there is no evidence that nomadic life in earlier centuries was substantially different from the way it was lived a century or two ago, these texts, faute de mieux, can be used as a basis for a general description of Mongolian nomadism.

The Mongols who returned to their homeland after the collapse of the empire went home to an almost total dependence on the pastoral economy.[9] Former military commanders and high-level officers formed a sort of nobility, and lower-echelon officers were absorbed into the general citizenry. These two groups were distinguished by owning more livestock and probably more of other kinds of possessions, but essentially everyone in the society led a similar lifestyle and participated in normal daily activities. These activities were traditionally divided between men and women, old and young, and not so much between nobility and commoners, or wealthy and poor. This is not to say, however, that there was not a hierarchy and that commoners did not owe their khans and princes certain corvée duties (*alba* in Mongolian) and taxes. But it was not a society in which the lord had unlimited power to seize the livestock of his people or to control arbitrarily where they nomadized, nor had he a natural claim to the products of his subjects' livestock. No sources state that the common Mongol herded other people's cattle while under the rule of his own khan. Livestock was the property of the herdsman, and he husbanded it as best he could.

What I have stated here differs considerably from the thesis of an often-quoted book on the social organization of the Mongols, which is subtitled *Mongolian Nomadic Feudalism,* a book that has had much influence on subsequent writing on the subject.[10] The author, Boris Vladimirtsov, was a member of the Soviet Academy of Sciences and is rightfully admired for his profound knowledge of the Mongolian language and the brilliant work he produced on Mongolian linguistics and literary studies. Yet, in a misguided attempt to apply Marxist theories wholesale to early Mongolian society, with very little supporting material from historic sources,[11] he constructed a shadow "feudal" society that exactly fit the pattern of medieval European feudal societies.

Vladimirtsov's version does not take into account a basic fact of Mongolian life: the seasonal transhumance that provides the animals with the best possible grazing lands year-round. The distance over which this transhumance takes place is dependent on many things, including the nature of the surroundings, the availability of water, and the size of the herds. But, increasingly, political factors have limited the distances of the transhumance.

The herdsmen were subjects of local khans and princes whose territory abutted that of neighboring khans and princes. This decreased the herdsmen's mobility. Clan and family affiliation also confined the herdsmen to traditional territories that could be nomadized by their own people. Yet they did not view themselves as owners of this land; it was land they used for grazing of their animals, pure and simple, and it was not unknown for them to allow the herds of neighboring families to graze on their land when the

others' territory was plagued by unusual circumstances, such as drought or other blights.[12]

Real exploitation and abuse under a rigidly hierarchical nobility began only after the Mongols' submission to the Qing. The areas of transhumance became fixed and limited. The aristocracy was tied to the Qing organization, which in many ways broke with traditional Mongol order. The administrative organization was changed and functioned as a strictly military hierarchy, and Mongol khans and princes were given patents, which tied them by an oath of allegiance to the Qing emperor. They were given a specific rank, accompanied by the right to wear the rank designation—a ball made of a jewel or semiprecious stone or a peacock feather on top of their hats—and this rank corresponded to a Manchu rank, giving them more or less unlimited rights to the possessions of their subjects. This rank also obliged them to pay taxes and tribute to the Qing government. These noble privileges led to heavier burdens on the common Mongol herdsman. At the beginning of the twentieth century it was not unusual for an absentee prince, who had settled into the fleshpots of Beijing and burdened himself with usurious loans, to have the livestock of his subjects seized to pay his increasing debts.

In these circumstances and under the territorial limitations imposed by the Qing government, it became impossible for a Mongol herdsman to be able to move away as he had before. Around 1910, with the many difficulties that beset the Mongol economy, poor herdsmen were reduced to a transhumance of as little as one-third mile. More affluent herdsmen would move over an area of six or twelve miles. In some areas of Mongolia, the distances far outreached these figures, however. Various climatic zones—the desert or semidesert, the steppe, and the mountain-forest—all gave rise to different transhumances. Careful modern studies have been made of the transhumance habits of the herdsmen from all sections of the Mongolian Republic.[13] Most of the distances moved are quite modest, but in the far west transhumance can cover 100–180 miles![14]

In the traditional nomadic pattern there are four seasonal moves, or encampments, one each for winter, spring, summer, and autumn. Not all nomads move through the four encampments; in some areas they move only between the winter and summer encampments.

The larger part of the year—four to five months—is passed in the winter encampment, roughly from November to April (fig. 3).[15] Some nomads even have permanent fixtures such as cattle sheds and corrals in this encampment. In Central Mongolia, for example, the winter encampment is an area fairly well protected from heavy winds; it should also have abundant grass. It usually has no convenient supply of water, which makes it impossible as a summer encampment, but in winter the animals can get enough water

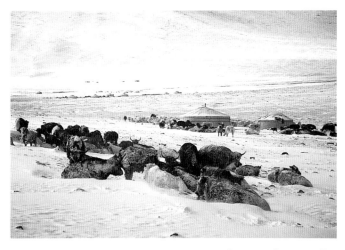

Fig. 3. *Ger* and livestock in a winter encampment. Photo: Cynthia M. Beall and Melvyn C. Goldstein.

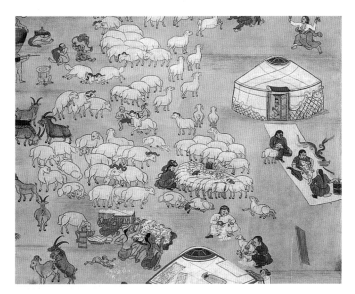

Fig. 4. Shearing and milking of sheep. Detail from *Airag Feast*, attributed to B. Sharav. Mineral colors on cotton, H: 53⅛ (135.0) W: 67 (170.0). Museum of Fine Arts, Ulaanbaatar. From Tsultem, *Mongol Zurag*, p. 163.

Fig. 5. A *ger* encampment. Photo: Kazuhiro Tsuruta.

from snowfall. This is a difficult season, and the livestock are usually quite emaciated and weakened at the end of it. Livestock in precarious condition are kept close to the *ger* and fed on hay. A common New Year's greeting is, "Did you safely bring your livestock into the New Year?"

In March and April, when new grass starts growing in the valleys, the move is made to the spring encampment. This is usually located in a level area to spare the weakened animals the burden of grazing on the slopes.

The summer encampment requires not only good grazing but also a reliable supply of water. This is an important season, lasting approximately from March until the middle of July, for it is then that the sheep are supplying milk. After that date all milk goes to the lambs so they can gather strength and be well fed before the winter. Also during the summer encampment, at the end of June, the sheep are sheared (fig. 4). Depending on the size of the herds, grazing may be depleted, and several small moves may take place during the summer. From the end of June until September is the joyful season when the mares can be milked, and the encampments flow with *airag* (see below, under The Horse). The camels need no herding attention during the summer but are allowed to graze at will, and they are only rounded up as it comes time to move to the autumn encampment.

Early autumn affords the most pleasant weather of the year. The autumn encampment is chosen so as not to be too distant from the winter camp. This season lasts about four to six weeks.

Most encampments are made up of groups of five to eight *ger* (fig. 5); on occasion one may find larger groups, of eight to twelve *ger*. These encampments consist of closely related individuals and are variously called *ail, ulus,* or *qotan*.

In the nineteenth century hunting was an occupation only of the poorest who could not make a living from their small herds.[16] Historical sources indicate that earlier hunting was practiced on a wider basis. Herdsmen did, however, periodically hunt wolves threatening their livestock. In the steppe and semidesert regions the hunting of antelopes and gazelles for their horns and meat was also popular. In the course of traveling it was also common to hunt marmots, an easy prey.[17]

Within the household, hides were prepared and tanned, various types of felt were manufactured, bridles, saddles, boots, pole-lassos, the elements of the Mongol *ger,* and knives were produced. In earlier times, other items were acquired mainly through barter from itinerant Chinese merchants, who supplied brick tea, cloth, clothing, grain, tobacco, and other staples the Mongols could not produce themselves. Now Mongols produce most of these items in their own factories, but they still import tea, tobacco, and cloth.

Fig. 6. Five-animals prayer flag. Xylograph. Courtesy of James Bosson.

THE LIVESTOCK BASIS OF THE NOMADIC SOCIETY

The well-being of the nomadic society in Mongolia is based on the five principal animals that are traditionally herded: horses, camels, bovines, sheep, and goats. These are known in Mongolian as *tabun qosighu mal,* literally "the five 'snouts' or 'muzzles' of livestock" (where "snout" is a classifier). Mongols are very conscious of the importance of these animals to their lives, and the animals are widely pictured in Mongolian art and literature—in fact, every aspect of Mongolian life is permeated by them (fig. 6). In recognition of this affection and respect, the great seal of the Mongolian People's Republic, from 1940 to 1960, displayed all five of the animals (fig. 7a). The seal showed a horse, ridden by a herdsman holding the Mongolian pole-lasso, galloping into the sunrise, while the other four categories of animals were por-trayed around the rim. After 1960, however, the herdsman mounted on his horse lost his pole-lasso and the other four animals were removed from the seal (fig. 7b).[18]

Not every herdsman herds all five animals, but most households include at least some animals of each category. In addition to the basic five, families keep fierce dogs to guard the settlement and protect the animals from wolves. These dogs can be very dangerous to strangers, and when a horseman approaches a settlement, he calls out from far away to get the owners to contain their dogs. Children will rush out and sit on the heads of the dogs until the visitor has dismounted and entered the *ger.* In mountainous areas,[19] herdsmen also keep Tibetan yaks *(sarlugh)* or, more frequently, yak hybrids *(qainugh),* since they produce more milk than normal yaks. Mules and donkeys can occasionally be found in Inner Mongolia. The Mongols do not traditionally

Fig. 7a. The Great Seal of Mongolia, 1940–60, showing the five kinds of animals. From *Bügd Nairamdakh Mongol Ard Ulsyn ündsen khuuli* (The Constitution of the People's Republic of Mongolia) (Ulaanbaatar: State Publishing House, 1954), cover.

Fig. 7b. The Great Seal of Mongolia, after 1960. From *Mongolian People's Republic,* p. 22.

keep chickens or pigs. These and other small animals and fowl are presently being raised in Mongolia, but this is a direct result of Russian or Chinese influence.

Since the five animals are the basis of the Mongol nomadic economy, the vocabulary used to refer to them is immensely varied and subtle. For example, the two smaller animals, sheep and goats, are referred to in a unit as *bogh* cattle, and the larger ones, camels, horses, and bovines, are called *bod* cattle. Relative characteristics are codified: "ones with a warm muzzle," horses and sheep *(qalaghun qosighutu)*, are differentiated from "ones with a cold muzzle," camels, bovines, and goats *(küiten qosighutu)*.

The number of cattle being spoken of is sometimes a fluid concept. Somewhat akin to the practice of counting the individual points of a buck's antlers, Mongols sometimes count cattle as so many "leg." This results in a very impressive number, which must be divided by four to arrive at the number of head of cattle being discussed. Alternatively, when large numbers of animals are being sold or bartered, an economic unit called a *bod,* for large animals, is used. All five animals can be accounted for in *bod.* One camel is worth 1½–2 *bod,* whereas one horse, one bovine, five to seven sheep, or seven to ten goats are all equivalent to one *bod.* It is unfortunately impossible to know how many animals belonged to earlier Mongol societies. Historic sources imply that livestock was normally plentiful, and herdsmen probably each had several herds.

A major problem in a nomadic society is the lack of forage *(jud)* and the consequent loss of livestock. The Mongols have developed a specialized vocabulary to describe the various situations that result in a loss of forage. These terms are a window onto the central concerns of the nomads' lives. Lack of fodder can be due to drought in the summertime *(ghang jud),* an excess of cattle in a limited area, where the ground is broken up by the cattle's hooves (literally, "hoof-jud," *tughurai-yin jud*), lack of snow in a waterless area (literally, "black *jud*," *qara jud*), or excessive snowfall that prevents the animals from digging down to the grass (literally, "white *jud*," *čaghan jud*).[20]

Only in recent times have we had specific information about periods in which the Mongols lost huge numbers of cattle because of these situations. For example, the 1880s through the early 1890s was a disastrous time. Not only was the winter of 1891–92 particularly severe, owing to "white *jud*," but the Chinese government exacted a heavy tax of livestock at the same time, an act that sent the Mongolian economy reeling for several decades to come.[21] Some Russian observers at the beginning of the twentieth century reported that livestock had been so reduced that there were in Mongolia, on average, only one horse, one bovine, eight to ten sheep and goats, and one-half camel per capita. By 1918 a Russian economist estimated the entire livestock holdings

in Outer Mongolia as follows: horses, 1,500,000; camels, 300,000; bovines, 1,400,000; sheep and goats, 9,500,000—that is to say, a total of 12,700,000 head of livestock. At the same time the approximate population of Outer Mongolia was 1,150,000 people.[22]

The Mongols have developed a vocabulary to describe their animals so precisely that even their horses do not have personal names. Instead, various descriptors are used to identify each individual animal. For camels and horses, for example, the basic identity is established by describing the animal's color. For camels there are thirty to forty terms;[23] for horses, over three hundred. Age designations and sex are helpful descriptors, and for horses there can be added terms describing the condition of the mane or tail, or other peculiarities, such as the presence of a brand or incisions on the ear. Likewise, for camels, there is a precise vocabulary used

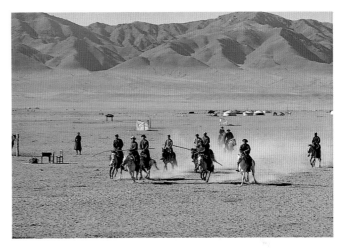

Fig. 8. Horsemen with pole-lassos. Photo: Dean Conger. Copyright National Geographic Society.

to describe the types of humps: both humps erect, the front hump erect and the back hump bending, to either right or left, and so forth. Armed with precise descriptions, a herdsman has no trouble picking an individual animal out of a herd. An admired and useful ability is a talent for observing and remembering the characteristics of all livestock that come one's way. Such a person (*mal-dur girqai kümün,* "one who is alert and observant with respect to livestock")[24] would be able to help a herdsman find a lost animal.

THE HORSE

The horse is more important to the life of the Mongols than any other of the five animals. No matter how little a foreigner knows about the Mongols, surely the image he has of the Mongol must include a horse (fig. 8). The horse is the common denominator of all Mongols; man or woman, old or young, all Mongols spend a large part of their lives on

horseback. Children are taught to ride when they are still so small that they must be tied to the saddle. But they soon learn. All the jockeys in the horse races, one of the main sports activities of the country and a mandatory ingredient of the national holiday, the Naadam, are children, both boys and girls, from the ages of eight to eleven. The races are long and grueling, covering many miles and often lasting several hours in a loop through the steppe. These races are the domesticized version of the early Mongols' long forays across their empire.

The horse is seldom used as a draft animal. It is as a mount that the horse, and with him his rider, shines in Mongolia. There are few sights in the world equal to seeing a Mongol rider sitting erect and motionless on a horse streaking across a plain at full gallop. This grace and majesty in posture are common to all Mongol riders. There is almost nothing an experienced Mongol rider cannot do in or from the saddle.

There is to all intents and purposes only one breed of horse in Mongolia, with a subgroup consisting of a true wild horse, the Przewalski horse *(taki)*, its probable ancestor. (Mongolia is the only place in the world where a true wild horse can now be found.) The adult Mongolian horse (called *mori* as an individual, *adughu* as part of a herd), also referred to as the Mongolian pony, is a rather short horse, measuring about thirteen hands (fig. 9). It has a fairly long and thick hair growth and a long-haired tail and mane. It is powerful and fast and has endurance and a lively temperament.

The herdsman chooses horses with particular traits for specific tasks. For instance, a winter mount should have a thick hide, dense, long hair, a stout stomach, should be stable when hobbled and fed, and should have vertical legs and firm hooves. A summer mount, by contrast, should have a thin hide, thin hair, not be too overworked, and, if young, should have a manageable disposition. A mount used for lassoing work should be of middling weight, without the habit of throwing, bucking, or being skittish, should have a short body and swift legs, be well trained in digging in when another animal has been lassoed, and be able to dash off and keep abreast of its target. The herdsman adheres to a long list of traditional requirements when choosing the right horse for the right task.[25]

The Mongolian linguistic attention to every detail of the animal is almost matched by the close attention paid to the terminology for all the accoutrements and paraphernalia connected with the use of the horse. The Mongolian saddle is usually a highly ornamented and elaborate work of art, befitting the high status of the animal within the culture (see cat. nos. 1–3). There are also plain workaday saddles, but they are rarer. The parade saddles of highly placed people, such as the Bogdo Gegen or other high ecclesiastical figures, are unique national treasures. The saddle *(emegel)* is based on a

Fig. 9. Mongolian horses grazing. Photo: Kazuhiro Tsuruta.

wooden frame with a high pommel and cantle. The seat is padded with felt and ornamental cloth secured usually with a beaten and patterned silver strip and with several elaborate silver fasteners. The skirt, flap, and saddle pad are made of multicolored embossed and appliquéd leather and felt. Attached in front of and behind the seat are long leather thongs, used for securing the hobbles or other belongings. The heavy metal stirrups themselves are often inlaid with a gold or silver ornament.

The rider carries several implements specific to Mongolia. The whip, unlike those used in Europe or America, consists of a wooden baton about twelve to eighteen inches long and a short whip part of no more than five to seven inches (fig. 10a).[26] A leather loop at the top fits over the wrist of the rider, and the whip itself is attached to the baton by winding a simple or braided thong around the lower end of the baton. The baton is not used to strike the horse, and the whip is never applied brutally. Hobbles are essential when the horse is left loose to graze for a short period. They are made of either braided leather thongs or horsehair and are usually both beautiful and practical pieces of craftsmanship. The most common types of hobbles fetter the two front or the two back legs. In addition, riders carry with them scrapers to remove the horse's sweat after a hard ride (fig. 10b). The scrapers look like a short, round-tipped sword and are made of bamboo, ivory, or even a pelican's beak. They are usually elaborately engraved or inlaid on one side and are worn stuck into the back of the sash that holds the rider's robe together.

The tool used by the Mongol herdsman when lassoing horses and cattle is unique to Mongolia. This pole-lasso

(ughurgha) consists of a willow or bamboo pole twenty-five to thirty feet long (figs. 10b–c). At the upper part of the pole is a twisted rawhide rope attached in such a way as to form a large noose. The remainder of the rope extends along the pole so the herdsman can pull the noose tight once it has been looped over the animal's head. A bulb is attached at the end of the pole to prevent its slipping out of the grasp of the rider.

Not only is the horse essential to the main economy of herding, but it also provides a number of products Mongolians use in their daily life. Mares are milked in the summer and autumn, after the foal has started suckling, which causes the milk to flow. The foal is then taken away and the milk is collected (fig. 11), but not before the foal has received sufficient nourishment. The Mongols never drink the mare's milk raw; it is placed in large ox-leather containers, where it is allowed to ferment. The fermenting milk is stirred frequently by all members of the household as they pass the vat.

The resulting beverage has a slight alcoholic content, somewhat weaker than beer, and is intensely sour—but very refreshing. This *airag*, the favorite drink of all of Mongolia, is identical with the koumiss produced in some Turkic cultures. The beginning of the *airag* season is eagerly awaited, and grown men drink or eat nothing else for the first few days of its production. The taste improves with the season, and the drink gives rise to impromptu games, parties, and amusements of all sorts.[27] It is also widely offered and drunk in connection with bigger ceremonies connected to rituals of the household, such as felt making, the insemination of mares, the branding of foals, the first cutting of children's hair, weddings, *obugha* ceremonies,[28] and various religious rites. No one ever starts drinking *airag* without first putting a ring finger in the bowl and smearing some of it on his brow. A symbolic oblation is then made by dipping the same finger and flicking some *airag* in all four directions. The *airag* can be further distilled into a clear alcohol not unlike vodka. This drink *(arki)* is not connected with any particular season, because it can be preserved and drunk at any time.

The hair of the horse's mane and tail is also widely used, especially in the production of rope. Horse hides are also used for all sorts of leather products. The Mongols have no taboo against eating horsemeat, but it is eaten very seldom and then not as a delicacy but only out of dire need. In some areas, and in more recent times, the eating of horsemeat has become more common, perhaps due to outside influences.

Without the horse there would be no Mongol life as we

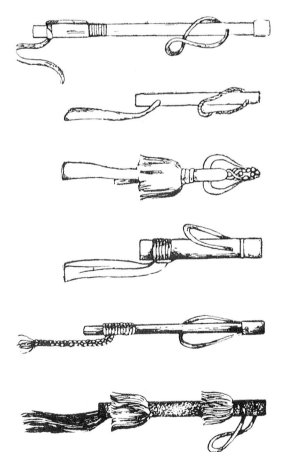

Fig. 10a. Various types of the Mongolian whip. From Badamkhatan, *Khalkhyn ugsaatny züi* (Khalkha Ethnography of the Nineteenth–Twentieth Centuries), p. 112.

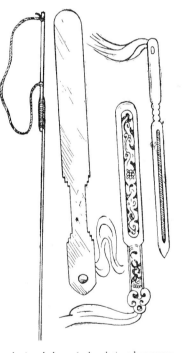

Fig. 10b. A pole-lasso *(ughurgha)* and scrapers. The pole-lasso and scrapers are not drawn to the same scale. From Badamkhatan, *Khalkhyn ugsaatny züi*, p. 112.

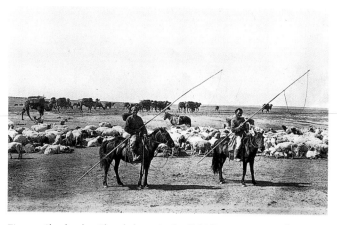

Fig. 10c. Shepherds with pole-lassos in the Gobi Desert, ca. 1930. Photo: J. B. Shackelford. Copyright National Geographic Society.

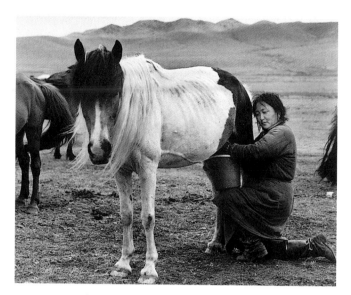

Fig. 11. A Mongol woman milking a mare. Photo: Builder Levy.

know it. Perhaps the horse's most important function is its symbolic and inspirational role. Art and literature are unimaginable without some reference to the horse or the equestrian life. The horse plays a large role in the epics, recited by itinerant bards, that have entertained the Mongol herdsman and his family through many centuries of long days and nights. The horse's beauty, color, strength, endurance, wisdom, and loyalty are all praised in verse after verse of rhythmic, strong, alliterative poetry. Love as a motif in Mongolian literature is more often a declaration of love for the horse, the paragon of virtue and beauty, than it is a declaration of love for a desired woman.

Mongolian folktales frequently feature a nominal hero of low status who sets out to accomplish great things and to challenge the evil khan. His magnificent mount carries him into the fray, but not before giving him elaborate instruc-

tions and detailed warnings about places he must not go and encounters and situations he must avoid. The hero then proceeds to every dangerous place and has every encounter that his steed has foretold. In each situation he blunders into, his steed again advises and saves him. The horse even brings the hero back to life when an encounter proves fatal. Eventually, this main character goes on to destroy the many barriers in his way and to defeat the khan, who, in the set formula of the folktale, "looking forward was smiling, looking backward was weeping," as he gives the kingdom and the hand of the princess to the conqueror. But no one needs wonder who the real hero is.[29]

THE CAMEL

The only type of camel the Mongols breed is the Bactrian camel (Camelus bactrianus L.), the two-humped camel that can endure the extremes of hot and cold so typical of the Mongolian homeland (figs. 12a–b). It is mainly herded in semidesert areas, which are unsuited to the other animals. It is a larger, stronger breed than the African dromedary and has a heavier growth of hair. Formerly, the camel (temege) played a crucial role in the trade routes that crossed Mongolia in all directions. Formed into caravans (temegen-ü jing), the camel was the most important means of exporting Mongolian products and importing goods of all kinds, such as tea, cloth, and luxuries. The deep, rhythmic sound of the bells tied around the necks of the lead camels in each string of animals was once a common sound throughout Mongolia.

Now, however, the camel is used mainly as a beast of burden, to transport the dismantled Mongolian ger from one pasturage to another. The household goods and even babies, safely tucked into baskets, ride on the backs of these powerful animals. The milk, meat, and hides of camels have their place in the Mongol economy, but the fine hair that is combed from the camels' wool is economically the most important product they provide.

The camel also shows up in the epics and folktales of the Mongols. There is, for example, a well-known folktale called "The Orphaned White Camel-Foal." The camel also has ritual and symbolic roles in Mongolian culture. Among the Mongols a camel—often a white one—is used for transporting the bride from her parental home.[30]

BOVINES

The bovines raised in Mongolia belong to a hardy breed able to withstand great heat and great cold and are generally designated as "Mongolian cattle" (mongghol-un üker). The general word for cattle is üker, which also means ox; included in the bovine category are the yak and the hybrids of the yak and Mongolian cattle. As with the other animals, cattle are referred to by different words depending on their age and sex, including descriptors for the absence, presence, shape,

and contour of horns. Yet the terminology for bovines is not as extensive or specific as that for horses, reflecting the relative importance of the animals to the culture.

As important as *airag* is, nothing compares with the significance of bovine products in the Mongolian economy, both for export and in daily life. Cow's milk and its products are a staple of the Mongolian diet. The milk is never, or almost never, drunk as such. It is added to the ever-present milk tea, which is consumed every day, all day long. The cream is used in several delicacies such as *jögekei,* a type of clotted cream, and *öröme,* made by boiling milk and remov-

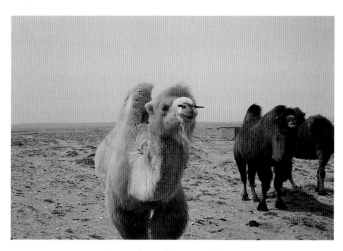

Fig. 12a. Bactrian camels near the Gobi Desert. Photo: James Bosson.

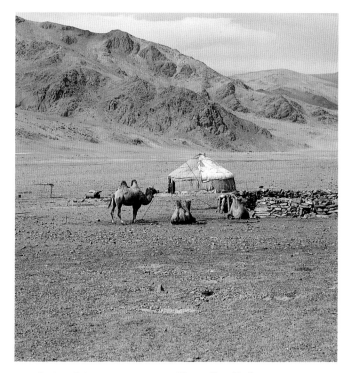

Fig. 12b. Camels in a *ger* encampment. Photo: Gary Tepfer.

ing the thick layer of cream that forms on top. It is usually so solid that it can be rolled up. This *öröme* is sometimes sweetened and eaten as a dessert.[31] The milk is also made into several cheeses, both hard and soft. Many of the cheeses are preserved by sun-drying on the roof of the *ger,* so that they can be eaten throughout the year. Further, the milk is churned into butter, some of which also becomes an ingredient of the milk tea.

Another important item of bovine production is *arghal,* dried dung, which is one of the main fuels in large parts of Mongolia. A common sight on the treeless steppe is the *arghal* gatherer picking up dung with her fork-shaped shovel, putting it into a large braided basket on her back. By tradition, this job belongs to young girls and old women.

Beef is widely eaten and is preserved, like the cheeses, by sun-drying it to form jerky. The hides are used in everything from rawhide ropes to saddles and boots. The horns are also used for a variety of products, such as the inside of the traditional Mongolian composite bow, which gives it its characteristic strength and piercing power. (This inside face is called *numu-yin elige,* "the liver of the bow.")

SHEEP AND GOATS

It is convenient to consider the last two of the five animals together. They are the smallest in size and are traditionally herded as a single group. Together they form the category called *bogh mal,* contrasted to the three larger kinds of animals, called *bod mal.*

Sheep are by far the most numerous of the herd animals, and they form the backbone of the herding economy. The Mongols raise several breeds of sheep, which are all variants of the fat-tailed sheep. This is a type of sheep that has developed an immense round, flat tail that consists entirely of fat. It is a favorite part of the mutton and is presented first to the guest of honor at a banquet.

Although the vocabulary for describing sheep is not as sophisticated as that for the other, larger, animals, this is not to say that the herdsman has no specific concern for individual sheep. When sheep have been brought up close to the *ger*—or, indeed, in their first few months, inside it, if they are born out of season—the owners show great tenderness toward the animals, and the sheep in their turn crowd around in a manner that suggests affection.

The sheep provides many valuable products. Sheep's milk is as widely used as cow's milk in the Mongol household, and mutton is by far the preferred meat. After slaughtering, which is done in such a way as to cause the animal as little suffering as possible,[32] almost every part of the carcass is used. The sheep is skinned and cut up. The blood is gathered in a vessel and, when the intestines have been washed out, is poured into them with some chopped fat and perhaps some barley to form a blood sausage.

Fig. 13a. The top construction of the *ger (toghona)*. Photos: Courtesy of James Bosson.

Fig. 13b. A lattice section *(qana)* folded for transportation.

The sheep's wool is an important material used in preparing felt to cover dwellings. In present-day Mongolia there is a burgeoning wool industry that produces blankets, fashion sweaters, and so on, but much wool is also exported as a raw product. Likewise, sheepskin is an important export item. Much of it, of course, is used within the country for winter clothing. With its multiple roles in Mongolian life, the sheep supplies a considerable portion of the Mongolian gross national product.

The goat is closely related to the sheep. In earlier times goat breeding was very limited,[33] as was the use of goat products. Goat's meat originally had no place in the Mongolian diet, and goat herding was an activity in which only utterly impoverished people engaged. Even now, the goat is not nearly as important as the sheep. It is milked and its milk is made into various cheeses, but goat's meat is seldom eaten, and not by preference. Goats provide hides for leather production, but their main economic significance is the production of angora wool, a profitable export item.

THE MONGOLIAN *GER*[34]

Several cultural and economic conditions combined to create the basis of and impetus for the development of the nomadic lifestyle, but this life could not have functioned in its classic simplicity were it not for the ingenious and functional dwelling, the yurt, the nomads developed over centuries (figs. 13a–f).

The name *yurt* originated in the Turkic languages, where it means "pasturage," "settlement," "homeland," or "dwelling."[35] It has come into English through Russian sources; the Mongol word is *ger.*

Sadly, the origins of the *ger* must remain unknown to us, for the archaeologist has no artifacts to study. This circular, felt-covered dwelling with wooden components was erected directly on the ground. The perishable felt and wood—traces of which might have provided some clues—were not left to decompose in situ but were moved from one encampment to the next. The only clues to their earlier appearance are occasional mentions in Chinese sources, where they were referred to as "domed huts," and more specifically in native Mongolian sources beginning with *The Secret History.* The early European envoys described the *ger,* and from the seventeenth century on there is an abundance of both written sources and depictions.

In modern times the *ger* has been used through the whole sweep of the Inner Asian steppeland, all the way from Manchuria to Afghanistan, by the Mongols, the Kalmucks, the Buriats, the Qazaqs, the Qirgiz, and Qashqai—Mongols and Turks all. Although each culture's structures have a distinctive shape and special features, they are basically the same dwelling.

The *ger* is a model of engineering and inventiveness. The form gives a minimum of resistance to the endless and

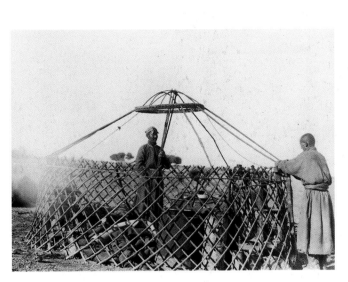

Fig. 13c. The long *uni* poles are used to attach the *toghona* to the wall.

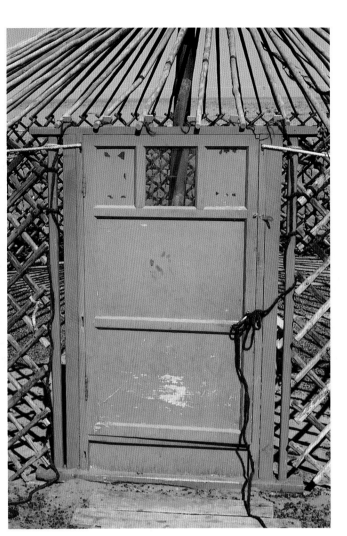

Fig. 13d. The wooden door frame and door are in place.

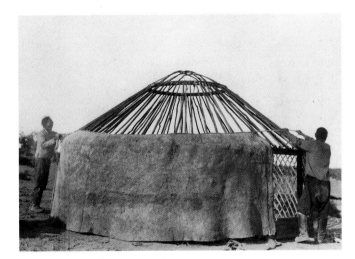

Fig. 13e. The first layer of felt is put in place.

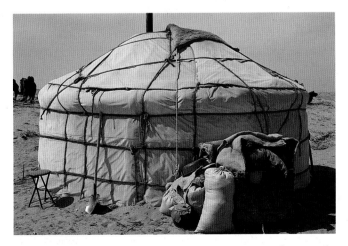

Fig. 13f. A completely erected *ger* with a canvas covering. Note the triangular piece of the opened *erüke* with its rope.

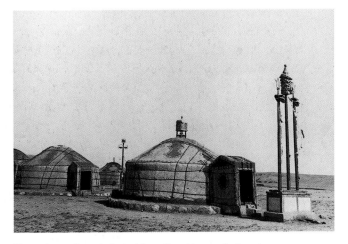

Fig. 14. A temple-*ger* in Inner Mongolia with a vestibule and permanent stone foundation.

often furious winds of the steppe. The construction materials all exist in the native environment, and all the components are made by the nomads themselves. In cold weather the *ger* provides a warm and cozy environment for the family, and in hot weather it provides airy protection against the direct, burning rays of the sun. The *ger* can easily be raised or dismantled in thirty to sixty minutes. When loaded onto a camel together with the household goods, babies, and newborn animals, the entire encampment can start transhuming in very short order.

The components of the *ger* are the lattice wall units *(qana)*, the circular wooden construction at the apex of the roof that frames the smoke hole *(toghona)*, the long poles that connect the *toghona* and the lattice wall *(uni)*, the two wooden pillars that hold the *toghona* in place, the wooden door frame, and the door, which is made of wood, thick felt, or both. A very important taboo prohibits treading on the threshold when entering the *ger*. This is the location of the protective spirit of the household, and to step on his head could have dire consequences.

The lattice wall unit determines the size of the *ger*. Each *qana* is made up of ten, twelve, or fifteen wooden laths, which are joined together by rawhide thongs tied through a drilled hole. When collapsed for transport, these units take up little space. The common size for a *ger* is four units. Well-to-do herdsmen sometimes construct *ger* of six to eight units. Formerly, the palace *ger* of khans, religious dignitaries, or government officials consisted of ten to twelve units (fig. 14).[36]

The felt covering of the *ger* comes in several sections. The wall covering is double, and the lower part (about 2½–3 ft. from the ground) can be removed in hot weather. The *ger* then functions as a sunroof, and the winds of the steppe can blow freely through the shaded interior. The roof covering leaves the smoke hole open. All these pieces are secured by horsehair ropes.[37] The smoke hole is covered by a loose square piece of felt, with a long piece of rawhide thong or horsehair rope attached to one corner *(erüke)*. This rope hangs down the roof of the *ger* and controls the position of the *erüke*. A common Mongolian riddle is based on its function: "What is triangular in the daytime and square at night?" Answer: "The *erüke*."

FELT

Felt *(isegei)* is obviously a crucial element in the Mongolian dwelling and is produced by each household. The majority of the sheep's wool is used for felt making; the Mongols have not traditionally produced yarn for either weaving or knitting.

Felt is made in the autumn, and all members of the household participate to some extent. A piece or two of old felt, called the "mother felt" *(eke isegei)*, are spread out on the ground and wetted. New wool is then carefully laid on top of the mother felt, sprinkled with water, and covered with two more layers of wool, each one wetted in turn. The top layer is covered with a layer of grass to prevent the wool from sticking together, and then the new wool and the mother felt are tightly rolled up. The roll is wrapped in a well-soaked ox hide and tied together with leather straps. Again it is wetted, and water is poured into the two ends of the roll. A long leather rope is looped around the roll, and two mounted riders pull it alternately in opposite directions and roll it back and forth some thirty to forty times. It is then unrolled, and the new felt, called the "daughter felt" *(keüken isegei)*, is separated from the mother felt. The Mongols then ritually proclaim that a "sweet daughter" has been born (figs. 15a–b).

The daughter felt is unrolled and three new layers of wool are spread on it. It is encased in leather, and the whole procedure is repeated. The finished felt is watered down again, dried, and leaned against the western side of the *ger*.[38] Although this is serious work, the autumn season and the ritual give a festive air to the procedure.

The type of wool used can change the quality of the felt. Some finer and thinner types of felt are produced by hand in much smaller pieces. Felt is mostly used to cover the *ger*, for rugs and pads to use on the ground, and to sleep on. Cushions, stockings to wear inside boots, and saddle pads are also made of felt.

The new *ger* shine white in their felt, but the surface of the fabric readily picks up dust, soot, and grime, and the brand-new look does not last long. In modern times it has become usual to cover the felt with an outside layer of canvas to help preserve it. Old *ger* that are hopelessly soiled are transformed into separate cooking *ger* in the encampment; the term for "kitchen" has become *boro ger*, or "gray yurt."

ARTISTIC EXPRESSION

In a nomadic society it is essential to acquire no more goods than can be easily transported from one encampment to another. As a result, artistic expression finds an outlet in the ornamentation of utilitarian objects. As mentioned above, great attention and wealth are spent on producing beautiful saddles. Appliqué work is sewn onto felt, and the masterpieces of silversmiths and goldsmiths were mainly heaped onto the elaborate head ornaments worn by married Mongol women (see cat. nos. 8–13).

As befits a nomadic society, oral literature played a large role. Folktales, epic stories, and songs traveled easily. The epics were usually recited by professional itinerant rhapsodes, who performed for housing and food, plus a donation. They accompanied themselves on the *qughur*, or "horse-headed fiddle."

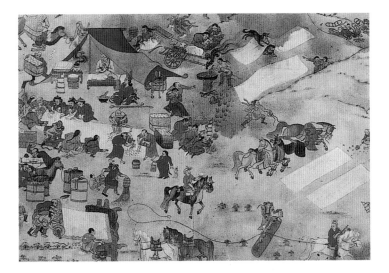

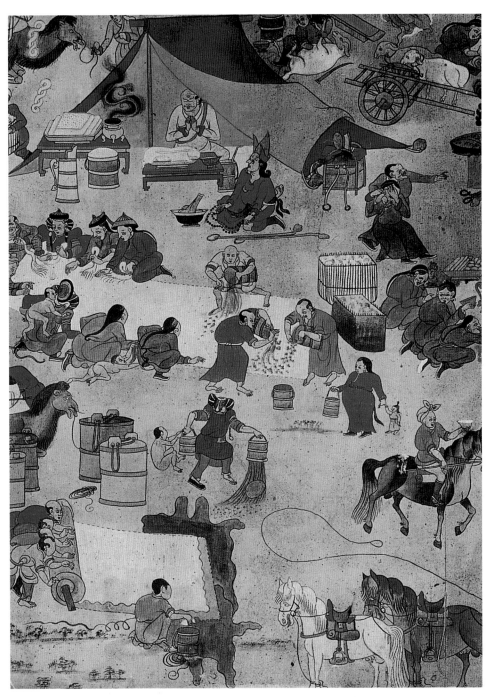

Figs. 15a–b. Felt making. *Autumn,* attributed to B. Sharav, and detail. Mineral colors on cotton, H: 53¼ (135.0) W: 67 (170.0). Museum of Fine Arts, Ulaanbaatar. From Tsultem, *Mongol Zurag,* pp. 166–68.

Painting and sculpture were developed only with the establishment of permanent settlements, concomitant with the second and widespread introduction of Tibetan Buddhism to Mongolia, and thus fall outside the scope of this essay. It was with the founding of the Erdeni Zuu Monastery, in 1586, that a new period of artistic expression began, and the First Bogdo Gegen became the most influential artist working in these modes. He was an inspiration to all future Mongol artists. Many of the objects in this exhibition are, indeed, his own work, or they have been created in the traditions of his school.

NOTES

1. Louis Bazin, "Un texte proto-turc du IVe siècle: Le distique Hiongnou du 'Tsou Chou,'" *Oriens* 1 (1948), 208–19.

2. Meanwhile, it is interesting to note that it was these Khitan who lent their name to identify all of China in many parts of the world. From the English *Cathay*, through the Russian *Kitai*, to the present-day Mongolian *Khiatad*, it has become a standard name for China and the Chinese.

3. Paul Pelliot, trans., *Histoire secrète des Mongols* (Paris: Adrien Maisonneuve, 1949); Paul Kahn, *The Secret History of the Mongols: The Origin of Chingis Khan* (San Francisco: North Point Press, 1984).

4. James Bosson, *A Modest Proposal: The Etymology of Mongghol* (Köke qota, 1990).

5. There are demonstrable historic relations between the languages with shared morphological features and demonstrable phonetic sound-shift laws, and also similar syntactical structures. Direct loanwords from one language to the other are also plentiful. But in general, these similarities are mainly discernible to scholars working in the field of historic linguistics. See Nikolaus Poppe, *Vergleichende Grammatik der altaischen Sprachen* (Wiesbaden: Otto Harrassowitz, 1960).

6. One such is the Moghol dialect spoken in Afghanistan, whose speakers were unaware until not long ago that there were other Mongol speakers anywhere else.

7. Nikolaus Poppe, *Introduction to Mongolian Comparative Studies* (Helsinki: Fenno-Ugric Society, 1955).

8. Hakluyt published William's account under the title *Itinerarium fratris Willielmi de Rubruquis de ordine fratum Minorum, Galli, Anno gra. 1253 ad partes orientales.*

9. There are numerous references to the fact that the Mongols who remained in distant places and in foreign cultures soon became acculturated and melted into the surrounding society. See K. P. Patkanov, *Istoria mongolov po armianskim istochnikam* (Mongolian History Based on Armenian Sources) (St. Petersburg, 1873), vol. 1, p. 57; Gennadii Evgen'evich Markov, *Kochevniki Azii* (The Nomads of Asia) (Moscow, 1976), pp. 108, 119.

10. Boris Ia. Vladimirtsov, *Obshchestvennyi stroi mongolov* (Social Structure of the Mongols) (Leningrad: Izdatel'stvo Akademii Nauk SSSR, 1934).

11. Markov, *Kochevniki Azii*, pp. 85ff.

12. Ibid., pp. 108, 119.

13. G. Shirnen, ed., *Bügd Nairamdakh Mongol Ard Ulsyn malchdyn nüüdel* (The Transhumance of the Herdsmen of the Mongolian People's Republic) (Ulaanbaatar, 1989).

14. Ibid., p. 82.

15. Here and following: Markov, *Kochevniki Azii*, pp. 108–9, quoting an unpublished manuscript by S. Badamkhatan.

16. Ibid., p. 115.

17. Marmots are prepared by removing the intestines and filling the body with heated stones, whereupon the body is dug down under the campfire. In this process of cooking from the inside, the hair is singed from the skin.

In earlier days, and also during the Qing era, there were communal hunts arranged partially as a ritual activity and partially as a sport. These hunts took the form of a *battue*, or drive (*aba* in Mongolian). The Qing emperor arranged annual *aba* near his summer residence, Jehol, that required the presence of many Mongol princes. Hunting was done by bow and arrow, rifle, traps and snares, by a kind of rigged bow and arrow that is sprung by the game, and in Western Mongolia, also by falcon.

18. Kh. Niambuu, *Övöögiin ögüülsen tüükh* (History Told by Grandfather) (Ulaanbaatar, 1990), p. 60.

19. Borjigidai B. Wangjil, *Köke jula* (The Blue Lamp) (Kölün Buir Aimag, 1990), p. 98.

20. Ja. Tsevel, *Mongol khelnii tovch tailbar tol'* (Explanatory Dictionary of Mongolian) (Ulaanbaatar, 1966), p. 281.

21. Markov, *Kochevniki Azii*, p. 103.

22. J. M. Maiskii, *Mongoliia nakanune revoliutsii* (Mongolia on the Eve of the Revolution), 2d ed. (Moscow, 1959), pp. 126–32.

23. Wangjil, *Köke jula*, pp. 172–75.

24. Tsevel, *Mongol khelnii*, p. 173.

25. S. Badamkhatan, ed., *Khalkhyn ugsaatny züi* (Khalkha Ethnography of the Nineteenth–Twentieth Centuries) (Ulaanbaatar, 1987), pl. 1, p. 63.

26. Ibid., p. 112.

27. Ibid., pp. 176–80.

28. Obugha (the vernacular form is *oboo*) are the stone cairns erected on top of a pass or on other elevated places, to which the traveler adds a stone or an offering. He or she then circles the cairn in a clockwise direction as a form of worship and pilgrimage.

29. Nikolaus Poppe, *Mongolische Volksdichtung* (Wiesbaden: Otto Harrassowitz, 1955).

30. Walther Heissig, *Geschichte der mongolischen Literatur*, 2 vols. (Wiesbaden: Otto Harrassowitz, 1972), p. 248; Nikolaus Poppe, "Ein altmongolischer Hochzeitsgebrauch," in *Studia Sino-Altaïca* (Wiesbaden: Franz Steiner, 1961), pp. 159–64.

31. A variant of the Mongolian *öröme* has spread throughout the whole Turkic world, which has its roots in the same traditions as the Mongolian. It can also be found in the elegant pastry shops of Istanbul under the name *kaymak*.

32. The animal is separated from the flock and then, held firmly, it is thrown on its back. With a long sharp knife the herdsman makes a quick incision right under the rib cage and inserts his hand and pinches off the flow of blood in the aorta. Within a few moments the animal is dead. Often an old piece of felt is put under the sheep to ensure that no blood spills on the ground. This practice conforms to an old Mongolian religious taboo against insulting the genius loci by spilling blood on his head.

33. Markov, *Kochevniki Azii*, p. 103.

34. D. Maidar and L. Darisüren, *Ger* (Ulaanbaatar, 1976), pp. 73ff.

35. L. S. Levitskaia, ed., *Etimologicheskii slovar' tiurkskikhi azykov: j, zh, y* (Etymological Dictionary of the Turkic Languages) (Moscow, 1989), pp. 254–55.

36. These palace *ger* were referred to as *örgüe*. The name of the later capital city of Mongolia, where the Bogdo Gegen's residence was, was Urga in Russian sources; this is a distortion of the name of the palace *ger*.

37. Badamkhatan, *Khalkhyn ugsaatny züi*, pp. 130–46.

38. Andras Róna-Tas, "Felt-Making in Mongolia," *Acta Orientalia Hungarica* 16 (1963), 199–215.

Mongolia

FROM CHINGGIS KHAN TO INDEPENDENCE

MORRIS ROSSABI

How did the "barbaric" Mongols produce works of such exquisite delicacy and refinement as those shown in this exhibition? Most Westerners conceive of the Mongols as rapacious plunderers, and the very names "Mongols" or "Chinggis Khan" or "Mongol hordes" often conjure up images of bloodthirsty brutes intent on looting, raping, and killing. Their enemies accused them of unimaginable atrocities. A thirteenth-century Persian historian observed that after one Mongol victory, "no male was spared who stood higher than the butt of a whip," and "eagles on mountain tops regaled themselves with the flesh of delicate women."[1] Such contemporary accounts, written by peoples defeated by the Mongols, are biased. The sculptures, paintings, and textiles reproduced in this catalogue, as well as Mongol patronage of the arts in the countries they subjugated, appear to belie the conventional wisdom about their thirst for conquest and about their barbarism. Their attempts to govern in China, Persia, and Russia and their support for trade, astronomy, and religion challenge their one-dimensional depiction as successful purely in military ventures. The destruction they wreaked and the massacres they perpetrated ought not to be discounted, but neither should their contributions and their more positive characteristics be minimized.

The Mongols were the most successful of the groups originating from Mongolia to challenge the sedentary civilizations to the south or west. The Xiongnu (whom some scholars link with the Huns) and the Turks among others had preceded them but did not occupy or seek to govern as vast a territory as the Mongols had. All shared a pastoral economy that required seasonal migrations to find the water and grass essential for the survival of their animals. Indeed their own survival depended on the sheep, goats, yaks, camels, and horses that they transported (or which transported them). Such reliance made them peculiarly vulner-able to the afflictions affecting their herds. Disease among their animals, drought, overgrazing, or the dreaded *jud* (any one of a number of conditions that denies the animals access to life-preserving grass) posed threats to their existence. The Mongols' mobility, which limited their ability to carry a surplus in case of emergency, exacerbated the difficulties inherent in their fragile economy and compelled them to seek grain, manufactured goods, and metals from neighboring civilizations. Simultaneously, their constant migrations imposed limits on the number of people in any one group, the optimal size amounting to several thousand individuals in a tribal unit. Thus, if they were denied trade by the sedentary civilizations, they had recourse only to hit-and-run raids, which surely troubled but did not imperil their more settled opponents. A confederation of tribes under centralized leadership would offer a more serious threat to these civilizations, but "any would-be supratribal ruler had to bring to heel a highly mobile population, who could simply decamp and ignore his claims to authority."[2]

CHINGGIS KHAN AND THE MONGOL EMPIRE

Chinggis Khan (1162?–1227) embodied just such a supratribal ruler who tried to overcome the pastoral nomads' natural resistance to leadership and control (fig. 1). Born into a family in the minor nobility with apparently scant wealth,[3] he faced an even less promising future with the murder of his father by another tribe.[4] Lacking a father from the age of nine compelled him to become more self-reliant and to develop survival skills in his rather forbidding environment. He learned to ride and to shoot a bow and arrow, but more important, he recognized the need for a network of loyal allies for both survival and advancement. Bonds with so-called blood brothers *(anda)* guaranteed him security while bolstering his status among the Mongols. Once he had received

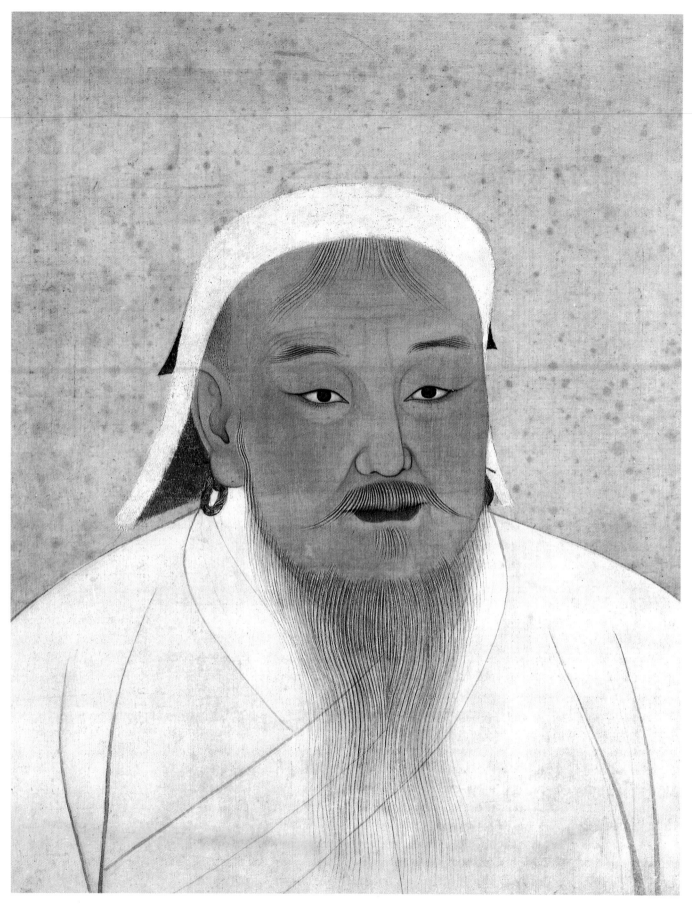

Fig. 1. *Portrait of Chinggis Khan*. Ink and color on silk, album leaf, H: 23⅜ (59.4) W: 18½ (47.0).
Collection of the National Palace Museum, Taiwan, Republic of China.

as much as he could from such an alliance, he turned against and attacked his erstwhile blood brothers, nearly always accusing them of betraying him. This pattern of seeking and then rejecting allies recurred throughout his career and was advantageous in his rise to prominence among the Mongols. Also contributing to his success were the lavish rewards and booty he awarded his followers after a victory. His treatment of defeated Mongol enemies proved beneficial as well. He dealt harshly with the unrepentant ones but pardoned many able commanders who, in turn, grateful for his compassion, transferred their loyalty to him.

Within a short time, his charisma, exploits, and calculating military mind had attracted a sizable force. First he created a nobility that was loyal to him. Undermining the authority of the old tribal chieftains, he promoted his own faithful retainers in an effort to break down tribal loyalties which might subvert his power. He dominated Mongol commoners and managed both to collect taxes from them and to have them serve in his military campaigns, partly by providing them with booty and partly by inducing fear of the consequences attendant on not fulfilling their obligations. He imposed tight discipline on his troops, punishing them severely for infractions. Fear, loyalty, and bravery persuaded them to perform extraordinary deeds, though some accounts of their absolute obeisance to Chinggis's commands are apocryphal. For example, one source writes that Chinggis, facing a disastrous shortage of food and thus the threat of mass starvation during one of his campaigns, ordered that one of every ten of his soldiers be killed and eaten. His order was carried out, and the expedition continued. This incident cannot be confirmed, yet transmission of this account served his purposes, for it demonstrated to foreigners and potential enemies the fear he inspired in his own forces and their dedication to him.

His military acumen is revealed in a variety of ways. First, he sought to secure an edge over his enemies through the use of psychological terror. His deliberate massacres and his shows of force sowed such fear that his opponents sometimes surrendered without putting up a fight. Yet the actual slaughters he condoned and the destruction he caused have led later historians to exaggerate his ruthlessness and savagery. Chinggis's victories were also due to the Mongols' superb cavalry and the composite bow, made of bamboo and the horns of cattle, which could be shot with high velocity and great force. Horses provided the Mongols with the mobility they needed in battle, and their ability to shoot a bow and arrow while riding gave them the upper hand in combat with ordinary foot soldiers. A well-designed sturdy stirrup enabled Mongol horsemen to be steadier and more accurate in shooting from horseback. In addition, a horse offered sustenance to its rider on long trips during which all the food had been consumed. The rider would alleviate his hunger by cutting into the horse's veins and drinking the blood that spurted forth. Finally, Chinggis was meticulous in his preparations. He had an elaborate intelligence network and would not set forth on a campaign without extensive information about the enemy.[5]

By 1206 his brilliant political and military skills enabled him to become ruler of all Mongolia. Yet what triggered his move out of his native territories? Ecological concerns no doubt contributed to his migration. A decline in temperature in the late twelfth and early thirteenth centuries in Mongolia, a shorter growing season, and desiccation of his lands generated crises for the pastoral nomads, who were dependent on but unable to accommodate to a changed environment.[6] Economic conflicts with the Jin dynasty, which controlled North China, exacerbated their economic woes by denying them trade for goods required in these difficult times.

Chinggis himself had specific imperatives driving him toward expansionism. To retain the loyalty of his blood brothers and supporters, he needed to provide them with booty.[7] Perhaps as important, he sincerely believed that the Sky God Tngri had entrusted him with the mission of unifying the known world under Mongol authority. An ardent believer in the shamanist worldview of the Mongols, Chinggis conceived of himself as the agent of the divine and of the ancestors. Despite his devotion to shamanism, however, he brooked no opposition, even from shamans; when the Mongols' leading shaman plotted to challenge Chinggis's authority, he ordered his subordinates to assassinate the man by breaking his back. Nonetheless, shamanism contributed to his and the Mongols' efforts to dominate the world in the name of the Sky God.

With such imposing ecological and ideological motivations and with a disciplined, loyal, and powerful cavalry and army, he embarked on military campaigns outside Mongolia. In 1209 he defeated the Tanguts, a people of mixed Tibetan and Turkic traits, in Northwest China and thus dominated the trade routes from China to Central Asia and the Middle East. He then turned to North China, and after a lengthy siege his troops, with the help of catapults hurling huge rocks on the enemy (fig. 2), occupied the city in the area of modern Beijing, a conquest which indicated that his military had taken a major step forward and could actually seize and not simply raid towns and cities. His next campaign was directed at Central Asia, whose ruler had committed the unpardonable crime of executing Chinggis's envoys, who had sought an increase of Mongol trade with the region. In 1219 he set forth, commanding two hundred thousand troops, to avenge the murder of his ambassadors. This was the campaign that definitely blackened Chinggis's reputation. No doubt his forces did more damage here than on any of their earlier expeditions, yet it was the presence of Persian chroniclers, who

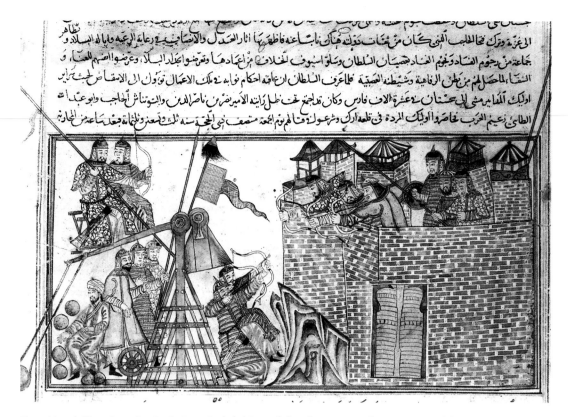

Fig. 2. *Mongols Using Catapult in Battle.* From Rashīd al-Dīn, Edinburgh University Library, Orms. 20, fol. 124v.

described the Mongol attacks in vivid and exaggerated detail, that contributed to the portrait of the Mongol conqueror as savage and bloodthirsty.[8] Actually, the Mongols swept into Bukhara, Samarkand, Herat, and other Central Asian oases and towns, and whenever they encountered stiff resistance, they ruthlessly suppressed the defenders, massacring many innocent victims, razing buildings, and ravaging the neighboring countryside. Nonetheless, the excesses of this four-year campaign have been overstated.[9]

Before having an opportunity to develop policies toward these newly subjugated lands, Chinggis died in August 1227, but he left behind a remarkable legacy. To begin with, he had been responsible for the first written language of Mongolian when he ordered one of his Uighur Turk captives to devise a script for it. This new development not only permitted the establishment of a government and administration but also helped to affirm Mongol ethnic identity and to offer opportunities for literary and other cultural efflorescences (including the later book covers and the decorated pages shown in this exhibition; see cat. nos. 47–62). Second, Chinggis adopted a policy of religious toleration in order to ingratiate himself with the clerical dignitaries in the territories he had seized. Despite his own shamanist views, he was aware that good relations with foreign religious leaders facilitated Mongol rule. Third, recognizing that the Mongols had few skilled administrators for such a large domain, he

recruited foreigners as interpreters, advisers, and officials. Fourth, he valued craftsmen, partly because they were in short supply among the Mongols, whose nomadic lifestyle virtually prevented the development of an artisan class and limited access to the essential raw materials. Thus he offered special privileges and tax exemptions to foreign craftsmen, and he and his descendants patronized foreign arts and crafts. As some of the Mongols eventually began to settle in towns, they produced their own craftsmen, some of whose products are displayed in this exhibition. Finally, not being afflicted by the Chinese emperors' scorn for commerce and merchants, Chinggis promoted trade within his domain. His successors pursued all of these same policies, setting the stage for the so-called *Pax Mongolica* in Eurasia and for a generally prosperous thirteenth century in their territories.

Chinggis failed, however, to establish a fixed and orderly system of succession. The tribal leaders who had accepted his authority owed loyalty to him but not to the office of Khan. They conceded that future khans ought to be his direct descendants. Naturally, individual leaders opted for different members of the Chinggisid line, precipitating disputes and eventually armed conflicts. Irregular, violent succession struggles became the rule, undermining Mongol unity. For example, two years elapsed before a *khuriltai* (an assemblage of the Mongol nobility) accepted what appeared to be Chinggis's own choice as successor, his son Ögödei. Ögödei's

election did not please the supporters of his younger brother Tolui, leading ultimately to a break between the descendants of these two sons of the progenitor of the Chinggisid line.

Ögödei (r. 1229–41) himself was encouraged to keep the Mongol domains intact and assumed the title of Khaghan, or Great Khan. He persisted in his father's divine mission of unifying the world under Mongol jurisdiction. By 1234 his troops had conquered all of North China, and in 1238 they occupied Korea. Other detachments attacked Georgia and Greater Armenia, but the expeditions in Russia and Eastern Europe were doubtless the most dramatic campaigns of Ögödei's reign. By 1240 Mongol forces reached as far west as Kiev, occupying much of Russia en route.[10] In 1241 they struck at Poland and Hungary and probably would have continued farther westward had not Ögödei's death resulted in a recall of the commanders of the expedition to Mongolia to elect a new Great Khan. The breadth of the western campaign staggers the imagination. The Mongol empire now spanned from Korea in the east all the way to Eastern Europe and thus became the largest contiguous land empire in world history. Later khans would expand the territory under Mongol control, but the empire reached its greatest east-west extent during Ögödei's reign. Because Ögödei recognized that such a sizable realm required an administrative center, he built the first Mongol town and capital of Kharakhorum, further evidence of the growing sophistication and sedentarization of a segment of the Mongol elite. Ögödei and his court at Kharakhorum formed a market for and became patrons of the arts and crafts and traded as well for Chinese and Persian artifacts, as testified by the treasure trove of craft goods in the region excavated by twentieth-century Russian archaeologists.[11] The creation of a fixed and regular tax structure, instead of the haphazard levies and confiscation that characterized pastoral nomadic practices, offered additional indications of the increasing refinement of the Mongol court and its non-Mongol counselors and officials.

Ögödei's death in 1241 initiated the fragmentation of the Mongol domains. The next decade witnessed a five-year interregnum, bloody succession struggles, and increased hostility among Chinggis's sons and grandsons. A remarkable woman and her four sons emerged as at least temporary victors in this internecine warfare. Sorghaghtani Beki, wife of Tolui and Chinggis's daughter-in-law, was influential in promoting her family's aspirations, and in 1251 she had the satisfaction of seeing her son Möngke selected as Great Khan. A consummate politician, a Nestorian Christian who patronized a variety of foreign religions, a powerful woman in a supposedly male-dominated military society, and a supporter rather than an exploiter of the non-Mongol peasants in the lands she controlled, she ensured that her sons received proper training and skills in literacy, combat, and administration to rule the empire. She was so astute and competent that she was renowned as far away as Persia, a historian there describing her as "extremely intelligent and able" and as "tower[ing] above all the women in the world."[12]

THE MONGOLS IN THE ERA OF KHUBILAI KHAN

Sorghaghtani Beki's adroit maneuvering paved the way for her sons Möngke (r. 1251–59) and Khubilai (r. 1260–94) to become Great Khans, but neither she nor they could stem the dissolution of the empire. It appeared at first that the two Great Khans would continue in their grandfather's footsteps by expanding the territories under Mongol control. In 1252 Möngke had finally brought Tibet under Mongol jurisdiction, initiating a relationship that would profoundly influence both peoples. In the following year, Khubilai commanded an expedition that pacified the kingdom of Dali in Southwest China. Another of Möngke's brothers, Hülegü, led the most far-flung campaigns during this time. In 1256 he headed into Persia, defeating the Ismāʿīlī order of Islam, and in 1258 he occupied Baghdad, executed the caliph, and toppled the ʿAbbāsid dynasty that had ruled the Middle East for five centuries. Despite this success, Möngke and his brothers proved unable to prevent the division of the Mongol domains into four distinct segments: the Great Khanate, which controlled East Asia, including the Mongols' original homeland; the Chaghadai Khanate, which was based in Central Asia; the Golden Horde, which dominated the sizable territory of Russia; and the Ilkhanate, which Hülegü founded to govern Persia and parts of the Middle East. These differing khanates became increasingly autonomous, and as their economic and political interests diverged, they came into conflict.

Thus when Khubilai ascended the throne as Great Khan and founder of the Yuan dynasty in 1260 (fig. 3), he was principally the ruler of Mongolia, Tibet, Korea, Manchuria, and North China and had only pro forma jurisdiction over the rest of the Mongol domains. It is no surprise then that Khubilai focused on China, the largest and potentially most prosperous territory under his control. Before he could do so, however, he faced a challenge to his authority from his younger brother Arigh Böke, still another indication of the disunity within the Mongol elite. Khubilai believed that the Mongols had to make accommodations to Chinese institutions and culture in order to rule, while Arigh Böke contended that such adaptations would dilute the purity of Mongol culture and lifestyle. Aside from their ideological differences, their own personal thirst for power brought them into conflict. Four years elapsed before Khubilai overwhelmed Arigh Böke's forces and could devote his attention to China, and another fifteen years passed before he finally defeated the Southern Song dynasty and incorporated South China into his domain (fig. 4). Nonetheless, by continuing

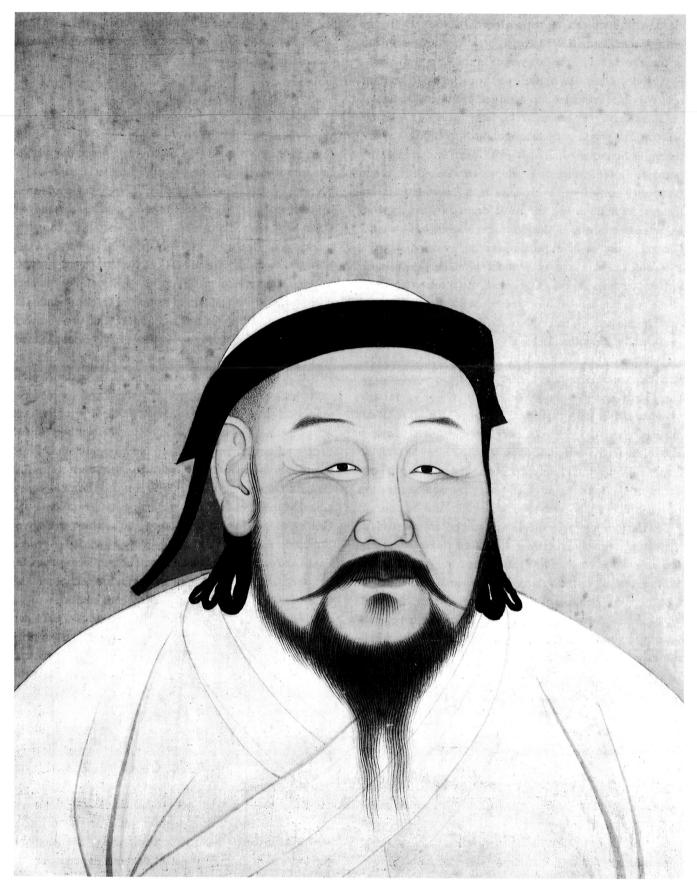

Fig. 3. *Portrait of Khubilai Khan*. Ink and color on silk, album leaf, H: 23⅜ (59.4) W: 18½ (47.0).
Collection of the National Palace Museum, Taiwan, Republic of China.

the expansion of the empire, he satisfied the traditional Mongols, who sought booty and wished to preserve the martial virtues.

Having in this way gained the confidence of some Mongols and deflected the hostility of others, Khubilai could focus on ruling. He was the Great Khan of the Mongols, but it was also important that he prove himself as the emperor of China. First, he adapted traditional Chinese institutions to govern the Chinese, devising central and local government offices that were familiar to the Chinese yet maintained some Mongol touches. Restoring many of the court ceremonies and rituals, he also built temples for his ancestors, a Chinese tradition, and adopted a Chinese name for his dynasty.[13] The clearest indication of his partial assimilation into Chinese culture was his transfer of the Mongol capital from Kharakhorum to Dadu (in the area of modern Beijing). He had already built a summer capital in Kaiping or, later, Shangdu (Coleridge's Xanadu), a site much closer than Kharakhorum to China; now with his accession to the Great Khanate, he signaled an intention to win over his Chinese subjects by constructing a capital based on Chinese models. Like earlier Chinese capitals, Dadu was surrounded by earthen walls, laid out in symmetrical east-west and north-south axes, accessible through eleven gates situated along various parts of the walls and surmounted by three-story towers, and centered on the Imperial City, where Khubilai and his mostly Mongol entourage resided and conducted affairs of state.[14] Yet Khubilai initially recruited a Muslim architect to help plan the city and later would employ other foreigners, including the Nepalese craftsman Anige, to construct a variety of buildings in the capital.[15] Khubilai sought to consider Chinese sensibilities but was also eager not to be limited to Chinese patterns and instead still wanted to establish a multiethnic empire and to be perceived as the ruler of a multiethnic domain.

Khubilai's economic and social programs reflected a blend of Chinese and non-Chinese practices. Like the Chinese dynasties, the court obtained the support of the peasantry through fixed taxes and limited demands for corvée labor. Yet unlike the traditional dynasties, it displaced the Chinese scholar-official class by abolishing the civil-service examinations, which had permitted that group to dominate society. Instead it relied on an international coterie of Mongols, Muslim and Christian Turks, Tibetans, and others to help govern. The Mongols also diverged from official Chinese policy in favoring artisans by tax and corvée exemptions. Adopting the attitudes of Chinggis and the early Mongols, they valued craftsmen, as well as painters, and this policy resulted in a profusion of jades, ceramics, textiles, and paintings, which reveal non-Chinese elements. Yet, due to the wide dissemination of Chinese models throughout the Mongol domains, Chinese forms influenced the arts in Central Asia, the Middle East, and even Europe.[16] Such Mongol

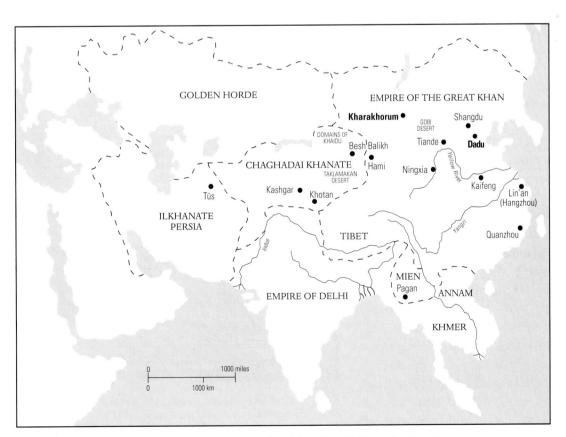

Fig. 4. Map of the Mongol empire in the Southern Song. Adapted from Rossabi, *Voyager from Xanadu*, p. 10.

Fig. 5. *Paizi [passport or safe-conduct pass] with Phagspa Script,* late 13th century. Iron with silver inlay, H: 7⅛ (18.0) W: 4½ (11.5). The Metropolitan Museum of Art, New York, Purchase, Bequest of Dorothy Graham Bennett, 1993 (1993.256). Copyright by the Metropolitan Museum of Art.

mors of a certain Prester John, reputedly a Christian ruler of the Mongols to whom they could appeal to terminate the attacks on his coreligionists in Western Europe.[17] Grasping at this unsubstantiated shred of information, the European monarchs and the popes dispatched at least two major embassies to the Mongol court. Giovanni dal Piano del Carpine (John of Plano Carpini) and William of Rubruck, the leaders of the two expeditions, met with the Mongol khans in 1246 and 1254 respectively, and both were severely rebuffed in their attempts to convert the Mongol elite to Christianity and to persuade the khans to accede to the orders of the popes and the European monarchs. Despite their failures, they both returned to Europe with reports that described, among other matters, the prosperity and commodities of East Asia, inspiring merchants to undertake the arduous journey to the east.[18]

Marco Polo was one such merchant who reached the Mongol capital in Dadu (fig. 6). Unlike other Middle Eastern or European traders, he remained in China and presumably suspended his mercantile career for about nineteen years, instead reportedly assuming several missions for the Great Khan. Scholars have at times questioned the veracity of his account of his stay at the Mongol court because misstatements, exaggerations, and errors have crept into the text. He probably magnified the status he enjoyed and the roles he was assigned. Yet Khubilai and his entourage and bureaucrats surely recruited foreigners as officials and counselors. Thus, it is not inconceivable that Marco had a position at court, though he did not have as significant an office as he asserts, nor did he have as critical or courageous a role as he depicts. Nonetheless, Khubilai's and the Mongol court's

patronage and willingness to borrow from other artistic traditions persisted into the seventeenth and eighteenth centuries and encouraged Mongol artisans to adopt Tibetan and Chinese designs and techniques in their sculpture, architecture, painting, book decorations, and textiles.

Equally critical for Mongol, and indeed world, history was their favorable attitude toward merchants and trade. Confucian Chinese officials had perceived commerce as demeaning and traders as parasites, but the Mongols did not share that attitude. Khubilai removed many of the previous limitations imposed on trade, paving the way for Eurasian merchants and for the first direct commercial contacts between Europe and East Asia. Trade between China and the Middle East and Europe flourished during this brief period of Mongol rule, with merchants and envoys receiving Mongol letters patent *(paizi),* which guaranteed them safe passage en route (fig. 5). Even before the inception of commerce, Europeans had, for the first time, reached Mongolia and China. Western Europeans had learned, with trepidation, of the Mongols' invasion of Hungary, but they also heard ru-

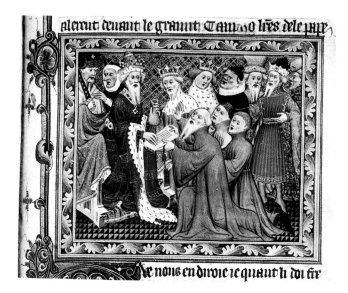

Fig. 6. *The Polo Brothers, Including the Young Marco, Presenting to Khubilai Khan Their Credentials from Pope Gregory X, and a Container of Oil from the Lamp of the Holy Sepulchre.* From an illumination in a 14th-century manuscript of the *Book of Ser Marco Polo.* The Bodleian Library, Oxford. Bodl. 264, fol. 220r.

efforts to employ non-Mongols indicate an openness to the influence of foreigners and foreign culture, which would also shape the Mongols' later response to Chinese and Tibetan culture.

They showed a similar eclecticism in the realm of ideas. Khubilai, for example, ordered a Tibetan Buddhist monk to devise a new alphabet, known as the Phagspa script in honor of its originator, that the Mongol ruler hoped would replace many of the written languages in the Mongol domains. This attempt proved to be fruitless, but it also reveals the court's aspirations toward universalism. A similar pattern may be perceived in its attitudes toward foreign religions. Despite their continuous performance of the rituals associated with shamanism, the Mongols reached out to other traditions as well. According to Marco Polo, Khubilai himself reflected this eclecticism when he said that "the Christians say their God was Jesus Christ; the Saracens Mahomet; the Jews Moses; and the idolaters Sagamoni Burcan [the Shakyamuni Buddha], who was the first god of the idols; and I do honour and reverence to all four."[19] His mother's Christian faith prompted him to assist the small Nestorian community in China, whom the Western Christian hierarchy regarded as heretics because of their divergent views of the Trinity and of the Virgin Mary.[20] He recruited numerous Muslims for his government, appointing them in particular to the financial administration of the empire and even entrusting one with the governorship of Yunnan, the territory of the subjugated kingdom of Dali.

His support and patronage of Tibetan Buddhism would turn out to have the greatest repercussions. His wife, Chabi (fig. 7), a devout Buddhist, clearly affected his attitudes and policies toward Buddhism, but the lama Phagspa (1235–1280), the chief figure in the Sakya order, made the most profound impression on the Great Khan. The Tibetan lama had not only developed a projected written language for the Mongol domains but had also instructed Khubilai in the tenets of Tibetan Buddhism. Perhaps as critical, Khubilai ordered his Tibetan instructor to tutor Zhenjin, his son and heir, in a more systematic way in the precepts of the faith. Accordingly, "Phagspa wrote a brief work entitled Ses-bya rab-gsal (What one should know), which was specifically designed to offer Chen-chin [Zhenjin] a description of his Buddhist order."[21] Khubilai demonstrated his support for the Buddhists by supplying funds for both the repair and the construction of monasteries and for the conduct of religious ceremonies, by providing laborers and artisans to the monasteries, and by offering monks a tax-exempt status. As a result of such subsidies, the monasteries flourished, establishing sizable estates and handicraft centers.

The motivations for Khubilai's patronage of Tibetan Buddhism were not purely religious. He sought secular benefits from his association with the Buddhist clerics, in par-ticular, endorsement for his status as Great Khan and ruler of all the Mongol domains. Phagspa indeed recompensed him by at times depicting him as a universal emperor (Chakravartin) and at other times associating him with Manjushri, the Bodhisattva of Wisdom, thus bolstering Khubilai's secular and religious positions. Such a portrait naturally justified Khubilai's rise to power and provided him with potent ideological weapons in his attempt to gain the allegiance of Buddhists within his lands. In turn, he bestowed numerous titles and honors on Phagspa, awarding his Tibetan supporter the title of State Preceptor (Guoshi) in 1260 and the even more prestigious appellation of Imperial Preceptor (Dishi) in 1270. In short, he provided tangible rewards to Phagspa while the Tibetan cleric honored him and broadened his appeal to Buddhists by portraying him as a protector and patron.[22]

This personal relationship culminated in a bond between the Mongols and the Tibetans, presaging an era three centuries later when the Mongol population virtually in toto converted to the Tibetan form of Buddhism. In the thirteenth century, however, the link was still limited to the elites among the two groups. Khubilai, for example, designated Phagspa to be the head of the Zongzhiyuan (Court of General Administration of Buddhism), which had as part of its purview the responsibility of governing Tibet. He then delegated the Tibetan religious leader to supervise the administration of Tibet, hoping that Phagspa would defuse some of the hostility directed at the Mongols. Opposition to Mongol rule did not, in fact, cease, but the Tibeto-Mongolian relationship, evidenced by Khubilai and Phagspa, was not entirely hostile and would lay the foundations for more equitable and harmonious contacts within two centuries after the fall of the Yuan dynasty, which had been founded by Khubilai. The histories of Tibet and Mongolia would often converge from this time on.

Khubilai and the Mongols, however, faltered in their relations with other lands. This was the first stage in the decline and fall of the Yuan dynasty. Toward the end of his reign Khubilai embarked on a disastrous expansionist policy. Sizable Mongol expeditionary forces were defeated in Japan in 1274 and 1281 and in Java in 1292–93, and incurred heavy losses in various regions in Southeast Asia. Expenses for these campaigns imposed financial burdens on the court, which already faced severe strains because of the dynasty's construction projects such as the building of the capital in Dadu, the extension of the Grand Canal toward Dadu, the expansion of the road network, and the establishment of postal stations in the empire. Such military and civilian expenditures necessitated revenues, which were obtained by levying stiffer taxes, by imposing additional monopolies on goods, and perhaps by deliberately inflating the currency.[23] At the end of Khubilai's reign in 1294, the court's financial condition had thus worsened considerably.

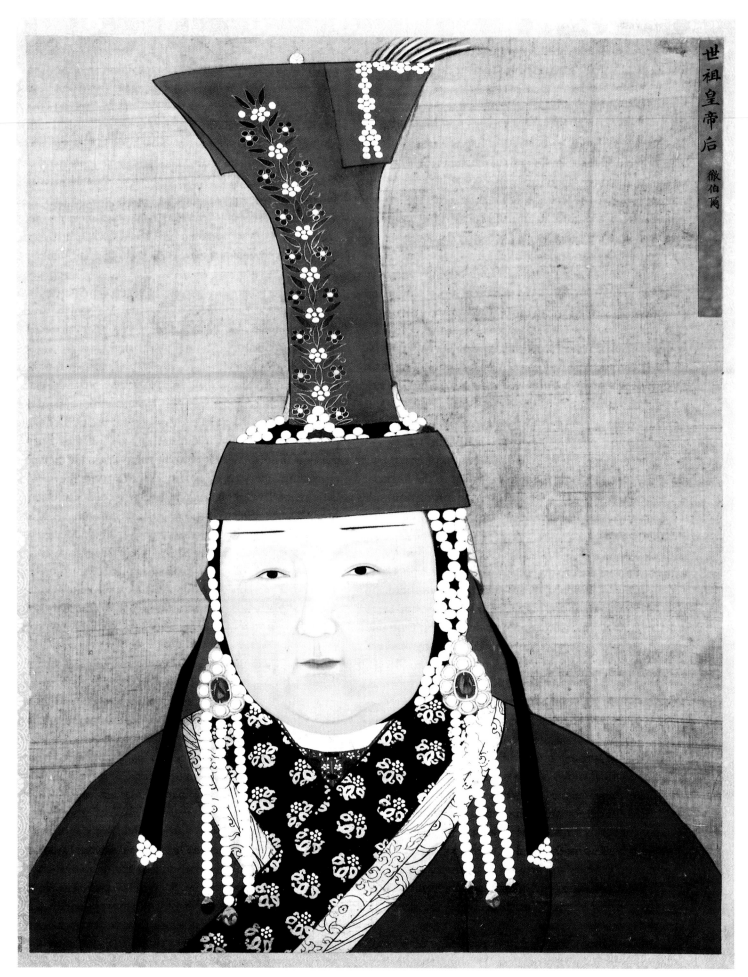

世祖皇帝后

徹伯爾

Fig. 7. *Portrait of Chabi, Wife of Khubilai Khan*. Ink and color on silk, album leaf, H: 24¼ (61.5) W: 19 (48.0).
Collection of the National Palace Museum, Taiwan, Republic of China.

Fig. 8. *Enthronement of Arghun Khan*, 16th-century Central Asian miniature. Abu Rabion Beruni Institute of Orientology, Uzbek Academy of Sciences, Tashkent, Uzbekistan. From Rossabi, *Voyager from Xanadu*, cover.

Later rulers of the Yuan faced tremendous obstacles. The need for revenues increased, and the concomitant imposition of additional taxes continued. Succession struggles, which had plagued the Mongols since the death of Chinggis, arose during the Yuan as well. The financial and political turbulence hampered the government in its performance of its essential tasks, leading to delays, decay, and deterioration. In the 1340s such lack of government attention to its basic responsibilities culminated in devastating floods of the Yellow River, creating a large population of homeless paupers. Rebellions erupted, and the Yuan military, which had also suffered as the court declined, was ultimately no match for the rebels. In 1368 Zhu Yuanzhang, one of the rebel leaders, ousted the last Yuan ruler, caused most of the Mongols residing in China to flee back to Mongolia, and established the indigenous Ming dynasty. Within two decades, a Ming army reached and sacked the Mongols' old capital of Kharakhorum, which is one of the reasons for the paucity of preserved art objects and handicrafts deriving from the great Mongol empire.

Similar problems bedeviled the other Mongol domains. The Chaghadai khans in Central Asia, who controlled the vast, frequently disunited territory composed of oasis dwellers, pastoral nomads, merchants, and subsistence farmers from a wide variety of ethnic and religious groups, scarcely

ruled for more than a few decades. Succession problems weakened the Chaghadai khanate, as did decades-long warfare with fellow Mongols of the Yuan dynasty. The Chaghadai khans had become so enfeebled that, after 1369, they became puppets at the court of the Central Asian Turkic conqueror Tamerlane (or Temür). They continued to have only nominal authority until the middle of the seventeenth century and were manipulated by various Turkic groups, including the Timurids, Tamerlane's descendants, and the Uzbek khanate. The Chaghadai khanate's internal divisions made it vulnerable to the depredations of other nomadic and bellicose peoples from the steppe.

The Ilkhanate in Persia and the Golden Horde in Russia harmed each other through sporadic warfare. They first came into conflict over Azerbaijan, which had a vital location along the east-west trade routes and also had lush pasturelands coveted by both Mongol khanates. Religion also divided the early khans, as one of the rulers of the Golden Horde had converted to Islam while the direct descendants of the first Ilkhan, including the renowned ruler Arghun Khan (r. 1284–91; fig. 8), were either Buddhists or Nestorian Christians and employed Buddhists, Jews, and Christians to rule a predominantly Muslim population in Persia. Like their fellow Mongol rulers elsewhere, the Ilkhans were unable to prevent conflicts over succession, and the dynasty fell into intermittent warfare after the death of the last universally accepted Ilkhan in 1335. Also like the other khanates, the Ilkhanate faced financial stresses, the result of wars and the court's lavish expenditures. The government's response in many reigns, with the singular exception of the era of Ghazan Khan (r. 1295–1304), was excessive and burdensome taxation, in part precipitating the chaos that led to the Ilkhanate's fall.

The Golden Horde survived longer as rulers of Russia, partly because they retained their pastoral nomadic lifestyle on the Russian steppe while remaining close enough to dominate the sedentary areas of the country. Moreover, since Russia had never been unified, considerable time elapsed before the Russian elite could challenge their nomadic rulers. In addition, Mongol policies benefited segments of the Russian economy, particularly trade. As the most recent study of the Golden Horde contends, "the international commerce the Mongols had fostered was a major cause of Russia's new urbanization and economic recovery."[24] Agriculture did not prosper because the Golden Horde, in contrast to the Ilkhanate and the Yuan dynasty, scarcely assimilated into or became involved with the local economy and thus rarely promoted the interests of the peasants and instead levied burdensome taxes on them. The Mongols' repressive political and economic policies inevitably led to rebellion and their ouster from Russia in the late fifteenth century.

Focus on the political problems and the downfall of the various Mongol khanates should not shroud their impact on

the cultures of the individual territories they ruled. Chinggis's admiration for crafts and his special dispensations for artisans influenced his descendants and successors, as a number of the khans became patrons of the arts and crafts and sciences. As noted earlier, Khubilai fostered developments in Chinese ceramics, jade, architecture, painting, and astronomy, and several of his descendants continued to sponsor artists and craftsmen. For example, his great-granddaughter Sengge added numerous paintings to the Imperial Palace collection. Similarly, several of the Ilkhans were benefactors of Persian culture. The development of Persian miniature painting in the fourteenth century owed much to Mongol taste and patronage. The Ilkhans also subsidized Persian poetry and historical writing, including the monumental universal history *Jāmiʿ al-tawārīkh* of Rashīd al-Dīn. A student of Persian literature who is not favorably disposed toward the Mongols nevertheless reluctantly acknowledges that "the principal historical works of the Mongol period are amongst the finest ever produced by any of the Islamic peoples."[25]

Mongol influence on or patronage of Russian arts and crafts is harder to gauge and document. The Golden Horde's conversion to Islam limited the Mongol impact and support for Russian arts and crafts, much of which was related to Eastern Orthodox Christianity. Since church construction was suspended for at least a century after the Mongol conquest, the Mongols had scant opportunity to influence or sponsor Russian craftsmen in this religious venue, though it should be noted that in the later phases of their occupation the great painter Andrei Roublev began to produce his icons. The Mongols also recruited architects and craftsmen to assist in constructing their administrative center in Sarai along the Volga River. In short, cultural life did not vanish in the Mongol domains and was, in fact, invigorated, a harbinger of khanate support for the Mongols' own arts and crafts in later centuries.

THE "DARK ERA" IN MONGOL HISTORY

What indeed happened to the Mongols after the demise of the empire in the mid-fourteenth century? In most histories of East Asia, they simply are not mentioned again until they reappear briefly in the seventeenth century. Yet they underwent significant transformations during these three centuries. In the immediate aftermath of the collapse of the Yuan dynasty, most of the Mongols returned to Mongolia, though some remained in China and served as interpreters, translators, and military men for the Ming dynasty.[26] They were no longer under centralized leadership and instead became increasingly disunited. Over the centuries, the Mongols in Central Asia gradually assimilated with the largely Turkic population of the region, though small communities in

Northwest China and modern Afghanistan retained their identities.[27] They were, however, vastly outnumbered and did not play decisive roles in the area. After their conversion to Islam in the late thirteenth and early fourteenth centuries, the Mongols in the Ilkhanate gradually merged into the local population. Few, if any, returned to Mongolia after the end of Mongol rule in Persia. The Golden Horde was composed of a relatively small number of Mongols, who were assisted in ruling by various Turkic groups whom they had subjugated. The vast majority of them also did not return to their original homelands after the Russians regained control over their own fates; most of them probably intermarried with their Turkic and other subjects in Russia.

The history of the Mongols from the fourteenth to the seventeenth centuries is thus generally confined to the territory of Mongolia and does not have the same Eurasian extent as in the thirteenth century. The Mongols' reduced circumstances limited their relations principally to China and Tibet. Despite their retreat from much of Asia, the Mongols could still pose a threat to China or, at least, the Ming court perceived that they could do so. The Mongols had not suffered a resounding defeat, nor had the Chinese conquered them. In fact, the early Ming emperors and court had been vastly influenced by Yuan dynasty rule. The first two emperors exhibited traits associated with the Mongol khans.[28] In contrast to their Chinese predecessors, they pursued a bellicose expansionist foreign policy aimed particularly at the Mongols and those who supported them during the Yuan. Military officials often superseded civilian officials, and the first emperor only grudgingly restored the traditional civil-service examinations as the principal route to power. Also unlike earlier Chinese dynasties, the newly founded court sought additional trade with foreigners and greater contact with foreign states, dispatching the envoy Zheng He to Southeast Asia, India, Persia, and the east coast of Africa in an effort to stimulate these lands to send tribute and trade embassies to China.

This unorthodox court alternated between a divide-and-rule policy and expansionist campaigns in dealing with the Mongols. The Yongle emperor (r. 1403–24), son and eventual successor of the first emperor, attempted to capitalize on the disunity that continued to hobble the Mongols during this time. The Eastern Mongols and the Oirat (one tribe of the Western) Mongols were the two most prominent such groups. The Chinese perceived both as implacable foes, and the Chinese sources fail to ascribe rational motives for the Mongols' actions. The Mongols, in this view, raided Chinese border settlements because they were by nature plunderers. Since the Eastern Mongols initially appeared to be the more hostile, the Ming court sought, through gifts, titles, and commercial privileges, to secure an alliance with the Oirats against their fellow Mongols.[29] The Oirats responded enthu-

siastically to such treatment, particularly the opportunity to obtain goods they required. Though less interested in the purely ceremonial trappings and patents offered by the court, they were content to accept the conditions set by the Ming as long as they secured commercial privileges.

The Eastern Mongols were less tractable, resulting in repeated conflicts. In 1409 the first hostilities erupted. The Chinese sources report that the emperor dispatched one hundred thousand cavalrymen, undoubtedly an inflated figure, to suppress the reputedly belligerent Eastern Mongols. Upon arriving at the Kerülen River, his troops captured a Mongol who revealed that the enemy was disorganized and retreating chaotically. Acting on this faulty and deliberately misleading intelligence, the Chinese commander led a segment of his army into pursuing the elusive Mongol forces farther into the steppe without taking into account or showing cognizance of the traditional Mongol tactic of a feigned retreat. Detached from his other troops, he fell into a deadly trap when the supposedly retreating Mongol military suddenly attacked and virtually wiped out his army. Learning of this disastrous defeat, the emperor personally led the first of his five campaigns into the steppelands, at the head of a huge force meant to intimidate the Eastern Mongols. His ploy was successful, for the leader of the Eastern Mongols was properly chastened and sought to negotiate. The two sides agreed to a fragile though decade-long peace settlement, under the terms of which the Mongols were permitted to trade with China under carefully prescribed conditions.[30]

This truce unraveled in the 1420s, compelling the emperor to lead four additional campaigns into Mongol territory. Three of the expeditions were directed at the Eastern Mongols, but one was aimed at the increasingly obstreperous Oirats. Nearly all of the campaigns turned out to be frustrating because the Mongols fled farther and farther away from China, and the Ming armies, separated from their supply lines, could not pursue the elusive enemy. They might encounter and defeat a detachment and then return to China, submitting reports of a resounding victory against the Mongols, but neither the Eastern Mongols nor the Oirats suddenly succumbed. By the time of the Ming emperor's death in 1424, tensions still prevailed, and his five expeditions had hardly promoted the creation of a regular and peaceful relationship between the Ming and the Mongols.

Instead, the unsettled relationship helped to prompt several efforts to unite the Mongols under one leader and perhaps to restore some of the glory of the Chinggisid era. The Oirat Esen launched the first such attempt. He did so in the traditional Mongol manner by seeking to prove his mettle as a military commander. Within a short period in the early 1440s, he had seized a considerable number of towns and oases along China's northwestern frontiers, sites that were

essential for the Ming's diplomatic and commercial relations with Central Asia, not to mention the security of its frontiers. Adding insult to injury, from the Ming standpoint, was Esen's abuse of the tribute system.[31] Instead of a few hundred men arriving with each mission, several thousand reached China, increasing the Ming's costs in transporting, feeding, housing, and offering gifts to the emissaries. Such rising expenditures caused Chinese officials to limit the number of Esen's missions and to reduce the presents and products granted them in trade. Esen responded with raids and attacks along China's borders to obtain the goods he could not secure through trade and tribute.

These conflicts erupted into full-blown warfare in 1449. Apparently misled by a court eunuch, the emperor underestimated the threat posed by Esen. He led an ill-conceived and ill-planned expedition into the steppelands. Early in September, Esen defeated the Ming forces, killed the eunuch, and captured the emperor, a devastating blow to China's image in East Asia.[32] The Oirat leader failed to capitalize on his unexpected victory, however, waiting for a month and a half to advance on Beijing. By then, the government had recovered and was able to withstand his brief siege of the city.

The victory over the Chinese marked the high point of Esen's attempt to unify the Mongols under his leadership, for within a few years his career totally unraveled. He encountered overwhelming obstacles in his efforts. First, he was not a direct descendant of Chinggis Khan and thus could not lay claim to the royal title. For quite some time he maintained a member of the Chinggisid line in his entourage as a figurehead, but his success against the Ming emboldened him to overreach and to assume the title of Khan, a tactical blunder because it led to numerous defections among conservative Mongols who disapproved of such an illegitimate usurpation of the title. Second, he faced an uphill battle in persuading the peoples residing in Mongolia that they belonged together as so-called Mongols. Since they did not identify themselves as "Mongols," he could not count on their support in a struggle, even with obvious foreigners such as the Chinese. Individual Mongols often considered themselves to belong to a specific tribe or sub-Mongol group, undercutting Esen's drive toward domination. Without such support, his hubris in assuming the title of Khan imperiled him. Within a year, he confronted a rebellion, during which he was assassinated.

In the late fifteenth and early sixteenth centuries, Batu Möngke of the Eastern Mongols had a more legitimate opportunity to unify the Mongols. A descendant of the Chinggisid line, Batu took the title of Dayan Khan, and in 1491 he proved himself by overwhelming the Oirats. Under his leadership, most of the Mongols prospered, trading with the Chinese or raiding Chinese settlements when denied trade. Yet again, however, the question of succession stymied his efforts. Defying the tradition of a *khuriltai* of the Mongol

nobility selecting the next khan, Batu sought to impose his own choice, his son Ulus Bolod, on the Mongols. Disaffection was the predictable result, and at Batu's death in the 1530s unity remained elusive. Yet his eleven sons would provide the princely heirs for Mongolia until modern times.[33] Moreover, at around his and his immediate successors' time, the modern divisions among the Mongols were delineated. The Chahar came to dominate in Inner Mongolia; the Khalkhas gathered together in the modern independent state of Mongolia; the Ordos became the major force in the desert area that encompassed the loop of the Yellow River; and the Tümed prevailed north of the Ordos region.

One of Batu Möngke's grandsons, Altan Khan (1507–1582), made one last effort to unite the Mongols in Ming times. Leading the Tümed Mongols, he managed to unite them as well as to bring the Ordos Mongols under his control, thus having authority over lands that directly bordered on China. Seeking to trade with the Ming, Altan Khan dispatched envoys to the Chinese court, at least one of whom the Ming authorities executed. In 1542 he retaliated with raids along the Chinese border and continued to attack along the frontiers throughout the 1540s, devastating the province of Shanxi. The Ming responded by setting up nine border garrisons and by beginning to build defensive walls along its northern frontiers.[34] The Chinese court remained inflexible, unwilling to accommodate Altan Khan by allowing the Mongols to trade for the products they needed. In 1550, however, Altan Khan circumvented the walls and drove all the way to the gates of Beijing, and this pressure compelled the Ming court temporarily to permit a border trade in Mongol horses and Chinese grain and textiles.[35] Yet the court reneged shortly thereafter and set the stage for continuous Mongol attacks for the next two decades. Finally, more pragmatic and conciliatory Chinese officials assumed power and effected a compromise in 1571. Under the terms of their agreement, the Mongol khan pledged to refrain from attacks on China in return for the opening of markets along the Chinese border. The court also bestowed the title of Shunyi Wang (Obedient and Righteous Prince) on Altan Khan, and the Mongol ruler accommodated the Ming court by turning over a number of Chinese defectors who had been assisting the Mongols. The court promptly executed these traitors.

Altan Khan progressed further than any of the previous rulers who had sought to unify the Mongols in the fifteenth and sixteenth centuries. First, the compromise he worked out with the Ming in 1571 reveals that he had recruited Chinese to help him organize a government that could rule a supratribal group. Their skills in administration, financial affairs, and craftsmanship enabled him to conceive of a true Mongol state. Second, his construction of a capital at Köke qota (Blue Fort), known to the Chinese as Guihuacheng (Return to Civilization City), in modern Hohhot indicated his desire first to emulate his ancestor Khubilai in seeking to govern rather than to engage as a tribal leader in attacks on agrarian civilizations and second to encourage some of his nomadic people to settle down. Built in the early years of his reign, it burned to the ground in 1559 but was reconstructed in 1575. Construction of the capital accentuated Mongol dependence on and value accorded to craftsmen. Most of the crafts produced for a nomadic culture would, of necessity, be small and portable, but the founding of a sedentary center offered increased opportunities for craftsmen, including architects, to fashion larger and more enduring artifacts. It is no accident that many of the objects in this exhibition derive from the period of accelerating sedentarization among the Mongols and were preserved primarily in the newly founded urban centers. In addition, a capital city and the possibility of a reunification of the Mongols posed a much more serious challenge and was alarming to the Chinese.

Yet Altan Khan's most invaluable and innovative contribution was adoption of a more universal and organized religion. Shamanism, the traditional worldview of the Mongols, suited a particularistic nomadic society but was not compatible with a state that had greater aspirations. Altan Khan sought a religion that would promote his efforts to unite the Mongols and that would perhaps link him with other civilizations. He also recognized that the new Mongol leadership that he had developed and cultivated following the so-called dark and chaotic period of the fifteenth and early sixteenth centuries yearned for a more sophisticated culture and more embellished rituals. Tibetan Buddhism, with its profusion of written texts, its more complex organization, its political involvements, its highly developed theology, and its elaborate and opulent ceremonies, provided a more suitable vehicle and symbol for unity. Phagspa, among other Tibetans, had introduced their form of Buddhism to the Mongols in the thirteenth century, and traces of the religion's tenets survived among the Mongol elite in the fifteenth and sixteenth centuries.[36] Altan Khan, prodded in part by his great-nephew the Khutukhtai Setsen Khung Taiji, ruler of the Ordos Mongols, now attempted to convert the entire Mongol population to Tibetan Buddhism, assuming that religious unity would translate into political unity.

Since Tibetan Buddhism was composed of a variety of orders, Altan Khan needed to select one for the Mongols. He eventually chose the reformed Gelug order founded by Tsongkhapa (1357–1419), who rooted out corrupt, insincere, and ill-educated monks from his order and demanded discipline, literacy, and sincere faith from his monastic followers.[37] In 1577 he invited its leader, Sonam Gyatsho (1543–1588), to instruct the Mongols in the tenets of the Gelug, or Yellow, order (yellow deriving from the color of the hats worn by the monks). The following year, the two men met in Kokonor (modern Qinghai). The Tibetan lama then pronounced

Altan Khan to be a reincarnation of Khubilai Khan, a tremendous boost to his status among the Mongols, and Altan Khan repaid the Tibetan cleric by granting him the title Dalai (Ocean) Lama, implying that the Tibetan's learning was as wide as the ocean, and by posthumously awarding the same title to the Tibetan lama's two predecessors. Much of the Mongol nobility followed the lead of Altan Khan and converted to Tibetan Buddhism, and within the next few decades ordinary Mongols either voluntarily or under pressure became Buddhists.

Even the Khalkha Mongols, who did not accept the jurisdiction of Altan Khan, were captivated by the new religion. Abadai Khan (1554–1588) of the Khalkhas received instruction and the title of Tüsheet (Pillar) Khan from the Dalai Lama, and in 1586, bearing witness to his new faith, the Tüsheet Khan ordered the construction of Erdeni Zuu, the first monastery in Mongolia, adjacent to the ruins of the old Mongol capital at Kharakhorum. The Mongol-Tibetan connection became even closer when the Fourth Dalai Lama, the reincarnation of the Dalai Lama who had traveled to Kokonor in the 1570s, turned out to be the great-grandson of Altan Khan. However, many ordinary Mongols never fully abandoned shamanism, and various khanates continued to suppress its practice throughout the seventeenth century.

The Ming viewed these developments with trepidation. The potential for a secular alliance between Mongols and Tibetans troubled the Chinese. As it turned out, however, the Chinese exaggerated the possible threat of such an alliance. Chinese fears about Buddhism were also misplaced. Their concern that Mongol conversion to Buddhism would lead to a growing militancy and an urge to spread the religion by force proved to be erroneous. Instead, by the eighteenth century, a large number of Mongol men had become monks, resulting eventually in a decline of the Mongols' military skills. Buddhism's emphasis on pacifism and its opposition to bloodshed may also have inhibited the rise of a powerful military force in the Mongol tradition.

The Chinese residing in Southern Mongolia were of great concern to the Ming. Some of these Chinese were prisoners of war, but many, reacting to the Ming's decline and to its inordinate demands for higher taxes and stiffer military and labor obligations, "began to believe that the Mongol style of life was less restrictive and onerous and accordingly fled to southern Mongolia."[38] They performed useful services for the Mongols as interpreters, ambassadors, and secretaries. As they had so often in the past, the Mongols recruited them as artisans, and in the late sixteenth century Chinese painters, metalworkers, and architects helped to build temples, palaces, and houses and to create vessels, weapons, and craft goods, still another indication of the significance of craftsmanship to the Mongols. The Mongols also sought Chinese assistance in agriculture, additional evidence that they were attempting to diversify their economy and, naturally, their style of life as well. Chinese experts taught some Mongols in Southern Mongolia the rudiments of farming, thus promoting their ability to be self-sufficient.

The peoples of Manchuria ought, however, to have been of even greater concern to the Ming. The Jurchen communities of Southern Manchuria had begun to unite under the leadership of a tribal leader named Nurhaci in the late sixteenth century. Some of these groups had abandoned the nomadic lifestyle and had turned to agriculture, which offered them both economic advantages (e.g., surplus) and the possibility of a more sophisticated administration.[39] Having had relations with the Chinese for most of the Ming era and having learned much from such contact, they were far more prepared for unity than the Mongols and simply awaited a charismatic and competent leader to offer them the organization they required. In the 1580s Nurhaci began to use the economic resources of Manchuria to increase his power in the area. He controlled gold and silver mines, gained a monopoly over ginseng, and dominated the trade in furs. With such financial support, he then adopted Mongol and Chinese military and administrative practices for his own government. Subverting the traditional tribal structure, he organized eight Banners (Manchu: niru) under the command of valued underlings, entrusting them with the task of developing a powerful army.

Over the next thirty years, he succeeded in subjugating the various peoples of Manchuria, and as they joined and intermarried with his own forces, the Jurchens gradually became a different people known as the Manchus. Nurhaci set up a bureaucracy to rule and fashioned a written language for Manchu based on the Mongol script. By 1616, believing that he was ready to challenge the Ming, he proclaimed himself emperor of the Jin dynasty, harkening back to the earlier Jin (1115–1234), the Jurchen dynasty that had ruled North China. He continued to encroach on Ming territory until his death about a decade later. His son consolidated Nurhaci's gains, annexed additional land, and in 1636 sought to establish a specific identity for the Manchu people by changing the name of the dynasty from Jin to Qing. Finally, Nurhaci's grandson was the beneficiary of all these efforts when the Qing overthrew the Ming and assumed power in 1644.[40]

THE QING AND THE LAST MONGOL EMPIRE

The Qing differed from most traditional Chinese dynasties in its policies toward the Mongols and other peoples along its northern frontiers. Earlier dynasties had deliberately refrained from expanding beyond what they perceived to be the boundaries of Chinese civilization. Their emperors and ministers contended that such conquests would be counterproductive and draining because a sizable force would be

required to occupy a territory with a restive and hostile population, an expensive venture with scant profit. The Manchu rulers of the Qing, however, already governed an alien population, the Chinese, so that rule over a relatively small number of Mongols and Central Asians did not appear burdensome. The Qing thus became increasingly involved in Mongolia, Central Asia, and Tibet.

Even before they assumed power in 1644, the Manchus had already established themselves in Inner Mongolia. Ligdan Khan (1592–1634), a Chinggisid, had attempted to restore the glory of the Mongol empire, partly through patronage of Buddhism and subsidies for temples and monasteries. Identifying with Chinggis and Khubilai and having himself portrayed as wise as the bodhisattva Manjushri, he supported the translation of the Tibetan Buddhist canon, the Kanjur, consisting of 1,161 texts in 108 volumes, into Mongolian. Despite his professed faith in Buddhism, he sought to unify the Mongols through force and intimidation. He was repeatedly accused of attacking fellow Mongols and plundering their animals. One group after another of his underlings defected, making him ever more vulnerable to his Manchu enemies. Capitalizing on Ligdan's difficulties, the Manchus, in 1632, launched an assault against him. He and his demoralized forces fled westward toward Tibet, where he hoped to establish a new base, but in 1634 he contracted smallpox and died; few Mongols mourned his passing.[41] The following year his son and successor submitted to the Manchus, and he married a Manchu princess to seal the alliance with them. Inner Mongolia and the Chahar Mongols were now ruled by the Qing dynasty.

The Khalkhas of Eastern Mongolia were plagued by the same disunity as the Chahar of Inner Mongolia. They were divided into a number of distinct khanates, each inhabiting a specific domain. The Tüsheet khanate, having received its title from the Dalai Lama and having been the site of the earliest Buddhist monastery, was the most significant because it dominated the central region of Mongolia stretching from the area just south of the Siberian village of Kiakhta down to the Gobi Desert. Yet it could not bring the various Khalkha Mongols, who resided in the Setsen khanate and the Zasagt khanate, together.

The Tüsheet Khan Gombodorji (1594–1655) tried to use Buddhism as a binding force. He advocated the selection of a young Mongol boy as a reincarnation of earlier great religious figures and thus as leader of the Buddhist establishment in Mongolia. The choice of a Bogdo Gegen (Living Buddha or Resplendent Saint) would, he hoped, be accepted by the Khalkhas and facilitate efforts at unification. The Bogdo Gegen would become a symbol around whom all the Mongols would rally; in effect, his value in the political unification of the Mongols could supersede his role as a religious leader. The Tüsheet Khan perceived his proposal as

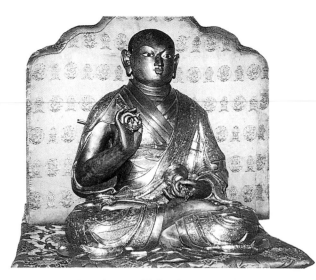

Fig. 9. *Portrait of Zanabazar*. Gold-plated copper. Bogdo Khan Palace Museum, Ulaanbaatar. From Tsultem, *The Eminent Mongolian Sculptor— G. Zanabazar*, pl. 5.

one means of encouraging patriotic sentiments among the Mongols: detaching the Mongols from the religious overlordship of the Dalai Lamas of Tibet, and having their own reincarnation, a Mongol, of great religious leaders of the past would surely arouse nationalistic feelings.[42]

The Tüsheet Khan proposed his own son Zanabazar (1635–1723) as the Bogdo Gegen (fig. 9; see Appendix 1). According to later accounts, his line of reincarnation stretched back to the time of the historic Buddha Shakyamuni, and the most recent emanation was a Tibetan historian who had passed on in 1635. A text on the lives of the Bogdo Gegens describes portents concerning Zanabazar's remarkable career even before his birth, and at the site of his birth, a pavilion in the steppelands, "white flowers grew up prettily though it was winter time." He could recite Buddhist chants at the age of three, and reputedly "signs of all the Buddhas have appeared on his distinguished body."[43] In 1638–39 the leaders of the Khalkhas accepted him as the Gegen, the holiest figure in Mongol Buddhism. At the age of fourteen, Zanabazar traveled to Tibet to study with the Dalai Lama and the Panchen Lama, and while there he was granted the Tibetan title Jebtsundamba Khutuktu (M: Bogdo Gegen). On his return to Mongolia he built monasteries, translated Buddhist texts from Tibetan to Mongolian, wrote poetry, and developed a new alphabet, known as the Soyombo, for Mongolian.[44] His other talents as a metal sculptor and painter may be observed in this exhibition. His abilities and his devotion to his faith were so well known throughout East Asia that the Kangxi emperor (1662–1722), the Manchu ruler of China, reputedly said that "the Dalai Lama, the Panchen Erdeni and Jebtsundamba, these three, are lamas who from many ages past have been Buddhas."[45] His patronage of the

monastery at Erdeni Zuu, which included a temple dedicated to him, contributed to its efflorescence and prosperity. In addition, his residence attracted a sizable population, among whom were merchants, resulting in the founding of the town of Urga (renamed Ulaanbaatar after the Communist revolution of 1921), which eventually became the capital of the Mongols.[46] He also kept the Mongols in touch with Tibet, China, and eventually Russia and became a valuable intermediary in the East Asian and Central Asian interstate and intertribal relations of the seventeenth century.

The grandiose expectations for the Bogdo Gegen were not fulfilled, however, as Mongol unity remained elusive. In 1640, a year after Zanabazar's selection as the religious leader of Mongol Buddhism, the khans of the Khalkhas and the rulers of the Western Mongols met to forge a stronger coalition. Despite general acceptance of the religious authority of the new Bogdo Gegen, the Mongols were unable to translate religious unity into political union. Such disunity harmed the Mongols when a dispute arose with the Manchu Qing dynasty in 1646. The Manchu armies capitalized on the Mongols' internal dissension to defeat them and compel them to refrain from attacking China and offering tribute to the Qing emperor. For the next four decades, peace prevailed along the borderlands between China and the Khalkhas, which also provided a respite for Zanabazar. The Bogdo Gegen now had the calm and the leisure to pursue his aesthetic interests and to start a workshop of artisans to create some of the objects in this exhibition.

The relationship between the Western Mongols and the Qing shattered this peace. Early in the seventeenth century, the Western Mongol group known as the Zunghars had begun to transform itself, a change that would lead to conflict with China. The Zunghar rulers sought to limit the seasonal migrations of their people and to encourage a more stationary style of life. They promoted agriculture, built palaces along the Emil River around which clustered shops and farms to cater to the sedentary inhabitants, sponsored a metal industry which began to produce the Zunghars' own weapons, suppressed shamanism and spurred the spread of Buddhism, and served as patrons for a newly developing class of artisans. In short, the Zunghars made significant strides toward a less mobile society in hopes of regenerating a great empire for the Mongols.[47] Yet, once again, succession problems and lack of unity would subvert efforts to foster a Zunghar empire.

Their ruler Galdan attempted to use the Zunghars' advances to establish what turned out to be the last nomadic empire in East Asia. As a child, Galdan, a member of the ruling family of the Zunghars, had been sent to Tibet to study with the Fifth Dalai Lama (d. 1682), cementing relations between the Mongols and the Tibetan Gelugpa. The Fourth Dalai Lama (d. 1617), enthroned in 1601, was, in fact, the

great-grandson of the Mongol Altan Khan. In 1642 Güshri Khan (d. 1655), the ruler of another Western Mongol group known as the Koshut, had once and for all crushed the Karmapa, the last remaining opposition to the Gelugpa, and installed the Fifth Dalai Lama as the unrivaled temporal and religious leader of Tibet.[48] Within a couple of years, the Dalai Lama was secure enough to initiate the construction of the Potala Palace in Lhasa, the colossal residence of future Dalai Lamas, which was completed only in 1695. Yet the Dalai Lama did not have sufficient wherewithal to resist the Qing emperor's demand for him to visit China, and in 1652 he traveled to China, where he was accorded an extremely cordial reception and was implored to devise a set of regulations for Chinese monasteries. It was this Dalai Lama and other Gelugpa monks with whom Galdan studied for some years in Lhasa. In 1671 Galdan's studies were, however, interrupted when he learned that his half-brothers had assassinated his brother Sengge, the khan of the Zunghars. Apparently with encouragement from the Dalai Lama, Galdan returned to Western Mongolia to avenge his brother's murder.

An exceptionally able and charismatic figure, Galdan quickly organized his dead brother's and his own supporters, crushed the usurpers, and proclaimed himself the khan of the Zunghars; yet he had even grander aspirations. He wished to restore the Mongols to their glorious epoch of the thirteenth century. He already appeared to have the powerful sponsorship of the Dalai Lama and of Tibet. Starting in 1679 he attacked and occupied much of Turkestan (modern Xinjiang), the region west of his domain. Yet he needed to attract the support of the Khalkha Mongols, who were squabbling among each other in the late seventeenth century. Moreover, an endorsement from the Bogdo Gegen would be even more vital in bolstering his legitimacy.

THE GREAT GAME IN EAST ASIA

Galdan's fate, however, would be intertwined with new forces in East Asia, for the seventeenth century witnessed the development of true international relations in the region of Inner Asia. The "Great Game," a term coined to describe the struggle between Russia and Great Britain in Central Asia in the nineteenth century, provides an apt phrase for this complicated and competitive era. The web of connections became increasingly more complex. The Chinese and the Mongols had been trying to work out a stable relationship since the founding of the Ming dynasty in 1368; as they fragmented and formed disparate groups, numerous Mongol peoples dealt with China; the Tibetans became involved when the Mongols converted to Buddhism starting in the late sixteenth century; and the Manchus became entangled in these relations when they conquered China in 1644. In the late seventeenth century, still other actors, the Russians,

played roles in what formerly had been an association between two peoples, the Chinese and the Mongols. The Russian government was eager to expand into Asia in order to avert attacks such as those from the Mongols in the thirteenth century, to obtain mineral resources and furs from Siberia and Manchuria, and to secure trade with the flourishing Qing empire. Such expansion inevitably led to clashes with the Qing, particularly on the Manchurian frontier. As the number of battles increased, each side naturally began to be concerned about the opposing side's possible negotiations with the Khalkha or the Zunghar Mongols. An alliance between one and the Mongols could pose a threat to the other's strategic or economic interests in East and Inner Asia.

The tsarist and Qing courts ultimately concluded that they had complementary objectives, which precluded an alliance with Galdan. Neither court had much enthusiasm for combat with the other, and both eventually abhorred an alliance with Galdan. The Russians sought regular commerce with China, diplomatic recognition, and an official presence. The Qing desired the withdrawal of Russians from the Amur River region, a demarcation of the borders with Russia that favored its interests, and control over trade and tribute with the tsarist court. The Treaty of Nerchinsk, negotiated in 1689 with the assistance of the European Jesuits (adding still another international element to the complex history of the Mongols from the seventeenth century on) stationed in China, in effect traded commerce for territory. The Russians were permitted to send caravans to China, as well as to have an embassy, a Manchu- and Chinese-language school for prospective Russian diplomats and interpreters, and an ecclesiastical mission, while the Qing received the territorial concessions it wanted.[49] Peace prevailed between Russia and China for the next century and a half.

Denied an alliance with Russia, Galdan also failed to elicit support from the other actors in this Great Game of the seventeenth century. Because Tibet, which he had relied on at least for religious legitimation, had its own troubles, it could offer little help. The Fifth Dalai Lama had died in 1682, and the regent who assumed power attempted to conceal the lama's death. The regent sought to bolster his own position and could scarcely devote much effort to Galdan's cause, though in theory he continued to support the Zunghar ruler. The Khalkha khanates, faced with discord and divisions among themselves, were not likely to challenge the Qing court to whom they had sent tribute for four decades. Thus Galdan appealed to Zanabazar to furnish him with the religious imprimatur he wished in his struggle with the Qing, who repeatedly rejected his requests for trade and therefore in part prompted his raids and attacks. Zanabazar, who was engrossed in his religious and artistic works, did not wish to become embroiled in a perilous effort to "restore" the Mongol empire. Instead, he concentrated on fashioning the gilt bronze images of the Amitabha and the Twenty-one Taras, among other sculptures (see cat. nos. 97 and 103–106).[50] Because of his family relationships, he was still aligned with the Tüsheet khanate, which remained implacably hostile to Galdan. Zanabazar, though seeking to be apolitical, had generally sided with the Tüsheet Khan in acquiescing to the Qing. When the Russians started to arrive in East and Inner Asia, he also tried to maintain good relations with them, as evidenced by the fine impression he made on Fedor Golovin, the principal Russian diplomat who negotiated the Treaty of Nerchinsk. According to a somewhat hyperbolic Mongol source, Golovin flatly asserted that Zanabazar was the only trustworthy Mongol leader.

Zanabazar's rejection of Galdan marked the beginning of the end for the Zunghar ruler. Smarting from this rebuff, Galdan concocted a pretext for an attack on Zanabazar, claiming that at an important meeting the Bogdo Gegen had insulted the Dalai Lama by his offensive behavior toward the Tibetan leader's designated representative. Late in 1688 Galdan unleashed an assault on Zanabazar's lands and destroyed part of the Erdeni Zuu complex and doubtless some of the objects produced by the Bogdo Gegen and the artisans in his workshop. Much of the territory of the Eastern Mongols fell to Galdan, forcing Zanabazar and the Tüsheet Khan to flee their native lands. The Qing provided sanctuary for both and, after the conclusion of the Treaty of Nerchinsk, set about to vanquish Galdan. Like other previous steppe rulers, Galdan now faced opposition within his own ranks, which weakened him considerably. His nephew Tsewang Rabtan, who resented Galdan's assumption of leadership of the Zunghar confederation, broke away and seized Zungharia, the Zunghars' native land. Aware of Galdan's problems, the Kangxi emperor personally led a military force into the steppelands in 1696 and decisively defeated the Zunghar ruler. Galdan either died or committed suicide the very next year. Though Tsewang Rabtan continued to threaten China's borderlands until the middle of the eighteenth century, the emperor's rout of Galdan signaled the last major nomadic challenge to Qing rule. In 1691 the Khalkha khans had already assembled in Dolonnor and had submitted to Qing authority in return for protection from Galdan.

THE MONGOLS UNDER FOREIGN RULE

Thus, from 1691 on, the Qing governed a large part of Mongolia and began, in its view, to "tame the unruly and barbaric" Mongols. One of its principal objectives was to isolate Mongolia. Russians needed to be excluded because they could, if given the opportunity, reemerge and perhaps challenge China's jurisdiction. Another of its goals was to prevent the intrusion of Chinese merchants into Mongolia. The court instructed its officials to monitor economic transac-

tions between Chinese and Mongols carefully, and it prohibited Chinese from buying land, building houses or shops other than in Urga, and intermarrying with the Mongols. It sought to restrain avaricious Chinese merchants from exploiting the Mongols and thus provoking social unrest.

Despite such attempts to prevent the disruption of traditional society, the Qing court itself initiated changes among the Mongols in order to facilitate its control and domination. The Lifanyuan (Court of Colonial Affairs), based in Beijing, held sway over Mongolia and appointed Manchu and Chinese officials, who took charge of Qing military garrisons stationed there, in Uliasutai and Khobdo.[51] Banners replaced the old tribal systems and undermined the authority of tribal chiefs, and Banner princes (jasag) showed their obeisance by submitting tribute to the court. Each Banner was restricted to specific lands and pasturages, limiting the traditional mobility of the nomads. To reduce the power of the khans, the Qing organized leagues that cut across the khanates, thus eroding the Mongols' loyalty to specific leaders. By assigning the leagues fixed territories, it ensured greater control and facilitated its efforts to collect taxes and to demand corvée labor and service at and maintenance of postal stations, watchtowers, and garrisons, burdensome duties for the Mongols. Such requirements, together with the creation of administrative centers and bureaucracies and the consequent development of towns, as well as the depredations of Chinese merchants, subverted the traditional Mongol economy, leading to increased poverty among the pastoral peoples.

The Chinese merchants were also responsible for the economic misfortunes of the Mongols in the eighteenth and nineteenth centuries. Before the Qing dynasty, Mongols arrived in China for trade, as Chinese merchants were not generally permitted to travel beyond the boundaries of China. Despite the Qing's severe restrictions on merchants' entry into Mongolia, Chinese traders now evaded the regulations by bribing officials who provided them with the precious licenses permitting entry into the reputedly closed-off lands of the Mongols. They frequently stayed far longer than the time specified on their licenses, and some even ventured into Mongolia without licenses. They took advantage of the Mongols' difficult economic position. As one historian of Mongolia has explained, "The Mongols produced seasonal animal products and needed to sell them as soon as they could, but their needs were continuous. Consequently [Chinese] traders could buy low, sell high, and extend credit."[52] The Mongols sold their animals in the spring and summer but required Chinese products such as flour, grain, textiles, silk, tea, pots, tobacco, ladders, and handicrafts throughout the year. The Chinese merchants loaned them money at appallingly high rates of interest, which enabled the Mongols to buy the goods they needed but simultaneously

caused them to become permanently indebted.[53] In addition, wily merchants on occasion swindled the Mongols, pawning off defective or inferior products and then using their connections with officials to deflect protest. As a result, "[s]ome of the Chinese accumulated vast fortunes through their dealings with the Mongols. Several became wealthy mainly by lending money at exorbitant rates of interest: in some cases, five per cent a month. Others enticed prosperous Mongol nobles and princes to purchase luxury products at absurdly high prices, again siphoning off the resources of the Mongols."[54] Ordinary Mongols became increasingly impoverished.

Buddhist monasteries also promoted changes in traditional Mongol society and spurred the further pauperization of the bulk of the Mongol population. By the middle of the nineteenth century, about 45 percent of males in Outer Mongolia had taken monastic vows. The sizable and sprawling monasteries contributed to the development of towns which required supplies, food, and crafts, and the resulting urbanization offered Chinese merchants additional opportunities to make incursions into the Mongol economy. Monasteries not only provided a market but also served as warehouses for their goods, staging areas from which they could venture into the steppe. Granted exemptions from taxation and corvée labor, the monasteries accumulated considerable property and wealth, as rich benefactors, including the jasag, contributed pasturelands and compelled their subjects to do the same. Donations also took the form of jewelry or other valuables and, perhaps most important, laborers. Jasag turned over these laborers (known as shabinar, or "disciples") to the monks as bondsmen whose work and finished products belonged to the monasteries. Enormous property and labor thus accrued to the lamaseries. By about 1900 they controlled about one-fifth of the total wealth of Outer Mongolia, and the Bogdo Gegen himself had about 22,000 lamas and approximately 28,000 shabinar under his personal jurisdiction.[55] At about the same time, nineteen incarnations resided in Outer Mongolia, and 157 had been discovered in Inner Mongolia. The Qing had fostered an expansion in the number of incarnations as a means of dispersing power, preventing the Bogdo Gegen himself from gaining so much authority and prestige that Mongols would rally around him and threaten Qing rule. For example, it championed the various incarnations of Jangjya Khutuktu in Inner Mongolia as a counterweight to the Bogdo Gegen.

The Buddhist monasteries in Mongolia served Qing interests. The message of pacifism in Buddhist doctrine subverted the more bellicose elements of nomadic culture; the growing impoverishment of Mongol nomads as they settled in towns and monasteries defused the military threat that they posed to China; the military threat itself became less potent as their martial skills, including those contributing to

a cavalry, eroded with increased sedentarization; and sedentarization facilitated Qing efforts to control them. The monastic establishment also made sharp distinctions between high-ranking lamas and ordinary lamas. Only the incarnations, their entourages, and their closest advisers benefited enormously from their positions, while the vast majority of humble lamas worked hard as herders or farmers to survive and to pursue their vows. Such a sharply defined and stable hierarchy, whose leaders profited from their relationship with China, made Qing rule easier to enforce.

Yet the continual Qing political and economic encroachments on the Mongols aroused hostility. Exploitation by Chinese moneylenders, the presence of Manchu garrisons, and the growing demands for corvée labor and other services embittered some Mongols and finally sparked a revolt in 1756–57 (fig. 10). A Mongol military commander, with the tacit support of the Bogdo Gegen, challenged Qing authority in Outer Mongolia. Unable to galvanize all or even a large number of the Mongols, he succumbed rather readily when the Qing forces faced him in battle.[56] Yet again, lack of unity and of nationalist feelings sabotaged Mongol military and political campaigns. The Qing authorities, accusing the Bogdo Gegen of complicity in the rebellion, decreed that future incarnations of the Living Buddha could be found only in Tibet. They wished, in this way, to avert a possible alliance between him and an anti-Qing independence movement among the Mongols and to ensure that future Bogdo

Gegens were not relatives of leaders in the Mongol nobility, a relationship that might link the Mongol religious and secular hierarchies in opposition to China's interests.

The Qing mandate compelling Tibetans to be chosen as future incarnations of the Bogdo Gegen was based on its dominance in Tibet. In 1717 the nephew of the deceased Zunghar Mongol Galdan had dispatched a force to suppress a fellow Western Mongol who had ruthlessly governed Tibet since 1705. The Zunghar troops crushed their opposition. Though the Tibetans initially welcomed them as saviors, the Zunghars' plundering of temples and monasteries and executions of several lamas enraged many Tibetans, who joined together with the Manchus in expelling the descendants of Galdan in 1720. The Qing claimed jurisdiction over Tibet and, after intervening in a Tibetan civil war in 1727–28, stationed a military garrison and an imperial resident (amban) to govern.[57] Having ruled Tibet for about three decades, the Qing revealed its confidence in its control of that land by mandating a Tibetan origin for each successive incarnation of the Bogdo Gegen starting in 1757.

With Tibet under its jurisdiction and with each Bogdo Gegen having no direct links with the Mongol nobility, the Qing dominated Mongolia until 1911. No major uprisings erupted to overthrow Qing rule in the eighteenth and nineteenth centuries, though local disturbances and sporadic attacks against Chinese merchants and officials persisted to the very end of the dynasty. Thus, "despite the illegal immi-

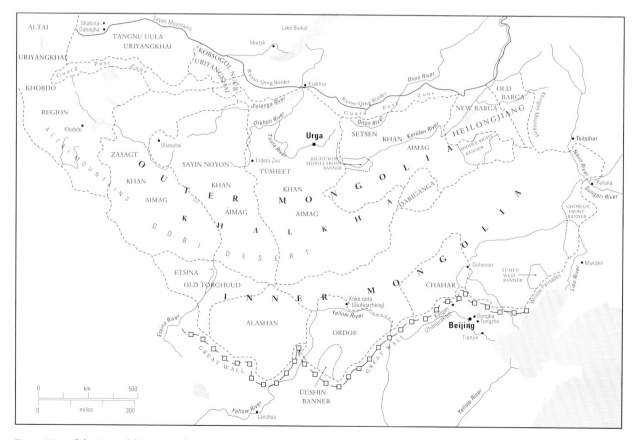

Fig. 10. Map of the Mongol divisions in the 18th–19th centuries. Adapted from *History of China* (Cambridge: Cambridge University Press, 1978), vol. 10, pt. 1, p. 55.

gration of Chinese colonists, the increasing impoverishment of lower-class Mongols, the oppressive rule of the Mongol nobility, the frequently corrupt administration of the Qing officials stationed in Mongolia, the rise of towns," and the growing economic and social power of the Buddhist monasteries, "the Qing government had managed to maintain its precarious hold on Mongolia until its first military encounters with the Europeans."[58]

Paradoxically, this period of foreign rule, which resulted in political and economic decline, witnessed a cultural efflorescence in Mongolia. Literature flourished, perhaps in response to the deteriorating conditions in the country. Oral literature recited by bards and storytellers began to be written down, and various legendary tales and sagas were thus preserved for future generations. Poetry and translations of Chinese novels were popular among the elite, and literature based on historical events came into vogue.[59] The novelist Injanashi's *Köke Sudur* (Blue Chronicle), a fictional version of Mongol history, was the most renowned of this genre of writing.[60]

Nonetheless, monasteries became the dominant force in the cultural flowering of Mongolia, as they were the preservers of learning and the arts. As the principal fixed centers in the country other than the buildings in which the Chinese and the Manchus lived and worked, the monasteries attracted the most learned and artistic Mongols. The largest of them had colleges of medicine, of philosophy, doctrine, and protocol, of mathematics, astrology, and divination, and of demonology and demon suppression, four types of institutions that ensured the monasteries' intellectual dominance in Mongolia.[61] Monks copied and translated Buddhist texts, printed books, and produced book covers. Thus it is no accident that every one of the fifteen book covers or pages displayed in this exhibition reflects a Buddhist origin. Each depicts either an important Buddhist figure such as the historic Buddha Shakyamuni and the founder of the Gelugpa, Tsongkhapa, or Buddhist symbols such as lotuses. The monasteries also became havens for artisans because the monks and the Bogdo Gegen offered a valuable market for crafts. Artisans fashioned hats for the Bogdo Gegen and hats and boots for a wife of one of the Bogdo Gegens (see cat. nos. 20, 28, and 30). The monasteries commissioned painters to produce thangkas and other paintings, many of which reflected Buddhist themes and subjects. Qing support for the monasteries thus indirectly contributed to the outburst of Mongol arts and crafts, which often incorporated Buddhist subjects and were patronized by the Buddhist hierarchy.

Qing control also exposed the artists and craftsmen of Mongolia to a wider world. Zanabazar, the Bogdo Gegen and one of the premier Mongol artists, spent part of each year in China and, in fact, died in Beijing in 1723.[62] His stays in China doubtless influenced his artistic endeavors. The Mongols' affinity with the Tibetans, partly due to the religion they shared, infused their art, and those viewers conversant with Tibetan art may find much that is familiar in this exhibition of Mongol art. The connections between the two became even closer after 1757, when the Qing demanded that the Bogdo Gegens be discovered in Tibet. Tibetan influence on Mongol culture and art persisted, particularly on the monasteries and the entire Buddhist establishment. Several of the Qing emperors encouraged such contacts because they themselves were patrons of Tibetan Buddhism, even building a number of Tibetan monasteries in Beijing. Supplementing the Chinese and Tibetan influences was the growing international context of East Asia in the nineteenth century. The nineteenth-century struggle between Russia and Great Britain in Central Asia brought the Mongols in touch with Russia and introduced Russian tastes and forms to the peoples of Mongolia.

However, the cultural influences from abroad transmitted via the monasteries did not stave off the economic and social deterioration of Mongolia in the late nineteenth and early twentieth centuries. The Buddhist establishment, including the Bogdo Gegen, exemplified this decline. A Bogdo Gegen openly flaunting a wife and thus deliberately ignoring the vow of celibacy and then contracting syphilis brought the Buddhist hierarchy into disrepute and provoked increasing social unrest. The fall of the Qing dynasty in 1911 precipitated even greater disturbances and more attempts to break away from Chinese control. Various members of the nobility, as well as the Bogdo Khan (the last Bogdo Gegen), jockeyed for power and turned to outsiders, including the tsarist court and later a bizarre and fanatic anti-Communist named Baron Ungern-Sternberg, for assistance. Chinese troops frequently raided or occupied Mongol territories and even reached the capital at Urga.

MONGOL INDEPENDENCE?

The beneficiaries of this unrest were those opposed to the nobility and the Buddhist establishment. In 1921 corruption, exploitation, and pillaging finally spurred some Mongols to cooperate with the Soviet Communist government and to request assistance from V. I. Lenin (fig. 11). They founded the Mongolian People's Republic in 1924, the very same year of the Eighth Bogdo Gegen's death (fig. 12). No other totally accepted incarnation has been discovered since then. The Mongol Communist Party and government set about to disempower the nobility, seizing its assets and pasturelands, and to compel the pastoral nomads to settle in fixed territories in order to facilitate control.[63] For the next six or so decades, the Mongol government modeled its policies on those of the Soviet Union, and Soviet political and economic involvement offered tremendous leverage over Mongolia,

Fig. 11. A. Setsentsokhio, *Meeting Lenin*. From *Sovremennoe iskusstvo mongolii* (Contemporary Art of Mongolia) (Moscow: Sovetskii khudozhnik, 1968), p. 8.

which traded almost exclusively with the Soviet Union or later the Communist bloc and relied on Soviet economic aid. With prodding from the Russians, the Mongol Communists ruthlessly suppressed any evidence of so-called Mongol nationalism. Cyrillic replaced Uighur as the script for the transcription of Mongolian. The history of the Mongol conquests was reinterpreted to emphasize their reactionary character, and Chinggis Khan was for over fifty years "banished from Mongolia's consciousness and history books by Mongol leaders [acquiescing] to Soviet allies who loathed the memory of 300 years of fierce Mongol subjugation."[64] Thus, when the Mongols planned a celebration in 1962 for the eighth centenary of Chinggis's birth, the Russians, fearful of the development of Mongol nationalism, prodded the Mongol government to cancel all such events and to purge nationalists who had sponsored such efforts. A number of officials and scholars were stripped of their positions, and numerous articles condemning Chinggis and depicting him as a barbaric conqueror rather than as a national hero appeared in Russian and Mongol journals.

However, the most severe blow to Mongol arts, crafts, and culture was the concerted attack on Buddhism in the 1930s. The government unleashed a campaign and an assault on the monasteries, which had been the repositories of learning and art during the era of Qing domination. This was not merely an antireligious campaign but also entailed confiscation of the property and assets of the monasteries, including land, animals, and buildings. Some monks responded with a rebellion in 1932, leading to government suppression which,

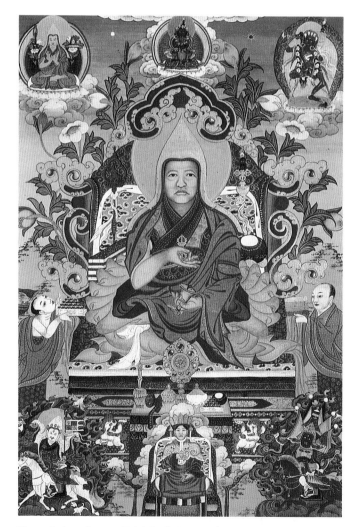

Fig. 12. Artist unknown, *Eighth Bogdo Gegen*. Colors on cotton, H: 24⅜ (62.0) W: 17⅛ (43.5). Bogdo Khan Palace Museum, Ulaanbaatar. From Tsultem, *Mongol Zurag,* fig. 174.

in turn, resulted in looting and destruction. The number of books, texts, paintings, textiles, and gold and silver vessels destroyed may never be known. The objects in this exhibition, fortunately, survived, but the relative paucity of such religious artifacts reflects the losses incurred during this period. According to official statistics, the number of lamas declined from more than one hundred thousand in the 1930s to fewer than one thousand by the 1980s.[65]

Starting in the late 1980s the withdrawal of Russian troops and the consequent lessening of Russian economic and political dominance, along with the move toward a multiparty system and a market economy, have reignited Mongol nationalism. Mandating that the old Uighur alphabet be restored as the Mongolian script, the government has ordered its use in the schools. The traditional ethnic heritage of the Mongols has been reaffirmed, and Chinggis Khan has been rehabilitated. Official sources and accounts now portray him as a national hero, with streets, hotels, songs, and even a brand of vodka named in his honor, and a cult has developed around him. Shamanist practices have reemerged, and Buddhism has been revived, with the number of worshipers, lamas, and monasteries all increasing. Interest in traditional Mongol arts and crafts, including the wearing of the Mongol national dress, the *del,* has intensified, the current exhibition benefiting from this resurgence. Accompanying this nationalism and the reduction of Soviet influence has been an openness to countries outside the Soviet bloc, including the United States, which has, in part, facilitated the development of this exhibition and cultural exchange in general.

Such openness offers hope for the Mongols' ability to overcome the traditional problems of a lack of unity and of the absence of a legal, orderly process for transferring power. An ideology that serves to unify the Mongols is essential. Yet their history bodes well for "their ability to survive as a distinct people with a distinct heritage, surrounded by far more populous states that pressured them to assimilate. . . . Over the past several centuries they have resisted both Sinicization and Russification and emerged strengthened."[66]

NOTES

The author is grateful to the Lucius Littauer Foundation and to the Asian Cultural Council for grants that provided an opportunity to examine Mongol sculptures, paintings, and craft articles in various locations in East Asia.

1. 'Alā' al-Dīn 'Aṭā-Malik Juvainī, *The History of the World Conqueror,* trans. John Andrew Boyle (Manchester: Manchester University Press, 1958), vol. 1, pp. 106–7, 178.

2. Joseph Fletcher, "The Mongols: Ecological and Social Perspectives," *Harvard Journal of Asiatic Studies* 46, no. 1 (June 1986), 14.

3. Jennifer Holmgren, "Observations on Marriage and Inheritance Practices in Early Mongol and Yuan Society," *Journal of Asian History* 20,

no. 2 (1986), 132–35, speculates that Chinggis's father was relatively poor and of low status.

4. The literature on Chinggis is voluminous. The most authoritative study is Paul Ratchnevsky, *Genghis Khan: His Life and Legacy,* trans. Thomas Haining (Oxford: Blackwell Publishers, 1991). Another work based on primary sources is Boris Ia. Vladimirtsov, *The Life of Chingis Khan,* trans. D. S. Mirsky (repr.; New York: Benjamin Blom, 1969). Morris Rossabi, "Genghis Khan," in *Encyclopedia of Asian History* (New York: Charles Scribner's Sons, 1988), vol. 1, pp. 496–98, offers a summary of his career. Temüjin was his name at birth; "Chinggis Khan" was the title he received when he was accepted as ruler of the Mongols in 1206.

5. H. D. Martin, *The Rise of Chingis Khan and His Conquest of North China* (Baltimore: The Johns Hopkins University Press, 1950), pp. 11–47, provides a dated though concise description of the Mongols' military innovations. Paul Pelliot and Louis Hambis, trans. and annotators, *Histoire des campagnes de Gengis Khan: Cheng-wou ts'in-tcheng lou* (Leiden: E. J. Brill, 1951), is useful for scholars.

6. Gareth Jenkins, "A Note on Climatic Cycles and the Rise of Chinggis Khan," *Central Asiatic Journal* 18 (1974), 217–26.

7. On the need for a steppe ruler to extract booty from the settled civilizations for his supporters, see Thomas J. Barfield, *The Perilous Frontier* (Oxford: Blackwell Publishers, 1989), pp. 46–50.

8. The most important of these chroniclers was Juvainī.

9. For example, Chang Chun, a Chinese Daoist who traveled through Central Asia in Chinggis's entourage, found many of the reputedly devastated towns to be flourishing. See Arthur Waley, trans., *The Travels of an Alchemist* (London: Routledge & Kegan Paul, 1931), pp. 68, 99–101.

10. A popularized version of these campaigns is James Chambers, *The Devil's Horsemen: The Mongol Invasion of Europe* (London: Cassell Publishers, 1988).

11. A report of the excavations is found in S. V. Kiselev, ed., *Drevnie mongolskie goroda* (Ancient Mongolian Cities) (Moscow: Nauka, 1965).

12. John A. Boyle, trans., *The Successors of Genghis Khan* (New York: Columbia University Press, 1971), p. 82.

13. Much of this section is based on Morris Rossabi, *Khubilai Khan: His Life and Times* (Berkeley: University of California Press, 1988).

14. See Nancy S. Steinhardt, "The Plan of Khubilai Khan's Imperial City," *Artibus Asiae* 44, nos. 2–3 (1983), 137–58, and her "Imperial Architecture along the Mongolian Road to Dadu," *Ars Orientalis* 18 (1988), 59–92.

15. Cary Liu, "The Yuan Dynasty Capital, Ta-tu: Imperial Building Program and Bureaucracy," *T'oung Pao* 78 (1992), 279, believes that the Muslim architect's role was limited. See also Anning Jing, "The Portraits of Khubilai Khan and Chabi by Anige (1245–1306), a Nepali Artist at the Yuan Court," *Artibus Asiae* 54, nos. 1–2 (1994), 40–86.

16. See, among many other studies, Yolanda Crowe, "Late Thirteenth-Century Persian Tilework and Chinese Textiles," *Bulletin of the Asia Institute* 5 (1991), 153–61; Anne E. Wardwell, "*Panni Tartarici:* Eastern Islamic Silks Woven with Gold and Silver, Thirteenth and Fourteenth Centuries," *Islamic Art* 3 (1988–89), 95–173; and Anne E. Wardwell, "Two Silk and Gold Textiles of the Early Mongol Period," *Bulletin of the Cleveland Museum of Art* 79, no. 10 (December 1992), 354–78.

17. For more on the Prester John legend, see Vsevolod Slessarev, *Prester John: The Letters and the Legend* (Minneapolis: University of Minnesota Press, 1959), and the intriguing though not totally accurate version in L. N. Gumilev, *Searches for an Imaginary Kingdom: The Legend of the Kingdom of Prester John,* trans. R. E. F. Smith (Cambridge: Cambridge University Press, 1987).

18. The latest translation of William of Rubruck's narrative is Peter Jackson and David Morgan, *The Mission of Friar William of Rubruck* (London: Hakluyt Society, 1990).

19. A. C. Moule and Paul Pelliot, *Marco Polo: The Description of the World* (London: George Routledge & Sons, 1938), vol. 1, p. 201.

20. See Morris Rossabi, *Voyager from Xanadu: Rabban Sauma and the First Journey from China to the West* (New York: Kodansha, 1992), pp. 24–29, for a brief description of Nestorianism. Also see the first volume of Samuel Moffett, *A History of Christianity in Asia* (New York: Harper-Collins, 1992), for additional information.

21. Rossabi, *Khubilai Khan*, p. 138. A translation of the text is found in Constance Hoog, trans., *Prince Jin-gim's Textbook of Tibetan Buddhism* (Leiden: E. J. Brill, 1983). Professor Charles Willemen of Ghent University is currently preparing an interpretive study of the text.

22. For more on Tibeto-Mongol relations during this period, the latest work is Luciano Petech, *Central Tibet and the Mongols: The Yuan-Sa-skya Period of Tibetan History* (Rome: Istituto Italiano per il Medio ed Estremo Oriente, 1990). Relations between the Yuan and Tibet persisted late into the period of Mongol rule. See Leonard W. J. van der Kuijp, "Shambhala: An Imperial Envoy to Tibet during the Late Yuan," *Journal of the American Oriental Society* 113, no. 4 (October–December 1993), 529–38.

23. Herbert Franke, *Geld und Wirtschaft in China unter der Mongolenherrschaft* (Leipzig: Otto Harrassowitz, 1949), pp. 101–6, argues that inflation was not a serious factor in Khubilai's reign.

24. Charles J. Halperin, *Russia and the Golden Horde* (Bloomington: Indiana University Press, 1985), p. 83.

25. John A. Boyle, ed., *The Cambridge History of Iran: The Saljuq and Mongol Periods* (Cambridge: Cambridge University Press, 1968), p. 621.

26. Henry Serruys writes about those Mongols who remained in China in "The Mongols in China, 1400–1450," *Monumenta Serica* 27 (1968), 233–305. For other works by Serruys on the same subject, see Henry G. Schwarz, *Bibliotheca Mongolica, Part I: Works in English, French, and German* (Bellingham: Western Washington University Press, 1978), pp. 342–43.

27. H. F. Schurmann has written about the Mongols who remained in Afghanistan in *The Mongols in Afghanistan: An Ethnography of the Moghuls and Related Peoples of Afghanistan* (Leiden: Mouton, 1962).

28. Edward L. Dreyer, *Early Ming China: A Political History, 1355–1435* (Stanford, Calif.: Stanford University Press, 1982), pp. 3–10.

29. Dmitrii Pokotilov, "History of the Eastern Mongols during the Ming Dynasty from 1369 to 1634," trans. R. Löwenthal, *Studia Serica*, ser. A, no. 1 (1947), 25–30; Edward L. Farmer, *Early Ming Government: The Evolution of Dual Capitals* (Cambridge, Mass.: Harvard University Press, 1976), pp. 1067–114.

30. L. C. Goodrich and Chaoying Fang, eds., *Dictionary of Ming Biography* (New York: Columbia University Press, 1976), vol. 1, pp. 12–13; Morris Rossabi, "Ming China and Inner Asia," in Denis Twitchett, ed., *Cambridge History of China: Ming II* (forthcoming).

31. David M. Farquhar, "Oirat-Chinese Tribute Relations, 1408–1446," in *Studia Altaïca: Festschrift für Nikolaus Poppe* (Wiesbaden: Otto Harrassowitz, 1957), p. 65; Ph. de Heer, *The Care-Taker Emperor* (Leiden: E. J. Brill, 1986), p. 16.

32. Frederick Mote, "The T'u-mu Incident of 1449," in Frank A. Kierman and John K. Fairbank, eds., *Chinese Ways in Warfare* (Cambridge, Mass.: Harvard University Press, 1974), pp. 251–58; Morris Rossabi, "Notes on Esen's Pride and Ming China's Prejudice," *Mongolia Society Bulletin* 9, no. 2 (Fall 1970), 31–39.

33. See Henry Serruys, *Genealogical Tables of the Descendants of Dayan-qan* (The Hague: Mouton, 1958), for a listing of these princely families.

34. Arthur Waldron, *The Great Wall of China* (Cambridge: Cambridge University Press, 1990), pp. 122–23.

35. Henry Serruys, "Four Documents Relating to the Sino-Mongol Peace of 1570–1571," *Monumenta Serica* 19 (1960), 48–66.

36. Henry Serruys, "Remarks on the Introduction of Lamaism into Mongolia," *Mongolia Society Bulletin* 7 (1968), 62–65; Henry Serruys, "Early Lamaism in Mongolia," *Oriens Extremus* 10, no. 2 (October 1963), 181–216.

37. Goodrich and Fang, *Dictionary of Ming Biography*, pp. 1308–9; see also Robert Thurman, *The Central Philosophy of Tibet* (Princeton, N.J.: Princeton University Press, 1984).

38. Morris Rossabi, *China and Inner Asia from 1368 to the Present Day* (London: Thames and Hudson, 1975), p. 46.

39. Morris Rossabi, *The Jurchens in the Yüan and Ming* (Ithaca, N.Y.: China-Japan Program, Cornell University, 1982), pp. 51–54.

40. David M. Farquhar, "The Origins of the Manchus' Mongolian Policy," in John K. Fairbank, ed., *The Chinese World Order* (Cambridge, Mass.: Harvard University Press, 1968), pp. 198–205. On the final Manchu victory, see Frederic Wakeman, Jr.'s monumental two-volume *The Great Enterprise* (Berkeley: University of California Press, 1985).

41. Charles R. Bawden, *The Modern History of Mongolia* (London: Weidenfeld & Nicolson, 1968), pp. 41–46.

42. See Morris Rossabi, "The Ch'ing Conquest of Inner Asia," in Denis Twitchett, ed., *Cambridge History of China: Early Ch'ing* (forthcoming).

43. Charles R. Bawden, *The Jebtsundamba Khutukhtus of Urga*, Asiatische Forschungen, Band 9 (Wiesbaden: Otto Harrassowitz, 1961), pp. 42–43. Owen Lattimore in *Mongol Journeys* (New York: Doubleday, Doran, and Co., 1941), pp. 308–16, writes about the legends concerning Zanabazar.

44. N. Tsultem, *The Eminent Mongolian Sculptor—G. Zanabazar* (Ulaanbaatar: State Publishing House, 1982), p. 7; Françoise Aubin, "L'époque de Zanabazar," in Gilles Béguin et al., *Trésors de Mongolie, XVIIe–XIXe siècles* (Paris: Editions de la Réunion des musées nationaux, 1993), pp. 36–38.

45. Bawden, *The Jebtsundamba Khutukhtus of Urga*, p. 53.

46. Robert A. Rupen, "The City of Urga in the Manchu Period," in *Studia Altaïca: Festschrift für Nikolaus Poppe*, pp. 157–69.

47. The most valuable studies on the Zunghar efforts in the seventeenth century are Il'ia Iakovlevich Zlatkin, *Istoriia dzhungarskogo khanstva, 1635–1758* (A History of the Jungharian Khanate) (Moscow: Nauka, 1964), and Mark Mancall, *Russia and China: Their Diplomatic Relations to 1728* (Cambridge, Mass.: Harvard University Press, 1971). Two recent works are M. Khodarkovsky, *Where Two Worlds Met: The Russian State and the Kalmyk Nomads, 1600–1771* (Ithaca, N.Y.: Cornell University Press, 1992), and Fred W. Bergholz, *The Partition of the Steppe* (New York: Peter Lang, 1993).

48. Tsepon W. D. Shakabpa, *Tibet: A Political History* (New Haven, Conn.: Yale University Press, 1967), pp. 103–14.

49. See Eric Widmer, *The Russian Ecclesiastical Mission in Peking during the Eighteenth Century* (Cambridge, Mass.: Harvard University Press, 1976), for a study of these missions.

50. Tsultem, *The Eminent Mongolian Sculptor—G. Zanabazar*, pp. 7–9.

51. Ning Chia, "The Lifanyuan and the Inner Asian Rituals in the Early Qing (1644–1795)," *Late Imperial China* 14, no. 1 (June 1993), 61–63.

52. Joseph Fletcher, "Qing Inner Asia, c. 1800," in John K. Fairbank, ed., *The Cambridge History of China: Late Ch'ing, 1800–1911, Part I* (Cambridge: Cambridge University Press, 1978), p. 57.

53. M. Sanjdorj, *Manchu Chinese Colonial Rule in Northern Mongolia*, trans. Urgunge Onon (New York: St. Martin's Press, 1980), p. 27.

54. Rossabi, *China and Inner Asia*, p. 154.

55. Larry W. Moses, *The Political Role of Mongol Buddhism*, Indiana University Uralic and Altaic Series, vol. 133 (Bloomington: Asian Studies Research Institute, Indiana University, 1977), pp. 125–27.

56. Charles R. Bawden, "The Mongol Rebellion of 1756–1757," *Journal of Asian History* 2, no. 1 (1968), 1–31.

57. Luciano Petech, *China and Tibet in the Early Eighteenth Century* (Leiden: E. J. Brill, 1950), pp. 108–25.

58. Rossabi, *China and Inner Asia,* p. 210.

59. Walther Heissig, *Geschichte der mongolischen Literatur* (Wiesbaden: Otto Harrassowitz, 1972), vol. 1, pp. 278–90.

60. For a useful translation and analysis, see John Hangin, trans., *Köke Sudur (The Blue Chronicle): A Study of the First Mongolian Historical Novel by Injannasi* (Wiesbaden: Otto Harrassowitz, 1973).

61. Moses, *The Political Role of Mongol Buddhism,* p. 135.

62. Bawden, *The Jebtsundamba Khutukhtus of Urga,* p. 67.

63. Two differing interpretations of Mongol history in the twentieth century are Robert A. Rupen, *The Mongols of the Twentieth Century,* Uralic and Altaic Series, vol. 37, nos. 1–2, 2 vols. (Bloomington: Indiana University Press, 1964), and William A. Brown and Urgunge Onon, trans., *The History of the Mongolian People's Republic* (Cambridge, Mass.: Harvard University Press, 1976).

64. Alicia Campi, "The Rise of Nationalism in the Mongolian People's Republic," *Central and Inner Asian Studies* 6 (1992), 51.

65. Moses, *The Political Role of Mongol Buddhism,* pp. 192, 262.

66. Morris Rossabi, "Mongolia: A New Opening?" *Current History* 91, no. 566 (September 1992), 283.

After Xanadu

THE MONGOL RENAISSANCE OF THE SIXTEENTH TO EIGHTEENTH CENTURIES

PATRICIA BERGER

In a tale still told in the nineteenth century, it was said that Khubilai Khan once gave his lama-preceptor Phagspa a gift of eight scarves, seven black and one white. The meaning of the gesture, Phagspa explained, was that he and Khubilai would not meet for seven lifetimes. He said, "The single white piece you offered means that when the time comes and we meet again, you will bear the name of gold (Altan), and I the name of water (Dalai)."[1]

Even if Phagspa's prophecy was the work of revisionist historians, as it probably was, its accurate evaluation of the symbolic significance of events that finally took place three hundred years later is uncanny. Indeed, the history of Mongolia in the centuries following the collapse of Chinggis's empire in East Asia was subtly crafted to resonate with the charisma of bygone days; Mongol leaders literally willed Phagspa's prophecy to life.

During the period from the sixteenth through the eighteenth centuries, and even into the modern era, a succession of khans, lamas, and demagogues, with greater or lesser degrees of success, consciously revived the ideals of Chinggis, his sons, and his grandsons, legitimizing their own aspirations for Mongol unity and greatness with a symbolism sanctioned by history. Harking back to the classical past, they reestablished ties with the Tibetan Buddhist hierarchy, itself in a state of transition, creatively adopted the Tibetan system of reincarnation to sidestep issues of lineage and pedigree, and used Tibetan techniques of swift enlightenment and divine empowerment to enhance their own powers and prestige. They also cast their eyes once again, longingly, on China and Central Asia, and actively dreamt of rebuilding the pan-Asian empire of Chinggis Khan.

By the early sixteenth century, few traces of Chinggis's empire remained in East Asia. The Mongols' nomadic, portable way of life continued as before, barely affected by earlier intermittent efforts to build permanent, Chinese-style cities on the steppe. The glory days of Khubilai's Xanadu

(Shangdu) and Ögödei's Kharakhorum had been temporarily eclipsed. Still, the potency of Chinggis's true legacy, the concept of a world empire ruled from Inner Asia, was carefully nurtured by Mongolia's increasingly fractious khans, who used his relics, enshrined in the Inner Mongolian Ordos region, and his lineage to support their own imperial pretensions well into the twentieth century.[2]

But an equally significant inheritance came from Chinggis's grandson, Khubilai, the first emperor of the Yuan dynasty. Khubilai and his Tibetan Buddhist preceptor, the Sakyapa lama Phagspa, had created a new, Inner Asian, Buddhist concept of statecraft—the dual principle—compelling enough to challenge China's Confucian system of heavenly mandate, ancestral homage, and moral rectitude. By Khubilai's time, Mongol aspirations far transcended China; they extended into Inner Asia and beyond. Thus Khubilai turned to Buddhism, but of a unique, Inner Asian type. His initiation into the Tibetan tantric rites of Hevajra, urged on him by his wife, Chabi, developed into an apparent partnership with Phagspa, with the two seated side by side as "the sun and the moon." On a practical level, this new relationship between lama and ruler resulted in the easy control of Tibet and the empirewide division of religious and secular affairs between priest and protector. On a symbolic level, it cast Khubilai as Chakravartin—world ruler, as an embodiment of Mahakala, the fierce, intelligent protector deity and tutelary genius of the Sakya order and of Phagspa, and, posthumously, as an incarnation of Manjushri, the Bodhisattva of Wisdom, who coincidentally dwelt on China's Mount Wutai.[3]

The symbolic underpinnings of Khubilai's charismatic rule had a history that went beyond Tibet, however. In some ways, they were as old as East Asian Buddhism, a refinement of ideas borrowed from China's earlier foreign dynasties of a Buddhist utopia reigned over by an incarnate-bodhisattva, the embodiment of virtue and wisdom. In the scheme Khubilai embraced, the secular emperor shared his

throne with his spiritual mentor, the one Mongol, the other Tibetan. Phagspa, adept in the world of pragmatic politics, appreciated the role that the visual arts could play in broadcasting this new concept of government. He invited a young Nepalese aristocrat and artistic prodigy named Anige, with an entourage of craftsmen, to come to the Mongol capital at Dadu (modern Beijing) and create works of art and architecture that would publically promote a Tibetan Buddhist ideology and honor Khubilai as its imperial patron.[4] The potential value of the symbolism embodied in the very style Anige and his followers introduced to China was not lost on later Mongols, Tibetans, and eventually Manchus, as they vied to create a new political structure for Inner Asia during the Mongol resurgence of the seventeenth century. In the state-sponsored Buddhist arts and propaganda of Mongols and Manchus alike, echoes of the legacies of Chinggis and Khubilai resonated even in modern times.

THE SECOND BUDDHIST CONVERSION

After the fall of the Mongols to the Ming in 1368, Toghon Temür, the last Yuan emperor, fled into Inner Mongolia with tens of thousands of followers, where he established a capital, Bars qota (Tiger City), on the banks of the Kerülen.[5] These postdynastic years are called the Northern Yuan, only because the right to succession remained in the Borjigin lineage of Chinggis, embodied in the Chahar Mongol khans of Inner Mongolia. The tenuous union built by Chinggis Khan and his offspring among the tribes of Inner and Outer Mongolia fell apart; would-be khans from the western regions contended with the war-weary remnants of the Yuan imperial family, and, for a time, the political power of Chinggis's lineage dimmed. The Chahar were exhausted by their border battles with the Ming, and, more and more, military strength, the key to a new Mongol empire, was gathered up into the hands of Mongol groups in the west.

Also dimmed was the role Buddhism played in Mongolia. Tradition holds that Buddhism disappeared after the Mongols' loss of China and that the Mongolian people returned to their shamanistic ways, but this may be more apparent than real, for Mongolia's monasteries were nomadic, like everything else Mongolian, and their locations were approximate and impermanent. Moreover, the Sakya conversion that Phagspa and other Tibetan lamas engineered with Khubilai's cooperation had been limited to aristocratic Mongols and probably had little effect on the lives of ordinary nomads. But, despite the shallowness of Mongolia's first conversion, Chinese records show a continuous, if slight, trickle of evidence for the survival of Buddhism in the fifteenth and early sixteenth centuries among aristocratic Mongols in Western Mongolia and China's northwestern territories. There is little or no evidence that it persisted in Eastern Mongolia or among the Khalkhas to the north.[6]

As early as the fifteenth century, the khans of Western Mongolia perceived that Buddhism could provide legitimacy to their claims to Mongol overlordship, which were otherwise frustrated by the fact that they were not direct descendants of Chinggis. The early emperors of the Chinese Ming dynasty, similarly aware of the potential importance of Tibetan Buddhism in the politics of Inner Asia, kept up relations with Tibetan and Mongol lamas, at least through the Chenghua reign (1465–87). To the dismay of his court, the Ming Yongle emperor (r. 1403–24) issued repeated invitations to the great Tibetan Buddhist reformer Tsongkhapa (1357–1419), the founder of the Gelugpa or Yellow Hats, to come to China and be his guru. Although Tsongkhapa refused, other lamas—Sakyapa, Gelugpa, and Kagyupa—came and received tribute and honorific titles, initiated Yongle into tantric rites, and even arranged interment rituals for his father and mother. In the process of diplomatic exchange, Yongle's patronage of the ritual arts resulted in bronzes, paintings, and textiles of sublime beauty, whose qualities would be emulated even in the eighteenth and nineteenth centuries.[7]

As the military strength of the Mongol tribes grew in the early sixteenth century (particularly in the west), so did the influence of the few Tibetan Buddhist monks, members of the unreformed, "red," Sakya and Kagyu orders, who happened into their midst. Their effect on Altan (the Golden) Khan of the Tümed (r. 1543–82), one of the pretenders to Chinggis's legacy born outside his lineage, was to make him realize that Khubilai's Buddhist statecraft could provide an alternative way to put down tribal sentiment, restore a centralized hierarchy, and legitimize his own desire to assume the throne. Altan Khan spent his early years in the field, where he challenged his rivals, drove the Northern Yuan Chahar emperor to the east as far as Liaodong, captured Kharakhorum, the ancient Khalkha capital of Chinggis's son Ögödei, in Outer Mongolia, and forged an alliance with the Ming.[8]

Altan Khan's life changed dramatically, according to one story told about him, when he was campaigning in the west, north of Kokonor. There he happened to capture two Buddhist priests who introduced him to the Dharma and won his conversion. Whether Altan Khan was battle-weary and wanted only to turn away from war and toward a spiritual life, or whether, at the other extreme, he cynically saw Buddhism as a sophisticated tool to use against his rival, the emperor of the Northern Yuan, will probably never be settled. In any case, he parlayed his conversion into a brilliant diplomatic coup.

In 1577 Altan Khan, on the advice of his nephew Khutukhtai Setsen Khung Taiji, invited the Tibetan lama Sonam Gyatsho to meet with him in the Inner Mongolian Ordos, the heart of Altan Khan's territory. Sonam Gyatsho, a Gelugpa monk in the lineage of Tsongkhapa, was from

Kokonor, in Tibetan Amdo (modern Qinghai). By this time the Gelugpa were on the brink of religious civil war with the unreformed, older orders, including the Sakyapa, who had cemented the first Tibeto-Mongolian alliance with Khubilai, and the Kagyupa, the spiritual advisers of the Tibetan kings. In view of what transpired, it is worth noting that the body of legend surrounding Altan Khan relates that he was converted, not in the field by two captive monks, but in a dream by a yellow monk (Gelugpa) and a red monk (unreformed). This later version of the conversion finesses the source of Altan Khan's first awakening, because what took place during his meeting with the Gelugpa Sonam Gyatsho was the fulfillment of Phagspa's own prophecy. At a high diplomatic summit at Kokonor, complete with gift giving and the exchange of exalted titles, Altan Khan named Sonam Gyatsho as Dalai Lama (the third, for two preincarnations were quickly found for him). The Mongolian term *Dalai* means "Ocean." Sonam Gyatsho recognized his new protector, Altan Khan, as the reincarnation of Khubilai Khan, and himself as the reincarnation of Phagspa.[9] Just as Phagspa had foretold, he and Khubilai had met again, Phagspa as "water" (Dalai) and Khubilai as "gold" (Altan). The significance of Altan Khan's choice of the title Dalai for Sonam Gyatsho runs very deep, for Chinggis too means "ocean," as does Atila, the name of the famous Hun who almost conquered Rome, and the Tibetan term for "ocean" also figured in the titles of more than one great lama before this date.[10]

Thus, in a single exchange, differences between the Sakyapa, who first granted Khubilai legitimacy, and the Gelugpa were sublimated, at least from the Mongols' perspective, and Altan Khan's support for the Gelugpa assured. In broadcasting his status as Khubilai-incarnate, Altan Khan could sidestep his lack of a proper pedigree and, relying on a higher authority, firmly base his claim to Mongol overlordship on Buddhist principles.

Altan Khan immediately set to work building a new monastery for the Dalai Lama in Köke qota, the Blue Fort (modern Hohhot), the capital he founded in Inner Mongolia. The new Dalai Lama, in his turn, used the fire mandala of the fierce protector Mahakala, tutelary genius of the Sakyapa, and Khubilai's own spiritual guide *(yidam),* to burn the Mongols' shamanistic ancestral images, the *ongod* (see cat. no. 18). In a decree promulgated in 1577, Altan Khan ordered that the shamans be purged, by force if necessary; he also banned the worship of *ongod* and bloody sacrifices to them, and commanded his people to pay homage to the Buddhist six-armed Mahakala instead.[11] But the spirits of shamanism were not eliminated; they were simply converted into Buddhist service, where they reappeared as protectors of the faith in the dreams and miracles that surround Mongolia's greatest lamas, and in the *tsam* ritual dances that were regularly held to destroy Buddhism's enemies. Buddhist lamas easily overwhelmed their shaman-rivals (who, after all,

had no institutional support), because they operated with hitherto unseen sophistication in the same sphere as shamans, apparently entering into trances, healing the sick, protecting herds and children with charms and spells, and exorcizing demonic influences. The powerful, sacred places of shamanism also became the natural sites for Buddhist monasteries, and so, in the process of conversion, at least part of the substance of shamanism remained intact.

Nonetheless, years later, in 1586, and after the death of Altan Khan, Khung Taiji harked back to Khubilai Khan's book of statecraft, *The Tenfold Virtuous White Chronicle of the Faith,* a text Khung Taiji rescued and edited, when he regretted the years Mongolia had spent in the darkness of shamanism. He praised Altan Khan and Sonam Gyatsho, "the twain Sun and Moon, by whose compassionate deeds the Dharma path of Ten Virtues had been restored," and reasserted the need for the "three countries of this side," China, Mongolia, and Tibet, to keep to the Buddhist virtues.[12]

Altan Khan was not single-handedly responsible for this new and sweeping reconversion of the Mongolian people to Buddhism. Other leaders, including the Chahar Zasagt Khan (r. 1558–92) and the Khalkha (Outer Mongolian) Abadai were also won over in the last decades of the sixteenth century. Zasagt Khan was first introduced to the Dharma by an unreformed lama in 1576, but after hearing of Altan Khan's exchange of titles with the new Dalai Lama, he invited Sonam Gyatsho to return to Mongolia in 1582. The Dalai Lama hesitated at first; invitations soliciting his favor had come also from the Ming Wanli emperor (r. 1573–1621), whose pious and powerful mother, the Empress Dowager Li, had stimulated a Chinese Buddhist revival.[13] The Dalai Lama finally undertook the journey in 1588, only to die en route.

Sonam Gyatsho's death was an opportunity Altan Khan's descendants could not ignore. They quickly seized their chance and found the Dalai Lama's reincarnation in a great-grandson of Altan Khan himself. During his short life, from 1589 to 1617, the Fourth Dalai Lama, Yonten Gyatsho, presided over an order that still struggled for primacy in Tibet, a process that would ultimately be resolved with Mongol military support only after his death, when the Great Fifth Dalai Lama took his place.

The Khalkha leader Abadai was the first of the Outer Mongolian khans to awaken to the potential—political and spiritual—that Tibetan Buddhism offered. Abadai was already familiar with Buddhist doctrine, which was probably taught to him by Sakyapa or Kagyupa lamas. But sometime between 1576 and 1577, around the time of Altan Khan's invitation to Sonam Gyatsho, Abadai too sought a meeting with him in Altan Khan's Köke qota. There Sonam Gyatsho granted him the title of Khan.[14]

Returning to Khalkha, Abadai founded his own khanate, the Tüsheet, and in 1586 Abadai subsidized the construction of Erdeni Zuu (Jewel Monastery), the oldest extant settled

monastery in Outer Mongolia.[15] Erdeni Zuu still stands, surrounded by a wall bearing 108 stupas, on the outskirts of the early Mongol capital of Kharakhorum, an area resonant with the symbolism of the old Mongol empire (fig. 1). The monastery's architecture was originally Chinese in style, built on the model of Altan Khan's monastery at Köke qota; Tibetan-style buildings were added later. Individual monasteries within the complex still reflect the devotional bent of Abadai himself, who honored Shakyamuni, the historic Buddha, the Buddhas of the Three Generations (past, present, and future), Padmasambhava (the saint who rid Tibet of its demons), and Gombo or Mahakala, protector deity and Lord of the Tents, into whose mysteries Phagspa had initiated Khubilai and whose intelligence Khubilai embodied. The sectarian nature of Erdeni Zuu in these early years is confusing, for if Abadai pursued the Third Dalai Lama, he was still unable to recruit the help of Gelugpa monks when the time came to dedicate his new monastery. And so Erdeni Zuu was consecrated by local Sakyapa lamas, whose particular icons continued to exert their influence even after Khalkha territory was brought securely into the Gelugpa sphere.

Even in the late eighteenth century, the Sakyapa carried real weight at Erdeni Zuu, especially when it came to Mahakala (despite the Third Dalai Lama's use of the fire mandala of Mahakala to burn the *ongod*). When the seventh abbot of Erdeni Zuu, Dakba Dorje, complained to the Khalkha Tüsheet Khan that the monastery lacked texts to guide rituals honoring Mahakala, he was ordered by the Jangjya Khutuktu, Rolpay Dorje, head of the Gelugpa in Inner Mongolia, to send a delegation of monks to Sakya itself to collect them. The Erdeni Zuu monks set off in 1776 for Sakya, where they received a transmission of rules concerning Mahakala, and were also given a shell that had allegedly been Phagspa's gift to Khubilai.[16] Thus, despite the importance of Altan Khan's compact with the Gelugpa, the Sakyapa still maintained a significant presence in Outer Mongolia even in the late eighteenth century, because they were half of a historic equation that symbolically united the Tibetan church with Mongolia's ruling class.

Nonetheless, the Gelugpa were ultimately able to win Mongolia into their fold because of their readiness to sanctify the claims of Mongol khans outside the lineage of Chinggis, such as Altan Khan, an activity as much in their own interests as in those of Mongolia's pretenders. Demonstrating their earnestness, they participated in mutual title-giving, aligning and equating themselves with the Mongolian aristocracy, they purged Mongolia's shamans, but borrowed their local spirits, they promulgated the Dharma ceaselessly through the translation of sacred texts, and, by staging huge, entrancing, public rituals, they ultimately drew in a dispersed, nomadic population.

Fig. 1. The monastery at Erdeni Zuu with its 108 stupas. Photo: Patricia Berger and Terese Tse Bartholomew.

LIGDAN KHAN AND PHAGSPA'S MAHAKALA

Despite the Northern Yuan Zasagt Khan's abortive attempts to meet with the Third Dalai Lama, in the early seventeenth century the Inner Mongolian Chahar aristocracy still demonstrated a sincere, if pragmatically inspired, reverence for Sakyapa traditions. The last of the Northern Yuan khans, Ligdan, came to the throne in 1604, at a time when the Chahar's ability to rally unity among Mongolia's tribes was already severely undermined by the growing strength of their neighbors to the east, the Manchus. As early as the 1590s, the Khalkhas had undertaken negotiations with the Manchu leader Nurhaci (1559–1626), and Mongols whose pastures bordered on Manchu lands had formed alliances with them. By the time Ligdan reached his majority, Nurhaci could resist any demands the Chahar tried to place on him, despite Ligdan's boast in a letter to Nurhaci that he bore the title Chinggis (Oceanic) Khan. Clearly the time had come for the Chahar to reassert their claims to Yuan legitimacy, which

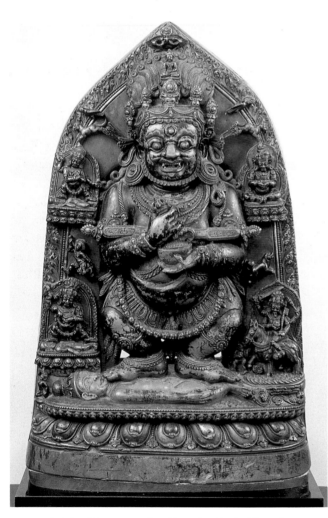

Fig. 2. Mahakala of the Tent, attributable to the school of the sculptor Anige, dated 1292. H: 19 (48.0) W: 11⅜ (29.0). Paris, Musée Guimet. Gift of Lionel Fournier. Photo: Réunion des musées nationaux, Evandro Costa.

they did with the help of a group of Sakyapa pundits who were missionizing at Ligdan's court. Their restatement of the sources of Chahar power is a brilliant example of how the Mongols used their symbolic legacy, embodied in art, in defense of political ambition.[17]

The symbolic structure they resurrected revolved around an image of Mahakala, which had purportedly been cast by Khubilai's own lama Phagspa, but was more likely done or at least supervised by his Nepalese protégé, the artist-prince Anige. A Tibetan source records that in 1274, at Phagspa's request, Anige made an image of Mahakala which was used in a ritual to aid the Mongols in their struggle against the Southern Song.[18] These images, perhaps one and the same, are now lost, but may have resembled a stone Tibeto-Chinese Mahakala, dated 1292, in the Musée Guimet, Paris (fig. 2).[19] A Qing dynasty chronicle, *Da Qingchao shilu*, records, well after the fact, the production and subsequent movements of the image, saying that Phagspa, "using much gold," cast the Mahakala, then took it to Mount Wutai (in modern Shanxi province, China) as an offering, only to carry it away to the Sakya region of Mongolia.[20] In 1617 Phagspa's Mahakala was mysteriously returned to Chahar by a Sakyapa lama named Sarba Khutuktu (*khutuktu* is a Mongolian title for an incarnate-lama), where it was installed with great pomp and became the center of a new imperial cult at Ligdan's capital in the east.

The importance of the Mahakala to Ligdan stemmed from the role this protector played in the conversion of Khubilai Khan and his subsequent identification with the emperor's enhanced, charismatic persona, an equivalence that accounts, more than anything else, for Mahakala's ongoing importance in the pantheon of Mongolian Buddhism (cat. nos. 79–81). Khubilai had been encouraged by his wife, Chabi, to allow Phagspa to initiate him into the *Hevajra Tantra*, which the emperor resisted. According to the seventeenth-century Mongolian chronicle *Erdeni-yin tobči*, one night, as Khubilai slept with the *Hevajra Tantra* tucked under his pillow, Phagspa, "in a miraculous reincarnation of the holy Mahakala," snatched the tantra, thereby rendering Khubilai incapable of argument when he and Phagspa debated the next day. Khubilai then accepted the four consecrations of Hevajra, but only, according to the eighteenth-century Mongol historian Siregetü Guosi Dharma, after he was told it would give him Phagspa's Mahakala-intellect, make him kinder, and assure him Buddhahood in a single lifetime.[21] Khubilai, in turn, granted Phagspa the title of King of Religion of Three Worlds, State Preceptor, thereby creating the dual principle of rulership.[22]

Mahakala was thus essential to the charismatic power of the Mongol emperor, responsible for his awesome intellect and loving-kindness, traits Khubilai embodied because of his mystical identification with the deity. But Mahakala was

also attractive to the Mongols because of his ferocity, his ability to grant military prowess, and because of his role as a protector-god and, in several forms honored by the Sakyapa, as the pole-wielding Lord of the Tents.[23] Mahakala was moreover linked to the idea of royal legitimacy through his earliest iconographic associations. Originally conceived as a male avatar of Kali, the bloodthirsty goddess-wife of the Hindu destroyer-god Shiva, or as Shiva's son, Mahakala was given a role in tantric Buddhism as an emanation of Vairochana, the Cosmic Buddha.[24] Both Shiva and Vairochana, the one in India, the other in China, had been used at different times to bolster the claims of royalty.

All of these ties, historical and mystical, came to Ligdan and the Chahar when Sarba Khutuktu brought them Phagspa's Mahakala. The Mahakala was the perfect symbol of Ligdan's right to rule, because it linked him to the deity's essential powers, just as it had Khubilai, while reasserting the significance of the Northern Yuan lineage he had inherited from Khubilai Khan. Small wonder then that the Sakyapa monks at Ligdan's court rapidly gained favor, for it was the Sakyapa (and only by adoption the Gelugpa) who particularly honored Mahakala. Three Sakyapa monks, Sarba Khutuktu, Manjushri Pandita, and Biligtu Nangso, created a small renaissance of Mongol imperial culture at Ligdan Khan's court, where they influenced the emperor to subsidize a massive translation into Mongolian of the Tibetan sacred canon, the Kanjur, between 1628 and 1629.

Given his new spiritually derived strength, Ligdan might have been able to implement an anti-Manchu, Mongol confederacy, but his own excesses (some writers speak of bad karma, others hint at incapacitating dyspepsia) led to his downfall. In 1634 the Manchus, now led by Nurhaci's eighth son, Huang Taiji (1592–1643), succeeded in driving Ligdan and his followers out of Jehol to the west, and into the Ordos. There Ligdan made a last stab at legitimacy by proclaiming his right to rule in front of the tents that enshrined Chinggis Khan's relics (fig. 3). Not content with this, he actually took the relics as he fled farther west to Kokonor, where he tried, unsuccessfully, to rally some of the western Mongol khans against the growing specter of the Gelugpa. Ligdan's piety and his reliance on the symbolism of Tibetan Buddhism had unavoidably embroiled him in Tibetan politics, but he died of smallpox in 1634, before he could have any lasting effect on the outcome of the sectarian drama that was unfolding between the Gelugpa and its rivals.

Immediately after Ligdan's death, the last remaining members of the Northern Yuan imperial family surrendered to the Manchu leader Huang Taiji at Köke qota, Altan Khan's old capital in Inner Mongolia. Ligdan's eldest son married a daughter of Huang Taiji and his Korchin Mongol empress, thereby effectively neutralizing Chahar pretensions to rule the Mongols, and his mother and sisters went to Mukden,

Fig. 3. The *ger* holding the relics of Chinggis Khan in Inner Mongolia, 1930s. Photo: Owen Lattimore. Reproduced by permission of the Lattimore Institute of Mongol Studies.

the Manchu capital, where they presented Huang Taiji with the Yuan imperial seal.[25]

The Manchus had grand ambitions that were about to be realized; in 1616 Huang Taiji's father, Nurhaci, had already proclaimed the Later Jin dynasty, with the intention of ruling not just Manchuria and Mongolia, but also China. So, when Manjushri Pandita, formerly part of Ligdan's own entourage, arrived at Mukden in February 1635 with Phagspa's Mahakala image, the Manchus quickly grasped its significance and usefulness. Huang Taiji was consecrated as a Buddhist in 1636 and just as rapidly set to work redesigning his capital at Mukden, cast in the form of a gigantic, three-dimensional mandala with the Mongols' Mahakala enshrined at its heart.

Nor does the story of the Mahakala end there. In 1694, shortly after the Manchu Qing dynasty brought the unruly Outer Mongolian Khalkhas into the imperial fold, the Kangxi emperor (r. 1662–1722) ordered that the image be brought to his capital at Beijing, a city associated with Mahakala's spiritual father, Vairochana.[26] There it was enshrined in a mansion that had been the residence of the Manchu regent Dorgon (1612–1650), Nurhaci's fourteenth son and Huang Taiji's brother. In 1776, the same year that the monks of Erdeni Zuu set out for Sakya in Tibet to learn the proper rituals to honor their favorite and ancient protector, the Mahakala Monastery was renovated and renamed Pudu si, the Monastery of Universal Passage.[27]

THE GREAT FIFTH DALAI LAMA

With the death of Ligdan and the capitulation of his family to the Manchus, the strands of history in Mongolia, Tibet, and China become even more interwoven, largely because of the emergence of a number of extraordinary personalities. Among them was the Great Fifth Dalai Lama, Losang Gyatsho (1617–1682).

After Ligdan fled west, he tried in the brief time left to him to form an alliance with the Khalkha khan Tsoght Taiji, ostensibly to support the Tibetan king in his struggles against the rising power of the Gelugpa. Meanwhile, Mongol tribes in Western Mongolia continued to be restive, especially the Zunghars, who, flexing their muscles, forced their neighbors west and south. The Koshut, another related western tribe, followed their leader Güshri Khan into Tibet, where, in 1640, he rapidly became involved in the tug-of-war between the Tibetan kings in Kham and Tsang and their Kagyupa advisers, and the Gelugpa, under the Fifth Dalai Lama and the First Panchen Lama (1569–1662). Güshri Khan succeeded in killing the king of Tibet and was named Sovereign Protector of Religion.[28] He put his son in charge of political affairs, but the new regent disliked life in Lhasa, preferring to spend his time nomadizing in the north near Tengri Nor. This left the stage clear for the Fifth Dalai Lama to fill the vacuum of power left in Güshri Khan's wake, a task he took on admirably.

By all accounts, the Fifth Dalai Lama was one of the most accomplished and visionary men of his time, a saint-ruler who conceived and built the great Potala Palace in Lhasa and named it after the mountain retreat of the bodhisattva Avalokiteshvara. He also systematically established Gelugpa rules in unreformed monasteries, literally by attrition, as their charismatic lama-leaders passed away, although he himself came from an aristocratic family with close ties to the unreformed Nyingmapa, Kagyupa, and Jonangpa. He is said to have been especially attracted to Dzogchen meditation and to the teachings of the Nyingmapa. (His portraits show him wearing a *phurba* [ritual knife] in recognition of this legacy.)[29] Having forged an alliance with one branch of the Western Mongols, the Great Fifth, as he is reverentially remembered, realized that the Manchus posed an even greater threat to the primacy of the Gelugpa. Thus began a series of diplomatic maneuvers that, at the time, brought the Dalai Lamas Manchu support, and Tibet a measure of security and independence.

In 1640, the same year the Dalai Lama convinced Güshri Khan to come to his aid, he also took a number of other steps to solidify his power base. First, he proclaimed himself and his four predecessors incarnations of Avalokiteshvara, the Bodhisattva of Compassion, an act that gave his assertion of primacy an incontrovertible spiritual basis and linked him to Songtsen Gampo (r. ca. 627–49), the first Buddhist king of Tibet, also believed to be an incarnation of Avalokiteshvara, and to the very progenitors of the Tibetan people, Avalokiteshvara and Tara. Second, the Dalai Lama extended this spiritual basis of power, rooted in the Tibetan system of reincarnation, to the Manchus, who had been loyal adherents of the Sakyapa since their usurpation of Ligdan's symbols of legitimacy, the Mahakala and the Yuan seal. In a joint letter, the Dalai and Panchen Lamas (by now recognized as incarnations of Amitabha, Buddha of the Western Paradise and spiritual father of Avalokiteshvara) together declared that the Manchu emperor Huang Taiji was, in fact, an incarnation of the Bodhisattva of Wisdom, Manjushri, the same bodhisattva Khubilai was said to embody, if only after his death.[30] The beauty of this declaration was that it simultaneously tied the Manchus to the glorious past of the Mongols, making them, and not any of Chinggis's descendants, the true heirs of the Yuan legacy. (By now, the Manchus had intermarried with the daughters of Mongolia's great khans so frequently that the distinction, at least genetically, was blurred.) But their newfound sacred connections also granted legitimacy to the Manchus' desire to rule China, because Manjushri was China's own bodhisattva, long known to be resident on Mount Wutai, where he had actually appeared to his earnest devotees in miraculous and spectacular displays of light as early as the Tang dynasty.[31] It also tied the Manchus to the Gelugpa, not only because the recognition of the Qing emperors as Manjushri-incarnate came from the Dalai Lama, but also because Manjushri had been manifest in Tsongkhapa, the Gelugpa founder, as well.

This new concept was further verified by happenstance and magic, helped along by the phonetic similarity between the Manchus' name and Manjushri's, and foretold in a prophecy of the Third Dalai Lama, who had stated that Manjushri bodhisattva would travel to the center (i.e., China, the Middle Kingdom), where he would convert the Chinese, Manchus, and Mongols. So, when the Great Fifth traveled to Beijing in 1652, a few years after the Manchu conquest of China, it was preordained that he and the Shunzhi emperor (r. 1644–61) should sit together (fig. 4) as "sun and moon, preceptor and protector,"[32] just as Phagspa and Khubilai, and later Sonam Gyatsho and Altan Khan, had done.

ZANABAZAR AND THE KHALKHA RENAISSANCE

And so by the 1650s Tibet, under the Dalai Lamas, and China, Manchuria, and parts of Inner Mongolia, under the Manchu Qing dynasty, had come to unsteady terms with one another. The Khalkhas, in Outer Mongolia, also saw the handwriting on the wall, and as early as 1636 they voluntarily began to send an annual tribute of the "Nine Whites," one

Fig. 4. The Great Fifth Dalai Lama and the Shunzhi emperor at their meeting in Beijing in 1652. Mural, Great Western Hall, Potala Palace. From Kiggell, *Buddhist Art of the Tibetan Plateau*, fig. 368.

white camel and eight white horses, to the Manchus (who by that time had already changed their dynastic name to Qing and were bent on conquering China).[33] Still, the Khalkhas had little intention of capitulating to Manchu ambitions, even though their ability to resist was weakened by their disunity.

In 1639 the Khalkha Tüsheet Khan Gombodorji (1594–1655), a direct descendant of Chinggis Khan and grandson of Abadai Khan, who had built Erdeni Zuu, presented an alternative plan for unity to the leaders of Khalkha's Seven Banners. Fearing the growth of Manchu power and the rising specter of a pan-Asian, Lhasa-controlled Buddhist empire, Gombodorji nominated his infant son as head of the faith in Outer Mongolia. While it is difficult to separate Gombodorji's political motivations from the web of magic and devotion in which the events of this period are couched, it is likely that Gombodorji realized the Khalkhas would never be united by a purely secular ruler. (The tragic example of the last Mongol emperor, Ligdan, who had died a few years before, had already demonstrated this.)

Gombodorji also realized that, even if the Manchus were in the ascendancy politically, the intellectual center of Inner Asian culture was in Tibet, now in the hands of the Dalai Lamas, and that it would be better to emulate the Dalai Lama's example than allow him to pull Mongolia completely into the Tibetan sphere. There was no ignoring the Dalai Lama, who was, after all, a Mongolian creation—the third (but the first to hold the title in his lifetime) was named by the Mongolian Altan Khan in emulation of Khubilai's elevation of Phagspa, the fourth was a Mongol by birth and the great-grandson of Altan Khan, and the fifth owed his political status to his protector, Güshri Khan, also a Mongol.[34]

Thus the child Zanabazar (S: Jñānavajra, 1635–1723), in early life known as the "Brilliant Child," and later as Öndür

Gegen, Lofty Brilliance, came to be the focus of Khalkha unity and the primate of Outer Mongolian Buddhism (cat. nos. 16–18 and 95). His birth and early years were accompanied by miracles and holy portents. Like many of Tibet's incarnate-lamas, he could, for example, recite the scriptures at an early age without having been taught, a feat made even more miraculous by the fact that he did it in a language—Tibetan—that he had not yet studied. All this could be taken as devoted hyperbole but for the fact that Zanabazar proved to be one of the polymathic geniuses of his age, a man who in his maturity would be honored by such titans as the Fifth Dalai Lama and the Qing Kangxi emperor.

Zanabazar spent his earliest years in Khalkha, but in 1649, at the age of fourteen, he set out for Tibet. He and his entourage wintered at Kumbum, Tsongkhapa's own monastery in Tibetan Amdo, and arrived in 1650 at Tashilunpo, the monastery of the Panchen Lama near Shigatse. From this point on some of the details of Zanabazar's life are preserved in both Tibetan and Mongolian chronicles; his days took on the rhythm of a young monk destined for high position. From the Panchen Lama he received the Yamantaka initiation, then left for Lhasa and a meeting with the Fifth Dalai Lama. In the Potala Palace the Dalai Lama initiated him into the rites of Vajrapani or, according to other sources, Vajradhara. He also recognized him as his own disciple and as an incarnation of the great, but unreformed, Jonangpa lama Taranatha (1575–1634), with a lineage stretching back to a disciple of Shakyamuni Buddha (see cat. no. 17), and conferred on him the Tibetan title of Jebtsundamba Khutuktu (M: Bogdo Gegen), along with the high and seldom-granted honor of using the yellow parasol.[35]

The Fifth Dalai Lama's choice of Taranatha as Zanabazar's immediate preincarnation was an astute political decision. Taranatha was a prominent lama of the Jonangpa, an unreformed order related to the Sakyapa, but characterized by a special view of enlightenment, which its adherents took to be a positive, reifiable, all-pervading substance. This doctrinal difference created a rift between the Jonangpa and the Gelugpa, but the Great Fifth's motivation in taking control of Taranatha's line was not spiritual; the Dalai Lama was well versed in both old and new tantras and was spiritually broad-minded. What motivated him was sectarian politics, for the Jonangpa had supported the Kagyupa in their relationship with the kings of Tibet, and though Taranatha's home monastery, Puntsagling, was in southern Tibet, west of Lhasa, he had spent many successful years missionizing in Outer Mongolia, still more Sakyapa than Gelugpa.

When Zanabazar arrived in Lhasa, the Sakyapa were already searching for Taranatha's rebirth and expected to discover him on their own. The Dalai Lama clearly wished to take control of Taranatha's lineage, and he just as clearly wanted to bring Zanabazar, and with him the Khalkhas, into

the Gelugpa fold. (Zanabazar's affiliations before arriving in Lhasa are unclear, but he was known as the "one who holds the Sakya banner of the great mind,"[36] and his father, Gombodorji, as the Tüsheet Khan, was protector of Erdeni Zuu, at the time a Sakyapa stronghold.) By naming Zanabazar his own disciple and finding in him the rebirth of Taranatha, thus usurping a Sakyapa privilege, the Dalai Lama brought the Khalkhas into the bosom of the Gelugpa.

Zanabazar left Lhasa to visit the places where he had spent previous lives, including Taranatha's recently renovated Puntsagling, where he gathered up images (a Maitreya, an Avalokiteshvara, a Tara) and texts to take back to Khalkha. When he returned home, he traveled with a grand entourage of six hundred monks who had been sent by the Dalai Lama, including fifty Tangut lamas from Amdo and artisans of all sorts.[37]

Zanabazar's career as a major Buddhist prelate now began in earnest. Apparently ceaseless in his labors, he mastered Tibetan, instigated and carried out huge translation projects, wrote commentaries on spiritual practice, created an alphabet for Mongolian (see Bosson, "Scripts and Literacy," fig. 7b), introduced the rites of the Gelugpa to his compatriots, designed and built monasteries, and, for our purposes perhaps most significant, began quickly to cast extraordinarily accomplished works of Buddhist sculpture.

His role as Khalkha's leading Buddhist was not only played out in the world of religion, however. Zanabazar was also a potent political symbol and eventually a pawn, if an enlightened one, in the Manchus' plans to bring all of Mongolia and Tibet under their control. Although the young Bogdo Gegen was able to devote several decades after his first trip to Tibet to religious affairs, by the 1680s the Western Mongolian Zunghars, led by Galdan, threatened to overrun Khalkha. In 1686 the Qing Kangxi emperor, sensing that Galdan was all that stood between him and the rest of Mongolia, insisted that the Khalkha princes meet with the Zunghars and settle their differences.[38] The Tibetan Ganden Shireetu, nominal head of the Gelugpa, was also sent by the Dalai Lama to attend the peace summit. There the Ganden Shireetu and Zanabazar were seated on daises of equal height, symbolizing their spiritual equality. Galdan objected and threatened the Khalkhas with war for what he considered to be an outrageous presumption on Zanabazar's part. By 1688 Galdan had moved his troops to Khalkha and Zanabazar was forced to flee his retreat near Erdeni Zuu with his brother's wife and children. At that point, pinned between Galdan on the west and Kangxi on the east and south, Zanabazar took the Khalkhas over to the Manchu side after rejecting a Russian alliance, because, he argued, the Russians "buttoned their clothing on the wrong side"[39] and were not Buddhist. The Manchus ultimately killed Galdan and dampened (though they did not extinguish) the Zunghar threat in 1696, five years after the great

convention of Dolonnor in 1691, when Zanabazar swore allegiance to the Kangxi emperor.

He followed the emperor to Beijing that same winter and stayed at the Huang si (Yellow Monastery), one of the major centers of Tibeto-Mongolian Buddhism in the Manchu capital. Zanabazar made the long trip from Urga to Beijing to visit the emperor for each of the next three years. During this time, his stock rose in Kangxi's eyes, as he demonstrated his piety over and over again in the face of attempts by Kangxi's courtiers to trick him into impious acts—they hid sacred images and texts beneath the rugs of his dais in the imperial audience hall, so that he would sit on them and defile them, but Zanabazar magically found the images and erased the text and thus saved his own reputation for sanctity.[40] In one famous incident, the Kangxi emperor asked Zanabazar to perform the rite of Ayusi (Amitayus) for him, to ensure his longevity. (The Qing emperors were especially devoted to Amitayus and his life-extending powers.) Secretly Kangxi had prepared an immense bell and *dorje* (S: *vajra*) for the ceremony, much too heavy for anyone to hold. Zanabazar ordered yards of silk from his storehouse in many colors and, when the ritual was underway, turned the silk into a rainbow, which was seen to bear an image of Amitayus. Zanabazar himself sat calmly, holding *dorje* and bell and chanting the scriptures. It was this incident that formed the basis of Zanabazar's fame in China.[41] When Zanabazar finally left Beijing to return to Urga, he was accompanied by a camel caravan of gifts so long it took three days to pass single file through the city gates.

Although Kangxi's court did not relish the thought of another powerful, brilliant Buddhist prelate, this time a Mongol, who could interact easily with the emperor, charm him with his intelligence and deep spirituality, and return home to incite Khalkha dissidence, Kangxi so enjoyed Zanabazar's company that he asked him to accompany him to Mount Wutai, the home of Manjushri (who was, of course, manifest in Kangxi himself), and a sacred place for the Mongols, all of whom hoped to be buried there. It was at Mount Wutai, in 1695, that Zanabazar learned his father, the Tüsheet Khan, had died, and he asked to return to Urga.[42]

THE SCULPTOR ZANABAZAR

In the decades before the Zunghar troubles came to a head, Zanabazar's prodigious artistic talent was already apparent. In fact, the earliest records of his sculpture date to the years immediately following his return from Tibet and resume in the 1680s and 1690s, when he visited Beijing. His personal involvement in making works of art is not unusual in the context of Tibetan Buddhism; what is striking is his sophisticated command of the technology of metalworking (cat. nos. 97–106). Great lamas were also great visionaries—the nature of

Tibetan Buddhist meditation makes this imperative—and they often gave verbal or visual form to their visions to provide spiritual guidance, all deeply enmeshed in a complex and recondite symbolism. Zanabazar's own incarnation lineage suggested an innate leaning toward iconography and the visual arts. His immediate preincarnation, Taranatha, supplemented and corrected a significant collection of *sadhana*, which describes in detail the visualizations of great lamas,[43] and which was the moving force in the refurbishing of images at his own monastery, Puntsagling. In the seventeenth and eighteenth centuries Mongolia's lamas, in particular, would often work to unscramble contradictions that cropped up when images were copied over and over; they thus had an important impact on the codification of the Tibetan pantheon (see Stoddard, "The Tibetan Pantheon").

When Zanabazar returned to Khalkha in 1650, there were few sacred images, certainly far fewer than were needed for religious practice and diplomatic exchange. Records state that Zanabazar sent gold and painted images of his own creation to the Qing Shunzhi emperor in 1655 and 1657,[44] made eight silver *suburgan* (reliquaries) and the gift of a complete monastery to the Kangxi emperor in 1683,[45] and, during his later visits to Beijing in the 1690s, cast images and even carved a Buddha out of a ruby for the Kangxi emperor.[46] He also set up forges at his meditation retreat near Erdeni Zuu and elsewhere to cast several large series, including a group of the Five Transcendent Buddhas (cat. no. 97) and a set of Twenty-one Taras, both benign and fierce (see cat. nos. 103–106).[47]

The allure of Zanabazar's sculpture, which is at once pure and palpably sensual, is traditionally explained by one of the more interesting details of his personal life. Far from being celibate, folklore maintains that Zanabazar was married, or at least kept a religious consort to help him in his practice of the *anuttara-yoga* tantras, where sexual yoga—actual or imagined—holds the promise of immediate enlightenment. (These practices were not encouraged by the Gelugpa founder Tsongkhapa, who deliberately abstained from them himself, and the clerically inclined, celibate Gelugpa have followed his example, reserving even the use of a mind-seal, a mental image of the consort, only for the moments after death.[48]) Zanabazar's consort, the Girl Prince, was renowned for her beauty, and her presence in Zanabazar's camp caused controversy among some of the Khalkha khans, who complained to him one day as he worked at his forge. The Girl Prince emerged from his tent, holding a lump of molten bronze in her hand, which she kneaded painlessly to form an image of the Buddha.[49] Her saintliness and artistry were thus made manifest, but she died when she was only eighteen years old. The many images of Tara that Zanabazar cast are all said to be modeled after her; White Tara (cat. no. 102) depicts her at puberty, and Green Tara, which leads the

group of twenty-one (fig. 5), shows her as a voluptuous, mature woman.

More enigmatic are the sources of Zanabazar's remarkable (and, based on what remains, almost unchanging) style, which, given its elegance, refinement, and sophisticated casting, resembles nothing so much as Nepalese sculpture of the twelfth and thirteenth centuries (e.g., fig. 6), a period during which the Newari artists of Nepal attracted attention and patronage in Tibet and China. Almost nothing still exists of the work of Mongol Buddhist artists who preceded Zanabazar in the period of empire and after. It is, therefore, tempting to suggest that Zanabazar and his advisers, who over and over demonstrated their familiarity with the history of Mongolia's classical period under Khubilai and Phagspa, and had studied how Altan Khan, Ligdan, and the Manchus reused their icons and symbolic formulae, were also aware of Phagspa's patronage of the Nepalese artist-prince Anige. On Phagspa's invitation, Anige had traveled with a group of his countrymen to Beijing to create a Nepalese-inspired, imperial Buddhist style, eventually giving up his monk's robes to head the Directorate-General of Artisans for the Mongol

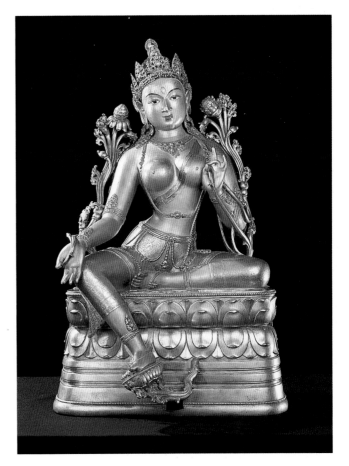

Fig. 5. Zanabazar, Green Tara. Bogdo Khan Palace Museum, Ulaanbaatar. Gilt bronze, H: 29⅞ (76.0) W: 18⅞ (48.0). Photo: Réunion des musées nationaux, Pascal Pleynet. Courtesy of Musée Guimet and G. Béguin.

government.[50] But, while Zanabazar may have known of Anige, it is still not possible to demonstrate that he ever saw any of his works (though he may well have). Even Ligdan's Mahakala had been moved by Zanabazar's day to the Manchu imperial sanctuary at Mukden. Probably very few, if any, pieces by Anige himself were extant in the late seventeenth century, though works in the style he introduced, both portable (printed sutras) and permanent (the Juyong Gate north of Beijing) certainly were.

In the late seventeenth century, Zanabazar was not the only person whose eye was tuned to an earlier aesthetic. The Gelugpa, under the Great Fifth Dalai Lama, were engaged in massive reconstructions and conversions of monasteries and religious monuments that had been destroyed during the Buddhist persecutions of Langdarma (d. 842) and, later, during the long conflict between the Gelugpa and the kings of Tibet. Zanabazar's own immediate preincarnation, Taranatha, refurbished the Jonangpa monastery, Puntsagling, between 1617 and 1618. Zanabazar visited there after receiving his title and incarnation lineage from the Dalai Lama in Lhasa—Puntsagling was, after all, one of his old homes. The paintings at the monastery, destroyed during the Chinese Cultural Revolution (1966–69), were redone at Taranatha's order in a style that was part Nepalese and part Indian (fig. 7).[51] Taranatha died in Khalkha, and he may have been the first to transplant an Indian- or Newari-inspired style there, when he built his own Mongolian monastery, also called Puntsagling.

Even more intriguing is another clue in Zanabazar's biography—that he stopped for the winter on his way to Tibet at Kumbum in Amdo. There, in Tsongkhapa's own monastery, a Manjushri Hall had been dedicated in 1592.[52] This hall, which was reconfigured in 1734 into nine separate chambers (hence an alternate name, Nine Chamber Hall), contains a group of figures in dried clay that are the closest prototypes of Zanabazar's work. They include the Five Transcendent Buddhas and two female bodhisattvas, Sarasvati (holding a *pipa*, or lute) and Vasudhara (fig. 8). Like Zanabazar's work, these figures have lithe, smooth, and lifelike bodies, accentuated by delicate, meticulously rendered jewelry and thin, silken garments. Their faces have sharpened nasal ridges, full lips, and tilted eyes with eyelids curving in a shallow S. Their

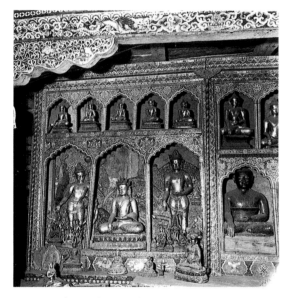

Fig. 6. Nepalese sculpture, 12th–13th century, in Yong-tsher Monastery, Nepal. Photo: David L. Snellgrove.

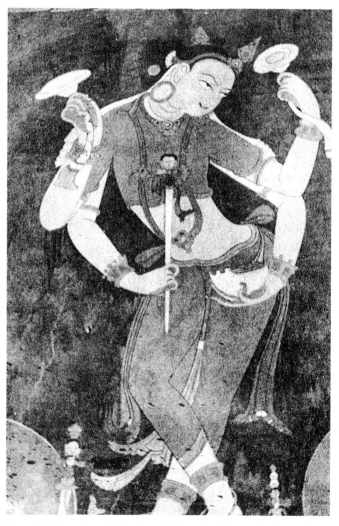

Fig. 7. Paintings redone in Nepalese-Indian style at Puntsagling. From Tucci, *Tibetan Painted Scrolls*, vol. 1, fig. 70, p. 200.

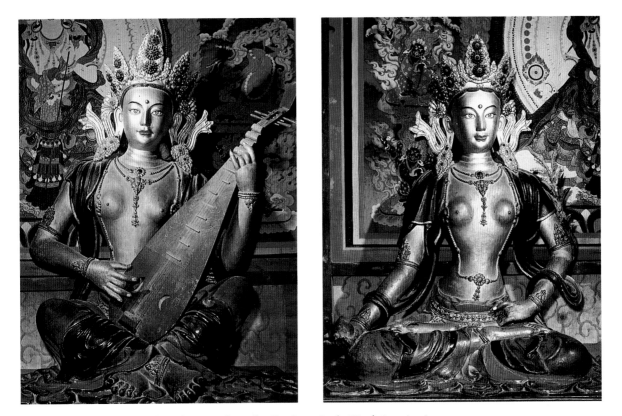

Fig. 8. Sarasvati and Vasudhara from the Manjushri Hall at Kumbum, Amdo (Qinghai province).
From Kiggell, *Buddhist Art of the Tibetan Plateau*, pp. 118–19.

crowns are decorated with the flat, flaring side pendants that appear in Zanabazar's work and in the work of most later Mongolian sculptors. What makes these similarities even more intriguing is the fact that, in the years after Zanabazar, the Mongols held the sculptors of Kumbum (many of whose monks were ethnic Mongols) in the highest esteem.

Finally, Zanabazar's biography also relates that he left Tibet with a huge entourage, provided by the Fifth Dalai Lama, among whom were a group of monks from Amdo bent on spreading the Dharma, and craftsmen of unspecified talents.[53] We can surmise (if we cannot assume), however, that bronze casters, probably Newari, were included in this group (one painter from Chenye Monastery in the Yarlung valley seems to have been),[54] for the sophistication of Zanabazar's own casting technique cannot have sprung untutored from him alone, while the Newari were undisputed masters of the craft, not just in Nepal but also in Tibet.

ZANABAZAR'S RITUAL REFORMS

Zanabazar's artful translation of an archaic, Nepalese style into a new, Mongolian idiom was only one aspect of a multifaceted effort on his part to bring the Khalkhas to Tibetan Buddhism and, more precisely, into the Gelugpa camp. His sophisticated understanding of art, politics, and public ritual, all of which he and later historians used to build a magical aura of saintliness around him and his office, speeded the

process of conversion and, to a certain extent, resulted in the Tibetanization of Mongolia's upper classes.

This effort included the introduction of the ritual style of the reformed Gelugpa, a process that was ultimately aided by tales of divine intervention, according to stories told in the traditional histories of the time. In 1655, for example, in one of the more dramatic actions of his life, Zanabazar gathered his entourage and suddenly set out for Tibet. Along the way their horses were stolen and Zanabazar wondered why his chosen spiritual protector, Begtse, had failed to safeguard his mission. (Begtse is the Mongolian Jamsaran; see cat. nos. 85, 87, and 89. He is one of the great protectors against the enemies of religion, who started his career as a shamanistic nature deity but was converted to the Buddhist cause by Sonam Gyatsho, the Third Dalai Lama.) Just then the missing horses appeared, galloping back to camp with the thieves tied to their tails. Clearly Begtse had not failed, and the Mongolian delegation arrived at Tashilunpo, the Panchen Lama's monastery near Shigatse, in seven days.[55] This speed was nothing short of miraculous, since the distance between Zanabazar's monastery at Urga and Tashilunpo, as the crow flies, is about 1,500 miles, under normal circumstances an arduous trek done in many month-long stages.

Despite their supernatural haste (they had appeared to onlookers as seven yellow ducks), the Mongols arrived to find that the Panchen Lama had died three days before. Zanabazar began to present mandala offerings to the Panchen's

lifeless body, and with the third, the body began to stir and the Panchen returned, well enough to give Zanabazar the Yamantaka initiation.[56] (The Panchen Lama did not die, in fact, until 1662.) This visit had an intense effect on Zanabazar, for when he returned to Khalkha in 1656, greeted by a prayer ceremony to wish him long life, he was determined to establish the public rites of the Gelugpa in Mongolia, in particular the Maitreya Festival as it was practiced at the Panchen Lama's Tashilunpo.[57]

THE MAITREYA FESTIVAL: LOOKING FORWARD TO THE NEW AGE

The Maitreya Festival may have had its origin in an obligation stated in the original *vinaya* (monastic rules) to carry images throughout towns and villages to spread the faith, but it was Tsongkhapa who made Maitreya (M: Maidari), the Buddha of the Future, its focus. Tsongkhapa held the first Maitreya Festival on New Year's Day, 1409;[58] the timing seems deliberate because Maitreya is a millenarian figure whose coming signals the beginning of a new age. He was also the source of five prestigious but noncanonical texts on the great compassion, which, according to pious belief, he personally dictated to the Indian sage Asanga (ca. fifth century). His significance for the reformist Gelugpa was so deep that they chose Ganden, the Tibetan for Maitreya's Tushita Heaven, as an alternate name for their order. Tsongkhapa named his first monastery Ganden, where as heir apparent and prince, Maitreya awaits his rebirth as Buddha. Ganden—"joy"—was also the name chosen for the tantric college-monastery built in Urga (Gandantegchinlin), and the name of the monastery Mongol monks would establish at the Yonghegong in Beijing. The hierarchs of the Gelugpa, from Tsongkhapa through the Dalai Lamas, would "go to Ganden," rather than simply die,[59] a euphemism preserved in the Festival of Lights that commemorates Tsongkhapa's death, Ganden Namcho.

Maitreya was expected literally to descend into his image during the course of the festival in his honor. Reporting on a visit the Sixth Dalai Lama (1683–1746, deposed in 1706) paid to Mongolia, the nineteenth-century Mongol historian Dharmatala said the Dalai Lama told his followers there that Maitreya had come down from Ganden and entered into an image, which was therefore particularly holy. (The Sixth Dalai Lama himself had also personally entered into a Maitreya image and become one with it.)[60]

Zanabazar also seems to have had a special relationship with Maitreya Buddha. Dharmatala, for example, records that Maitreya was the chief object of Zanabazar's meditations,[61] but an unusual tie is also suggested in a more recent controversy surrounding Zanabazar's reincarnation lineage. While traditional histories agree that Zanabazar was the rebirth of the Jonangpa lama Taranatha and his fourteen earlier incarnations, another view is that Taranatha is actually an epithet of Maitreya, and that Zanabazar was a reincarnation of a Tibetan lama called the Maidari Khutuktu, who died, like the Jonangpa Taranatha, just before Zanabazar's birth in 1635.[62]

In the years that followed Zanabazar's first introduction of the Maitreya Festival to Mongolia at Erdeni Zuu in 1657, the ritual was performed at every monastery at least annually and sometimes more frequently. The Maitreya Festival was the occasion for nomadic Mongols to gather around monasteries, for informal markets to spring up, and for incarnate-lamas (*khubilgan*) to give blessings to the people. Sometimes as many as thirty thousand lamas would participate, as happened in 1877 in Urga.[63]

The ritual took the form of a clockwise circumambulation of the monastic *khüree* (circle). The entire monastic community, with the singular exception of the Bogdo Gegen, arranged according to hierarchy and joined by ranks of lay devotees, hauled an image of the future Buddha around the *khüree* in an elaborately decorated cart carrying the *Five Tracts of Maitreya* and decorated by a huge green head of a horse or an elephant.[64] (In the southern Mongolian and Tibetan versions of the festival, Maitreya often rides in a sedan chair carried on the shoulders of monks, without the Outer Mongolian green horse's head.[65])

The Maitreya Festival is vividly portrayed in a number of written descriptions and panoramic views of it as it was performed in the nineteenth and early twentieth centuries. In paintings of the festival, ranks of monks playing long horns and drums preceded high-ranking lamas, *khutuktu* carried in litters, and the arrival of Maitreya's horse-headed cart. People of low status, much smaller in scale, marched along the edges of the crowd. Aristocratic patrons, dressed in elegant yellow robes and black fur hats, brought up the rear. Maitreya's cart stopped at each point of the compass, where, at some monasteries (e.g., Erdeni Zuu), a *tsam* ritual dance was performed to stamp out the enemies of religion, and where sections of the *Five Tracts* were chanted. In one painted version of the festival at Lamyn Gegeen Khüree (cat. no. 42), Maitreya is clearly visible, both as a descending deity and as an image, through the open curtains of the cart. He is a slender, standing figure, radiating time-honored Nepalese ideals, a princely bodhisattva with his hair in a high chignon, draped in an antelope skin and delicately threaded jewels, looking very much as Zanabazar depicted him at least twice.[66] A gilt bronze Maitreya by Zanabazar (cat. no. 100) was the very piece used in the annual Maitreya Festival around Zanabazar's Da Khüree. Another of Zanabazar's Maitreyas, kept at Gandantegchinlin Monastery in Ulaanbaatar, was used in their own Maitreya Festival, a much more exclusively monastic rite with few lay participants.

Figs. 9a–b. The Maitreya Festival at Batu khalagh süme as photographed by Sven Hedin on his 1927 expedition. Courtesy of Folkens Museum Etnografiska, Stockholm.

Although the original inspiration for Zanabazar's Maitreya Festival came, according to several different traditional sources, specifically from Tashilunpo, it was only one of many Tibetan monasteries to possess a colossal figure of the Future Buddha and to practice the Maitreya circumambulation. Interest in the Future Buddha in Tibet waxed and waned, as the social causes of millenarianism—poverty, oppression, and instability—came and went. Maitreya's popularity in China had fluctuated in much the same way, and China's rulers often took political advantage of Maitreya's overtones of hope and change. The non-Chinese Toba emperors of the Northern Wei (385–534) had a huge seated Maitreya carved at the cave-temples of Yungang in the late fifth century as part of their own effort at legitimation and assimilation, and the Tang usurper, Empress Wu Zitian (r. 684–705) had one made at Dunhuang in the late seventh century, while broadcasting the news that she was, in fact, Maitreya-incarnate.

It is not surprising that the Gelugpa, bent on purging Tibetan Buddhism of any vestiges of decadence, took such a strong interest in Maitreya. They also promoted other visions of utopia, most notably that of the kingdom of Shambhala, described in the *Kalachakra* (Wheel of Time) *Tantra*. This powerful myth, the inspiration for, among other things, James Hilton's *Lost Horizon,* tells of a magical country, bound by ice and snow, whose first king, Suchandra, went to India on a "stone horse with the power of the wind,"[67] to learn the *Kalachakra Tantra* from Shakyamuni Buddha himself. The Kalachakra literature reveals that Shambhala will have thirty-two kings in all (the twenty-ninth king is reigning now), and that the reign of the thirty-second king will bring an apocalypse and the dawning of a new age of universal enlightenment. The kings of Shambhala, arranged into a mandala, were a favorite subject of Gelugpa meditations in Tibet and Mongolia both (cat. nos. 45 and 46).

Zanabazar went on to introduce the Maitreya Festival and the Monlam (prayer ceremony) that usually precedes it and returned to Erdeni Zuu in 1681 to stage the ritual again. Soon the significance of this rite, with its message of a new age, had caught on throughout Mongolia. In Inner Mongolia, Maitreya's ritual and the Monlam had been similarly promoted by Neyiči Toyin (1557–1653), a powerful incarnation from Köke qota. The Maitreya Festival continued to be held in Mongolia into modern times, as the early-twentieth-century painted record of it shows; several descriptions of the festival at the Inner Mongolian monastery Batu khalagh süme appear in travelogues written by various members of the expedition led by Swedish explorer Sven Hedin into Inner Asia in 1927 (figs. 9a–b; the expedition photographer Lieberenz even recorded it in cinematic form).[68] Finally, a side note to the Mongols' ongoing belief in the imminence of the "new age" is the propagandistic use made of Shambhala and

its ambiguous location during the conflicts between Mongol Communists and non-Communists in the 1920s. At that time also, the "New Lama," Ölzii Jargal, a Bolshevik who injected his Communism with millenarian overtones, was killed by an anti-Communist contingent and afterward was remembered in popular songs that urged Mongolia to "follow the path of the New Age!"[69]

TSAM: RITUAL DANCE-THEATER

Another powerful public religious display with great propagandistic potential, for both church and state, was the ritual dance-theater—the *tsam.* The origins of the exorcistic *tsam,* which incorporates indigenous elements in Tibet and Mongolia both, is in the old tantras of the Nyingmapa. But its ability to give living form to the visions of notable lamas led to its adoption and evolution by other orders as well, including the more clerical Gelugpa.[70] The *tsam* was danced in most monasteries to exorcize the enemies of religion, literally to destroy demonic forces, but also, on a more subtle level, to obliterate the ego, the enemy of enlightenment. The fact that the *tsam* was so susceptible to interpretation and open to the integration of new characters made it a perfect tool in the peaceable reconversion of Mongolia to Buddhism.

Like the Maitreya Festival, the *tsam* was a daylong ritual, usually held at every monastery once a year and, as such, eagerly awaited by nomadic herdsmen, who saw it as a chance to gather together, barter, and court potential mates. The *tsam* required careful preparation, both physical and spiritual. Weeks before the ceremony, monks fabricated or repaired embroidered silk costumes and elaborate papier-mâché and leather masks (cat. nos. 31–41), and drew the boundaries of the dance arena at the monastery's main door with chalk or flour.

In the Erleg Khan (Yama) *tsam* (fig. 10), a popular version of the sacred dance witnessed in the late nineteenth century by the Russian Mongolist Aleksei Pozdneyev, a prayer service was first offered to Yamantaka, conqueror of the Lord of Death, Yama, the last of the masks to make an entrance.[71] The choreography was complex and long, carried out with little desire for dramatic compression. A pair of dancing skeletons, Citipati (cat. no. 31), set the scene and cleansed the area by chasing away a crow, image of the scavenger. They were followed by a pair of *acharya,* Indian pundits introduced, according to legend, to the *tsam* cast by Zanabazar himself after the pair magically appeared and gave him a staff, still in use at Gandantegchinlin Monastery in Ulaanbaatar, and a copy of the *Tales of King Vikramaditya.*[72] Next came a series of figures intended to serve as a formal audience more than as active participants in the *tsam*—the Chakravartin king and his wife and son, and Kashin, king of Kashmir (cat. no. 32). Kashin has the jolly, open face of the last arhat, Hvashang,

and, like Hvashang, has a large family of sons, but in the Mongolian version of the *tsam,* his role was specifically to welcome the Buddha into his own home. These royal figures took their seats, occasionally rising to greet the arrival of the protectors of the Dharma, including Lhamo, Mahakala (Gurgon, cat. no. 37), and Begtse (Jamsaran) and his eight associates (cat. no. 39).

A comic interlude starring the White Old Man, Caghan ebügen (popularly called Tserendug, cat. no. 33), preceded the climax, when a large group of lama-meditators entered, wearing black hats, without masks, but carrying *phurba,* the ritual knives associated with the Nyingmapa (cat. no. 41). The final figure was Yama, the Lord of Death (cat. no. 40), who began the swirling, circular dance that is the climax of the *tsam.* An image made of dough *(lingka),* representing the ego and the enemies of religion, was brought before this formidable group and ritually killed. Each figure then led the circular, mandalic dance in turn and exited into the monastery behind.

The daylong *tsam* allowed ample time for improvisation and for the integration of bits of stage business that had specific, local meaning. As with their Tibetan counterparts, Mongolian lamas were quick to take advantage of the *tsam*'s open format. They expanded the cast of characters to include the spirits of Mongolia's sacred high places, whose origins were pre-Buddhist and shamanistic: the Garuda-like bird of Bogdo Ula (cat. no. 34), worshiped devoutly, if erroneously, as the birthplace of Chinggis Khan; the spirit of Bayan Jirüke, a young man with a high chignon and yellow face (cat. no. 36); the spirit of Cenggeltü Mountain, an old yellow-faced man; and the Dark Old Man of Songgina (cat. no. 35).[73] The Dark Old Man, in particular, was a legendary opponent of Buddhism, who, like Begtse, capitulated and converted to become one of the religion's great protectors.

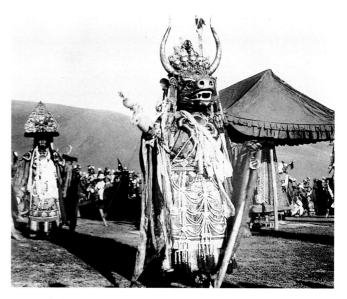

Fig. 10. The last Erleg Khan (Yama) *tsam* at Urga in 1937. From Tsultem, *Mongolian Sculpture,* p. 193. See also Berger, "Buddhist Festivals," fig. 3.

Similarly, the White Old Man, Čaghan ebügen or Tserendug, another pre-Buddhist, shamanistic figure, was the Mongols' own protector-spirit of the herds and of fertility, Lord of the Earth and Waters. But in form and character (generally comical and often drunk), he was reminiscent of the Chinese monk Hvashang, and even more of the Chinese Daoist god of longevity, Shoulao. His great potential to capture public interest was rapidly grasped by missionizing Buddhists, who, in a popular prayer, made it clear that his powers were confirmed by the Buddha himself. Mongol Buddhists also credited him with giving wise counsel to Green Tara, and he was the subject of a fully Buddhist prayer written around 1760 by a great cultural synthesizer, the Inner Mongolian lama Mergen Diyanči. Mergen Diyanči also gave him a deer as a mount, thereby identifying him with the Chinese Shoulao.[74] In most later representations (e.g., cat. no. 18), Čaghan ebügen has an enormous cranium, swollen and bald, a long, flowing white beard, and a gnarled walking stick, just as Shoulao has. The *tsam*, with its own roots in ancient shamanistic Tibet, was the perfect medium through which to promote a new blending of Tibetan Buddhist, Chinese Daoist, and Mongol culture.

If the *tsam* was not restricted in its cast of characters, neither was it limited to a single "plot." Several different frameworks evolved, some of them departing from strict ritual form to include descriptive narrative and, in the nineteenth century, even spoken dialogue.[75] The Geser *tsam* is an example of the new narrative type, closer to theater than to religious rite.[76] The story was based on the Tibetan epic-legend of the great hero-on-horseback, King Geser of Ling, who defended Tibet from all enemies and was ultimately brought into Buddhist service as a Dharma king, or Chakravartin, a protector of religion in the mold of India's King Ashoka (third century B.C.), Tibet's Songtsen Gampo, and

Mongolia's Khubilai Khan. Geser probably was borrowed from a Turkic source, but was quickly identified with Kubera (or Vaishravana, the god of wealth, cat. nos. 76 and 77) and introduced to Mongolia in a translation of his epic around 1614, where his exploits made him an immediate favorite. His history soon became entwined with another great culture hero, China's god of war, Guandi, a historical figure of the third century. Guandi was the object of Manchu admiration; the novel that tells his tale, *Sanguozhi* (Romance of the Three Kingdoms), had been translated into Manchu as early as 1647, and, in the mid-eighteenth century, the Qianlong emperor's own lama-guru, the Jangjya Khutuktu Rolpay Dorje, composed a prayer to him, which was distributed in Manchu, Mongolian, and Tibetan. The Manchus brought Guandi into the Tibeto-Mongolian pantheon in the early nineteenth century, equating him, like Geser, with Vaishravana. At the same time, as part of their syncretic efforts, they expended great energy in building shrines to Guandi along the Mongolian border, where multilingual inscriptions identified the deity in Chinese as Guandi and in Mongolian as King Geser.[77]

Even Chinggis Khan, only doubtfully exposed to Buddhism in his lifetime and certainly never converted, was integrated forcibly into the Buddhist pantheon, again through the agency of the Manchus. The Second Jangjya Khutuktu (Rolpay Dorje's predecessor) composed a prayer to Chinggis around 1690, and other later Buddhist prayers to the Mongol conqueror, including one by Mergen Diyanči (who had brought the White Old Man safely into the fold), praise Chinggis as a Chakravartin and protector of religion. Mergen Diyanči's prayer was still in common use in Mongolia in the 1930s.[78]

MONASTERY BUILDING IN KHALKHA

When Zanabazar was first recognized as Jebtsundamba Khutuktu and Bogdo Gegen, Outer Mongolia had only one permanently established monastery, Erdeni Zuu, which had been built in a style at least partly Chinese, and eventually partly Tibetan, at the order of his great-grandfather, Abadai. On his return from Tibet in 1651, Zanabazar set up his own palace-residence at a site near the confluence of the Selbe and Tula rivers, close to the center of modern Outer Mongolia. His encampment consisted of a circle *(khüree)* of monastic *ger* (yurts), divided into segments, or *aimag*, that clustered around his own personal quarters, a format that gave it the name Da or Yikh Khüree (Da küriyen or Yeke küriyen; great circle, fig. 11). Urga, the name that later attached itself to the monastery complexes of Zanabazar's successors, was a Russified version of *örgöö*—palace—and a recognition of the significance of the Bogdo Gegen's residence there. The *aimag* divisions of Da Khüree or Urga, only seven when Zanabazar

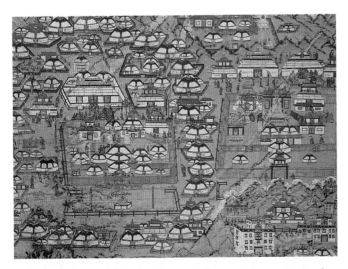

Fig. 11. View of Urga in the mid-19th century by an unknown artist. Gandantegchinlin Monastery, Urga. Mineral colors on cotton, H: 44¾ (113.5) W: 60¼ (153.0). From Tsultem, *Mongol Zurag*, fig. 155.

founded it but expanded to twenty-eight in the late nineteenth century, reflected the composition of Khalkha as a whole. Most monastic *aimag* survived through the patronage of local khans, each of whom replenished his *aimag's* population in Da Khüree with young men from his own district (also translated as *aimag*). There were certain exceptions; three of Zanabazar's original *aimag* were devoted to serving the Bogdo Gegen and one was initially created to house a group of missionizing monks from Amdo, brought to Mongolia by Zanabazar, but by the nineteenth century Da Khüree was a microcosm of Khalkha and even nomads in the deepest countryside recognized and felt loyalty to their monastic *aimag* in the capital.[79]

Throughout the eighteenth century and well into the nineteenth Urga's location was only approximate. Between 1719 and 1779, a period of only sixty years, it moved, if not annually, then at least seventeen times.[80] During his lifetime, Zanabazar himself lived at Urga only intermittently; his residence away from the capital was determined by seasonal changes, by his pastoral duties, and by politics, which took him to Beijing, Dolonnor, and Jehol in the 1690s to pay court to the Kangxi emperor. The Fifth Dalai Lama and the Jangjya Khutuktu, prelate of Dolonnor, found him in Belchir, in Inner Mongolia, in 1685,[81] and Galdan forced him to flee to southeastern Mongolia from Erdeni Zuu in 1688. This pattern continued with his successors, until their movements from Urga were curtailed as part of the Qianlong emperor's crackdown, which brought a Mongol supervisor *(amban)* to Urga in 1758 and a second, Manchu, counterpart in 1761.

Slowly but inexorably parts of Urga took on a more permanent form, with each of the monastery's functions assigned to a different *aimag,* or temple. Da Khüree had separate sections for the *khutuktu* himself, for general assemblies of monks *(khural),* for the physicians and astronomers, for printing and storing sacred texts, and for the worship of specific deities. One important business of the monastery was the study of advanced theology, the curriculum called the *tsanid* first introduced to Khalkha in the lifetime of the Second Bogdo Gegen, Zanabazar's immediate successor (1724–1757). Monks engaged in this difficult study lived along with the rest of the community in Da Khüree, but by the early nineteenth century, when Urga had grown into a busy political and economic center, the monks found that their peace and quiet had been compromised. Gandantegchinlin was established in 1809 to provide solitude for the *tsanid* monks at some distance from Da Khüree, and in later years it even served occasionally as the Bogdo Gegen's residence. The style of Gandan's architecture is Tibetan, although the main assembly hall, with its golden, pyramidal roof, is essentially an immobile *ger*-like structure that has been made to conform to squared-off, sedentary standards (fig. 12).

Other temples at Da Khüree remained unabashedly nomadic, precisely because the *ger* carried with it such a clear sense of Mongol identity. The foremost example was the temple of Abadai (Baruun örgöö), which was the khan's own immense *ger* (it could hold an assembly of three hundred monks), moved to Da Khüree from Erdeni Zuu in Zanabazar's day. The chief deity in Abadai's temple was Begtse, protector of the Bogdo Gegens; the temple's patron was naturally the Tüsheet Khan.[82]

The Maidar Temple, dedicated to Maitreya, a deity who was, as we have seen, especially close to Mongol hearts, also incorporated a round *ger*-like roof (fig. 13). The Fifth Bogdo Gegen (1815–1842) constructed it sometime between 1820 and 1836 in the middle of Da Khüree to house an immense seated figure of the future Buddha (over 54 ft. high). The gilt brass Maitreya was depicted seated on a lion throne, legs down in the European posture. It was made in seven separate parts (head, chest, two arms, lower trunk, two legs) in Dolonnor, the center of Manchu administration in Inner Mongolia, and shipped in parts to Urga. The Chinese artist, whose Mongol name was Ayush-tunjan, had metalworking shops in Dolonnor and Urga,[83] but in the nineteenth century Dolonnor was the source of most of the sculpture used in both Inner and Outer Mongolia (and a significant part of what was used in the Manchu court) and most of the metalworkers in Urga were Mongolized Chinese from Dolonnor, their work a distant echo of Zanabazar's (see Bartholomew, "An Introduction to the Art of Mongolia").

Once reassembled, the Maitreya was enclosed in a temple-structure of Chinese design that kept collapsing, probably because of its ramshackle construction. The monastic hierarchy, however, fearing a supernatural cause, dispatched a delegation to Tibet to consult with the Panchen Lama, whose opinion was that the Maitreya objected to the Chinese design of its temple. It was subsequently rebuilt in Tibetan style, but with the conical roof of a *ger*.

Maitreya and his worship were also the source of considerable friction between the monastic community and the Chinese merchants who built a *maimaicheng* (business town) at the edge of Da Khüree in the nineteenth century. Inevitably, Maimaicheng grew and encroached on the *khüree* itself, making it impossible for the Maitreya procession to make its way freely around the monastery. Complaints were dispatched to Beijing several times in the mid-nineteenth century calling for the withdrawal of the merchants or, alternatively, for permission to move the *khüree;* the Lifanyuan, the Manchu government bureau in charge of frontier affairs, tried both approaches without success.[84] The distance between the monastery and town was measured annually, and Urga assumed a three-part (though still mostly portable) shape—Da Khüree, Gandan, and Maimaicheng.

For all the energy the Manchus invested in controlling

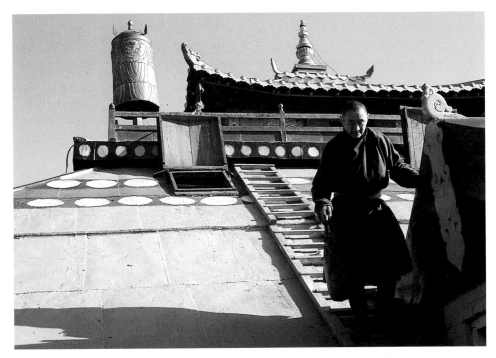

Fig. 12. The main assembly hall at Gandantegchinlin Monastery in Ulaanbaatar (Urga). Photo: Patricia Berger.

the prestige and power of the Bogdo Gegens, they did not succeed in creating an imperially subsidized monastery in Urga in Zanabazar's lifetime, as they did for the Jangjya Khutuktu in Inner Mongolian Dolonnor and for the Panchen Lama at Jehol, where the Qianlong emperor built a slavish model of Tashilunpo to honor his visit to the Manchu court in 1780 on the occasion of Qianlong's seventieth birthday.[85] Whatever plans the Kangxi emperor might have had were temporarily thwarted by his death in 1722; Zanabazar organized and supervised the imperial obsequies and passed away himself at the Yellow Monastery in Beijing the next year, after which his remains were piously transported back to Da Khüree.

Kangxi's son, the Yongzheng emperor, carried out his father's wishes, allocating the one hundred thousand silver *liang* mandated in his father's will to build a monastery for the Bogdo Gegen in 1727. The site for the monastery, Amarbayasgalant (or Amur bayasqulangtu, Monastery of Happiness and Peace), was set at the location of Da Khüree at the time of Zanabazar's death, but work was not completed until 1778, by which time Da Khüree had moved many times.[86] Zanabazar's mummy was taken there and interred in a *suburgan* (stupa). In 1797 the Fourth Bogdo Gegen ordered that Zanabazar's *suburgan* be opened and a painted portrait of him prepared based on his mummified remains (see, e.g., cat. no. 16).[87]

Amarbayasgalant, one of the three monastic establishments still extant in Khalkha and the object of a UNESCO conservation effort, was designed as a *keyid,* a hermitage in

Fig. 13. An early-20th-century view of the Maidar Temple at Urga. From D. Maidar, *Mongoliin arkhitektur ba xot bagulalt* (Ulaanbaatar, 1972), fig. 63.

the Tibetan tradition, not as a nomadic *khüree*. Its buildings are arrayed along a north-south axis, as Chinese monasteries are, and while the buildings themselves are also Chinese in style, they cleverly incorporate innovative roof structures unlike anything seen in China or Mongolia.

The imperial stele that was erected at Amarbayasgalant in 1737 to record the details of its foundation, an eloquent work of the Manchu imperial chancery, written in Qianlong's own voice, is quick to state the allegiance of the Qing emperors to the Gelugpa, while simultaneously asserting their own primacy in secular matters and crediting themselves with Mongolia's happiness and prosperity.[88] In this sense it was a warning to potential dissidents, similar in tone to a proclamation that Qianlong had placed in 1792 in the

courtyard of the Yonghegong (Ganden in Tibetan) in Beijing, decades after the complex, once his father's princely palace, was converted into the Chinese headquarters of the Mongol Gelugpa.[89]

A final architectural project, the imperial temples at Jehol (Chengde), the Manchu summer retreat, must also be mentioned, even though they were located in China, not Khalkha. Jehol was begun under Kangxi and its outer monasteries completed under Qianlong as the mollifying front the Manchus presented to the Mongols after they capitulated. It was at Jehol, amid shrines dedicated to Tibetan Buddhist deities and away from the crowds of Beijing, that the Manchus met with their new Mongol vassals. The strategy embodied in the Jehol monasteries was born of the Manchu assumption of the Mongol legacy after their defeat of Ligdan. At Jehol, the Mongols could comfortably worship in monasteries specifically built to honor their loyalty to the Manchus, and the Manchus could greet and offer hospitality to the great prelates of Tibetan Buddhism. The Monastery of Universal Peace, Puning si, was built in the style of Samye Monastery, Tibet's oldest, between 1755 and 1758, and Putuozongcheng, a smaller copy of the Fifth Dalai Lama's Potala, commemorated Qianlong's sixtieth birthday and his devout mother Xiaosheng's eightieth in 1771. In 1780, the Xumifushou, a replica of the Panchen Lama's monastery, Tashilunpo, was built for Qianlong's seventieth birthday celebrations, which the Third Panchen Lama attended.

The Mongols themselves were frequent guests at Jehol, where artists of the Qing court did paintings intentionally flattering their sensibilities. A Chinese painter portrayed the Third Bogdo Gegen when he visited the emperor at Jehol, and other portraits, in oils, were done of Mongol leaders at Jehol by the European Jesuit painters of Qianlong's court.[90] A large, collaborative work by Chinese court painters, lama-artists (Tibetan or Mongol), and the Bohemian Jesuit portraitist Ignatius Sickelpart (Ai Qimeng, 1708–1780) records the meeting in 1770 of the Mongol Torghut khan Ubashi and the Qianlong emperor in the main assembly hall of Putuozongcheng, where they listened to the Third Bogdo Gegen explicate sacred texts (fig. 14).[91]

It is also at Jehol that Zanabazar's true heirs are found. Sculpture there follows the rigorous ideals the Mongol artist described in his own work—fluid, lithe figures delicately embellished with a filagree of jewels, Nepalese rather than Tibetan in taste (fig. 15). Jehol's sculpture represents the next generation of the style, with even more emphasis placed on refined, elegant surfaces, less on the flesh that breathes life into Zanabazar's work. In this we may detect the subtle hand of the Dalai Lama, whose fifth incarnation had sent artists home with Zanabazar, and whose seventh (1708–1757), according to his autobiography, dispatched a group of six Nepalese artists, as well as Nepalese and Tibetan monks and

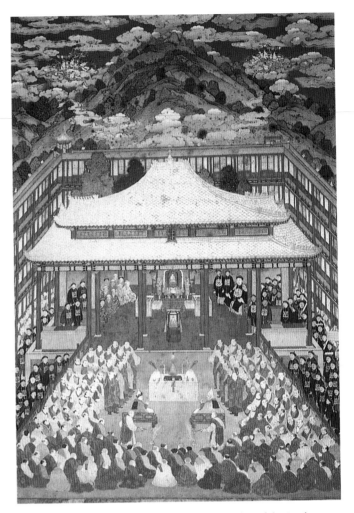

Fig. 14. The Third Bogdo Gegen preaching in the replica of the Potala at Jehol. From *Mountain Manor for Escaping the Summer Heat* (Beijing: People's Fine Art Publishing House, n.d.), p. 46.

doctors, to Beijing in 1744, to assist in the building and staffing of the Yonghegong.[92] The imperial monasteries of Jehol and Beijing thus became the visual embodiment of the Manchu policy of control through religion—where Buddhism, regulated from Beijing, brought an apparent unity of purpose to Manchus, Mongols, and Tibetans alike.

OTHER MONGOL PUNDITS

Zanabazar's contributions to the inspiring, often mysterious and magical mythos of the new Manchu-dependent Khalkha state went a long way toward reconciling the Mongols to political reality. His efforts at converting the Mongols to Tibetan Buddhism, specifically to the doctrines of the Gelugpa, were not solitary, however. Other brilliant lamas accomplished similar transformations in other parts of Mongolia. The Oirat Zaya Pandita (1599–1662), for example, missionized in Western Mongolia during the seventeenth century, where he adapted a Uighur-based script to the Oirat dialect.[93] Neyiči Toyin, son of a Western Mongolian Torghut khan, trained at Altan Kahn's Köke qota, purged the shamans

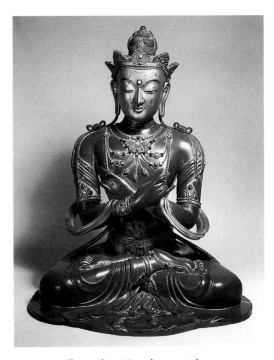

Fig. 15. Vajradhara. China, Qing dynasty, 18th century. Wood with lacquer and gilding, inlaid with semiprecious stones, H: 38 (96.5) Circ.: 36 (91.5). Asian Art Museum of San Francisco, The Avery Brundage Collection.

through the unique method of offering to trade cows and sheep for shamanist ancestral figures *(ongod),* and by promulgating far and wide unorthodox rites to Yamantaka as a powerful substitute for the shamans' exorcistic prayers. He was widely criticized as lacking discrimination, to which he responded, "You are perfectly right, but how can these simple people understand the deepest secrets, when one preaches to them just once? I am trying to gain their attention."[94]

The Inner Mongolian counterpart to Urga's Bogdo Gegens were the Jangjya Khutuktus, the only line of incarnations created (and not simply condoned and regulated) by the Manchus.[95] The Jangjya Khutuktus were based in Inner Mongolia at Dolonnor, near the site of Khubilai's summer capital, Shangdu (Xanadu). Rolpay Dorje (1717–1786), the third and greatest of the line, was a Tibetanized Mongol from Amdo, who was schooled together with the Qianlong emperor, and later, as an adolescent, in Tibet (fig. 16). When grown, he returned to court, by then Qianlong's, and became the emperor's prime adviser on religious matters. He was responsible for translations into Manchu and Mongolian of the Tibetan Buddhist canon, the Kanjur, and its commentaries, the Tanjur, a type of pious patronage repopularized by Altan Khan, Abadai, and Ligdan. Like Zanabazar, Rolpay Dorje was an artist in his own right (to whom, sadly, no extant works can be attributed), but he was also well known for his iconographic expertise. He oversaw the reproduction by the court painter Ding Guanpeng of the twelfth-century Yunnanese Long Scroll of Zhang Shengwen, correcting its iconography and rearranging the contents,[96] and, with his spiritual teacher, Erdeni Nomyn Khan, he compiled an authoritative pantheon of the deities of Tibeto-Mongolian Buddhism that was in print even in the early twentieth century.[97] He also advised the emperor on Mongolia and Tibet, helping to craft a policy that firmly underscored the Manchu inheritance of Mongol prerogatives. He traveled with Qianlong to his seat at Dolonnor and to the summer palaces at Jehol. Rolpay Dorje also accompanied the emperor on his pilgrimages to Mount Wutai, where the Mongol built his own retreat and meditated with the emperor, sharing visions of Manjushri.

In 1753 Rolpay Dorje articulated and amplified the Mongol-inspired symbolism of the Manchu state, when he translated the biography of Phagspa, one of his own preincarnations, into Mongolian. Happening on the section that describes Phagspa's initiation of Khubilai into the mysteries of Hevajra in a water-ox year, he recalled that he had given Qianlong a Samvara initiation in a wood-ox year, and thus was brought to the realization that the religious ties that linked him to Qianlong had existed through many previous existences.[98] Thus, Rolpay Dorje's pontifical role was sanctified by history, and much of his career was taken up by the requirements of sacred and secular ritual, meeting with and regulating the choice of the Dalai Lama, Panchen Lama, and, eventually, the Bogdo Gegen.

Rolpay Dorje worked with Qianlong to centralize Tibetan Buddhism; while recognizing the authority of the Dalai and Panchen Lamas as Buddhism's main prelates, Qianlong nonetheless asserted that their right to authority

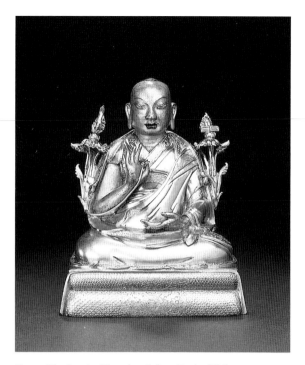

Fig. 16. The Jangjya Khutuktu Rolpay Dorje. Gilt brass; cast in several parts, with chasing, cold gold paste, and pigments, H: 6½ (16.5). The State Hermitage, St. Petersburg, Prince Ukhtomsky Collection. Photo: Copyright John B. Taylor.

came from him and insisted new incarnations be chosen under his auspices, using the famed golden *bumba* (vessel), out of which the name of the true incarnation was drawn from a host of candidates' names. A parallel policy was the Qing effort in the eighteenth century to syncretize, according to their own political needs, the different religious traditions of those they ruled. Their patronage and dissemination of comprehensive translations of Buddhist literature into Manchu and Mongolian was part of this strategy (cat. nos. 47–62), their desire to erase or ease differences in local belief another. Examples of the latter include the equation of the Tibetan Geser and the Chinese Guandi, and the acceptance of Chinggis Khan and Confucius into the Tibeto-Mongolian pantheon. A prayer-poem cast in the idiom of Tibetan Buddhism was, as we have seen, written to Chinggis by the First Jangjya Khutuktu, and a text found at the Yonghegong, itself a reconciliation in architecture and art of Chinese and Tibeto-Mongol ideals, treats the ancient Chinese sage, Confucius, to all intents and purposes, as an incarnation of Manjushri (and, by extension, as a preincarnation of the Manchu emperors).[99]

ZANABAZAR'S SEVEN SUCCESSORS

Zanabazar had a total of seven successors, the last of whom died in 1924. None inherited his greatness and, while each was the object of love and fierce loyalty among the Khalkhas,

the powers allowed by the Manchus to the Bogdo Gegens were increasingly diminished. Nonetheless, some of the symbolism of their illustrious predecessors survived. The Bogdo Gegen, for example, continued to wear a small gold *dorje* on his hat, in lieu of a Manchu rank-bead. This insignia did not come from Beijing but from the Third Dalai Lama, who had granted the right to wear it to Abadai Khan, Zanabazar's great-grandfather, along with the title Vachirai-sain Khan—Good Vajra King.[100]

The Second Bogdo Gegen, like Zanabazar, was the son of a noble Khalkha clan. His father, Darkhan Chingwang, was raised in Beijing and twice married to Chinese princesses, but it was his Khalkha wife who bore the incarnation of Zanabazar. As a child, he spent most of his time in Dolonnor, waiting out the Zunghar wars and Khalkha unrest. Even so, during his lifetime, the wealth and *shabinar* (serfs) of the Urga seat grew immensely, so much so that in 1754, the Qianlong emperor appointed a *shangzudba* (treasurer) to oversee the prelate's secular affairs, insisting that the Bogdo Gegen spend his time in study and prayer. He died of smallpox in 1757, after assuming the form of a fierce guardian and magically quelling an outbreak of the disease in the *khüree* itself.

The birth of the Third Bogdo Gegen saw a further erosion of Mongol control over the discovery of their own incarnate-lama. The Manchus, in an attempt to put an end to rivalries among noble Khalkha families, each of whom backed a different favorite, insisted that the new incarnation be confirmed in Tibet, specifically by the Dalai and Panchen Lamas and the state oracles.

To the dismay of the Khalkhas, the Third Bogdo Gegen was born to a princess in the royal house of Litang, in eastern Tibet. In a replay of the events surrounding Zanabazar's own integration into the Tibetan and Manchu power structure, the young incarnation was brought first to Jehol, to pay his respects to the Qianlong emperor and to receive initiations from the Jangjya Khutuktu. Only then did he proceed to Urga, where he died at the age of fifteen. His swift demise again kindled hope among the Khalkhas that they might influence the next discovery. The wife of the Tüsheet Khan was pregnant; portents pointed to this child as the next incarnation, but to the Khalkhas' chagrin, the child was a girl. Meanwhile, from Tibet, word arrived that the new incarnation had appeared as a cousin of the Seventh Dalai Lama. This Fourth Bogdo Gegen, called "Angry Aspect" because of his stern stance against monastic torpor, was a religious activist. He ordered many sacred images from Tibet. He opened Zanabazar's *suburgan* at Amarbayasgalant and had a painted portrait made of him, using it to make the first icon of his predecessor, funded by all four of Khalkha's *aimag* (see, e.g., cat. nos. 16 and 95). He had ten thousand images of the Buddha cast to offset the Qing emperor's decision to order the execution of a Mongol minister (which he diplomatically

condoned, deploring only its effect on the emperor's karma). In 1802 he built eight *suburgan* at Jehol; in 1803 he went to Tibet and came home fired with the desire to promote the study of the *Kalachakra Tantra,* for which purpose he built a new monastery. In 1809, in one of the greatest achievements of his life, he built Gandantegchinlin to house more suitably monks engaged in the *tsanid.* His death came in 1813, as he made his way back to Khalkha from Mount Wutai.

The fifth and sixth incarnations, again both Tibetans, died young, one of syphilis in 1842, the other, at age six, after spending only fifty-nine days in Urga. At this point, some Mongols began questioning the ultimate destiny of the line, wondering if the sixth was not the last. In a sense, the sixth was the last not to succumb to the temptations brought by isolation, boredom, and great wealth.

Only two more rebirths were to come. The seventh was born in 1850, again in Tibet. Arriving in Urga in 1855, he showed early interest in art, but after a famed, magical conflict with the shaman Setsen Khan Artased, in which he absorbed the khan's lightning bolts and forced him to submit to Buddhism, he was subverted by the khan's own sons to the pleasures of the flesh.[101] When he died in 1868, rainbows appeared, visible in Mongolia and China alike, that pointed in two separate directions, to the southeast, toward Dolonnor, and to the southwest, toward Tibet. Despite Khalkha hopes, the eighth and last incarnation of the line was born once again in Tibet, this time to a family led by one of the managers of the Dalai Lama's estates. Easily bored, this Bogdo Gegen at first diverted himself harmlessly enough with mechanical toys, clocks (see cat. no. 26), illustrated journals from Europe, and a large menagerie of stuffed, exotic animals (including a giraffe, whose neck was shortened to fit him into the Gegen's Russian-built winter palace). By 1885 he had become violent, beating his monks and landing blows on innocent bystanders. He spent his time with a rough, rowdy crowd, hardly monastic, and took numerous lovers, male and female. Yet it was he who was called on to lead Mongolia into the modern era; when the Manchu Qing dynasty fell to the forces of the new Chinese Republic in 1911, the Bogdo Gegen became the Bogdo Khan—the enlightened khan—assuming the Mongol title the Qing had usurped centuries before for themselves.

THE END OF THE LINE

Mongolia's moment of independence was to be short-lived, lasting only to 1915, when the country was returned to Chinese suzerainty by the Tripartite Treaty of Kiakhta, signed by China, Mongolia, and Russia. But in the years just after the Chinese revolution, Mongolia was reorganized under the rulership of the Bogdo Khan, the only candidate with sufficient charisma to unite Khalkha's wayward princes. A bicameral legislature *(khural),* with an upper house of lords and a lower house of lesser nobles, served as a main governing body. The Bogdo Khan, however, was cast in a role of autocratic authority, the dual principles now merged into one ruler, who wore the elegant yellow, Chinese-made, nine-dragon robes of a Manchu prince (cat. no. 19).

The Bogdo Khan now enjoyed all the privileges and pleasures of a secular monarch (not that he had ever been abstemious). His first consort, Dondogdulam, known as Ekh Dagin (Mother Dakini), was cast into a complex role as the wife of a theocratic ruler. She was painted by the modern master Sharav (1869–1939), for example, as an oracle wearing a five-Buddha crown and holding the bell and *dorje* that symbolize her husband's tie to Vajradhara and Vajrasattva (cat. no. 26). She died in 1923 and was replaced by the wife of a wrestler, "who let her go with a shrug."[102] This successor, however, led a life of notorious excess, carrying on openly with her hairdresser and other lovers. The Bogdo Khan, meanwhile, did nothing to change his own behavior and soon fell prey to the ravages of tertiary syphilis and blindness.

The solution to this dilemma was sought, of course, in Buddhist lore. To improve the Bogdo Khan's vision, the Mongolian ambassador to the Russian tsarist court, Khandadorji, took up a collection nationwide to cast a massive image of Avalokiteshvara, "Who Regards with His Eyes." The figure alone cost 100,000 taels of silver; the building to house it at Gandan Monastery in Urga another 23,000. In 1912 supporters of the Bogdo Khan, wishing to prolong his life, commissioned ten thousand figures of Ayusi (Amitayus), the Buddha of Long Life and the focus of so much devotion at the Qing court. This request strained the forges of Mongolia, and so nine thousand were cast in Poland, in an authentic Nepalese-inspired style.

The Eighth Bogdo Gegen was truly a figure caught on the cusp of history. Raised within a conservative religious system, chosen by magic and divination, he ultimately lacked the flexibility to adopt modern means to solve Mongolia's problems. As the Chinese, Russians, and the Mongolian People's Army pressed upon Urga, he staged exorcisms to allay the danger. Even late in life, he was painted in a format that harked back to the early days of the Dalai Lamas, with his spiritual father, Zanabazar, hovering above him, surrounded and enfolded by Zanabazar's holy meditations on the Buddhist pantheon—and on Maitreya's heaven (cat. no. 18).

The amazing strength and credibility of the belief structure the Bogdo Khan embodied were eventually turned against him and the Buddhist church by the numerous forces—Red, White, and Chinese—vying to unseat him. In 1921, for example, the White Russian maverick Baron Ungern-Sternberg, whose bloody and cruel campaigns had terrorized the nation, promised he would re-create the

Mongol empire's past glories.[103] Communists also made clever use of Buddhist lore in their own propaganda, claiming, after the Bogdo Khan's death in 1924, that King Geser of Ling, the messianic hero whose cult had been encouraged in Mongolia by the Manchus, was simply a prefiguration of the transforming power of Soviet socialism.[104] On the other hand, a 1920s Buddhist tract identified Lenin with Langdarma, the apostate Tibetan king and enemy of the faith,[105] while a group of independent khans in Western Mongolia prophesied the imminent return of Amursana, tragic leader of an anti-Manchu revolt in 1757.[106]

Communist propaganda also took advantage of the ambiguous, but northern, location of utopian Shambhala by suggesting that it was really in the Soviet Union. In fact, after the Bogdo Khan's death, visions of Shambhala seemed to loom on Mongolia's horizon. The Party Congress claimed that a ninth incarnation of the Bogdo Gegen would never be found, for he had reincarnated in General Hanumanda of Shambhala. The matter was ultimately submitted to the Dalai Lama for decision, and the ninth incarnation, actually found in Northern Mongolia, was quickly shuffled off-stage.[107] Meanwhile, plots to reinstate him or an alternative candidate, organized by Japan (touted as another potential site of Shambhala during the Japanese takeover of Manchuria in the 1930s) and the Panchen Lama, in exile in China, involved rumors of the Panchen poised to invade Mongolia with the armies of Shambhala under his command.[108]

Other revolutionary leaders did not take such a cynical approach to Buddhism. Jamtsarano, a Buriat Mongol and a Buddhist, saw great potential within Buddhism and urged that the religion be purged and revitalized, brought back to the principles of Shakyamuni himself. His Renewal Movement failed to convince the Communist leadership, however.[109] After 1937, following a precedent set by Stalin's repression of the Russian Orthodox Church, the Mongolian People's Republic adopted a policy of no tolerance toward Buddhism, executing tens of thousands of monks, torching Buddhist monasteries, literally purging all traces of Buddhism from the Mongolian landscape. This wanton action, born of built-up frustration over the church's unrepentant decadence and wealth, ended in the wholesale destruction of much of Mongolia's artistic heritage and the suppression of her wealth of symbols. Among these was a pattern of governance—the dual principle of Khubilai Khan and Phagspa—which had been dealt a fatal blow by the Chinese revolution of 1911, when the Manchus, self-proclaimed heirs to the traditional symbols of Mongolia, were toppled. In Mongolia, the events of the early twentieth century demonstrated that the theocratic state of the Bogdo Gegens, the true legacy of Chinggis and Khubilai, could not be salvaged, that it lacked balance once power was invested in the hands of one deeply flawed man and an outmoded, top-heavy, cynical church.

All of the losses—cultural and spiritual—that the Buddhist purges of the late 1930s inflicted on the Mongolian people are now, finally, being mourned as Mongolia looks forward to a new age of independence and revitalization.

NOTES

1. As told in Damcho Gyatsho Dharmatāla, *Rosary of White Lotuses, Being the Clear Account of How the Precious Teaching of Buddha Appeared and Spread in the Great Hor Country,* trans. Piotr Klafkowski (Wiesbaden: Otto Harrassowitz, 1987), pp. 220–21.

2. Owen Lattimore, *Mongol Journeys* (New York: Doubleday, Doran, and Co., 1941), p. 102. Lattimore attended the annual ceremony in homage of the relics and said that they were an important part of Japan's attempt to win the Mongols over in the 1930s.

3. David Farquhar, "Emperor as Bodhisattva in the Governance of the Ch'ing Empire," *Harvard Journal of Asiatic Studies* 38, no. 1 (June 1978), 5–35. This identification of Khubilai with Manjushri first crops up in the multilingual inscription on the Juyong Gate, north of Beijing. The gate was built in 1345.

4. Heather Karmay, *Early Sino-Tibetan Art* (Warminster: Aris and Phillips, 1975), pp. 21–23; Anige's biography, in *Yuanshi, Ershiwu shi* edition (Taipei: Kaiming Bookstore, 1969), vol. 8, ch. 203, biography 90, p. 457.

5. Henry Serruys, "A Manuscript Version of the Legend of the Mongol Ancestry of the Yung-lo Emperor," *Analecta Mongolica,* The Mongolia Society Occasional Papers, no. 8 (Bloomington, Ind.: The Mongolia Society, 1972), p. 22.

6. Larry W. Moses, *The Political Role of Mongol Buddhism,* Indiana University Uralic and Altaic Series, vol. 133 (Bloomington: Asian Studies Research Institute, Indiana University, 1977), pp. 83–89; Sechin Jagchid, "Buddhism in Mongolia after the Collapse of the Yuan Dynasty," in *Traditions réligieuses des peuples altaïques* (Paris: Presses Universitaires de France, 1972), pp. 4–58.

7. Karmay, *Early Sino-Tibetan Art,* pp. 72–97.

8. Charles R. Bawden, *The Modern History of Mongolia* (London: Weidenfeld & Nicolson, 1968), pp. 25ff.; Moses, *The Political Role of Mongol Buddhism,* pp. 90–107.

9. The meeting is so described in Saghang Sečen's *Erdeni-yin tobči,* written in 1662, and translated by Samuel Grupper, "The Manchu Imperial Cult of the Early Ch'ing Dynasty: Texts and Studies on the Tantric Sanctuary of Mahākāla at Mukden" (Ph.D. diss., Indiana University, 1979), p. 73.

10. I am grateful to James Bosson for directing me to Omeljan Pritsak, "Der Titel Attila," in *Festschrift für Max Vasner zum 70. Geburtstag,* Veröffentlichungen der Abteilung für Slavische Sprachen und Literaturen des Osteuropa-Instituts, Band 9 (Wiesbaden: Otto Harrassowitz, 1956), pp. 404–19.

11. This subtle bit of doctrinal diplomacy also linked the new Dalai Lama with Phagspa and Khubilai, who presumably embodied Mahakala's power. See Charles R. Bawden, *The Jebtsundamba Khutukhtus of Urga,* Asiatische Forschungen, Band 9 (Wiesbaden: Otto Harrassowitz, 1961), p. 35 (text lv); Walther Heissig, "A Mongolian Source to the Lamaist Suppression of Shamanism in the Seventeenth Century," *Anthropos* 48, nos. 3–4 (1953), 514.

12. Dharmatāla, *Rosary of White Lotuses,* p. 227.

13. See Marsha Weidner et al., *Latter Days of the Law: Images of Chinese Buddhism, 850–1850* (Lawrence: Spencer Museum, University of Kansas; Honolulu: University of Hawaii Press, 1994), pp. 60–61, 164.

14. See Bawden, *The Jebtsundamba Khutukhtus of Urga*, p. 36 (text 2r).

15. See Egly Alexandre, "Erdeni-zuu, un monastère du XVIe siècle en Mongolie," *Etudes Mongoles* 10 (1979), 7–33; Aleksei M. Pozdneyev, *Mongolia and the Mongols*, trans. John Roger Shaw and Dale Plank, Uralic and Altaic Series, vol. 61 (Bloomington: Indiana University Publications, 1971), pp. 281–302.

16. Aleksei M. Pozdneyev, *Religion and Ritual in Society: Lamaist Buddhism in Late Nineteenth-Century Mongolia*, trans. Alo Raun and Linda Raun, The Mongolia Society Occasional Papers, no. 10 (Bloomington, Ind.: The Mongolia Society, 1978), p. 419. Phagspa's conch shell had been handed down from the time of Shakyamuni Buddha and was given to him by Khubilai in 1253. It was still kept at Erdeni Zuu in the late nineteenth century, according to Pozdneyev. See Yang Shuwen et al., *The Biographical Paintings of 'Phags-pa* (Beijing: New World Press; Lhasa: People's Publishing House of Tibet, 1987), p. 52.

17. The story that follows is taken with some additions from Grupper, "Manchu Imperial Cult."

18. Anning Jing, "The Portraits of Khubilai Khan and Chabi by Anige (1245–1306), a Nepali Artist at the Yuan Court," *Artibus Asiae* 54, nos. 1–2 (1994), 47. The author quotes *rGya Bod yig tshang* (1434) (Sino-Tibetan History), trans. Chen Qingying as *Han Zang shiji* (Lhasa: People's Publishing House of Tibet, 1986), p. 173.

19. Heather Stoddard, "A Stone Sculpture of mGur mGon-po, Mahākāla of the Tent, Dated 1292," *Oriental Art*, n.s., 31, no. 3 (Autumn 1985), 278–82; Gilles Béguin, *Art ésotérique de l'Himalaya: La donation Lionel Fournier* (Paris: Editions de la Réunion des musées nationaux, 1990), cat. no. 21, pp. 52–56.

20. Grupper, "Manchu Imperial Cult," p. 91. Grupper also notes that the Sakyapa region of Mongolia is most likely to mean the area around Sining, in modern Gansu province, where Sakyapa fiefs were established in the thirteenth and fourteenth centuries; see p. 125 n. 56.

21. Ibid., pp. 52–54.

22. Ibid., p. 53, who translates the Mongolian title Khubilai conferred on Phagspa according to a passage in Saghang Sečen's *Erdeni-yin tobči*, a chronicle of Mongolian history from primeval times to 1662. Grupper translates from I. J. Schmidt's edition, *Geschichte der Ost-Mongolen und ihres Fürstenhauses verfasst von Ssanang Ssetsen Chungtaidschi der Ordos* (St. Petersburg, 1829).

23. See René de Nebesky-Wojkowitz, *Oracles and Demons of Tibet* (The Hague: Mouton, 1956), pp. 38–67.

24. William Edward Soothill and Lewis Hodous, *A Dictionary of Chinese Buddhist Terms* (Taipei: Chengwen Publishing Company, 1968), p. 97.

25. This seal, according to legend, had been cast by China's first emperor, Qin Shihuang, and had been passed down into the hands of Khubilai Khan and kept by his successors throughout the Northern Yuan. See Hidehiro Okada, "The Yuan Seal in the Manchu Hands: The Source of the Ch'ing Legitimacy," in *Altaic Religious Beliefs and Practices*, Proceedings of the 33d Meeting of the Permanent International Altaistic Conference, Budapest, 24–29 June 1990 (Budapest: Research Group for Altaic Studies, Hungarian Academy of Sciences, 1992), pp. 267–70. Okada compares the Manchu assumption of the Mongol right to rule to a parallel series of events in Russia, where Grand Duke Ivan IV assumed the title of Tsar for the first time in 1547, when much of Russia was still under the "Tartar yoke." Pressed to legitimize his reign, Ivan abdicated in favor of Simeon Bakbulatovich, a Mongol and grandson of Khan Ahmad of the Golden Horde and a descendant of Chinggis. Simeon then abdicated in favor of Ivan after less than a year, thereby becoming the conduit for his right to rule and legitimizing Ivan in Mongol eyes.

26. Grupper, "Manchu Imperial Cult," p. 165.

27. Ibid., pp. 184–85. See also L. C. Arlington and William Lewisohn, *In Search of Old Peking* (Peking: Henry Vetch, The French Bookstore, 1935), pp. 127–28. Our recent attempt to trace the fate of the Mahakala produced information from Luo Wenhua of the Palace Museum, Beijing, who reported that one of two things happened to it. Either it did not leave Mukden for Beijing and was taken by the Japanese in World War II, or it did come to Beijing's Mahakala Temple (Pudu si), whence it disappeared. An image of Mahakala now in the temple (and mentioned by Arlington and Lewisohn) is not Phagspa's, according to Luo.

28. Dharmatāla, *Rosary of White Lotuses*, p. 248.

29. Geoffrey Samuel, *Civilized Shamans: Buddhism in Tibetan Societies* (Washington and London: Smithsonian Institution Press, 1993), p. 464.

30. Farquhar, "Emperor as Bodhisattva," pp. 19–20.

31. See Raoul Birnbaum, *The Mysteries of Mañjuśrī: A Group of East Asian Mandalas and Their Traditional Symbolism*, Society for the Study of Chinese Religions, Monograph 2 (Boulder, Colo.: Society for the Study of Chinese Religions, 1983), p. 9.

32. Dharmatāla, *Rosary of White Lotuses*, p. 253.

33. Bawden, *The Modern History of Mongolia*, p. 59.

34. Ibid., pp. 53–55.

35. See Bawden, *The Jebtsundamba Khutukhtus of Urga*, pp. 44–45.

36. Pozdneyev, *Mongolia and the Mongols*, p. 327.

37. Ibid., p. 328.

38. This story is recounted in many places. See, e.g., Dharmatāla, *Rosary of White Lotuses*, pp. 339–40; Bawden, *The Modern History of Mongolia*, pp. 70–75.

39. Bawden, *The Jebtsundamba Khutukhtus of Urga*, p. 45.

40. Ibid., pp. 50–51.

41. Ibid., pp. 51–52.

42. Dharmatāla, *Rosary of White Lotuses*, pp. 338–41; Pozdneyev, *Mongolia and the Mongols*, pp. 324–38.

43. Taranatha collected 73 *sadhana* texts, in the Beijing edition of the Tanjur, some of which were newly executed versions, others ancient versions that he corrected, and still others ancient versions offered without change. See Lokesh Chandra, *Sādhana-māla of the Panchen Lama*, part 1, Śatapiṭaka Series, vol. 210 (New Delhi: International Academy of Indian Culture, 1974), pp. 6–7.

44. Dharmatāla, *Rosary of White Lotuses*, p. 339; Pozdneyev, *Mongolia and the Mongols*, p. 328.

45. Pozdneyev, *Mongolia and the Mongols*, p. 331.

46. Ibid., p. 333.

47. N. Tsultem, *The Eminent Mongolian Sculptor—G. Zanabazar* (Ulaanbaatar: State Publishing House, 1982), p. 8.

48. Samuel, *Civilized Shamans*, pp. 276, 511.

49. Bawden, *The Modern History of Mongolia*, p. 57.

50. See Luciano Petech, *Medieval History of Nepal* (Rome: Istituto Italiano per il Medio ed Estremo Oriente, 1984), pp. 99–101.

51. Gilles Béguin et al., *Trésors de Mongolie, XVIIe–XIXe siècles* (Paris: Editions de la Réunion des musées nationaux, 1993), pp. 72–77. See also Giuseppe Tucci, *Tibetan Painted Scrolls* (Rome: La Librairio del Stato, 1949), vol. 1, figs. 63, 67, 70, 74.

52. Gilles Béguin dates the construction of this hall to 1626 (attributing this dating to Liu Lizhong, *L'art bouddhique tibétain* [Paris: Librairie You-Feng, 1989], p. 18), different from the 1592 found in several Chinese works on Kumbum (see, e.g., Yang Qingxi, *Taersi* [Xining: Qinghai Nationalities Press, 1984], pp. 130–31; *Taersi gaikuang* [Xining: Qinghai People's Press, 1987], pp. 52ff). While noting a stylistic similarity to Zanabazar's work, Béguin suggests that the dried clay figures in the Manjushri Hall may date to the Qianlong period, because they are placed against what appears to be a late fresco and would have been

too bulky to move around. (Béguin gives the Qianlong period as 1636–95, instead of one hundred years later, an error that does not substantially affect his argument.) The Manjushri Hall was actually renovated in 1734, two years before Qianlong ascended the throne. It is likely the paintings behind the figures were done on fabric and applied to the wall after painting, which would not have made it necessary to move the figures at all. Stylistically, the figures in the Manjushri Hall appear significantly earlier than their backdrop. See *Trésors de Mongolie*, p. 72.

53. Pozdneyev, *Mongolia and the Mongols*, p. 328.

54. Anne Chayet and Corneille Gest, "Le monastère de la Félicité tranquille, fondation impériale en Mongolie," *Arts Asiatiques* 46 (1991), 73.

55. Bawden, *The Jebtsundamba Khutukhtus of Urga*, pp. 47–49.

56. Pozdneyev, *Mongolia and the Mongols*, p. 329.

57. This effort on Zanabazar's part is described in Dharmatāla, *Rosary of White Lotuses*, p. 343; Pozdneyev, *Mongolia and the Mongols*, p. 330.

58. "The Maitreya Procession," *Chö-yang* 1, no. 2 (1987), 94–95, describes the Maitreya Procession as it was performed around the Jokhang in Lhasa. The article cites another authority for the origin of the procession, the *Prophecy of Langru*, which said that in future a Maitreya image would be placed on a chariot, people would make offerings to it, and therefore it would appease all harm.

59. See, e.g., Dharmatāla, *Rosary of White Lotuses*, pp. 230–31, where the Third Dalai Lama receives a letter from Tsongkhapa telling him to "Go to Ganden!" See also p. 262, describing the Ganden Namcho commemorating Tsongkhapa's death, or "the Second Buddha's departure for Ganden."

60. Ibid., pp. 274–75.

61. Ibid., p. 343.

62. G. Schulemann, *Geschichte der Dalai-Lamas*, 2d ed. (Leipzig: Otto Harrassowitz, 1958), p. 220; Bawden, *The Jebtsundamba Khutukhtus of Urga*, pp. 2 and 45 n. 8.

63. Pozdneyev, *Religion and Ritual in Society*, p. 503.

64. Ibid., pp. 496–505.

65. See Marylin Rhie and Robert A. F. Thurman, *Wisdom and Compassion: The Sacred Art of Tibet* (San Francisco: Asian Art Museum of San Francisco; New York: Tibet House and Harry N. Abrams, 1991), cat. no. 97, pp. 268–70, a portrait of the Third Dalai Lama surrounded by vignettes of his visions, dreams, and teachings, includes a depiction of a Tibetan Maitreya Festival. A twice-life-size image of Maitreya is placed in a wheeled cart pushed by a troupe of monks. The scene refers to a between-state experience (just before his rebirth as Third Dalai Lama), when he visited Tushita Heaven and saw Maitreya.

66. One of these figures is in the Museum of Religious History, Choijin-Lama Temple collection, and another is kept at Gandantegchinlin in Ulaanbaatar. At least one other very similar figure exists; see *Wisdom and Compassion*, cat. no. 32, p. 141. Marylin Rhie does not directly attribute this Maitreya (Arthur M. Sackler Museum, Harvard University) to Zanabazar, but she notes its similarity to his work and to the Maitreya dated 1093 in Narthang Monastery. One of the two similar Maitreyas in Gandantegchinlin, Ulaanbaatar, is published in Tsultem, *The Eminent Mongolian Sculptor—G. Zanabazar*, pl. 44.

67. Edwin Bernbaum, *The Way to Shambhala* (Garden City, N.Y.: Anchor Press, 1980), p. 11.

68. See Sven Hedin, *History of the Expedition in Asia, 1927–1935* (Stockholm and Göteborg: Elanders Boktryckeri Aktiebolag, 1943), part I, pp. 90–92 and pl. 13. Another description is in Henning Haslund, *Men and Gods in Mongolia*, trans. Elizabeth Sprigge and Claude Napier (London: Kegan Paul, 1935; repr., Stelle, Ill.: Adventures Unlimited Press, 1992), pp. 39–63.

69. Walther Heissig, *A Lost Civilization: The Mongols Rediscovered*, trans. D. J. S. Thomson (London: Thames and Hudson, 1966), p. 139.

70. Samuel, *Civilized Shamans*, pp. 266–67.

71. This *tsam* is described thoroughly in Pozdneyev, *Religion and Ritual in Society*, pp. 505–21.

72. Lokesh Chandra, *Eminent Tibetan Polymaths of Mongolia*, Śatapiṭaka Series, vol. 16 (New Delhi: International Academy of Indian Culture, 1961), p. 14.

73. Walther Heissig, *The Religions of Mongolia*, trans. Geoffrey Samuel (Berkeley: University of California Press, 1980), pp. 109–10.

74. Ibid., pp. 76–81; Antoine Mostaert, "Note sur le culte du Vieillard blanc chez les Ordos," in *Studia Altaïca: Festschrift für Nikolaus Poppe* (Wiesbaden: Otto Harrassowitz, 1957), pp. 108–17.

75. The line between ritual and theater was very finely drawn in Tibet and Mongolia, as it is elsewhere. L. Austine Waddell describes the traveling troupes of professional actors and actresses in Tibet, who performed, masked, in piously scripted plays, based on *jataka* tales, such as the story of Prince Vessantara and the travels of Sudhana. See Waddell, *The Buddhism of Tibet or Lamaism* (London, 1895; repr., Cambridge: W. Heffer & Sons, 1967), pp. 539–65, where several Tibetan scripts are given in full. Walther Heissig recounts the popularity of the "Tale of the Moon Cuckoo" (and other plays) in Mongolia. "Moon Cuckoo" was a dramatic version of a popular, moralizing Buddhist tale Heissig found a fragment of in Beijing. The Noyon Khutuktu Rabdshai (b. 1803), in an effort to raise money for his impoverished, unreformed monastery, had traveled far and wide with a troupe to perform a version of the story he wrote ca. 1831. He probably based it on a blockprint of the story, dated 1770, the same edition that Heissig found part of in Beijing. See Heissig, *A Lost Civilization*, pp. 211–30.

76. *Religious Mask Dancing "Tsam" in Mongolia* (N.p.: Zhuulchin, Mongolian National Tourist Association, n.d.), a postcard folder with text.

77. Heissig, *The Religions of Mongolia*, pp. 93–101.

78. Ibid., pp. 63–64. However surprised Chinggis might have been to find himself the object of Buddhist prayers, he was not alone. The Manchu Qianlong emperor (r. 1736–95) also had himself integrated into mandalas (he was, after all, Manjushri-incarnate and a Dharma king), generally as the focus of a meditative field of assembly. See, e.g., an example kept at the Gugong, Beijing, in *Cultural Relics of Tibetan Buddhism Collected in the Qing Palace* (Beijing: Forbidden City Press, The Woods Publishing Company, 1992), pl. 32. Another similar piece is still in worship at the Yonghegong.

79. Pozdneyev, *Mongolia and the Mongols*, pp. 43–45, 52–53.

80. Ibid., p. 45.

81. Dharmatāla, *Rosary of White Lotuses*, p. 279.

82. Ibid., pp. 60–61. The Baruun örgöö was reconstructed in 1993 in Ulaanbaatar.

83. Ibid., pp. 61–62.

84. Ibid., pp. 46–49.

85. See Terese Tse Bartholomew, "Three Thangkas from Chengde," in *Tibetan Studies*, Proceedings of the 5th Seminar of the International Association for Tibetan Studies (Narita: Naritasan Shinshoji, 1992), vol. 2, pp. 353–60; Anne Chayet, *Les temples de Jehol et leurs modèles tibétains* (Paris: Editions Recherches sur les civilisations, 1985).

86. A complete study of Amarbayasgalant appears in Chayet and Gest, "Le monastère de la Félicité tranquille," pp. 72–81.

87. Pozdneyev, *Mongolia and the Mongols*, p. 355.

88. Ibid., pp. 19–22.

89. Chayet, *Les temples de Jehol*, p. 56. This 1792 inscription is only one of a group Qianlong placed at the Yonghegong. See Ferdinand Lessing, *Yung-ho-kung: An Iconography of the Lamaist Temple in Peking* (Stockholm and Göteborg: Elanders Boktryckeri Aktiebolag, 1942).

90. Pozdneyev, *Mongolia and the Mongols*, p. 354. See also Bartholomew, "Three Thangkas from Chengde," pp. 353–60; "Qing gongting huajia

Lang Shining nianpu" (Chronology of the Qing Court Painter Giuseppe Castiglione), *Gugong Bowuyuan Yuankan* 2 (1988), 62.

91. Yang Boda, *Qingdai Yuanhua* (Beijing: Forbidden City Press, 1993), pp. 74–75. I am grateful to Terese Bartholomew for this information on the activities of Jesuit painters in Jehol.

92. Valrae Reynolds, et al., *Catalogue of the Newark Museum Tibetan Collection,* 3 vols. (Newark, N.J.: The Newark Museum, 1986), vol. 3, p. 26.

93. Bawden, *The Modern History of Mongolia,* p. 52.

94. Heissig, "A Mongolian Source to the Lamaist Suppression of Shamanism," pp. 1–29, 493–536; Heissig, *The Religions of Mongolia,* pp. 39–40.

95. The biography of Rolpay Dorje, third in the line (sometimes counted the second), was written by his disciple, Chu-bzan Nag-dban thub-bstan dban-phyug, and is titled *rDorje-'chan lcan-skya Rol-pa'i rDorje ye-ces bstan-pa'i sgron-me dpal-bzan-po'i rnam-par thar-pa dad-pa'i padmo rnam-par 'byed-pa nima 'od-zer.* It has been translated into Chinese as *Zhangjia guoshi Ruobi Duoji chuan* (Beijing: Minzu Press, 1988); and into German by Hans-Rainer Kämpfe, *Ni ma'i 'od zer/Naran-u gerel: Die Biographie des 2. Pekinger Lcan skya-Qutuqtu Rol pa'i rdo rje (1717–1786),* Monumenta Tibetica Historica, Abt. 2, Band 1 (Sankt Augustin: Wissenschaftsverlag, 1976).

96. The Ding Guanpeng version of Zhang Shengwen's Long Scroll has been published as a reproduction volume; see *Fajie yuanliu tu* (Hong Kong: Commercial Press, 1992).

97. Dharmatāla, *Rosary of White Lotuses,* pp. 328–29. The pantheon was reprinted by Eugen Pander and edited by Albert Grünwedel as *Das Pantheon des Tschangtscha Hutuktu,* in *Veröffentlichungen aus dem königlichen Museum für Völkerkunde in Berlin,* 1, fasc. 2–3 (1890).

98. Chayet, *Les temples de Jehol,* p. 62.

99. Ferdinand D. Lessing, "Bodhisattva Confucius," in *Ritual and Symbol: Collected Essays on Lamaism and Chinese Symbolism,* Asian Folklore and Social Life, Monograph 91 (Taipei: Chinese Association for Folklore, 1976), pp. 91–94.

100. This detail and the sketch of the Bogdo Gegens that follows are taken from Pozdneyev, *Mongolia and the Mongols,* pp. 339–92.

101. Bawden, *The Modern History of Mongolia,* p. 158.

102. Ibid., p. 166.

103. Moses, *The Political Role of Mongol Buddhism,* p. 163.

104. Ibid., p. 180.

105. Bawden, *The Modern History of Mongolia,* p. 265.

106. Moses, *The Political Role of Mongol Buddhism,* p. 180.

107. Bawden, *The Modern History of Mongolia,* pp. 262–63.

108. Ibid., p. 264.

109. Moses, *The Political Role of Mongol Buddhism,* p. 182.

An Introduction to the Art of Mongolia

TERESE TSE BARTHOLOMEW

Tibetan Buddhism, a highly ritualistic religion with a huge pantheon of gods and goddesses, inspired the religious art of Mongolia (fig. 1). As in most religions, there is a need to create cult images in painting and sculpture, as well as ritual objects and other paraphernalia associated with worship of the deities.

The objects in this exhibition associated with religious worship date from the seventeenth to the twentieth centuries and are the result of the second wave of conversion to Buddhism in Mongolia. They are inspired by Tibetan art, itself a fusion of the art styles of Tibet's neighboring countries—India, Nepal, and China. There was a great deal of cultural exchange and travel between Tibet and Mongolia; Tibetan lamas proselytized in Mongolia, and Mongolians went on pilgrimages to Tibet. Young Mongolian monks traveled to the monasteries of Tibet, such as Kumbum in Amdo, and Ganden, Drepung, and Sera in Lhasa, to further their studies. When these travelers returned to Mongolia, they brought religious objects home with them. High monks of Mongolia and Tibet visited one another and exchanged numerous presents, many of them religious artifacts. These religious objects, often of a high artistic caliber, were in turn copied by local craftsmen. As a result, there was much mingling of artistic styles between Mongolia and Tibet.

Mongolia's southern neighbor, China, was ruled by the Manchus from the seventeenth through the early twentieth centuries. The Manchus were also followers of Tibetan Buddhism, and they too produced paintings, sculptures, and ritual objects made in the Tibetan style, not only for the emperors' personal use but also as gifts for the high lamas of Tibet and Mongolia. Many of these Chinese art objects of Tibetan inspiration, known as "Sino-Tibetan" or "Tibeto-Chinese" art, were made during the Qianlong period (1736–95), when this type of art reached great heights.[1] During the reign of the Qianlong emperor, the Bogdo Gegen of

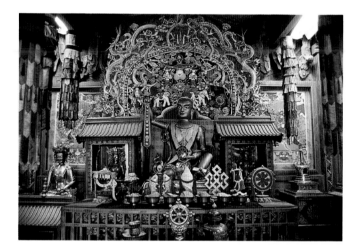

Fig. 1. *Mahasiddha* in Yadam Temple, Choijin-Lama Temple Museum, Ulaanbaatar. Photo: Hal Fischer.

Mongolia came once a year to China bringing the "Nine Whites" as tribute. In return for the eight white horses and one white camel, the Bogdo Gegen was given the specified gifts of a silver cylindrical tea vessel weighing thirty *liang* (40 oz.), two silver teapots, and ninety-nine bolts of various types of silk, brocade, and other cloth.[2] This was merely the official gift exchange. The Bogdo Gegen was presented with other personal gifts, such as the sutra covers (cat. nos. 47–49) and the hand drum (cat. no. 23) in this exhibition. The Bogdo Gegens in their turn gave other tribute gifts to the Qianlong emperors. Buddhist statues were among the tribute gifts when Zanabazar, the First Bogdo Gegen of Urga, sent his envoy to the Qing court in 1655.[3]

Mongolian artists, like their Tibetan counterparts, followed the prescriptions of religious texts in order to create a sacred image. The sculptor or painter fashioning the image of a god had to comply with the iconography and proportions of that particular deity set down in the religious texts. Examples of Tibetan pantheons derived from texts abound.

The pantheon of the Mongolian Kanjur, completed at Do-lonnor in 1720, is one of these.[4] The *Three Hundred Icons* by the Third Jangjya Khutuktu, Rolpay Dorje (1717–1786), the State Preceptor of the Qing dynasty, was one of the popular texts often used by the artists of Mongolia.[5] Another Mongolian pantheon, containing five hundred icons, is based on the works of the Fourth Panchen Lama (1781–1852).[6]

SCULPTURES

Although a bronze seated Buddha from Mongolia may share iconography with examples made in Tibet or China, certain characteristics distinguish the images. The ornamentation, the shape of the lotus petals on the pedestal, and the way in which the base plate is inserted and held in place often give clues as to the country of origin. Even within Mongolia, there were variations between the works produced in Inner Mongolia and Outer Mongolia. The sculptures of Zanabazar illustrate these differences.

THE ZANABAZAR SCHOOL OF SCULPTURE OF OUTER MONGOLIA

In the late seventeenth and early eighteenth centuries, the sculptor par excellence among the Buddhist countries of Asia was the Bogdo Gegen Zanabazar (1635–1723), the First Jebtsundamba Khutuktu and the greatest sculptor of Mongolia.[7] His artistic talent was already apparent when he was a young boy, when his fondness for drawing and building houses was observed.[8] He went to Tibet at age fourteen, where he was ordained by the Panchen Lama and proclaimed by the Fifth Dalai Lama as the Jebtsundamba Khutuktu. At that time the Potala Palace was being reconstructed, and Zanabazar must have come into contact with the many artisans and craftsmen at work in Lhasa. Upon his return to Mongolia in 1651, he was accompanied by hundreds of Tibetan lamas and many artists and craftsmen, sent by the Fifth Dalai Lama to propagate the faith and to build monasteries.

Zanabazar's greatest contribution to Mongolian art was his gilt bronze sculpture. His works include the Vajradhara in Gandantegchinlin (see cat. no. 99, fig. 1), the Museum of Fine Art's Five Transcendent Buddhas (see cat. no. 97), the youthful White Tara (cat. no. 102), and the Green Tara in the Bogdo Khan Palace Museum modeled after a more mature woman (see Berger, "After Xanadu," fig. 5). The sculptures of Zanabazar portray youthful figures and are beautifully proportioned. Their faces are characterized by high foreheads, thin arching eyebrows, high-bridged noses, and small fleshy lips. The jewelry is exquisite, especially the long simple strands of beads that hang across the figures' torsos. His works have a peaceful, contemplative look and share many characteristics with Nepalese sculpture. Both Gilles Béguin and Patricia Berger have discussed the sources for his work.[9]

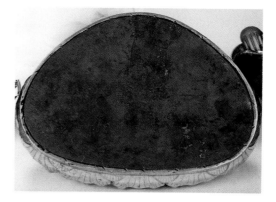

Fig. 2. An example of a Chinese-style Mongolian sculpture base with chisel marks.

The sculptures of the Zanabazar school were generally made in two pieces; the body and the pedestal were made separately and then soldered together. The smaller sculptures were made in one piece and sometimes a mold was used to produce multiple wax models (see cat. nos. 113–115). Most of the sculptures were gilded, and the mercury gilding is especially beautiful. Following Tibetan tradition, the faces were sometimes painted with cold gold (gold powder in a solution of yak-skin glue) and the eyes and lips colored with mineral pigments. Peaceful deities had their hair painted blue, while wrathful guardians were given heads of orange-red hair.

The lotus pedestals of the sculptures by Zanabazar and his school are distinctive. Instead of the oval and rectangular throne types common in Tibet, they show a preference for circular or drum-shaped pedestals (see cat. no. 107) and semi-oval pedestals with tall bases such as the ones for the four Taras (cat. nos. 103–106). The Zanabazar school of sculpture is also distinguished by the beautiful and varied lotus petals; such variations are not to be found on the sculptures of Tibet, Nepal, and China. There is much variety; the petals can be plain, single, double, wavy, scalloped, or they can have their tips bent forward. In the set of the Five Transcendent Buddhas, of which the Amitabha is included in this exhibition (cat. no. 97), the lotus petals are distinctly different on each pedestal. There is generally a border of pearl beading on top and occasionally below. Sometimes a wavy line is found on the bottom of the pedestal. Special emphasis was paid to the lotus stamens. They were carefully incised, either as vertical striations below the top row of pearl beading or in fan-shaped groupings between the lotus petals.

Images in Mongolia, following the Tibetan tradition, were consecrated after they were made. Sacred objects such as rolls of prayers and other relics were inserted inside the statue, and the base was sealed with a metal plate. The standard decoration for the base plate was an incised double *dorje,* although some base plates were left plain. Not every sculpture retains its base plate and relics, as many of them

have been lost or removed through the centuries. If a sculpture has its original base plate in place, it is sometimes possible to determine the work's provenance from the way in which the plate is secured and the style in which the double *dorje* is depicted. In most Sino-Tibetan sculptures, that is, bronze images made in Beijing and Inner Mongolia, the base plate is held in place by small points, made by chiseling along the edge of the base toward the base plate (fig. 2).

On the sculptures made by Zanabazar and his school the base plates were inserted in a different way. In general, they were carefully made to fit snugly over the cavities, not held in position by chisel points on the base, as is the case in Chinese and Inner Mongolian sculptures. (However, there are always exceptions; the standing Maitreya in this exhibition [cat. no. 100] has chiseled marks on its base.)

Previous authors have discussed variations among the double *dorje* in Chinese, Nepalese, and Mongolian art. Regarding the center circle over the crossed *dorje,* Dr. P. H. Pott observed that in Nepalese bronzes there are circles within the circle, while Chinese examples contain the *yin-yang* symbol, the motif of two dotted interlocking commas.[10] A. Neven made a further study of these designs and con-

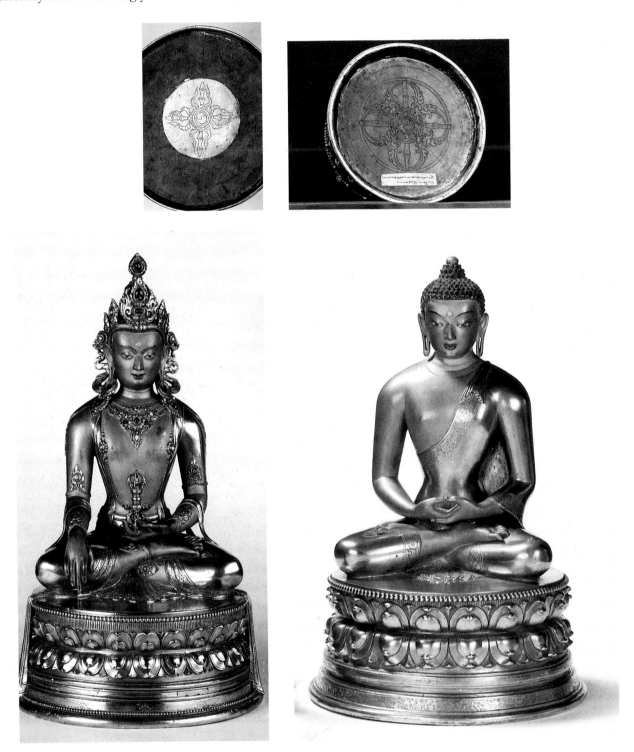

Fig. 3. Sculptures and bases by Zanabazar and his school. Left: Akshobhya (cat. no. 98); right: Medicine Buddha (cat. no. 107).

firmed that the *yinyang* symbol definitely denotes an image of Chinese origin.[11] In some instances, pectoral fins in the form of two brackets were added to the *yinyang* symbol, transforming it into twin fish, and sometimes scales were incised on the fish. Neven noticed that this motif appears on pieces originating from Kham (Eastern Tibet/Western China), China, and Mongolia, and that the images with this particular motif can be dated to the seventeenth century at the earliest.

The extant bases of sculptures attributed to Zanabazar and his school are unique. The double *dorje* on the base plate, if present, is especially well done and is sometimes gilded. As for the circle in the center over the crossed *dorje,* some are plain while others have the three whirling segments, a design symbolizing ceaseless change and the blissful mind radiating compassion.[12] (This design also appears on the base plate of Yongle bronzes of the Ming dynasty in China, but it is not gilded.) The gilding of the double *dorje* is a special characteristic of the works of Zanabazar and his school (fig. 3) and has not been seen elsewhere.

The Arthur M. Sackler Museum of Harvard University has a beautiful late-seventeenth-century image of a standing Maitreya (fig. 4).[13] Its utter simplicity, serenity, and exquisite workmanship stamp it as a work by either Zanabazar or his school. A circular base plate was soldered onto the rectangular pedestal, and on it was incised a double *dorje* with the characteristic gilding peculiar to the Zanabazar school of sculpture.

A recent gift to the Asian Art Museum, a Shakyamuni Buddha with a gilt double-*dorje* base plate (fig. 5), is similar in style to the Medicine Buddhas in the exhibition (cat. no. 107). The base plate is intact, but the center portion is obscured by a small metal plaque inscribed: *J. Johnson, Quarter Master, 99th Reg., China Campaign, 1860.* Quartermaster Johnson was a member of the Allied forces that occupied Beijing and destroyed the Summer Palace (Yuanming Yuan); this Mongolian sculpture was most probably looted from there. It could easily have been one of the gifts from the various Bogdo Gegens to the emperors of the Qing dynasty stored in the Summer Palace.

In the Chang Foundation of Taipei is a large Kubera whose style and workmanship are typical of the work of Zanabazar and his school (fig. 6). Kubera, the dispenser of wealth, sits with both legs pendant on a large lion. The attribute in his raised right hand, which would have been a club or banner, is lost. His left hand rests gently on his small rodentlike mongoose, which is spilling jewels from its mouth. A pyramid of jewels is piled neatly on a small table below Kubera's feet. Kubera is sumptuously coiffed and bejeweled. His crown is similar to Amitayus's (cat. no. 108); his hair, like that of the Taras (cat. nos. 103–106), is parted into three sections that flow down his back. The head of Kubera's lion resembles that of a camel. Since Mongols were not familiar

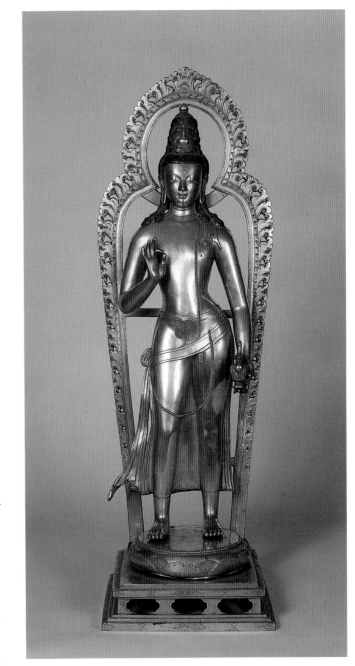

Fig. 4. Zanabazar, late 17th century. Maitreya Bodhisattva and base. Gilt bronze with traces of pigment, H: 24⅝ (62.4) W: 8½ (21.5) D: 7⅝ (19.4). Courtesy of the Arthur M. Sackler Museum, Harvard University Art Museums, Gift of John West.

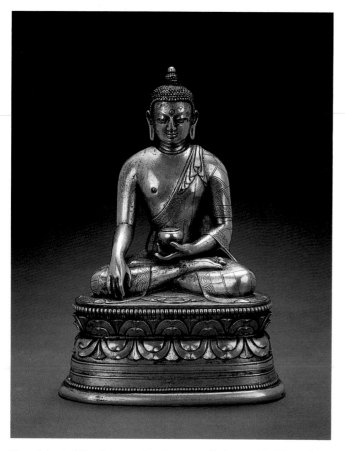

Fig. 5. School of Zanabazar, early 18th century. Shakyamuni Buddha and base. Gilt bronze, H: 9¾ (28.0). Asian Art Museum of San Francisco, Gift of Mr. and Mrs. Johnson S. Bogart, 1994.131.

with animals such as the lion and the mongoose, their representations of them are somewhat fanciful.

Kubera's lotus throne is oval. The three rows of lotus petals are flat and serrated, and each petal is incised with three lines. The stamens are prominent below the row of beading. All these features are characteristic of Zanabazar and his school.

Sculptures made by Zanabazar and his school are rare even in Mongolia and are considered national treasures. Besides the three examples in the United States and the one in Taiwan, two excellent examples, a Manjushri and a Vajradhara with consort, are in the Ferenc Hopp Museum of Eastern Asiatic Arts in Budapest.[14] There are some in Buriatia, but they have not been published.

Some sculptures of Outer Mongolia are amalgams of pieces gathered from various places and combined to form a single sculpture. The base, halo, and even attributes that appear together may not have been intended to do so. It is difficult to say whether this is a Mongolian custom, or one caused by necessity. This is certainly true in Chinese art, as in porcelains and lacquers from the Ming dynasty. The Qianlong emperor of China was known to have remounted Tibetan thangkas in the Chinese style. Years of warfare in the Urga area, natural disasters such as fire, and the massive devastation of temples during the 1930s have destroyed many of the art objects in Mongolia. When the museums and temples were established again in recent years, the curators and monks may have combined certain objects out of necessity. In this exhibition, the halo and throne of the large Vajrasattva (cat. no. 99) are not original, but the halo is probably contemporaneous.

The large Buddha in the group of Medicine Buddhas is different in style from the rest of the group (cat. no. 107). The Buddha Shakyamuni in the Asian Art Museum of San Francisco is an example of two different elements being combined to form a masterpiece (fig. 7). The seated Buddha is the work of the school of Zanabazar and so are the pedestal and halo, a beautiful creation with Garuda standing triumphantly over the *naga,* whose tails link organically with the curling tendrils of the *makara.* However, a difference in the color of gilding and the original height of the halo indicates that the two pieces do not belong together. But in typical Asian fashion (the piece had a Tibetan provenance), the two pieces have been joined.

THE DOLONNOR OR INNER MONGOLIAN STYLE

The bronze images of Zanabazar and his school are the best among the sculptures of Outer Mongolia. When discussing Mongolian sculpture, László Ferenczy remarked that it was unfortunate that most of the works known from Mongolian temples were not made in situ but in China or Tibet.[15] Actually, some of the so-called Chinese sculptures were

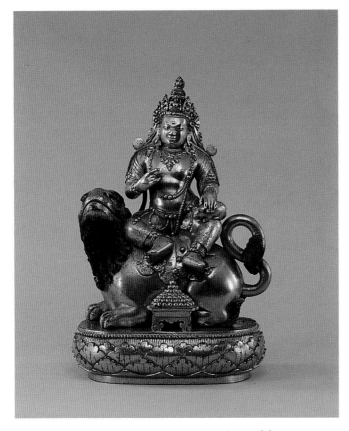

Fig. 6. School of Zanabazar, early 18th century. Kubera. Gilt bronze, H: 11⅞ (30.2). Courtesy of the Chang Foundation, Taipei.

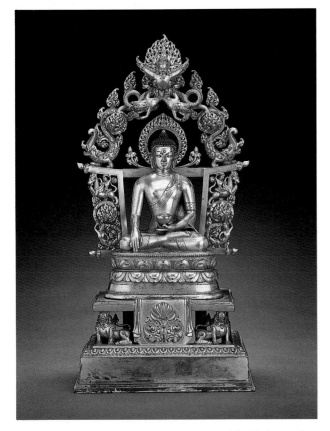

Fig. 7. School of Zanabazar, early 18th century. Buddha Shakyamuni enthroned. Gilt bronze, H: 27¾ (70.5). Gift of the Asian Art Museum of San Francisco General Acquisitions Fund and an anonymous friend of the Asian Art Museum. Photo: Kazuhiro Tsuruta.

made in Inner Mongolia, or by Dolonnor craftsmen residing in Urga.

Dolonnor (C: Duolun), about two hundred miles northwest of Beijing, is located near the ox-bow section of the Luan River in the old province of Chahar, now the southeastern section of Inner Mongolia (see map showing temples of Mongolia and Tibet, front endpapers). This part of Inner Mongolia is one of the largest producers of iron and coal in China, and Dolonnor, at least through the first quarter of the twentieth century, was famous for its manufacture of Buddhist images in bronze.[16]

In 1844, when the missionary Abbé Huc was in Dolonnor, he saw a caravan of eighty camels leaving with the various parts of a single Buddha image intended as a present for the Dalai Lama.[17] A. M. Pozdneyev, who traveled to Mongolia in 1892, mentioned Dolonnor several times in connection with statues. In his description of the crafts and industrial establishments of Urga, he noted that the majority of braziers and *burkhan* (Buddha-image) makers came from Dolonnor.[18] When the temple of Dachin-kalbain süme of Urga was being rebuilt in 1892, six thousand *liang* of silver were appropriated for the purchase of *burkhan* from Beijing and Dolonnor.[19] The main image of the Maidari Temple (built around 1820 to 1836) in Urga was also made in Dolonnor. The Maitreya image was made in seven separate parts by a Chinese craftsman of Dolonnor and was shipped from there to Urga.[20] From the descriptions of Huc and Pozdneyev, we know that Dolonnor images were made in pieces and then riveted together, that the craftsmen were capable of producing images of immense size, and that many of the artisans worked in Urga.

Dolonnor was also important historically; this area, once full of rich pastures, is located next to the site of Shangdu (Xanadu), the summer capital of Khubilai Khan. It was in Dolonnor, in 1691, that Zanabazar, accompanied by the princes of the Khalkha, met with the Kangxi emperor of China and recognized his suzerainty. As a result, many important monasteries were built there with imperial patronage, and Dolonnor became "the single most important center of Mongolian Buddhism in southern Mongolia."[21]

One of the Chinese names for Dolonnor is Lama miao, or "Lama Temple," named after the many monasteries located there. The two most famous monasteries are Koke süme and Shira süme. Koke Monastery (C: Huizong si) was built by the Kangxi emperor in 1711, and it was staffed by monks from the 120 Banners of Mongolia. In 1731 the smaller Shira Monastery (C: Shanyin si) was established by the Yongzheng emperor for the Jangjya Khutuktu Ngawang Losang Chöden. The same Jangjya Khutuktu supervised the editing and blockprinting of the Mongolian Kanjur in Dolonnor from 1717 to 1720, under imperial orders of the Kangxi emperor.

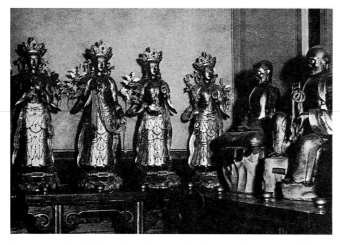

Fig. 8. Back chapel, Shira süme (Shanyin si), Dolonnor. From Henmi, *Man-Mō ramakyō bijutsu zuhan* (Illustrated Lamaist Art of Manchuria and Mongolia), pl. II.94.

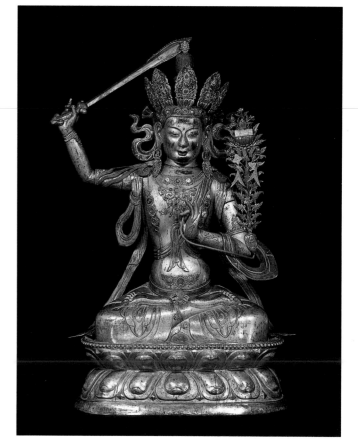

Fig. 9. Manjushri. Epi Khalkha süme, Chahar, Inner Mongolia, ca. 1700. Gilt copper alloy, with lacquer and pigments, inset with gems, H: 71 (180.3). Courtesy of Folkens Museum Etnografiska, Stockholm. Photo: Copyright John B. Taylor.

In the early twentieth century, the Japanese scholar and photographer Henmi Baiei visited Dolonnor and took pictures of both monasteries. The bronze images he photographed in Shira süme (Shanyin si) (fig. 8) are adorned with the characteristic large, flat, five-leafed crowns and have scarves billowing behind their ears and outside their elbows.[22]

In the 1930s, while traveling in the Chahar region of Inner Mongolia, the Swedish explorer Sven Hedin found six monumental brass statues in an abandoned temple. This temple, named Epi Khalkha süme, was near Dolonnor.[23] It is likely that the sculptures were manufactured in Dolonnor, the main center for images. Hedin purchased these statues, which include a Tsongkhapa, a standing Vajrapani, a Manjushri (fig. 9), and a Shadakshari Avalokiteshvara, and took them back to Sweden. The heads, bodies, limbs, and pedestals of these full-bodied sculptures were made separately of beaten copper alloy and fitted together. Decorative elements such as the attributes, earrings, five-leaf crowns, and the billowing scarves were also made separately and further inlaid with turquoise, coral, and lapis lazuli. The ear pendants and the decorative leaves in the crown are flat, and the curvilinear scroll patterns are distinctly Mongolian. They are identical in style to the images photographed in the Dolonnor temples. In discussing the Vajrapani, Marylin Rhie stated that "this image, and the others from this set, can be taken as indicative of the Mongolian school around 1700."[24] The present writer agrees and would like to bring this a step further by calling this particular school of sculpture the Dolonnor, or Inner Mongolian, style.

In this exhibition the silver Amitayus (cat. no. 67), Lhamo (cat. no. 83), and Begtse (cat. no. 84) are different in appearance and manufacture from the sculptures of the school of Zanabazar. The last two are part of a set of Eight *Dharmapala* made for the Choijin-Lama Temple in Ulaanbaatar, erected in 1903–6 in honor of Lubsankhaidav, the

brother of the Eighth Bogdo Gegen. Instead of being cast in two pieces like many of the Zanabazar sculptures, they were hammered in the repoussé manner; the head, body, limbs, scarves, attributes, halo, and pedestal were all made separately and fastened together with rivets, dovetail joints, and clasps. The ornaments in their crowns and earrings are similar to pieces made in Inner Mongolia, such as the Stockholm Manjushri. There is no doubt that these pieces were made in the Dolonnor style, possibly by Dolonnor craftsmen residing in Urga.

In discussing the Stockholm piece, Rhie also mentioned that while the style is Tibetan in tradition, the "elements forecast developments seen in Chinese Buddhist art of the Qianlong period,"[25] a correct observation of Inner Mongolian influence on Sino-Tibetan art.

THE INFLUENCE OF MONGOLIAN ART ON SINO-TIBETAN ART

Rolpay Dorje, the Third Jangjya Khutuktu, and thus the highest incarnate-lama of Inner Mongolia, was the State Preceptor of China during the Qianlong period. During this time, many Sino-Tibetan art objects were produced. Rolpay Dorje was responsible for designing the major temples, among

them Yonghegong and the temples in Jehol (Chengde). An artist himself,[26] a specialist in Buddhist iconography, and responsible for compiling at least three pantheons, he no doubt masterminded and supervised the decoration and furnishing of these temples. The number of images needed, together with the thousands of sculptures cast for the emperor's mother's three birthdays (she was a fervent Buddhist) must have been considerable.[27] While some of these commissioned pieces were done directly in the imperial workshop (Zuobanchu) in Beijing, it is probable that others were manufactured elsewhere. Dolonnor, being an area famous for its bronze casting, as well as the home base of the Jangjya Khutuktu, could logically be the source for many of the commissioned pieces.

Many of the extant sculptures from the Qianlong period, whether of wood or metal, are similar in style to these Dolonnor pieces. A seated Amitayus belonging to the Asian Art Museum and bearing the Qianlong reign mark, the five-leaf crown, the flat earrings with Mongolian scrollwork, and the scarf (fig. 10) is very close in style to the Stockholm Manjushri. The method of construction is also identical, with the various components made separately in beaten and repoussé copper alloy. In looking at this piece, one must conclude that it was made either in Dolonnor or by a sculptor from Dolonnor. The lamas of Yonghegong were Mongolian, and some of them could have come from the Jangjya Khutuktu's temple in Dolonnor. Some of these lamas must have been trained artists, and they in turn taught the artists in the imperial workshops.[28] The artists of the imperial workshops were a mixed bunch; besides Chinese from the various provinces, there were Jesuit missionaries from Europe and their Chinese students, Nepalese, and at least two jade carvers were Tibetan.

PAINTING

The Buddhist paintings of Mongolia are directly related to the painting tradition of central Tibet. They are executed on cotton stretched on a frame. The cloth is first sized with a solution of chalk, glue, and *arki* (milk vodka), then polished with a smooth stone when dry.[29] The image is then drawn in charcoal according to the proportions in the *shastra,* or sometimes the artist may use a pounce. The pigments consist of mineral and vegetable colors mixed with yak-skin glue. The finished piece is framed with silk brocades from China, and a thin stick and a wooden roller are inserted at top and bottom for hanging.

Mongolian paintings, following Tibetan traditions, can be painted on white, red, or black backgrounds. While the majority of paintings are executed on a white background, there are special images painted on a red ground *(marthang),* such as the Shakyamuni in this exhibition (cat. no. 64). Paint-

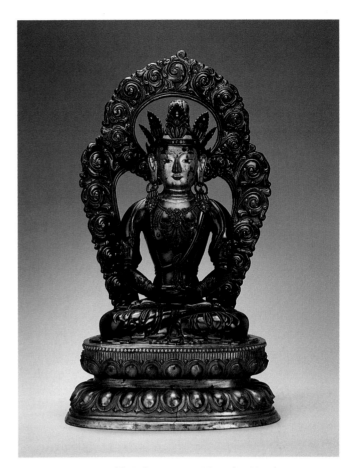

Fig. 10. Amitayus. Possibly Dolonnor, Inner Mongolia, Qing dynasty, Qianlong mark and period (1736–95). Copper alloy, partially gilt, inset with gems, H: 32¾ (83.8). Asian Art Museum of San Francisco, B60 S534, The Avery Brundage Collection. Photo: Kazuhiro Tsuruta.

ings on a black ground, termed *nakthang,* often depict wrathful deities and are kept in the *gönkhang,* the special room in the temple reserved for guardian deities.

Like Tibetan thangkas, Mongolian paintings are noted for their fluid lines, contrasting colors, and intricate designs in gold. Characteristic Mongolian elements can be detected, such as the lotus pedestal in the thangka of Ganesha (cat. no. 75), whose petals are similar in style to those peculiar to the Zanabazar school of sculpture. His flaming halo with pearls is again Mongolian, showing a close affinity with works in the Tibeto-Mongolian pantheon.[30] The presence of the five principal animals (camel, horse, yak, sheep, and goat), soft peaks, and colorful clouds in the shape of Chinese *ruyi* fungus are all characteristic of Mongolian paintings. Another feature peculiar to Mongolian paintings is the use of dotted brushstrokes on low-lying hills, such as those in the background of the thangkas of Ganesha and the Twenty-five Kings of Shambhala (cat. no. 46), giving them a mosslike appearance.

APPLIQUÉS

The appliqués *(zeegt naamal)* of Mongolia are like giant thangkas or paintings. The embroidery needle and thread

take the place of brush and ink, while pieces of silk and brocade are transformed into areas of color. Where one finds gold highlights in Buddhist paintings, in appliqués one finds gold threads, carefully couched along the edges, and golden brocades are cut into jewelry shapes.

Appliqué thangkas came into Mongolia together with Vajrayana Buddhism. Mongolians were familiar with this technique, for the excavated felt carpet of the Huns from the Noyon Uul burials already showed a combination of embroidery and appliqué.[31] The Urga area is especially renowned for the appliqués decorating its temples and palaces, which were done by men and women under the supervision of famous artists in the late nineteenth and early twentieth century. Apart from Tibet, appliqués are also made in China and the Himalayan kingdom of Bhutan. In Bhutan, only men produce this type of art.

Appliqués are called "silk paintings" in Mongolia because silk is the main material for creating this art form. Silk has been imported from China since ancient times. Every year, bolts of silk and brocades were given by the Chinese emperors to the high lamas and princes of Mongolia, as return gifts for their tributes or as personal gifts. Besides being made into garments, silk was used for accessories such as belts, hats, and purses. In the monasteries, silk was utilized in many ways: to clothe lamas and deities alike; for cushions and throne backs; for canopies; and for framing thangkas. Any scraps left over were fashioned into elaborate temple hangings (fig. 11), tassels for drums and other ritual objects, and, of course, made into appliqués.

The appliqué of Dorje Dordan (cat. no. 86) is one of the best in Mongolia. It is pieced together with many interesting types of silk and brocade, including scraps of dragon-robe material. The appliqué of Begtse is further ornamented with tiny coral beads (cat. no. 85). The addition of gems such as coral, pearls, and turquoise in appliqué is a purely Mongolian practice, and not found elsewhere.

BOOK DECORATION

The majority of book covers in this exhibition belonged to the Bogdo Gegens of Mongolia. These extraordinary works of art are not all Mongolian in origin; at least three of them were gifts from the Manchu emperors of China. The Mongols realized early that books were essential to the dissemination of Buddhism. Although Tibetan was the liturgical language of Mongolia, rulers, both Mongol and Chinese, made sure that the Kanjur and Tanjur were translated into Mongolian and published. Sutra-printing took place in many monasteries of Mongolia, on paper purchased from China and Tibet (see Bartholomew, "Book Covers," fig. 1). When Zanabazar visited Lhasa, he returned to Khalkha with the *Jad-damba*, written in gold on leaves of sandalwood.[32] Again

in 1683, he commissioned yet another Kanjur from Tibet, as he was concerned with the religious education of the Khalkhas.[33] In 1804 the Fourth Bogdo Gegen acquired from Lhasa a Kanjur, written in gold on black paper.[34] When the last Bogdo Gegen passed away, these books and others were transferred from his palace library to the National Library.

The same technique used in painting is applied to book decoration. Mongolian sacred texts are outstanding for their lavish ornamentations. The text of the *Sanduin jüd* is embossed on sheets of silver and gilded (cat. no. 62). In another example, the "nine jewels" (gold, silver, coral, pearls, lapis lazuli, turquoise, steel, copper, and mother-of-pearl) were ground up for use as pigments, and the sutra was written in the nine colors on black paper in a fine calligraphic hand (cat. no. 59).

Wood is scarce in Mongolia, especially the type of hardwood used by Tibetans for carving book covers. There are some hardwood covers in the Bogdo Gegens' collection, but in general Mongol scribes illustrated the title page on paper and then framed it with softwood, which was then embellished with Chinese brocades. The back covers of Mongolian sacred texts, following Chinese tradition, often depict the Guardians of the Four Quarters.

MINOR ARTS

The Mongols are an artistic race and have a tendency to decorate every item on their body, inside their *ger,* and on the trappings of their animals. This is demonstrated not only by their highly developed handicrafts but also by many folk sayings in which knowledge is demanded from men and manual dexterity from women.[35]

The Mongolian national costume is a robelike garment called a *del,* which, like the Tibetan robe, has no pockets. The *del* is worn with a thin silk sash several yards long wound tightly around the waist. Attached to the sash are essential objects such as the eating set, tinder pouch, snuff bottle, and tobacco and pipe pouches. Mongolians, like the nomadic Tibetans and Manchus, use an ingeniously designed eating set incorporating a sharp knife and a pair of chopsticks, and sometimes including a toothpick, ear pick, and a tweezer. Some of the fancier containers, such as the sheath belonging to the wife of the Bogdo Khan (cat. no. 29), are made of precious metals and embellished with semiprecious stones.

The tinder pouch or flint and steel set consists of a small leather pouch with a strip of steel attached to its lower edge. Depending on one's station in life, the tinder pouch can be a utilitarian piece, or it can be a work of art such as the example belonging to a giant in catalogue number 6.

Decorations on these accessories often show a combination of Tibetan, Mongolian, and Chinese motifs. The two major types of pattern in Mongolian decorative art are the

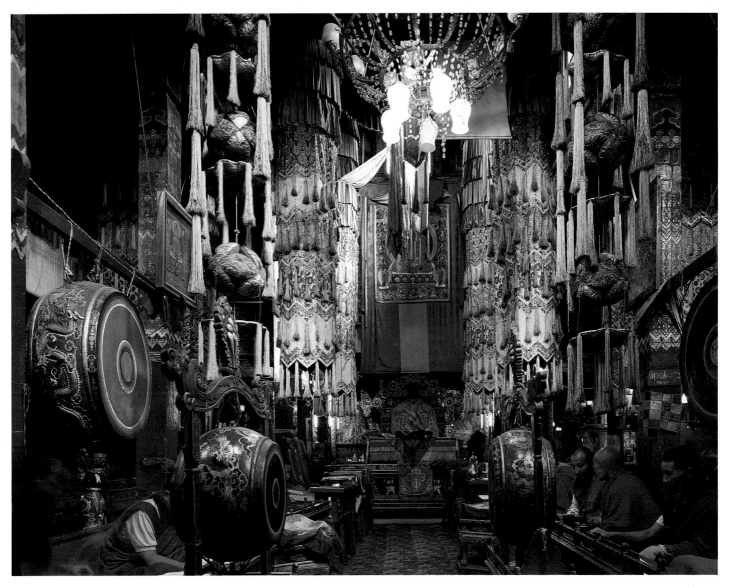

Fig. 11. Interior of Gandantegchinlin Monastery, Ulaanbaatar, showing the rich array of silk and brocade.
Photo: Kazuhiro Tsuruta.

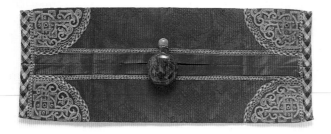

Fig. 12. Agate snuff bottle and pouch, 19th century. Agate, silk damask with braid and ribbon, Bottle H: 3¼ (8.2); Pouch L: 21⅞ (55.0) W: 8¼ (21.0). Bogdo Khan Palace Museum, Ulaanbaatar.

Fig. 13. Diagram of Mongolian pulling stitch. Terese Tse Bartholomew.

khee (ornament), "which creates the rhythm" and the *ugalz* (volutes, scrolls), "which emphasizes the form."[36] Together, they create balance. There are five types of Mongolian motifs: geometric, zoomorphic, botanical, naturalistic, and symbolic. Geometric designs include *alkhan khee,* or meander; *tümennasan,* or eternity pattern; *ölzii utas,* or "happiness" knot; *khan buguivch,* or khan's bracelet; *khatan süikh,* or queen's earrings; *zooson khee,* or coin; and *tuuzan khee,* or ribbon. Zoomorphic designs consist of hornlike and noselike (C: *ruyi*) scrolls; the four friendly animals (elephant, monkey, hare, and dove; cat. no. 25), the four strong animals (lion, tiger, dragon, and the mythical bird Garuda); the twelve Asian zodiac animals (rat, ox, tiger, hare, dragon, snake, horse, ram, monkey, rooster, dog, and boar); and the circle made up of two fish (C: *yinyang*). Botanical motifs are represented by the lotus (purity), peony (prosperity), and peaches (longevity). Water, flames, and clouds are shapes from natural phenomena, while symbols refer to the Soyombo (see Bosson, "Scripts and Literacy," fig. 7a), the Eight Auspicious Symbols, the Seven Jewels of the Monarch, and the Three Jewels. Many of these designs are of Tibetan and Chinese origin, but they merged with the basic Mongolian motifs into a rich decorative repertoire.

Many of these decorative motifs can be found on embroidered cases for snuff bottles, which are also attached to the Mongolian's belt. The habit of taking snuff probably came to Mongolia from China in the eighteenth century and by the mid-nineteenth century it was widespread. It was customary for the emperors to give fancy snuff bottles as gifts to their courtiers and foreign guests, especially the high lamas of Mongolia and Tibet. It was, and still is, the custom to exchange snuff bottles when Mongols meet each other, and to offer the bottle again at the conclusion of business. While many snuff bottles were imported, Mongolia, with its rich deposits of agate and other semiprecious stones, also produced its own.

During the Qing dynasty, snuff bottles were carried in kidney-shaped brocade bags with a gathered top.[37] Snuffbottle bags made by Mongols are larger than the Chinese ones. Made of padded brocade, the Mongolian version is rectangular, with a slit opening down the middle. The bag is worn doubled over one's belt, thus keeping the bottle secured and protected even while on horseback. The example in figure 12 belonged to the last Bogdo Gegen, the last ruler of Mongolia. It is of red damask, decorated with fancy braids and piping, and embroidered with a typical Mongolian *ugalz* design. Variations of this motif are seen on leather boots, stockings, and clothing.

The embroidery consists of a special type of pulling stitch, also known as the silk-locking stitch, in which two separate threaded needles are used simultaneously (fig. 13).[38] As explained by Wang Yarong, the first thread is passed through the cloth from the back, and the second thread emerges slightly above the first needle. The first thread is then looped counterclockwise around the second needle, and the second needle makes a backstitch to hold the loop in place. The second needle emerges forward, and the first thread makes another loop to be held down by the backstitch of the second needle. The first thread does not show on the back of the material, because it only coils on the surface of the cloth. The second thread serves only to fasten the loops made by the thread of the first needle. The embroidery is done in rows next to each other, in graduating colors. This type of embroidery is also seen on the tassel of the hand drum in catalogue number 23. Abbé Huc was especially impressed with what the Mongol women could do with the needle:

> It is difficult to understand how, with tools so coarse, they can produce articles [clothes, hats, and boots] that are almost indestructible, though it is true that they take plenty of time to do their work. They excel also in embroidery, and exhibit in this a skill, taste, and variety that is really admirable. It is very doubtful whether it would be possible to find, even in France, embroideries as beautiful and perfect as those sometimes executed by Tartar women.[39]

Generally speaking, Mongolian religious art closely followed the iconography and techniques of Tibet. But in every form of Mongolian art, there are minor details that betray its provenance. The green textured strokes on the rolling hills found in paintings are a Mongolian characteristic, as is the inclusion of pearls and semiprecious stones in appliqués. When a group of animals is shown in an appliqué or a painting, the Mongolian artists and craftsmen would include the "five snouts."

Although Mongolian sculptures follow the proportion and iconography of Tibet, Mongolia has its own schools of sculpture. The school of Zanabazar is distinguished by its exquisitely cast sculptures sitting on thrones with a wide variety of lotus petals. The artisans of Dolonnor, Inner Mongolia, manufactured large images out of pieces of hammered copper, and their headdresses and earrings have a distinctive style.

Chinese influence is discerned in the decorative motifs found in jewelry and utensils such as snuff bottles, eating sets, and tinder pouches. The decorative repertoire of Mongolia is thus made up of Mongolian volutes and scrollwork, auspicious motifs from Tibetan Buddhism, and Chinese motifs such as *shou* (longevity) characters, dragons, coins, peaches, and bats.

NOTES

1. Terese Tse Bartholomew, "Sino-Tibetan Art of the Qianlong Period from the Asian Art Museum of San Francisco," *Orientations* 22, no. 6 (June 1991), 34–45.

2. Zhang Yuxin, *Qing zhengfu yu lama jiao* (The Qing Government and Lamaism) (Beijing: Xizang renmin Press, 1988), p. 112.

3. Zhang Yuxin, *Qingdai sida huofo* (The Four Living Buddhas of the Qing Dynasty) (Beijing: Zhongguo renmin da xue Press, 1989), p. 37.

4. Lokesh Chandra, *Buddhist Iconography* (New Delhi: International Academy of Indian Culture and Aditya Prakashan, 1991).

5. Blanche Christine Olschak and Geshé Thupten Wangyal, *Mystic Art of Ancient Tibet* (London: George Allen and Unwin, 1973), pp. 113–85.

6. Lokesh Chandra, *Cultural Horizons of India* (New Delhi: International Academy of Indian Culture and Aditya Prakashan, 1993), vol. 3, p. 438.

7. See Berger, "After Xanadu," and "Zanabazar."

8. N. Tsultem, *The Eminent Mongolian Sculptor—G. Zanabazar* (Ulaanbaatar: State Publishing House, 1982), p. 7.

9. Béguin, "Les sources de Zanabazar," in Gilles Béguin et al., *Trésors de Mongolie, XVIIe–XIXe siècles* (Paris: Editions de la Réunion des musées nationaux, 1993), p. 64–81; see also Berger, "After Xanadu."

10. P. H. Pott, *Introduction to the Tibetan Collection of the National Museum of Ethnology, Leiden* (Leiden, 1951), p. 38.

11. *Lamaistic Art* (Brussels: Société Générale de Banque de Bruxelles, 1975), p. 18.

12. Valrae Reynolds et al., *Catalogue of the Newark Museum Tibetan Collection* (Newark, N.J.: The Newark Museum), vol. 1, p. 74.

13. Marylin Rhie and Robert A. F. Thurman, *Wisdom and Compassion: The Sacred Art of Tibet* (San Francisco: Asian Art Museum of San Francisco; New York: Tibet House and Harry N. Abrams, 1991), cat. no. 32.

14. László Ferenczy, "Ādi-Buddha Vajradhara," *Orientations* 21, no. 2 (February 1990), 43–45.

15. Ibid., p. 43.

16. Chen Do and Shi Zhonghua, eds., *Xinbian Zhongguo dili* (New Chinese Atlas) (N.p., n.d.), p. 52.

17. Abbé E. R. Huc, *Recollections of a Journey through Tartary, Thibet, and China during the Years 1844, 1845, and 1846* (New York: D. Appleton and Co., 1852), vol. 1, p. 37.

18. Aleksei M. Pozdneyev, *Mongolia and the Mongols*, trans. John Roger Shaw and Dale Plank, Uralic and Altaic Series, vol. 61 (Bloomington: Indiana University Publications, 1971), p. 69.

19. Ibid., p. 58.

20. Ibid., p. 61.

21. Paul Hyer and Sechin Jagchid, *A Mongolian Living Buddha: Biography of the Kanjurwa Khutughtu* (Albany: State University of New York Press, 1983), p. 55.

22. Henmi Baiei, *Man-Mō ramakyō bijutsu zuhan* (Illustrated Lamaist Art of Manchuria and Mongolia) (Taipei: Hsin wen-feng, 1979), pls. II.94, 96, and 104.

23. Håkan Wahlquist, personal correspondence.

24. Rhie and Thurman, *Wisdom and Compassion*, p. 68.

25. Ibid., p. 145.

26. Tuguan Luosang Queji Nima, Chen Qingying, and Ma Lianlong, *Zhangjia guoshi Ruobi Duoji chuan* (Beijing: Minzu Press, 1988), p. 197.

27. See Bartholomew, "Sino-Tibetan Art of the Qianlong Period."

28. Luo Wenhua, personal correspondence.

29. N. Tsultem, *Development of the Mongolian National Style Painting "Mongol Zurag" in Brief* (Ulaanbaatar: State Publishing House, 1986), p. 13.

30. Chandra, *Buddhist Iconography*, vol. 1, pp. 75–202.

31. Tsultem, *Mongol Zurag*, fig. 3 [p. 1].

32. Pozdneyev, *Mongolia and the Mongols*, p. 327.

33. Ibid., p. 331.

34. Ibid., p. 356.

35. Academy of Sciences, People's Republic of Mongolia, *Information Mongolia* (Oxford and New York: Pergamon Press, 1990), p. 348.

36. Ibid.

37. N. Tsultem, *Mongolian Arts and Crafts* (Ulaanbaatar: State Publishing House, 1987), pl. 69.

38. Wang Yarong, *Chinese Folk Embroidery* (London: Thames and Hudson, 1987), p. 139.

39. Huc, *Recollections of a Journey through Tartary, Thibet, and China*, vol. 1, pp. 62–63.

Scripts and Literacy in the Mongol World

JAMES BOSSON

Throughout their known history, the Mongols have been a mobile people who have been in touch with a multitude of cultures and religions. They have formed, and formed part of, diverse confederations that grew large, powerful, and complex. Several of the cultures they came to know had a knowledge of the written word using either scripts of their own invention or scripts they had borrowed. The Mongols, like so many other cultures, developed a written language using a borrowed script to meet the demands of administration and religion.

The earliest appearance that we know of Mongolian in writing may have been in the fifth and sixth centuries in the northwestern part of China. Or should I say, rather, that we do *not* know about, because no examples of this script are extant. The Tuoba state, also known as the Tuoba Wei, became firmly established as a military and political power in northwestern China.[1] Their nucleus was a typical nomadic confederation made up mainly of Turkic and Mongol clans, as witness the names and titles preserved in Chinese sources.[2] Hidden behind the Chinese transcription *Tuoba* is the Altaic name of the confederation: *Tavghach*. This name figures in some of the earliest Turkic written sources and gradually became the name applied to the Chinese in Old Turkic.[3] Thus the distant and largely unknown ethnos received the name of an intervening, but related, people.

There are no extant examples of the Tuoba/Tavghach script, nor do we know anything about its structure and shape. Chinese sources relate that they had their own literature,[4] so the script was probably widely used.

Although the Tavghach script as an example of the earliest mode of writing Mongolian must be designated as conjecture, the next instance of a script used to write Mongolian is on more certain ground.

In the tenth century another group of nomadic warriors came from the northwest and conquered large parts of

North China, where they established the Liao dynasty (907–1125). The dynastic name is, of course, a Chinese name that they adopted to legitimize themselves in the Chinese world order. The real name of the confederation behind the dynasty was *Khitan* (also *Kitai*).

Already in the year 920 the Khitan started devising a new script to be used for their language. First the so-called large script, consisting of several thousand characters, was invented, and five years later the small script, consisting of several hundred characters, was devised. The "large" and "small" designation obviously had nothing to do with the size of the characters, but rather with the number of graphemes involved. The large script was probably more ideographic in principle, and the small script probably introduced more phonetic features.

This script was inspired by the Chinese writing system. It is written in "characters" built up with a sequence of strokes, and some of the graphemes bear a resemblance to specific Chinese characters.[5] A number of texts and lapidary inscriptions in the Khitan language have been preserved, but despite much study and many attempts, no major decipherment of this script has been possible as yet. What has been possible, however, is to reconstruct a series of Khitan words that have been preserved in Chinese transcription, and these reconstructions establish the language of the Khitans as a Mongol language that shows phonetic similarities with Dagur, an East Mongolian language.[6]

Although it has been reported that there was a respectable Khitan literature, little has been preserved, and although the script was still used to some extent among the Kara Khitai, who established themselves in East Turkestan, and even survived until the Jin dynasty, it was soon moribund, due probably to its complexity (fig. 1).[7]

It is with the rise of Chinggis Khan and the Mongol confederation—soon to be empire—that we see the devel-

opment of an unequivocally Mongol script and literature. There are no indications that the Khitan script was ever used to write what we can now with justification call the Mongol language—this despite the fact that a direct descendant of the founder of the Liao dynasty, Yelü Chucai (this being the Chinese transcription of his name; a plausible reconstruction of the Khitan name has not yet been proposed), in 1218 entered the service of Chinggis Khan and soon rose to become his main adviser on Chinese affairs. It is known that Yelü Chucai was literate in the Khitan script.[8]

In the official history of the Yuan dynasty it is recorded that in the year 1204 Chinggis Khan commanded a captured, literate Uighur of the Naiman confederation by the name of Tatatunga to write Mongolian using the Uighur script.[9] And *The Secret History of the Mongols* recounts that in 1206 Chinggis Khan commanded his adopted brother Shigi Qutuqu to record his laws and edicts in blue script on white paper and to have them bound into a book. This blue book was to serve as a guide from generation to generation, and anyone who transgressed against these laws was to be punished.[10]

Thus we have a date attached to the official introduction of the Mongol script. Yet there is an amazing regularity in the orthography and the treatment of grammatical suffixes beginning with the earliest extant texts. Some phonetical features also imply that the orthography and the use of this script to write Mongolian far predated the official introduction of the script. Some scholars speculate that the Uighur script was probably used earlier by Mongol speakers in other confederations, and that Chinggis Khan's edict officially introduced a writing system that had already been established.[11]

The earliest extant text is an inscription on a stone stele called the Stone of Chinggis, which is now in the Hermitage Museum in St. Petersburg. The inscription commemorates the feats of a nephew of Chinggis Khan, Yisüngge, in an archery contest that took place around 1225–27 (fig. 2).[12]

This script, which is variously called the Uighur, Uighur-Mongol, or just Mongol script, has since become the main vehicle of the Mongol language. The script was used by the Turkic-speaking people of the Uighur confederation, which was established in the area of East Turkestan about the eighth and ninth centuries. The Uighurs in their turn had borrowed the script from the Sogdians, an Iranian people who inhabited the area of Sogdiana to the west of the Uighurs, and who had Samarkand as their capital. The Uighurs had both religious and commercial contacts with the Sogdians, and they gradually adapted their script to the Uighur language. The Sogdian script in its turn ultimately went back to some form of Aramaic script.

The Uighurs originally wrote their script horizontally, but under the influence of Chinese it became a vertically written script, read from left to right. Inscriptions on the walls of cave-temples unambiguously attest to this.

Fig. 1. An inscription in the small Khitan script from the tomb of the Xuan Yi empress. From *Qidan xiaozi yanjiu* (Studies on the Small Khitan Script) (Beijing: Social Science Publishers, 1985), fig. 8.

Fig. 2. The inscription on the Stone of Chinggis, the oldest extant text in the Uighur-Mongol script. The State Hermitage, St. Petersburg.

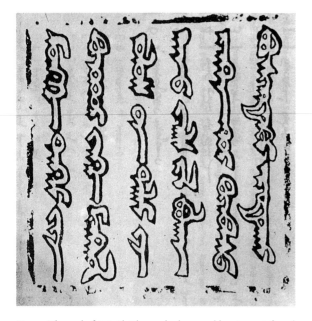

Fig. 3a. The seal of Güyük Khan, who became khan in 1246, found on a document kept in the Vatican archives. An example of the early period when the script was still used in its Uighur ductus. From Dobu, *Uyighurjin mongghol üsüg-ün durasqaltu bičig-üd* (Monuments of the Uighur-Mongol Script) (Beijing: Ündüsüten-ü keblel-ün qoriya [Nationalities Publishing House], 1983), p. 15.

Fig. 3b. Classical Mongolian ductus is illustrated by several pieces in this exhibition, including this manuscript page, cat. no. 58.

Fig. 3c. An example of a modern typeset text written in the Uighur-Mongol script. From D. Gongghor, *Qalqa tobčiyan* (Concise History of the Khalkhas) (Beijing: Ündüsüten-ü keblel-ün qoriya [Nationalities Publishing House], 1991), vol. 2, p. 313.

When the Mongols adopted the script, they also wrote it in vertical lines. In the early era of using the script, the ductus and appearance of the script closely resembled the Uighur script, but over time a distinct Mongol ductus was developed, and it turned into the mellifluous and beautiful script of classical Mongolian (figs. 3a–c).

The Mongol script is phonetic, but several graphemes are ambiguous and can be read in at least two ways—in the case of consonants it is usually both a voiced and an unvoiced variant of the same phoneme. This ambiguity together with the archaic orthography has made the script a lingua franca for various dialects, since it does not represent the phonetic pattern of any one present-day dialect. However, writers of a few radically divergent dialects have felt a need to develop new scripts, as we shall see.

The main centers of literacy among the Mongols were government offices, where administrative and legal documents were drafted and recorded, and where political and official histories were written; the other centers were the temples and monasteries, which became increasingly significant as centers of literacy and administration as the role of the Buddhist church came to pervade the entire Mongolian society.

After Chinggis Khan wisely decreed that the Mongols should become literate, their ability to codify and record their diplomatic and political acts did much to legitimize their rule. The advice proffered by the Khitan Yelü Chucai, "Although you have gathered your realm on horseback, it is impossible to rule it from horseback," is recorded as having been spoken to Chinggis's son and successor, Ögödei Khan, but it is not at all unlikely that he gave the same advice to Chinggis Khan.[13]

The Mongols soon made the Uighur script their own. In religious histories there are various pious stories attributing the devising of the script to certain early religious personages, but these stories are not very believable—at the most, these personages may have devised some orthographic rules for the script that was already in use. What cannot be denied is that the various commissions that were set up to translate and codify the Buddhist religious compendia, the Kanjur and the Tanjur, into Mongolian, played the role of a sort of Mongolian Académie française, which established the orthography, good usage, and terminology for the written language. And it is in this form that the language is still written today.

When Khubilai Khan was well into establishing his imperial power as the Yuan emperor, he felt the need for a script that could be employed in writing all the languages of the empire, and he accordingly ordered the invention of such a script by Phagspa Lama, the Tibetan religious and political figure whom he had brought to Beijing and who had gained a great deal of influence over him. This edict went

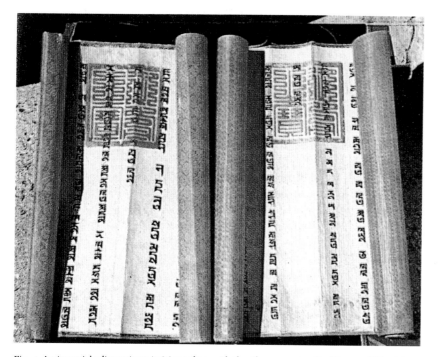

Fig. 4. An imperial edict written in Mongolian with the Phagspa script. Jin Zhou and Zhu Li,
Tibet: No Longer Mediaeval, p. 33; James Bosson, "It's Springtime for 'Phags-pa!" *Kungliga vitterhets
historie och antikvitets akademiens konferenser: 12* (Uppsala, 1983), p. 17.

out in 1269, and Phagspa Lama set about the task immedi-
ately. Being a Tibetan, he turned to the script he knew best,
and on the basis of the Tibetan syllabary he devised what has
variously been known as the square script, or the Phagspa
script. He changed the Tibetan graphemes to a square, box-
like shape and adjusted the script to be written from top to
bottom and from left to right, whereas Tibetan is written
horizontally (fig. 4).14

This new script was complicated and quite cumbersome
to write, but schools were set up to teach the script and gov-
ernment bureaus were commanded to use it in writing offi-
cial documents. This was the first time a phonetic script was
employed to write the Chinese language—and that has been
of great interest to Sinologists. However, one can easily
imagine the resistance put up by Chinese scribes and schol-
ars to replacing their precious and beloved heritage by a new,
"barbarian" script. The Mongols reacted in a similar way
and passively resisted the new script. At one point it became
forbidden to use the Uighur-Mongol script.15 It even reached
the seemingly impossible point where an imperial edict had
to be issued more than once.

Nevertheless, a number of official documents, edicts,
and proclamations were written in the script. Some have
been preserved on paper and others as stone inscriptions.
The script was also used on insignia identifying imperial
envoys. Its widest continuous use has been on official and
personal seals. Some fragments of the first known printed
Mongolian book of lay content have been found written in
this script.16

Despite the limited number of texts in the Phagspa
script, these have been of inordinate importance in the study
of the Mongolian language, because the texts give a pho-
netic representation of how the Mongolian language was
spoken in the thirteenth century. Here one might add that
Mongolian has appeared in two other scripts that also have
served to define the phonetics of Mongolian in the thir-
teenth century. Some dictionaries and vocabularies of Mon-
golian have been preserved in the Arabic script17 and, most
important of all, the earliest Mongolian historic-literary text,
The Secret History of the Mongols (1240), has been preserved in
a very precise transcription in Chinese characters (fig. 5).
The original was most likely written in the Uighur-Mongol
script, but that text has been lost. The very fact of the Chi-
nese transcription probably saved this gold mine of informa-
tion for posterity, since it served as camouflage to hide it
from the perpetrators of the book burnings and destruction
of Mongol books during the Ming dynasty.

Notwithstanding the efforts of Khubilai Khan, the Phag-
spa script was gradually dropped from even the most cen-
tral government bureaus. Yet the script has an appeal as an
ornamental writing style and has remained alive until today
in seals, ornamental inscriptions in temples, on title pages of
books, and, not least, on stamps issued in Ulaanbaatar.

Another ornamental variant of the script, the so-called
recumbent square script, has been ascribed to the First
Bogdo Gegen, Zanabazar, who lived in the seventeenth and
eighteenth centuries. This script is merely Phagspa script re-
turned to the horizontal mode of Tibetan script without

Fig. 5. *The Secret History of the Mongols* as it has been preserved in Chinese transcription. From B. J. Pankratov, *Yuanchao bishi: Sekretnaia istoriia mongolov* (Yuanchao bishi: The Secret History of the Mongols) (Moscow: Izdatel'stvo Vostochnoi Literatury, 1962), p. 296.

Fig. 6. The horizontal square script ascribed to Zanabazar. From Chandra, *Life and Works of Jibcundampa I*, nos. 791–92.

in the Soyombo script. Its importance as a script is overshadowed by the fact that it has become the symbol of Mongolian independence and national pride.

Despite the supradialectal quality of the Uighur-Mongol script, as mentioned above, speakers of the West Mongolian or Oirat dialect felt a need to express the divergent phonetics of their speech in script. This task was carried out by the person who became one of the outstanding religious personages among the Oirats. He was born into a Koshut family in the Altai Mountains in Western Mongolia and was recognized as a reincarnate-lama. He is known under his religious title, Zaya Pandita (1599–1662). The script he composed became known as the Todo script, or clear script. It was based on the classical Mongolian script, and with the addition of several new graphemes and diacritical marks he

many other changes in the graphemes. This script has only been used for some inscriptions in temples and for writing prayers and *dharani*. A sample syllabary is included in a collection of works ascribed to the First Bogdo Gegen (fig. 6).[18]

The Soyombo script is another ornamental and highly complex script that is connected with the name of the First Bogdo Gegen (fig. 7a). According to some sources, he introduced the script in 1686. This script is generally based on an Indic script called the Lantsha script, and the *Soyombo* in its name originates from the Sanskrit word *svayambhu*, "self-sprung." It was too complex to become widely used, but it has been employed to write prayers and other short religious texts (fig. 7b). Very likely, it was the intention of its originator that it should be used in just this way.[19]

The greatest significance of this script is that its initial grapheme became the coat of arms of the Mongol state, and it appears prominently on the Mongol flag. This symbol is also referred to as *Soyombo*. It also appears in the center of the new Mongolian one-hundred-*tugrik* bill (fig. 8). One prominent Mongolian scholar has his personal seal written

Fig. 7a. The initial grapheme of the Soyombo script. This grapheme has no phonetical value but is placed at the beginning of all texts in Soyombo. It has become the state symbol of Mongolia.

Fig. 7b. A rare xylograph text in the Soyombo script of the religious text *Itegel*. From Rintchen, "Zwei unbekannte mongolische Alphabete," pp. 70–71.

was able to represent phonemes peculiar to Oirat and also to distinguish between the vowels *ö* and *ü*, and *o* and *u*, and to indicate the length of vowels (fig. 9).[20]

The Todo script became widely used among the Oirats and the Kalmucks. Many Buddhist religious works have been written in this script, as have edicts, diplomatic notes, and other lay works. Parts of the New Testament were typeset and published in it in Russia during the nineteenth century. Today many literary, historical, and political texts, as well as newspapers and magazines, are published in this script in Xinjiang in the People's Republic of China.

The Buriats, who live both east and west of Lake Baikal, also speak a distinctly variant language, but they too used the classical Mongolian script for their literary expression. Although the Buriats were the last of the Mongols to convert to Buddhism, a lively religious community developed in Buriatia during the nineteenth century, and there was considerable literary activity at various monasteries that had been established in Buriat territory. There was also a blooming of intellectual activity in the Buriat lay community. Buriat scholars made a name for themselves in St. Petersburg, Siberia, and Mongolia.

One of the most noted of these Buriats was also a religious grandee, the lama Agvan Dorzheev, who became a significant diplomat with personal access to both the Dalai Lama and the Russian tsar. Among his notable achievements was the founding of a Tibetan-style monastery in the Novaia Derevnia section of St. Petersburg. This temple became the center of activity for Buriats, Kalmucks, and other Mongols living in Russia. After the dark years of Stalin and his successors, it was desecrated and used variously as a physical training center for workers, a military radio station later converted for jamming foreign radio broadcasts, and then as a laboratory of the Zoological Institute, when to the outrage of the Buddhist religious community, an elephant from the zoo in Riga was dissected in its basement! Finally in 1990 it was reconsecrated and again serves its original purpose.[21]

On the linguistic plane, Agvan Dorzheev in 1905 devised a new Buriat alphabet. Again this was based on the classical Mongolian script. The script contains twenty-eight graphemes, four diacritical marks, and six punctuation marks. This new alphabet also became known as the Vagindra script (fig. 10). Agvan Dorzheev often signed his writings with *Vagindra,* which is the Sanskrit version of his Tibetan name, *Ngag-dbang* (Ngawang).

Within the next years several literary works were published in this script, both lithographs of handwritten originals and in typeset fonts. All of these publications were printed in St. Petersburg. Some manuscripts written in this script have also reportedly existed in the Buriat homeland.[22]

Along with the many disruptions of the twentieth century came some sharp upheavals in the history of Mongol literacy. In 1930 the Latin alphabet was introduced to write most of the minority languages of the Soviet Union. The Kalmucks, who had for some time used a partially Cyrillic script in writing Kalmuck, changed to the Latin script on 1 January 1930. A Latin transcription was also introduced for

Fig. 8. The present-day 100-*tugrik* note issued by the Mongol Bank. Here several variants of the script are used for their decorative effect. On the left-hand side is a calligraphic version of the vertical script (reading "Mongol Bank"); in the middle is the Soyombo initial; and on the right-hand side is the regular vertical script: "Mongol Bank, hundred *tugrik.*"

Fig. 9. The first two pages of the *Sutra of Great Liberation* (T: *Thar-pa chen-po*) in the Oirat translation done by Zaya Pandita, written in the Todo script devised by him. Oirat title: *Xutuqtu yeke toniluqsani zügtü delgeröülügči kemēkü yeke kölgeni sudur orošibo.* Undated manuscript, probably 18th century. Courtesy of the East Asian Library (Mong. 44), University of California, Berkeley.

Fig. 10. The new Buriat script composed by Agvan Dorzheev, illustrated in the folktale "Eriyekheng khübüng." From Almas Narnai, *Sbornik mongolo-buriatskoi narodnoi poezii, II* (A Collection of Mongol-Buriat Folk Poetry, II) (St. Petersburg, 1911), pp. 56–57.

Fig. 11. Cyrillic script was used even in Mongolian publications in Inner Mongolia. From *Quriyalta/Khuraalt* (The Harvest) (Beijing, 1956) and *Nököd-ün-iyen ner-e kündü-yin tölüge/Nökhdiinkhöö ner khündiin tölöö* (For the Honor of Our Comrades' Name) (Beijing, 1956).

Buriat, and in the Mongolian People's Republic, long under the influence of the Comintern and the Soviet government, the same script was introduced. But scarcely had a generation become literate in Latin script when the xenophobia of Stalin took hold, and a decree was promulgated that ordered a new script based on the Russian alphabet, and including every letter of that alphabet. Kalmuck then reverted to the Cyrillic script, as did Buriat. In the Mongolian People's Republic the Cyrillic script was introduced in 1940, with a five-year conversion period allowed (fig. 11).

Throughout these official changes a large part of the literate population has continued to write their personal papers and correspondence in Mongolian script. Included in this number are many of the top party and government officials—who are in charge of enforcing this decree. I have often seen this with my own eyes, including a stolen glance at the speech notes of the prime minister, who was reading from his handwriting in traditional Mongolian vertical script! During the long period from 1940 on, scholars still managed to publish many books in the classical script as long as they dealt with historical or literary texts of an earlier period.

In Inner Mongolia the traditional script has been in uninterrupted use until the present day. During the high season of Soviet-Chinese friendship, a decision was made to convert Inner Mongolia also to the Cyrillic script, but that reached no further than an occasional title page in both Mongolian and Cyrillic script (fig. 12). When the rupture between the Soviet Union and the People's Republic of China took place, the Cyrillic conversion was immediately scrapped.

Today the history of the Mongol script has come full circle, for the parliament of the new Mongolia has reintroduced the Mongol script in all its glory, with an initiation date of 1994.

Fig. 12. An example of a title page including six variants of script. This is an ethnographic-linguisitic atlas giving the title in Soyombo, Cyrillic, vertical calligraphic, normal vertical, Todo, and Phagspa scripts. From B. Rinchen, *Mongol Ard Ulsyn ugsaatny sudlal khelnii shinjleliin atlas* (An Atlas of Ethnographic and Linguistic Research on the Mongols) (Ulaanbaatar, 1979).

NOTES

1. Wolfram Eberhard, *Das Topa-Reich Nordchinas* (Leiden: E. J. Brill, 1949).

2. Jacques Bazin, "Recherches sur les parlers T'o-pa," *T'oung Pao* 39 (1950), 228–339.

3. A. von Gabain, *Alttürkische Grammatik* (Leipzig: Otto Harrassowitz, 1950), p. 338.

4. D. Kara, *Knigi mongol'skikh kochevnikov* (Books of the Mongol Nomads) (Moscow: Nauka, 1972), p. 9.

5. Karl A. Wittfogel and Chia-sheng Fêng, *History of Chinese Society: Liao (907–1125)* (Philadelphia: The American Philosophical Society, 1949), pp. 241–53; Qinggertai et al., *Qidan xiaozi yanjiu* (Beijing: Social Science Publishers, 1985).

6. L. Ligeti, "A kitaj nép és nyelv" (The Khitan People and Language), *Magyar Nyelv* 23 (1927), 301–10.

7. Wittfogel and Fêng, *History of Chinese Society,* pp. 244–53, 669–70.

8. N. Ts. Munkuev, *Kitaiskii istochnik o pervykh mongol'skikh khanakh* (A Chinese Source on the First Mongol Khans) (Moscow: Nauka, 1965), pp. 11–23.

9. *Yuanshi* (History of the Yuan Dynasty) (Beijing: Zhonghua Shuji, 1976), vol. 10, p. 3048.

10. Paul Pelliot, trans., *Histoire secrète des Mongols* (Paris: Adrien Maisonneuve, 1949), p. 78.

11. Kara, *Knigi mongol'skikh kochevnikov,* p. 17.

12. Dobu, *Uyighurjin mongghol üsüg-ün durasqaltu bičig-üd* (Monuments of the Uighur-Mongol Script) (Beijing: Ündüsüten-ü keblel-ün qoriya [Nationalities Publishing House], 1983), pp. 1–7.

13. Munkuev, *Kitaiskii istochnik,* pp. 19, 106. Although this dictum has widely been ascribed to Yelü Chucai, it goes back to a similar pronouncement by Lu Jia, as recorded in Sima Qian's *Shiji* (Historical Records) (Beijing, 1959), p. 2699.

14. Nicholas Poppe, *The Mongolian Monuments in Hp'ags-pa Script,* trans. and ed. John R. Krueger (Wiesbaden: Otto Harrassowitz, 1957).

15. Kara, *Knigi mongol'skikh kochevnikov,* p. 30.

16. G. J. Ramstedt, "Ein Fragment mongolischen Quadratschrift," *Journal de la Société Fenno-Ougrienne* 27 (1912), 3; P. Aalto, "Altaïstica," *Studia Orientalia* 7, no. 2 (1952), 1–9; P. Aalto, "A Second Fragment of the Mongolian *Subhāsitaratnanidhi* in Mongolian Quadratic Script," *Journal de la Société Fenno-Ougrienne* 57 (1955), 5; J. Bosson, "A Rediscovered Xylograph Fragment from the Mongolian 'Phags-pa Version of the *Subhāsitaratnanidhi,*" *Central Asiatic Journal* 6, no. 2 (1961), 85–102.

17. E.g., Nikolai Poppe, *Mongol'skii slovar' Mukaddimat Al-Alab* (The Mongolian Dictionary Mukaddimat Al-Alab) (Moscow and Leningrad, 1938).

18. Kara, *Knigi mongol'skikh kochevnikov,* p. 96; Lokesh Chandra, *Life and Works of Jibcundampa I,* Śatapiṭaka Series, vol. 294 (New Delhi: International Academy of Indian Culture, 1982), pp. 791–92ff.

19. Ts. Shagdarsüren, *Mongol üseg züi: Tergüün Devter (Ert üyees 1921 on xürtel)* (Mongol Scriptology: From Ancient Times until 1921) (Ulaanbaatar: Shinjlex Uxaany Akademi, 1981), pp. 71–97; B. Rintchen, "Zwei unbekannte mongolische Alphabete aus dem XVII. Jahrhundert," *Acta Orientalia* 2 (1952), 63–71.

20. Kara, *Knigi mongol'skikh kochevnikov,* pp. 77–84.

21. A. J. Andreev, *Buddiiskaia sviatynia Petrograda* (The Buddhist Shrine of Petrograd) (Ulan-Ude: Agentstvo EkoArt, 1992).

22. Kara, *Knigi mongol'skikh kochevnikov,* pp. 95–98; N. Amagaev, Alamzhi-Mergen, *Novyi buriatskii alfavit* (The New Buriat Alphabet) (St. Petersburg: Narang, 1910); Rinchen, *Mongol bičgiin xelnii züi: Udirtgal* (Grammar of Literary Mongolian: Introduction) (Ulaanbaatar: Shinjlex Uxaany Akademiin Xevlex Üildver, 1964), pp. 172–75.

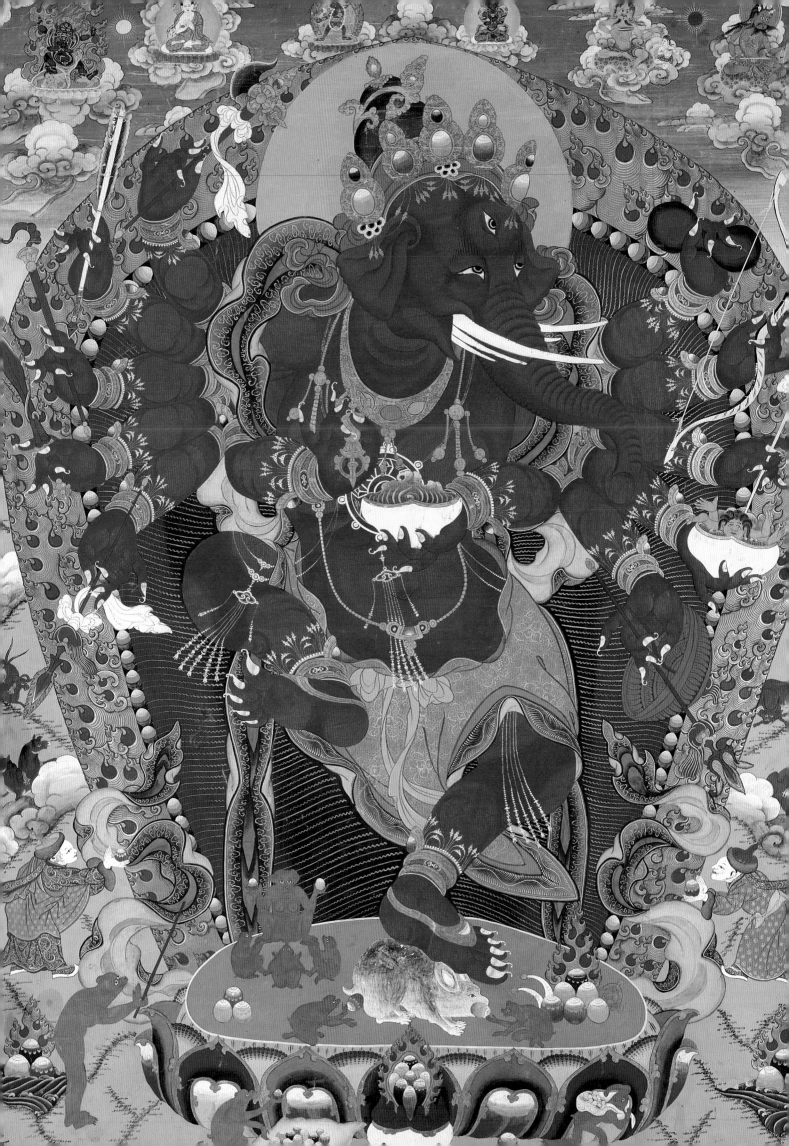

Catalogue

NOTE TO THE READER

Dimensions are given in inches and centimeters, inches first. Height, or length, precedes width; depth or diameter, where applicable, follows. Full citations for references given in the notes can be found in the Selected Bibliography. Authors are indicated by their initials: T.T.B. = Terese Tse Bartholomew; P.B. = Patricia Berger; and J.B. = James Bosson.

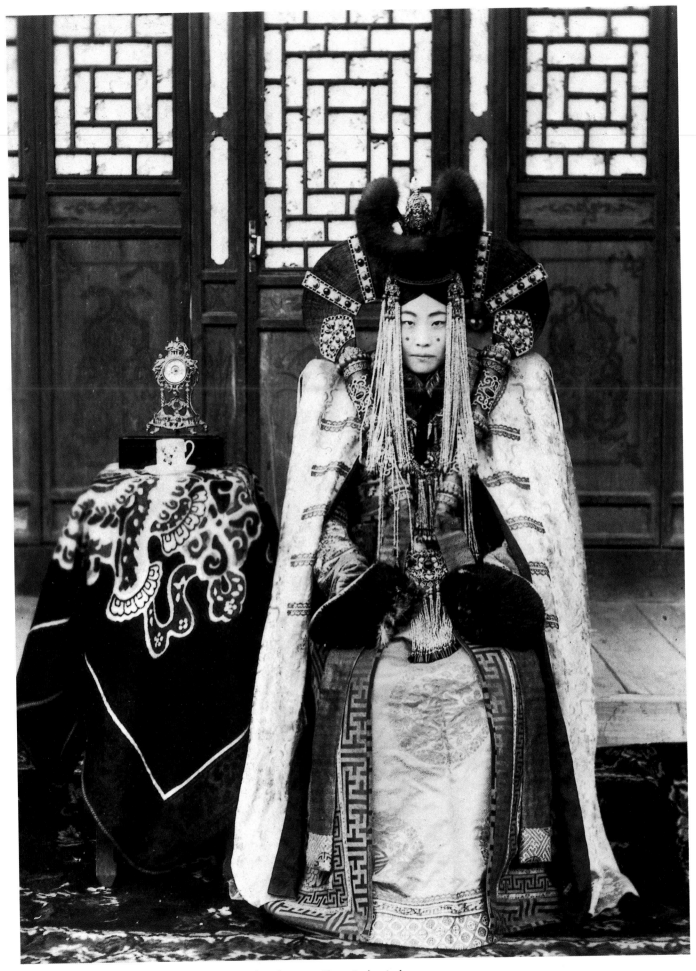

Fig. 1. A wealthy Khalkha woman in elaborate dress, early 20th century. Photo: Luther Anderson.
Copyright National Geographic Society.

Nomadic Life

TERESE TSE BARTHOLOMEW

The Mongols, being a nomadic people, generally have not expressed their artistic talents in monument building. It was only after they settled down that temple building began in earnest, along with the creation of rich furnishings, sculptures, thangkas, appliqués, and ritual objects. In general, the artistic creativity of the Mongols found an outlet in the decoration of their portable belongings, such as saddles, horse trappings, tools and kitchen utensils, and, above all, personal jewelry.

Mongol saddles are wonderful creations encompassing such techniques as metal casting, leather work, appliqué, and embroidery. The silk brocades and Tibetan woolen material used in adorning the saddles in this exhibition resulted from the trade between the Mongols and their neighbors.

The lives of the Mongols and their traditional economy rely on the "five snouts," the horse, camel, bovine (yak and cattle), sheep, and goat. These animals often appear in their artistic creations, such as the double-spouted ewer in this exhibition (cat. no. 4). Jewelry, embroidery, leather work, and wood carvings often employ zoomorphic motifs, such as the horns of the wild sheep and the nostrils of cattle. The Khalkha ornaments (cat. nos. 7–10) and the carved book covers (cat. nos. 51 and 52) provide excellent examples of these motifs.

The tribes of Mongolia distinguished themselves from each other by their costumes and their women's jewelry. From the basic materials of silver, turquoise, and coral, each tribe created its own distinctive features. Although not all the tribes are represented in the jewelry section, the small selection in this exhibition gives us an idea of the variety one finds in Mongol ornaments.

The jewelry displayed and illustrated once belonged to married women of the various tribes. It made up the dowries given to them by their parents on the day of their marriage. The jewelry and ornaments are symbolic of their marital status, wealth, and tribal affiliation. Among them, the ornaments of the Khalkhas are the most ostentatious (fig. 1). The skullcaplike headdress, hair clips, and braid cases consist of fine filigree worked into intricate knots, intertwined into *ugalz*, or the wild sheep horn motif, and then embellished with turquoise and coral. The filigree ornaments of the Buriat employ motifs such as the Chinese coin with the square opening, swastikas, and queen's earrings (two interlocking circles, also known as *ölzii*). The Uzemchins wear beaded headdresses consisting of an elaborate network of tiny coral, turquoise, and other beads.

The smiths of Mongolia, known as *darkhan*, were respected members of society. Their trade was hereditary, passed from father to son. These versatile craftsmen worked with various metals, and they produced all types of products associated with nomadic life, from harnesses to sacred images and ornaments. Although their tools were few and primitive, the results were astounding. Armed with a saddle bag of tools, these itinerant *darkhan* traveled from *ger* to *ger* seeking employment. Some of the smiths were Chinese; they sold their products and made jewelry to order.[1]

The ornaments worn by men are of a more practical nature. Attached to the ornate pendants on their sashes are eating sets containing knives and chopsticks, and tinder pouches secured by a toggle, often in the shape of an ingot to represent riches. The *del* (the Mongolian national dress) does not have pockets, and other essential objects, such as snuff bottle, pipe, and tobacco, are contained within beautifully embroidered bags, folded and strung onto one's sash.

1. Boyer, *Mongol Jewelry*, p. 158.

1. KHALKHA SADDLE

20th century
Wood, leather, wool, silver, and iron
H: 58¼ (148.0) W: 13⅜ (34.0)
Museum of Mongolian History

2. SADDLE FOR A HIGH LAMA

20th century
Wood, pigments, leather, brocaded silk, and silver
H: 68⅞ (175.0) W: 13 (33.0)
Museum of Mongolian History

3. BURIAT SADDLE

20th century
Wood, leather, wool, and silver-plated copper and iron
H: 58⅝ (149.0) W: 12¾ (32.5)
Museum of Mongolian History

Mongolian life would be impossible without the horse, and the Mongol language reflects the people's abiding concern for the sex, age, conformation, color, and disposition of each animal in their care. Horse trappings received similar attention and solicitude; the Mongols even engendered prayers for their protection to the shamanist spirit Jayagagchi tngri, the *tngri* of fate.[1]

The Mongolian saddle, with its often elaborate fittings and ornaments, varies from tribe to tribe and signals the status and origin of the rider. These three saddles, all from the twentieth century, were made for three very different uses. The first (cat. no. 1) is a type that was used by Khalkha men and women of central Outer Mongolia. Constructed over a split wooden frame, it has side skirts covered with pigmented and appliquéd leather and a seat with heavy, striped Tibetan wool stamped with crosses. The edges of the high pommel and cantle are finished with strips of repoussé silver. Bosses of silver, the two near the back in the shape of locks, decorate the frame and seat. The Khalkhas customarily evaluated saddles on the basis of their silver ornaments, called "whites." Thus a saddle could be an eight-whites saddle, a ten-whites saddle, or, as here, a twelve-whites saddle, the highest category. The long yellow leather pad fitted to this saddle is also elaborately decorated with strips

of black and green appliquéd leather. Leather straps *(gan-zaga)* hang down from silver bosses on either side of the rider's leg; they were used to hold equipment or to secure game after the hunt. These eight straps had a meaning beyond mere utility for Mongol horsemen, who customarily said an incantation over them before setting out, following a tradition initiated by Chinggis Khan himself. The Mongol folklorist B. Rintchen wrote that "it is passed down by tradition that Holy Chinggis Khan once made an offering to the straps of his golden saddle . . . this is the reason why today the saddle and the bridle of the lord of gifts will be purified, the eight saddle-straps spoken over and a blessing recited."[2]

Even the highest members of Outer Mongolia's ecclesiastical aristocracy rode on horseback, despite the fact that the Manchu emperors of China, their overlords, awarded some the privilege of being carried in litters or carriages. The second saddle shown here (cat. no. 2) was intended specifically for a high lama. Its pommel and cantle are both enameled yellow, decorated with designs in brown enamel, and edged with chestnut and green Russian leather. All the fittings are silver, and the long straps that hang down on either side of the rider's leg are tightly woven, tasseled cords of silk. Sumptuous brocaded yellow silk woven in a dragon-rondel pattern covers the seat, side skirts, stirrup pads, and long,

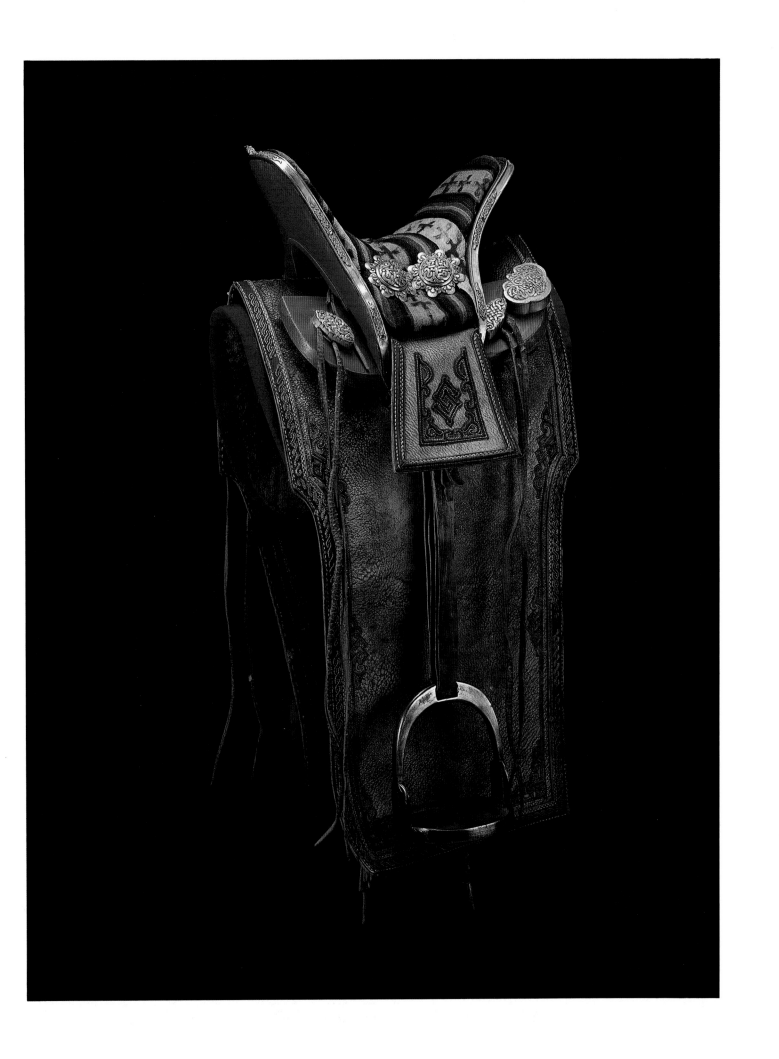

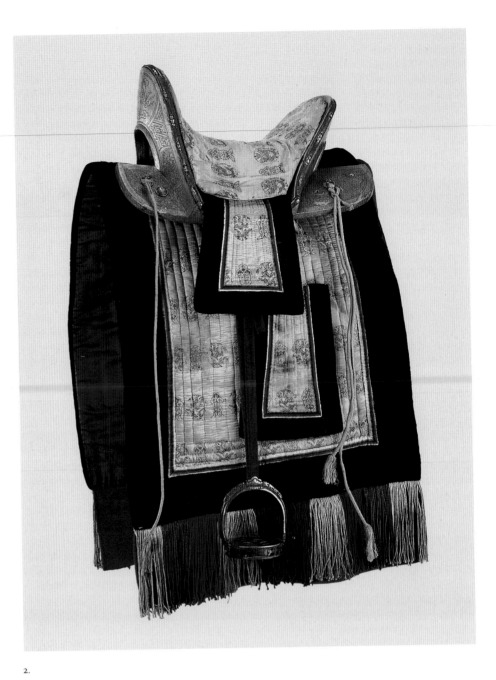

2.

fringed underpad. The use of silk of this color and weave was bestowed by the Manchu emperors only as a mark of the highest favor.

The third saddle (cat. no. 3) is a Buriat design, made by the descendants of an ancient Mongol tribe that nomadized around Lake Baikal. The Buriats still live north of the lake in what is now Russia and along the northern and eastern borders of Outer Mongolia. Their saddles and many of their other traditional artifacts are distinctive. This saddle's seat and side skirts of heavy black Russian leather are both heavily embossed with silver-plated copper fittings. The saddle pad is a tough, textured hide. —P.B.

1. Heissig, The Religions of Mongolia, p. 54.

2. Ibid., pp. 67–68. Heissig translates B. Rintchen, Les matériaux pour l'étude du chamanisme mongol, pp. 47–48.

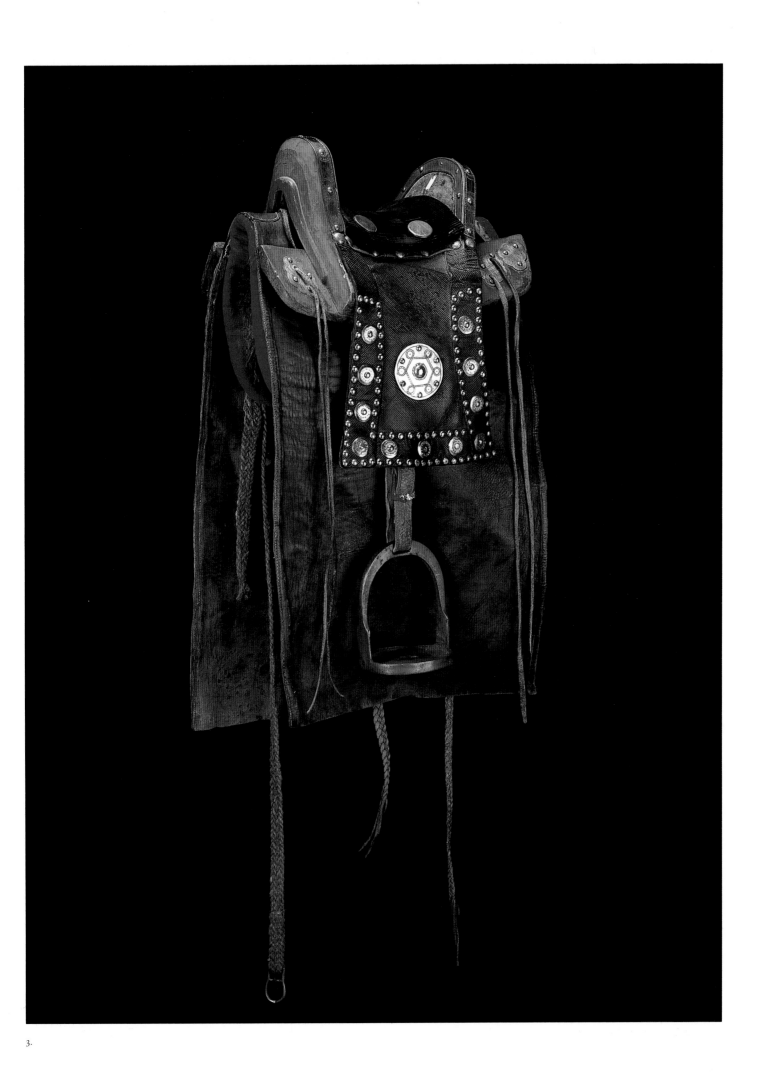

3.

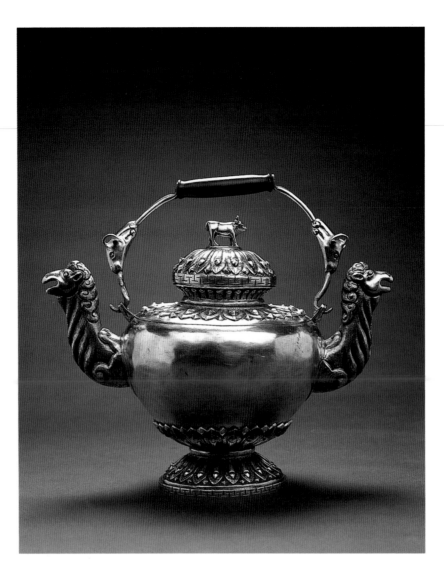

4. DOUBLE-SPOUTED EWER

Early 20th century
Silver with high copper content
H: 10 (25.5) W: 11⅝ (29.4) Diam.: 6⅜ (16.2)
Museum of Fine Arts

If the use of lotus petals on the lid, shoulder, and base of this vessel indicates that the craftsman was influenced by Tibetan forms, the design concept of the ewer is purely Mongolian. A cow surmounts the lid, the heads of two rams decorate the overhead handle, while camels with open mouths form the spouts. A vertical wall divides the interior of the ewer into two parts, so that two separate beverages can be served. The fretwork decorating the lid and the base is known as the wall motif, inspired by the Great Wall, which once separated Mongolia from China.

The lives of the Mongols and their traditional economy rely on the horse, camel, bovine (yak and cattle), sheep, and goat, and three of these "five snouts" are depicted on this vessel.[1] The horse provides mobility and *airag*, the fermented mare's milk that is the national beverage of Mongolia. The sheep, goat, and bovine are sources of food and wool, as well as of fuel and shelter. The two-humped Bactrian camel is the beast of burden, providing transport on the trade routes. The white camel, together with eight white horses, constituted the "Nine Whites," traditional tributes from the Khalkha khans to the emperors of China.[2] Abbé Huc, in his famous memoir on his travels to Mongolia and Tibet in the mid-nineteenth century, mentioned meeting with the khan of Alashan, whose entourage included a white camel all bedecked with yellow cloth, a tribute for the Daoguang emperor of China.[3] —T.T.B.

Published: Tsultem, *Mongolian Arts and Crafts,* pl. 34

1. See Bosson, "Who Are the Mongols, and Why?"; Rossabi, *Khubilai Khan,* p. 3.

2. Ning Chia, "The Lifanyuan and the Inner Asian Rituals in the Early Qing (1644–1795)," p. 70.

3. Huc, *Recollections of a Journey through Tartary, Thibet, and China,* vol. 1, p. 226.

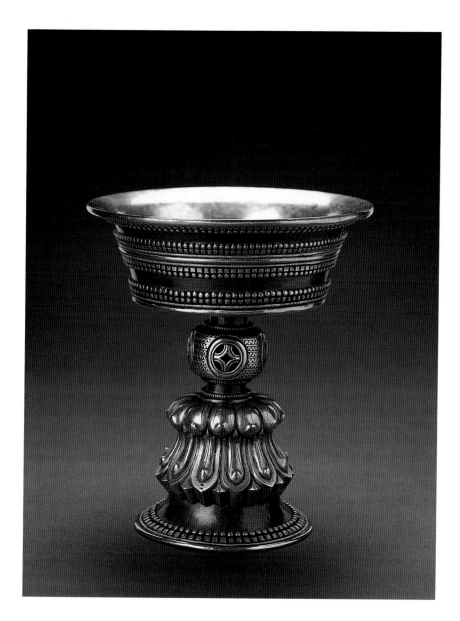

5. BUTTER LAMP

19th–20th century
Copper, brass, and silver
H: 5 (12.5) Diam.: 4½ (11.5)
Museum of Fine Arts

Butter lamps are permanent fixtures on Buddhist altars, whether in a large temple complex or inside the *ger*. Based on a Tibetan prototype, the butter lamp consists of a flaring bowl-shaped top resting on a bell-shaped base. There is often a hole through the center, where the wick, a small stick wrapped with cotton, is inserted.

The interior of the lamp is of silver, and the outside shows decorative bands of brass against a plain copper surface, creating a colorful contrast. The small section above the lotus petal on the base bears four coin motifs in openwork on a finely engraved background. The coin motif is based on the Chinese *qian* (cash) with a square opening. It is a symbol for riches and is part of the Mongolian decorative repertoire (see cat. no. 11).

Such objects were made by the *darkhan*, or smiths, who were highly respected in Mongolian society for their skills. It is a hereditary trade, with fathers passing their secrets to sons. The *darkhan* made a large variety of objects, from daily utensils, tent and horse trappings, and weapons, to Buddhist statues, ritual objects, and tribal jewelry.[1] —T.T.B.

Published: Tsultem, *Mongolian Arts and Crafts*, pl. 36

1. Tsultem, *Mongolian Arts and Crafts*, pp. 8–9.

6. ORNAMENTS FOR A GIANT

Early 20th century
Silver, leather, ivory, and ebony
Eating set H: 20⅝ (52.3) W: 7⅝ (19.4)
Museum of Mongolian History

Like most Asian garments, the Mongolian *del* does not have pockets, so important utensils such as eating sets and flint pouches are attached to one's sash by means of pendants and toggles.

This eating set and flint pouch originally hung from two pendants by means of two long silver chains with hooks ornamented with luck-bringing bats. The pendants were worn on either side of the body, threaded onto the sash through loops of Russian ox hide. When not in use, the eating set was stuck into the folds of the sash, and the flint pouch was worn at the back.

Mongolians, like the nomadic Tibetans and Manchus, used an ingeniously designed eating set, which comprised a sharp knife and a pair of chopsticks, and which sometimes included a toothpick, ear pick, and tweezer. The wooden container for the knife and ivory chopsticks is encased in silver. A silver loop locks the knife and chopsticks in place so that they would not fall out when the owner was on horseback or engaged in other vigorous activities. The decorations show strong Chinese influence. The top band is ornamented with symbols of the four literary pursuits of the Chinese scholar—the seven-stringed *qin,* the chessboard, a case of books, and two painting scrolls. The twelve zodiac animals, in two rows, decorate the bottom casing. They are shown against a background of lotus and leafy scrolls, below which is a band of the mountains-and-waves motif. The knife has an ebony handle. Its butt bears a lotus-and-leaf motif. The top portions of the chopsticks are ornamented with the wealth-bringing coin motif.

Before the appearance of matches and lighters, the tinder pouch, or flint and steel set, was an essential piece of equipment consisting of a small leather pouch with a strip of steel on its lower edge. The pouch, when in use, contained small chips of flint and dried material such as shredded bark, mugwort *(Artemisia vulgaris),* and edelweiss blossom for use as tinder. In order to create a spark, a piece of tinder is pressed against a chip of flint held in the left hand, and the chip is hit a glancing blow with the steel edge of the pouch, held in the right hand.[1] The spark will cause the tinder to smoulder, and with it one can light a pipe or a fire. The silver repoussé on the pouch shows the twelve animals of the zodiac, and the steel piece is inlaid with silver filigree and blue enamel. The braided silver chain, attached to the pouch, terminates in a silver toggle in the shape of an ingot (M: *jamba*). The toggle, inserted first under and then over one's sash, kept the pouch in place.

This set of unusually large ornaments and utensils was specially made by a Mongol craftsman for the giant Ondor Gongor, a bodyguard of the Bogdo Khan when the Mongolian government delegation visited Russia in 1918. Between 1924 and 1972 the set was in a private Hungarian collection, from which the Museum of Mongolian History bought it.

—T.T.B.

Published: Tsultem, *Mongolian Arts and Crafts,* pl. 64

1. Cammann, *The Land of the Camel,* p. 68.

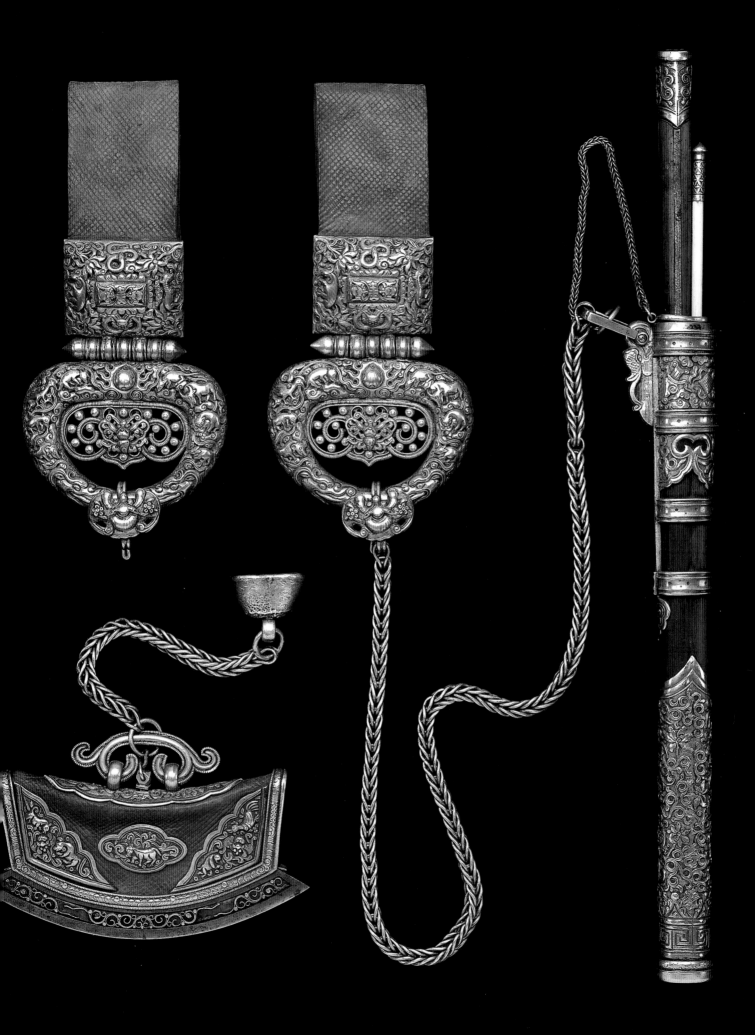

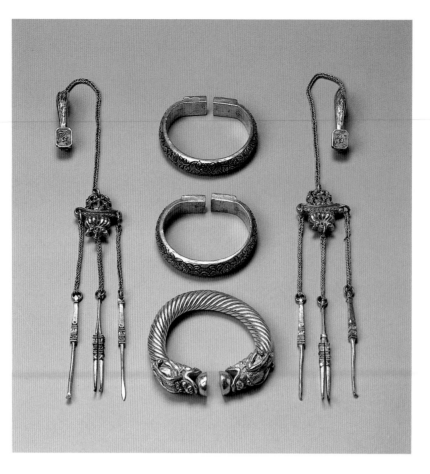

7. SET OF KHALKHA WOMAN'S ORNAMENTS

19th–20th century
Silver
Chatelaine H: 14¾ (37.4) W: 1⅜ (3.5)
Museum of Fine Arts

Chatelaines were worn by the women of Khalkha as well as those of other tribes in Outer and Inner Mongolia.[1] Beautifully crafted, these chatelaines were worn as ornaments, though they also served a utilitarian purpose. A clip, in the shape of a *ruyi* scepter, secured the chatelaine to a button on one's *del*. Shaped like a back scratcher with a cloudlike formation on the turned-up end (in this instance a square head ornamented with a lily and a butterfly), the *ruyi* (or "as-you-wish") scepter is an important Chinese motif for granting one's wishes. A chain whose links resemble a foxtail connects the *ruyi* scepter to a pendant shaped like a flower basket, and from it dangle three more foxtail chains holding three implements. They are, from left to right, an earpick for removing ear wax, a pair of tweezers for facial hair, and a nail cleaner. The implements and the baskets are decorated with engraved designs, while the scepters' floral patterns appear

against a punched background. For Mongolian men, these implements are cleverly integrated into their eating sets (see cat. no. 6).

The single bracelet, skillfully twisted, terminates in two dragon's heads in high relief. They each bite half a pearl. There are variations of this motif among Mongolian bracelets.[2] Dragon bracelets are also common in cultures of other Asian countries, such as China, Bhutan, Tibet, India, and Nepal. This particular example is of superb workmanship.

The pair of bracelets is engraved with symbols of the four scholarly pursuits—chessboard, *qin* (musical instrument), books, and painting, plus bats among flowers. They may be the work of a Chinese craftsman. —T.T.B.

1. Boyer, *Mongol Jewelry,* figs. 96–97, pp. 138–39.

2. Ibid., figs. 99–100, pp. 142–43.

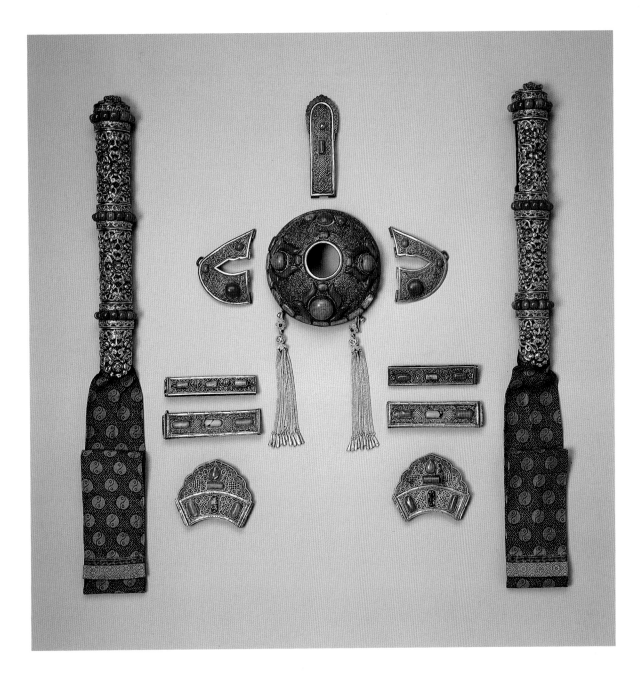

8. KHALKHA WOMAN'S HEADDRESS

19th–20th century
Gold, silver, coral, and turquoise
Cylinders H: 27¾ (70.6) W: 2½ (6.2)
Museum of Fine Arts

Married women of the Khalkha tribe of Outer Mongolia were distinguished by their horn-shaped hairdo and their distinctive jewelry.[1] Underneath a high pointed hat with turned-up brim, the women wore a silver helmetlike skull-cap with a circular opening on top, wing-shaped ear pieces, and a neck plate. Two silver tassels, consisting of chains and small pendants, dangle from two hooks attached to the front of the skullcap. The women wore their hair parted in the center. Stiffened with congealed fat, the hair was combed into two flat, hornlike forms which stood out at least sixteen inches from the head (fig. 1). The horns were held in place by four hair clips and two end clips. The rest of the hair, braided into pigtails, was kept inside two cylinders, further ornamented with long pieces of gold brocade.

Henning Haslund, with the Swedish expedition to Mongolia in 1923, was very impressed with the headdresses and costumes of married Khalka women. Their beautiful robes

of costly material were provided with wadded protuber-
ances which rose six inches from their shoulders.[2] A Mongol
prince well versed in the ancient lores told Haslund the fol-
lowing legend:

> The Khalka Mongols derived their origin from a union
> between one of the nature spirits and a cow. The cow
> that gave suck to the first Khalka Mongol infused into
> him the love of cattle-rearing and nomadic life and,
> that the coming race should not forget their origin, the
> Khalka women were charged to wear a coiffeur reminis-
> cent of a cow's horn, and their dresses were furnished
> with projections on the shoulders which called to mind
> the prominent shoulder-blades of the cow.[3]

The silver openwork jewelry consists of a tightly inter-
laced pattern of endless knots and spirals in fine filigree in
conjunction with coral and turquoise. Coral pieces, shaped
into lotus blossoms, decorate the skullcap, while turquoise
is interspersed with coral on the hair clips. The tassels in-
clude a silver flower inset with blue glass, followed by an
openwork bead with the coin design, below which is an-
other flower, whose petals enclose the silver chains with
conical pendants. Three strands of coral beads encircle each
of the cylinders, decorated with silver blossoms and gilt *ruyi*
in openwork. The gold brocade, imported from China, dis-
plays an overall pattern of *yinyang* against a background of
swastikas.

When a Khalkha maiden was to be married, her parents
would order a set of jewelry from the *darkhan*. The head-
dress would be presented to her on the morning of the wed-
ding day, during the ceremony in which the "wife's hair"
(ekhner üs) was combed out and the young woman became
a "married lady" *(avghai khün)*. Married women wore such
headdresses throughout their lives. —T.T.B.

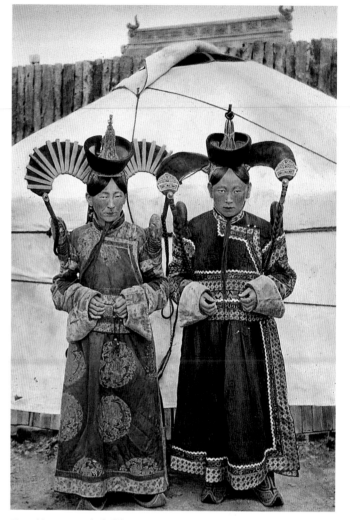

Fig. 1. Two married Khalkha women in front of a *ger,* early 20th century.
Photo: J. B. Shackelford. Copyright National Geographic Society.

1. For more examples, see Boyer, *Mongol Jewelry,* pp. 19–24.

2. Haslund, *Tents in Mongolia (Yabonah),* p. 69.

3. Ibid., pp. 69–70.

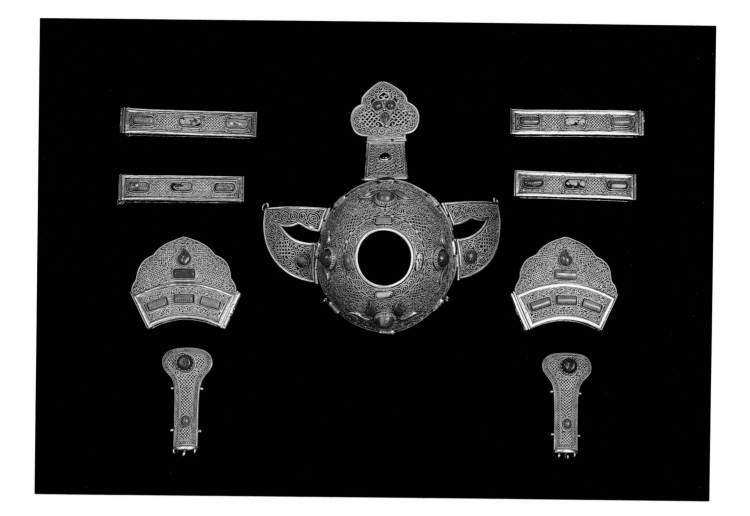

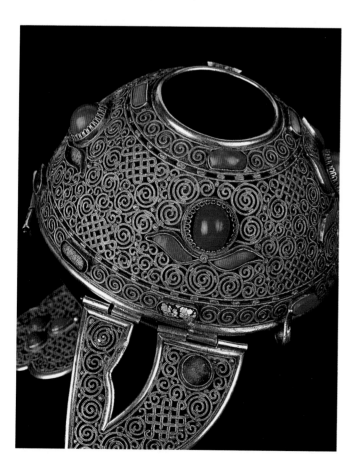

9. KHALKHA WOMAN'S HEADDRESS

Late 19th–early 20th century
Silver, coral, and turquoise
Headdress H: 9½ (24.0) W: 9¼ (23.5)
Museum of Mongolian History

While most of the pieces of this headdress are identical in shape to those of catalogue number 8, the keyhole-shaped ornaments are peculiar to this set. The endless knot is especially convoluted, resembling in its complexity the knotwork in Irish manuscript illumination. From their shape and the presence of small loops, these ornaments must have been used to decorate the top part of the two braids, beneath the end clips.

The detailed photograph of the headdress shows how the various components—the knots, spirals, turquoise, and coral—are ingeniously fitted together into a homogeneous and pleasing composition.

—T.T.B.

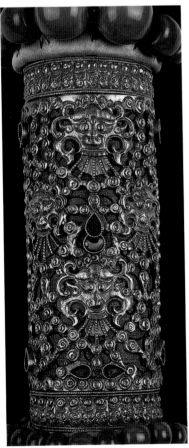

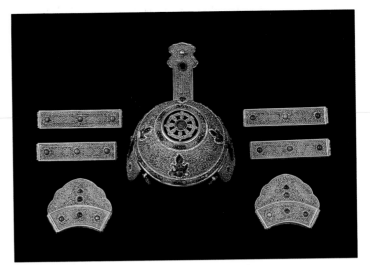

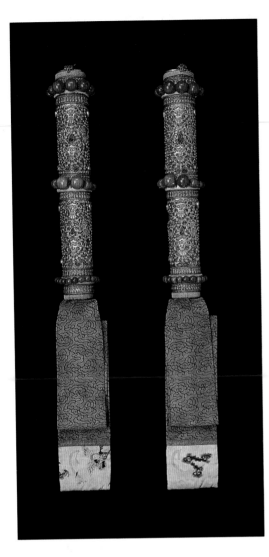

10. KHALKHA WOMAN'S HEADDRESS AND BRAID SHEATHS

Late 19th–early 20th century
Gilt silver, seed pearls, jade, coral, glass,
and faceted semiprecious stones
Headdress H: 1 (2.5) W: 14¼ (36.3)
Sheath H: 48 (122.0) W: 3¾ (9.5)
Museum of Mongolian History

Unlike the previous two examples, this headdress is gilded. The circular opening on the top of the headdress also differs, in that it is fitted with the Wheel of the Law, whose eight spokes represent the eightfold path of Buddhism. Although the design is similar to the previous examples, the stones are different. Seed pearls are used as inlays and to surround the other inset jewels, which are coral, turquoise of various colors, and stones of the quartz family. Some of the settings have lost the original inlays and are now filled with glass beads simulating precious stones.

The braid casing, or sheath,[1] is made of a cloud-pattern golden brocade wrapped around a metal tube, with a long flat piece of brocade below. The front half of the tube is covered with gilt silver openwork as well as repoussé, displaying an intricate design of animal masks among jeweled garlands. Once ornamented with turquoise and coral beads, the sheaths now retain only a few. The outstanding features are the three rows of bright coral beads interspersed with a few glass imitations. Already in the eighteenth century, the glass industry in Beijing was quite successful in creating imitations of precious and semiprecious stones. Glass beads simulating turquoise and coral were, and still are, an item of export to Tibet and Mongolia. —T.T.B.

1. The pair of braid sheaths was not part of the original set. In an effort to assemble complete sets of jewelry, quite often the museum had to buy what was available, and thus many pieces come from different sets of jewelry.

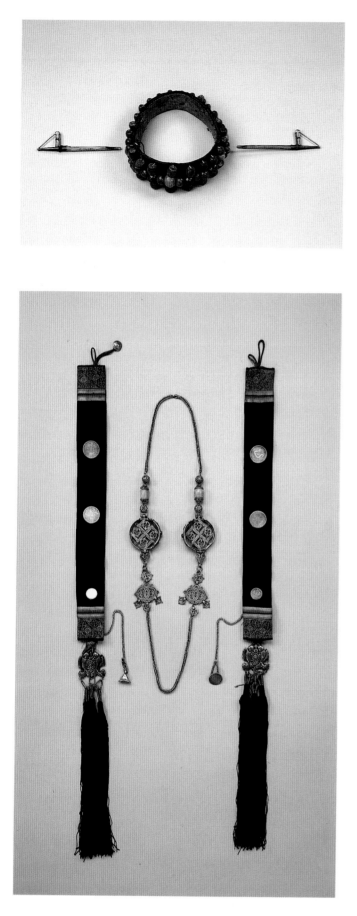

II. BURIAT JEWELRY

Early 20th century
Silver, coral, amber, copper, wood, velvet, and silk
Headband H: 2½ (6.4) Diam.: 9½ (24.0)
Braid cases H: 46⅞ (119.0) W: 5½ (14.0)
Necklace H: 27¼ (69.2)
Hairpins H: 6½ (16.5) W: 2⅛ (5.3)
Museum of Mongolian History

The Buriats are a tribe that historically has lived in the region around Lake Baikal. These pieces of jewelry, like the others in this exhibition, were worn by married women. The circular headband of reddish brown velvet is sewn with large beads of coral, amber, and lapis lazuli of varying sizes. A strand of nine smaller coral beads dangles from the back.

Among the pieces is a pair of wooden sticks inserted into copper cones. A copper tube with a rounded top, encased in silver, is soldered onto the copper cone at right angles to the stick. A twisted wire, attached to the pointed end of the copper cone, goes through the rounded top of the tube, makes a right-angle turn, and is tied to the end of the copper cone. These two contraptions were used to fix false hair in place,[1] right before the hair was fashioned into two braids and inserted into the braid cases. The tubes standing upright on the sticks held the headband in place.

The braid cases are made of black velvet decorated top and bottom with colorful bands of silk and brocade. They are ornamented with six Russian and Chinese silver coins ranging in date from 1875 to 1913. Attached to the braid cases are silver pendants, double-fish ornaments enclosing the Wheel of the Law, and six black tassels. A small silver ingot and coin dangle from the two chains hanging from the bottom of the cases.

A silver foxtail chain, worn suspended from the top of the head, bears intricate ornaments in silver filigree work. Starting from the top, they consist of two filigree balls made up of six coin motifs soldered together, amber beads with silver decoration, another pair of coin balls, and large circular ornaments enclosing swastikas and coins, the edges of which display more filigree work and were once inset with stones (only one coral bead remains). Below the circular ornaments are small *ruyi*, linked to coins, and queen's earrings with three coin dangles, again linked with a foxtail chain. The filigree work is of superb craftsmanship and is typically Mongolian, showing a fusion of Chinese and Tibetan Buddhist motifs.

This set of ornaments was purchased in 1983 from T. Samjid, in Bayan Uul sum, Dornod *aimag*. —T.T.B.

Published: Some of these pieces are included in Heissig and Müller, *Die Mongolen*, no. 90a,b

1. Boyer, *Mongol Jewelry*, pp. 29–30.

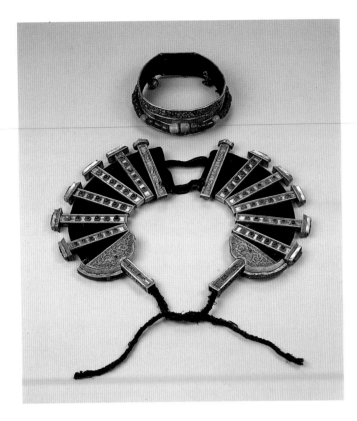

12. BARGA WOMAN'S ORNAMENTS

Late 19th century
Silver, coral, and amber
Headband H: 2⅜ (6.0) Diam.: 7⅛ (18.0)
Hairpiece H: 15 (38.0) W: 26¾ (68.0)
Pouches H: 21⅝ (55.0) W: 8¼ (21.0)
Front ga'u H: 17⅛ (43.5) W: 9⅛ (23.0)
Back ga'u H: 27⅜ (69.5) W: 32¾ (83.2)
Museum of Mongolian History

These ornaments, presented by parents of the Barga tribe to their daughters on their wedding day, were worn daily by the married women. The headdress and hair ornaments of a Barga woman signified that she had a husband and was the mistress of a family.

The silver headband is strung with thirty-three coral and amber beads. The band itself has two rows of decorations. The top band is ornamented with the attributes of the Eight Immortals of Chinese mythology: basket, flute, fish drum, fan, sword and fly whisk, castanets, gourd, crutch, and lotus. However, although normally only the sword is coupled with the fly whisk, the twin attributes of the immortal Lu Dongbin, in this instance, the fly whisk is shown with every one of the symbols mentioned above. This misunderstanding of Chinese iconography may indicate that this was the work of a Mongol craftsman, instead of an itinerant Chinese silversmith. The bottom row shows a mixture of Chinese auspicious symbols, bats and peaches for longevity, symbols of the four scholarly pursuits, mixed up with the Eight Buddhist Symbols. A decorative silver ball, incised with the *shou*, or longevity, character, dangles from the back.

Two pieces of Masonite covered with black cloth and decorated with T-shaped silver hair clasps simulate the hairpiece of the Barga women. A large number of stones is missing from this set and was replaced with glass beads in various colors.

All married women of Mongolia wore pouches, but the ones from the Barga tribe are outstanding for their large size. They were worn on both sides of the body, reaching down to the knees. The circular plaques bear raised swastikas (an auspicious Buddhist symbol) inset with coral and glass simulating malachite, surrounded by bands of filigree work. Pendants of various designs hang from chains attached to loops soldered to the large plaques. They consist of interlocking circular earrings (queen's earrings), a pair of circular ornaments with *ruyi* designs, and a pair of bell-shaped ornaments with endless knots. The side pouches were purchased in 1969 from Namjiliin Sugar, a citizen of the Khölönbuir sum of Dornod *aimag*.

Barga women wore amulet boxes on both front and back. These amulet boxes, or *ga'u,* were introduced from Tibet. The Barga women's *ga'u* are especially elegant. They were once filled with relics, printed prayers, and similar objects for warding off evil. The shrine-shaped amulet is decorated with the theme of the Buddha's first preaching in the Deer Park at Sarnath, India. The first preaching is usually equated with "setting the Wheel of the Law in motion" and is aptly represented by the wheel shown between two kneeling deer. The compressed space of the *ga'u* causes the wheel, surmounted by three jewels and ornamented with a scarf, to rise like a lotus blossom between the two animals. The bottom part of the ornament shows a relief of two dragons with tails raised confronting a bowl of offerings above the mountains and waves. Five green silk tassels, attached to the bottom loops, further ornament the piece.

The red brocade garment, worn on the back, is sewn with six more silver amulet boxes. Each of the round and square *ga'u* is crossed with a double *dorje,* except plantain

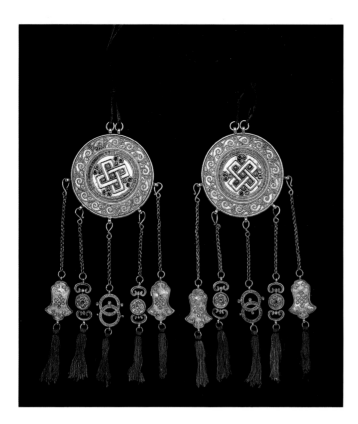

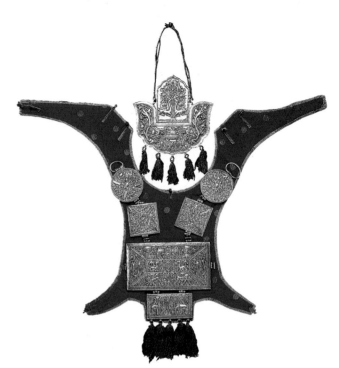

leaves take the place of the prongs of the scepter. On the round boxes, the lotus medallions in the center bear a *shou* character and the Eight Auspicious Symbols occupy the eight sectors. On the square boxes, a *yinyang* formed by two fish takes the place of the *shou* character, and the attributes of the Eight Immortals (see headband above) are separated by plantain leaves. The rectangular box, divided into five sections, shows the *khyung* bird above, two dragons on the side, and the "first preaching" motif in the center, while a tiger and a leopard roam among the peaks below. The wish-granting gem flanked by two elephants above mountain peaks ornaments the smaller box below, which is also attached with five silk tassels.

The workmanship of the *ga'u* is excellent, and the ornamentations show an interesting combination of Chinese decorative motifs and iconographic elements from Tibetan Buddhism. By the late nineteenth century, they were homogenized and absorbed into the Mongolian repertoire.

In August 1989 the museum purchased the front and back *ga'u* from Khölönbuir sum of Dornod *aimag*. The various parts of this set of Barga ornaments were all purchased separately. Due to years of unrest, it is almost impossible to find complete sets of these ornaments. In an effort to collect and preserve these relics of their culture, the officials of the Museum of Mongolian History make an effort to gather what they can, and exhibit them together as a set.

—T.T.B.

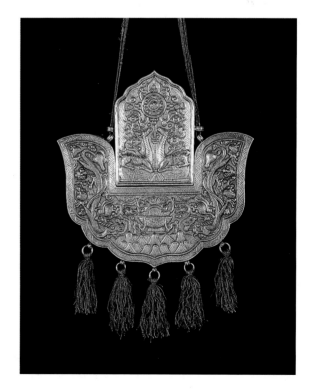

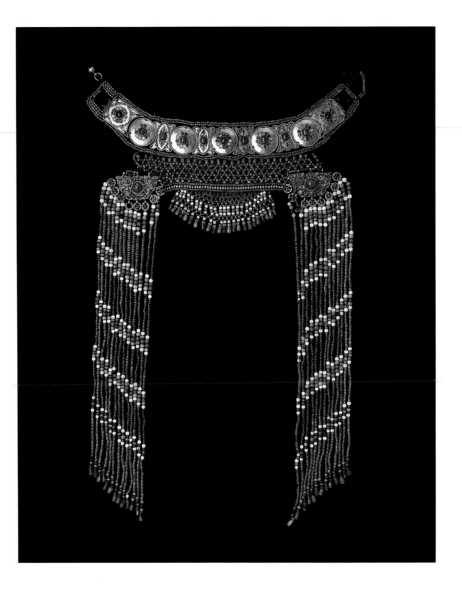

13. HEADDRESS OF AN UZEMCHIN WOMAN

Early 20th century
Enameled silver, coral, and turquoise on cotton
H: 25⅜ (64.5) W: 16⅛ (41.0)
Museum of Mongolian History

The married women of the Uzemchin tribe wore a head-dress of strung coral beads called a *shüren tatuurga,* or "coral cord." Compared to the headgear of the Khalkha ladies, the Uzemchin headdress is less ostentatious, and the emphasis is not on a vast amount of gold and silver but on coral beads and their elaborate threading.

The headband of black cotton bears eleven silver plaques (M: *daalintai*) cunningly fitted together and is decorated with red coral beads and colored enamels in yellow, turquoise, lapis blue, and aubergine. Below the headband is an intricate network of small coral, silver, and turquoise beads, beneath which is yet another, even finer, fringe of similar materials terminating in turquoise and coral teardrops. The latter

fringe framed the forehead perfectly, with the teardrop beads covering the eyebrows. On the two sides are gilt butterfly-shaped pendants, with enameling in turquoise and auber-gine. Each of the butterflies is strung with eight silver coin-shaped ornaments, from which hang thirteen beaded tassels. The sections of coral beads are separated by white glass, carnelian, and turquoise beads. Similar to the fringe above, the tassels also terminate in teardrop-shaped coral and turquoise beads.

The headband was secured by attaching the two loops on one end to the silver buttons on the opposite end. Only one silver button remains, and it is decorated with a Chinese *shou,* or longevity, character. The silver button is of Chinese workmanship. The turquoise and aubergine enameling on silver is typical of the jewelry made in Beijing earlier this century.

This headdress was purchased in 1983 from a herdsman of Sergelen sum, Sükhbaatar *aimag.*　　　—T.T.B.

Published: Heissig and Müller, *Die Mongolen,* pl. 94

Renaissance and Reincarnation

PATRICIA BERGER

In 1691 the First Bogdo Gegen of Urga (T: Jebtsundamba), Öndür Gegen, or Zanabazar, as he is popularly known, was at the Manchu court in Beijing. There, his wisdom and miraculous powers won the admiration of the Kangxi emperor and his pious mother, leading the Empress Dowager to ask her son, "Is the Blessed One a Bodhisattva or a Buddha?" The emperor replied, "The Dalai Lama, the Panchen Erdeni and the Jebtsundamba, these three, are lamas who from many ages past have been Buddhas."[1] In Kangxi's day the Dalai and Panchen Lamas and the Bogdo Gegen had all been recognized as Buddhism's three most important incarnations (M: *khubilgan*; T: *tulku*), enlightened teachers who had renounced nirvana to reappear in physical form in fulfillment of the bodhisattva's vow to save all sentient beings.

The concept of the *nirmanakaya,* the visible emanation body assumed by a Buddha or bodhisattva, is as old as Mahayana Buddhism, but reincarnation or directed rebirth is a refinement that emerged in Tibet only in the fourteenth century, created perhaps more out of political than spiritual necessity, in response to an impetus that came from the Mongols.[2] By that time, Tibet was already under Mongol rule, administered by the Sakya order, an arrangement that began when Khubilai Khan named the Sakya lama Phagspa his Imperial Preceptor (cat. no. 14). Lamas of other orders had also come to proselytize among the Mongols, however, most notably Karma Paksi (1206–1283), the second head of the Karmapa, who visited Khubilai's camp in 1255 but eventually accepted the patronage of Möngke, Khubilai's elder brother.

Over the following decades, the power of the Sakyapa grew with Khubilai's protection. Its lamas were not celibate; they married, raised families, and passed on their positions to their sons, and as administrators for the Mongols in Tibet, they amassed enormous wealth, eventually rivaling the country's aristocratic clans. The instability this accumulation of wealth created may have been the reason the Mongols decided to invite the Third Karmapa, Karma Paksi's successor, to the enthronement of their new emperor, Toghon Temür, in 1333. The Karmapa was a celibate suborder of the Kagyupa, and Toghon Temür may have seen them as an alternative to the partisan, family-based Sakyapa. The Third Karmapa had also made a startling assertion; even as a child he had claimed to be the rebirth of Karma Paksi himself, not just his appointed heir. In acknowledgment of this, the invitation the Mongol court issued to him included the golden seal Möngke had given to Karma Paksi, returning it to the Karmapa's current incarnation and its rightful owner.

The Third Karmapa stayed at the Mongol court until his death in 1338, which he claimed was magically brought about by an evil official. Before he died, he predicted when and where his rebirth would take place, assuring his own control over the continuance of the Karmapa lineage. He is believed to be the first Tibetan lama to have done so, and his prediction, quickly fulfilled, set an important precedent— now even celibate orders, the Kagyupa, the Kadampa, and eventually the Gelugpa, could perpetuate their leadership through reincarnation. It was a mechanism that avoided rivalry between potential heirs to the throne and obviated oedipal turmoil between father and son (since the "father" was dead before his heir could be conceived).

Sixteen years later, in 1354, the Sakya regency in Tibet crumbled, and Toghon Temür made no move to come to their aid. Nine years earlier, by imperial command, the Juyong Gate was dedicated north of Beijing, complete with an inscription in five languages honoring Khubilai, for the first time, as an incarnation of Manjushri, China's Bodhisattva of Wisdom.

Mongolia's politics were literally motivated by the recognition of incarnations and reincarnations during the period of cultural reawakening from the sixteenth through the

early twentieth centuries, when newfound spiritual lineages were offered up to support the imperial pretensions of Mongols and Manchus alike. Ligdan Khan claimed direct descent from Chinggis and even took his title as his own. Altan Khan exchanged honors with the Gelugpa lama Sonam Gyatsho, a third-generation disciple of Tsongkhapa (cat. no. 15), and became the new Khubilai to his Dalai Lama's Phagspa, symbolically reconstructing the Tibeto-Mongolian alliance of the thirteenth and fourteenth centuries.

Further refinements were added to the Dalai Lama's charismatic persona during the lifetime of the Great Fifth, who promoted the idea that the Dalai Lamas were actually incarnations of the Bodhisattva of Compassion, Avalokiteshvara, one of the primordial parents of the Tibetan people, who had also manifested himself in Songtsen Gampo, Tibet's first Buddhist monarch. The Fifth Dalai Lama expanded on this metaphor by recognizing his beloved teacher, Losang Chökyi Gyaltsen, as a manifestation of Amitabha, Avalokiteshvara's heavenly father, and establishing him at Tashilunpo as the Panchen Lama.

Other links with the transcendent realms of Buddhism were being forged simultaneously by the Manchus, whom the Fifth Dalai Lama recognized as fulfilling a prophecy made during his third incarnation that Manjushri would return to the center (i.e., China) and unite Tibet, Mongolia, and China into a single Buddhist empire. In 1640 he and the Panchen Lama wrote to the Manchu leader, Huang Taiji, addressing him as the "Manjughosha [Manjushri] Great Emperor," and justifying his right to rule not just China but also the whole of Khubilai's empire. Soon, the Manchus were calling themselves Khubilai, just as Altan Khan had done.[3]

The Khalkhas of Outer Mongolia were no less active in establishing Buddhist bona fides for themselves. Abadai Khan, born a direct descendant of Chinggis, went to great lengths to have Sonam Gyatsho, the newly named Dalai Lama, come to Khalkha and conduct a full inauguration of Erdeni Zuu, the monastery Abadai had built there in 1586. His devotion won him recognition as an incarnation of Vajrapani,[4] and this tradition continued to adhere to his great-grandson, Zanabazar, who became the First Bogdo Gegen of Urga.

Zanabazar's precise spiritual affiliations are not as clearcut as those of the Dalai and Panchen Lamas. When he traveled to Tibet in 1649 to receive consecrations from their hands, he was initiated first into the mysteries of the *vajra-* (thunderbolt) bearing bodhisattva, Vajrapani (or Vajradhara, the transcendent Adi-Buddha), but his later portraits often show him holding the attributes—bell and *vajra*—of Vajrasattva, a deity whose nature is intertwined with that of Vajradhara (cat. no. 99). At least one nineteenth-century biography describes him as an incarnation of Manjushri, the Bodhisattva of Wisdom who simultaneously manifested

himself in the Manchu emperor (and earlier in both Khubilai and Tsongkhapa).[5] Still another theory suggests that Zanabazar was an incarnation of Maitreya, the Buddha of the Future whose rituals and prayers he personally practiced and especially promoted in Khalkha.[6]

The line of his spirit's human manifestations is much clearer, because while Zanabazar was in Tibet, the Fifth Dalai Lama declared him the rebirth of Taranatha, the great scholar of the Jonangpa, whom the Gelugpa looked on as rivals. By adopting Taranatha's spiritual identity, Zanabazar inherited a history of preincarnation stretching back to the disciples of Shakyamuni himself. Fifteen of his prebirths left their marks on human history; untold others were born intermittently over a period of two millennia, in different universes, to benefit other sentient beings (cat. no. 17).[7]

The Bogdo Gegens of Urga were allowed to be reborn seven more times after Zanabazar's death; all but Zanabazar and his first successor were Tibetans, chosen with the approval of the Qing Manchu government in an effort to limit the consolidation of Khalkha power. Three final candidates were nominated, representing the spirit, word, and body of the incarnation; of these only one, the spirit *khubilgan,* would eventually travel to Urga to be enthroned, while the other two remained in monasteries founded by Taranatha. The choice was made in Lhasa, in the presence of the Dalai and Panchen Lamas and the Manchu *amban* (administrator), who supervised the drawing of the candidate's name from a golden *bumba* (vessel). A new incarnation was usually picked at the age of one-and-a-half or two years, and he spent his earliest years in Tibet with his parents at Taranatha's monastery, Dakdan Puntsagling, which had been converted to Gelugpa use. Preparations for bringing him to Mongolia were long, costly, and carefully planned; the Russian Mongolist Aleksei Pozdneyev reported that it took two or three years to organize the trip to fetch a new Bogdo Gegen, and that it cost about 350,000 silver rubles to bring the eighth incarnation home.[8] Often, the Gegen would stop in Jehol or Dolonnor to pay his respects to the Qing emperor and, most especially, to the Jangjya Khutuktu, Inner Mongolia's greatest incarnate-lama. Then he would assume his position in Urga, where, in later years, he was forced to remain unless he had the express permission of the Qing emperor to travel. Despite these inconveniences and restraints (many of which they ignored), the Bogdo Gegens were very wealthy, reborn into vast estates with thousands of *shabinar* (serfs), and monasteries whose storehouses were full of works of art, household goods, food, and cash.

The Bogdo Gegens were expected to spend their lives in spiritual pursuits, an imperative that became clearer from the time of the Qianlong emperor (r. 1736–95) on. In fact, several of them made notable contributions to Buddhist literature, art, ritual, and practice, but, by the mid-nineteenth

century, the dynamism of the line seemed to have dissipated. Its very survival was cast into doubt when the fifth and sixth died very young, and, with the death of the eighth in 1924 (by then crowned Bogdo Khan, emperor of Mongolia), the Mongolian government refused to allow his successor to be enthroned. This rebirth, who would have been the ninth of the line, was found in Mongolia proper and now lives in Dharamsala, the Indian refuge of the Fourteenth Dalai Lama.

Zanabazar was far from being the only incarnate-lama in Mongolia. Indeed, by the nineteenth century, there were hundreds of them, many of whom lived in Beijing in the Yellow Monastery (C: Huang si),[9] and most Mongolian monasteries of any size had one or more resident *khubilgan*. They added status and charisma to the institutions they graced, but, with few exceptions, they were swept away by the radical changes that transformed Mongolia in the 1930s.[10]

1. Bawden, *The Jebtsundamba Khutukhtus of Urga*, p. 53.

2. Although the great Tibetan sage Marpa (1012–1096) possessed the secret of projecting his spirit into a recently dead body, a technique he passed on to his son, where its transmission ended. Tucci, *The Religions of Tibet*, pp. 35–36. For a discussion of reincarnation's first appearance among the Karmapa, see Wylie, "Reincarnation: A Political Innovation in Tibetan Buddhism."

3. Farquhar, "Emperor as Bodhisattva," pp. 19–20.

4. Bawden, *The Jebtsundamba Khutukhtus of Urga*, p. 35.

5. Kämpfe, "*Sayin Qubitan-u Süsüg-ün Terge,*" 13 (1979), pp. 95–96.

6. Schulemann, *Geschichte der Dalai-Lamas*, p. 220.

7. Pozdneyev provides a list of Zanabazar's fifteen earthly preincarnations; see *Mongolia and the Mongols*, pp. 321–22.

8. Ibid., pp. 369–71.

9. Dozens of *tulku* still live there, gathered from monasteries all over Tibet and Mongolia.

10. The lives of two modern incarnations, each the last of his line, have been recorded. One is the Diluv Khutagt, an Inner Mongolian incarnate-lama who was deeply involved in the political events of the 1920s and '30s. His reminiscences were recorded in a lengthy interview by Lattimore and Isono, *The Diluv Khutagt*. The life history of another Inner Mongolian incarnation can be found in Hyer and Jagchid, *A Mongolian Living Buddha: Biography of the Kanjurwa Khutughtu*.

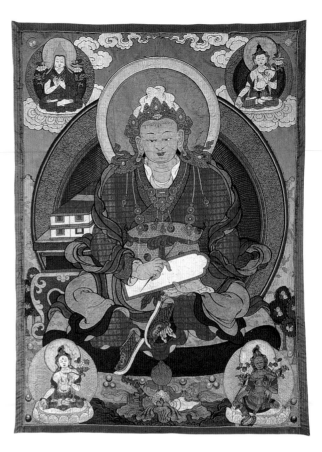

14. PHAGSPA LAMA

Uran Namsarai (d. 1913)
Early 20th century
Silk appliqué
H: 61⅜ (155.0) W: 44⅜ (112.6)
Museum of Fine Arts

Phagspa (1235–1280) was a Tibetan who played a very important role in the history of Mongolia. In 1244, as a young prince of Sakya, Phagspa, together with his brother Chanadorje, accompanied their uncle Sakya Pandita (1182–1251) as hostages to meet Godan Khan, second son of Ögödei. Sakya Pandita surrendered Tibet to the Mongols in order to avoid bloodshed and mass destruction, but he succeeded in converting Godan Khan to Buddhism. Thus began the *chöyön,* or "patron and priest," relationship between the Mongol rulers and the Sakyapa monks of Tibet. After the death of Sakya Pandita, Phagspa took his place and became Khubilai Khan's mentor (see Berger, "After Xanadu"). He became the State Preceptor of the Yuan dynasty in 1260 and the Imperial Preceptor ten years later, when he was given temporal power over all of Tibet. When Khubilai Khan asked for artists and craftsmen, it was Phagspa who recommended Anige, the phenomenal Nepalese artist who came to Dadu in 1260 with twenty-four artisans and contributed greatly to the art of the Yuan dynasty.

This stately appliqué emphasizes yet another aspect of Phagspa; he was the creator of the square-headed Phagspa script, the official script of the Yuan dynasty (see Bosson, "Scripts and Literacy," fig. 4). This script was used on all official documents and seals (see cat. no. 96).

Phagspa, in princely costume, sits with left leg bent and right leg pendant on a pile of cushions. His hair is covered with a piece of silk in the manner of the Tibetan kings, and he wears elaborate jewelry. The silk pieces for his costume were carefully chosen. His red robe is woven with gold *shou,*

or longevity, characters, a colorful contrast to the more somber gray scarf, which billows from his elbows in the same style as the scarf of the silver Amitayus (cat. no. 67). The stack of books on the table behind him indicates his great scholarship, while the stylus and tablet reveal him as the creator of the official script of the Yuan dynasty.

The clouds in the sky support two figures enthroned on lotus pedestals. The lama on the left wears a yellow hat and carries the sword and book. Although these attributes of Manjushri usually identify the figure as Tsongkhapa, the founder of the Gelug order, they are also the symbols for Sakya Pandita, Phagspa's uncle. The deity on the right depicts the white form of Manjushri, the Bodhisattva of Wisdom. He lowers his right hand in *varada mudra,* the gift-bestowing gesture, while his right hand, raised in *vitarka mudra,* the gesture of argument, carries a lotus upon which rest the flaming sword and the book of transcendent wisdom. Sakya Pandita, Tsongkhapa, as well as Phagspa are all incarnations of the Bodhisattva of Wisdom.

The White and Green Taras (the latter of which appears to be more blue than green) are seated beneath Phagspa. A lotus emerges from the lake below, carrying the peaceful offering of the five senses: a mirror for sight, a musical instrument for sound, fruit for taste, sweet curds in a conch for smell, and a knotted silk scarf for touch.

Women seamstresses, under the direction of the artist Uran Namsarai, created this wonderful work in the early twentieth century at Urga.　　　　　—T.T.B.

Detail of base.

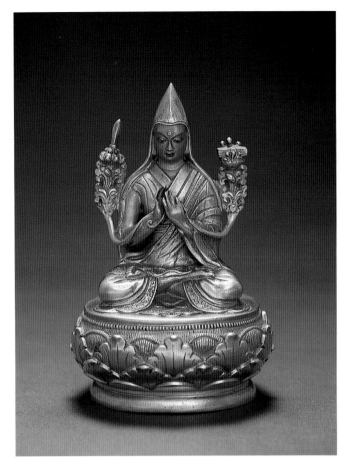

15. TSONGKHAPA

School of Zanabazar
18th–19th century
Gilt bronze
H: 5⅛ (13.0) W: 3½ (8.9)
Museum of Fine Arts

Tsongkhapa (1357–1419) was one of the greatest religious figures of Tibet. He was a native of Amdo, near Kokonor in what was northeastern Tibet. An excellent scholar, he revived the Buddhist religion in a purer form. He founded the Gelug (Virtuous) order, whose members are distinguished by their yellow hats and are well known for their celibacy, monastic discipline, and scholarship. Both the Dalai and the Panchen Lamas are from this order. The Gelugpa and the Mongols came to depend on one another for support and power. The Gelugpa lama Sonam Gyatsho, the Third Dalai Lama, converted the Mongol ruler Altan Khan, who gave him the title Dalai (see Rossabi, "From Chinggis Khan to Independence," and Berger, "After Xanadu"). Thereafter the Gelugpa played an important role in the religious and political life of Tibet.

Tsongkhapa instituted the Monlam, or Festival of Great Prayer, during the New Year at the Jokhang Temple in Lhasa; this became the most important gathering in Lhasa until 1959 (see cat. no. 44). Tsongkhapa also founded the Ganden (Joyous Mountain) Monastery in 1409. His students in turn established Drepung (1416), Sera (1419), and Tashilunpo (1447). Ganden, Drepung, and Sera, illustrated in catalogue number 44, are among the temples where Mongolian monks furthered their education. In 1578 Kumbum Monastery was founded at Tsongkhapa's birthplace in Amdo. This monas-tery was closest to Mongolia and thus attracted many Mongolian students. The First Bogdo Gegen, Zanabazar, stopped at Kumbum on his way to Lhasa in 1649 (see Berger, "After Xanadu").

In this sculpture, Tsongkhapa wears monastic robes and the peaked yellow hat with the long flaps typical of his sect. He is always shown as a monk with a peaceful face. With eyes downcast, he sits in the posture of meditation (dhyana-sana) upon the lotus throne. His hands, in the gesture of preaching (dharmachakra mudra), hold the ends of two lotus blossoms, which in turn support the sword of wisdom which cleaves the clouds of ignorance, and the book of transcendent wisdom. These are also the attributes of Manjushri, the Bodhisattva of Wisdom; Tsongkhapa is believed to be his emanation.

Tsongkhapa's drum-shaped throne is one of the types favored by the sculptors of the Zanabazar school. The shape of the petals is also characteristic of the school. There are two rows of alternating serrated lotus petals, pointing upward, each incised with five lines. Oval clumps of stamens appear between the petals of the top row, and above them is a continuous row of carefully incised stamens, bordered by a row of pearl beading. It is fortunate that the sculpture's base plate is intact. It shows a gilded double dorje, again a trademark of the Zanabazar school of sculpture. —T.T.B.

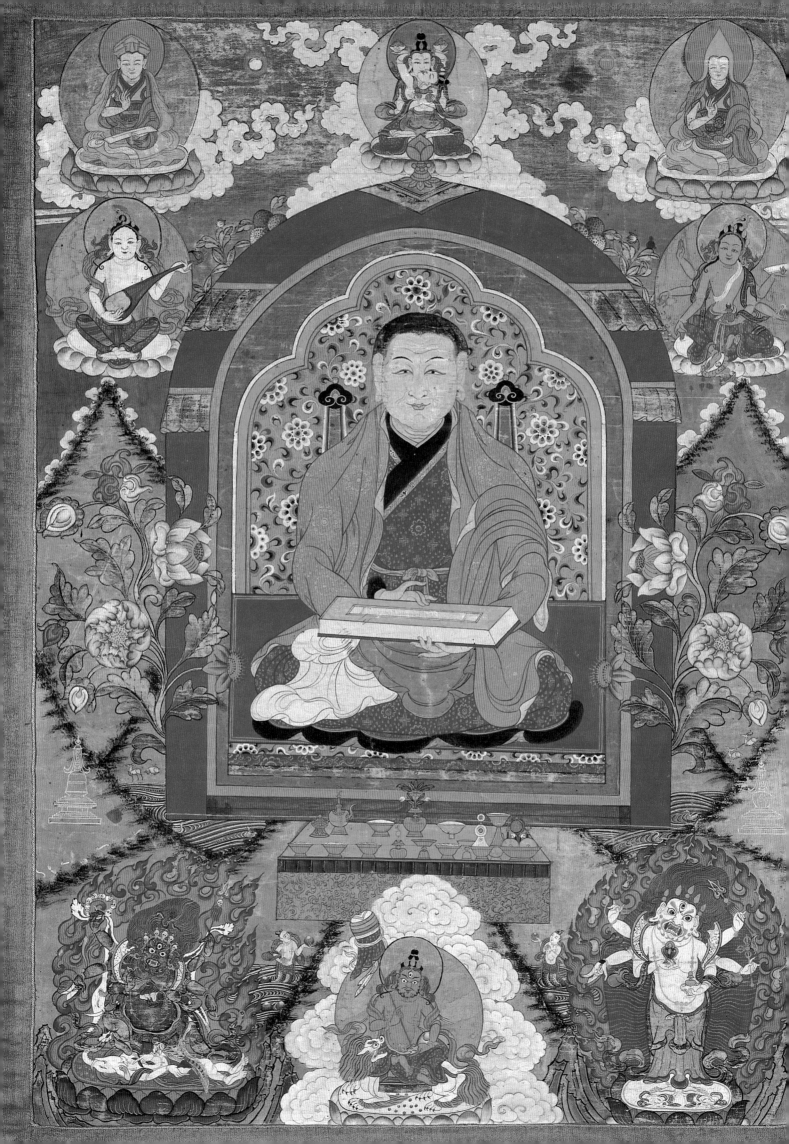

16. PORTRAIT OF ZANABAZAR

Attributed to Zanabazar (1635–1723)
Late 17th–early 18th century
Colors on cotton
H: 35¾ (90.8) W: 27½ (69.7)
Museum of Fine Arts

This fine portrait of the First Bogdo Gegen, Zanabazar, is traditionally said to be a work of his own hand, although there is no evidence beyond his great reputation as an artist to support the claim. Zanabazar is best known for his bronze sculpture, and, if historical records can be trusted, he also worked as a painter. The nineteenth-century Mongol historian Dharmatala, for example, wrote that in 1657, when Zanabazar was invited to an assembly at Erdeni Zuu, he both taught and painted the Full Perception and made three large figures of gold to present to the Manchu emperor.[1] Erdeni Zuu, founded by Zanabazar's great-grandfather, Abadai Khan, was the repository of this portrait until recently. Zanabazar never took up permanent residence within its walls, probably because his affection for the Gelugpa made it politically inexpedient to live in a monastery that had been consecrated by a Sakya lama and generally followed Sakyapa rules. But he was often invited to Erdeni Zuu to be honored by the Khalkha nobility (for it was Khalkha's oldest Buddhist monastery), and in 1653 he built a retreat for himself nearby, called Shibeetü-uula, where he set up a forge.

Zanabazar is shown isolated by an arched frame, within which he sits on a shallow, lotus-shaped cushion against a flowering backdrop that recalls Chinese brocaded silk. Peonies, flowers that in China signify prosperity, curl luxuriously from behind his enclosure. He holds a sacred text in his lap as a mark of his great erudition. Offerings are laid out before him on a low platform; the stemcups and bowls that hold them are also classic Chinese shapes.

Protective and auspicious deities and patrons surround the central image of Zanabazar. Below are the god of wealth and Guardian of the North, Vaishravana (center); and two forms of Mahakala, blue (left) and white (right), the *dharmapala* whose significance for the Mongols dated back to the time of Khubilai Khan. The six-armed White Mahakala is both a god of wealth and the special protector of Mongolian Buddhists.

Hovering in the sky above are Vajrasattva and his consort in sexual embrace (top); Vajrasattva/Vajradhara were strongly linked to Zanabazar, who is often depicted holding Vajrasattva's attributes, the *vajra* and bell. In the upper left and right corners are the First Panchen Lama and the Great Fifth Dalai Lama, both of whom brought Zanabazar into the Gelug order and granted him sacred initiations. Just below them are two female bodhisattvas—Sarasvati (left, holding an Indian *vina*, or lute), goddess of music, poetry, learning, knowledge, and speech, and Vasudhara, goddess of abundance (right).

Several aspects of this portrait suggest that a Chinese-influenced hand may have been at work. Details like the Chinese brocaded silk backing Zanabazar's throne and the Chinese-style porcelains lining his offering table can be explained by the avid trade and exchange of gifts between China and Mongolia, which was enthusiastically revived with the founding of the Manchu Qing dynasty in 1644. Other elements, such as the exuberantly blooming peonies and fuzzily outlined triangular hills, which appear also in a portrait of Zanabazar's mother, the Khansha Khangdajamts (fig. 1), were the stock in trade in the eighteenth century of the lama-artists who worked at Jehol (Chengde), the Manchu summer retreat northeast of Beijing. These painters were often called upon to record the regular meetings that took place in Jehol between the Manchus and their Mongol vassals (see Berger, "After Xanadu"). Aleksei Pozdneyev noted, for example, that the Qianlong emperor ordered his Chinese painters at Jehol to do a portrait of the Third Bogdo Gegen, which he sent back to the lamas in Urga after the Gegen's premature death in 1773.[2] Visual memorials of this kind helped the Manchus maintain and proclaim the

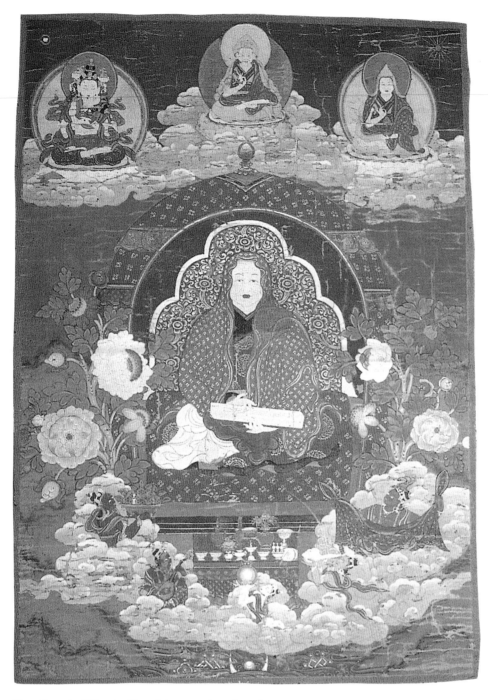

Fig. 1. Portrait of Khansha Khangdajamts, mother of Zanabazar, 18th century. Colors on cotton. Museum of Fine Arts, Ulaanbaatar. From Tsultem, *The Eminent Mongolian Sculptor—G. Zanabazar,* pl. 94.

legitimacy of their rule over Mongolia, and it is possible that Zanabazar's portrait was done, not by himself, but by an artist working in the Manchu court, after the Khalkha prelate visited Dolonnor and Beijing in 1691 to seek Manchu protection against the invasion of the Zunghars. —P.B.

Published: Tsultem, *The Eminent Mongolian Sculptor—G. Zanabazar,* pl. 93; Béguin et al., *Trésors de Mongolie,* fig. 4, p. 33

1. Dharmatāla, *Rosary of White Lotuses,* p. 339.

2. Pozdneyev, *Mongolia and the Mongols,* p. 354.

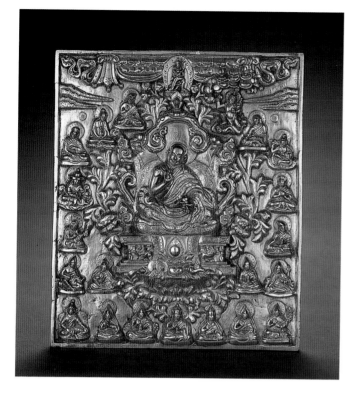

17. ZANABAZAR AND HIS PREINCARNATIONS

18th century
Gilt bronze
H: 9¾ (24.9) W: 8¾ (21.4) D: 1 (2.5)
Tev Aimag Museum

varahi (Diamond Sow), above his throne back. Immediately clockwise Vajravarahi reappears with her skull-encrusted staff, skull cup, and chopper, followed by thirteen seated figures, the preincarnations, who seem to grow out of the foliage surrounding Zanabazar's throne. Seven more figures, including a prince, four lamas wearing pointed caps, and two other royal personages (center), sit below in a row.

Tsultem's identification of the subject of this plaque, a theme repeated in an identical clay plaque in his own collection (fig. 1), presents an interesting conundrum, however, for Zanabazar is traditionally said to have had fifteen (and not thirteen) rebirths on earth over a period spanning 2,596 years, from the time of Shakyamuni to the death of Taranatha. (He also had innumerable other rebirths in other worlds during this time.) The thirteen figures surrounding Zanabazar are each carefully differentiated according to type, and these types (if not their numbers) match a list of Zanabazar's preincarnations given by Aleksei Pozdneyev, which he based on a record kept in the treasurer's office in Urga. (Pozdneyev warned, however, that the list varied from monastery to monastery.)¹ Of the preincarnations shown on the plaque, some are *mahasiddha,* the great adepts of ancient times; others are lamas with pointed hats; one, immediately to the left of Zanabazar, carries a *phurba* (ritual knife) and is dressed like a *shanag,* the tantric adept of the *tsam* (see cat. no. 41). Together, they convey a sense of the richness and diversity of the tantric lineage Zanabazar inherited.

—P.B.

1. Pozdneyev, *Mongolia and the Mongols,* pp. 321–22 and 473 n. 80.

It was not until the fourteen-year-old Zanabazar traveled to Tibet in 1649 that the Great Fifth Dalai Lama recognized him as an incarnation of the lama-historian Taranatha and gave him an incarnation lineage that stretched back more than two millennia to the time of the historic Buddha, Shakyamuni. The motivations for this grant were just as political as they were spiritual. Taranatha belonged to the Jonangpa, an order affiliated with the Sakyapa. Like the Kagyupa, the Sakyapa and Jonangpa stood in the way of Gelugpa control over Tibet, and sectarian rivalry had broken out into open warfare by the early decades of the seventeenth century. Taranatha had, moreover, successfully missionized in Mongolia, an old Sakyapa stronghold, and established several temples there before returning to Tibet. The Great Fifth was able to neutralize Taranatha's influence in Mongolia by his enthusiastic reception of Zanabazar, which essentially shifted Khalkha loyalty from the Sakyapa to the Gelugpa.

According to the Mongol art historian N. Tsultem, this cast gilt bronze plaque shows Zanabazar surrounded by his many preincarnations. He sits in the center on a lion throne, holding his attributes, the bell and *dorje,* with the offerings of the five senses arrayed below him, and the patron deity (*yidam*) Chakrasamvara, who embraces his consort Vajra-

Fig. 1. Portrait of Zanabazar and the appearances into which his spirit was reborn, 18th century(?). Clay with pigments. Private collection of N. Tsultem, Ulaanbaatar. From Tsultem, *The Eminent Mongolian Sculptor—G. Zanabazar,* pl. 3.

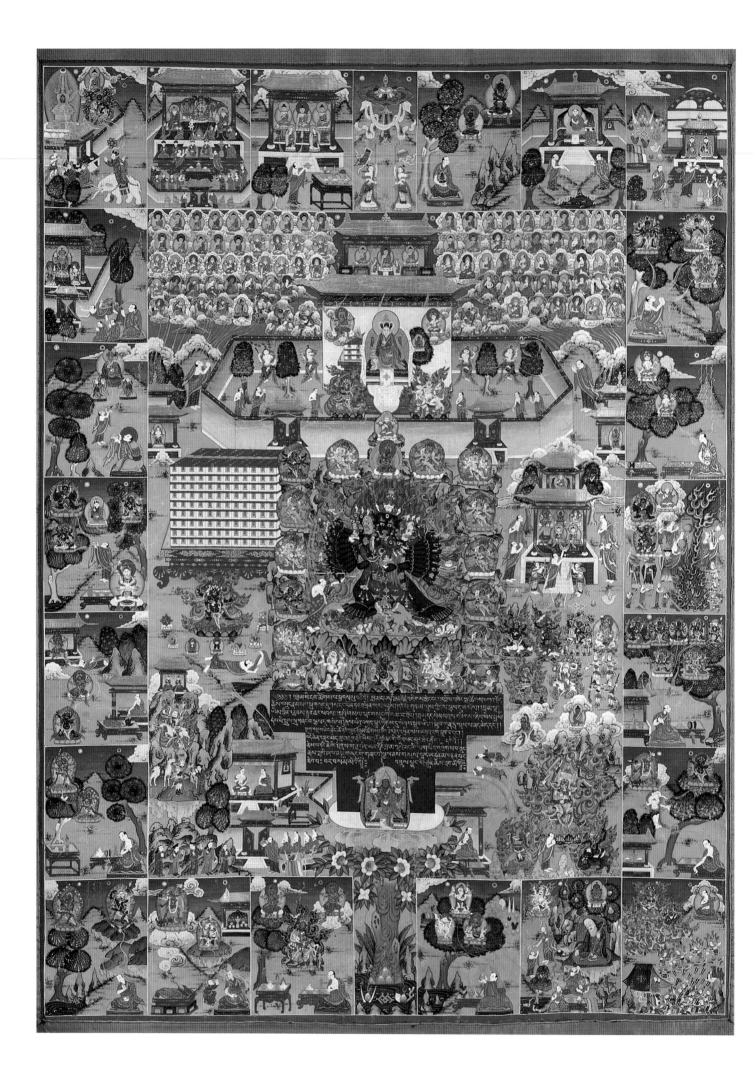

```
┌─────┬─────┬─────┬───┬────┬─────┬──────┐
│  1  │  2  │  3  │ 4 │ 5  │  6  │  7   │
├─────┴──┬──┴─────┴───┴────┴──┬──┼──────┤
│  23    │                    │  │  8   │
├────────┤          B         │  ├──────┤
│  22    │                    │  │  9   │
├────────┤    D          G    │  ├──────┤
│  21    │          A         │  │  10  │
├────────┤                    │  ├──────┤
│  20    │                    │  │  11  │
├────────┤    E      C     F  │  ├──────┤
│  19    │                    │  │  12  │
├─────┬──┴──┬─────┬──┬────┬───┴──┼──────┤
│ 18  │ 17  │ 16  │  │ 15 │  14  │  13  │
└─────┴─────┴─────┴──┴────┴──────┴──────┘
```

18. MEDITATIONS OF THE BOGDO GEGEN

Late 19th–early 20th century
Colors on cotton
H: 104⅝ (265.7) W: 59⅝ (151.4)
Bogdo Khan Palace Museum

This masterful and complex thangka is a visual hagiography of the Bogdo Gegens of Urga, revealing their spiritual epiphanies, perhaps through many rebirths. It is also a schematic theology and history of the faith, which diagrams the relationship between meditator and deity and recalls the most significant moments in the reconversion of Mongolia to Buddhism. The anonymous artist has chosen a traditional composition that subtly reinforces the distinction between events as we perceive them and the true nature of things, which can only be revealed symbolically. He accomplishes this end by arranging a series of twenty-three lively, historic episodes around a field with three main iconic focuses: the central image of the protector of the Gelugpa, the thirty-four-armed Yamantaka (A), shown *yab-yum* with his consort and surrounded by protector deities (fig. 1); the portrait above of Zanabazar (B), the first to bear the title Bogdo Gegen (T: Jebtsundamba; fig. 2); and the portrait below (C) of the Tibetan-born eighth and last of the line (1870–1924; fig. 3). The Eighth Bogdo Gegen sits on a throne against a dark blue backdrop inscribed with a long prayer in Tibetan, invoking the Buddhas, bodhisattvas, and tutelary deities. This prayer also provides a stage for Yamantaka and his retinue. The whole towering three-part central structure rises up from a flowering tree whose roots are submerged in waves.

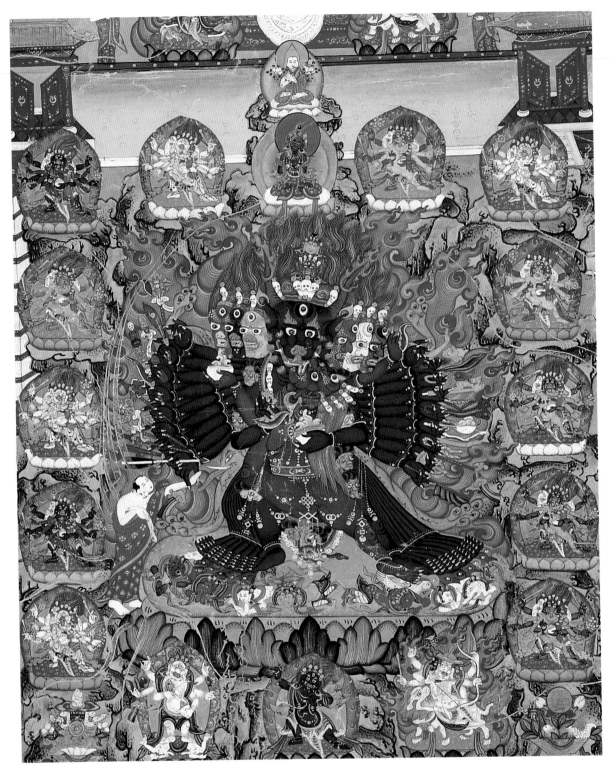

Fig. 1. Detail of Yamantaka (A).

Zanabazar appears in his guise as Chakravartin-ruler, wearing a hat decorated with a *dorje* (S: *vajra*) and holding his attributes, the bell and *dorje*, which signal his relationship to Vajradhara and Vajrasattva, the entwined forms of the Adi-Buddha and supreme source of the esoteric Vajrayana. The second story of Zanabazar's palace-shrine is occupied by the Buddhas of the Three Times (Kashvapa, Buddha of the Past Time; the historic Buddha, Shakyamuni, attended by his disciples Ananda and Kashyapa; and the Future Buddha, Maitreya). Their presence reinforces the equation of the Bogdo Gegen with Vajradhara / Vajrasattva, because the Adi-Buddha is "the embodiment of the Buddhas of the Three Times, the nature of the Triple Gem, and the essence of the three kayas (bodies) of the Buddha."[1] Directly above Zanabazar, hovering to the right and left, are the White and Green Taras, with whom he had a special spiritual link (see cat. nos. 103–106), and below him are Begtse (left), protector of the Bogdo Gegens and Dalai Lamas, and the white, lion-mounted Pehar (right), chief of the Five Kings and guardian of monasteries.

Images that reiterate great moments in the history of Mongolian Buddhism are scattered around the central iconic block containing Yamantaka and his protective force. The large stack of sutras to the left (D) is the Tibetan Buddhist canon, the Kanjur, which was translated into Mongolian in 1628–29 with the patronage of Ligdan Khan. Ligdan's rare handwritten edition was later revised, edited, cut into woodblocks, and printed at the order of the Kangxi emperor in 1717–20.[2] Below this sacred library, the Bogdo Gegen can be seen flying above a pavilion where he sits with Manjushri (of whom Yamantaka is a manifestation), in a composition that recalls the sacred conversation between the Bodhisattva of Wisdom, Manjushri (whom at least one text says Zanabazar embodied),[3] and the pious householder, Vimalakirti (E). This meeting also underscores how important the con-

version of the Bogdo Gegen's lineage to the Gelugpa was to Tibet's religious hierarchy, for the Gelugpa's founder, Tsongkhapa, was Manjushri-incarnate.[4] The Bogdo Gegen above flies toward Yamantaka himself, a bit of narration that may refer tangentially to the First Bogdo Gegen, Zanabazar, and his miraculous flight to visit the Panchen Lama in 1655. It was from the Panchen Lama that Zanabazar received the empowerment of Yamantaka, an act that strengthened his link to Tsongkhapa's spiritual legacy (see cat. no. 90). In the bottom left corner is a scene (F) identified by a gilt inscription in Mongolian as the Bogdo Gegen's obeisance to the "Red Buddha," or Begtse, the war god who subsequently became his and the Dalai Lama's special protector.[5]

The episodic border scenes that surround this multipart central image are also identified by Mongolian inscriptions, and they similarly establish a spiritual inheritance for the Bogdo Gegens that enmeshes them in a complex web of connections to the Gelugpa, to the older Sakyapa, to Mongolia's shamanist base, and to its Manchu overlords. These scenes unfold clockwise, beginning in the upper left corner, where, in an uninscribed vignette (1), a child (Zanabazar?) and an aristocratic adult (his father, the Tüsheet Khan?) ride toward a radiant stupa graced by Shakyamuni and guarded by Lhamo, chief protectress of the Gelugpa. Immediately to the right (2) an elaborate ceremony is underway, attended by nobles, monks, and *mahasiddha*; the inscription is ambiguous, stating that this was "How the great saint Aqa Burung [Dayan Gegen] and our Vajradhara Bogdo Lama with increasingly great serenity performed the bow (or Dharma) festival." Following this, left of center, the Bogdo Gegen receives the endowment of power *(abhisheka)* from the Buddhas of the Three Times (3), and, right of center, he "absorbs in his own heart" the image of Vajradhara, shown first with his consort, then singly, and finally as an image that the Bogdo Gegen cradles in his arms (5). Next the Bogdo Gegen

Fig. 2. Detail of Zanabazar in his palace (B).

Fig. 3. Detail of the Eighth Bogdo Gegen (C).

Fig. 4. Detail of scenes 5–7.

receives the "power of the Dharma, and the bell and *dorje*" from the Fifth Dalai Lama (6), and, in the upper right corner (7), he bestows a consecration and blessings on the Kangxi emperor and the "Mother of the Nation," Kangxi's own mother, the Empress Dowager (fig. 4).

These historical incidents from the life of Zanabazar are followed on the right side with scenes where the Bogdo Gegen, in one or another of his eight later incarnations, takes the Kalachakra oath and receives an endowment of power from the goddess Tara (8), and in the following scene meditates to absorb Tara into her own image (9). Skipping a scene, he is endowed with the power of the many protective deities (11), and in the second episode from the bottom (12) he is granted the power of Naro-dakini and Vajrapani, accomplished with the intercession of the white elephant-headed god, Ganapati, as the empowering, diaphanous gilt funnels that join both deities to the Bogdo Gegen are joined in Ganapati's body.

Interrupting these purely spiritual events are two scenes with significant political overtones. In the fourth from the top (10), the Third Dalai Lama and Altan Khan preside over the burning of the shamanist *ongod* (fig. 5). The victim burning in the flames resembles the dark-faced spirit of Songgina, a notoriously powerful shaman who was expunged

and absorbed into Buddhism during the persecutions of shamanism led by Neyiči Toyin in the mid-seventeenth century (see cat. no. 35). In the sky above is Neyiči Toyin's favorite protector, Yamantaka, along with the Lord of Death, Yama, and Tsongkhapa (who honored Yama, but especially his conquerer, Yamantaka, as a transformation of himself-as-Manjushri). In the last scene on the right side, the Bogdo Gegen watches a pitched battle between the war god Begtse and his eight minions, and a troop of armored warriors (13).

The bottom frame honors gods and goddesses of wealth and long life and the goddess-protectors of the faith. In the second scene from the right (14), the Bogdo Gegen receives an endowment of power from the originally shamanistic White Old Man (Čaghan ebügen) in his new Buddhistic role as a god of longevity (fig. 6; see cat. no. 33). The White Old Man sits in a grotto holding his dragon-headed staff, his specific function made clear and enhanced by the presence of Amitayus, the red Buddha of Infinite Life, who hovers above. Just to the left, he receives another endowment of power from Trinley Chenpo (who could be Zaya Pandita of the Khalkhas [1642–1715]). In the following scene (15), the Bogdo Gegen is empowered by White Mahakala (the special protector of Mongolian Buddhists), Ganapati, and Vaishravana, a powerful combination ensuring good luck,

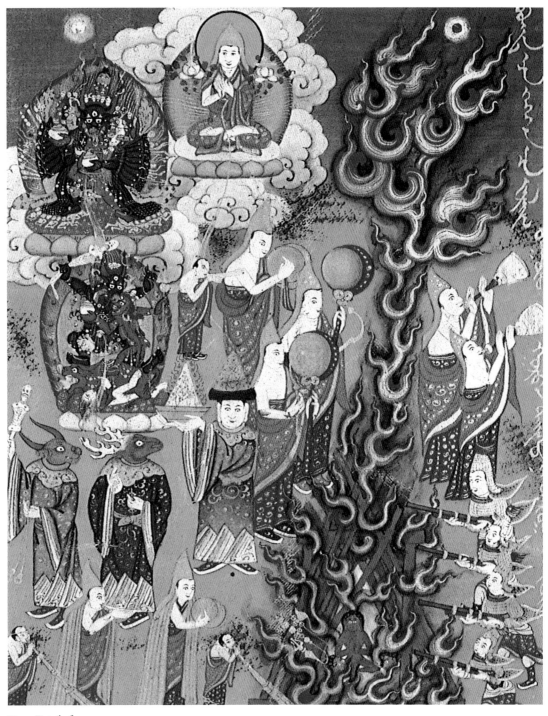

Fig. 5. Detail of scene 10.

wealth, and well-being. To the left of center are two panels, one (16) dominated by Lhamo, protectress of the Gelugpa, the next (17) by Naro-dakini, protectress of the Sakyapa. The final scene on the bottom depicts an empowerment from Kurukulla, the archeress and goddess of wealth, and the lion-headed *dakini,* Simhavaktra (18).

The final, left side of the frame follows with another empowerment from Kurukulla (19); a meditation on Green Tara (20); a scene of homage to the Bogdo Gegen lineage (21), with Vajrasattva *yab-yum* below, and Yamantaka with

two forms of Mahakala above; an homage to Padmasambhava (22), the "Great Teacher" who tamed Tibet's indigenous deities and converted them to Buddhism; and a final endowment of power from Maitreya, the Future Buddha (23) (fig. 7). The Future Buddha appears as a princely gilt bodhisattva, seated European fashion with legs down within a garden that must be construed as Ganden, his Tushita "Heaven of Joy," the temporary destination at death of Tsongkhapa and the Dalai Lamas. The suitability of this last episode is striking, for Maitreya was not only the giver of the

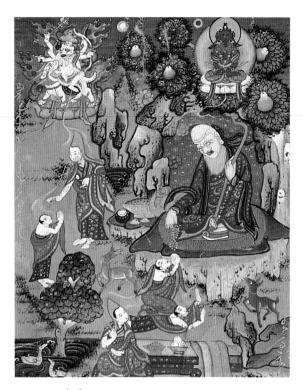

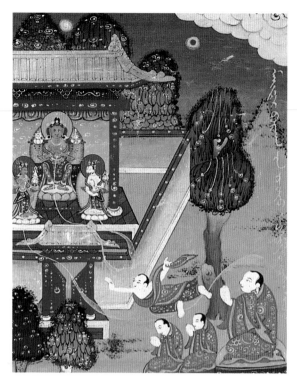

Fig. 6. Detail of scene 14. Fig. 7. Detail of scene 23.

tantras and, thus, a source of the Vajrayana itself, but he was also a powerful symbol, especially for Mongolian Buddhists, of their unquenchable hope for a new age.

An inscription attached to the back lining of the thangka, entitled "The Secret Biography of the Eighth Bogdo Gegen," is a worthy literary counterpart to this tightly interwoven, delicately painted, visionary composition. Using substantially different means, "The Secret Biography," with its surprising, witty resolution, also imbues what appears to be a formalized, highly structured piece of writing with unexpected symbolic value. James Bosson's translation and exegesis follow. —P.B.

1. Khenpo Könchog Gyaltsen, trans., *The Great Kagyu Masters*, p. 7.

2. Chandra, *Buddhist Iconography*, p. 8.

3. Kämpfe, "*Sayin Qubitan-u Süsüg-ün Terge,*" 13 (1979), pp. 95–96.

4. At least one biography of Zanabazar says that he also was an incarnation of Manjushri. See Kämpfe, "*Sayin Qubitan-u Süsüg-ün Terge,*" 13 (1979), p. 95.

5. These inscriptions were translated by James Bosson.

THE SECRET BIOGRAPHY OF THE EIGHTH BOGDO GEGEN

The most remarkable document of this exhibition is a text that was written on the reverse of *The Meditations of the Bogdo Gegen*. The text is written in Tibetan in a minuscule but fairly legible *u-chen* script. Despite the limited space, the text is voluminous.

At the end of the text, a colophon gives the title: "The Biography Secreting the Clear Knowledge of the Eighth Reincarnation of the Jebtsundamba, Jetsun Ngawang Losang Chökyi Nyima Tenzin Wongchuk Palsangbo (Rje-btsun ngag-dbang blo-bzang chos-kyi nyi-ma bstan-'dzin dbang-phyug dpal-bzang-po), is contained hereon; and it is very secret, indeed."

This is a most enticing title, considering the tumultuous times the Eighth Bogdo Gegen lived through, and the importance of his role in reestablishing Mongolian independence after the fall of the Qing dynasty, not to mention the increasing political and military pressure from the north after the Russian Revolution, which came to have such a sweeping effect on Mongolian politics and life. Here, indeed, is source material of the first order.

To our knowledge, the text of this secret biography has never been published anywhere before. It is a unique manuscript that certainly deserves our attention.

There is another unique text that may contribute a great deal to the understanding of this text. It is written in Mongolian and carries a similar—but not identical—title: *Boghda jibjundamba qaghan siregen-dür jalaraghsan-u nighuča teüke*, "The Secret History of the Bogdo Jebtsundamba's Ascension to the Royal Throne." This text is written in a notebook of twenty-six pages with six lines to a page, which could result

in a text of roughly the same length as the text at hand. The manuscript is kept in the collection of the Institute of Orientology of the Russian Academy of Sciences in St. Petersburg. It formerly belonged to the private library of the famous Mongolist Boris Iakovlevich Vladimirtsov. Unfortunately, we have not had an opportunity to consult this manuscript.[1]

When one approaches our text, it reads on the surface like a convoluted series of religious verses conveying prayers and paeans to the religious traditions of Padmasambhava, Tsongkhapa, and the Jebtsundamba, that is, the Gelug, or the Yellow Hat, order of Tibetan Buddhism. Tantric rites play a great role in this school, and an initiation given by a spiritual teacher is a necessity for understanding rituals and texts. In this tradition, it is most likely that the key to reading the hidden meaning of the text was conveyed by the author to chosen initiates. In fact, toward the end of the text, mention is made of the initiation given for secret mnemonic verses, which were the key required for a text of this type. One might call it a type of acrostic puzzle. In any case, one can be quite certain that no written key exists, and, considering the turmoil and almost complete crushing of the Mongolian religious community that took place in the 1930s, it is almost beyond doubt that the oral tradition has been disrupted and lost.

By scrutinizing the beginning of the text we were able to extract the names/titles of the eight historical Jebtsundambas. The elements of their names have been set in bold in the transliteration text, and the number of the reincarnation is indicated in parentheses. This gives us a list as follows:

1. Blo-bzang bstan-pa'i rgyal-mtshan (pronounced Losang Tenbey Gyaltsen)
2. Blo-bzang bstan-pa'i sgron-me (Losang Tenbey Drönmey)
3. Ye-shes bstan-pa'i nyi-ma (Yeshe Tenbey Nyima)
4. Blo-bzang thub-bstan dbang-phyug (Losang Tupten Wongchuk)
5. Blo-bzang tshul-khrims 'jigs-med (Losang Tsultrim Jikmey)
6. Blo-bzang dpal-ldan bstan-pa (Losang Palden Tenpa)
7. Ngag-dbang chos-kyi dbang-phyug 'phrin-las rgya-mtsho (Ngawang Chökyi Wongchuk Trinley Gyatsho)
8. Ngag-dbang blo-bzang chos-kyi nyi-ma bstan-'dzin dbang-phyug (Ngawang Losang Chökyi Nyima Tenzin Wongchuk).[2]

This gives a hint of the construction of the text. Separate syllables or short groupings of syllables are extracted from the surface text and, when pieced together, give the secret reading.

In a tour de force the author has incorporated in his text the meaning of the segments of the names. Religious texts are usually formulaic and quite stiff in style, which aided him in supplying the surface text. Yet in many passages the meaning becomes convoluted and forced.

Despite assiduous attempts, we have not been able to discover a pattern or system to decode the text. The transla-tion of the surface text is given in a very literal way here, which we felt was necessary in order to give readers an opportunity to attempt their own decipherment. Hence the transliteration is also given in full (see Appendix 2). Good luck! *Tashi Delek! (Bkra-shis bde-legs!)*

Praise to the Teacher! We pay homage to the lama, the tutelary deities and the Three Refuges, who are the source of perfect joy and the root lineage of the three times, together with the heroes, *dakini,* the protectors of the doctrine, and the guarding spirits, who through their compassion have come here to remain steadfastly—*dza: huboho:* To the lamas who are inseparable from the ones who have taken the vows—*padmakamalastam*—who are the body of all the Buddhas assembled, who are the essence of *Vajradhara,* who are the root of the Three Refuges—to these we pay homage!

We pay homage at the feet of the Jebtsun lama who became the supreme bearer of the standard of the doctrine of the Second Buddha and Losang Drakpa, to the unsurpassed guide of endless beings.

We pay homage to the intimate of virtue, he who seized the lamp of the teachings of the good tradition of Tsongkhapa, the actor of the saffron mind-treasure, the tutor of the illuminator of the obscurity of the minds to be converted.

We pay homage at the feet of the Jebtsundamba, the protector of the people of the North, the sun of the doctrine that shines in the ten directions and enlightens the obscurity of this world, he who disperses the ten million light beams of the five kinds of divine wisdom.

We pay homage to the holy Jebtsun lama, the protector of living creatures, he who has become the essence of all protectors of the sea of the fearless Ishvara of the doctrine of the foremost, who is able to guide the ones of fine intellect who have a good destiny.

We pay homage at the feet of the Jebtsun lama who holds the victory banner of the teachings fearlessly when all the religious traditions of Tsongkhapa, the doctrine of Buddha, and the two traditions rise in the sky.

We pay homage at the feet of the Jebtsun lama, who hoists the victory banner of the religion that conquers all the hosts of devils, who entirely grasps the tradition of the tantric doctrine of the *munindra*[3] Shrisumati.

We pay homage to the essence of the congregation of protectors of the miraculous sea of deeds that bring usefulness to others, to the mightiest of the doctrine, to the learned and righteous who clarifies the doctrine of the sutras and tantras of the Yellow Hat sect.

We pay homage to the great and mighty Jebtsun who holds the lotus garden of the doctrine and gives a threefold increase through the brightness of the only sun of the doctrine in the firmament of the one of good intellect and mighty speech.

At the time when the glorious and wise one came to the Jewel Throne of Kalapa[4] and established himself there, the heroic commander of the horde was drafted at the command of the sovereign of the land. The heroic commander made a request to amuse himself; he vanquished the barbaric hordes of the four military wings, and the mighty king ruled by the wheel of dominion in the twelve-partite territories. May we be born into the first circle assembled by that mighty king!

And further, may we achieve human form in all rebirths and meet with the Yellow Hat doctrine, and may we become participants in the virtuous dances of the foremost protector, and may we become inseparable adherents of those who have logic!

Having seen this life's dance performance of the utmost illusion and of the wealth of this world, which is mere driftwood; by giving birth to a mind for love and compassion, may we enter into the deeds of the Prince of the Great Teachings!

May we quickly attain an entrance onto the pair of perfected good roads of the two degrees of meditation, preserving as more valuable than our lives the vows, the promises, the *siddhi,* and the root, having cleaned away defilements of the three media with the rivers of the four consecrations!

By belief in the host of illusion bodies of the Lord lama, who is the foremost in the field of virtue, and by the power of prayers may the undesirable debilitators, such as illness, famine, and war, become allayed in that field!

May the timely rains and the yearly cattle-increase always be good! May the king and his subjects stay on the path of the ten virtues! May the doctrine and the steadfastly believing ministers gather together, and may the accumulation of auspiciousness increase like a summer lake!

Enjoying prosperity and happiness in the splendor of the religion, and always in our rebirths being inseparable from the absolutely pure lama; having become supremely accomplished in the virtues of the holy vows and the way, may we quickly attain the rank of the Vajradhatu!

Having the code of the marvelous and pure full release, and having the great fortitude of the actions of the surgingly powerful prince, performing the yoga of two degrees of supreme happiness and nirvana, may we meet with the doctrine of the noble-minded victor!

We pay homage with great reverence through body, speech, and mind to the tantra lama who bestows the foremost blessings; we also pay homage to the mild and furious gods, to the tutelary deities who bring down a rain of accomplishments, and to the protectors of the doctrine and to the *dakini,* who clear away all mortal dangers!

We present a collection of the best spiritual offerings, with which it is possible to fill the heavens completely. We confess and atone for the sins we have committed and accrued from time without beginning. We have rejoiced in virtue in ever so many sublime rebirths, and we have been enjoined to turn the wheel of the profound doctrine. Firmly residing at the rim of *samsara,* we have made prayers and have accumulated complete virtue such as this.

Because of having been victorious together with the prince of the three times, like an all-encompassing prayer, he clears up all obscurity and nonknowledge of all people. The All-Knowing will make a benediction for the sake of disseminating [the doctrine]. He mercifully protects us from hell and evil times, which are greatly degenerate and around which excessively great mental gloom has gathered. Having doused all the great fires of various sufferings that come when the fruit of sin and its miseries ripen, we pray that you give us extensive and perfect happiness that is in harmony with the loving mind that is bereft of anger and spite!

Protect, oh protect, you benefactor without deception! Behold, oh behold, you treasure of limitless compassion!

Be constant, oh be constant, you stern tutelary deity of the teacher! Meditate, oh meditate and protect us right away!

Spread the sunbeams of the victorious doctrine in the ten directions, and establish all beings permanently in the glory of happiness! Terminating accumulations that will cause mental obscurity, make us quickly, quickly comprehend and be in the ranks of the All-Knowing!

May we realize the blessings of the truth of the three foremost lamas and the undeceiving power of the causes of the unchanging realm of the doctrine! Through the deeds of having faithfully observed the doctrine, may I and others who revere it realize all the fruition according to our wishes! Having calmed all the weak and frail up to the end of this temporal state by the blessings of all the assembled refuges, may we have the good fortune to enjoy ourselves in the perfection of the self-sprung accumulations of the goodness of existence and conversion.

Homage to Manjushrighosha! We pay homage to the Three Precious Ones! May the lama, the personification of mercy, and the Three Precious Ones, and the tutelary deities, and the prescient heavenly sages, may they fulfil our excessive prayers!

May we obtain the five self-achievements of becoming human beings, being born in the central province of Ü, having our full faculties, having faith in our object of veneration, and likewise not returning to our former deeds!

And may we attain the five other achievements of constant compassion for others, the coming to this world by the Buddha, and the preaching of the doctrine, being firmly constant in the doctrine and its precepts.

May we be freed by the Buddha from the eight obstacles to bliss and empty stupidity; may we be freed from being in hell, being *preta,*[5] animals, and long-lived gods, and may we be freed from heretical views!

May we attain the seven exalted treasures: faith and alms giving, hearing the doctrine and following the religious law, sublime wisdom, knowing shame, and having modesty.

May we attain the seven virtues: long life, health and happiness, a good body, good fortune, and breeding, wealth, and intelligence. May we meet with lamas whose flow of compassion does not cease, who are diligent in explicating the Three Baskets and the tantras without mistakes or illusions.

May our abilities increase higher and higher in accordance with how we ponder and preserve what they have said about the fully released bodhi-mind and the teachings of the pregnant mantras.

May the two kinds of defilement and our propensities become pure through our cognition of clarification and emptiness being inseparable, or the manifested and emptiness being made a pair, or happiness and emptiness being supreme!

Examining desire and being content, and having renounced all ways of obtaining a livelihood that are improper for someone with the bodhi-mind, may we live by what is proper according to the doctrine!

May we be freed from the five most terrible crimes, such as one who kills an arhat or his parents, one who creates discord among the harmonious *sangha,*[6] and who draws blood of a Tathagatha.

May we be released from the five next most terrible sins: burning a stupa, killing a bodhisattva, dishonoring nuns, killing one's teacher, and robbing the church's possessions.

May we be released from the ten sins: killing, stealing, lying, fornicating, slandering and backbiting, talking foolishly, being covetous, being ill-willed, and harboring heresy.

May we be released from the eight hot hells: the uninterrupted hell, the supremely hot hell, the hot hell, the hell of wailing loudly, the hell of whimpering, the hell of concentrated suppression, the hell of the black lines, and the hell of those revived again and again.

May we be released from the eight cold hells: the blistered hell, the hell of broken blisters, the hell of tooth gnashing, the hell of "brrr," the hell of lamentation, and the hell of sores that burst like large utpala lotuses.[7]

May we be spared from these border hells: the very near and vicinity hells, the marshes of rotting corpses, the marshes of filth, the pits of burning embers, the unfordable rivers, and the mountains of sharp flint.

May we be delivered from places of the *preta,* those who have external filth and those who have internal filth, those who have defiled food and drink, and those who have a wheel of flames.

May we be delivered from the realm of those beasts, who, being either inhabitants of the sea or being dispersed over the land, are stupid dolts who eat one another and commit killing and cutting, enslaving and beating!

May we be released from all suffering: the gods have migration and fall, the *asura* have fighting and battling,[8] the humans have birth, aging and death.

May we be born into the supreme paradise of the supreme intelligence of Manjughosha, of the compassion of Avalokiteshvara, of the magic powers of Vajrapani.

May we be born into paradise by the doctrines of Shariputra, by the magic of Maudgalyayana, and by the auditing and learning of Ananda.

May we be born into paradise by the knowledge of Nagarjuna, by the omens of Sarahapa, and by the ability and power of Shava.

May we be realized by the truth of the Triratna, by the blessings of the Buddhas and bodhisattvas, by the completely perfected archery field of the two accumulations, and by the truth of the doctrine itself.

May we get through to the continent of release, having firmly mounted the steed of happiness, having mastered it with the reins of prayer, and having rapidly compelled it with iron self-discipline.

May the good fortune of the Triratna come about, being the Buddha who has renounced this world and has transcendental knowledge, being the holy doctrine of instruction and true knowledge, and the *sangha* of the bodhi-mind of the ten stages of bodhisattvahood.

We worship at the feet of the Jebtsun lama, who, although he has attained the highest rank as the perfected Trikaya, in accordance with his wish, through the Second Losang Gyalwa, has become the foremost bearer of the standard of victory of the doctrine. May I and others, without exception, who have attained human birth, by being diligent in the deeds of com-

pletely pure virtue, may we before long be born in Shambhala in the north, and may we attain the transcendental actions of a bodhisattva! Having taken on the nature of the powerful Hanumanda, and at this time of having strapped on the sword in our hearts in order to hinder the oath-breaking enemy, may we also, by your help, be born into your very retinue and cause joy to you, oh Lord and Protector! May all who pray thus and who adhere to the gracious lama inseparably, having quickly renounced the seed of the two kinds of defilement, may we all quickly attain the complete and finished secret of our own self-interest and that of others!

Although the Buddhas without exception have become its
 father,
By the power of the truth that engenders in the mind an
 adherence to the Buddha doctrine,
And by the bodhisattva nature, for the sake of profound schol-
 arship in this world,
May the doctrine of Tsongkhapa spread!

Formerly in the five kinds of eyesight of Indra,
Saying that by his vows he has great courage in this life,
By the truth of these encomiums of the bodhisattvas and
 Buddhas,
May the doctrine of Tsongkhapa spread!

For the sake of propagating the lineage of pure doctrine
 and its implementation,
He presented before the Buddha a rosary of white crystal,
Through the conch of religion appearing and through the
 truth of the prophecy,
May the doctrine of Tsongkhapa spread!

May pure reflection always cause one to be liberated from
 limited understanding!
May pure meditation cause spiritual languor and ignorance to
 be cleansed away!
May pure actions be completed like the dicta of the Buddha!
May the doctrine of Tsongkhapa spread!

May the one who has listened manifold times and understood
 in detail become learned!
By the manner in which he has thought through the meaning
 of what he has heard, may he become conscientious!
And by having dedicated all doctrines to the good of creatures,
 may he become good!
May the doctrine of Tsongkhapa spread!

That honest one, who by acquiring the truth
In order not to violate at all the most secret,
In instructing concerning someone's mnemonic rhymes, may
 he prevent all noxious deeds!
May the doctrine of Tsongkhapa spread!

Listening to the explanation of the revealed doctrine in the
 Tripitaka,
And investigating the perceived doctrine and the three tenets,
May our adeptness and complete release by realizing them be
 marvelous!
May the doctrine of Tsongkhapa spread!

Outward by the act of listening to the explanations, may we
 become peaceful and tamed!
Inward may we become faithful and trustworthy by the two
 series of yoga!
May we be helpful in conveying the sutras and tantras along
 the good road with no impediment!
May the doctrine of Tsongkhapa spread!

May emptiness itself be explained as a drop of matter!
May the great joy of successfully invoking a deity be by means
 of fruition through yoga!
May the quintessence of the 80,000 sermons of the Buddha
 spread!
May the doctrine of Tsongkhapa spread!

Through the power of the sea of guardians of the doctrine
 bound by oath,
Such as the lord protector of the threefold path of mankind,
From Tara and Kubera to Yama, etc.,
May the doctrine of Tsongkhapa spread!

In short, may the doctrine of Tsongkhapa spread
Through the everlasting life of the blessed lama
And of the blessed adherents of the faith, the learned and
 the reverend who fill the earth,
And through the increase of the mighty patrons of the
 doctrine!

Homage to the Teacher: The protective lord Losang Tenbey
Nyima and the excellence of Losang Tenzin Gyatsho full of
grace, and inseparable therefrom also to Lama Dorje Jikmey,
to them we place a prayer with body, word, and thought
concentrated in worship! In all the situations of this life, the
future life and purgatory, however it turns out, in what situa-
tion we are fit for rebirth or fit for suffering, we pray that you
regard us with mercy and receive us kindly without abandon-
ing us, for in you rests our only hope.

Particularly in the fair region of Kalapa at the time of carrying
out the task of converting the savages by the Wheel of the
Law, having become lord at the top of the wheel, may we
achieve the consecration of Vajradhara in meditation!

In a period when everyone enjoys long life and health, at the
festival of abundant joy and glory when that completely white
accumulation of good omens, the rising moon, has reached its
fullness, may the standard of virtue of all white deeds blaze
forth!

Oh, gathering of the Three Refuges and lama Vajradhara,
we send a prayer to the gracious lamas, who as teachers have
taught the spiritual disciples in order to tame and convert
them, and then bestowed the gift of the profound sutras and
tantras.

May I and all other degenerate beings by force of our exertions
in pure and virtuous actions, before long has passed, may we
be born in Shambhala of the north and reach the limits of
bodhisattva deeds!

In this way, having taken refuge without deception in the
Three Preciousnesses, a little bit through the power of the
virtuousness of prayer, and renouncing the seeds of the two
defilements, may we quickly achieve the complete cleansing
away of others' and our own self-interest to its limits!

Although he achieved the supreme rank of the perfect Trikaya,
by his own intent, through Padmasambhava he becomes the
foremost holder of the victory banner of the doctrine—I pay
homage at the feet of Jebtsun lama!

May I and all other degenerate beings, by force of our exer-
tions in pure and virtuous actions, before long has passed, may
we be born in Shambhala of the north and reach the limits of
bodhisattva deeds!

At this time of my having taken up the manners of fierce
Hanumanda, and so feeling the pain of the signs of oath viola-
tions and the spiritual enemies in my heart, I, again, being
born into your very own retinue, may you, oh Protector, be
pleased!

All the persons who have sent a prayer like this, receiving the
gracious lama without separation, having quickly renounced
the seeds of the two defilements, may we quickly achieve the
complete cleansing away of others' and our own self-interest
to its limits!

The one who possesses perfection, like a mountain of gold,
Protector of the Three Worlds who has renounced the three
impurities, Buddha who possesses eyes like extended lotus
wings:
This is the first blessing of happiness in this world!

Close to him is the supreme and most immovable, renowned
in the three worlds, the object of veneration of gods and men,
The holy Dharma that gives peace to all beings:
This is the second blessing of happiness in this world!

The blessed prosperity of the Holy Sangha's devout hearing of
the tradition, the object of veneration of human beings, of
gods, and of *asura,* The most supreme of congregations, the
basis of modesty and glory:
This is the third blessing of happiness in this world!

—J.B.

1. *Mongolica: Pamiati akademika Borisa Iakovlevicha Vladmirtsova, 1884–1931*
(Mongolica: A Memorial to the Academician Boris Iakovlevich Vladi-
mirtsov, 1884–1931), p. 295. The manuscript has the subtitle *Ilaghughsan-u
köbegün-ü Bayasqulang-un qurim-un dalai* (The Sea of Feasts of Joy of the
Prince of Victory); Aleksei Georgievich Sazykin, *Katalog mongol'skikh
rukopisei i ksilografov Instituta Vostokovedeniia Akademii Nauk SSSR* (A
Catalogue of the Mongolian Manuscripts and Xylographs of the Insti-
tute of Oriental Studies of the Academy of Sciences of the USSR) (Mos-
cow: Nauka, 1988), vol. 1, p. 137.

2. Two slightly divergent lists are given in Dharmatāla, *Rosary of White
Lotuses,* pp. 487–89.

3. "The Lord of Ascetics," an epithet for a Buddha.

4. Kalapa is the name of a mythical land in the northern part of Asia,
and also the name of the capital of the mythical northern Shambhala.
In this text it refers to Mongolia.

5. A *preta* is a being damned to be a monster with a huge belly and a
throat thin as string, so that he may never satisfy his hunger.

6. *Sangha* is the community of monks, the third of the Three Refuges.

7. Two of the cold hells have subcategories that are not listed in the
verse.

8. *Asura* are non-god spirits, something like the Titans in Greek mythol-
ogy. They were originally gods but, through their boasting of being
more pious than others, were expelled from the heaven of the gods.

19. WINTER *JIFU* OF THE EIGHTH
BOGDO GEGEN

Late 19th–early 20th century
Gold and silver couched silk with velvet facings
L: 58⅛ (147.5) W (including sleeves): 100¾ (256.0)
Bogdo Khan Palace Museum

20. WINTER HAT OF THE EIGHTH
BOGDO GEGEN

Late 19th–early 20th century
Silk and fur
H (excluding ties): 7½ (19.0) W: 11 (28.0) Diam.: 14⅝ (37.0)
Bogdo Khan Palace Museum

21. *MAGUA* OF THE EIGHTH BOGDO GEGEN

Late 19th–early 20th century
Cloth of gold
L: 28 (71.1) W (including sleeves): 64 (162.6)
Bogdo Khan Palace Museum

The Manchu emperors of China proclaimed their legiti-
macy through an elaborately ordered symbolic system that
was nowhere more brilliantly expressed than in clothing.
Even the minutest details of dress were carefully regulated
through sumptuary laws that determined everything from
the color, cut, and decoration of robes to the shape of court
hats, the composition of their brims and tassels, and the de-
sign of their rank-defining insignia. To be granted the right
to wear certain types of dress was a high honor; to be given
a set of court clothing an even higher one.

The Bogdo Gegens of Urga were often favored with im-
perial largesse, and the biographies of their lives treat the
granting of the right to use certain colors and symbols of
position as marks of the highest regard. One of the first signs

19.

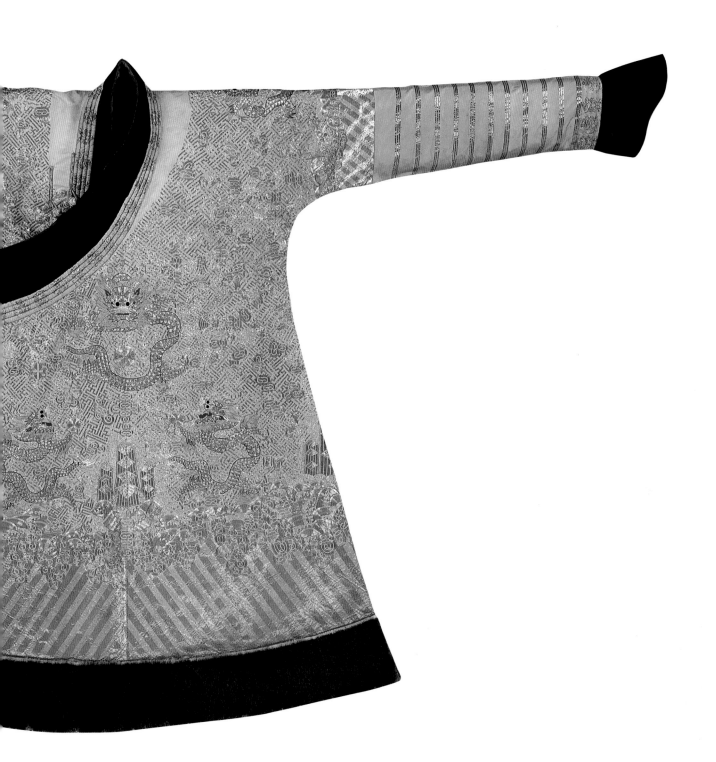

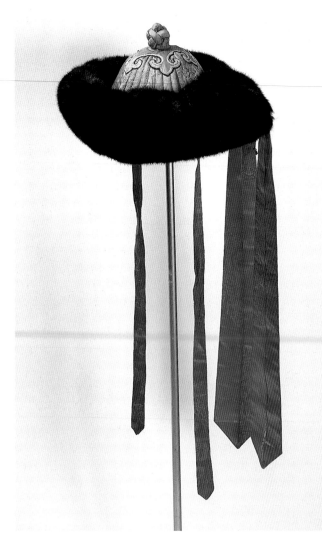

20.

of Manchu favor for Zanabazar came when the Kangxi emperor permitted his mother, the Empress Dowager, to hear Zanabazar read the scriptures (and when she made her famous comment that he "resembled the full moon"). She and the princes and children then gave him "a pearl diadem, a robe with a pearl border, a set of religious robes, a rosary of nine jewels, forty whole pieces of brocade, and a hundred whole pieces of silk cloth each of a different colour." To this Kangxi responded with perceptive insight, "The Blessed one was formerly much more beautiful than this: now all the dust of the earth of Peking has stuck to him."[1]

Nonetheless, these gifts continued to be given to all the Bogdo Gegen's seven incarnations. The second got coral beads from the Qianlong emperor in 1736, as well as sixty sables, nine pieces of silk, silk damask woven with a design of dragons, and the right to have a fence with a yellow border for his field palace. In 1756 he received a new and grander title from Qianlong, along with varicolored materials and the right to ride in a reddish yellow carriage. (Reddish yellow was a color only one notch below the more brilliant imperial yellow.) This grant was repeated for the third incarnation, who was allowed a red carriage; and the fourth, whose carriage was reddish yellow and whose field palace was yellow. Following his father's pattern, the Jiajing emperor gave the Fifth Bogdo Gegen a yellow-belted tent, intending it as a hint, however, that he need not present himself at court (which would have been much more costly for both the Gegen and the emperor).

Though none of the Bogdo Gegens presented themselves to the Beijing court after 1840, they continued to receive gifts of clothing, even during the early Republican period. (Many of these are, ironically, imperial in design and symbolism; see cat. nos. 27–29.) These three articles of dress —a dragon robe (C: *pao* or *jifu,* auspicious robe), winter hat, and riding jacket (C: *magua*)—all belonged to the Eighth and last Bogdo Gegen, probably given to him as gifts in the late nineteenth or early twentieth century. The styles of each of these garments were set much earlier, however, and the last Bogdo Gegen, like his predecessors, also wore hand-me-downs of extraordinary sumptuousness, such as a full-length silk-lined sable cloak that had belonged to Zanabazar (fig. 1). Aleksei Pozdneyev also notes that, in general, the Gegen dressed in monk's robes, while on his hat he wore an insignia in the form of a *dorje* (symbolizing the pure mind), to which he had a hereditary right because of his descent from Abadai Khan, who was granted it by the Third Dalai Lama.[2]

Fig. 1. Zanabazar's sable cloak, late 17th–early 18th century. Sable lined with silk. Bogdo Khan Palace Museum, Ulaanbaatar. From Tsultem, *The Eminent Mongolian Sculptor—G. Zanabazar,* pl. 108.

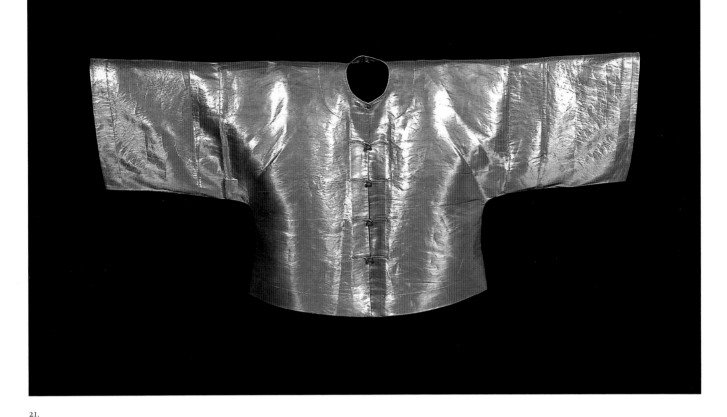

21.

The heavy wear on the nine-dragon robe seen here (cat. no. 19) shows that, regardless of when it was sent, the Gegen must have worn it often after he was installed as emperor of Mongolia in 1912. The golden color of this robe made it appropriate for a Manchu prince of the blood, and its cut and design were appropriate for court occasions that were less formal, by Manchu standards. Its splendid overall metallic sheen comes from delicately couched threads, which carry almost the entire design, a style of embroidery that was increasingly popular at the turn of the century. The front facing, hem, and horse-hoof cuffs are all black velvet. The Gegen's hat (cat. no. 20) was also designed for winter wear; it is not a Manchu-style court hat but a true Mongolian hat that has been raised to the highest level of elegance. Made of appliquéd silk damask and rimmed with lustrous fur (mink or sable), the hat was finished off by a silken knot and held in place by long silk chin-ribbons of a type designed by Zanabazar, in his words, "to exemplify the road by which to become a Buddha, along the road of sutras and dharanis."[3]

The Bogdo Gegen's riding jacket (cat. no. 21), meant to be worn over an inner robe (C: *neitao*), conforms exactly to the standards set for this garment by the Manchu court. The yellow riding jacket (C: *huang magua*) was given as a sign of the highest favor, and the right to wear it was one of the most desirable honors the court could grant, because it signaled that the wearer held an honorary position in the imperial Banner and bodyguard.[4] The Bogdo Gegen's jacket is extraordinary even within this exalted company, however, being cloth of gold, woven of filaments of silk wrapped with gold. Legend has it that the Gegen often wore this jacket for feasts, where the menu was mutton eaten off the bone, and that afterward, he would simply throw it in the fire to burn away the stains. It seems unlikely, however, that he ever treated the jacket so casually, for its condition is nearly pristine.

—P.B.

1. Bawden, *The Jebtsundamba Khutukhtus of Urga*, pp. 52–53 and n. 7.

2. Pozdneyev, *Mongolia and the Mongols*, p. 383. He also says the *dorje* by rights was worn by the Tüsheet Khan himself, but after Khalkha came under Manchu rule in 1691, the Tüsheet Khans were forced to wear the coral bead given to them by the Qing court.

3. Bawden, *The Jebtsundamba Khutukhtus of Urga*, p. 62.

4. Dickinson and Wrigglesworth, *Imperial Wardrobe*, pp. 116–17.

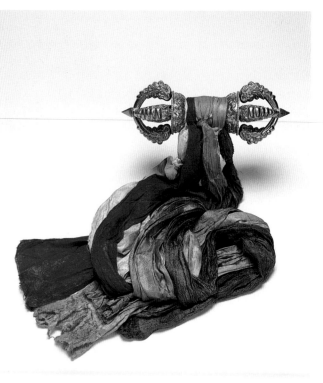

22. LARGE *DORJE*

19th century
Gilt metal with silk *khatak*
H: 12 (30.6) W: 4¼ (10.9) L (of *khatak*): 53½ (136.0)
Bogdo Khan Palace Museum

This *dorje* is the five-prong type, consisting of four massive curved prongs springing from *makara* heads (crocodilelike mythical beasts of Indian origin) positioned around a center post. The cylindrical grip is ornamented with a row of leaflike lotus petals pointing outward. *Khatak* (ceremonial scarves) of five colors (white, red, blue, yellow, and green) are knotted around the center of the *dorje.*

The *dorje* and the bell are the most important ritual objects of Tibetan Buddhism. They are held in the right and left hands, respectively, of religious practitioners and are a necessary part of their prayers and rituals. The *dorje* represents the male aspect of fitness of action or skillful means; the bell stands for wisdom or supreme knowledge, a feminine aspect. Used as a pair, they symbolize the union of these aspects, which leads ultimately to enlightenment.

A massive *dorje* was central in an important event that brought Zanabazar to fame in China.[1] The Kangxi emperor (r. 1662–1722) asked Zanabazar to bestow on him the consecration of the Buddha of Long Life (M: Ayusi; T: Amitayus). In preparation for the ceremony, and in order to test the young monk, the emperor ordered the construction of a bell, three feet high and two feet wide, weighing 120 pounds, and a *dorje* half that size. Zanabazar's disciples, meanwhile, requested five-colored silk for decorating the neck of the ritual vase (the attribute of Buddha Amitayus). During the ceremony, a brilliant rainbow issued from the vase, and the Buddha Amitayus appeared above it. In the midst of this wondrous happening, Zanabazar picked up the gigantic bell

and *dorje* with ease and recited the scriptures. This ritual object may be a later copy made to commemorate this event.

The tradition of using *khatak* came from Tibet. During the Qing dynasty (1644–1911), special *neiku* (Inner Treasury) *khatak* were commissioned by the court to be given to lamas and dignitaries of Mongolia and Tibet. The scarves of thin silk came in various lengths and colors and were woven with auspicious designs and poetry in Tibetan script. These ceremonial *khatak* were highly treasured by the lamas of Tibet and Mongolia and were sometimes reused in the mounting of thangkas, as the dust curtains for the sacred images. During the reign of the Qianlong emperor (1736–95), it was customary to include *khatak* among the presents the emperor gave in return for the tribute gifts from the Dalai and Panchen Lamas. Recorded gifts included gilt silver vessels, bolts of silk, five large *khatak,* forty small *khatak,* and ten five-colored *khatak.*[2] A five-colored *khatak,* found inside a gilt mandala, was included in the Sino-Tibetan exhibition held in the Palace Museum.[3] —T.T.B.

1. Bawden, *The Jebtsundamba Khutukhtus of Urga,* pp. 51–52. See also Berger, "After Xanadu."

2. Zhang, *Qing zhengfu yu lama jiao* (The Qing Government and Lamaism), p. 111.

3. *Cultural Relics of Tibetan Buddhism Collected in the Qing Palace,* cat. no. 127–2.

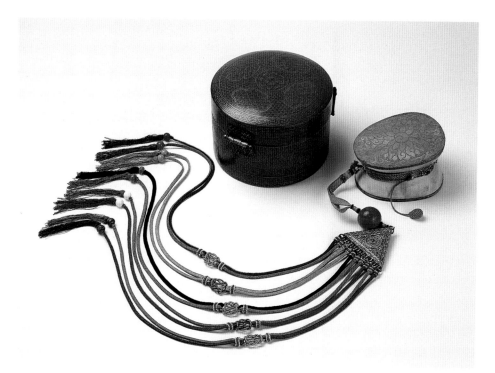

Inscriptions in Chinese, Manchu, Mongolian, and Tibetan inside drum container.

23. HAND DRUM

Qing dynasty, 18th century
Ivory, colors on leather, silk tassels, and gilt decoration
with inlaid semiprecious stones
Drum H: 4 (10.2) Diam.: 4¼ (10.8)
Tassel L: 33 (83.7)
Case H: 4⅛ (10.5) Diam.: 6½ (16.4)
Bogdo Khan Palace Museum

This type of drum is based on the *damaru* introduced from India, where it was, and still is, used by ascetics. In Mongolia and Tibet, such drums can be made from skullcaps, wood, or other materials. To use the drum, one holds the cord closest to the drum and twists it with a back-and-forth motion using one's wrist. This sets the two strikers in motion; they hit the drum alternately and produce a loud hollow sound. A hand drum of this type is used by Buddhist practitioners during rituals, especially for punctuating prayers.

The two halves of the ivory drum, carved in the shape of craniums, are covered with leather dyed the traditional green and decorated with a gilt lotus. An elaborate gold band, which is decorated with three *dorje* inlaid with turquoise against a "gold coin" background, girdles the waist. The beaters, encased in crocheted yellow silk, hang from the band. Attached to the drum is a sumptuous tassel. A large red coral bead hangs on a yellow cord, held in place by red-, white-, and blue-covered wires wound around the cord. Below the coral is a gilt triangular ornament with raised decoration and coral and turquoise inlays attached to ten metal loops. Hanging from the loops are multicolored tassels, which are linked to the bottom tassels with alternating gold

and silver wires twisted into endless knots. The bottom tassels are strung with beads of amber, turquoise, coral, ivory, and lapis lazuli. The tassels are further ornamented with seed pearls and tiny red coral beads. Such sumptuous materials and attention to detail could point to only one place of manufacture—the Palace Workshop of the Forbidden Palace in Beijing. In fact, an ivory hand drum with almost identical tassels is in the National Palace Museum in Taipei.[1]

The red lacquered leather-covered wooden container for the drum is equally interesting. In the red silk–lined interior, a palace label (from the Forbidden Palace of Beijing) in four languages is attached to the lid. The Chinese inscription reads: *liyi yu kabula gu*, or "jade *kapala* [skull] drum of benefit." This is followed by similar inscriptions in Manchu, Mongolian, and Tibetan. *Liyi* is the Chinese equivalent of the Sanskrit term *adishthita*, a technical term for "blessings and empowerment"; the Tibetan form is *chinlap*.[2]

This label poses a problem. The hand drum is made of ivory, yet the label says "jade." "Jade" in China can mean any hardstone as well as jade, but it does not include ivory. This means that this box must have been taken from another drum in the last two hundred years. The drum and its container point to a Chinese provenance, and their workmanship is typical of the Qianlong period (1736–95). This was most probably a gift from the Qianlong emperor to the Second or Third Bogdo Gegen, who lived during his reign.

—T.T.B.

1. *Masterpieces of Chinese Tibetan Buddhist Altar Fittings,* cat. no. 49.

2. The author is grateful to James Bosson for the explanation of this term.

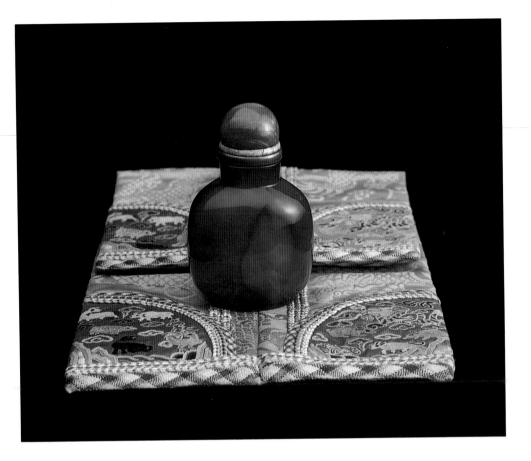

24. AGATE SNUFF BOTTLE WITH
EMBROIDERED POUCH

Late 19th century
Agate, coral, and gold; silk and brocade
Bottle H: 4⅝ (11.8) W: 4⅛ (10.5)
Pouch L: 20¾ (52.6) W: 8⅛ (20.5)
Bogdo Khan Palace Museum

The snuff bottle, stored inside its brocade bag, is one of the essential objects carried by Mongolians on the sashes around their waists. The habit of taking snuff came to Mongolia from China in the eighteenth and nineteenth centuries. Originally introduced by European missionaries, it soon became fashionable in the Qing court. It was customary for emperors to give fancy snuff bottles as gifts to their courtiers and foreign guests, especially the high lamas of Mongolia and Tibet. Snuff taking soon gained popularity among the Mongols. It was, and still is, the custom to exchange snuff bottles for a pinch of snuff when Mongolians meet each other, and to offer snuff again at the conclusion of business. While many snuff bottles were imported, Mongolia, with its rich deposits of agate and other semiprecious stones, also produced its own. Silver bottles with Buddhist motifs, ornamented with turquoise and coral, are usually attributed to Mongolia. Modern Mongolian bottles are larger and less fancy than Chinese examples, and some of the stoppers are taller.

This bottle, which once belonged to the Eighth Bogdo Gegen, is made of brown agate and is of Chinese origin. The bottle is well hollowed, and the oval base is nicely finished. The stopper of red coral has two collars, one of dyed ivory and one of gilt metal. The spoon is of ivory, and there is still some snuff inside the bottle.

The pouch is made of bright yellow brocade with a five-clawed dragon motif. The red center strip, now faded to a pale orange, is decorated with three strands of braid. The four corners, ornamented with braids and piping, are embroidered with the twelve animals of the zodiac. The animals on the right are the rat, ox, tiger, rabbit, dragon, and snake. Opposite them are the horse, ram, monkey, rooster, dog, and boar. They float among wish-granting *ruyi*-shaped clouds, and beneath them are Chinese peaks-and-waves motifs.

—T.T.B.

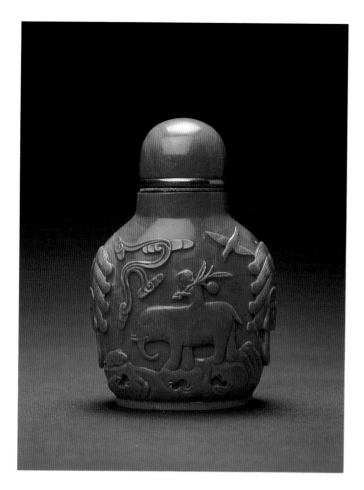

25. SNUFF BOTTLE WITH EMBROIDERED POUCH

Late 19th century
Coral, gold, and silver; silk and pearls
Bottle H: 3⅞ (9.9) W: 3 (7.7)
Pouch L: 15 (38.0) W: 7½ (19.0)
Museum of Fine Arts

This beautiful example carved in coral is of Chinese work-manship. The stopper is also of coral, with a gilt silver collar and an ivory spoon. One side of the bottle shows a lion and his cub playing with a brocade ball. This motif, known as *taishi xiaoshi* in Chinese, is a popular design for snuff bottles and represents a wish for high rank. The other side portrays a monkey riding on an elephant, accompanied by a bird and a rabbit. These are the Four Amicable Friends of a Buddhist fable, who represent concord and harmony in the jungle of life.¹ This design is not in the Chinese snuff-bottle repertoire but is a traditional Tibetan motif symbolizing friendship and brotherhood. It is often found painted on the wall near the entrances to temples in Tibet and is a motif beloved by Mongols. Judging from its material, its quality of carving, and subject matter, this bottle must have been a gift from China, specially commissioned for a high Mongol, or even for the Bogdo Khan himself. Usually, the animals are stacked one on top of another in this order: elephant, monkey, rabbit, and bird. The Chinese craftsman may have misunderstood and placed the rabbit and bird elsewhere.

Throughout the Qing dynasty, snuff bottles were kept in kidney-shaped brocade bags with a gathered top.² Mongolians make a special pouch for their snuff bottles much larger than the Chinese ones. The rectangular Mongolian version is made of padded brocade and has a slit opening down the center. The bag is worn doubled over one's sash, which keeps the bottle secured and protected, even while the wearer is on horseback. This example is in yellow brocade and deco-rated with fancy braid and piping. The corner decorations show Chinese influence. They consist of Chinese *shou* (lon-gevity) characters and bats embroidered with seed pearls and tiny coral beads. The bat *(fu)* shares the same sound as the word for "blessing" and constitutes one of the most popular decorative motifs in Chinese art. When the bat is combined with the *shou* character, they form a pun for *fushou,* or blessings and long life. —T.T.B.

1. Olschak, *Ancient Bhutan: A Study of Early Buddhism in the Himalāyas,* frontispiece [p. 7].

2. Tsultem, *Mongolian Arts and Crafts,* pl. 69.

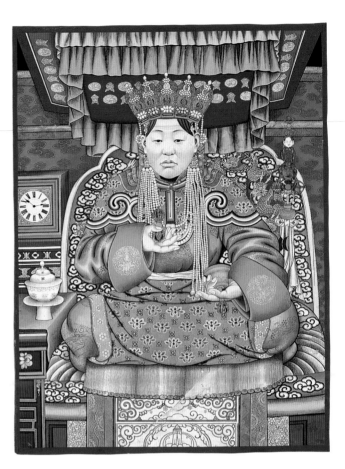

26. PORTRAIT OF EKH DAGIN DONDOGDULAM

B. Sharav (1869–1939)
Ca. 1912–23
Colors on cotton
H: 45¼ (115.0) W: 34 (86.2)
Museum of Fine Arts

Dondogdulam was the first consort of the Eighth Bogdo Gegen, married to him after Mongolia declared its independence from China in 1911, following the Chinese Republican Revolution. She came from a wealthy and noble family in Khentii, in north-central Khalkha. When the Eighth Bogdo Gegen was crowned Outer Mongolia's theocratic ruler in 1912, Dondogdulam was enthroned at his side, as Ekh Dagin (Mother Dakini). According to Iwan Korostovetz, the observant Russian ambassador to China and Mongolia during this turbulent period, Dondogdulam exercised extraordinary political influence over her husband.[1]

Aside from playing a political role, Dondogdulam also had sacred responsibilities and was identified as the mother of the nation, as a *dakini* (sky walker and protector), and as the goddess Tara. Her identification with Tara has very ancient roots, for the Nepalese and Chinese queens of Songtsen Gampo, Tibet's first Buddhist king (r. ca. 627–49), were both incarnations of Tara by virtue of being consorts to their husband, who was Avalokiteshvara-incarnate. Even in the early Ming dynasty, the mother of the Yongle emperor (r. 1403–24), Empress Ma, was held to be an incarnation of the benevolent goddess.

Dondogdulam was also an oracle *(gürtüm),* just as the Eighth Bogdo Gegen's younger brother, the Choijin Lama, was. It is in the guise of an oracle that the early modern painter Sharav has depicted her, wearing a five-Buddha crown and holding the *dorje* and bell, the attributes her husband shared with Vajradhara and Vajrasattva. She sits facing her audience on a lama's throne with a canopy hanging above her head. (She had such a throne in the Avalokiteshvara Temple in Urga, where she, controversially in the minds of some, sat next to her husband.) A *khatvanga* (tantric ritual staff) and drum, used in Buddhist rituals, are at her left, and her teacup, poised on a cupstand, stands at her right. The European clock set at a few minutes to three must be from the Bogdo Gegen's large collection. Like the Manchu emperors and empresses of China, he had a great interest in European gadgets of all sorts, and an inventory done in 1877 counted 974 clocks and watches.

Despite the intrusion of modern appliances and the overall realism of his style, Sharav has cast Dondogdulam in a sacred role, set in a far from realistic space. Her face is painted *en grisaille;* the tones of her costume and setting are flattened and subdued, much as they would be in a tinted black-and-white photograph. The effect is disturbing, as if she is no longer part of this world, but a denizen of another realm. —P.B.

1. Korostovetz, *Von Cinggis Khan zur Sowjetrepublik,* pp. 154, 162.

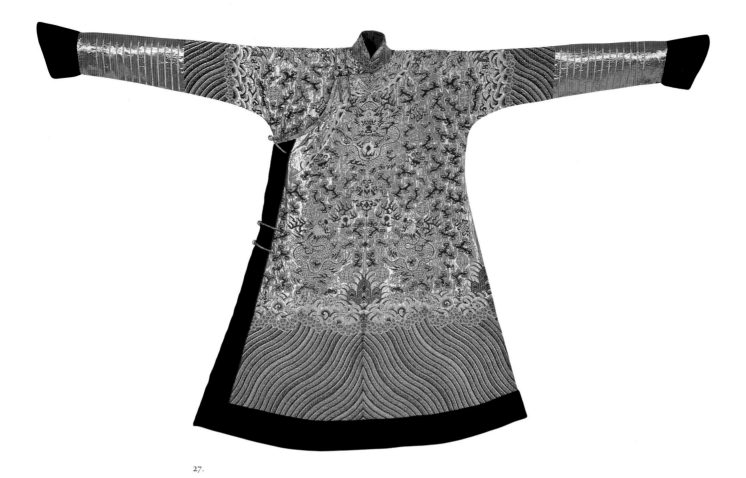

27.

27–30. IMPERIAL REGALIA OF EKH DAGIN DONDOGDULAM

Early 20th century
Robe (gold brocaded silk, velvet, and silk crepe, with gold buttons); hat (silk gauze, silk satin, seed pearls, rickrack, and lacquer); belt (brocaded silk, gilt metal, semiprecious stones, and diamonds), knife handle (jade) and sheath (filigreed gilt silver); boots (leather, silk braid, embroidered threads) and socks (cotton, silk, and wool)
Robe H: 54½ (138.5) W (including sleeves): 58⅛ (147.5)
Bogdo Khan Palace Museum

Like her husband, Ekh Dagin Dondogdulam was the recipient of sumptuous personal gifts from Republican China and from the other nations of Asia. Mongolia was free of Chinese overlordship only from the Revolution in 1911 until 1915, when it became clear that the nation could not survive as an independent state and submitted once again to the Chinese. During these years and afterward, until her death in 1923, Ekh Dagin dressed as an empress in the Manchu mold, but with a certain Mongolian sense of style. Many of the more elegant parts of her costume ironically came from the Republican Chinese government, which had turned its back on the rituals of Manchu court life but which continued to produce costumes in the old imperial style for its Mongolian nobles.

Parts of this luxurious regalia were undoubtedly a gift to the new Mongolian empress from the newborn Chinese Republican government; other parts came from Russia or from cities along the Central Asian Silk Route, such as Bukhara. The robe, which crosses the chest to fasten snugly under the arm and down the side, has Manchu-style horse-hoof-shaped cuffs. It is made of Chinese gold brocaded silk in a sophisticated weave that is subtly iridescent. The garment is patterned like a classic court robe, with nine imperial dragons (one is unseen, hidden under the front flap),

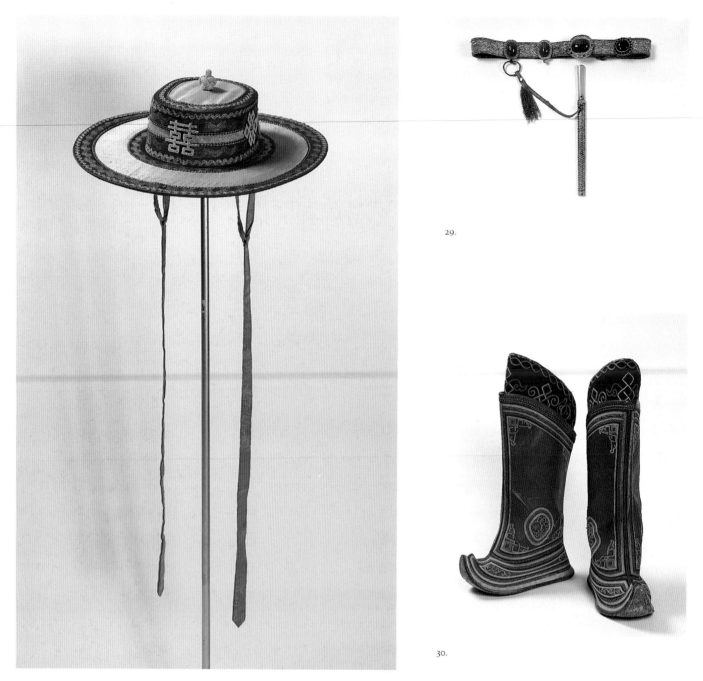

28.

29.

30.

supplemented by the Daoist Eight Precious Things (fan, sword, gourd, clappers, flower basket, bamboo tube and rods, flute, and lotus, which are symbols of the eight Chinese Daoist immortals), and *shou* (longevity) characters. A bowl of peaches, also symbolizing long life, appears on the back. All these long-life symbols suggest that this robe may have been intended as a birthday gift.

Dondogdulam's belt, worn over the robe Mongolian style, is Russian brocade with four large semiprecious stones set into gilt silver and ringed with faceted diamonds. The belt has rings to hold the empress's daily necessities, her chopsticks and knife, tweezers, ear pick, and nail cleaner. Two items remain—her filigreed gilt knife case, perhaps of Indian workmanship, and the jade handle of her meat knife.

Dondogdulam's boots are in an undiluted Mongol style, made, however, of multicolored, pieced Russian leather with upturned toes and decorated with braid and embroidery. The soles are of ox hide. Her boot socks *(oim),* made of heavy, quilted cotton with brocaded silk edging and embroidered wool borders, have a pattern of endless knots.

A hat of Chinese-patterned silk gauze completes the costume. Brimmed, with two side ties, it is decorated with rickrack and *shou* characters in squared and cursive forms and square *xi* (double happiness, a symbol of marital bliss) characters. The hat is lined with red patterned gauze and has a sweatband covered with black lacquer. —P.B.

Buddhist Festivals in Mongolia

PATRICIA BERGER

In the centuries between the collapse of Chinggis's empire and the Buddhist revival of the late sixteenth century, the Mongols almost unanimously returned to their ancient shamanist ways. The reintroduction of Tibetan Buddhism, however, added new levels of complexity to Mongolian ritual life. Buddhism's earliest Mongol converts viewed the shamans as enemies of Buddhist belief, but they nonetheless held shamanist spirits in deep respect. They therefore launched campaigns to purge the shamans and burn their ancestral figures (ongod), but they also creatively brought many of the spirits of shamanism into the Buddhist pantheon. Some of the rituals and invocations of shamanism were also taken up by Buddhist lamas, both to pacify the spirits and to reconcile the population to conversion. Buddhist lamas rewrote shamanist prayers, created Buddhist lineages for the spirits of mountains, rivers, and herds, and incorporated veneration of the shamans' sacred rock piles, the oboo, into their ritual schedules (fig. 1). These so-called yellow shamans (in contrast to the original, non-Buddhist, black shamans), with their invocations written in Tibetan script, contributed to a twofold process in which Mongolian ritual life was Tibetanized and Tibetan Buddhism Mongolized.[1]

In Mongolia, as in Tibet, most Buddhist activities took place in monasteries, where the daily khural, or prayer meetings, were restricted, by and large, to the monastic community. Buddhist monks entered the public arena for special events in the life of the individual, especially transitions such as birth, marriage, and death. The calendar of large-scale public rituals and festivities was also tied to a natural rhythm, that of the seasons and the nomadic life; it was designed to infuse Buddhist meaning into the onset of spring and the beginning of the new year, the flowering and end of summer, the quiet of fall, and the first, dark days of winter.

In the Mongolian calendar, the New Year begins with the first sixteen days of spring, the Tsaghan sara, or White Month. For Mongolian Buddhists, the White Month became the time when the faithful remembered the miracles of Shakyamuni and paid homage to Buddhist and shamanist deities alike. Major rituals were celebrated in honor of the guardian protectors, to ask their aid in the year to come.[2]

In Da Khüree, the center of Mongolian Buddhist life and the seat of the Bogdo Gegen, the lunar New Year's celebration culminated in the Maitreya Festival; its timing both commemorated the Gelugpa founder Tsongkhapa's introduction of it in Tibet on New Year's Day, 1409, and emphasized its millenarian motives. Zanabazar, the First Bogdo

Fig. 1. The oboo, or sacred rock pile of the shamans, was converted to Buddhist use. Photo: Eugene Lee Stewart, ca. 1920. Copyright National Geographic Society.

Gegen, brought the Maitreya Festival to Mongolia from Tibet in 1656. This was a particularly unsettled time in Mongolia's history, as the Khalkhas were struggling to regroup themselves against the onslaughts of the Zunghars to the west and the Manchus to the south. Zanabazar was personally devoted to Maitreya, probably because of the hope the Future Buddha offered for the coming of a new age, and he cast numerous Maitreya images, showing him both as a young prince and as a consecrated bodhisattva (cat. nos. 100 and 109).

The Maitreya Festival was designed to encourage and prefigure Maitreya's descent from his Tushita (T: Ganden) Heaven. Responding to prayers and invocations, the Future Buddha entered an image of himself, which was loaded along with the *Five Tracts of Maitreya* onto a cart or palanquin and carried clockwise around the monastery. A depiction from the twentieth century of the festival at Lamyn Gegeen Khüree illustrates the deity hovering above an image of himself, already placed in a green horse-headed cart, and surrounded by crowds of lamas and government dignitaries (cat. no. 42, fig. 1).

The Future Buddha figured significantly in another Gelugpa ritual, Jula-yin bayar (T: Ganden Namcho), the Festival of Lights, held on the twenty-fifth day of the first month of winter, the time of the winter solstice.[3] As many as ten thousand lanterns were set all around monasteries on this day to dispel the darkness of the solstice. Jula-yin bayar commemorated Tsongkhapa's death, when he was said to have "gone to Ganden," Maitreya's Tushita Heaven, but, like most Buddhist rituals, it also had a wider purpose—to weave the events of Buddhism into the natural calendar, easing the death of the old year and the birth of the new.

One Buddhist ritual with significant non-Buddhist overtones, even in Tibet, was the *cham* (M: *tsam*), the sacred dance that was often held in the last days of the Tibetan lunar year or sometime during the first month. The Tibetan Buddhist dance took many forms, but it was essentially an exorcistic ritual, during which dancers, masked and costumed as deities, destroyed the demonic forces that obstruct enlightenment, symbolized in the form of a human figure made of dough *(lingka)*. The origins of the sacred dance are a matter of debate. Practitioners of Tibet's indigenous Bön faith have a long tradition of dance and trance and Tibetans danced in rites designed to kill enemies and affect the weather, but tradition holds that sacred dancing originated in India.[4]

The first recorded Buddhist sacred dance in Tibet was in 842, when the lay tantric Lhalung Pelki Dorje performed a Black Hat dance as a ruse to assassinate Langdarma, the faithless, apostate Tibetan king. Dance probably was used very early in the rituals of the Nyingmapa, Tibet's oldest Buddhist order, and the Sakyapa, too, held sacred dances, some of them incorporating new characters designed to

hold the interest of the crowd (e.g., cat. no. 31). It was the Fifth Dalai Lama (1617–1682) who introduced dance into the reformed Gelugpa ritual calendar. The Great Fifth's interest in Buddhist ritual and practice was not bound by sectarian politics. He learned about the intricacies of the sacred dance from his Nyingmapa guru, Gyurme Dorje, whose monastery, Mindroling, was famed for its dances with one hundred or more different masks, and he even coauthored a dance manual *(chamyik),* which outlined the proper performance of a dance in honor of Yama, the Lord of Death,[5] eventually the most popular of the dances the Gelugpa staged. In Mongolia, Yama was equated with Erleg Khan, a shamanistic lord of the underworld, an association that ensured the dance's popularity and wide acceptance.

The power of the sacred dance comes from its use of masks, which, in Tibet and Mongolia alike, were intricately designed to impersonate a wide pantheon of fierce protectors and local spirits, both terrible and comic. The dancers, all monks, embodied the deity they impersonated through the medium of the mask. Dancers prepared by meditating on their roles and on the central figure of the dance, the deity with whom they ultimately identified (for the Gelugpa, most often Yama). The whirling dance itself encouraged a trancelike, meditative state.

The connection between the sacred dance and the use of trance in Tibetan-style Buddhism is intriguing; the state Nechung oracle, whose role was to prophesy while entranced, also used dance in his practice. In Mongolia, where shamans regularly used trance as a medium for exorcism and as a way of communicating with a huge pantheon of ancestors, the connection is even clearer. The Mongolian *gürtüm lama,* who used trance to expel demons and read the future, also participated, while in trance, in the sacred Buddhist dance.[6]

The power of some masks extended beyond the dancers who wore them. One Mahakala mask caused the Seventh Dalai Lama to see the deity himself; another mask of Jinamitra was sought out by pregnant women to ensure an easy birth.[7] The mask's sacredness, like that of all the icons of Tibetan-style Buddhism, was based on its origins in the visionary dreaming of great tantric adepts. Thus, when dance masters, in the interests of proselytizing, began to augment the cast with comical figures who interacted with the lay crowd, they were criticized by more orthodox Buddhists for defiling valid meditative visualizations with theatrical imagination.

The first *tsam* held in Outer Mongolia, according to the eminent folklorist B. Rintchen, was in 1811 at Da Khüree.[8] It was staged according to the choreography outlined in the Fifth Dalai Lama's dance manual and included 108 masks, one for every bead on the Buddhist rosary. However, there is spotty evidence to suggest that *tsam* dancing was prac-

ticed in Mongolia, especially in Inner Mongolia, before this. The great Inner Mongolian proselytizer, Mergen Diyanči, wrote a dance manual for his own monastery's use sometime around 1750, which was published in Beijing in a woodblock edition.[9] Pozdneyev also records that the monks of Erdeni Zuu, wanting to stage a *tsam*, sent a mission to Urga in 1787 to ask the Bogdo Gegen's help in designing masks and choreography. The Bogdo Gegen deputized a Tibetan monk, Rabdan, who was a specialist in sacred dance, to help the project along. A Chinese cabinetmaker, Liu Shengyu, was brought from Köke qota to Erdeni Zuu to build the stage, and pious women set about sewing and embroidering the costumes.[10] Even earlier, Zanabazar himself is said to have commissioned two masks of Indian sages he encountered on the road, which Lokesh Chandra records are still kept at the Choijin-Lama Temple in Ulaanbaatar.[11]

When the Choijin-Lama Temple was built for the State Oracle, the younger brother of the Eighth Bogdo Gegen, in the early twentieth century, the site of the Da Khüree *tsam* was moved there. The first Choijin-Lama *tsam* was held in 1916, and dances were repeated annually on 25 August until the Buddhist persecutions of the 1930s (fig. 2).

From 1811 on, most Mongolian monasteries performed a sacred dance annually or biannually, usually on the anniversary of the ritual's introduction at the monastery. The Mongolian *tsam* had a brilliantly staged, complex format, rich with elaborate costumes and massive, sculptural masks, that brought to life the pantheon represented in painting and sculpture. Choreographed into a vast, circular, animated mandala, the dance's protagonists were, most often, the *dogshid* (T: *drakshay*), fierce, protector deities of Tibetan Buddhism, who were joined in the dance by the Black Hats, representing tantrics initiated into the mysteries of the Lord of Death, and finally by Yama himself. Most of these figures came directly from Tibet. Soon, however, Buddhism's very enemies were converted and became part of the Mongolian cast: the White Old Man, Čaghan ebügen; Garuda, the god of Bogdo Ula; the Dark Old Man; and other folk spirits amplified the cast of characters, sometimes comically, and gave the Mongolian *tsam* a unique, regional flavor (fig. 3; cat. nos. 33–35). In Mongolia the very theatrical Geser *tsam* was also regularly performed. It exalted the great mounted hero of Ling and included in the cast his famous wind horse, played by two monks, one front and one back.

Mask making became one of the greatest art forms practiced by Mongolian monks, who prepared and refurbished masks and dance costumes in the weeks before the performance. They built their masks of papier-mâché and clay. Pieces of *khatak,* silk scarves often woven with prayers or mantras that were given as gifts to lamas, were incorporated to ensure the sacred character of the work. This mixture of materials was formed in kaolin clay molds and, when dry, the mask was sanded, painted, gilded, jeweled, and wigged with horsehair.

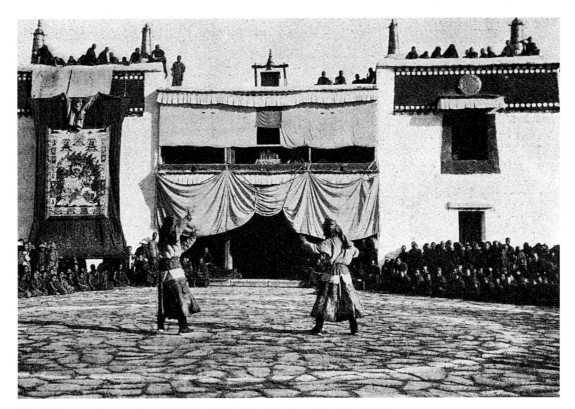

Fig. 2. The *tsam* as it was performed at Urga in the early 20th century. From Korostovetz, *Von Cinggis Khan zur Sowjetrepublik,* p. 247.

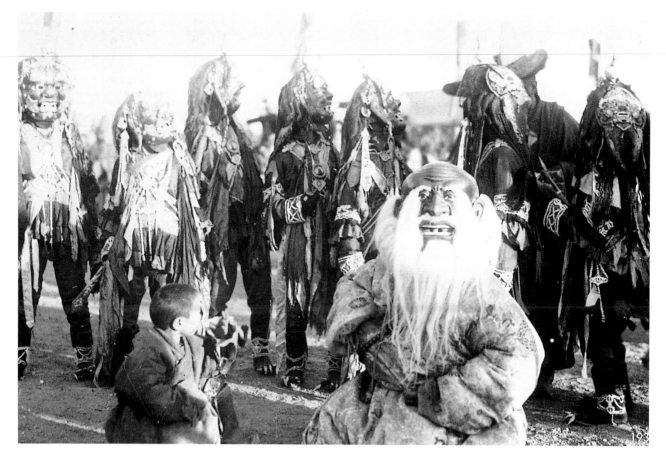

Fig. 3. The White Old Man in the last *tsam* performed at Urga in 1937. From Tsultem, *Mongolian Sculpture*, fig. 193.

Each monastery had its own style of mask making. About a century ago, the monks of Da Khüree, the great circular encampment of the Bogdo Gegens at Urga, re-made and renovated their costumes under the direction of Puntsag-Osor, a sculptor well versed in the staging of the *tsam*. The Da Khüree masks are immense and quadrangular, so large that dancers had to look through the mouths or nostrils. The great coral-encrusted mask of Begtse (M: Jamsaran), protector of both the Dalai Lama and the Bogdo Gegen, which was made at the time of the Da Khüree renovation, is by far the most famed of their productions (fig. 4). The monk-artists of Janjin Choir Monastery, south of Ulaanbaatar on the road that passed through Inner Mongolia to Kalgan (Zhangjiakou), made masks that were often fitted with glass eyes, through which the dancer could look directly. Manchir (Manjushri) Monastery, closer to Ulaanbaatar, made smaller-scale masks, typically finished off with a hedge of matted horsehair. The monastery at Manchir, along with hundreds of other monasteries, was burnt to the ground in the Stalinist purges of the 1930s; *tsam* masks are all that remain of its ritual life.

1. Rintchen, *Les matériaux pour l'étude du chamanisme mongol* (1975), pp. xi–xiii.

2. Pozdneyev, *Religion and Ritual in Society*, pp. 370–71.

3. Ibid., p. 388.

4. Nebesky-Wojkowitz, *Tibetan Religious Dances*, pp. 1–2.

5. Ibid. Nebesky-Wojkowitz translates the Fifth Dalai Lama's dance manual.

6. Heissig, *The Religions of Mongolia*, p. 81.

7. Kohn, "Mani Rimdu: Text and Tradition in a Tibetan Ritual," p. 83.

8. Forman and Rintschen, *Lamaistische Tanzmasken*, p. 62.

9. Heissig, *The Religions of Mongolia*, p. 81, and Heissig, *Die Pekinger lamaistischen Blockdrucke*, no. 162,22, p. 153.

10. Pozdneyev, *Mongolia and the Mongols*, p. 288.

11. Chandra, *Eminent Tibetan Polymaths of Mongolia*, p. 14.

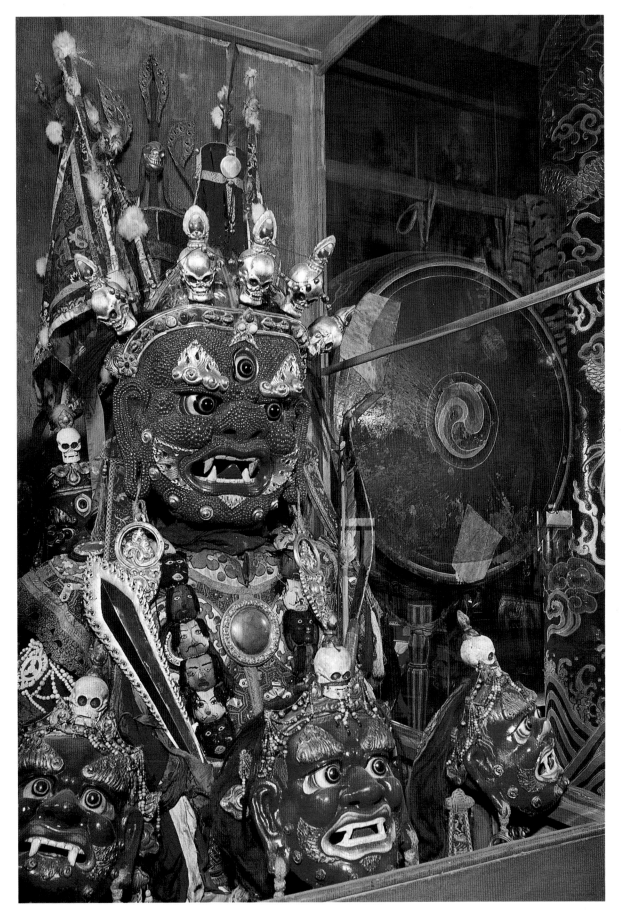

Fig. 4. The great coral-encrusted Begtse mask, at the Choijin-Lama Temple Museum, Ulaanbaatar. Photo: Kazuhiro Tsuruta.

31. CITIPATI, LORD OF THE FUNERAL PILE (M: DURTEDDAGVA, *ERBEKEI*)

Da Khüree style
19th century
Papier-mâché with polychrome, silk, cotton, and leather
H (including earrings): 35¼ (89.5) W: 17 (43.0)
D: 18⅛ (46.0)
Choijin-Lama Temple Museum

Citipati, one of the paired Lords of the Funeral Pile, is a skeleton companion of Yama, the Lord of Death. In the nineteenth-century Erleg Khan (Yama) *tsam* described by Aleksei Pozdneyev, the two Citipati were the first to appear. They are skull-masked figures, dressed in tightly fitting white garments painted or appliquéd with ribs and bones, who perform a dance before the *lingka,* a piece of dough in the shape of a boy that is the embodiment of obstacles to enlightenment and the object of the *tsam's* exorcism. Despite their gruesome appearance, they also had a comic role in both the Tibetan and Mongolian sacred dance. In Mongolia, they teased the White Old Man, Čaghan ebügen, into drinking too much, then tucked him in for a nap when he passed out.[1]

The use of Citipati in the *tsam* was an innovation introduced at Sakya Monastery in Tibet with what appears to be a purely theatrical motive—to add to the spectacle and drama of the dance and to draw in the lay audience. The innovation, which must have been a popular one, drew criticism from more orthodox clerics, who protested that the Lords of the Funeral Pile were not the valid re-creations of visionary dreaming but only the products of a theatrical imagination.[2] The sacredness of the *tsam,* for some, required that each of the masks bring to life the visualizations of great lamas. The Fifth Dalai Lama, for example, who introduced sacred dance to the Gelugpa and even coauthored a dance manual for the *tsam* held at Namgyal Monastery, in the Potala precinct, did not include them in his cast of characters.[3]

This Citipati mask is one of a pair presently kept at the Choijin-Lama Temple Museum in Ulaanbaatar. It is the image of a skull, rendered in papier-mâché at a scale much larger than life. The skull has three empty eye sockets and is topped with a crown of five additional jeweled skulls, attesting to its high rank among the denizens of the dead, and a multitiered silk parasol that radiates behind. Rainbow-colored fans, which resemble butterfly wings and give Citipati the name *erbekei* (butterfly) in Mongolian, burst from the sides of his now earless cranium, and his mouth gapes in an unnerving grin.

—P.B.

Published: Tsultem, *Mongolian Sculpture,* pl. 209

1. Pozdneyev, *Religion and Ritual in Society,* pp. 510–11, 519.
2. Kohn, "Mani Rimdu: Text and Tradition in a Tibetan Ritual," pp. 81–82.
3. Nebesky-Wojkowitz, *Tibetan Religious Dances,* p. 87.

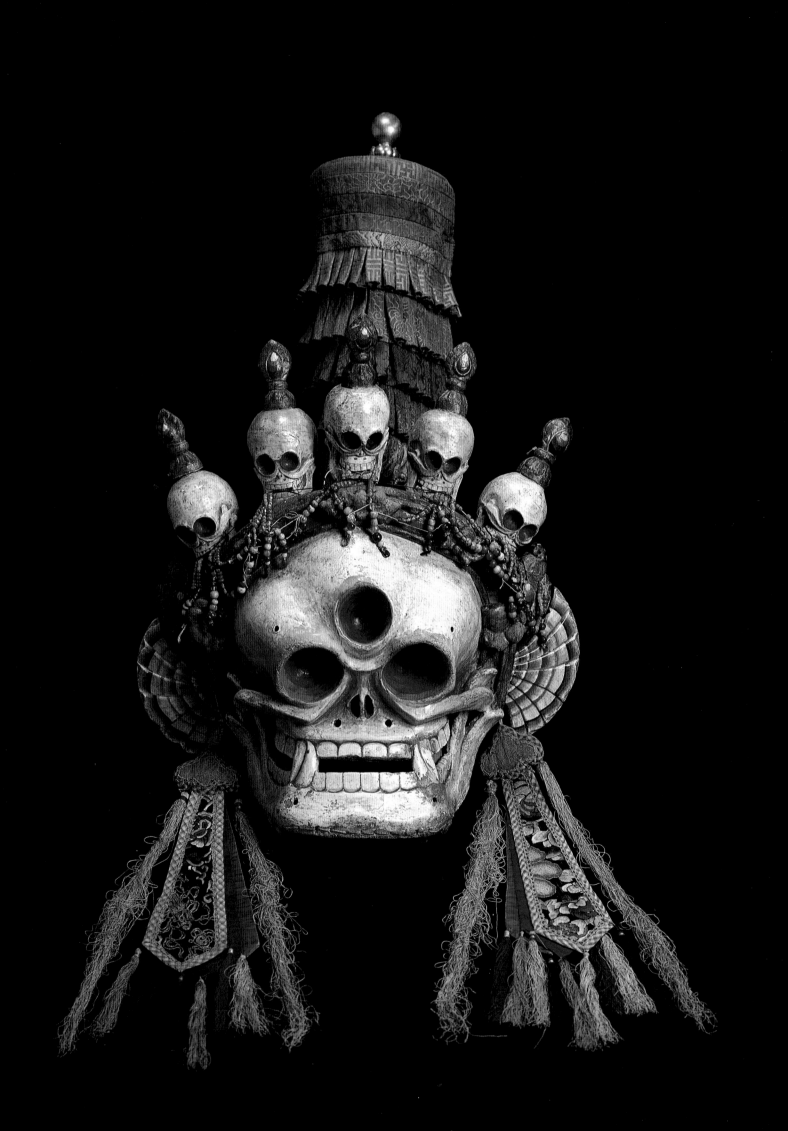

32. KASHIN KHAN AND HIS EIGHT SONS

Da Khüree style
19th century
Papier-mâché and polychrome
Kashin Khan H: 14⅜ (36.5) W: 15 (38.0) D: 13¼ (33.5)
Choijin-Lama Temple Museum

Kashin Khan and his eight bright-faced sons play a solemn role in most Mongolian *tsam* as official greeters of each mask as it emerges from the temple and enters the dance circle. The Mongols believe Kashin Khan is an incarnation in the lineage of the kings of Kashmir, who greet each Buddha as he arrives on earth. His name, Kashin, is derived from the Tibetan word *khache* (literally "big mouth"), which means "Kashmiri" or "Muslim." In Mongolia Kashin Khan enters the *tsam* just after the skeletal Citipati and holds a long silk *khatak* (scarf) to welcome all the masks that follow.[1] His boys each play a different musical instrument and, sitting on the sidelines through much of the *tsam,* provide the music for the dancers who follow.

Masks of the type used to represent Kashin Khan and his small associates are used in Tibetan ritual dances also, but in totally different and, occasionally, comical roles. There, the same round, smiling face can portray the rotund arhat Hvashang, who, together with Dharmatala, was added to the original group of sixteen enlightened ones in Tibet. (Arhats can also be found in groups of five hundred or more.) This Hvashang has many of the same characteristics as the fat Future Buddha, Budai (a form of Maitreya), including a love of children, but he may have become Kashin (Kashmir) Khan in the Mongolian *tsam* because of the many tales that tell how the five hundred arhats fled to Kashmir after being threatened with death by the Indian King Ashoka (who later repented, converted, and became an ardent patron of Buddhism).[2] The arhat Hvashang appears in sacred dances at Tashilunpo and Kumbum, where he is greeted with respect and offerings of prayer scarves.[3]

In Tibet, however, this same mask can also represent the historical Chinese monk Hvashang Mahayana, who in 792 participated in a great religious debate with the Indian sage Kamalashila at Tibet's oldest monastery, Samye. When this Hvashang appears in the dance, he is a buffoon and the com-ical object of the crowd's ridicule, for the quietist Chinese monk was roundly defeated by Kamalashila, who advocated a more compassionate, engaged bodhisattva path.[4] The victory of the Indian over his Chinese rival may have had as much to do with contemporary Inner Asian politics as with Hvashang's philosophical stance, since Tibet was openly at war with China at the time of the debate. —P.B.

Published: Tsultem, *Mongolian Sculpture,* pls. 196–201

1. Pozdneyev, *Religion and Ritual in Society,* pp. 513ff.; Nebesky-Wojkowitz, *Tibetan Religious Dances,* pp. 40, 44, 48, 58, 62, 82–83.

2. See Visser, *The Arhats in China and Japan,* pp. 21–30, on the groups and councils of the five hundred arhats.

3. Nebesky-Wojkowitz, *Tibetan Religious Dances,* pp. 48, 58.

4. Ibid., p. 83.

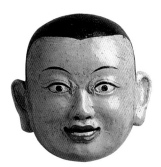
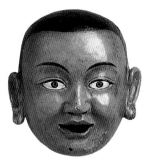
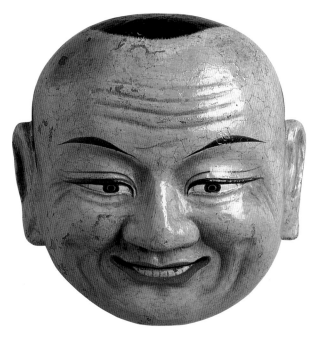
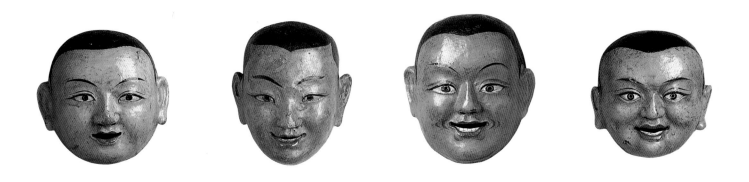

33. ČAGHAN EBÜGEN, THE WHITE OLD MAN

Da Khüree style
19th century
Papier-mâché, cotton, and horsehair
H: 41⅜ (105.0) W: 15⅛ (38.5) D: 11¾ (29.8)
Museum of Fine Arts

The White Old Man, Čaghan ebügen, popularly called Tse-rendug, is a Mongolian shamanistic folk figure, one of the ninety-nine heavenly beings *(tngri)* that preside over all aspects of life and death. Čaghan ebügen wears the white robes of the shamans of Chinggis Khan (and of the great khans themselves) and carries a dragon-headed staff, a variation on the horse-headed staffs shamans carried. He is the guardian of the fertility of the people and their flocks, who rises above injury and danger and who, like the Buddhist Yama, notes the sins of mankind in his role as Lord of Life and Death.[1]

Like any number of native Mongolian spirits, the White Old Man was brought into the Buddhist fold, a scene depicted in the meditation thangka of the Eighth Bogdo Gegen (cat. no. 18, fig. 6), where the Bogdo Gegen pays him a visit and receives an empowerment from him. The White Old Man was actually introduced into the Mongolian Buddhist pantheon by the 1630s, when the First Bogdo Gegen, Zanabazar, was still a child, for a prayer to him already in wide use at the time tells of his meeting with the Buddha, who confirmed his powers. In the 1760s, Mergen Diyanči, the Inner Mongolian lama who contributed so much to the syncretization of Buddhism and Mongolian shamanism, wrote an uncompromisingly Buddhist prayer to him.[2] At the same time, he also gave the White Old Man a deer as a mount and a bulbous cranium, so that he resembled Shoulao, the Chinese Daoist god of longevity.

The White Old Man's greatest role in Mongolian Buddhism was in the *tsam,* where he played the role of a buffoon who, nonetheless, had deep symbolic significance. In most Mongolian *tsam,* the White Old Man, stiff with age, totters into the dance near the beginning. He sets to work with his staff, beating a tiger skin, which he "kills." His youth now restored, he performs an energetic dance, offers snuff to the crowd, accepts donations in return, drinks too much, and is tucked in by the skeletal Citipati after he passes out. The White Old Man's revitalization mirrors the death of the old year and the birth of the new, an apt reference to the late season when *tsam* are often staged.

The White Old Man was one of Mongolia's most important additions to the cast of the *tsam,* and, until the early twentieth century, he only appeared in *tsam* held in Mongolia proper and in parts of northeastern Tibet that were predominantly Mongol. The White Old Man became part of the Tibetan dance cast, however, after the Thirteenth Dalai Lama dreamt of him during his Mongolian exile (1904–6) and subsequently had him included in the sacred dance held at Namgyal Monastery, within the precincts of the Potala.[3]　—P.B.

Published: Tsultem, *Mongolian Sculpture,* pls. 194–95

1. Heissig, *The Religions of Mongolia,* pp. 51, 76–81.
2. Ibid., p. 78, and Mostaert, "Note sur le culte du Vieillard blanc chez les Ordos," p. 109.
3. Nebesky-Wojkowitz, *Tibetan Religious Dances,* pp. 44, 65.

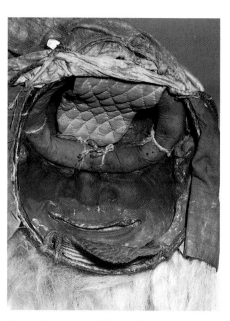

View of the interior of the mask.

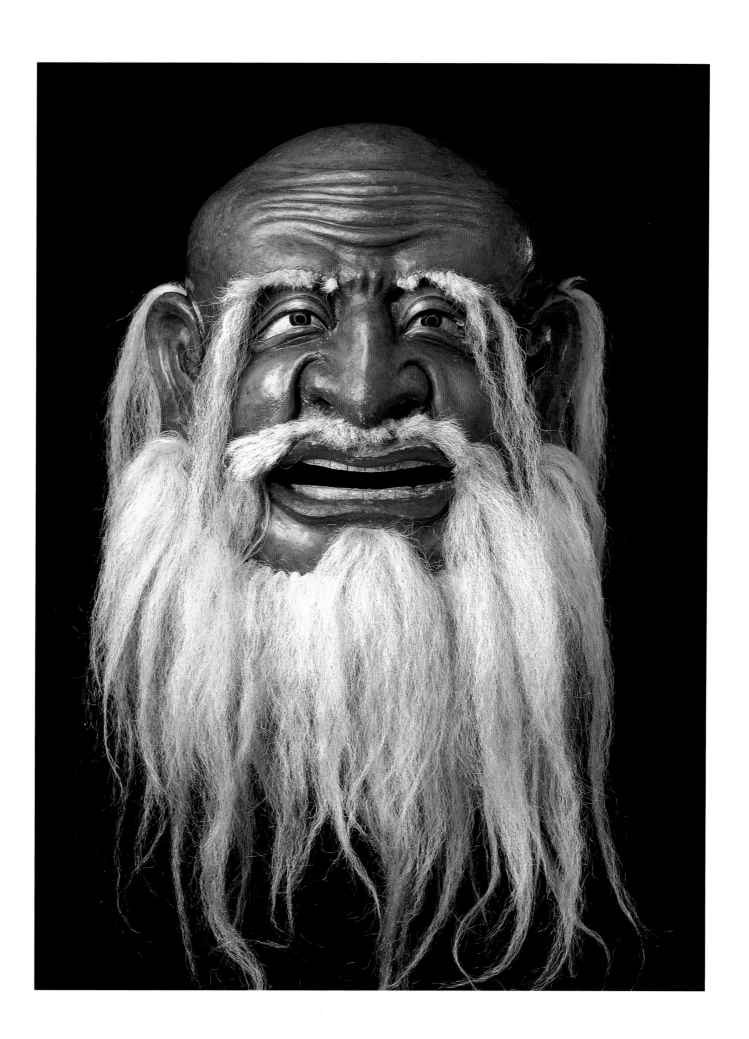

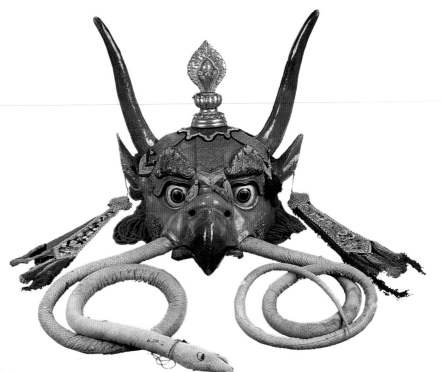

34. GARUDA, SPIRIT OF BOGDO ULA

Da Khüree style
19th century
Papier-mâché with polychrome, gilt, silk, and cotton
H: 20⅝ (52.5) W: 18½ (47.0) D: 16⅛ (41.0)
Choijin-Lama Temple Museum

Garuda, the Devourer, was originally an ancient Hindu sun symbol, half-vulture, half-man, who served as the vehicle of the god Vishnu and his wife, Lakshmi, and lived on a diet of *naga* (snakes), the ultimate creatures of the earth. In Buddhist belief, Garuda became the vehicle of Vajrapani and, paired with a twin, the symbol of the transcendent Buddha Amoghasiddhi.

Garuda eventually took on another important role in Tibetan Buddhism as well, because of his similarity to the mythical Himalayan *khyung* bird. Four bull-horned *khyung* protected the four directions, and a *khyung* appeared in the company of mountain spirits in the sacred dances of the Bön, the indigenous, pre-Buddhist religion of Tibet.[1] With his heavenly associations and his sworn enmity to the evil forces of the earth, Garuda appealed to Mongolian Buddhists, whose own native shamanism honored the sky above all, as a logical character for their own version of the *tsam*.

In the Mongolian *tsam* Garuda plays the role of one of the Lords of the Four Mountains, a group of local figures that won acceptance and popularity because they were taken directly from Mongolian shamanism and grafted onto Tibetan Buddhist belief. Garuda represents the god of Bogdo Ula, the sacred mountain south of modern Ulaanbaatar (see also cat. nos. 35 and 36).[2] All four mountain gods were "converted" to Tibetan Buddhism by the efforts of the Third Dalai Lama, whose campaign eventually became part of an official Manchu policy aimed at easing the differences between Mongolian folk beliefs and those of officially sanctioned Buddhism.

This Garuda mask was probably made as part of the renovation of *tsam* costumes in Da Khüree led by the monk-artist Puntsag-Osor at the end of the nineteenth century, for it appears in photographs of the last *tsam* held at the Bogdo Gegen's *khüree* in the late 1930s.[3] The fierce, orange bird is brilliantly conceived, with green curving bull's horns of the Himalayan *khyung*, bull's ears, and a bovine snout that rears up behind its pronged beak. It has flaming gilt eyebrows and cheeks, and a gilt finial, decorated with jewels bursting from a lotus, crowns its head. Its formidable jaws grip the hapless *naga*, a naive but expressive creature crafted of stuffed, patterned cotton. Garuda's frightful hair is made of red string, and it wears an elegant headpiece and ear pendants of appliquéd, embroidered, and tasseled silk. —P.B.

Published: Tsultem, *Mongolian Sculpture,* pls. 188–89; Rintchen, "Urgaer Pantomimen," fig. 3

1. Nebesky-Wojkowitz, *Tibetan Religious Dances,* pp. 256–58.

2. Heissig, *The Religions of Mongolia,* p. 109.

3. See, e.g., Tsultem, *Mongolian Sculpture,* pl. 188.

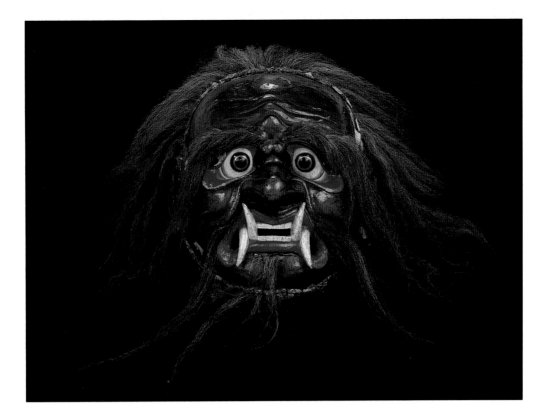

35. THE DARK OLD MAN, SPIRIT OF SONGGINA

Da Khüree style
19th century
Papier-mâché, polychrome, and horsehair
H: 12¼ (31.0) W: 13 (33.0) D: 12⅝ (32.0)
Choijin-Lama Temple Museum

Tibetan Buddhism, and the *tsam* in particular, became the repository for many of Mongolian shamanism's spirits and concepts. Most significant was the Mongols' reverence for heaven and high places, given expression in ceremonies of sacrifice to heaven, to heavenly beings *(tngri),* and to the spirits of mountains, and in rituals of the *oboo,* the sacred pile of rocks. All of these rituals were eventually incorporated into Buddhist practice in Mongolia.

While this process of syncretization was a carefully planned effort, promoted by the Manchu government of China and Mongolia, it is described in traditional literature in mythic terms. Thus, Sonam Gyatsho, the Third Dalai Lama, did battle with the war god Begtse and brought him into the church as a major protector. He also burned the shamanist ancestral figures *(ongod)* using the fire mandala of Mahakala, purged the shamans, and forced their conversion to Buddhism in what is described as a holy crusade (see cat. no. 18).

Begun by the Third Dalai Lama and promoted by Altan Khan and other early converts to Buddhism, the campaign to eliminate the influence of the shamans continued well into the twentieth century, when the crafters of Mongolia's first constitution still felt a need to ban them officially. The shamans resisted conversion from the sixteenth century on, continuing their ancient practices surreptitiously and battling openly with the forces of the Tibetan Buddhist hierarchy. One such shaman was the powerful Dark Old Man, who was eventually defeated and buried in the Songgina Mountain, one of Outer Mongolia's greatest and most sacred peaks. His spirit thereafter came to personify the spirit of the mountain.[1]

The Dark Old Man played a prominent role in the Outer Mongolian *tsam* as one of the Lords of the Four Mountains (Songgina, Bogdo Ula, Čenggeltü, Bayan Jirüke), who appear near the beginning of the sacred dance. This Dark Old Man is one of the greatest extant masks of this shamanistic figure, made for use in the Da Khüree *tsam*. His black, bleary-eyed face, with its long white fangs and unkempt black hair, tinged with a sorrowful ferocity, successfully captures, and tames, the memory of pre-Buddhist Mongolia.

—P.B.

Published: Tsultem, *Mongolian Sculpture*, pl. 205; Rintchen, "Urgaer Pantomimen," fig. 4

1. Heissig, *The Religions of Mongolia*, pp. 105–10; Heissig, "A Mongolian Source to the Lamaist Suppression of Shamanism in the Seventeenth Century" 3–4 (1953), 493–536; Rintchen, "Urgaer Pantomimen," pp. 444–48; and Forman and Rintschen, *Lamaistische Tanzmasken*, pp. 116–19.

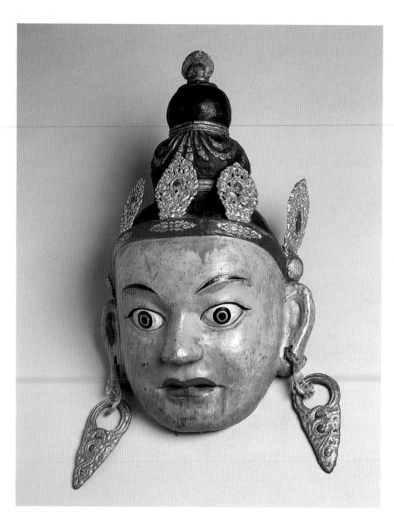

36. THE SPIRIT OF BAYAN ĴIRÜKE

Da Khüree style
19th century
Papier-mâché, polychrome, and silk
H: 25¼ (64.0) W: 14¾ (37.5) D: 11⅜ (29.0)
Choijin-Lama Temple Museum

This yellow-faced young prince is the third of the four Lords of the Mountains, the spirit of Bayan Ĵirüke, a mountain east of modern Ulaanbaatar and sacred to Mongolian shamanism (see also cat. nos. 34 and 35).[1] Like so many figures in the Mongolian *tsam,* Bayan Ĵirüke complemented a concept already personified in Tibetan sacred dance, that of the spirits of the four directions. The tradition of using directional figures seems to have been very ancient in Tibetan dances; in sacred dances of the Nyingmapa, for example, the *ging,* four to sixteen supernatural beings of lower rank taken from the indigenous Bön pantheon, portray the subsidiary points of the compass.[2] In the dance manual *(chamyik)* of the Fifth Dalai Lama, four gate guards, each with the head of a different bird, appear at the beginning of the dance.[3]

The Mongolian *tsam* also included a number of Flag Bearers (M: *shogjon*) in its cast, minor figures who stood at the periphery of the dance space, both representing and guarding the four directions. An alternate interpretation of this mask is that it is such a *shogjon;* his yellow color would indicate that he symbolizes the east, just as Bayan Ĵirüke does. Masks similar to this one appear in the role of Flag Bearers in photographs of a recent re-creation of the *tsam* held in Ulaanbaatar. The Flag Bearers may be an earlier, less completely assimilated Tibetan group, which later found a more perfect Mongolian expression in the Lords of the Four Mountains.

—P.B.

Published: Rintchen, "Urgaer Pantomimen," fig. 2

1. Rintchen, "Urgaer Pantomimen," pp. 441–48.
2. Nebesky-Wojkowitz, *Tibetan Religious Dances,* p. 81.
3. Ibid., pp. 98–99.

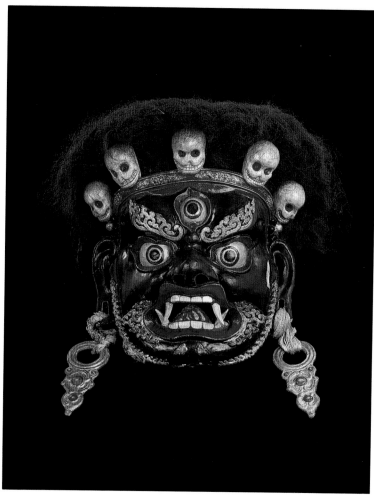

37. MAHAKALA (GURGON)

Manchir Monastery style
19th century
Papier-mâché, polychrome, gilt, horsehair, and cotton
H: 18⅛ (46.0) W: 20½ (52.0) D: 13⅛ (33.5)
Choijin-Lama Temple Museum

Mahakala is one of the most prominent guardian figures in Tibetan Buddhism; his forms number between seventy-two and seventy-five, some of them Indian in origin, others Tibetan.[1] While Mahakala imagery pervades the pantheons of all of Tibet's religious orders, his popularity in Mongolia owes a great deal to his early importance to the Sakyapa (see Berger, "After Xanadu") and, subsequently, to Khubilai Khan, who took him as his personal deity after his historic conversion to Buddhism. Later, in the fifteenth century, the Gelugpa adopted many of the Sakyapa's variations on Mahakala, and he became one of their Great Protectors of the Law (S: *dharmapala;* T: *drakshay;* M: *dogshid*). After the second conversion of Mongolia to Buddhism in the sixteenth and seventeenth centuries, forms of Mahakala sacred to the Sakyapa and the Gelugpa were honored there in both icons and in the sacred *tsam.*

Mahakala had already played many different roles in Tibetan sacred dances of every order, often appearing in multiples of six and, at Kumbum, taking on as many as twenty-six separate forms in a single performance.[2] In his black-faced form, Mahakala can represent his main, six-armed manifestation (when his role is taken by two dancers working together) or Gurgon, Lord of the Tents, a two-armed form of the deity particularly beloved by Mongol Buddhists. Descriptions of Mongolian *tsam,* however, usually have the Mahakala, adorned with a crown of five skulls, entering the dance as one of nine Great Protectors.

This black Mahakala has a single snub-nosed face contorted with rage, three bulging eyes, flaming eyebrows and beard, dangling earrings, and the diadem of five skulls worn by all the Great Protectors. His wig is a felted tangle of horsehair, tamed into the loaflike form favored at Manchir Monastery, once a thriving establishment south of Urga but unfortunately destroyed during the Stalinist purges of the late 1930s.

—P.B.

1. Nebesky-Wojkowitz, *Oracles and Demons of Tibet,* p. 38.

2. Filchner, *Kumbum Dschamba Ling,* pp. 308–29.

38. HAYAGRIVA (M: DAMDINSANDOV, KHAYINKIRVA)

Janjin Choir Monastery style
19th century
Papier-mâché with polychrome and gilt
H: 26¾ (68.0) W: 18⅛ (46.0) D: 8⅝ (22.0)
Choijin-Lama Temple Museum

Hayagriva is a Great Protector (S: *vidyaraja*) and, together with Yamantaka, one of the most popular personal, tutelary deities *(yidam)* among the Gelugpa, particularly in Mongolia (see cat. no. 78), a figure devotees could choose to identify with in their meditations. Originally conceived as a form of the Hindu god Vishnu, Hayagriva was brought into the Buddhist pantheon in the sixth century as a manifestation of Avalokiteshvara, the Bodhisattva of Compassion, and a member of the Lotus Family of deities presided over by the Buddha Amitabha. His main role is as a destroyer of the obstacles standing in the way of enlightenment and as a Great Protector, particularly of sacred texts.[1]

Hayagriva is one of the very few *yidam* to assume a role as Great Protector in the *tsam* ritual dance. Like Buddhas and bodhisattvas, the *yidam* were generally ranked too high to appear in the dance.[2] Although the nineteenth-century Russian Mongolist Aleksei Pozdneyev does not mention Hayagriva's participation in the Erleg Khan (Yama) *tsam*,[3] Hayagriva did play a role in several different Tibetan performances, especially at Kumbum in Amdo.[4] Similarly, in the *tsam* held as part of the ritual Mani Rimdu, Hayagriva has profound significance.[5] Mani Rimdu's style was strongly influenced by Mindroling, a Nyingmapa monastery known for its elaborate dances using a hundred or more masks, whose head lama in the seventeenth century, Gyurme Dorje, was the guru of the broad-minded Fifth Dalai Lama. It was the Great Fifth who actively promoted the sacred dance among the Gelugpa and later influenced its development in Mongolia. In Mani Rimdu, which revolves around the figure of the Lord of the Dance (identified with Lokeshvara and Avalokiteshvara), Hayagriva is the "wisdom mind hero living inside Lokeshvara's heart" and is called on to perform a horse dance in which he "dissolves the three worlds in the objectless realm."[6]

This large papier-mâché mask of Hayagriva depicts him in his role as one who expels demons and defines borders and who builds a Diamond Pavilion to keep out obstructive forces where devotees may dwell until Maitreya, the Future Buddha, comes. He has the red face of the Lotus Family, flaming red hair, three bulging eyes, fangs, and a green horse's head at his crown of skulls. Green, which combines hot and cold, is the color of ease and skillful means.

This Hayagriva mask is said to come from Janjin Choir Monastery, which was south of Da Khüree (Urga) in Setsen Khan *aimag,* along the flanks of Bogdo Ula Mountain. The monastery consisted of three Tibetan-style temples dating to the early Qianlong period (1736–95). Choir had 1,500 monks, none an incarnate-lama, and despite the fact that it was near a major trade route linking Urga to Chinese Kalgan (Zhangjiakou), it was known for its strict discipline and lack of luxuries (such as alcohol).[7] N. Tsultem describes the masks of Choir as small in scale, about the size of a human face, and fitted with glass eyes through which the dancer could look directly.[8] This mask, however, has neither of these characteristics; it has painted eyes, and its grand scale requires the wearer to look through its horrific mouth.

—P.B.

1. Gulik, *Hayagriva: The Mantrayanic Aspect of Horse-Cult in China and Japan.*

2. Nebesky-Wojkowitz, *Tibetan Religious Dances*, p. 75.

3. Pozdneyev, *Religion and Ritual in Society*, pp. 505–21.

4. Nebesky-Wojkowitz, *Tibetan Religious Dances*, p. 57.

5. Kohn, "Mani Rimdu: Text and Tradition in a Tibetan Ritual."

6. Ibid., pp. 26–29.

7. Pozdneyev, *Mongolia and the Mongols*, pp. 405–11.

8. Tsultem, introduction to *Mongolian Sculpture,* unpaginated.

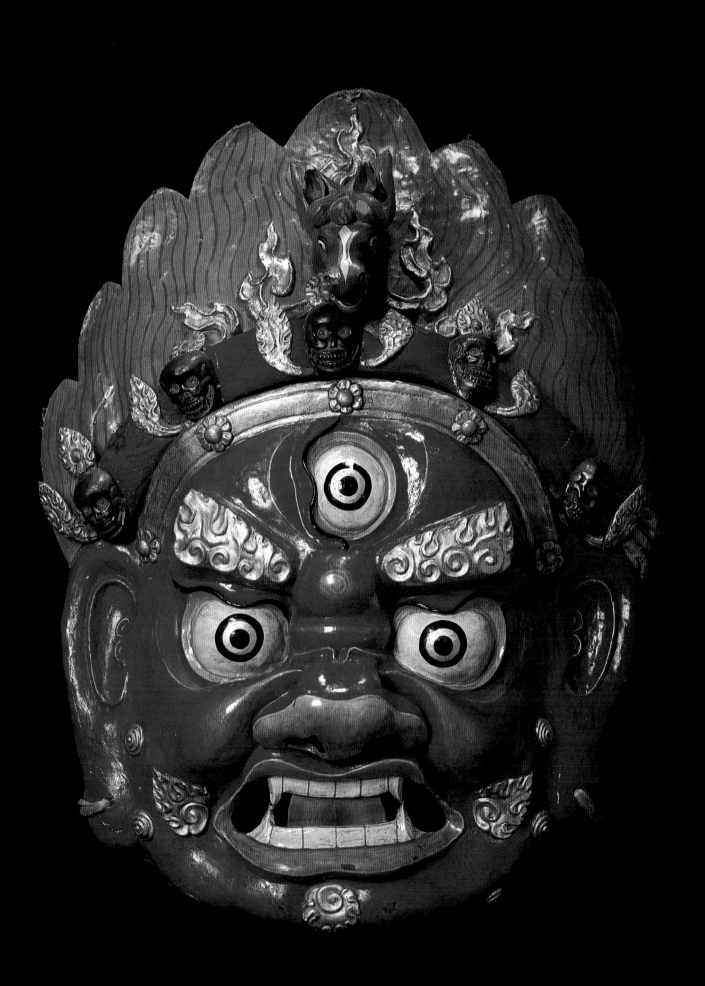

39. SWORD BEARER (M: *SELMEČI*)

19th century
Papier-mâché with polychrome, gilt, horsehair,
leather, and silk
H: 30¾ (78.0) W: 10¼ (26.0) D: 9⅝ (24.5)
Choijin-Lama Temple Museum

The Eight Sword Bearers, or Masters of the Knife (M: *selmeči*; T: *tritok shenpa gye*), form the inner retinue of the war god and Great Protector Begtse (M: Jamsaran; T: Jamsing).[1] Although Begtse, the "hidden coat of mail," was a guardian of the Dalai Lamas (and of the Bogdo Gegens of Da Khüree), he rarely was part of the cast of Tibetan ritual dances. Mongols believed that Begtse only appeared in the Tibetan pantheon in the late sixteenth century, shortly after he was "converted" to Buddhism following a struggle to keep the Third Dalai Lama (and Buddhism) out of Mongolia. The supposed conversion of this pre-Buddhist war god had potent symbolic value, however, and he soon assumed a central place in the Mongolian Buddhist pantheon and in the Mongolian *tsam*. He was also honored with a special dance held three times a year at Kumbum in Amdo, a Tibetan monastery near the Mongolian border that attracted a large Mongol population.[2]

Begtse's importance in Mongolia was undisputed, both because of his military prowess and because of his role as protector of the Bogdo Gegens and, by extension, of the nation.[3] Mongolia's greatest extant *tsam* mask, made when all the Da Khüree masks were renovated in the late nineteenth century, represents the war god at a monumental scale, his coral-encrusted human face contorted with ferocity, and his head crowned with a diadem of five skulls and five triangular flags (see Berger, "Buddhist Festivals in Mongolia," fig. 4). Begtse's flags, like the costumes of most *tsam* dancers, resemble those worn by Chinese actors when they do battle on stage. Despite their sacred role, Mongolian and Tibetan ritual dancers owed part of their public effectiveness to a fine sense of theater, at least some of it borrowed from their Chinese neighbors.

The Eight Sword Bearers were much smaller in scale than the magnificent Begtse. All wore similar human-faced masks, terrible and fierce, crowned with a single jeweled skull. The Sword Bearers also wore red costumes, with flame-appliquéd jackets and trousers, abbreviated bone pectorals, bone anklets, and had red fanged feet. This Sword Bearer resembles a raging fire: his brow and chin burst into golden flames, his gilt fangs and eyes glare, and his wild red hair and long silk and leather ear pendants stream behind. The relatively small size of this mask, its sketchy execution, and its unsettling resemblance to an actual enraged human face suggest it was not made at Da Khüree, but was probably the product of an outlying monastery. —P.B.

1. Nebesky-Wojkowitz, *Tibetan Religious Dances,* pp. 57–60, 79.

2. Ibid., p. 57.

3. Pozdneyev, *Religion and Ritual in Society,* p. 518; Lessing, *Mongolen: Hirten, Priester und Dämonen,* pp. 110–36.

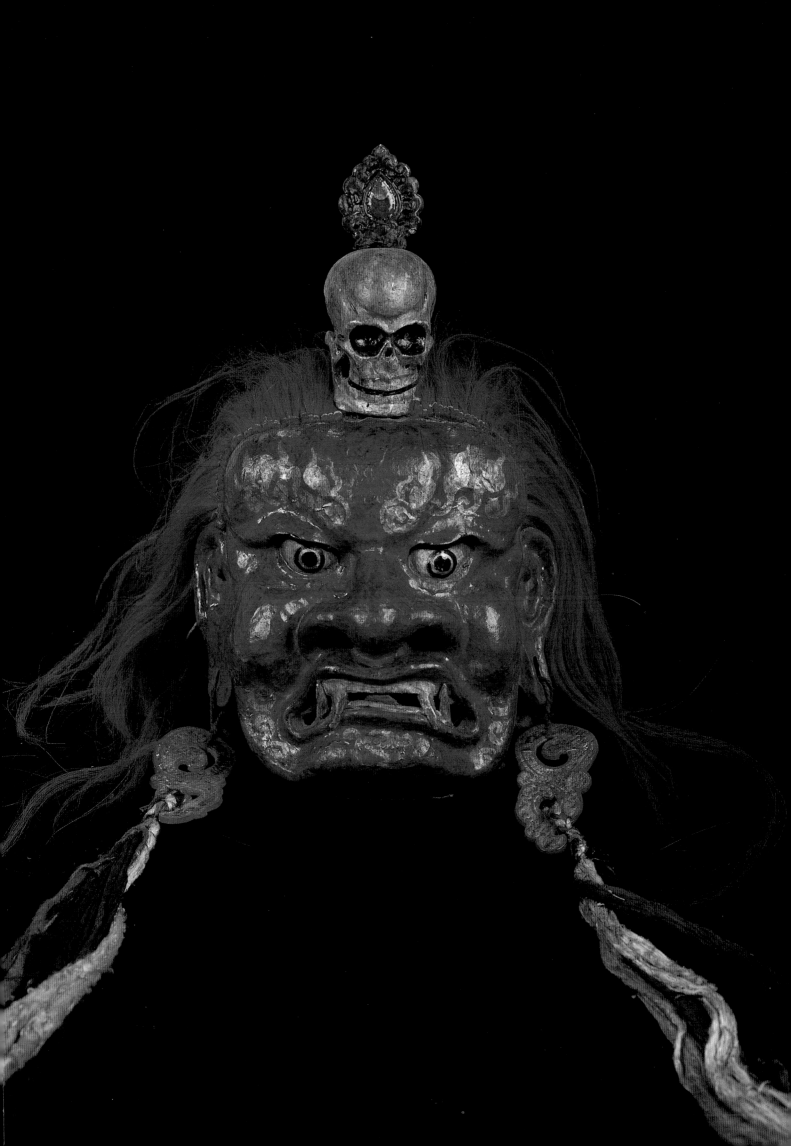

40. YAMA, LORD OF DEATH (M: CHOIJIL, ERLEG KHAN)

Janjin Choir Monastery style
19th century
Papier-mâché with polychrome, gilt, horsehair, and silk
H: 19½ (49.5) W: 18⅞ (48.0) D: 19¾ (50.0)
Choijin-Lama Temple Museum

Yama, the Lord of Death, is the central figure in most of the sacred dances of the Gelugpa, the god who can strip away all obstacles to enlightenment. Yama enters the dance after all the other members of the cast have appeared and after most of the comic stage business has been played out. It is Yama or one of his stag-headed messengers who ceremoniously kills the *lingka,* the dough figure that embodies demonic forces and mental obstructions, and starts the final, mandalic dance of all the players with himself at its heart.

Yama is the Mongolian Choijil, who was also identified in Mongolia with the pre-Buddhistic, Siberian Erleg Khans, nine shamanistic lords of the lower world and its denizens.[1] The infinitely expandable nature of the Tibetan pantheon, which opened itself up to new forms of deities seen in the dreams of great lamas, as well as to powerful local spirits, eased the Buddhist assimilation in Mongolia by equating its gods with native spirits and heroes whenever possible. Yama's equation with Erleg Khan is part of a process, officially sanctioned in the eighteenth century by the Manchu government, that also brought Begtse, the White and Dark Old Men, and Garuda into the Mongolian pantheon.

In his primary outer and inner forms, Yama is a blue, bull-headed god, standing on a blue bull, who kneels on a prostrate woman. Red is the color of the secret form of Yama, who tramples on a red bull (see cat. no. 90). It is also the color of the Yama of the West, represented by this mask, one of a group of minor Yamas of the Four Quarters.[2] The large red bull's head is forcefully three-dimensional. The mouth, with its flat, ruminant's teeth, is pulled back into a carnivore's snarl, the three eyes split the furrowed brow, and the curving horns and alert ears create a jagged, menacing silhouette. A diadem of five jeweled skulls symbolizes the Lord of Death's high rank.

This Red Yama mask is said to have come from Janjin Choir (see also cat. no. 38). Located on the road that led from Urga to Kalgan, Janjin Choir was a monastery known for its exceptional austerities and brilliant *tsam* masks.

—P.B.

Published: Tsultem, *Mongolian Sculpture,* pl. 179

1. Nebesky-Wojkowitz, *Oracles and Demons of Tibet,* p. 538.
2. Ibid., p. 83; Nebesky-Wojkowitz, *Tibetan Religious Dances,* p. 77.

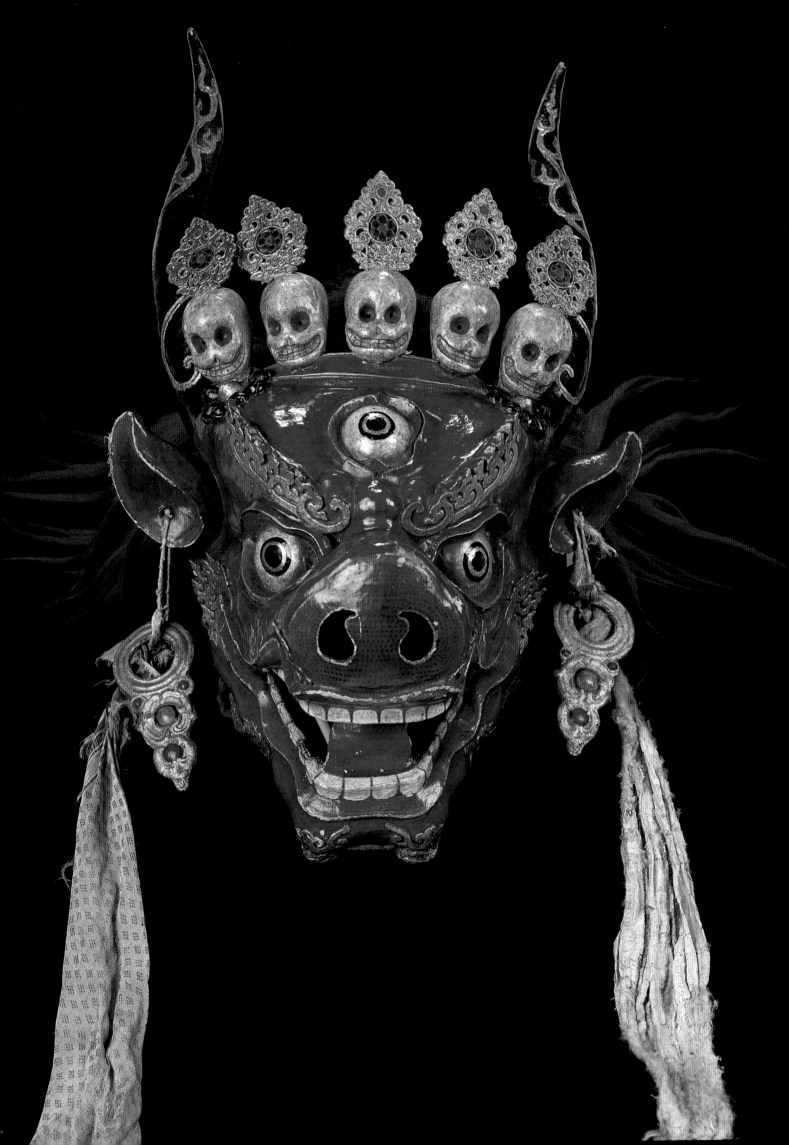

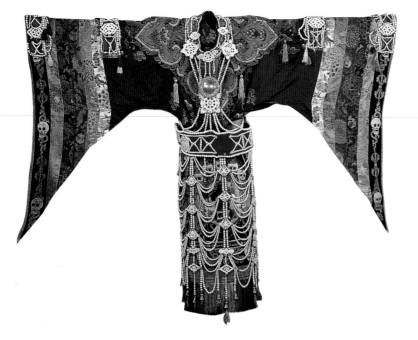

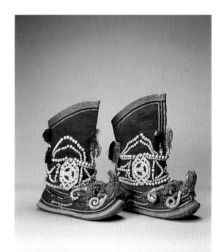

41. *TSAM* REGALIA FOR A BLACK
HAT DANCER

Da Khüree
Late 19th century
Silk, cotton, leather, ivory, and copper alloys
Robe L: 56¾ (144.0) W (including sleeves): 91¾ (233.0)
Museum of Fine Arts

The Black Hat dancers, *shanag,* are the only participants in the *tsam* who perform without masks. They are tantric adepts who have been initiated fully into the mysteries of Yama, the Lord of Death central to most Gelugpa sacred dances.[1] In some *tsam* their role is to "kill" the *lingka,* the dough figure that embodies obstructions to enlightenment; in other *tsam* the Black Hats' appearance only marks the moment when other, masked, figures, either Yama or one of his associates, dispatch the *lingka.*

Despite appearing without masks, the Black Hats are elaborately costumed and armed with ritual knives *(phurba)* and skull cups *(kapala).*[2] Their huge, black fur–rimmed hats have high golden crowns in the form of skeletons cut off at the waist, which are crested with sacred jewels *(chintamani).* These hats symbolize the world of existence: the wide brim calls to mind voidness and the world's foundations; the high crown is the image of the world-mountain, Mount Sumeru.[3]

The Black Hat dancers' under-robes are made of appliquéd and embroidered Chinese silks; the wide sleeves, cut as they are for costumes of actors in the Chinese opera, end in band upon band of damask and brocaded silk, appliquéd with skulls and *dorje,* and beaded with ivory *chakra* (wheels). Robes for the *tsam* were sometimes gifts of the Manchu court or altered by devout Mongol women from the discarded robes of Mongol aristocrats, which were also gifts from the Manchus.

This robe is partially covered by a tasseled, four-cornered cape or tippet *(dok-yik),* which is appliquéd with four of the five symbols of the Buddhist families of deities—the lotus, *dorje,* jewels, and sword—and encrusted around the neck with ivory ornaments in the form of a *chakra.* Tied around the waist is a heavy, rainbow-fringed apron *(mod-yik),* emblazoned with a demonic skull-crowned White Mahakala and eleven additional skulls, all done in heavy appliqué. Over the whole are the six bone ornaments (here made of ivory), which hang from the neck, spill onto the chest, where they are caught by a shamanic mirror, and connect to a four-tiered ivory apron. The Black Hat's multicolored, thick-soled boots, adorned with ivory festoons, are made of sculpturally appliquéd, stuffed cotton in the form of long-snouted *makara,* crocodilian water spirits. —P.B.

Published: Béguin et al., *Trésors de Mongolie,* cat. nos. 31–33; Tsultem, *Mongolian Arts and Crafts,* pl. 78

1. Nebesky-Wojkowitz, *Tibetan Religious Dances,* pp. 1, 80, 93, also mentions the popular belief that the Black Hats represent Bön priests, devotees of Tibet's indigenous religion, while learned lamas tend to interpret them as tantric adepts.

2. The Black Hats' costumes are described in Nebesky-Wojkowitz, *Tibetan Religious Dances,* pp. 94–98; Pozdneyev, *Religion and Ritual in Society,* pp. 508–9; and Hansen, *Mongol Costumes,* pp. 148–50 and passim.

3. Nebesky-Wojkowitz, *Tibetan Religious Dances,* pp. 95–96.

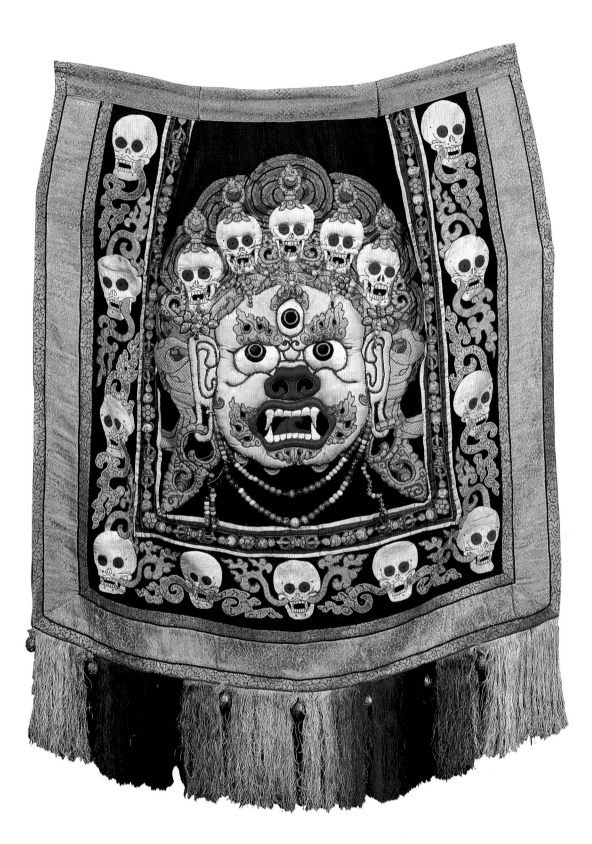

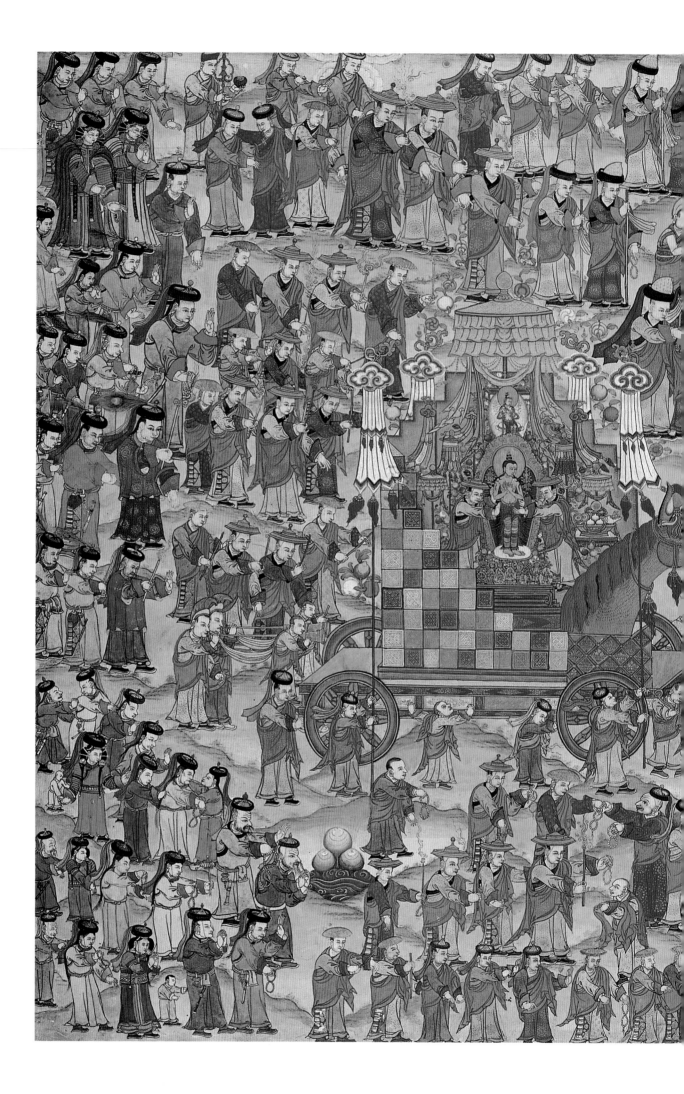

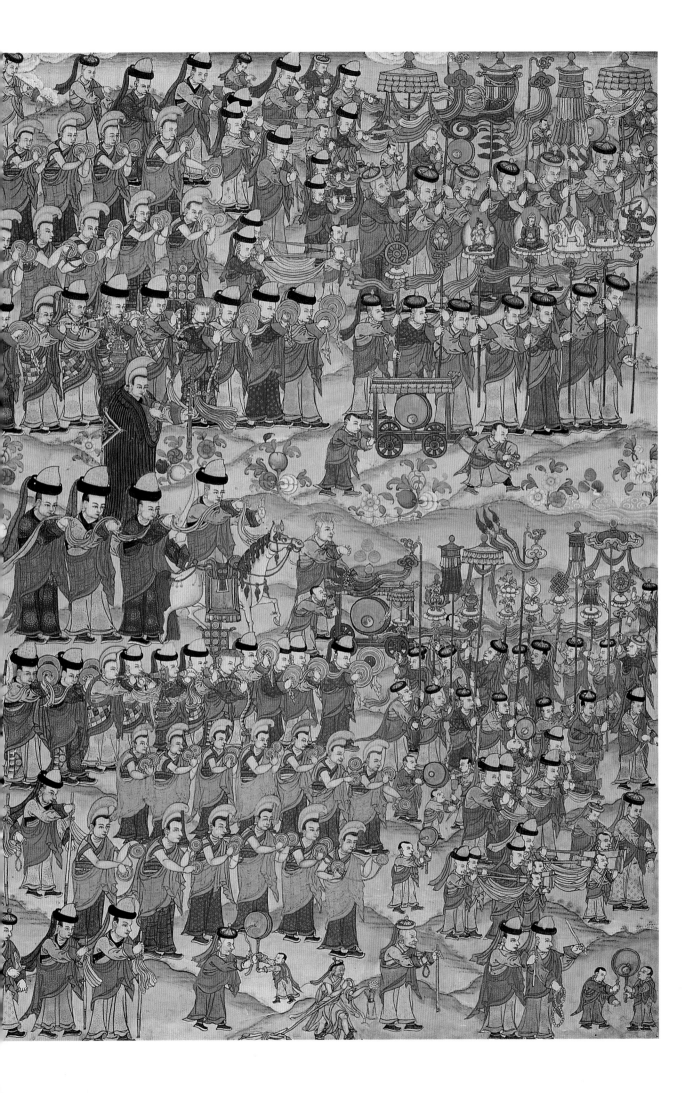

42. THE MAITREYA PROCESSION AT LAMYN GEGEEN KHÜREE

G. Dorj (1870–1937)
Late 19th–early 20th century
Colors on cotton
H: 27 (68.6) W: 39½ (100.2)
Museum of Fine Arts

The Maitreya Festival, created by the Gelugpa founder Tsongkhapa on New Year's Day, 1409, was introduced to Outer Mongolia by Zanabazar after his return from Tibet in 1656. Here the early modern painter G. Dorj captures the festival as it was performed at Lamyn Gegeen's *khüree*, about 370 kilometers southwest of Urga and south of the road that connected Urga to the Manchu administrative center at Uliasutai.

Lamyn Gegeen was the popular name of Erdene Bandid Khutagt, who, along with the Bogdo Gegen himself and Zaya Pandita of the Khalkhas, was one of three great Khalkha *khubilgan* (incarnate-lamas), who were commonly distinguished as the white, yellow, and black *ger* khans, because their kitchen *ger* were covered with felt of these colors.[1] Pozdneyev reports that about fifty years before his own visit to Outer Mongolia (that is, in the 1840s), Lamyn Gegeen moved into Sayin Noyon Khan's *aimag* (modern Bayanhongor province) and forced another great *khubilgan*, Nomyn Khan, to move to the west into Zasagt Khan's *aimag*, claiming the two could not live in such close proximity and, more disingenuously, that Nomyn Khan was needed in areas where Buddhist belief was still weak.[2]

Dorj has placed the Maitreya Festival in a blue-green landscape studded with flowers, sacred jewels, and peaches. Two groups of monks, wearing pointed hats rimmed in black fur, lead the procession with standards bearing the Seven Treasures of the Chakravartin, symbols of Maitreya's imminent world rulership (above), and the Eight Buddhist Treasures (below). A central group of five lamas—perhaps Lamyn Gegeen himself, dressed in a maroon pleated robe with a double *dorje* on his back and yellow cockscomb hat, and four others who tend the riderless white horse that also marks Maitreya's royal status—precedes the green horse-headed cart carrying his image (fig. 1). Two monks steady the Maitreya, who appears as a youthful bodhisattva, while the Future Buddha himself, seated on a lotus in the European position, legs down, hovers above the statue, as if he is descending into it. This apparent sacralization of the figure of Maitreya recalls an incident recorded by the nineteenth-century monk-historian Dharmatala, who wrote that the Sixth Dalai Lama urged his followers to worship a certain image of Maitreya because "the true Maitreya Buddha descended from Heaven and sank into this image" and added that "whatever happens, do not forget that I have entered this Maitreya circle and become one with it."[3]

Ranks of monks surround the central group of lamas, who represent the yellow, religious side of the Mongol hierarchy. They roll drum carts, play hand drums, blow on long horns, carry elaborate parasols, and hand out strings of prayer beads. Behind Maitreya's cart are elegantly dressed representatives of the black, secular government and other lay devotees, including women in the classic cow-horn headdress. —P.B.

Published: Tsultem, *Mongol Zurag*, pl. 153

1. Lattimore and Isono, *The Diluv Khutagt*, p. 251; Pozdneyev, *Mongolia and the Mongols*, p. 272.

2. Pozdneyev, *Mongolia and the Mongols*, p. 134.

3. Dharmatāla, *Rosary of White Lotuses*, pp. 274–75.

Fig. 1. Green horse-headed cart carrying the image of Maitreya.

43. GREEN HORSE'S HEAD FOR MAITREYA'S CART

Damdinsüren (1868–1938)
Early 20th century
Wood, velvet, metal fittings, paint, and horsehair
H: 34⅞ (88.5) W: 9½ (24.0) L: 32⅞ (83.5)
Museum of Fine Arts

The Maitreya Festival held at the Bogdo Gegen's Da Khüree (Urga) was one of the most splendid in Outer Mongolia, rivaled only by the spectacle the Ilaghughsan Khutuktu staged at his monastery, Duutuin Khüree, west of Da Khüree. The Da Khüree Maitreya Festival was held on the last day of the New Year's celebration near the end of spring and followed a prescribed path around the Bogdo Gegen's monastic residence. In the nineteenth century this Maitreya Way was often a point of contention between the Mongol religious hierarchy and the Chinese merchants, whose Maimaicheng, the business town that served the *khüree*, threatened to overrun it.

The monks of Da Khüree pushed Maitreya's cart, colorfully painted and equipped with a parasol and a carved horse's head, all around the *khüree*, stopping at the cardinal points to chant the *Five Tracts of Maitreya*, which were packed into the cart along with Zanabazar's own image of the Future Buddha (cat. no. 100). Crafting and renovating the horse-headed cart and the other accoutrements of the ceremony were regular monastic responsibilities.

This green head of a horse is all that remains of the Maitreya cart used at Da Khüree in the early twentieth century. The artist Damdinsüren, most likely a monk, carved the head out of a core of joined wood, then covered it with velvet in the green color that symbolizes ease and skillful means. The bridle is also velvet, embellished with fittings of gilt copper. A gilt wooden finial tops the horse's head, which rears back in an expressive display of spirit. His mane is appropriately horsehair, dyed a brilliant red. —P.B.

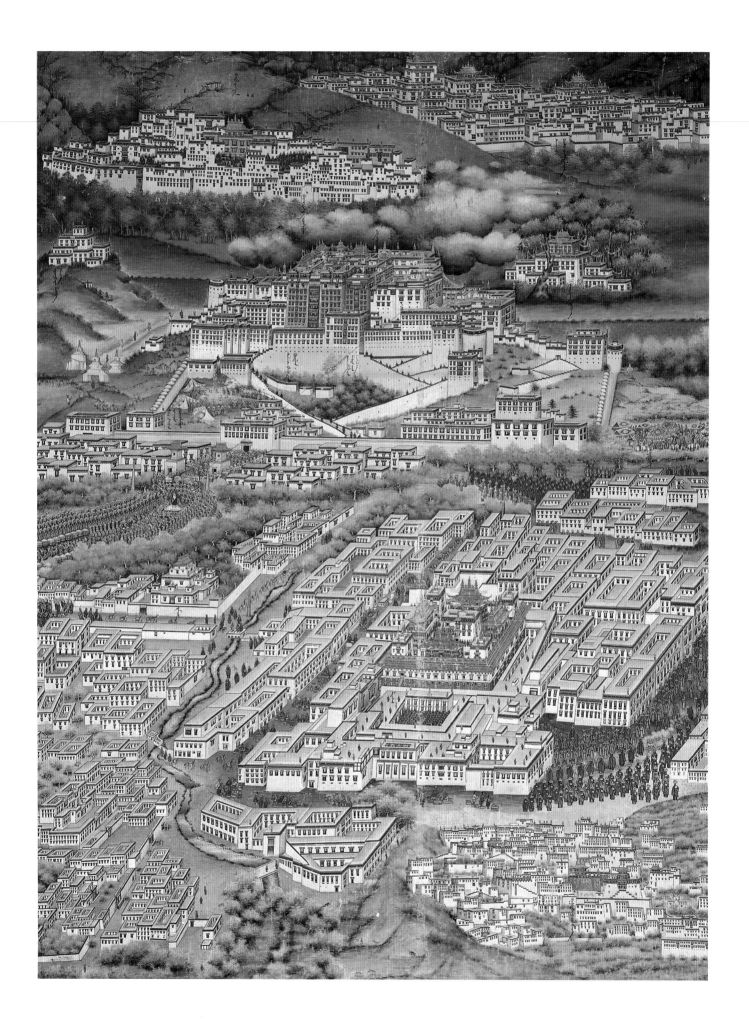

44. LHASA DURING THE NEW YEAR

B. Sharav (1869–1939)
Early 20th century
Colors on cotton
H: 65½ (166.7) W: 50¼ (127.7)
Museum of Fine Arts

Lhasa, the capital of Tibet, is the Mecca of Tibetan Bud-
dhism. This composite painting of Lhasa and its surround-
ings was the work of a Mongolian artist. The main buildings
of Lhasa and the temples in the outskirts have been juxta-
posed into a bird's-eye view of the city. Skillfully depicted,
the individual buildings are easily recognizable. The artist
portrayed Lhasa during the New Year's celebration, during
the time of the Thirteenth Dalai Lama (1876–1933).

Dominating the landscape is the red-and-white Potala
Palace (1). Named after Avalokiteshvara's abode, it is an ap-
propriate name for the residence of the Dalai Lamas, who
are incarnations of Avalokiteshvara. The construction of the
Potala began in 1645 under the order of the Fifth Dalai Lama,
who consolidated the existing buildings on the hill into one
impressive structure. Within the palace, the Dalai Lamas
resided in the section that is painted red, while the white
sections were the administrative quarters of the Tibetan
government. The roofs of the Potala are gilded, and the
sight of these golden roofs glittering in the sunlight must
have delighted weary pilgrims as they descended the last
mountain pass into the valley of Lhasa.

Tents have been set up in the lower left courtyard below
the Potala (2), where spectators in nobleman's attire watch
a *tsam* dance. Across from the Potala is Chagpori Hill; upon
its summit stands the Medical College of Lhasa (3). Between
Chagpori and the Potala lies the Pargo Kaling (4), where a
group of stupas guards the western gateway to the city.

The Thirteenth Dalai Lama (5), identified by his mus-
tache, is leaving the Potala in a grand procession seated on a
large palanquin (fig. 1). Monks and monk musicians line
both sides of the street. Among the noblemen marching in
front of the palanquin is the Oracle of Nechung, the Dalai

Lama's soothsayer, distinguished by his helmet and colorful
flags behind his shoulders.

A strange happening is taking place behind the Dalai
Lama. A man is sliding down a rope (7) strung diagonally
between one of the lower turrets of the Potala and one of
the stone steles below the Potala (fig. 2). The abbés Huc and
Gabet, in February 1846, observed this unusual ceremony
during the New Year in Lhasa. This is Huc's account:

> They have at Lha-Ssa [Lhasa] a kind of gymnastic exer-
> cise, called the *dance of spirits*. A long cord, made of
> leathern thongs firmly plaited together, is fastened to
> the summit of the Buddha-La [Potala], and descends
> to the foot of the mountain. The *spirit dancers* pass up
> and down this cord with an agility that can only be
> compared to that of cats and monkeys. Sometimes,
> when they have reached the summit, they extend their
> arms, as if going to swim, and fly down the cord with
> the rapidity of an arrow. The inhabitants of the province
> of Ssang [Tsang] are reputed the most skillful in this
> kind of exercise.[1]

When Sir Charles Bell witnessed this strange ceremony
during the New Year of 1921, the rope had been lowered to
one of the bottom turrets, as in this painting. He mentioned
that the rope was formerly attached to the top of the Red
Palace on the summit of the Potala, a drop of three hundred
feet or more. However, this was discontinued after the death
of one of the performers.[2] By the time of Hugh Richardson
and Spencer Chapman (1937), the men of Tsang no longer
slid down the rope but instead performed acrobatic tricks on
a tall pole during the second day of the New Year. Every year
certain villages in Tsang provided these men as a form of

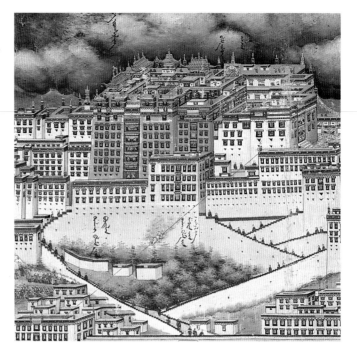

Fig. 1. Detail of scene 5.

Fig. 2. Detail of scene 7.

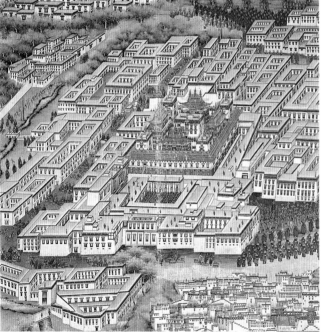

Fig. 3. Detail of scene 8.

Fig. 4. Detail of scene 13.

taxation. The Fifth Dalai Lama imposed this duty on them as punishment, because the king of Tsang and his people opposed him when he seized power in 1632.[3] The way the rope is attached in this painting is in accordance with Bell's description. That, coupled with the presence of the Thirteenth Dalai Lama, allows us to date this painting as early twentieth century, before his death in 1933.

Mongolian inscriptions identify the important sites of Lhasa. The building below the Dalai Lama is the Ramoche (6), the seventh-century temple built by Princess Wen Cheng of China to house the image of the youthful Shakyamuni Buddha, the Jo Rinpoche, a statue brought by her from China and considered to be the most sacred image of Tibet. Wen Cheng, together with Brikuti of Nepal, the two wives of Songtsen Gampo, brought Buddhism to Tibet in the seventh century. In the years that followed, the Jo Rinpoche was transferred to the Jokhang (8), the Cathedral of Lhasa, as well as the destination of all the pilgrims (fig. 3). A long procession is marching toward the Jokhang. Inside the Jokhang, the courtyard is full of monks from the monasteries nearby, all gathered together for the Monlam Chenmo, or "great prayer," instituted by Tsongkhapa (see cat. no. 15), which took place on the fifth and sixth days of the New Year.

The road encircling the Jokhang is the Barkor (9), the center of commerce for the city. After paying their respects to the statue of the Jo Rinpoche, the pilgrims shop at the Barkor. The painting shows groups of merchants, already lining the street with their merchandise.

The three important temples shown in this painting are Ganden (10), Drepung (11), and Sera (12). Established by Tsongkhapa (see cat. no. 15) and his students in the early fifteenth century, these monasteries were the places young Mongol monks (if they could afford it) would go for higher religious study.

Norbulingka, the Jewel Park and summer palace of the Dalai Lamas, has been placed to the right of the Potala by the artist (13). Among the festive tents set up there, the yellow one in the center is the type used for distinguished visitors, perhaps the Bogdo Gegen (fig. 4).

There are prototypes for this type of painting in Tibet, showing Lhasa during the New Year, and the temples in its vicinity.[4] However, this painting stands out for its bold composition, its clarity, and its superb workmanship. —T.T.B.

1. Huc, *Recollections of a Journey through Tartary, Thibet, and China,* vol. 2, p. 231.

2. Bell, *The Religion of Tibet,* p. 127.

3. Chapman, *Lhasa: The Holy City,* pp. 313–14; Richardson, *Ceremonies of the Lhasa Year,* pp. 18–20.

4. Rhie and Thurman, *Wisdom and Compassion,* cat. no. 155; Béguin, *Dieux et démons de l'Himālaya,* cat. nos. 279 and 280; Essen and Thingo, *Die Götter des Himalaya,* cat. no. I-152.

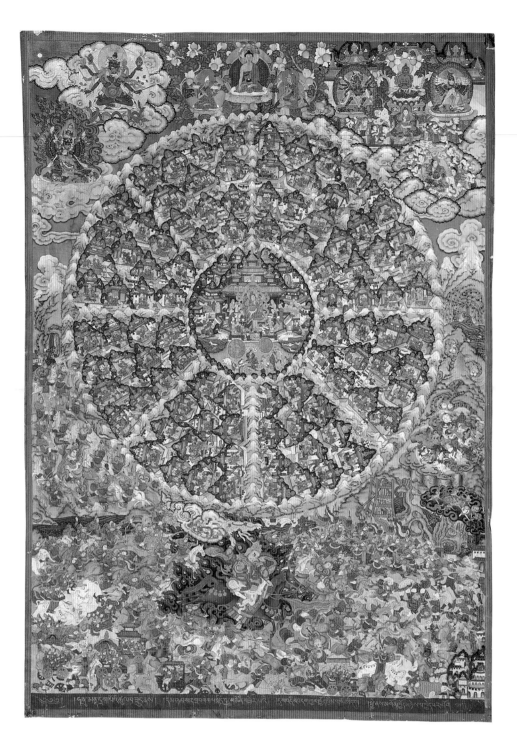

45. SHAMBHALA

Late 19th century
Thangka, colors on cotton
H: 33⅞ (86.1) W: 24⅛ (61.2)
Museum of Fine Arts

Shambhala is a mystical kingdom believed by followers of Tibetan Buddhism to be located somewhere north of Tibet. Shaped like an eight-petaled lotus, the kingdom of Shambhala is surrounded by two rings of snow-covered peaks. A series of enlightened kings lives in the Kalapa Palace in the center of this kingdom, encircled by their vassals who in-habit the twelve principalities within each of the eight sec-tions. It is believed that at the end of the world Rudrachakrin (T: Drakpo Korlojen), the last king of Shambhala, together with his general Hanumanda, will emerge from the king-dom to destroy the barbarians from the west, and Buddhism will enter a golden age and flourish in the world.

Tibetan lamas believe that Shambhala is a Buddhist Pure Land, a special type of paradise reserved for those on their way to nirvana.[1] One can make rapid progress toward enlightenment in Shambhala by studying the *Kalachakra,* the Wheel of Time or Time Machine, considered to be the most complex and secret among Tibetan teachings. The Buddha Shakyamuni, just before his death, took on the form of the deity Kalachakra and preached this doctrine at a place called Dhanyakataka, in southern India. Among the audience was Suchandra, the first king of Shambhala. He took this teaching back to his country, built a three-dimensional mandala, and taught this doctrine to his countrymen.[2]

All the major orders in Tibet studied the *Kalachakra,* especially the Gelugpa, who considered it the most important doctrine. In one of his visions, Tsongkhapa, the founder of the Gelug order, was taught this doctrine by a king of Shambhala. Drepung, one of the three important Gelugpa monasteries near Lhasa, was actually named after Dhanyakataka, the place where Buddha preached the *Kalachakra.* The Third Panchen Lama, Losang Palden Yeshe (in China considered the sixth, 1737–1780), wrote a guidebook to Shambhala, while other Panchen Lamas were considered to be incarnations of the kings of Shambhala.[3] Another guidebook was translated by Taranatha (1575–1634), the preincarnation of Zanabazar.[4] The Fourth Bogdo Gegen was especially interested in the *Kalachakra* doctrine.[5] He initiated the Kalachakra (M: Duinkhor) service in Urga in 1801. In 1805, after his visit to Tibet, he established the Manla (god of medicine) service according to the principles of Duinkhor. In 1806 he established a temple, Dachin-kalbain süme, a special *datsang* (college) for the school of Duinkhor, and in his zeal to promote the doctrine, he gilded the roof of the temple mentioned above.[6]

Not only did Shambhala and the *Kalachakra Tantra* influence Tibetan religion and culture, they also affected the political history of Tibet and Mongolia. Dorjieff, the Buriat lama who was one of the Thirteenth Dalai Lama's tutors, in his effort to curry political favor for Russia among the Tibetans, spread the story that Russia was Shambhala and the tsar was the king who would restore Buddhism.[7] The Mongolian national hero Sükhbaatar, who founded the Mongolian People's Republic in 1921, composed for his troops a marching song that includes the words: "Let us die in this war and be reborn as warriors of the king of Shambhala!"[8] And later, in order to end the line of Bogdo Gegens, a resolution was passed by the Mongolian Communist Party Congress of 1926: "and as there is a tradition that after the Eighth Incarnation he will not be reincarnated again, but thereafter will be reborn as the Great General Hanumanda in the realm of Shambhala, there is no question of installing the subsequent, Ninth Incarnation."[9]

This painting of Shambhala is depicted according to the Tibetan tradition. The last king is enthroned in the Kalapa Palace in the center of the mandala-like country of Shambhala. In the scene before his throne, he is teaching his subjects the *Kalachakra* text. Below, a great battle is taking place, and Rudrachakrin, the future king of Shambhala on his blue horse, is spearing the leader of the barbarians. The Buddha Shakyamuni surmounts the thangka, flanked by Tsongkhapa (left) and a Bogdo Gegen(?) (right). The upper left-hand corner shows two deities floating on Mongolian-style visionary clouds with dark scalloped edges: Guhyasamaja (Lord of the Diamond Body, Speech, and Mind of All the Tathagatas)[10] and Vajrabhairava in a halo of flames. On the right, the blue Vajradhara is accompanied by Samvara (left) and Kalachakra (personification of the *Kalachakra Tantra*). Below them, a king, possibly the first king, Suchandra, is preaching the tantra to his subjects.

The Tibetan inscription reads: "Hanumanda having taken on the characteristics of Drag-po, at this time when the vow-breakers and enemy demons [in the context this probably refers to the Muslims] plunge the blade into the heart, I also by your [aid] having been [re-]born into the retinue itself [this may also mean: into *samsara* itself], come, oh, you protector, to cause joy!"[11]

The mystical country of Shambhala inspired much literature in the West, including James Hilton's famous 1933 novel, *Lost Horizon.* —T.T.B.

Published: Béguin et al., *Trésors de Mongolie,* cat. no. 25

1. Bernbaum, *The Way to Shambhala,* p. 9.

2. Ibid., p. 14.

3. Ibid., p. 185.

4. Ibid., p. 186.

5. Podzneyev, *Mongolia and the Mongols,* p. 356.

6. Ibid.

7. Bell, *Tibet Past and Present,* p. 63.

8. Bernbaum, *The Way to Shambhala,* p. 18.

9. Ibid.

10. Rhie and Thurman, *Wisdom and Compassion,* p. 277.

11. The author is grateful to James Bosson for the translation.

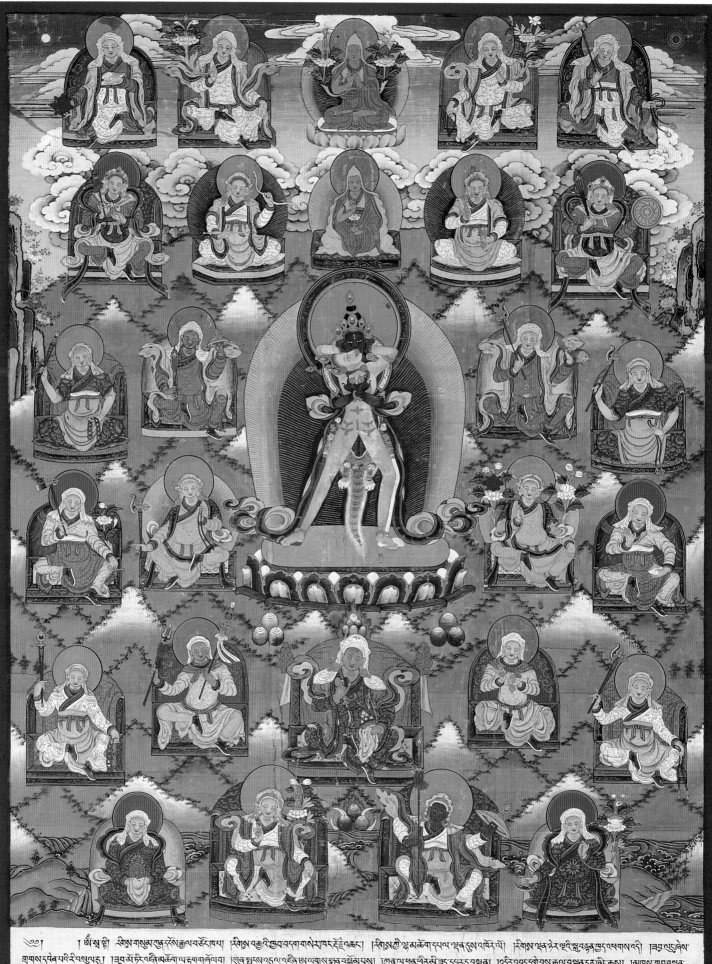

༄༅། །ཨོཾ་སྭ་སྟི། རིགས་གསུམ་ཀུན་འདུས་རྒྱལ་བའི་དབང༌། རིགས་བཅུ་དུས་བཞུ་བདག་ཉིད་འཛིན་རྗེ་བཙུན། རིགས་ཀྱི་སྣ་ཚོགས་དཔལ་ལྡན་ཕུན་ཚོགས་འབྱོར། རིགས་བདག་རྩ་རེ་སྐྱེ་སྟུ་རྒྱ་བརྒྱུད་འཕགས་མཆོག །རྗེ་བཙུན་ནས། གསལ་བའི་རིག་འཛིན་ཏུ། །རྒྱལ་བོའི་འཛིན་སྐལ་དགུ་དུ་བགན་ལས། རྒྱུ་འབྲས་སྒྱུར་དུ་འཛིན་ལུགས་བསྟན་ནས་བུ། །རྒྱུ་འབྲས་བདེ་ཆེན་ཉིད་ནས་རྣམ་པ་བརྒྱུན། རྗེ་འཕགས་གཡོ་འགྱུ་རྒྱུ་བརྒྱུད་རབ་བྲེངས་ནས། །ཐམས་ཅད་བརྒྱུན་བུ། འཛིན་རྣམ་བེ་བྱུན་བསམ་བཏན་བར་བར་བ། རྒྱུ་བ་འགས་རྒྱུད་བདེ་བདེ་བེ་བྱོ་བ་འགྱོ་བ། །རིགས་བཅུ་རྒྱུ་བརྒྱུད་འཛིན་འཆེ་བཞིན་འཇི་འགྱུར་འཔ། །དཔས་འཛིན་བྱེ་པར་ཕུ་དཔར་བཀྲག །བདག་གཉིས་བར་ཏུ་འཆི།

46. KALACHAKRA AND THE TWENTY-FIVE KINGS OF SHAMBHALA

18th century
Thangka, colors on cotton
H: 37½ (95.0) W: 28½ (72.3)
Museum of Fine Arts

The kingdom of Shambhala is dedicated to the glory of Kalachakra, the personification of the *Kalachakra Tantra*. This tantra contains mystical teachings on cosmology and astrology and is central to the doctrines of the Gelug order. Kalachakra (no. 28 in diagram) is a *yidam*, or archetype, deity. He stands on the yellow sun disk upon the lotus pedestal and wears a tiger skin. He is always shown with two feet, but he can have many heads and hands. In this example, he has one head, and his two hands, holding the *dorje* and bell, are crossed in the *vajrahumkara mudra* (gesture of highest energy), embracing his yellow-colored *yum*, or consort. The two figures represent the union of wisdom and compassion, which is necessary for enlightenment, so that they can in turn help others in the process of liberation from suffering.[1]

Tsongkhapa (no. 26), founder of the Gelugpa, appears in the middle of the top register. Below him is another Gelugpa lama (no. 27), holding the long-life vase containing a lotus, identified by inscription as Serkhang Rinpoche.

The twenty-five seated figures represent the kings of Shambhala who are supposed to preserve and teach the *Kala-chakra*. This lineage was founded by Manjushrikirti (no. 1),

who simplified the teachings of the *Kalachakra*. His attributes are the sword and book, and the Panchen Lama is believed to be his reincarnation. Manjushrikirti united the various factions of Shambhala into one diamond caste; he and his descendants were thus given the title of Kulika or Rikden, "Holder of the Castes."[2] Most of the kings are supposed to rule for one hundred years each, and a Panchen Lama will be reborn as the last king, Rudrachakrin (no. 25), who will deliver the world from evil forces.[3] The kings are placed against a landscape of snow-covered peaks. The green textured strokes on the mountains are typical of Mongolian painting.

A symbol that represents the essence of the *Kalachakra* doctrine is the "all powerful ten" (T: *namchu wongden*), or "the ten of power" or "ten powerful ones." This emblem, consisting of the flame, sun, and moon (*om*, *ha*, and *sva*) and the seven syllables (*ha*, *ksha*, *ma*, *la*, *wa*, *ra*, and *yam*) woven together, is often used as an auspicious symbol to decorate Tibetan and Mongolian monasteries.[4] It is also the symbol found on many of the sutra covers (see cat. nos. 48, 50, and 52), for good luck and protection.

THE TWENTY-FIVE KULIKA KINGS OF
SHAMBHALA (RIKDEN NYERNA):

1. Manjushrikirti (book and sword)
2. Pemakar (prayer beads and lotus)
3. Sangpo (wheel and conch)
4. Namgyal (hook and noose)
5. Shenyensang (bow and arrow)
6. Rinchenchak (*dorje* and bell)
7. Kyapjuk Beh (Vishnugupta) (trident and prayer beads)
8. Nyimadrak (sword and shield)
9. Shintusangpo (sword and shield)
10. Gyatsho Namgyal (axe and head)
11. Gyalka (Durjaya) (club and chain)
12. Wönang Nyima (axe and lasso)
13. Dawa'i Wö (wheel and conch)
14. Natsok Suk (hook and lasso)
15. Sagyong (chopper and skull cup)
16. Tayay Nyen (hammer and lotus)
17. Sengge (*dorje* and bell)
18. Pegyong (trident and *khatvanga*)
19. Namparnön (club and chain)
20. Dobochay (drum and gems)
21. Magakpa (Aniruddha) (hook and lasso)
22. Miisenge (wheel)
23. Wongchuk (chopper and skull cup)
24. Taye Namgyal (Anantajaya) (*dorje* and bell)
25. Drakpo Korlojen (Rudrachakrin) (spear and shield)

Written across the bottom is an inscription in Tibetan.
It reads:

> These are the particularly exalted images of the twenty-
> five noble ones, Tsongkhapa, the All-Pervading Lord
> from Serkang, Vajradhara [Jebtsundamba], Tükor [Kala-
> chakra], etc. Having remained in meditation in the
> foremost profound meditation in the ravine-hermitage
> called *zab lung,* [I], Ala Mengomba, who has renounced
> the world and clings to the *vinaya*, and for the unlimited
> benefit of all have had them painted. By this virtuous
> endeavor, may the doctrine of victory spread and ex-
> pand. May Kedrup [here, the disciple of Tsongkhapa?]
> and the whole realm rejoice, and may I and all others
> please him that the Noble King may support us![5]
>
> —T.T.B.

1. Bernbaum, *The Way to Shambhala*, p. 127.
2. Ibid., p. 234.
3. Ibid., p. 29.
4. Ibid., pp. 125–26.
5. The author is grateful to James Bosson for the translation.

Book Covers

TERESE TSE BARTHOLOMEW

The book covers of this exhibition, with the exception of the small embroidered cover (cat. no. 60) and the printing block (cat. no. 56), all belonged to the last Bogdo Gegen, who became the Bogdo Khan. These were his personal books, used by him in his daily rituals, until his death in 1924, when they were transferred to the State Central Library.

Since they contained the words of Buddha, religious books were, and still are, treated like precious objects in Mongolia. Following the Tibetan tradition, they are carefully wrapped with precious silk and brocade and stored securely on high shelves in the temples and *ger*. Copying a sutra, similar to painting a thangka, is a meritorious act. The book covers of this exhibition are splendid examples of the reverence pious monarchs and high monks paid to the sacred words of the Buddha. Gold, being the most precious of metals, is used lavishly and often in conjunction with gems.

Some of the sutras are Chinese in origin and were gifts from the Qianlong emperor. These elegant creations from the palace workshops were a combination of the emperor's taste and the State Preceptor Jangjya Khutuktu Rolpay Dorje's vast knowledge of Tibetan religion and art. In comparison, the Mongolian book covers parallel the Chinese works in craftsmanship but surpass them in their exuberance and choice of material.

The official languages for the Qing court relating to Buddhism were Chinese, Manchu, Mongolian, and Tibetan. Although Tibetan is the liturgical language of Mongolia, the sutras in the exhibition include examples in Mongolian, and many important religious texts have been published in Mongolia since the thirteenth century (fig. 1). These texts were written in various scripts, such as the Uighur, Soyombo, and Phagspa scripts, as well as Lantsha, a stylized script based on *devanagari* and used for mantras and title pages.

The author is extremely grateful to James Bosson for translating the information supplied by the State Central Library, and all the Tibetan and Mongolian inscriptions.

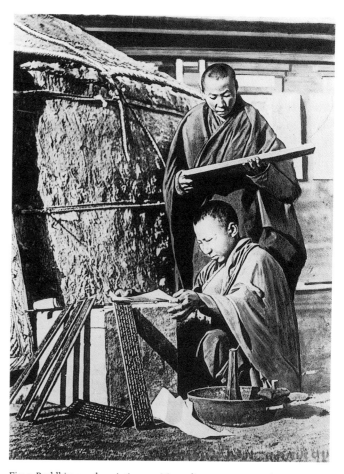

Fig. 1. Buddhist monks printing at a Mongolian monastery, early 20th century. Photo: Hiram Bingham. Copyright National Geographic Society.

Canonic Texts

LEWIS R. LANCASTER

One of the most important texts in Mahayana Buddhism is the *Astasahasrika Prajnaparamita Sutra* (The Perfection of Wisdom in Eight Thousand Lines). It is considered to be the earliest of the *Prajnaparamita* texts and the oldest form of a Mahayana sutra. The Chinese had a copy of the Sanskrit text in the middle of the second century and made a translation in 179. The text was translated into Tibetan many centuries later by the missionary monks Shakyasena and Jñānasiddhi from Northern India with the help of Dharmatashila. The use of the text in rituals is widespread, and it is still the case that most Tibetan and Mongolian monasteries will house a set of the *Prajnaparamita*, which they call *Yum*, or Mother. This term came to be used because the sutra itself says that it is the "mother" of all Buddhas and bodhisattvas.

Copies of the Sanskrit form of the *Asta* are preserved among the Newari Buddhists in Nepal, and there the recitation of the text is an important ritual of the religious community. It is not surprising to find numerous copies of this particular text and even to find it preserved on gold. The recitation of the text was considered to be an essential part of certain ceremonies, and its importance was highlighted by the production of beautiful manuscript copies with illustrations. As late as the tenth century in the Pala dynasty in India, special copies of the *Asta* were made; some of the best examples can be found in the British Museum. Damtsik Dorje (1781–1855) recorded the recitation method of the *Astasahasrika Prajnaparamita Sutra* as a part of his collected works. It was just this recitation method that would have been taught to novice monks during the time that Zanabazar was training in Lhasa.

Translation of Buddhist texts from Sanskrit into Tibetan started in the seventh century and continued until the thirteenth. It was this corpus of Tibetan texts that would eventually be used to make the Mongolian version of the Buddhist canon. After the translation, the major texts in the Tibetan canon were continually being edited, corrected, and revised. Thus it is difficult to establish the exact date for any reading found in the Tibetan version; the work of many hands has produced a composite, and it is nearly impossible to determine the date various sections were written for any of the Buddhist documents. For several centuries after the translation projects, manuscript copies of the canonic texts were made by scribal monks in major monasteries. As we know the Tibetan Buddhist canon today, the work of making a complete copy would have been formidable. Divided into two sections, the Kanjur and the Tanjur, the canon grew, until by the eighteenth century it had more than 4,500 different texts.

Printing, rather than relying on handwritten copies, of the Buddhist canon originated in China, and the first attempt to put the entire Chinese version on printing blocks was done in the tenth century under the aegis of the Northern Song. At the woodworking center in Chengdu, 130,000 blocks were carved in the process of creating a set of reverse-image xylographs. Although other groups in East Asia followed the lead of China and produced printing blocks for the Buddhist canon, the Tibetans seem to have followed the Indian model and relied more on manuscripts than print for the preservation and dissemination of texts. This changed in the eighteenth century, when the first block-print edition was prepared by the Manchu court in Beijing. The blocks were completed in 1724 and are known as the Beijing Edition. Soon, some of the large monasteries made their own editions: Narthang, Derge, and Choni, and in this century a new edition from Lhasa was printed.

In the first half of the seventeenth century, monks in Mongolia made the first major translation of the Kanjur. Completed by 1629, this portion of the canon numbered 108 volumes, following the Tibetan list of texts. For more than a century this was the basic material available for the study of

traditional Buddhism in Mongolia. The lack of a translation of the Tanjur was a source of concern. These treatises contained the commentarial texts which were a primary tool for monastic training in Tibet. The Qianlong emperor, who reigned from 1736 to 1795, appointed a group in 1741 to make a new official word list matching Tibetan and Mongolian words for the Buddhist vocabulary. The head of the team was the Jangjya Khutuktu Rolpay Dorje (1717–1786) and the resulting document, given the Tibetan title *Dag yig mkha pa'i 'bhyun-gnas,* served as a guide for the translation of the Tanjur into Mongolian. The Tanjur has the same year of completion as the *Dag yig,* and it also mirrored the Tibetan in having 225 volumes. When the full canon was finally in Mongolian, it was put onto printing blocks and a standard edition was established.

The early manuscript copies of the translations, from the middle of the seventeenth century, were put on paper using wooden or reed pens. This was the primary method of writing used by the Tibetans in Central Asia, unlike the Chinese, who used brushes for most of their important secular and religious copy work.

When texts were printed or copied in China, the format was determined by the standard paper sizes, which were strictly controlled by government regulations. Since paper was used as a medium of trade, it was necessary to have the size of every sheet standardized. Tibetans did not have such restrictions, and they made paper in a variety of sizes and formats. For the Buddhist texts, the sheets were long and narrow, keeping the form of the palm-leaf manuscripts that were used in India. The sheets of paper were stacked and bound with cord, again much like a sheaf of palm leaves. The Chinese pasted the sheets together and rolled them into a scroll, later adopting accordion-folded sheets, which were easier to store and read. Tibetan paper was heavy and soft and would not easily have been rolled. Thus the volumes of the Tibetan canon are distinct from the rest of the Buddhist canons of East Asia, and this style of stacked sheets came to be reflected in the Mongolian copies. Having this format for the books of the canon, the Tibetans and Mongolians made covers that were placed on the top and bottom of the leaves. Since the covers were made of wood or metal, they became objects for artisans to decorate. Elaborate carvings appear on some of the outer sides of the covers and paintings and special scripts on the inner portion.

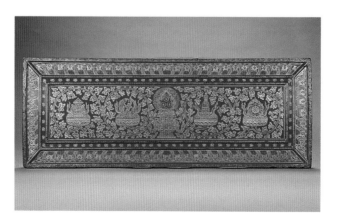

Fig. 1. Sutra cover (one of a pair). Ming dynasty, Yongle period, 1410.
Red lacquer with *qiangjin* decoration, H: 10⅝ (27.0) L: 28¾ (73.0).
Courtesy of Benjamin W. Yim and Family Collection. R1993.14.1-b.

47. BOOK COVER WITH LOTUS SCROLLS

M: Eldeb tarni
China, Qing dynasty, Qianlong period (1736–95)
Red lacquer with *qiangjin* (engraved gold) decoration
on wood
H: 4⅞ (12.4) W: 15¼ (38.6)
State Central Library

Covered entirely with cinnabar lacquer, this sutra cover is decorated in the *qiangjin* manner, a Chinese technique in which lines are engraved into the lacquer surface, then filled with gold by means of a lacquer adhesive. In the central panel, the mantra *Om mani padme hum,* in Lantsha script, is borne on lotus blossoms within looping foliate stems. Narrow raised borders with gold cross-hatchings surround the central panel and frame the four trapezoidal panels containing classic scrollwork. The two narrower ends contain carvings in relief: a *kala* grasping meandering foliage emanating from its mouth, and the three flaming jewels (M: *ghurban erdeni*).

The verso is equally impressive: framed by lotus scrolls, the central text begins with the salutation to the triple gems (Adoration to the Buddha, Adoration to the Dharma, Adoration to the Sangha) and includes many mantras and *dharani* (spells). The Tibetan script is carved in *shuangkou,* a Chinese technique in which the outline of the alphabets is incised.

This cover is identical to the ones belonging to the Kanjur commissioned by the Qianlong emperor in the thirty-fifth year of his reign (1770). The 108 volumes were a gift to his mother, the Empress Chongqing, on the occasion of her eightieth birthday in 1771.[1] Examples of the 1770 Kanjur came in two sizes; this cover from Mongolia is of the smaller type. The Kanjur covers, in turn, were based on prototypes from the Ming Yongle period. Sets of Kanjur were produced in 1410 by the order of the Yongle emperor and were given to the Sakya and Sera Monasteries of Tibet (fig. 1).[2] The covers, like the Beijing and Mongolian examples, were also made of wood and decorated with cinnabar lacquer in the same *qiangjin* technique. The covers have similar raised borders, but the lotus scrolls are more elaborate. They issue from a vase in the center containing the triple gems and enclose four of the Eight Auspicious Symbols.[3]

The year 1771 was an eventful one in the history of the Qing dynasty. The Kalmucks, a Mongolian tribe that had left Mongolia years before, decided to return to China the same year for political reasons.[4] They arrived in China a month before the completion of the magnificent Potala Temple at Jehol (Chengde), a smaller version of the one in Lhasa. The Qianlong emperor decided to use this temple to commemorate several events: his mother's eightieth birthday; his own sixtieth birthday, which had occurred the year before; and the return of the Kalmucks from Russia. The Third Bogdo Gegen, Yeshe Tenbey Nyima, was present at the inauguration of the temple. This historic gathering was recorded by the court artists in the form of a thangka, showing the emperor, the Kalmucks, the Bogdo Gegen, and the monks (see Berger, "After Xanadu," fig. 14).

It was the emperor's custom to give presents to visiting dignitaries. This book cover could have been among the gifts given to the Third Bogdo Gegen during his visit to China in 1771. Several copies of the Kanjur were made in 1770, for another set was given to the Seventh Dalai Lama of Tibet, and extant examples are kept in the Potala Palace at Lhasa.[5]

—T.T.B.

1. *Cultural Relics of Tibetan Buddhism Collected in the Qing Palace,* pl. 84.1–3.

2. Jiacuo et al., "The Two Yongle Versions of the Kanjur in Lhasa" (in Chinese).

3. Lacquer covers of the Yongle Kanjur appeared in the Kathmandu market in the 1980s. Since then, some of them have been acquired by museums and private collectors. See fig. 1 and Watt and Ford, *East Asian Lacquer: The Florence and Herbert Irving Collection,* no. 49.

4. Hedin, *Jehol: City of Emperors,* pp. 29–68.

5. *Chibetto,* pp. 213–14.

48. BOOK COVER WITH SILK CURTAINS

M: Qutughtu tegünčilen iregsen dolugha-yin urid-un
irügel-ün ilghagha-yi delgeregülen kemegdeküi yeke
kölgen-ü sudur
T: 'Phags pa de bzin gshegs pa bdun gyi sdon gyi smon
lam gyi khyad par rgyas pa zhes bya ba theg pa chen
po'i mdo
S: Śrīsaptatathāgatapūrvapranidhānaviśesavistara
nāmamahāyāna sūtra
China, Qing dynasty, 18th century
Embroidered silk and wood
H: 4¼ (10.7) W: 14¼ (36.3)
State Central Library

Yijing (635–713), the Chinese monk who went to India, translated this sutra on the vows of the seven Buddhas.[1] The work contains fifty-eight pages of text handwritten in gold on black paper with pagination in Chinese. The first and last pages are inset into wooden panels, which are painted with gold lacquer in a low-relief design and covered with five silk curtains.

Illustrated here is the top cover. The finely executed manuscript, inset into the wooden cover, depicts two seated Buddhas flanking two lines of spells (dharani) in Lantsha and Tibetan scripts written in gold. The Buddhas, outlined in fine gold lines and with their faces, torsos, and limbs painted in gold, stand out in sharp contrast against the dark background. Shakyamuni, on the left, carries an alms bowl, with his right hand in the earth-touching gesture (bhumisparsha mudra). The Medicine Buddha on the right also carries an alms bowl, with his lowered right hand displaying the gift-bestowing gesture (varada mudra). He carries a branch of the myrobalan plant, the symbol of healing power.

Three mystic monograms, in relief, decorate the back of the cover. Known as namchu wongden in Tibetan, the monogram is composed of ten Sanskrit syllables and is surmounted by sun, moon, and flame symbols. It represents the elements of the cosmos discussed in the Kalachakra doctrines.[2] The mantra Om mani padme hum, in Lantsha script, is repeated along the edges of the cover.

The five curtains of yellow, red, green, blue, and white silk are finely embroidered in satin stitch. They each contain a center panel bordered by ten dragons chasing pearls. The top yellow curtain has Lantsha script in the center panel. The red curtain has mantras worked in black silk. The next three are decorated with the Eight Buddhist Symbols supported on lotus blossoms and enclosed within scrolling vines.

This cover, with its low-relief decoration and five silk curtains, is very close in style to the 1770 Kanjur covers (see cat. no. 47), which also have the namchu wongden monograms decorating the backs and mantras in Lantsha script along the sides. Its sumptuousness is certainly on a par with sutras produced during the Qianlong period. This is most probably another gift brought back to Mongolia by the Third Bogdo Gegen. —T.T.B.

Published: Tsultem, Mongolian Arts and Crafts, pls. 116–17

1. Ding Fubao, ed., Foxue da cidian, p. 2839; see also Taishō, no. 451, cited in Hōbōgirin.

2. Reynolds et al., Catalogue of the Newark Museum Tibetan Collection, vol. 1, p. 70.

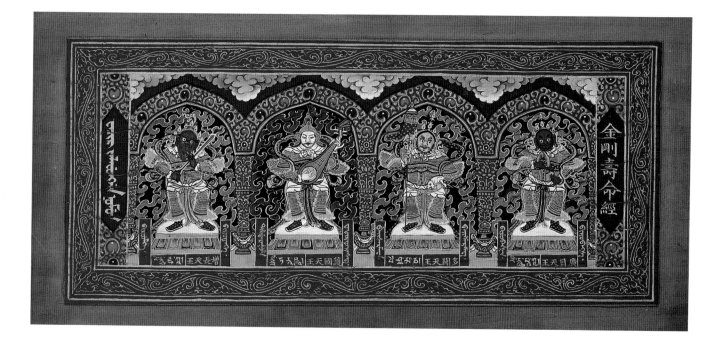

49. BOOK COVER WITH FOUR GUARDIAN KINGS

M: Qutughtu včirnasun kemegdekü toghtaghal tarni
T: 'Phags-pa rdo-rje-tshe zhes bya ba'i gzungs
C: Jingang shouming jing
Manchu: Wacir jalafungga nomun
China, Qing dynasty, 18th century
Paper and wood with painted decoration
H: 5¼ (13.3) W: 11¼ (28.7)
State Central Library

Guardians of the Four Quarters usually protect the last page or back cover of sutras (see also cat. no. 52). The top cover, not shown in this exhibition, depicts Čebegmid (Amitayus), Dorj-sembe (Vajrasattva), and Včirbani (Vajrapani). This su-tra,[1] translated literally as the *Vajra* Long-Life *sutra,* contains *dharani,* or spells, for increasing one's longevity, and it was one of the many sutras translated into Chinese by the famous Indian monk Vajrabodhi during the Tang dynasty. The covers of this sutra are made of sandalwood, and the sutra itself is written in gold ink on blue paper in the four official languages used in Buddhist inscriptions during the Qing dynasty: Chinese, Manchu, Mongolian, and Tibetan.

The paintings of the guardians are recessed into the sandalwood. They stand on lotus pedestals, beneath mandorlas of flaming jewels. The jeweled halo was a typical Mongolian motif introduced by the many Mongolian monk-painters of the Qing palace. (Even today, the Yonghegong in Beijing is staffed by Mongolians.) The green Virudhaka (south), on the left, brandishes a sword, while Dhritarashtra (east), col-ored white, plays the lutelike *pipa.* The yellow Vaishravana (north) holds the banner and the gem-spitting mongoose. Next to him, the red-faced Virupaksha (west) carries a *chör-ten,* or stupa-shrine. Flanking the guardians are the titles of the book written in Manchu (left) and Chinese (right).

In style of decoration and format this sutra is very similar to the ones produced in the imperial palace of Beijing during the Qianlong period.[2] The title in Chinese and Manchu is a good indication of its Chinese provenance. During that time, sutras dealing with longevity were often included among birthday gifts. Longevity sutras written in gold were given to the Qianlong emperor and the Jangjya Khutuktu Rolpay Dorje as birthday presents.[3]

—T.T.B.

1. The *Hōbōgirin* cites *Taishō,* no. 1132.

2. *Cultural Relics of Tibetan Buddhism Collected in the Qing Palace,* pl. 87.

3. Tuguan Luosang Queji Nima, Chen Qingying, and Ma Lianlong, *Zhangjia guoshi Ruobi Duoji chuan,* pp. 297, 325.

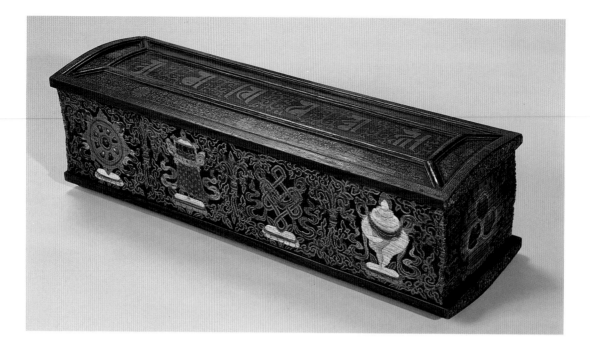

50. SUTRA WITH PAINTED TEXTBLOCK AND WOODEN COVERS

M: Qutughtu bilig-ün činadu kiǰaghar-a kürügsen naiman
mingghatu kemegdekü yeke kölgen sudur orosibai
T: 'Phags pa shes rab kyi pha rol tu phyin pa brgyad
stong pa
S: Ārya aṣṭasāhasrikā prajñāpāramitā sūtra
China, Qing dynasty, Qianlong period, dated 1783
Paper and wood
H: 7¼ (18.4) W: 25 (63.5) D: 6⅛ (15.4)
State Central Library

Written in Beijing by Čültem Čoyinpel in the forty-eighth year of *gnam skyong* (Qianlong, 1783; it is noteworthy that the reign-title is here written in Tibetan, a practice very seldom followed), this sutra on the Perfection of Wisdom in Eight Thousand Lines contains 369 pages of fine calligraphy in gold ink on indigo paper. Many of the pages are illustrated with Buddhist images, painted in gold and other colors.

The covers are ebony. The mantra *Om mani padme hum* is written in gold on the central panel of the top cover. In between the Lantsha characters are stylized *dorje* with their prongs ending in leafy scrollwork. The four side panels are painted with chrysanthemums and scrolling vines, while the borders are filled with fretwork. *Kala* heads and foliate scroll-work decorate the two ends of the top panel. Flaming triple gems enhance the ends of the bottom panel.

This example is particularly remarkable. Not only are the wooden covers highly ornamented, but the four sides of the sutra are also decorated. The sides were first painted with black ink, and then designs were applied in colors. The Eight Buddhist Symbols, representing peace, are shown in sets of four on the two long sides. Like the Lantsha charac-

ters on the top panels, the eight symbols are separated by stylized *dorje*. The short end on the left displays the emblem of the *Kalachakra* or *namchu wongden,* resting on a lotus pedestal and surrounded by a mandorla of flaming jewels, and on the right appears an offering of the flaming triple gems.

The tradition of painting the edges of sutras must have originated in Tibet. The Palace Museum of Beijing has several examples of sutras with painted textblocks.[1] The earliest painted sutra in the Palace Museum is dated to the Chenghua period of the Ming dynasty (1465–87); like the present example, the edges were first blackened with ink. The majority of the palace sutras with painted textblocks were produced during the Qianlong period. On the *Amogha-pasa Sutra* in the Palace Museum, the Eight Buddhist Symbols, as in this Mongolian example, are separated by stylized *dorje*.[2]

—T.T.B.

1. *Cultural Relics of Tibetan Buddhism Collected in the Qing Palace,* pls. 83, 84, 86, and 93.

2. Ibid., pl. 93.

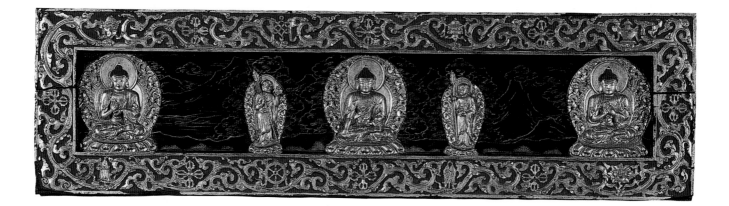

51. BOOK COVER WITH THREE BUDDHAS AND TWO MONKS

M: Qutughtu bilig-ün činadu kiǰaghar-a kürügsen naiman
mingghatu kemegdekü yeke kölgen sudur orosibai
T: 'Phags pa shes rab kyi pha rol tu phyin pa brgyad
stong pa
S: Ārya aṣṭasāhasrikā prajñāpāramitā sūtra
19th century
Carved gilt wood
H: 7 (17.8) W: 25⅞ (65.6)
State Central Library

Buddha Shakyamuni, attended by his two great disciples,
Shariputra and Maudgalyayana (noted for their intellectual
and mystical powers),[1] ornament the recessed portion of this
sutra cover. Two more Buddhas, with their hands in the ges-
ture of preaching, flank the group. The figures, as well as the
ornamental border, are intricately carved and gilded. The
border contains elaborate scrollwork known as *ugalz,* or wild
sheep's horn. It encloses alternating double *dorje* and the
Eight Auspicious Objects, which symbolize peace. While the
figures are placed against a dark brown background with a
landscape painted in gold, the border motif and the heads of
the Buddhas are highlighted in blue. The design of the verso
is similar to the top cover of catalogue number 50, showing
the mantra *Om mani padme hum* in Lantsha script separated
by stylized *dorje* and surrounded by bands of decoration.
The Lantsha characters and the *dorje,* in this case, are carved
in low relief.
 —T.T.B.

Published: Tsultem, *Mongol Zurag,* pl. 124; Tsultem, *Mongolian Arts and
Crafts,* pl. 119

1. Rhie and Thurman, *Wisdom and Compassion,* p. 76.

52. BOOK COVER WITH FOUR GUARDIAN KINGS

M: Qutughtu bilig-ün činadu kijaghar-a kürügsen naiman mingghatu kemegdekü yeke kölgen sudur orosibai
T: 'Phags pa shes rab kyi pha rol tu phyin pa brgyad stong pa
S: Ārya aṣṭasāhasrikā prajñāpāramitā sūtra
19th century
Gold and colors on black lacquer in gilt wood border
H: 6⅞ (17.6) W: 25⅞ (65.8) D: 1 (2.5)
State Central Library

The presence of the Four Guardian Kings indicates that this is the back cover of a sutra, and it is indeed the back cover for the sutra discussed in catalogue number 51. Similar to the front panel, the middle section is recessed, and the border design is identical. A single brocade curtain protects the painting beneath. From left to right, the guardians are Virudhaka (south), fingering his long sword; Dhritarashtra (east), playing his *pipa;* Vaishravana (north), carrying the banner and mongoose; and Virupaksha (west), supporting a *chörten* and grasping a serpent. The guardians, each surrounded by a halo of flames, are rendered in fluid gold lines, and only the faces and hands are painted.

The verso is equally impressive. Three *namchu wongden* characters, supported on lotus pedestals and framed with a halo, are carved in low relief in the center panel. The gold and blue symbols appear against a dark background, painted with a landscape in gold. The same artist must have painted the three landscapes on the front and back covers of this sutra, for they share the same fluid and lively brushwork. The artist has a sure and deft hand and a fine feeling for line and form. —T.T.B.

53. PAGE FROM CATALOGUE NUMBER 52

M: Qutughtu bilig-ün činadu kijaghar-a kürügsen naiman
mingghatu kemegdekü yeke kölgen sudur orosibai
T: 'Phags pa shes rab kyi pha rol tu phyin pa brgyad
stong pa
S: Ārya aṣṭasāhasrikā prajñāpāramitā sūtra
19th century
Gold pigment on blue paper
H: 6⅞ (17.6) W: 25½ (64.7)
State Central Library

This page from catalogue number 52 has been dyed blue, the
text portion darkened, and the border highlighted in gold,
to show off the calligraphy in gold ink. The text is bilingual,
with Mongolian words written below the Tibetan text. The
Tibetan word for "one" (gcig) is written on the narrow end
on the left, indicating that this is the first page of the sutra.

The scribe for this sutra was Luvsanjaltsan; he wrote
it in the nineteenth century in a location the inscription
calls Neyislel Küriyen (the classical name for Da Khüree,
modern-day Ulaanbaatar). —T.T.B.

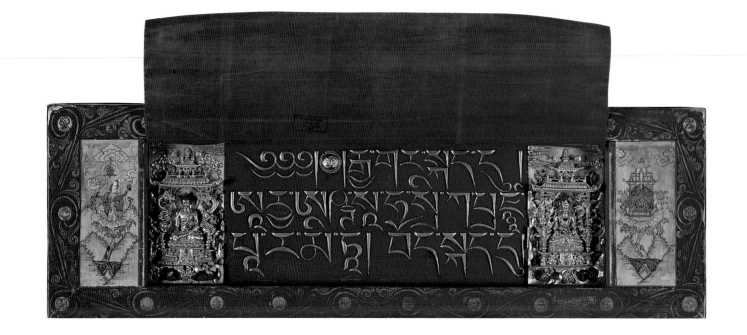

54. BOOK COVER WITH SHAKYAMUNI AND AMITAYUS

M: Qutughtu bilig-ün činadu kiǰaghar-a kürügsen naiman
mingghatu kemegdekü yeke kölgen sudur orosibai
T: 'Phags pa shes rab kyi pha rol tu phyin pa brgyad
stong pa
S: Ārya aṣṭasāhasrikā prajñāpāramitā sūtra
19th century
Wood inset with gilt bronze figures
H: 9⅝ (24.3) W: 30⅜ (77.0) D: 1⅞ (4.9)
State Central Library

Three pieces of brocade protect this very elaborate cover, the *ka,* or first volume of this sutra. The Tibetan script of pure gold, stating the title in Sanskrit and Tibetan, is executed on a blue background, flanked by two gilt bronze images and two paintings. The raised border is decorated with gold scrollwork, enclosing bowls of offerings. The syllables *E wam,* engraved on the gilt silver *yinyang* motif, appear at the beginning of the inscription. The relief images of Buddha Shakyamuni and Amitayus are superbly rendered. Shakyamuni, left, carries an alms bowl with three flaming gems (in this case, pearls), while his right hand is in the earth-touching gesture. Amitayus, right, carries the vase of elixir of immortality topped by a Tree of Life. The Buddhas sit on elaborate thrones inlaid with pearls and semiprecious gems. Their domain is a typical thangka-like landscape of rocky crags with waterfalls, clouds, trees, a pond with fish, fowl and other creatures, and the sun and the moon.

Flanking the Buddhas are two paintings depicting the Auspicious Symbols for the universal monarch, or Chakravartin. On the left, a lotus growing from a pond supports the Seven Jewels of the Monarch. These symbols, all indispensable to the universal monarch, are the Wheel of the Law, the wish-granting jewel, the queen, the minister, the general, the horse, and the elephant. These became the treasures of the Buddha in his role as the spiritual monarch of the universe. Opposite them are the Seven Secondary Treasures related to the universal monarch. While the Seven Royal Jewels grant wisdom, power, and wealth to the Chakravartin, the Secondary Treasures make him invincible and assist his rule.[1] They consist of the sword, which commands respect and quells rebellion without bloodshed; the hide of the ocean serpent, which can withstand the elements and keeps one comfortable in all weather and, when beheld by ugly women, makes them beautiful; the throne, which removes obstacles; a garden, where the king and queen can enjoy great delight; a house, where the king sleeps in joy and happiness; a robe, which is fire- and weaponproof, and which protects the king from cold, heat, hunger, thirst, and weariness; and comfortable shoes, which can go long distances and do not sink in the snow.

This sutra once belonged to the Eighth Bogdo Gegen, who became the Bogdo Khan. The symbolism of the two paintings on this sutra is therefore appropriate for his status.

The 355 pages are handwritten in gold on black paper. The scribe and editor was the Bhikshu Lodoishirav, who did the work, according to the inscription, in Yeke Küriyen (Yikh Khüree, today's Ulaanbaatar). The back cover, not shown in this exhibition, contains pictures of the Four Protectors.

—T.T.B.

Published: Tsultem, *Mongolian Arts and Crafts,* pls. 54–55; Tsultem, *Mongol Zurag,* pl. 124

1. The author is grateful to Patricia Berger for translating the following explanation from the text *'phags pa dam pa'i chos dran pa ñe bar gžag pa* in Loden Sherap Dagyab Rinpoche, *Buddhistische Glückssymbole im tibetischen Kulturraum,* pp. 117–21.

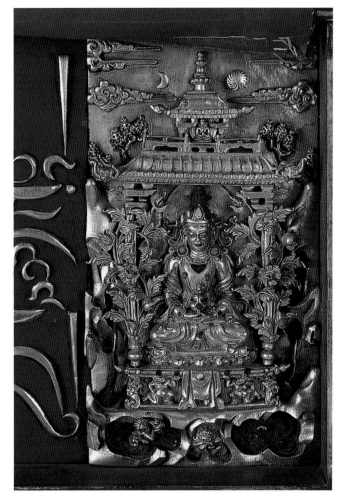

Amitayus.

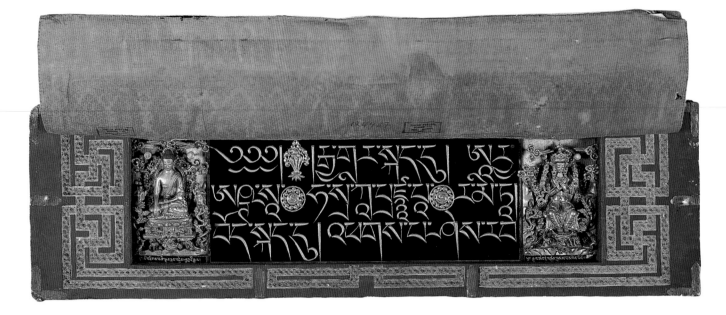

55. BOOK COVER WITH SHAKYAMUNI AND MAITREYA

M: Qutughtu bilig-ün činadu kijaghar-a kürügsen naiman
mingghatu kemegdekü yeke kölgen sudur orosibai
T: 'Phags pa shes rab kyi pha rol tu phyin pa brgyad
stong pa
S: Ārya aṣṭasāhasrikā prajñāpāramitā sūtra
19th century
Wood inset with gilt bronze figures
H: 8¼ (20.9) W: 29⅜ (74.6) D: 1½ (3.8)
State Central Library

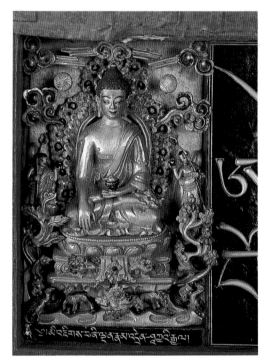

Buddha Shakyamuni.

Five brocade curtains protect this beautiful cover with inset wood carvings, gilded and highlighted in colors. Two golden bands of tortoiseshell pattern, interlocked into swastikas, a symbol of skillful means and wisdom, decorate the blue borders. Inside, a pair of intricately carved Buddhas flank a Tibetan inscription in raised gold script against a black background. The inscription, giving the titles in Sanskrit and Tibetan, is further decorated with the three flaming jewels and two medallions with the vortex motif. The sutra, totaling 385 pages, was written by an unknown scribe.

Buddha Shakyamuni, on the left, carries an alms bowl with his left hand, while his right is lowered in the earth-touching gesture *(bhumisparsha mudra).* He sits on a lotus pedestal above a lion's throne draped with a curtain ornamented with a double *dorje.* Behind him is a flaming mandorla with jewels. Two disciples attend him in a wooded setting with trees, birds, and beasts. The sun and moon are shown above and the offering of the five senses below.

On the right, Maitreya is seated in the European position, with both feet on the ground. His hands are in the gesture of preaching while carrying lotus blossoms and a vase. Small lotus pedestals support his feet; a jeweled mandorla emanates from his body. Like Shakyamuni, he is placed in a woodland setting with wildlife, trees, and a lake. —T.T.B.

Published: Tsultem, *Mongolian Arts and Crafts,* pls. 56–57

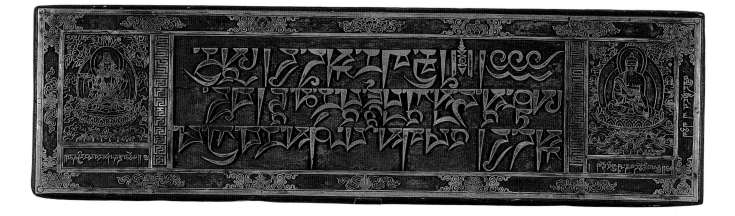

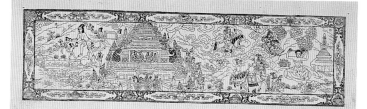

56. PRINTING BLOCK WITH PRINT

M: Qutughtu bilig-ün činadu kijaghar-a kürgsen
naiman mingghatu kemegdekü yeke kölgen sudur
orsitai
T: 'Phags pa shes rab kyi pha rol tu phyin pa brgyad
stong pa
S: Ārya aṣṭasāhasrikā prajñāpāramitā sūtra
19th century
Copper on wooden core
Block H: 5¾ (14.5) W: 21⅜ (54.2) D: ¾ (1.8)
Print H: 7¾ (19.6) W: 23¾ (60.2)
State Central Library

The copperplate for printing the *Naiman mingghatu (Astasa-hasrika)* came from a set of 748 pieces, a cooperative effort by many artists at the end of the nineteenth and beginning of the twentieth century. The block holds two copperplates, front and back, adhered to it with a mixture of ashes, sand, and wood tar. The recto, as indicated by the short inscription on the right (left on the print), *brgyad stong pa gcig,* is for printing the first page of the first volume of the sutra. The Eight Auspicious Symbols, shown alternately with offerings, frame the title. The latter, identical to catalogue numbers 54 and 55 (except that the Tibetan title has two more syllables), is introduced by the Soyombo initial (see Bosson, "Scripts and Literacy," fig. 7a). The title is flanked by a Buddha on the left, identified in Tibetan as *rgyal ba'i cod pan shakya'i tog,* or Shakyamuni, and the goddess Prajnaparamita *(bcom ldan shes rab phar phyin ma),* who personifies this text. Next to the images are two mantras placed vertically in Phagspa script:

l: *Om muni muni maha muniya*
r: *Māhā, a a a a a a a a a*

What is unusual about the title page is the combination of Tibetan, Soyombo, and Phagspa scripts, a distinguishing feature not seen in the other covers.

The verso, framed by a similar border design, depicts the story of Buddha Shakyamuni when he was a prince. A scene at the palace at Kapilavastu, surrounded by trees, shows the prince riding in a chariot, encountering for the first time sickness, old age, and death. On the right, the prince escapes from the palace on his horse, Kanthaka, and he cuts off his hair in preparation for his ascetic life. —T.T.B.

Published: Tsultem, *Mongolian Arts and Crafts,* pl. 59

Verso.

57. MANUSCRIPT PAGE IN MONGOLIAN SCRIPT

M: Bilig-ün činadu kijaghar-a kürügsen-ü maghtaghal
T: Shes rab-kyi pha rol tu phyin pa'i stod pa
S: Prajñāpāramitāstutam
1905
Gold on black paper
H: 6¾ (17.2) W: 21 (53.4)
State Central Library

Recto.

This folio, written in Mongolian, is from the Eight Thousand Verses in praise of Prajnaparamita, volume *ka* (one), page 341.[1]

Through its spreading, may it be of use to living creatures who have a present and future fate! Having been composed of all the good virtues of a superior birth in this holy *Prajñāpāramitāṣṭasāhasrikā*, and being adorned by the beauty of the good fortuned religious texts, the accomplished leader of religious and lay rule, Tümei erdeni sečen qung tayiji, Lady Bodisung and Toghtaqu sečen čökegür tayiji ordered it, and particularly by order of Bsodnam nomči and Tayičing gonbo tayiji, Bsam gdan sengge has translated and composed it in Mongolian.

Having started writing it on the 15th of the first month of spring of the first year of Nayiraltu töb [Manchu: Hūwaliyasun Tob; C: Yongzheng = 1723] and having finished it on the 15th of the middle month of autumn, it was given to Buyantu Dalai who resided outside the Čamen (Qianmen) gate, who engraved it on printing blocks and published the sutra. I wrote it basing it on that sutra. This sutra was finished on an auspicious day of the middle month of the autumn of the blue horse year, the thirtieth year of Badaraghultu törö [Manchu: Badarangga doro; C: Guangxu = 1905].

—J.B.

1. See Heissig, *Catalogue of Mongol Books, Manuscripts and Xylographs*, pp. 213–14; Heissig, *Die Pekinger lamaistischen Blockdrucke*, p. 21.

Recto.

58. MANUSCRIPT PAGE IN MONGOLIAN SCRIPT

M: Bilig-ün činadu kijaghar-a kürügsen-ü maghtaghal
T: Shes rab-kyi pha rol tu phyin pa'i stod pa
S: Prajñāpāramitāstutam
1905
Gold on black paper
H: 6¾ (17.2) W: 21 (53.4)
State Central Library

Verso.

Folio 342 from the same volume, recto, includes:

Hymn of Praise of the *Prajñāpāramitā*

[Herein] is contained a compendium of tales such as the original preaching of the doctrine of *Prajñāpāramitā* when Shakyamuni Buddha had manifestly penetrated through [suffering] and become a Buddha.

On the verso we read:

I bow to the Mother Prajñāpāramitā, who has victoriously passed through. I kneel thus reverently and without illusions before you, limitless Prajñāpāramitā, you, having become sinless in all and every of your bodies have looked after the sinless ones. Whoever sees you, who are uncontaminated like the firmament, without beginning, and imponderable, that person sees a Tathāgata.

Oh, saintly Mother who is rich in virtues, the Buddhas and the lamas of sentient beings are not properly a category distinct from you.

If one reveres you, the compassionate fosterer of the worshipers, like the moon and moonbeams, you who are at the forefront of the doctrine of the Buddhas, then one will proceed easily, by the help of the Lord of Compassion and the great intrinsic nature.

He who for a moment sees you with a pure mind and in the proper way, that one . . .

—J.B.

59. MANUSCRIPT PAGE WRITTEN IN COLORS

M: Bilig-ün činadu kijaghar-a kürügsen jaghun mingghatu
T: Shes rab kyi pha rol tu phyin pa stong phrag brgya pa
S: Ārya aṣṭasāhasrikā prajñāpāramitā sūtra
1905
Colors on black paper
H: 7¼ (18.4) W: 23⅞ (60.7)
State Central Library

This manuscript page, dyed black, is brilliantly illustrated in various mineral colors. These are the so-called nine jewels: ground gold, silver, coral, pearl, turquoise, lapis lazuli, mother-of-pearl, steel, and copper. This is the twenty-fifth folio from the first volume of the above-named sutra.

The two red circles shown in the middle of the page hark back to the palm-leaf sutras of ancient India. The early manuscripts of India were written on the leaves of the talipot palm (*Coryoha Umbraculifera Linn*).[1] The leaves were stacked together between two wooden boards. To keep the leaves in place, two holes were pierced in each page, and a cord was strung through them and tied around the boards. Tibet and Mongolia followed the tradition of stacking the pages of sutras between two boards; however, the pages are not pierced. When the Tibetan scribes first began to copy Indian sutras, they copied the two holes as well, and these circles persisted as decorative motifs. —T.T.B.

1. Om Prakash Agrawal, "Care and Conservation of Palm-Leaf and Paper Illustrated Manuscripts," in Guy, *Palm-Leaf and Paper: Illustrated Manuscripts of India and Southeast Asia*, p. 84.

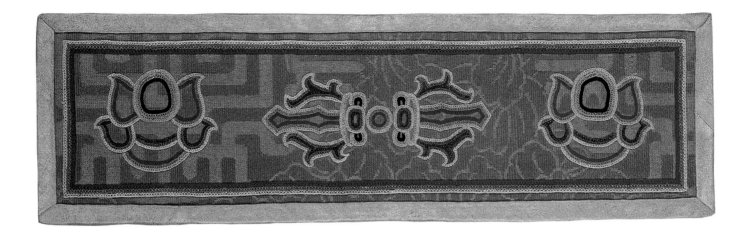

60. KHAN SUDRA (BOOK COVER WITH *DORJE* AND LOTUSES)

M: Čogtu kürdütü sakil kemegdekü-yin yeke
yovagacara-yin ündüsün-ü qaghan orsiba
T: Dpal 'khor lo sdom pa zhes bya ba rnal 'byor ma
chen mo'i rgyud kyi rgyal po
19th century
Embroidered silk
H: 2⅝ (6.8) W: 9 (23.0)
State Central Library

This sutra has 173 pages. The top cover features a patterned brocade, embroidered with a *dorje* between two lotuses in the typical Mongolian stitch (see Bartholomew, "An Introduction to the Art of Mongolia," fig. 13). The *dorje* and lotuses consist of three rows of stitching with the colors progressing from light to dark.

Although it is not clear in what year the sutra was written, in the eighteenth century the Jangjya Khutuktu Rolpay Dorje (see Bartholomew, "Book Covers") had it cut on printing boards, and the sutra is printed on Chinese paper in black ink. This sutra originally came from Gandantegchinlin Monastery. There are a total of five copies of this text in the State Central Library of Ulaanbaatar. —T.T.B.

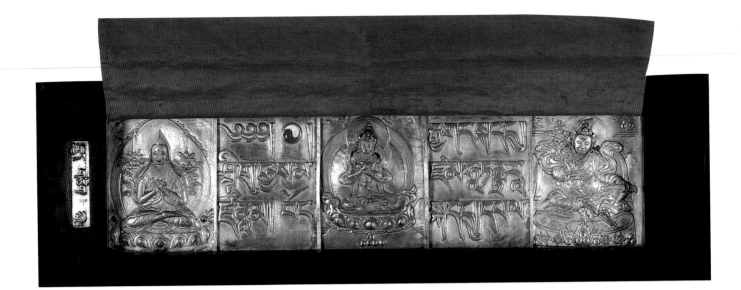

61. BOOK COVER WITH TSONGKHAPA, VAJRADHARA, AND KING

M: Sanduin jüd
T: Gsang 'dus kyi rgyud
S: Guhyasamājatantra [mahā] rāja
19th century
Gold and silver with embroidered silk panels
H: 8¾ (22.1) W: 29⅛ (74.0)
State Central Library

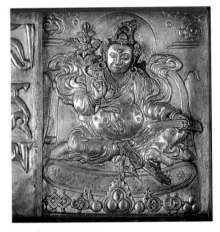

King figure.

In Mongolia this sutra is known as "The Great Khan of the Tantra Called the Secret Collection." One of the first Sanskrit works translated into Tibetan in the eighth century,[1] this sutra is very important to the Gelugpa.

This particular volume was produced at Manchir Monastery (to the south of Bogdo Ula) at the end of the nineteenth century, under the direction of Dagwa. Many craftsmen were involved in the elaborate production, and the end product was presented as a religious offering by the believers. This volume consists of 220 pages of flat-hammered silver with the letters in raised gold. Altogether, fifty-two kilograms of gold and silver were used in this volume.

In its workmanship and materials, this sutra is unique. The folios, encased in ebony, are made of silver with gold decoration and further inlaid with precious stones. Two brocade curtains protect the title page. On the second curtain, four *dakini*, embroidered in colored silk, play on the *pipa*, flute, and large and small drums.

The three sacred images are separated by two panels of texts. On the left, Tsongkhapa is depicted with his hands in the gesture of preaching *(dharmachakra mudra)*. His attributes, resting on lotuses, are the sword and the book. Next to him, the text panel displays raised Tibetan text in gold. The *yinyang* motif is of red coral and bone. Vajradhara, in the center, holds the bell and *dorje* in the gesture of highest energy *(vajrahumkara mudra)*. On the right is a rotund figure who resembles a king. He wears a brocade robe and sits in the posture of ease on a cushion. A *khatak* is draped on the back of his throne. His right hand, in the gesture of argument *(vitarka mudra)*, holds a lotus surmounted by a *dorje*. His left hand, placed on his lap, holds a book. Whereas Tsongkhapa and Vajradhara have offerings of jewels, the king is given coral, rhinoceros horn, earrings, and other offerings. —T.T B.

Published: Tsultem, *Mongolian Arts and Crafts*, pl. 58; Tsultem, *Mongol Zurag*, pl. 122

1. Snellgrove, *Indo-Tibetan Buddhism*, vol. 1, p. 183.

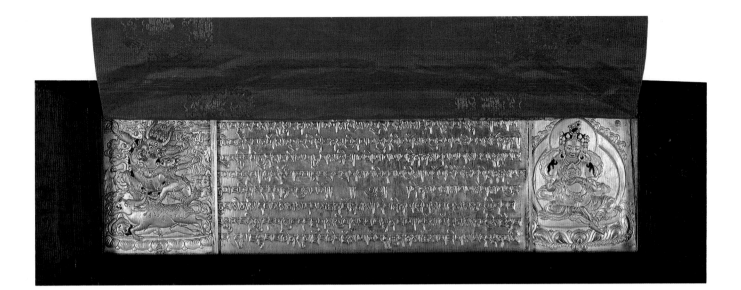

62. BOOK COVER WITH YAMA AND USHNISHAVIJAYA

M: Sanduin jüd
T: Gsang 'dus kyi rgyud
S: Guhyasamājatantra [mahā] rāja
19th century
Gold and silver with embroidered silk panels
H: 8¾ (22.2) W: 29⅛ (74.0) D: 1 (2.5)
State Central Library

Belonging to the same set as the preceding object, this cover is decorated equally sumptuously. The first curtain is of gold brocade, and the second has four *dakini* embroidered on blue silk, holding offerings of a floral garland, incense, a lamp, and curd.

On the silver inset, the raised Tibetan text is gilded, while the two flanking deities are only partially gilded. The figures were once painted with mineral colors, traces of which still remain. On the left, the guardian deity Yama and his sister, Yami, are standing on the buffalo above a lotus pedestal. Yama holds the skeleton club and noose, and Yami carries the trident and skull bowl. In front of the pedestal is a skull offering. On the right, the four-headed Ushnishavijaya, goddess of victory, sits in the posture of ease on her pedestal and carries the Wheel of the Law. —T.T.B.

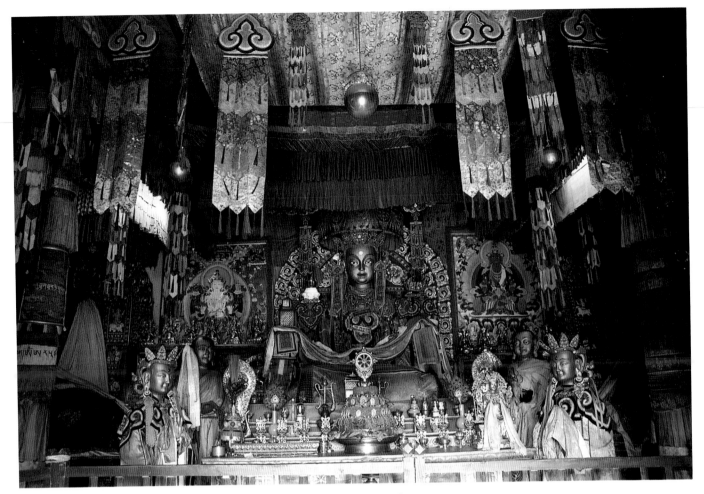

Fig. 1. Temple interior at the Choijin-Lama Temple complex, Ulaanbaatar. Photo: Hal Fischer.

The Tibetan Pantheon

ITS MONGOLIAN FORM

HEATHER STODDARD

THE TIBETO-MONGOLIAN WORLD OF VAJRAYANA BUDDHISM

Since prehistoric times, Central Asia has been one of the great crossroads of humanity, a vast space of mobile populations, where many of the key elements of civilization have been shared and spread, from East to West and vice versa. Among the varied succession of civilizations, a spiritual one —that of Tibetan Vajrayana (tantric) Buddhism—thrived over the best part of the last millennium, under the special patronage of two of the greatest Central Asian empires, the Mongol and the Manchu. Spreading from Lhasa to the Ordos, from Ladakh to Siberia, from Beijing to St. Petersburg, the Buddhism of Tibet contributed peace and stability and ultimately ensured that the ancient "scourge" of mounted warriors would disappear forever from the high Central Asian steppe. Its holy language, classical Tibetan, became the lingua franca of the educated Buddhist world, and its pantheon—especially the later Gelugpa one, favored by the Dalai Lamas—was also known far and wide, from the tents of simple herdsmen to the courts of emperors. It was the rich visual manifestation of a many-faceted, many-layered, mystical view of the phenomenal world (fig. 1).

ORIGINS OF THE PANTHEON

Around the fourth century, the great religious tradition of India had reached a point of unparalleled depth and intensity. This was accompanied by a powerful interaction between the different religious schools and led the Buddhists to integrate within their own tradition many yogic and meditational practices that then prevailed in India. These teachings spread via land and sea, first into Central Asia, China, Korea, and Japan, then a little later on, directly northward through Kashmir and Nepal, over the Himalayas and into Tibet. This last transmission from the Holy Land took place between the seventh and twelfth centuries, by which time Buddhism was being destroyed by the onslaught of Islam. However, by the twelfth century, the immense corpus of Buddhist texts had been translated into Tibetan; the full range of teachings imparted; and the Tibetans were already busily engaged in a new propagation of the teachings in Central Asia. Thus, well before the rise of the Mongols, the Tibetan lamas were constructing monasteries and giving teachings in the Ordos and in oases along the Silk Route. By the mid-twelfth century they were Imperial Preceptors at the court of the Tangut emperors, and their reputation must have been excellent, for one century later, in 1260, Phagspa —nephew of Sakya Pandita, the greatest Tibetan scholar of that time—was in turn appointed State Preceptor at the court of Khubilai Khan. This first conversion of the Mongols began with the basic precepts of Buddhism, but very soon members of the imperial clan were being initiated into the major tantric cycles. Such teachings require knowledge and use of a huge pantheon, both for ritual preparation of mandalas and for visualization during meditation, so we may be sure that a large number of Buddhist deities were already familiar to the Mongol ruling class by the thirteenth and fourteenth centuries. Little remains of the great wealth of the Yuan however, for after the fall of the dynasty the early Ming rulers were ruthless in eradicating what they considered to be foreign and corrupt, especially the art and teachings of the Buddhist tantra.

As with other world religions, when Vajrayana spread in India and through Asia, it absorbed many non-Buddhist deities, overpowering them, demonstrating the superior energy of the tantric teachings, transforming the irascible local deities into potent protectors of the faith. Furthermore, many religious teachers had their own mystical visions and created new practices over the centuries, adding new forms to an already rich pantheon. Lineages of human teachers were

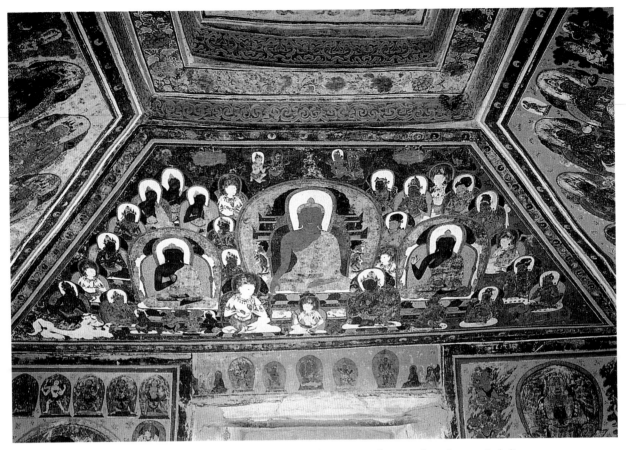

Fig. 2. Dunhuang cave no. 465. View of ceiling with Tathagata Buddhas showing row of patrons above doorway, including possible portrait of Sakya Pandita, ca. 1247. From *Chūgoku Sekkutsu: Tonkō mokōkutsu* (Tokyo: Heibonsha, 1982), vol. 5, no. 153.

included, starting from the Buddha Shakyamuni himself, his disciples, and the great "innovators" and philosophers, who marked the important stages of development of the Buddhist teachings. Then came the eighty-four *mahasiddha*, or "great realized ones," who emerged in India between the eighth and twelfth centuries, at the time of the full flowering of Vajrayana. They, the great mystical yogis and masters of unconventional routes to enlightenment, may have formed the basis of the important Tibetan tradition of portraiture, through which individual teachers were remembered as their lineages spread. In Tibet these are present from the earliest representations. Thus the pantheon of Vajrayana remained and remains, even today, a dynamic, evolving entity, based on a central idea of the unlimited power of emanation of the Buddha mind.

MONGOL EMPIRE: THE EARLIEST EXAMPLES OF THE PANTHEON

The few Buddhist remains dating from the Mongol period in China show that there was a rich artistic tradition, and while the religious teachings themselves sprang essentially from one main fountainhead, the cultural context was a far-reaching, multiethnic, polyglottal spiritual empire. This is reflected in the works of art themselves. In the Thousand Buddha Caves of Dunhuang we find the earliest known example of Tibetan art connected with the Mongol empire. Cave number 465, situated at the northern extremity of the complex, consists of an antechamber with a small tantric chapel, in the center of which stands a raised mandala platform. Perhaps a life-size stucco image, representing one of the great tutelary deities, presided there. All around, paintings of major deities of the tantric cycles, some in *yab-yum* embrace, adorn the walls. Vajrakila, Samvara, Mahavairochana, Vajrayogini, and eighty-four *mahasiddha* spread out below. On the four sloping triangles of the ceiling, the four Tathagata Buddhas and hosts of bodhisattvas seem to reflect the preceding era of Tibeto-Tangut religious exchange. A row of patrons sits above the doorway. The temple itself, which constitutes a kind of tantric "pantheon," may have been executed around 1247, during the visit of Sakya Pandita to the court of Godan Khan, and a faded portrait of the former may be above the main door (fig. 2).

In 1280 Khubilai Khan ascended the Dragon Throne in Dadu (Beijing) as supreme ruler of the empire. His enthronement immediately followed the Mongol conquest of South China, where a new office of Buddhist affairs had been set up, three years previously, in Hangzhou (former capital of

the Southern Song), under the direction of a Tibetan monk. Some evidence of his activity may still be seen, for example, in the tantric stone sculptures of the Feilaifeng caves (ca. 1292; fig. 3). These show distinct Chinese stylistic influence, while the xylographic illustrations of two Buddhist Tripitaka collections, carved also during his term in Hangzhou (ca. 1300), that is, the Chinese *Jisha zang* and the Tangut *Xixia zang,* show pronounced Tibetan stylistic affiliation. Here, as in Dunhuang, the surviving deities form part of a full-blown pantheon existing at that time. The same is true of the superb bas-relief stone carvings found on the Juyong Gate archway, north of Beijing, dated 1345 (fig. 4) and executed under the supervision of a Tibetan monk by command of the last Mongol emperor, Toghon Temür (r. 1333–68). Here the "Gate of Glory," flanked by four *lokapala* guardian kings and a series of finely executed Buddhas and mandalas, displays a mixture of stylistic sources, reflecting the artistic wealth of the empire. The accompanying *dharani* texts carved inside the archway are inscribed in no fewer than six different scripts: Lantsha (a form of Sanskrit), Tibetan, Phagspa, Chinese, Tangut, and Uighur.

The school of Tibetan Buddhism that dominated the Mongol dynasty was that of the great monastery of Sakya, in Tsang province, Central Tibet, from whence came all the Imperial Preceptors, beginning with Phagspa. And it was Phagspa who invited the highly gifted Nepalese-Newari artist, Anige, to Khubilai Khan's court, where he was soon made director of imperial workshops. He brought with him a whole team of apprentices, who had been working in Tibet on a major project before arriving in Dadu. Thus the principal school of Buddhist art current at the Mongol court was that of the Newaris of Khatmandu, expressing Buddhist art in an already sophisticated Tibetan style. Vajrayana Buddhism had been present in their land for centuries, and the artisans had been regularly employed to decorate monasteries and temples in Tibet since the seventh century. Anige's

influence was immense, and the artists of his multiethnic school, like the translators of Buddhist texts, no doubt became adept in reproducing whatever stylistic language the donors demanded, be it Tibetan, Chinese, Tangut, Uighur, Newari, or perhaps combining all these, into a newly evolving Mongolian dynastic style. However, fundamentally, the earliest Tibetan pantheon known to the Mongols was that of the Sakyapa school, expressed in the artistic idiom of the Newari, or Belri, style, as it was called in Tibet.

The main protector of the Sakyapa was Mahakala of the Tent, or Gurgon, who was also made special protector of the Yuan emperors. In 1292 a magnificent sculpture representing this deity was carved in black stone, with a Tibetan inscription mentioning both Khubilai Khan and Phagspa, as well as the "best artist in the world," who signed with a Tibetan name (see Berger, "After Xanadu," fig. 2). Another sublime example of the art of the Mongol period—again surviving into twentieth-century Tibet—is the huge *kesi* (silk tapestry) thangka of the tantric deity Yamantaka, dated by the present author to around 1328–29 (fig. 5a). It commemorates a unique occasion: the coming together of two Mongolian princes, Khoshila and Tugh Temür, who reigned, in turn, briefly as eighth and ninth emperors of the dynasty (fig. 5b). The thangka shows portraits of the princes with their ladies, as if assembled for a tantric initiation, or maybe in commemoration of their meeting, which was followed immediately by the assassination of Khoshila in August 1329. The extraordinary finesse of execution, the iconographic precision of the deities, the quiet beauty of the human figures, which include a lineage of twelve Tibetan lamas— perhaps the Imperial Preceptors—make this mandala a major textile masterpiece. If this alone survived, it would testify to the magnificence of the Mongol empire.

Putting these various examples together we could no doubt form a substantial early "Mongolian version of the Tibetan pantheon." However, not long afterward, we do

Fig. 3. Tantric sculptures at Feilaifeng: Ushnishavijaya within a stupa, and guardian deities, late 13th century. Photo: Paula Swart.

Fig. 4. Juyong Gate archway with Garuda motif, 1345. Photo: Kazuhiro Tsuruta.

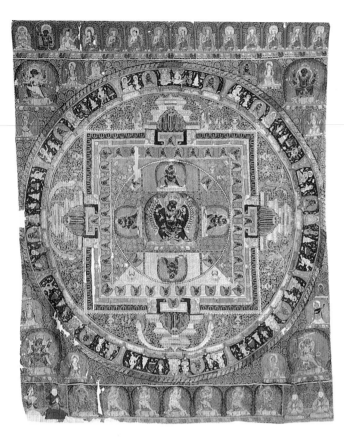

Fig. 5a. Vajrabhairava mandala, ca. 1328–29. Silk tapestry *(kesi)*, H: 96⅞ (246.1) W: 82 (208.3). The Metropolitan Museum of Art, Purchase, Lila Acheson Wallace Gift, 1992 (1992.54). Photo: Copyright by the Metropolitan Museum of Art.

Fig. 5b. Detail of lower left corner of the tapestry, showing Tugh Temür (r. 1329–32), who ruled as Emperor Wenzong of the Yuan dynasty, and his brother Khoshila.

have what is perhaps the earliest surviving example of a deliberately created pantheon of Tibetan Vajrayana. Dated 1431, it is titled *All the Buddhas and Bodhisattvas* (C: *Zhufo pusa*) and was published in Beijing, in two xylographic volumes consisting of sixty images in "Tibetan style," with accompanying polyglot texts in Tibetan, Chinese, Lantsha, and Mongolian (fig. 6). Although it belongs to the early Ming dynasty, the whole work emerges as a fine example of that same multiethnic, multilingual Buddhist empire that was firmly established by Khubilai Khan and Phagspa in 1260, which continues—in spite of certain interruptions—right up to the end of the twentieth century.

The *Zhufo pusa* pantheon represents the teachings of another school of Tibetan Buddhism, transmitted through the fifth Black Hat Karmapa of Tibet, Deshinshekpa (1384–1415), to the donor of the work, who seems to have been Chinese, and who perhaps became a disciple of the lama when he visited Beijing in 1407. Yongle, third and greatest of the Ming emperors, had invited Deshinshekpa and several other lamas, in an attempt to resuscitate the former Mongol dynastic links with Tibet. Yongle was the most cosmopolitan of the Ming emperors, familiar with Mongol ways from his childhood years near the Northern Chinese border. However, his approach to Tibetan Buddhism appears to have been influenced by the Chinese divide-and-rule policy regarding the neighboring peoples, in that he contacted not one but all the lamas of the principal monasteries in Tibet, offering them presents, titles, and diplomas (documents confirming their honorific titles), if they would visit him in Beijing, that is, pay tribute to the emperor of the Middle Kingdom. Several did go, and were highly honored, but it should be said that none held any political position, and so the import of his gesture was limited and fell into abeyance after his death. Among the presents he offered were numerous finely gilt Buddhist statues, and we might speak of a "Yongle" pantheon, made for Tibet. He also gave copies of the first Chinese xylographic print of the Tibetan Kanjur (the Buddhist canon), and the rare extant illustrations that come from this edition also point to the existence of an earlier "pantheon," based on a Tibetan original, which was no

doubt circulating in China under the Yuan. Among the lamas whom Yongle invited to his court was Tsongkhapa (1357–1419), founder of the reformed Gelug order. The unworldly monk refused several invitations and stayed in Tibet, but his teachings, his school, and the attendant pantheon were destined to spread throughout Central Asia and beyond.

THE RISE OF THE GELUGPA: THEIR PANTHEON IN MONGOLIA

As we have noted, Vajrayana generates a plethora of deities stemming from a multitude of lineages and teachers, who at different periods preferred certain rituals and practices, giving pride of place to a particular pantheon. Furthermore, in rituals of initiation, each individual may choose a tutelary deity *(yidam)*, in accordance with his or her spiritual tendency, and each monastery or school may choose a special protecting deity, or even several of them. Thus, in Tibet, differences arose not only in the pantheon but in the new rituals, music, sacred dance, and chanting associated with the teachings. These still belonged to one common tradition and were never exclusive of one another. It was rather a matter of emphasizing some deities more than others. The Gelugpa favor especially the female deity Tara; the bodhisattvas Maitreya and Manjushri; and the great tantric *yidam,* Guhyasamaja, Chakrasamvara, Kalachakra, Yamantaka, Vajrabhairava, Raktayamari, and the six-armed Mahakala; while their main protectors are Palden Lhamo, Vaishravana, Begtse, and Dorje Shukden. They also created thangkas showing their own pantheon of human teachers, or Tree of Life, centered on the lama Tsongkhapa (cat. nos. 69 and 70).

The renaissance of Buddhism among the Mongols in the mid-sixteenth century is intimately linked with the emergence of the Dalai Lamas of Tibet and the rise to dominance of the Gelugpa school. In the same way as the Sakyapa originally rose to politico-religious power, on the strength of their brilliance as scholars and teachers, the Gelugpa rose to unprecedented heights. Sonam Gyatsho (1543–1588) was the highly gifted reincarnation of Gedun Gyatsho, former abbot

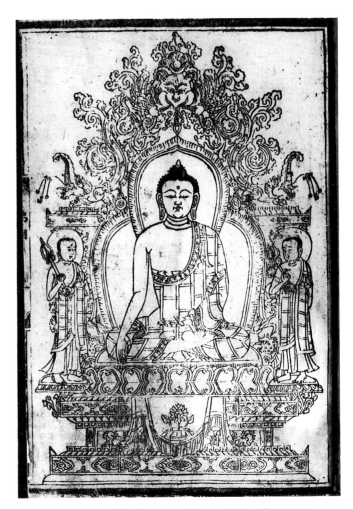

Fig. 6. Shakyamuni Buddha, frontispiece from an edition of the *Zhufo pusa,* dated 1431. Photo: Réunion des musées nationaux, Musée Guimet.

of Drepung, who himself was the reincarnation of Gedündrup, one of Tsongkhapa's main disciples. Sonam Gyatsho's fame reached the ears of Altan Khan, who invited him to Mongolia in 1577, following the antecedent of Phagspa and Khubilai Khan, who had met three centuries earlier. Sonam Gyatsho taught and converted the khan, who in turn bestowed on him the title of Dalai, or Ocean, Lama, with his predecessors being retrospectively recognized as the first and second of the line. The new Dalai Lama chose a special, standing White Mahakala as protector of Mongolia (see cat. no. 80). Later on, following his passing away, one of Altan Khan's own grandsons was recognized as the Fourth Dalai Lama, and in this way the ancient and powerful spiritual-temporal relationship between the Mongols and Tibetans was compounded.

Apart from the new White Mahakala, the Gelugpa pantheon echoed this politico-religious link by giving increasing favor to certain pre-Buddhist deities from Central Asia, integrating them as protectors of the Dharma in Tibet. The legends surrounding them are complex, entangled, and no doubt echo times of terrible warfare and invasion. Let us

take Pehar and Begtse as examples (see cat. nos. 18, 84, 85, 87, and 89). In many ways they overlap each other. Both are intimately linked, in the early stages of their respective legends, to pre-Mongol times, that is, to the Tanguts who preceded the Mongols in the patron-priest relationship with Tibet. At first they were at war but later became close allies within the Buddhist world system. Both deities have the attributes of warriors—coats of mail, helmets, weapons, and strange motley armies. They echo the Central Asian (and Tibetan) ideal of a pre-Buddhist warrior-king possessed of divine powers, who in some cases was himself protected by a volatile, irascible deity which could be captured by the enemy and made into their protector. The Sogdians, who preceded the Tanguts, also followed this belief. Once within the Buddhist pantheon, the deity was given a new function: to combat the "enemies of the doctrine." In Tibet, "King" Pehar was made protector of Samye in the eighth century by Padmasambhava, but later on, after a checkered career, the Dalai Lamas gave him the supremely powerful role of State Oracle of Tibet. The second example, Begtse, was favored particularly by the Second Dalai Lama, who made him protector of his newly founded monastery of Chokhorgyel, near the oracle lake of Tibet. Begtse too rose in status at a later date, when the Fifth Dalai Lama made him special protector of the Tibetan government.

Another strong Central Asian link between the Gelugpa school and the Mongols is the tantric cycle of the Wheel of Time, or *Kalachakra* (see cat. nos. 45 and 46), whose principal deity resides in the heart of the northern paradise of Shambhala. The *Kalachakra* is associated with millenarian prophecies regarding the rise of Rikden, a great warrior-king who would defeat the "red" armies and reinstall Buddhism at the end of the "Degenerate Age." Literal interpretation of this tantric teaching, which found favor from Mongolia to St. Petersburg in the eighteenth and nineteenth centuries, sent many hopeful pilgrims off in search of Shambhala, which was thought to be situated somewhere in the heart of Asia.

ZANABAZAR AND HIS SCHOOL

The iconography of the magnificent sculptures created by Zanabazar (1635–1723) and his school does not seem to differ substantially from the Gelugpa pantheon. However, his double heritage—at once a "living receptacle" of Chinggis Khan's spirit and a reincarnation of the great Tibetan historian Taranatha (1575–1634), who belonged to the nonorthodox Jonangpa school—might induce us to expect a different tendency in his spiritual practice, and thus in the deities he produced. Taranatha had died in Mongolia, one year before Zanabazar's birth, and when Zanabazar went to Tibet, as an adolescent lama, he received initiation into the Gelugpa *yidam*, Yamantaka, from the Panchen Lama. But from the Dalai Lama he received Vajradhara, the Adi-Buddha associated more closely with the old, Red Hat schools of Tibetan Buddhism, to which the Fifth Dalai Lama himself was strongly drawn. The two grand lamas both confirmed him as the reincarnation of Taranatha and gave him the title of Jebtsundamba. In spite of the abolition of his school by the Fifth Dalai Lama, no controversy seems to have arisen concerning this identity, and his line effectively became the third major Gelugpa lineage of Central Asia and the source for the supreme lama of all Mongolia.

The Gelugpa pantheon that prevails in Central Asia to this day—or rather the one that is being reestablished following the fall of the Soviet Union—spread from Tibet to Mongolia in the seventeenth century. It was carried into Siberia and Buriatia in the eighteenth and nineteenth centuries before journeying as far as St. Petersburg at the end of the nineteenth century. The lamas were those of the great Gelugpa lineages: the Dalai Lamas of Lhasa, the Panchen Lamas of Tashilunpo, the Jebtsundamba Khutuktus, or Bogdo Gegens, supreme among the Mongols, the Jamyang Shebas of Labrang in Amdo, and the Jangjya Khutuktus of the Manchu court in Beijing. Their enduring power and influence were based on a highly structured and stable monastic system and rigorous intellectual discipline allied with powerful tantric teachings and rituals. These combined well with imperial rule, as against the mobile, individualistic activities of the shamans of Central Asia. Their pantheon reflects the whole range of Buddhist teachings, from the secret, inner teachings of Vajrayana to the very human portraits of the most outstanding lamas of those lineages, including even their sanctified mothers, as is the case with Zanabazar.

The Mongolian nature deities, such as the White Old Man and the Dark Old Man (cat. nos. 33 and 35), were also made into allies. They, with the spirits of the watery underworld, appear in the sacred *tsam* dances and as minor figures in the Buddhist cosmogony. By transforming these pre-Buddhist "gods and demons" into protectors of the Dharma, the lamas succeeded—as they had in Tibet—in incorporating the pre-Buddhist world of Inner Asia into their universal system. The pantheon itself still constitutes a strong statement about a complex and mysterious world, comprehensible in its varied visual splendor, even by those who do not have direct access to the sacred texts and teachings.

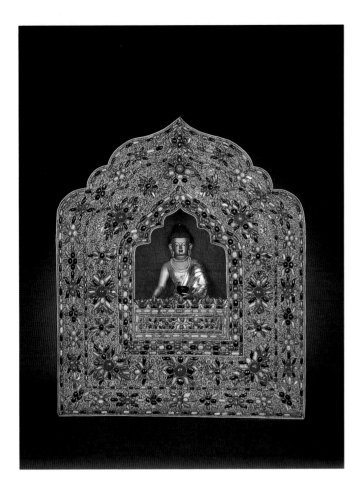

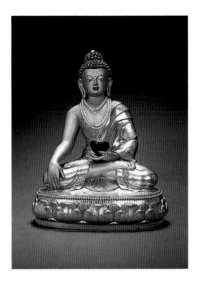

63. SHAKYAMUNI BUDDHA IN SHRINE

19th century
Gilt bronze with partial cold gold, pearl necklace, and gilt copper alloy with glass simulating semiprecious stones
Image H: 12⅞ (32.8) W: 10¼ (26.0)
Shrine H: 33⅝ (85.5) W: 28½ (72.5)
Bogdo Khan Palace Museum

The *ga'u*, a reliquary box worn by Tibetans, inspired the shape of this jeweled shrine. These reliquary boxes, usually made of silver, are worn on the outside of one's arm; sometimes Tibetan men string them bandolier-style across the chest when they travel. The box has an opening in the center, revealing the image of one's protective deity housed within. The image for the *ga'u* can be painted, cast in bronze, or made in the shape of a *tsha-tsha* (clay image pressed in a mold).

This shrine is a much larger and more elaborate version of the traveling *ga'u* and was made to be placed on an altar table inside the Bogdo Khan Palace. It is beautifully decorated with Mongolian filigree and a sumptuous array of inlaid glass simulating turquoise, coral, and jet. Already in the eighteenth century, China was producing glass imitating semiprecious stones, a fact attested by the large number of glass snuff bottles made to resemble various precious stones. Glass beads imitating turquoise and coral, the two stones most highly valued by Tibetans and Mongolians, were used as trade items for Tibet and Mongolia. The inlay work of glass in three colors is well thought out and executed. Following the contour of the shrine, rows of blossoms are separated by lines of inlaid glass. Three more rows frame the

shrine opening, with lotus buds in front of the Buddha. Some of the glass beads have been molded into petals. As in the Khalkha headdresses, the turquoise and coral pieces used to form the lotus blossoms have been shaped (cat. nos. 8 and 9). This seems to be a Mongolian tradition, as the stones in Tibetan inlays are seldom carved into the shape of petals.

The Buddha enshrined in the center belongs to the Zanabazar school of sculpture. The youthful Buddha sits in meditation holding an alms bowl. This and the earth-touching gesture *(bhumisparsha mudra)* displayed by his right hand identify him as the Buddha Shakyamuni. His face, upper torso, and limbs are gilded with cold gold and then painted. Typical of peaceful deities, his hair is colored blue. The border of his monk's robe is beautifully chased with designs. The string of pearls is a later addition.

The lotus base has trefoil-shaped petals, incised stamens, and pearl beading. The lotus petals decorate only the front; the back is left plain. The Buddha and the lotus base are cast separately; he sits snugly in a shallow depression cast in the pedestal. Both the Buddha and his pedestal are sealed with base plates, but only the base plate of the pedestal is held in place by chiseled points. —T.T.B.

64. BUDDHA SHAKYAMUNI

19th century
Gold on red ground *(marthang)*
H: 71¼ (181.0) W: 43½ (110.5) D: 1¾ (4.5)
Bogdo Khan Palace Museum

Although the majority of Tibetan thangkas are done on a white ground, there are examples with red, black, and even gold grounds. In general, paintings with red and gold backgrounds depict peaceful deities, while black grounds are reserved for wrathful gods. Gold is used for line work in both red and black thangkas, whereas red is preferred for paintings with gold backgrounds. The color of the red background is vermilion (T: *tse*), obtained by crushing cinnabar in a mortar and adding a weak solution of animal glue.

The Buddha Shakyamuni sits in meditation at the center of this painting, surrounded by 335 small Buddha images. He carries an alms bowl in his left hand, and his right is lowered in the *bhumisparsha mudra,* the earth-touching gesture. This gesture recalls the moment when he was challenged by the demon Mara, and he summoned the earth goddess Bhudevi (by pointing his hand toward the earth) to witness his right to attain Buddhahood, thus defeating Mara and his host. This gesture, besides being the symbol of the Buddha Shakyamuni, is also used by the Buddha Akshobhya, one of the Five Transcendent Buddhas.

Shakyamuni's hair is painted blue, as befits a peaceful deity. His head and the exposed parts of his body are painted gold, while fine gold lines delineate the border designs on his robe. The foliage and flowers behind the Buddha are especially well done.

The smaller Buddhas are shown with various *mudra.* Since one obtains merit by painting or sculpting sacred images, the execution of these multiple images represents a meritorious undertaking. —T.T.B.

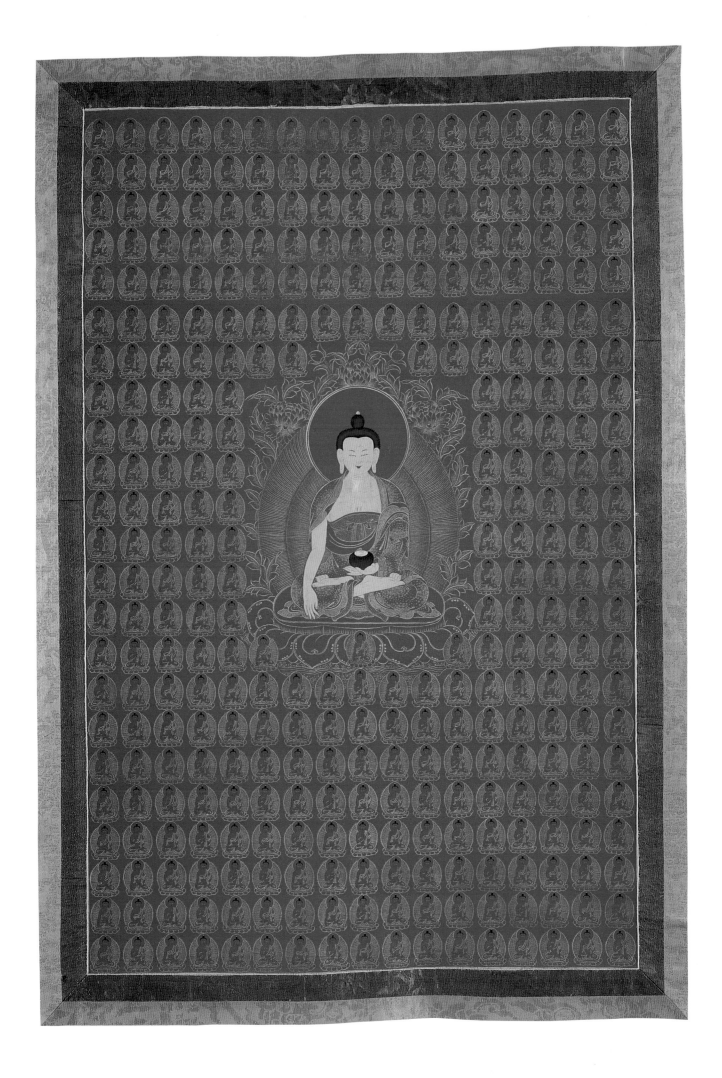

65. EMBROIDERY OF MEDICINE BUDDHAS

Early 19th century
Embroidered silk and couched gold threads
H: 30⅛ (76.6) W: 27⅜ (69.4)
Choijin-Lama Temple Museum

The Medicine Buddhas, worshiped for their power of healing, are popular all over Asia, not only in Mongolia and Tibet. They are often shown in the company of Buddha Shakyamuni, possibly the middle figure in the first row (see cat. no. 107). The blue Buddha in the middle of the second row is Bhaishajyaguru, the chief among the Medicine Buddhas. His image once graced the Medical College of Lhasa, above Chagpori, or the Iron Mountain (see cat. no. 44). His left hand holds a medicine bowl, while his right, in *varada mudra,* the gift-bestowing gesture, holds a branch of the myrobalan plant, the emblem of universal healing power. This medicinal plant (*Terminalia chebula, T.* spp.) grows in India and Asia and is an important Himalayan dye and mordant. Yellowish green in color, the fruit has pointy ends and is five sided. The Buddhas appear under an elaborate canopy with billowing ribbons and jewel pendants, all topped by a flaming pearl. They are depicted against a background of hills, interspersed with small groups of trees.

The Buddhas are embroidered on yellow silk in satin stitch. Those in the top row must have been covered at one time by another painting or hanging, for they still retain their original colors. The rest of the Buddhas are faded. The silk background is of the bright yellow hue associated with the emperors of China. The embroidery is excellent and is of a quality associated with the Qing palace. The *ruyi*-shaped clouds and the way they cluster around and on top of the Buddha images are highly reminiscent of an eighteenth-century *kesi* (silk tapestry) depicting the Buddhas of the Three Generations, now in the Asian Art Museum of San Francisco.[1] This embroidery could very well have been a gift from the Qing court to one of the Bogdo Gegens of Mongolia.

—T.T.B.

1. Weidner et al., *Latter Days of the Law,* cat. no. 6.

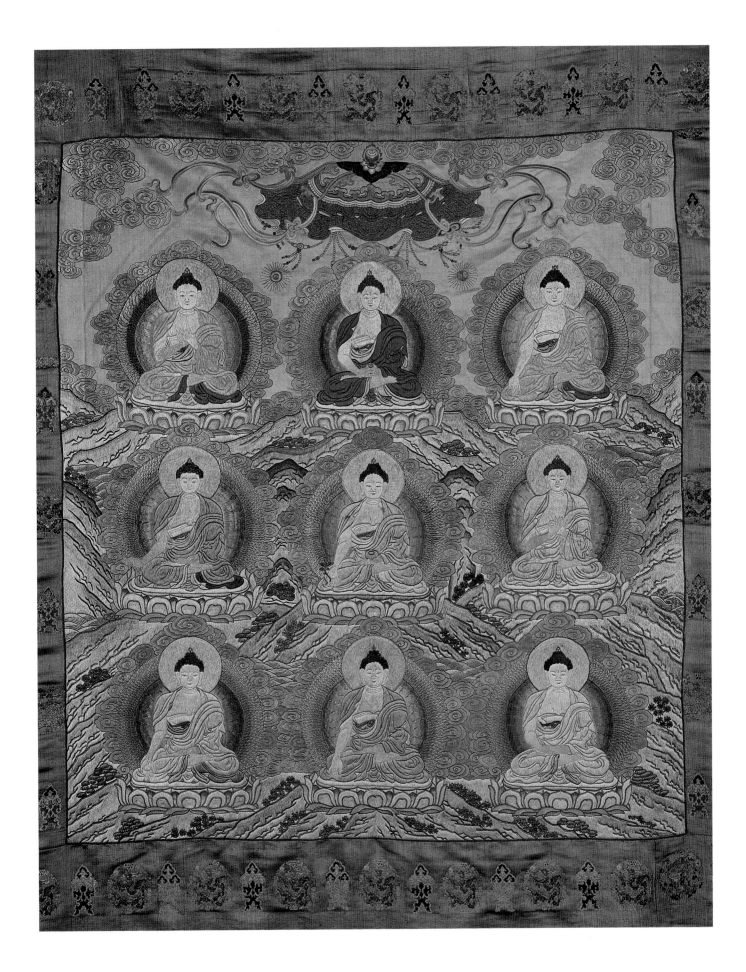

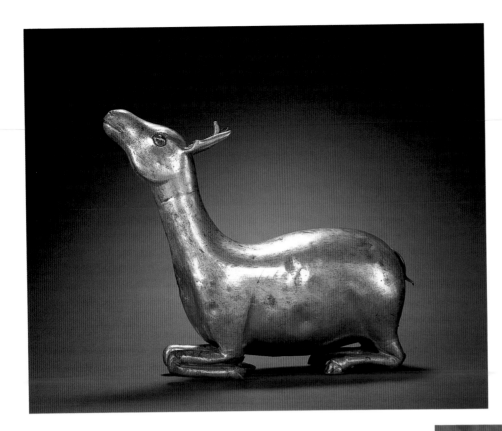

Fig. 1. Deer decorating a temple roofline at Sera Monastery, Tibet. Photo: Terese Tse Bartholomew.

66. DEER WITH A SINGLE ANTLER

Late 18th–19th century
Gilt copper alloy
H: 18⅝ (47.3) L: 33⅞ (86.0) D: 6¾ (17.0)
Choijin-Lama Temple Museum

The Buddha Shakyamuni's career as a great teacher began immediately after his enlightenment with his sermon in the Deer Park at Sarnath, when he first turned the Wheel of the Law. There, surrounded by deer and disciples-to-be, he preached the middle path as the only way to find release from suffering. The iconography symbolizing this event was set very early; probably the most famous representation is the sandstone First Sermon from Sarnath, which was carved in the fifth century and exemplifies the subtleties of the Gupta style. Set in the base below the exquisite Buddha is a Wheel of the Law, which the Buddha has just set in motion; it is flanked by adoring worshipers and two deer, who are shown in profile and are so damaged that only their outlines can be discerned. Representations such as this must have been what lay behind the gilt repoussé copper deer seen here, who sits quietly with his legs folded beneath him and

gently lifts his single-antlered head as though listening to the Buddha's teachings.

Deer appear with some frequency in Buddhist stories, for the Buddha himself once lived on earth as a deer in a previous life. The *Ruru jataka* tells of how the Buddha showed his compassion by saving the king who tried to kill him. Although the deer *(ruru)* is usually shown with a full set of antlers, in the twentieth-century *Astasahasrika Pantheon* he appears, as here, with a single, cone-shaped horn.[1]

This lovely, smooth-bodied deer must have once been one half of a pair intended as roof decorations for a temple (fig. 1). His construction is technically similar to that of the repoussé wolf (cat. no. 88), which was once part of Begtse's retine. —P.B.

1. Chandra, *Buddhist Iconography*, no. 1765.

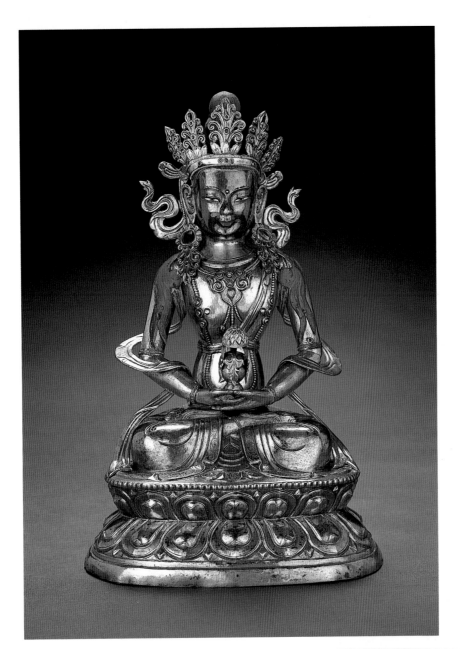

67. AMITAYUS (M: AYUSI)

Dolonnor style
19th century
Silver with colors
H: 10⅞ (27.5) W: 6⅞ (17.5) D: 7⅛ (18.2)
Bogdo Khan Palace Museum

Detail of base.

Amitayus, the Buddha of Boundless Life, grants longevity to his worshipers. The figure is shown seated, resting his hands in *dhyana mudra* (gesture of meditation) and holding his attribute, the vase containing the elixir of immortality from which grows the Tree of Life. He wears his hair in a high chignon, with locks cascading down his shoulders. In accordance with Tibetan tradition, Amitayus, a peaceful deity, has blue hair, as opposed to a wrathful deity, whose hair would be painted orange-red.

Amitayus's five-leaf crown rises from a band edged with beading and was once inset with semiprecious stones. The five leaves, worked in repoussé, have also lost their jewels. Two ribbons flutter behind his ears, and his earrings are in the forms of floral medallions whose pendants repeat the design of the leaves in his crown. The ends of his scarf flare out from his elbows, wind around his forearms, and rest on the pedestal.

The flat five-leaf crown, earrings, and the way his scarves

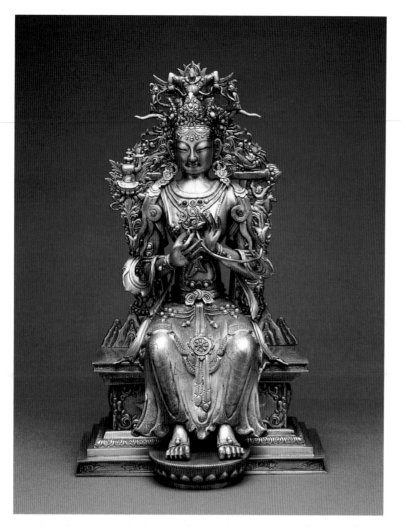

Fig. 1. Seated Maitreya, mid-18th century. Embossed silver, assembled from several parts, with chasing, and pearl, turquoise, coral, and smalt inlay, H: 11¼ (28.6). The State Hermitage, St. Petersburg, Prince Ukhtomsky Collection. Photo: Copyright John B. Taylor.

are depicted are characteristic of the sculptures from Dolonnor in Inner Mongolia (see Bartholomew, "Introduction to the Art of Mongolia," fig. 9, and cat. nos. 83 and 84). Other features indicating the works of Dolonnor origin include the way the arching eyebrows meet above the nose and the compact and tightly knit composition. Such a piece would have been made in Dolonnor, or by a Dolonnor artist residing in Urga.

Statues made of silver are rare. A silver Maitreya in the State Hermitage in St. Petersburg (fig. 1) is earlier in date and is of superb workmanship. In this piece, the crown, the way the hair curls below Maitreya's shoulders, and the depiction of the scarves also indicate an origin in Dolonnor.[1]

Statues of Amitayus are commissioned to promote longevity for the donor or for the recipient. The Qianlong emperor of China commissioned thousands of Amitayus statues for the sixtieth, seventieth, and eightieth birthdays of his mother, the Empress Dowager. The emperor himself, on the occasion of his seventieth birthday in 1780, received 19,934 statues of Amitayus from his subjects.[2] In 1912, in a ceremony to promote longevity for the Eighth Bogdo Gegen, 10,000 statues of Ayusi (Amitayus) were purchased. Nine thousand of them were made in Poland, each costing over twenty-three Russian rubles.[3]

The sculpture of Amitayus is complete with its base plate, held in place by three brackets. This type of bracket is also seen on the images of Lhamo (cat. no. 83) and Begtse (cat. no. 84).

—T.T.B.

Published: Tsultem, *Mongolian Sculpture,* no. 98

1. Rhie and Thurman, *Wisdom and Compassion,* cat. no. 33.

2. Wan, Wang, and Liu, *Qingdai gongting shi,* p. 278.

3. Bawden, *The Modern History of Mongolia,* p. 147.

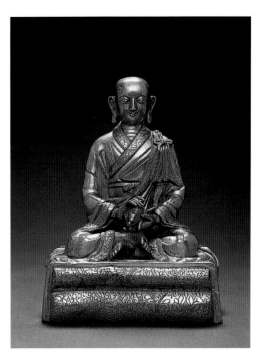

68. THE ARHAT BAKULA

19th century
Gilt bronze
H: 6⅛ (15.5) W: 4⅝ (11.8) D: 3¼ (8.4)
Museum of Fine Arts

The arhats (worthy ones) were among the first Buddhists to attain enlightenment following the path laid out by the Buddha himself. In early Buddhism, arhatship, which implied open-mindedness, detachment, selflessness, and cessation of suffering, was the goal of every monk. Although the arhat has remained a worthy ideal in Buddhism, the Mahayana concept of the bodhisattva, the perfectly compassionate, unselfish being who foregoes his own nirvana until all others are freed from suffering, eventually proved more attractive. The groups of arhats, originally disciples of Shakyamuni, were made Protectors of the Law, and asked to stay in the world as a "field of blessedness" until the Buddha's Dharma played itself out.

It was in China that the arhats (C: *luohan*) found their greatest popularity, because their eccentric individualism and independence resembled the concept of the Daoist immortal, who also lived independently "among mountains and streams" and sought harmony with nature. The Sixteen Arhats, all of them Shakyamuni's disciples, were expanded to eighteen, and eventually to five hundred.

Chinese lists of the sixteen or eighteen arhats differ in some respects from Tibetan ones, and one figure who did not appear in China was Bakula. For Tibetan Buddhists, Bakula, with his jewel-spitting mongoose, represents freedom from spiritual poverty. He is said to live with nine hundred other arhats in Uttar-Kuru,[1] a continent that also appears as a land of arhats in Chinese lists, where it is inhabited by Subinda (who was eliminated in the Tibetan group). Bakula's name may provide a clue to his appearance in Tibet with his mongoose, however. The Sanskrit word for mongoose is *nakula,* close enough to Bakula's name, but Nakula was also one of the original Chinese group who did not survive in Tibetan lists. Nakula was a disciple of the Buddha,

known as a solitary adept, who felt he did not need to spread the Dharma among the unenlightened, because other monks could do it.[2]

The Museum of Fine Arts in Ulaanbaatar presents this image of Bakula as a work of the Da Khüree (Urga) school, made in the nineteenth century. The chisel marks on the bottom, however, suggest that it is the work of Chinese hands, perhaps of a Chinese artisan working in Urga, Dolonnor, or even Beijing. Aleksei Pozdneyev wrote that in the late nineteenth century there were Chinese bronze craftsmen working in Maimaicheng, the business town that attached itself to the Bogdo Gegen's *khüree,* but that the bronzes of Maimaicheng, while high in quality, were more expensive than those brought in from Dolonnor.[3] The similarity of this Bakula to one included in the Baoxiang Lou bronze pantheon, however, also suggests this Bakula may be a Chinese product made in the Tibetan style.[4] The Baoxiang Lou pantheon is so-called because it was kept in the Baoxiang Lou of the Cining Palace, within the Forbidden City in Beijing; its 787 figures may have been cast in honor of the eightieth birthday of the Qianlong emperor's devout mother, in 1771. In both the Mongolian and Baoxiang Lou examples, Bakula wears a robe with ornamental floral borders and sits on a double cushion decorated with floral motifs, holding a mongoose above his lap in his left hand while stroking it affectionately with his right. —P.B.

1. Doboom Tulku, *Sixteen Arhats.*

2. Visser, *The Arhats in China and Japan,* p. 81; Weidner et al., *Latter Days of the Law,* p. 265.

3. Pozdneyev, *Mongolia and the Mongols,* p. 69.

4. Clark, *Two Lamaistic Pantheons,* vol. 2, p. 40.

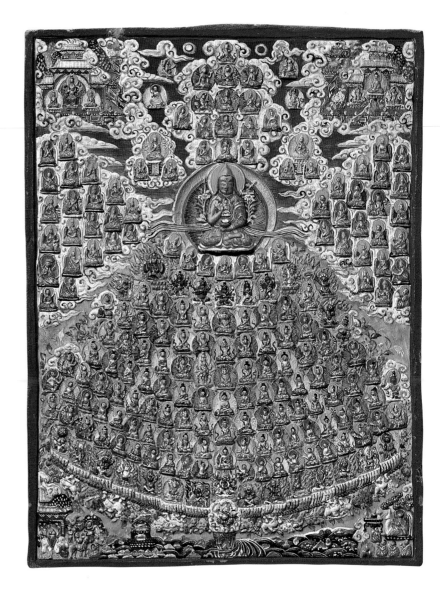

69. TREE OF LIFE

19th century
Terracotta with colors
H: 10⅝ (27.0) W: 7⅞ (20.0)
Museum of Fine Arts

70. TREE OF LIFE

19th century
Papier-mâché with colors
H: 18 (45.7) W: 12 (30.5)
Bogdo Khan Palace Museum

These two Trees of Life are identical in every way but medium; one is terracotta, the other papier-mâché. Both are mandalic *tsha-tsha,* mold-made votive plaques that could be mass-produced quickly and inexpensively.

The tree that supports the hierarchy of beings above grows from the waters of life, which abound with bejeweled flotsam and are ringed by devotees and offerings that include (left) a green horse and a white elephant. The composition focuses on Tsongkhapa (1357–1419), the founder of the Gelugpa whose text-based reforms led to a transformation not just of Buddhist practice but of the entire political structure of Tibet and Mongolia. He wears the pointed hat of Gelugpa lamas, carries a bowl, and bears a small Buddha within his chest. His attributes are held aloft on long-stemmed lotuses. They are the sword and the *Prajnaparamita Sutra,* reminders that he is an incarnation of Manjushri, Bodhisattva of Wisdom. Emanating from Tsongkhapa's head, like the branches of a tree, is an assembly of *mahasiddha,* lamas, and dancers, who surround Vajradhara, the transcendent Adi-Buddha and source of all other Buddhas. Similar assemblies of figures sit in the clouds that grow from streamers coming out of Tsongkhapa's sides. In the upper corners are heavenly visions—Amitabha's Western Paradise (right), and the Tushita Heaven of Joy (left) of the Future Buddha, Maitreya, where Tsongkhapa and all the Dalai Lamas went immediately after their deaths.

Another assembly supports Tsongkhapa and his crown of deities and paradises like the roots of the tree. This group is arranged in horizontal ranks, with a ring of lions in the bottom row, followed by rows of fierce Protectors of the Law, Buddhas and bodhisattvas who gather around an eleven-headed Avalokiteshvara. Above is a row of patron deities *(yidam),* all shown *yab-yum* with their consorts. In the top row are lamas who gracefully bow and gesture toward the center.

The papier-mâché example kept in the Bogdo Khan Palace Museum has been fitted with an elaborate copper frame that is silvered and partially gilt. —P.B.

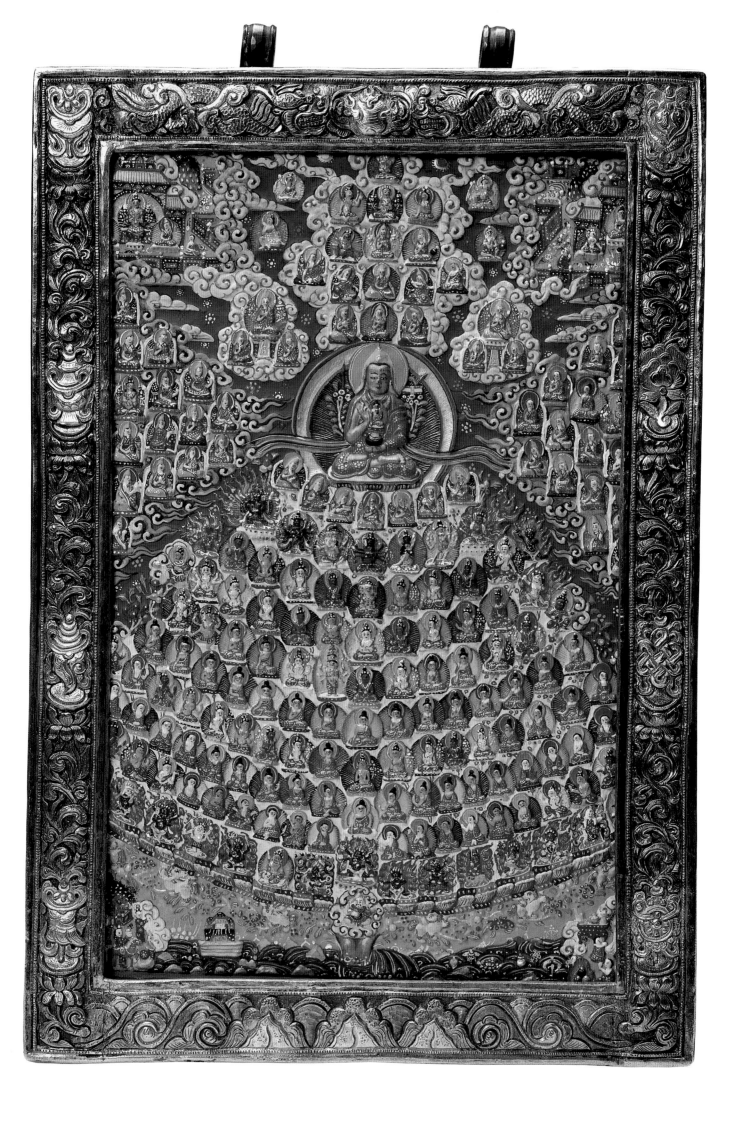

71. ICONOMETRIC DRAWING OF VAJRAVARAHI

Luvsanbaldan (early 20th century)
Early 20th century
Ink and light colors on cotton
H: 26⅛ (66.4) W: 18⅝ (47.4)
Museum of Fine Arts

This iconometric drawing of Vajravarahi, the Diamond Sow, reveals the demanding standards Buddhist artists followed in the creation of images, where the internal proportions of divine figures had symbolic significance, and the relationship in size of one class of deity to another announced their position in a sacred hierarchy.[1] Zanabazar is said to have followed the *Dashatala* ("ten palm") system of iconometry and remained faithful to proportions laid out in ancient Indian texts, such as the *Pratimalakshana*.[2] Here, the early-twentieth-century artist Luvsanbaldan adheres to the same system, literally caging his subject within an architectonic grid that determines the position of her ankles, pelvis, waist, lowered shoulder, and hairline, as well as the angle of her calf, thigh, torso, and breasts. Colors are also subtly hinted at with light washes that mold Vajravarahi's voluptuous body.

Vajravarahi is a Buddha in female form, called the Diamond Sow (a literal translation of her name) because she has wrestled with and defeated the sow of delusion and successfully incorporated it into her own being. The small sow's head, attached to the right side of her head like an excrescence, symbolizes her triumph, and she dances on a deity of delusion, whose defeat is palpable. Luvsanbaldan has equipped Vajravarahi with all her usual attributes, from her flaming hair to her gruesome garland of cut heads, her staff *(khatvanga)*, cradled in the crook of her left elbow and topped with more heads and a skull, her skull cup dripping with blood, and her *vajra*-handled chopper. She is virtually naked but for a tasseled girdle, a bandolier embossed with the wheel of her consort, Chakrasamvara, and jewelry of every description.[3] The horror of her image is mitigated, however, by Luvsanbaldan's elegant line and his delicate detailing of the goddess's face and the heads of her garland, all of which create a mesmerizing, if ambivalent, atmosphere. Although literally boxed in by tradition, Luvsanbaldan's Vajravarahi has an incomparable finesse, perhaps even more so to the contemporary Western eye because of the insights it provides into the artist's process of creation. —P.B.

1. See Bannerjea, *The Development of Hindu Iconography*, for a study of sacred iconometry.

2. Tsultem, *The Eminent Mongolian Sculptor—G. Zanabazar*, p. 7.

3. See, e.g., the Vajravarahi presented in the *Astasahasrika Pantheon*, reproduced in Chandra, *Buddhist Iconography*, no. 1511.

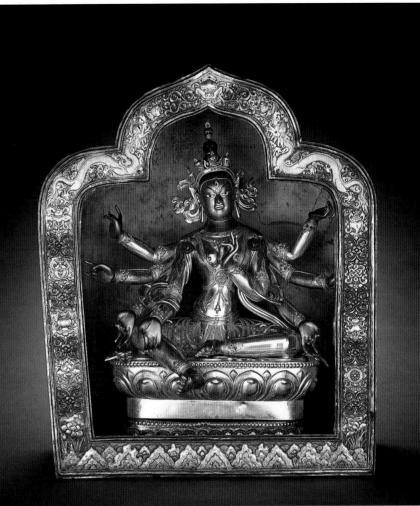

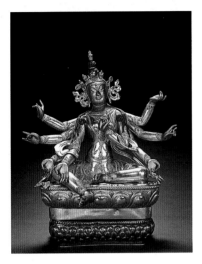

72. LAMANTERI

19th–20th century
Gilt bronze and silver shrine
Image H: 18½ (21.5) W: 19⅛ (48.5)
Shrine H: 26 (66.0) W: 21⅝ (55.0) D: 12½ (31.7)
Choijin-Lama Temple Museum

Lamanteri is the Mongolian name for this wrathful form of the goddess Tara. While on display in the Choijin-Lama Temple Museum, her upper right hands hold a flaming sword, a trident, and a wooden knob; her left hands carry a vase and a *khatvanga*. These attributes appear to be later additions and have been removed.

The goddess's skull crown, hair, ribbons behind her ears, and the scarf around her arms are characteristic of the Dolonnor style and show a similarity with catalogue numbers 67, 83, and 84. The workmanship is excellent and compares favorably with that of earlier images from this school. According to museum records, this image was made by a Da Khüree artist, either a Mongol craftsman of Urga or a Dolonnor artist residing in Urga.

This Lamanteri is placed on a silver lotus pedestal of an older vintage and is enclosed in a shrine-shaped *ga'u* covered with a gold satin damask. The silver shrine is partially gilded, with the designs of a *kala* mask and the Eight Auspicious Symbols raised in relief.

A somewhat similar Lamanteri appears in an unpublished nineteenth-century thangka of Zanabazar's mother in the Museum of Fine Arts, Ulaanbaatar. In the thangka, Lamanteri is depicted in blue. As in this sculpture she has eight arms and wears a tiger skin. Her left hands hold a chopper, a drum, and an arrow, with her lower left hand in the gift-bestowing gesture *(varada mudra)*. Her right hands hold a skull cup, a trident, a bow, and a *khatvanga* and lotus. Together with Naro-dakini (cat. no. 18, scenes 12 and 18), this wrathful Tara figured in Zanabazar's mother's meditations.

—T.T.B.

Detail of base.

73. KAKASYA

19th century
Gilt bronze embellished with colors
H: 11 (27.8) W: 7½ (19.2)
Museum of Fine Arts

Kakasya is a guardian goddess with the face of a crow. She appears as a half-naked figure with distended breasts; her bulging belly, ornamented with a jeweled discus and encircled by a snake, drapes over the tiger-skin lower garment. Kakasya dances upon a corpse lying above a lotus pedestal. Her right hand carries the chopper, and her left should have supported a skull cup, now lost. She is shown with the third eye, she wears a crown of five skulls, and her red hair stands on end. Her drapery ends swirl upward, endowing her dynamic pose with further movement.

Kakasya is described in the *Nishpannayogavali,* an informative work on mandalas and their deities by the late-eleventh–early-twelfth-century Mahapandita Abhayakara Gupta. The crow-faced Kakasya, accompanied by Grdhrasya (vulture-faced), Garudasya (Garuda-faced), and Ulukasya (owl-faced), guards the intermediate quarters of the *Kalachakra* mandala.[1] The *Nishpannayogavali* describes these four animal-faced goddesses as nude, dancing on a corpse, wearing garlands of severed heads, and carrying choppers and skull cups, while a *khatvanga* hangs from their shoulders.[2] Additional information from Mallmann associates Kakasya with the cycle of Heruka/Hevajra as well as Kalachakra.[3] She is also found in the mandala of Samvara.[4]

A male form of this deity is described in Jangjya Khutuktu's pantheon, *Zhufo pusa shengxiang zan,* as Kakasya-Karmanatha.[5] He stands in a dancing pose without a corpse and carries the chopper and skull cup. This deity is shown in the company of guardian deities associated with Mahakala. Nebesky-Wojkowitz mentions a bird-headed form of Mahakala (raven instead of crow), with a beak of meteoric iron.[6] He is depicted in the *Narthang Pantheon* as Kakasya Karma-Mahakala (T: Legön Charokdongjen).[7] This deity has the characteristic beak, holds the chopper and skull cup, wears the garland of skulls, and dances on a corpse on the pedestal. Since the mammary glands are present on this sculpture, she cannot be a form of Mahakala. Thus she is identified as one of the bird-headed goddesses associated with the mandalas of various *yidam.*

The sculpture and base were cast separately and then joined. The lotus pedestal is the type associated with Sino-Tibetan and Inner Mongolian sculptures, and one row of petals does not go all the way around the back of the sculpture. Another Chinese feature is the character *wang* (king) inscribed above the head of the tiger behind the sculpture. This is the Chinese convention for depicting a tiger, for, according to the Chinese, he is the king of beasts. The base plate is intact and held in place not by chiseled but by punched points. The center of the double *dorje* shows the twin fish symbol.

—T.T.B.

1. Bhattacharya, *The Indian Buddhist Iconography,* p. 319.

2. Ibid.

3. Mallmann, *Introduction à l'iconographie du tântrisme bouddhique,* pp. 204–5.

4. Pal, *The Art of Tibet,* no. 14.

5. Clark, *Two Lamaistic Pantheons,* fig. 304, p. 300.

6. Nebesky-Wojkowitz, *Oracles and Demons of Tibet,* p. 48.

7. Chandra, *Buddhist Iconography,* vol. 1, no. 860, p. 323.

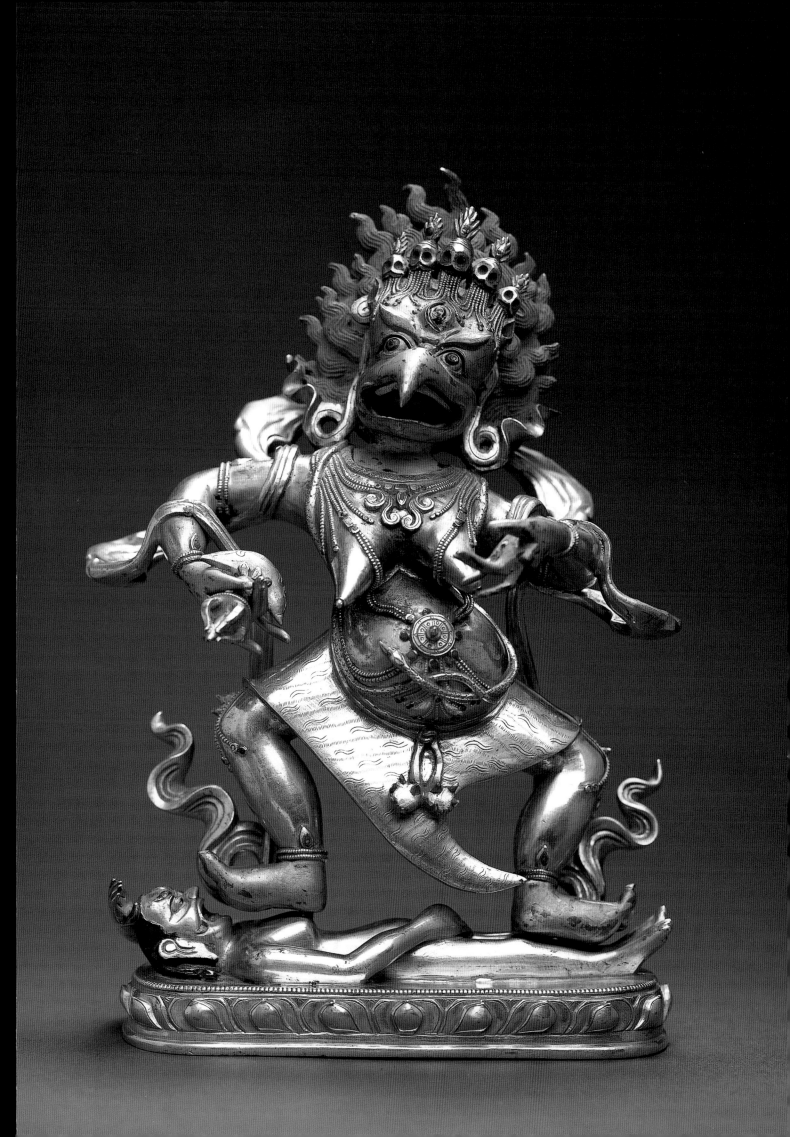

74. *GOBIIN LHA* (FIVE SPIRITS OF DESTINY)

Late 19th–early 20th century
Colors on cotton
H: 11⅜ (29.0) W: 9⅛ (23.3)
Bogdo Khan Palace Museum

Outer Mongolians traditionally believed that when a child was born, the *Gobiin lha* were born with him. These five spirits stayed by his side throughout his life, acting as guardians who supported his activities and improved his fortune and well-being. The *Gobiin lha* were just one of several categories of protective spirits in Mongolian shamanism, which also included the spirits of dead shamans *(ongod)* and heavenly guardians *(tngri),* who could be reached with a shaman's intervention.

This small votive image focuses on a single female, called Mo lha in Mongolian folk belief, who rides a white-muzzled ass, holds a mirror and an arrow used in divination, and is responsible for protecting the child's left armpit. Mo lha is surrounded by four other mounted figures, all male, who are assigned to protect other vital parts of the child's body. Thus Jul lha (upper left) protects the head; Da lha (upper right), the right shoulder; Srog lha (lower right), the heart; and Po lha (lower left), the right armpit.[1] Da lha also went by the name of Dayičin tngri, a shamanist sky spirit equated in the eighteenth century with the Chinese war god Guandi and even worshiped at the Yonghegong, the Tibetan Buddhist enclave in Beijing, for his powers of divination.

Other aspects of this painting suggest that by the late nineteenth century, the meaning of the *Gobiin lha* was multivalent, capable of being inserted into a shamanist or a Buddhist context, or into a popularized blend of the two. Buddhist elements are very plain here; the blue Vajrapani (who was once put in charge of the elixir of life) hovers above Mo lha's head, and below her are the Green and White Taras, who were also a source of long life. Even more striking is Mo lha's resemblance, both physical and symbolic, to one of the Tibetan Five Sisters of Long Life, Tingi Shalsangma (M: Sayin nigürtü eke). Like the *Gobiin lha,* the Five Sisters were originally non-Buddhist spirits, mountain goddesses who guarded five glacial lakes near the border of Tibet and Nepal.[2] They were among the many native deities converted to Buddhism by Padmasambhava, who was invited to Tibet in the late eighth century to tame the country's demons. Although the sage's biography is silent on the subject, the tradition is that Padmasambhava bound the Five Sisters by oath to serve Buddhism, whereupon they entered the entourage of a form of Lhamo, called Palden Maksor Remati. Lhamo is the guardian of the Dalai Lamas, and she is also known as the Great Life Mistress, who uses her two dice to determine the life span of men.

The Five Sisters had a popular following in Tibet as deities who inhabited the world of men and could be asked to grant long life. Ceremonies for them were supposed to take place in a remote and beautiful part of the countryside, where they were given all sorts of offerings, including a *torma* of medicine, a bronze mirror, crystal, peacock feathers, turquoise, and dice made of conch shell.

Tingi Shalsangma's attributes are identical to Mo lha's; the illustrated Mongolian Kanjur produced between 1717 and 1720 shows the Tibetan goddess riding the same white-muzzled wild ass and holding the divination mirror and arrow.[3] She is the second of the Five Sisters, whose leader is the lion-mounted Tseringma (M: Urtu nasutu eke), and, in fact, it is Tseringma's name that is applied to this image at the Bogdo Khan Palace Museum, where it is kept. Tingi Shalsangma was no mere follower of Tseringma, however, for she also had a special role in Tibetan Buddhism as a goddess of divination. This special talent probably enhanced her popularity in Mongolia and made it easy to conflate her and her sisters with Mo lha, the one female among the *Gobiin lha.*

—P.B.

1. I am indebted to Ms. Onon Michid of the Museum of Fine Arts, Ulaanbaatar, and to Terese Tse Bartholomew for these identifications.

2. The fullest description of the Five Sisters and their cult is in Nebesky Wojkowitz, *Oracles and Demons of Tibet,* pp. 177–81.

3. Chandra, *Buddhist Iconography,* no. 344.

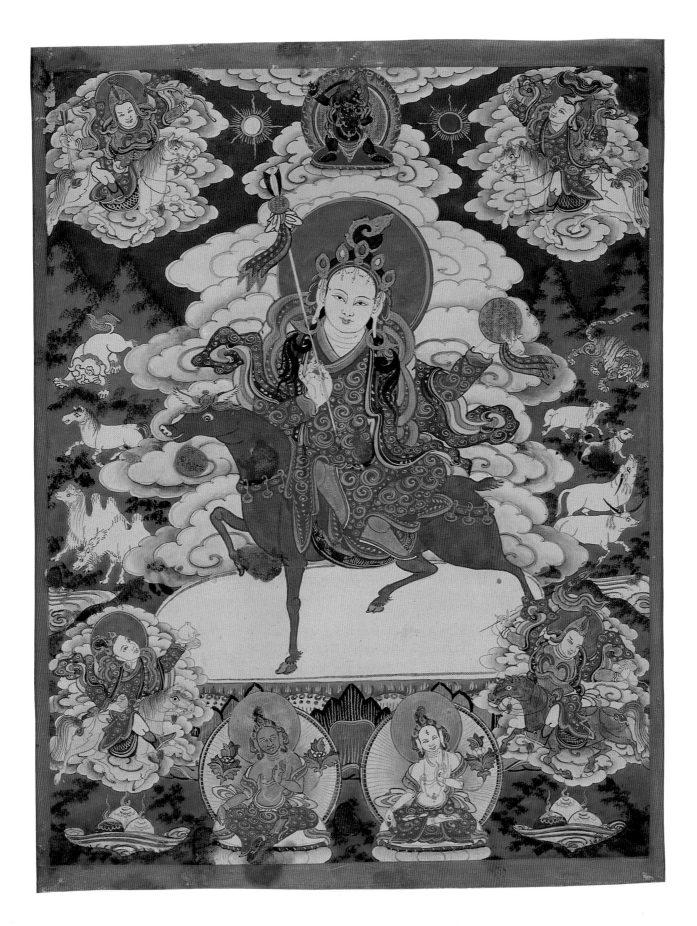

75. GANESHA (M: TSOGDOGMARAV)

Da Khüree style
19th century
Colors on cotton
H: 61 (154.9) W: 46 (116.8)
Bogdo Khan Palace Museum

Fig. 1. Cat. no. 18, scene 12.

Fig. 2. Cat. no. 18, scene 15.

Ganesha is a Hindu god who has been assimilated into the Tibetan pantheon. Among his many names is Vighneshvara, Lord of Obstacles. Although he is widely worshiped as the Remover of Obstacles in India, in Tibet he appears in two main forms, as an auspicious god of beginnings, and as an obstacle-creating demon. Ganesha came to Mongolia with the introduction of Buddhism. As an obstacle-creating demon and an enemy of religion, he is trampled by the various forms of Mahakala (see cat. nos. 79 and 80). In this superb thangka, Ganesha is depicted as an auspicious god whom people invoke before embarking on any undertaking. He is also a god of wealth because his rat vehicle is conceived as a jewel-spitting mongoose, the animal carried by Kubera, the Buddhist god of wealth (see cat. no. 77).

In Mongolia Ganesha appears in both his white and his red forms. The twelve-armed red Ganesha (Maharakta Ganapati), auspicious god of wealth, dances on his vehicle upon the golden sun disk above the lotus pedestal. His rat vehicle resembles a mongoose, and the jewels he spills forth from his orifices are busily picked up by a family of mice.[1] Ganesha's main hands carry the *dorje* and a blood-filled skull cup. His right hands brandish axe, arrow, elephant goad, sword, and spear. In his left hands are a pestle, bow, *khatvanga, kapala* containing a corpse, and a shield and trident. The depiction of this Ganesha is in accordance with the one shown in the *Five Hundred Gods of Narthang,* the Mongolian pantheon based on the works of the Fourth Panchen Lama (1781–1852). The section dealing with deities who are "auspicious at the beginning" contains a twelve-armed Maharakta Ganapati who dances on a mongooselike rat.[2] There is a slight discrepancy: the latter carries the *driguk* (chopper with a half-*dorje* handle) and skull cup, while this example carries the *dorje* and skull cup.

As the god of wealth, Ganesha is heavily bejeweled and crowned with gems. His flaming mandorla is filled with gems, and two Mongols offer jewels to him, while more gems are placed above and below his pedestal. His lotus pedestal is influenced by the Urga school of sculpture. The stamens of the lotus blossoms are carefully painted between the petals, in the same fashion as those incised on the pedestal of Sitasamvara (cat. no. 101). Excess jewels beneath the pedestal are bundled up and carried away by two mice.

Six gods float on visionary clouds above the central image. They are, from left to right, the guardian Mahakala, the philosopher-saint Nagarjuna with his halo of snakes, the goddess Nadi-dakini, the Adi-Buddha Vajradhara, and Saraha and Shavaripa, two *mahasiddha* with bows and arrows.

Small textured strokes delineate the rolling hills behind the god. The landscape is filled with clouds, lakes with flaming gems, and the five animals of Mongolia: pairs of camels, horses, yaks, sheep, and a goat.

On the back of the thangka is a long inscription in Tibetan, interspersed with mantras; it contains a lengthy prayer to Ganesha asking for wealth and prosperity.

Ganesha appears twice in the thangka of the meditations of the Bogdo Gegen (cat. no. 18, scenes 12 and 15). As a two-armed figure carrying the jewel and the radish, he channels to the Bogdo Gegen empowerment from Naro-dakini and Mahakala (fig. 1). In another scene he is shown as a white figure with many arms. The three wealth-bringing gods of Mongolia—White Mahakala, Vaishravana, and Ganesha—are showering blessings on the Bogdo Gegen (fig. 2).

—T.T.B.

Published: Béguin et al., *Trésors de Mongolie,* cat. no. 24

1. A fifteenth-century thangka of a Maharakta Ganapati in a New York private collection shows the deity accompanied by monkeys, not the micelike creatures in the Ulaanbaatar example; Pal, *Tibetan Paintings,* pl. 26.

2. Chandra, *Buddhist Iconography,* no. 522.

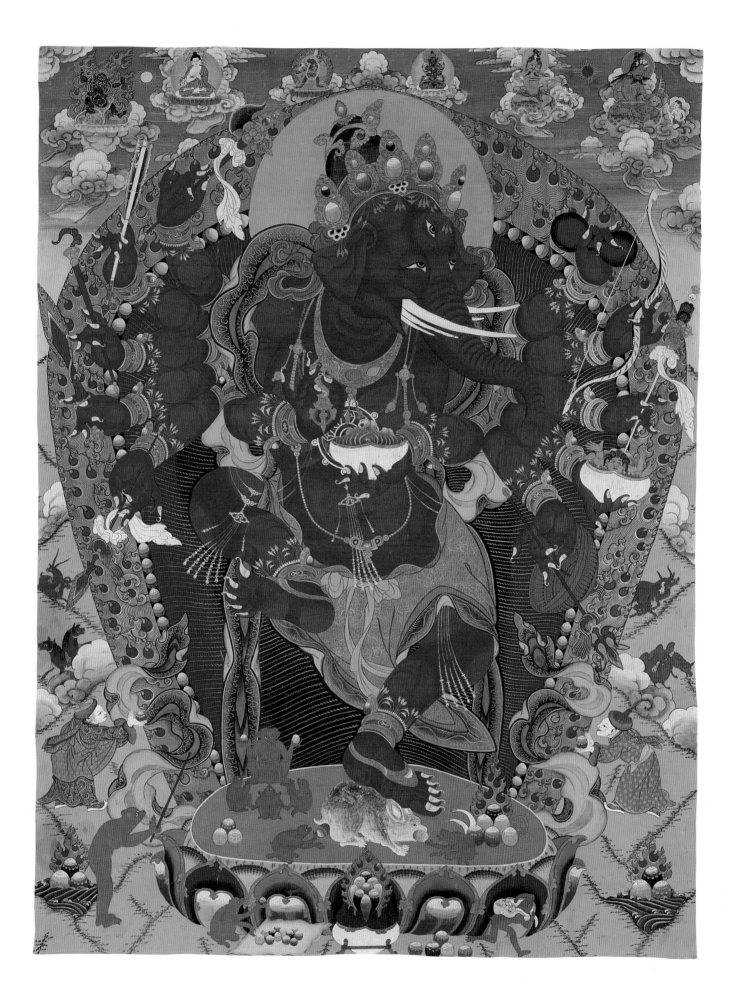

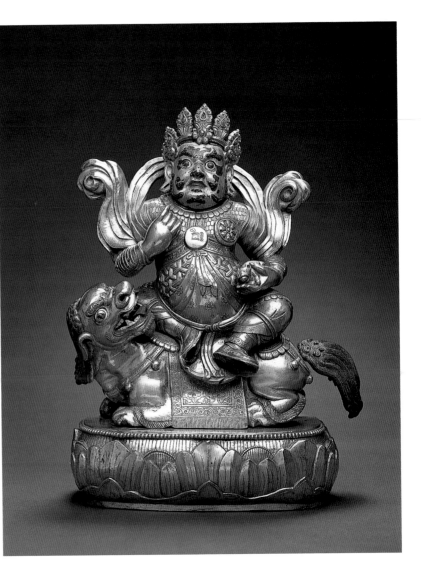

Detail of base.

76. VAISHRAVANA

19th century
Gilt copper alloy
H: 14¼ (36.0) W: 11¼ (28.7)
Museum of Fine Arts

Vaishravana is shown in two aspects in Mongolia: as a defender of the faith and the Guardian of the North, and as a god of wealth and dispenser of treasures. In the company of the *lokapala,* or Guardians of the Four Quarters, Vaishravana protects the Buddhist law against harmful forces. He and his three companions therefore act as sentinels for the entryways in Mongolian temples and protect the back covers of Buddhist manuscripts (see cat. nos. 49 and 52).

Vaishravana is depicted as a dwarfish figure with a rotund belly. He sits comfortably on the back of his lion vehicle, who looks up at him. Vaishravana's right hand once held a banner, and his left hand still carries a jewel-spouting mongoose. His cuirass, showing various scale patterns, is ornamented with a mirror inscribed with *bai,* his seed syllable (a Sanskrit syllable representing the essence of the deity).

Vaishravana is one of the tutelary deities of the Bogdo Gegens. He is depicted on the portrait of Zanabazar (cat. no. 16), and in catalogue number 18 he is bestowing blessings on the Bogdo Gegen together with White Mahakala and Ganesha, two other gods of wealth (scene 15).

A mixture of styles is seen in this sculpture. Vaishravana wears a five-leaf crown inset with turquoise and coral. The flat leaves are reminiscent of Dolonnor ornaments (see cat. nos. 67, 83, and 84). Dolonnor craftsmen made their images out of pieces of beaten metal, and this figure is composed of five separate pieces: the head, body, lion, base, and lion's tail. The lotus pedestal, with its interesting petal form and the emphasis on stamens, is based on the work of the school of Zanabazar.

The lion wears two strands of rattles and a saddle blanket finely chased with scrolling and wish-granting clouds. Similar chasing decorates Vaishravana's robes and scarves.

A detail of the base clearly shows how the sculpture is attached to the lotus pedestal by means of notches. The base plate is lost, but the chiseled marks on the base show how the points once held the base plate in place.　　—T.T.B.

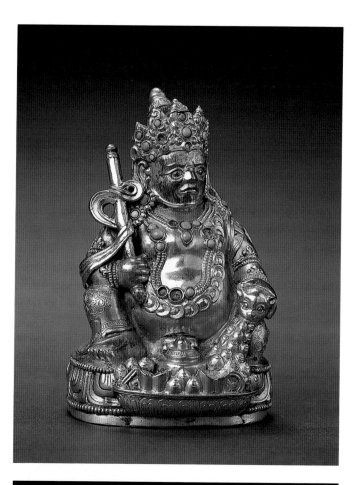

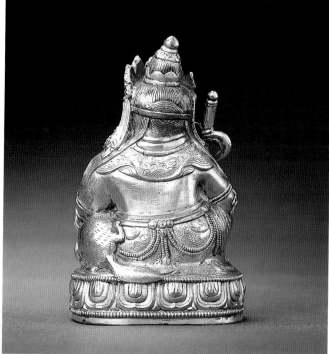

Detail of base.

77. VAISHRAVANA AS KUBERA

19th century
Gilt bronze with turquoise inlay
H: 4⅝ (11.6) W: 2⅞ (7.3)
Museum of Fine Arts

Kubera, a form of Vaishravana, appears here as the god of wealth. Rather than being shown in his usual suit of armor, he is conceived as a richly clad, rotund figure sitting regally, holding his club and squeezing the neck of a large mongoose, from whose mouth pours a stream of gems. As the dispenser of riches, Kubera wears a garment beautifully chased with floral patterns. His hair is dressed in a topknot, with two long strands of hair lying along his shoulders. His five-leaf crown, earrings, and two necklaces are studded with turquoise, and a longer necklace resembles a garland of coins.

The mongoose symbolizes generosity, for it conquers the snakes of avarice. The treasure, contained in a bowl incised with lotus petals, consists of wish-granting jewels, a treasure vase, and ingots. Ingots, also known as sycee (C: *sizi*), are hoof-shaped lumps of silver or gold used in China from early times until the mid-twentieth century. They have a wide circulation, as far as Tibet and Mongolia, and symbolize wealth in China and Mongolia. In the set of utensils for a giant (cat. no. 6), the ingot-shaped toggle indicates a wish for wealth.

The lotus pedestal of this piece has a single row of downward pointing petals, and each petal has three incised lines. The base plate is inserted without the use of chiseled points, and the center of the double *dorje* on the base plate is left plain (see detail). —T.T.B.

78. GUHYASADHANA HAYAGRIVA
(M: DAMDINSANDOV, KHAYINKIRVA)

T. Tsend
19th century
Patchwork of silks with gold couching and embroidery
H: 111⅝ (283.5) W: 79½ (202.0)
Museum of Fine Arts

In Tibeto-Mongolian Buddhism, Hayagriva, the Horse-Necked or Horse-Headed One, functions as a *yidam,* a personal or tutelary deity. He is a form of the Bodhisattva of Compassion, Avalokiteshvara, but in Mongolia, as in China and Tibet, his extraordinary popularity stemmed just as much from his conflation with various local horse gods, an idea not all lamas endorsed.[1]

Hayagriva's first incarnation was in the Hindu pantheon, however. Originally, he had a paradoxical identity both as an enemy of Vishnu, the Hindu creator-god, and as his manifestation. As Vishnu, he was a sweet-voiced reader of the sacred Vedas and their protector, a role he carried with him when he was absorbed into the Buddhist pantheon.[2]

Around the early sixth century, when Indian Buddhism absorbed more and more of the tantric ideas and god-based iconography of Hinduism, Hayagriva was accepted as a *vidyaraja,* a protector-king. He was the Excellent Horse Heruka, the Glorious Steed, and King of Wrath, a god invoked in services for the Great Protectors because of his ability to dispel demons or remove the obstacles or distracting thoughts that block enlightenment. In the *yoga*-tantra texts translated in China as early as the Tang dynasty (618–906), including several versions of the *Mahavairochana Sutra,* Hayagriva-as-*vidyaraja* was placed close to Avalokiteshvara, within the Lotus Family of deities emanating from Amitabha. In the twelfth century, the Tibetan sage Atisha put Avalokiteshvara, with Hayagriva nearby, at the heart of the mandala of the *Guhyasamaja Tantra,* a text widely honored in Mongolia.

This silk patchwork image of Hayagriva follows precisely the iconography for the mystic, incantation form of the deity, Guhyasadhana Hayagriva, presented in the *Three Hundred Icons,* a Tibetan-language xylograph with a preface by the Jangjya Khutuktu Rolpay Dorje (1717–1786), Inner Mongolia's greatest Buddhist incarnation and adviser to the Qianlong emperor. The *Three Hundred Icons* was printed in Beijing in the Qianlong period (1736–95) and widely disseminated throughout Mongolia.[3]

The tantric protector Hayagriva is coral, the color of the sunrise, as befits a member of the Lotus Family. He has three terrible heads, blue, coral, and white, and three bluish horse's heads spring from his three crania. His hair is like flames, and the terrific aspect of his nature is vividly portrayed by his crown of skulls, his garland of freshly severed heads, his capes of flayed human and elephant skins, and his tiger-skin skirt. He tramples a snake under each of his eight feet. Guhyasadhana Hayagriva has six arms. In his right hands he holds a *dorje,* a trident, and a sword; with his upper left hand he forms the *karana mudra,* a gesture used in magical practice to conjure up and exorcize demons, and his other two left hands hold a banner and a noose. He stands on a lotus and is surrounded by a halo of flames set against a backdrop of blooming lotuses and clouds. A Tibetan prayer, rendered in red thread at the bottom of the image, reads:

> Having thus pronounced a prayer and allied ourselves
> with the tutelary deity Wangchen lha [Hayagriva], and
> entirely freeing ourselves from the sphere of external
> and internal demons, may we attain the place of the
> White Lotus Ruler![4]

This Hayagriva is typical of the masterful images in silk produced in Mongolian workshops from the eighteenth through the early twentieth centuries. It was designed by one of the great masters of Da Khüree (Urga), T. Tsend, who came from either Daichin-beis or the Gobi region. Tsend's virtuoso methods in laying out a huge appliqué of Vajrapani (measuring 46 by 35 ft.), used over the entrance of the Yellow Palace during the annual *tsam,* were described by the late-nineteenth–early-twentieth-century artist Dulamiin Damdinsüren as follows: "When Tsend 'painted' the Vajrapani, he stretched a number of pieces of new felt out on the green sward next to the river Selbe (which ran through Urga). He prepared a great piece of white cotton, on which he drew the image of the future Vajrapani with a stick of birchwood charcoal."[5] After preparing the underdrawing, scraps of multicolored Chinese silks in various late-nineteenth-century

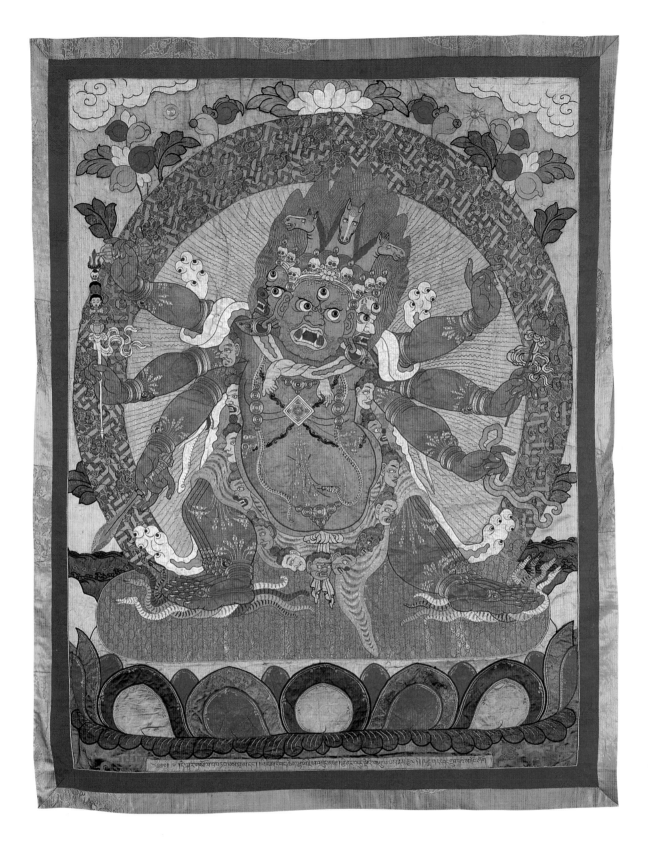

patterns—plain, damask, satin, and brocaded—were cleverly integrated into a prodigiously complex patchwork composition, highlighted with embroidered silk and couched gold threads, and shored up from behind with paper. Sacred textiles such as this were generally designed by monks for major ritual occasions, such as the *tsam,* but were executed by devout women. —P.B.

Published: Tsultem, *Mongol Zurag,* pl. 81

1. Lessing, *Yung-ho-kung,* p. 95.

2. Gulik, *Hayagriva: The Mantrayanic Aspect of Horse-Cult in China and Japan.*

3. The Tibetan title is *sku-brnyan brgya-phrags-gsum.* See Olschak and Wangyal, *Mystic Art of Ancient Tibet,* no. 167, pp. 154–55. The entire pantheon by the Jangjya Khutuktu is reproduced here.

4. The author is grateful to James Bosson for the translation.

5. Translated from D. Dashbaldan, "Peintures de soie," in Béguin et al., *Trésors de Mongolie,* pp. 194–95.

79. SIX-ARMED MAHAKALA

Early 20th century
Silk appliqué
Overall H: 124⅞ (317.0) W: 61 (155.0)
Image H: 60 (152.5) W: 39½ (100.4)
Bogdo Khan Palace Museum

Mahakala is the wrathful form of Avalokiteshvara, the Lord of Mercy. He is also one of the Eight *Dharmapala*, the Guardians of the Law, whose duty is to protect Buddhism against its enemies, to preserve the integrity of its teachings, and to protect its devotees from being distracted from their path to enlightenment. These eight protectors are venerated by the various orders of Tibetan Buddhism, although some might be singled out for special worship. Mahakala has been worshiped in Mongolia since the days of Khubilai Khan. Phagspa introduced the two-armed form of Mahakala, holding the chopper, skull cup, and horizontal staff, commonly known as Lord of the Tent (see Berger, "After Xanadu," fig. 2). When the Third Dalai Lama came to Mongolia, he introduced the type of Mahakala worshiped by the Gelug order.

The ferocious deity tramples the obstacle-creating, prostrate Ganesha on a sun disk above a colorful lotus pedestal. The white Ganesha is adorned with gold jewelry, and his attributes are a skull cup of jewels and a radish. Mahakala's upper hands carry the prayer beads of skulls and a trident for destroying passion, aggression, and stupidity, while simultaneously holding aloft the skin of an elephant. In his central hands are the drum, "the sound of which awakens one from the sleep of ignorance," and the lasso, "which helplessly binds the caprices of confused mind,"[1] while his main hands hold the chopper and skull cup, symbolizing "the de-struction and transmutation of inner addictive and outer demonic obstructions of one's quest for enlightenment."[2] He is surrounded by an aureole of flames, symbolizing the burning of all hindrances and ignorance.

A blue-colored Buddha, beautifully embroidered and couched in gold thread, appears above the flames enveloping Mahakala. The sun and moon represent the twin unity of contrast.

The various embroidery techniques in this appliqué include satin stitch and couching. The face of Mahakala is especially impressive, with eyes and mouth embroidered with silk floss, and hair, mustache, and beard carefully couched in gold threads.

The appliquéd offerings on the bottom mounting are most unusual, because they are traditionally shown within the composition. The three skull cups contain blood, offerings of the five sense organs, and a triangular *torma* (dough offering) for wrathful deities. Around them are pairs of animals, among them the "five snouts," fierce Tibetan mastiffs with their traditional red collars, and birds. These animals are effectively depicted in black and outlined in red and gold couching.

—T.T.B.

1. Trungpa, *Visual Dharma*, p. 112.

2. Rhie and Thurman, *Wisdom and Compassion*, p. 295.

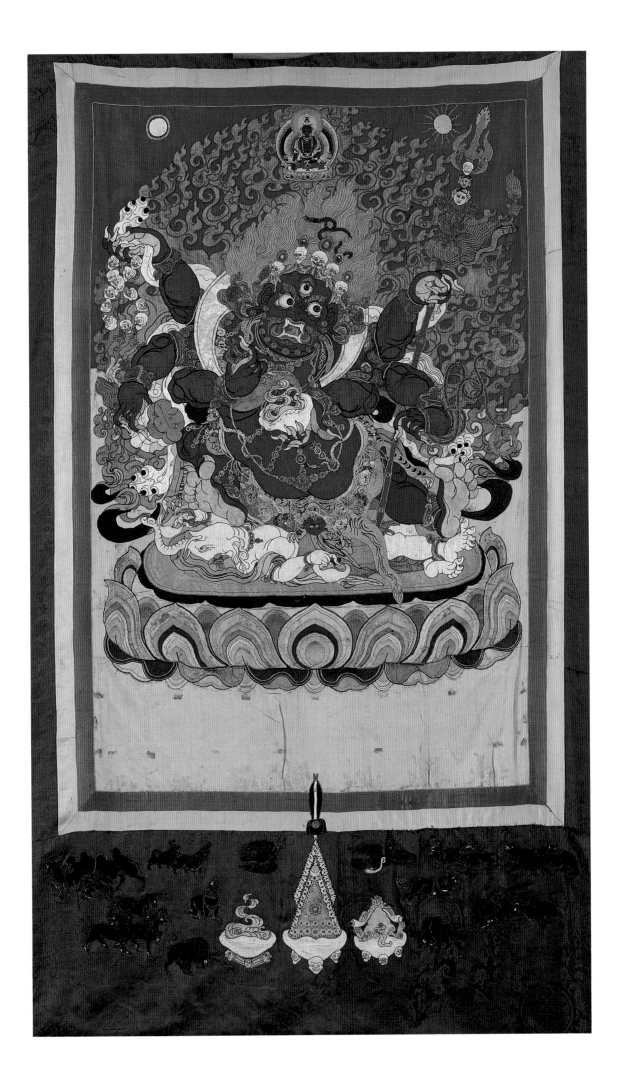

80. WHITE MAHAKALA (T: GÖNKAR; M: GONGGOR)

Early 20th century
Silk appliqué
Overall H: 129¼ (328.2) W: 88 (223.5)
Image H: 64½ (163.7) W: 48 (121.8)
Bogdo Khan Palace Museum

The Third Dalai Lama introduced the worship of this form of Mahakala to Mongolia (see Stoddard, "The Tibetan Pantheon"). The White Mahakala is worshiped as the god of wealth, and his veneration is widespread in Mongolia.

Unlike other forms of Mahakala who trample on a single image of Ganesha, the six-armed White Mahakala stands in a frontal position and steps on two prostrate Ganeshas, regarded as obstacle-creating demons (see cat. no. 75, where Ganesha is shown as an auspicious god). The elephant-headed gods appear to be conversing with each other, while holding their attributes of skull cup with jewels and white radishes. Mahakala is supported on a lotus pedestal, where a piece of golden brocade takes the place of the sun disk. As a god of wealth, Mahakala carries the flaming jewel and a skull cup containing the vessel filled with the elixir granting wisdom and life. His right hands wield the chopper with the *dorje* hilt and rotate the skull drum with long tassels, while his left hands brandish the trident and elephant goad. He wears a crown of five jewels, embroidered in graduated colors. His three eyes and mouth with rolled-back tongue and fangs are also embroidered, while his eyebrows, mustache, and beard are carefully couched in gold thread. Tiny seed pearls further embellish the jewels and ornaments. The mauve-colored silk is used effectively to bring out the white body and enhance the golden halo around Mahakala.

Dancing *dakini* of five colors surround Mahakala, each carrying a skull cup containing a vessel and an elephant goad. Surmounting the appliqué are two deities floating on visionary clouds. Vajradhara on the left crosses his hands in the *vajrahumkara mudra,* or gesture of highest energy; his jewelry is represented by tiny corals and seed pearls. The use of real jewelry in an appliqué is a Mongolian characteristic and is not found elsewhere. On the right, Tsongkhapa, founder of the Gelug order, carries two lotuses supporting the book and sword.

The White Mahakala was one of the tutelary deities of the First Bogdo Gegen and figured in the meditations of the Eighth, and last, Bogdo Gegen. In the portrait of Zanabazar (cat. no. 16), the White Mahakala, the six-armed Mahakala, and Vaishravana are shown on the bottom row. In catalogue number 18, scene 15, the three gods of wealth (White Mahakala, White Ganesha, and Vaishravana) are bestowing blessings upon the Bogdo Gegen. —T.T.B.

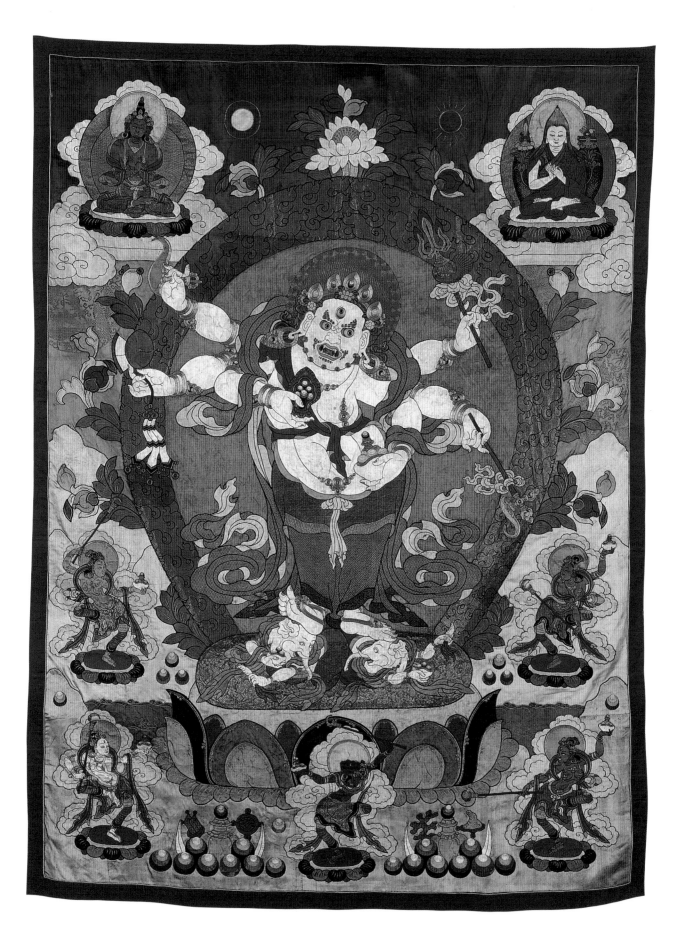

81. OFFERINGS TO MAHAKALA

Late 19th century
Silk appliqué
H: 52½ (133.5) W: 101 (256.5)
Museum of Fine Arts

In the *gönkhang* (M: *gonhon*), the special room in Buddhist monasteries dedicated to the worship of wrathful guardian deities, one often comes across thangkas and appliqués depicting numerous offerings, but except for their attributes, the central deities are never conventionally shown. These paintings and hangings are known as *gongdze,* or propitiation substances, and they are specially created for ceremonies to placate these deities.

This extraordinary appliqué, pieced together with satin, damask, and brocades, and utilizing such techniques as gold couching, satin, split satin, and stem stitches, was the combined labor of numerous seamstresses and tailors working under the direction of Mongolian artists in the late nineteenth and early twentieth century in Urga.

The crown of five skulls, elephant hide, floral scarf, and attributes of sword, spear, string of skull prayer-beads, chopper, and skull cup indicate that the missing figure is Maha-

kala, one of the Eight Guardians of the Law and protector of Mongolia (fig. 1). He is supposed to stand on the prostrate figure lying on a sun disk, upon a lotus pedestal, above the ocean of blood contained in a triangle, within a ring of mountains. In front of the arrangement of Mahakala's attributes is an altar with two rows of offerings. The top row shows a towering triangular dough offering *(torma)* for wrathful deities, flanked by pairs of skull bowls with blood and butter lamps. The second row has seven skull bowls with various human parts. At the base of the altar are pairs of musical instruments: conch, cymbals, and thigh-bone trumpets. Below them is the model of the cosmos, Mount Meru, the *axis mundi,* surrounded by the four continents.

Stretched across the top of the appliqué are the flayed skins of a human being, a tiger, and an elephant, garlanded with eyeballs, hearts, and intestines. Below them are thirteen ravenlike black birds, hovering above the peaks and car-

Fig. 1. Detail of attributes of Mahakala.

Fig. 4. Detail of food offerings.

Fig. 5. Detail of the Seven Secondary Treasures of
the Monarch.

Fig. 2. Detail of the Eight Auspicious Symbols.

Fig. 3. Detail of the Seven Jewels of the Monarch.

rying a human eye and bowels. The third row contains, from left to right, the Eight Auspicious Symbols (umbrella, twin golden fish, vase, lotus, conch, endless knot, standard of victory, and the Wheel of the Law; fig. 2) and the Seven Jewels of the Monarch (Wheel of the Law, wish-granting jewel, the queen, the minister, the elephant, the horse, and the general; fig. 3).

The fourth row contains health-inducing food offerings in skull bowls (fig. 4): the mirror reflects the contemplator's fate; the *giuvam,* a yolklike secretion from the glands of an elephant, used medicinally; yogurt presented by a peasant girl to the Buddha after his meditation; *kusha* grass given by a grass vendor to the Buddha for his mat; peaches for longevity; a conch shell symbolizing Buddha's teaching; vermilion powder; and mustard seeds. Racks of ritual weapons are placed in the fifth row, including chopper, *phurba,* chains, swords, bell and *dorje,* and bow and arrows. There are musi-

cal instruments such as oboes, chimes, telescoping trumpets, and drums, and the Seven Secondary Treasures of the Monarch (fig. 5; see also cat. no. 54): sword, hide, throne, garden, house, robe, and shoes.

The bottom register is filled with pairs of animals: wolves, tigers, snow lions, dogs, hounds, elephants, and the "five snouts"—camels, horses, yaks, sheep, and goats.

—T.T.B.

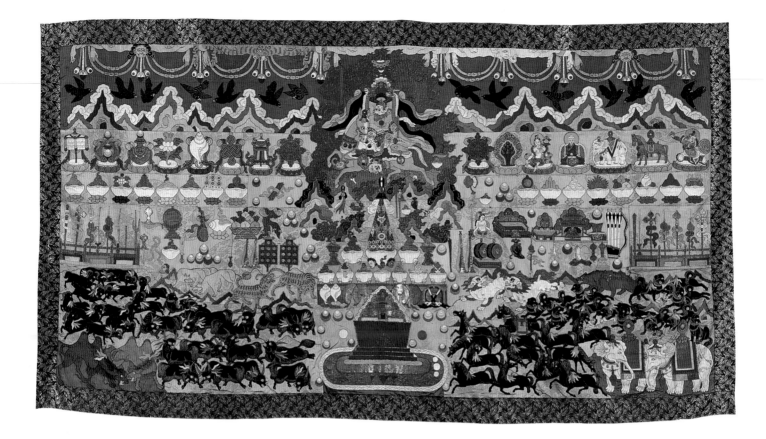

82. OFFERINGS TO PALDEN LHAMO

Early 20th century
Silk appliqué
H: 48¼ (122.5) W: 96⅝ (245.5)
Museum of Fine Arts

This propitiation appliqué is exactly identical to the one for Mahakala (cat. no. 81), except for the central deity. The mule crossing the sea of blood surrounded by mountains can carry none other than Palden Lhamo, the only woman among the Eight Guardians of the Law, and the fierce protector of the Dalai and Panchen Lamas. Although her image is not visible, her ornaments and her specific attributes are all clearly depicted. Looking at this appliqué, one has to visualize the goddess sitting sidesaddle on her mule upon the flayed skin of her son with her pendant legs fettered by chains. The mule has an eye on its haunch, the mark left by an arrow shot by Lhamo's husband from one of her past lives. Lhamo carries in her right hand a staff surmounted by a half-*dorje* for smashing the brains of those who have broken their promises. Her left hand supports the skull cup from a person born from an incestuous union. In the appliqué, the skull cup, shown upside down, floats above the mule. Lhamo wears a crown of five skulls, a white lion ear-

ring on her right ear, and a serpent earring on her left ear. The crescent moon appears in her hair, while the sun disk ornaments her navel. Her other attributes hang from the trappings of her mount: the ball of magic thread, a pair of dice for divination, a stack of red tablets, and a skin bag full of diseases for germ warfare against enemies of religion. The germs from the bag are the excess ones left over from the time when Lhamo tried, out of compassion, to swallow the world's diseases.[1]

The rest of the appliqué is identical to catalogue number 81. Like it, this example also shows beautiful embroidery in a variety of stitches. Especially effective is the stitching depicting the feathers of the black birds. —T.T.B.

1. Rhie and Thurman, *Wisdom and Compassion,* p. 301. For other descriptions of Palden Lhamo, see Nebesky-Wojkowitz, *Oracles and Demons of Tibet,* pp. 22–37; Tucci, *Tibetan Painted Scrolls,* vol. 2, pp. 590–94.

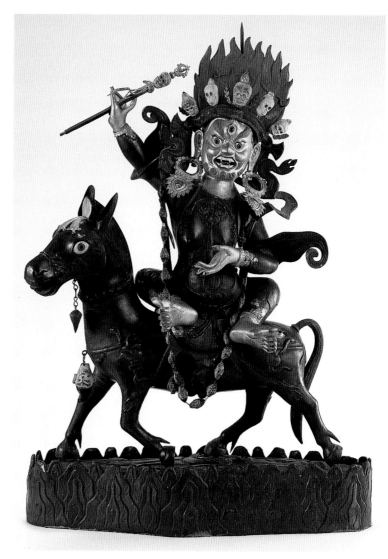

Detail of base.

83. PALDEN LHAMO

Dolonnor style
Early 20th century
Copper alloy, partially gilt, and colors
H: 33⅛ (84.0) W: 23⅜ (59.5)
Choijin-Lama Temple Museum

Palden Lhamo, the chief guardian-goddess of the Tibetan pantheon, is the only female among the Eight Guardians of the Law.[1] She is worshiped by every order of Tibetan Buddhism. As the special protectress of the Dalai and Panchen Lamas, she is venerated by the followers of the Gelug order in Tibet, China, and Mongolia. This statue, together with that of Begtse (cat. no. 84), came from the set of Eight Guardians from the *gonhon* (T: *gönkhang*), the main shrine of the Choijin-Lama Temple. This temple was erected between 1903 and 1906 in honor of Lubsankhaidav, the Eighth Bogdo Gegen's brother.

Following standard iconography, Lhamo sits sideways on her mule, who carries her across the sea of blood. Her pedestal is distinctively different from those of her companions. She alone has a lozenge-shaped pedestal surrounded by the Himalayan ranges, enclosing the sea strewn with corpses, skulls, body parts, and entrails. Lhamo killed her son, who was an enemy of Buddhism, and his flayed skin became her saddle blanket. She usually gnaws on a corpse, but it is not shown in this representation. Lhamo brandishes the skull club topped by a half-*dorje*. Her left hand should hold a skull

bowl, but it is missing. Her other attributes—the bag of diseases, book, and pair of dice—are attached to her mount with snake trappings. Lhamo wears the crown of five skulls and a garland of freshly severed heads. In her flaming hair is a half-*dorje,* and a snake threads its way horizontally across her locks. The empty spike above her hair once secured her peacock-feather headdress.

Unlike the statues by Zanabazar and those of his school, which are cast in a single piece, this statue is made of sheets of beaten copper soldered together. The method of construction and the style of the crown, flat earrings, and billowing scarves are typical of the works of Dolonnor in Inner Mongolia. This statue could have been imported from Dolonnor or made by a Dolonnor sculptor in Urga in the early twentieth century.

The bottom of the piece is covered with a piece of cloth stamped with the double-*dorje* motif.

—T.T.B.

1. Nebesky-Wojkowitz, *Oracles and Demons of Tibet,* pp. 22–37.

84. BEGTSE (M: BEGZE, JAMSARAN)

Dolonnor style
Early 20th century
Copper alloy, partially gilt, and colors
H: 37½ (95.5) W: 29½ (75.0) D: 14⅛ (36.0)
Choijin-Lama Temple Museum

Begtse is the protector of Mongolia. Until recently, Begtse was believed to be a Mongolian deity, his presence in the Tibetan Buddhist pantheon an example of Buddhism's absorbing what it could not suppress. It was believed that Begtse did not come into the Buddhist pantheon until after the conversion of the Mongols in the second half of the sixteenth century.[1] Begtse means "hidden coat of mail," but he is also known as Jamsing, or "brother and sister," for he is often accompanied by his sister, Rikpay Lhamo (M: Ökin tngri; see cat. no. 83). In Tibet he is worshiped as one of the Eight *Dharmapala,* or Guardians of the Law, the god of war, as well as the protector of the Gelugpa. Grünwedel recorded a legend that when the Third Dalai Lama went to Mongolia to convert Altan Khan, Begtse tried to obstruct his path with demons in the form of various animals. The Dalai Lama then took the form of a four-armed Avalokiteshvara, and his horses' hooves left prints in the shape of the sacred mantra *Om mani padme hum.* At this, Begtse admitted his defeat and converted to Buddhism.[2]

Recent research by Amy Heller reveals that Begtse was worshiped in Tibet as early as the fifteenth century. Historically, he is first mentioned in the 1494 biography of the First Dalai Lama under the name Begtse Jamdrel.[3] The First Dalai Lama taught his rituals to his pupil, who was the father of the Second Dalai Lama.[4] Begtse and Lhamo together were the guardians of the Chokhorgyel, the personal monastery of the Second Dalai Lama, founded in 1509.[5] Begtse was also the personal protector of the Third Dalai Lama. As he spread the Gelug order to Kham (eastern Tibet) and Mongolia, the worship of Begtse became highly popular in these areas.

Together with the Lhamo of catalogue number 83, this Begtse is part of the set of Eight *Dharmapala* guarding the *gonhon,* the main shrine of the Choijin-Lama Temple. Begtse stands in the archer pose, with his right leg bent and left leg extended, a typical posture for wrathful deities in Tibetan art. He steps on two corpses, a horse and a human figure, lying on the pedestal. Begtse is clad in chain mail and wears the crown of five skulls and garland of freshly severed heads, while a fish pendant dangles from his waist. His right hand brandishes the scorpion-handled sword; his left hand holds the human heart, and in the crook of his arm are the banner, bow, and arrow.

The Choijin-Lama Temple was erected between 1903 and 1906 in honor of Lubsankhaidav, the Eighth Bogdo Gegen's brother. The set of Eight Guardians must have been commissioned around that time from Dolonnor or from Dolonnor craftsmen in Urga. Typical of Dolonnor sculptures, this Begtse is made of various pieces of copper alloy. The figure is made separately from the pedestal. The crown, garland of skulls, earrings, scarves, fish pendant, and all his attributes were made individually. Similar to the image of Lhamo, the piece is partially gilt and highlighted with colors. The faces of Begtse and Lhamo are identical and probably came from the same mold. At this time, in the early twentieth century, Dolonnor was still a major center for the production of Buddhist images and ritual objects. However, comparison to the eighteenth-century Dolonnor images in the Folkens Museum Etnografiska, Stockholm, reveals a decline in quality in the Mongolian examples.[6]

The pedestal is filled with offerings of juniper leaves and branches. Because of their fragrance, juniper branches are burned as incense offerings in both Mongolia and Tibet.[7] The base plate, similar to the ones belonging to Lhamo and the silver Amitayus (cat. no. 67), is held in place by small metal clamps. The double-*dorje* motif is stamped on the piece of cloth covering the base plate. —T.T.B.

1. Nebesky-Wojkowitz, *Oracles and Demons of Tibet,* p. 88.

2. Grünwedel, *Mythologie des Buddhismus in Tibet und der Mongolei,* p. 82.

3. Amy Heller, personal correspondence, 1994.

4. Ibid.

5. Heller, "Historic and Iconographic Aspects of the Protective Deities Srung-ma dmar-nag," p. 479; Dowman, *The Power-Places of Central Tibet,* p. 259.

6. See Bartholomew, "Introduction to the Art of Mongolia," fig. 9; Rhie and Thurman, *Wisdom and Compassion,* cat. nos. 1, 35, 36, and 96.

7. Heissig, *The Religions of Mongolia,* p. 46.

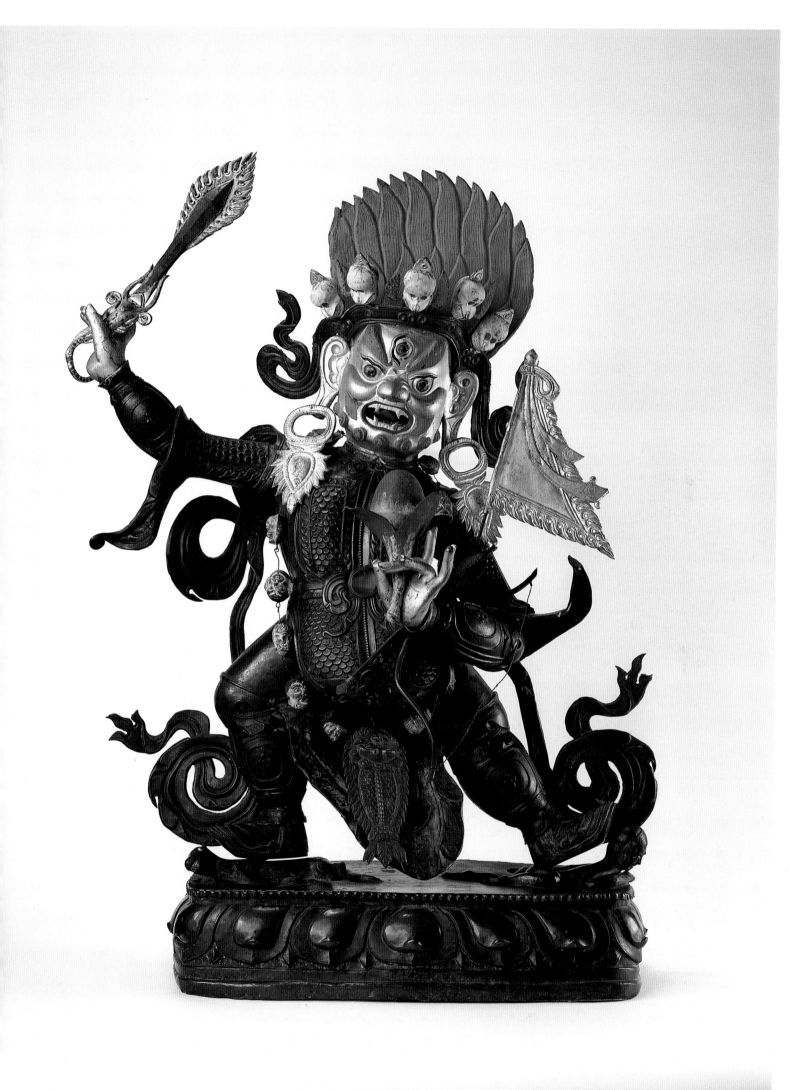

85. BEGTSE (M: BEGZE, JAMSARAN)

Zütger
Early 20th century
Silk appliqué with coral beads
H: 132¼ (336.0) W: 94⅞ (241.0)
Bogdo Khan Palace Museum

Against a background of flames, Begtse, the protector of Mongolia, stands in the militant archer pose on the sun disk supported by a lotus pedestal. According to Tibetan iconography, wrathful deities are shown with red hair standing on sun disks (gold or red), while peaceful deities with blue hair stand on moon disks (white).

In the late nineteenth century in Mongolia, the Jamsaran *dogshid* service was performed daily in Urga,[1] and a thangka or appliqué such as this one could have been used as an aid to visualize the deity. Pozdneyev translated the recitation of this service, and his description is in accordance with the way Begtse is depicted here. According to Pozdneyev, Begtse, or Jamsaran, is visualized as stepping on the human and equine corpses lying on the sun disk, which rests upon the lotus pedestal. He has a red face and two hands. His right hand holds the flaming copper sword for cutting those who break their vows. In his left hand he holds the heart and kidneys of enemies of the faith, while the bow and arrow and the red leather banner are held in the crook of his arm. Four fangs appear in his opened mouth, and his tongue moves rapidly. He has three eyes and an angry countenance. His brows and mustache (appliquéd in gold) are supposed to blaze like the fire at the end of the world. Begtse wears the crown of five skulls, copper armor, and a red silk garment. In this representation the skin of a sea monster dangles from his waist. On his chest is the mirror with the seed syllable *bram* embroidered with tiny coral beads. A bracelet of two rows of coral beads encircles his left wrist. The use of actual jewels in an appliqué is characteristically Mongolian. Jewels have not been found on Tibetan, Bhutanese, or Chinese appliqués.

Rikpay Lhamo, Begtse's sister and consort, appears on his right. She has a red face and a blue body, and rides naked on her bear who is chewing on a corpse. She is lifting her copper sword against the enemies of the faith, and the iron peg *(phurba)* in her left hand is for fastening the obstacles to salvation to one place. On Begtse's left is the Red Master of Life, charging on his mad wolf with his spear upraised, while his snare pulls an enemy of religion behind him.

The offerings to Begtse, shown before his lotus pedestal, are, from left to right, a rhinoceros horn, gold coins, a pair of emperor's earrings, elephant tusks, triple gems, a *baling* sacrifice, more triple gems, more elephant tusks, queen's earrings, scrolls, and a branch of coral. The *baling* sacrifice, according to Pozdneyev, is called *shatrak marki,* meaning "flesh and blood *baling*,"[2] and is made of barley flour mixed with water. The human hand, foot, eyeballs, nose, tongue, ears, heart, and brain in the *baling* sacrifice represent the enemies and obstacles to the faith, and they are being brought before the gods for punishment. At the end of the *dogshid* service, this dough sacrifice is burned behind the monastery's walls.[3]

Zanabazar, the First Bogdo Gegen, appears in the upper left-hand corner. He is seated on a lion throne and holds the *dorje* and bell. On the right is Tsongkhapa (see cat. no. 15), the founder of the Gelug order of Tibetan Buddhism.

The combination of fabrics used in this appliqué is truly impressive; the beautifully embroidered fragment used for Begtse's trousers is particularly lovely. The pieces of gold cloth are similar to the material used in the Bogdo Khan's jacket (see cat. no. 21). According to N. Tsultem, the artist Zütger supervised the construction of this appliqué. Zütger then went to Tibet at the request of the Thirteenth Dalai Lama. He died there, according to the Mongols, poisoned by Tibetan medicine. This image once hung in the Kalachakra Temple in Urga, now destroyed.[4] —T.T.B.

Published: Tsultem, *Mongol Zurag,* no. 74–75; Béguin et al., *Trésors de Mongolie,* cat. no. 28

1. Pozdneyev, *Religion and Ritual in Society,* pp. 430–42.

2. Ibid., p. 428.

3. Ibid.

4. As told by Tsultem to Patricia Berger, 1994.

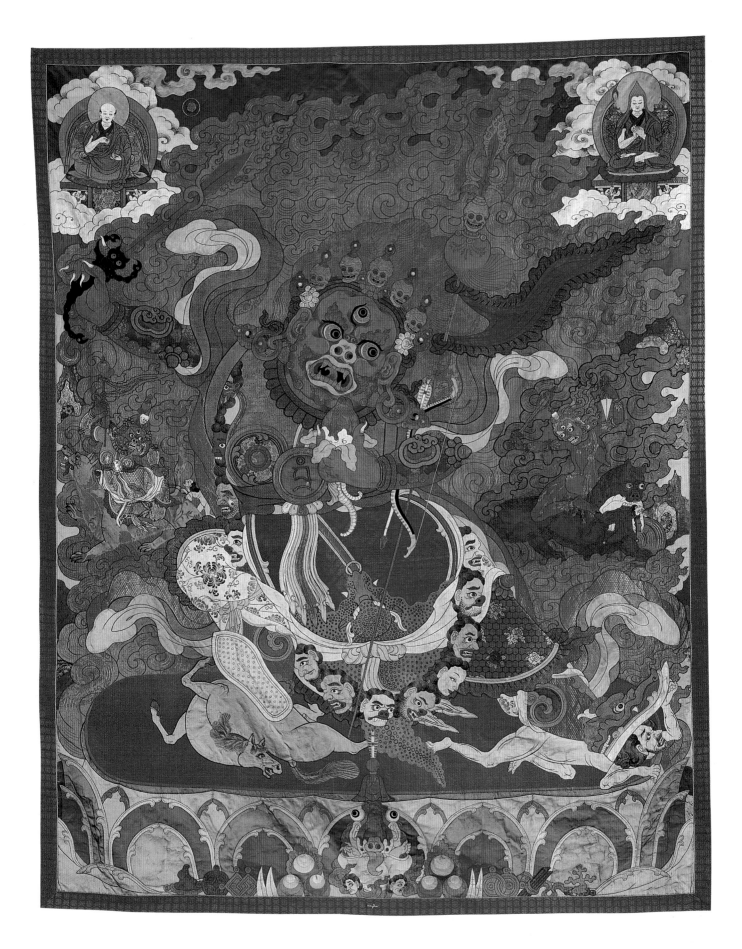

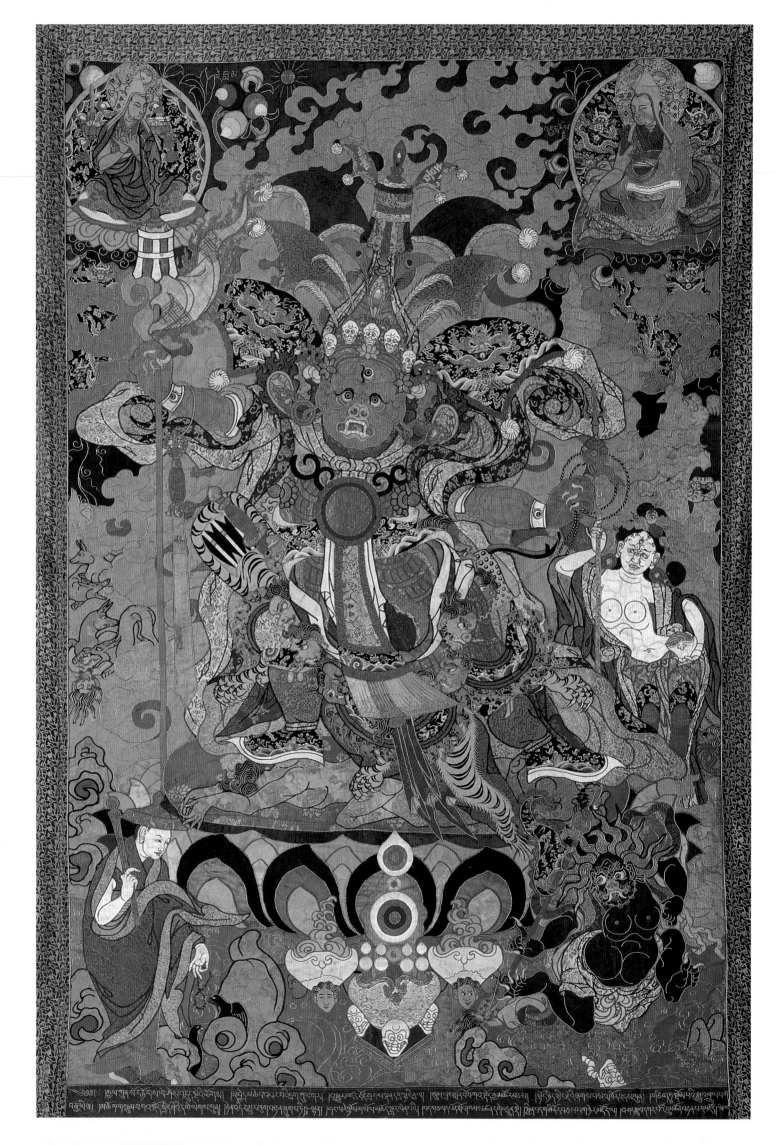

86. DORJE DORDAN

Perenlay
1834
Silk appliqué
Overall H: 110½ (280.5) W: 79⅛ (201.0)
Image H: 70⅝ (179.4) W: 45⅝ (115.8)
Museum of Fine Arts

Among the appliqués in this exhibition, this stupendous example is outstanding for its powerful composition, warm palette, choice of material, and intricacy of design.

Dorje Dordan, also known as the Chief Minister, is a very important figure in the retinue of Pehar. Pehar is the guardian of Samye, the earliest temple built in Tibet, as well as being the deity who possesses the State Oracle of Nechung (the Dalai Lamas' oracle; T: Gnas chung). Dorje Dordan is also believed to be an emanation of Begtse.[1]

The way Dorje Dordan is depicted corresponds directly to the iconographic details translated by René de Nebesky-Wojkowitz.[2] The fierce guardian dwells in the midst of a billowing fire cloud, below which storms the sea of blood strewn with body parts of enemies and obstacle-creating demons, and, most unusual, Chinese-style *taihu* rocks. He stands with his right leg bent and his left leg extended over a corpse, on a sun lotus (pedestal with sun disk). Like Pehar and Begtse, he is clad in military attire: cuirass, six flags flying from his shoulders, high boots, flayed skin of a tiger, and with a mirror on his breast, where the seed syllable *hrih* is embroidered in tiny corals. (According to Nebesky-Wojkowitz, he is supposed to come forth from the syllable *bhrum*.[3]) His attributes are the banner topped by a lance and the snare for catching the "life-breath" of enemies. His other weapons include a sword, a tiger-skin quiver, and a bow in a leopard-skin case. His red face has a terrific expression, he has three eyes, and his forehead is creased in a frown. His mouth, wide open, bears fangs and a rapidly moving tongue. He wears a garland of heads and a skull crown topped with a high canopied helmet, above which flutter two brocade flags woven with the Chinese character *xi* (happiness). The overall hue is coral, perhaps alluding to the deity's heavenly abode of red coral.

Dorje Dordan is accompanied by his half-naked consort, carrying the trident and a skull cup, and by a horrific black demon with wild locks, spearing an enemy of religion and clutching intestines. A monk, possibly the donor, stands in the lower left corner carrying a staff and prayer beads. The Tibetan inscription embroidered next to him identifies him as a *lonpo*, or minister. Inscriptions embroidered in gold identify the two lamas presiding above: Tsongkhapa appears on the left and Jamyang Chöje, on the right. Jamyang Chöje Tashi Paldan was the disciple of Tsongkhapa, who founded Drepung Monastery in 1416.[4]

The Tibetan inscription embroidered at the bottom of the piece reads:

> Dorje Dordan, king of the gods of war, who has the discriminate wisdom of all the Buddhas and who sets twirling the fierce dance of the resplendent fangs that devour the multitude of demons, together with his consort, sons, his ministers, and his innumerable attendants, by a hundred magic acts that fix together all the *samsara* and nirvanas through the lasso of *shunyata* and compassion, may all the blessings of the gentle rule of the Three Preciousnesses and their attendants quickly have a firm residence in this world. Be it so. We, teachers, students, monastic collegians, and the whole monastic community, who have on every occasion offered our devotion, prayers, and offerings to the gods, provide us with infallible patrons. Make firm the banner of the pure teaching and implementation [of the Buddha's doctrine]! Be it so.[5]

This appliqué displays a brilliant use of silk brocades. The fabric for the deity's boots, the two large flags on his shoulders, and the halos behind the two lamas came from an eighteenth-century *kesi* (silk tapestry) dragon robe. The particular patches were cut from the sections for cloud collars, cuffs, and sleeves.

—T.T.B.

1. Nebesky-Wojkowitz, *Oracles and Demons of Tibet*, pp. 125–26.

2. Ibid., p. 125.

3. Ibid.

4. The author is grateful to James Bosson for this identification.

5. The author is grateful to James Bosson for this translation.

87. SMALL PLAQUE WITH BEGTSE

19th century
Papier-mâché
H: 5 (12.9) W: 6⅛ (16.51) D: ⅞ (2.4)
Museum of Fine Arts

Begtse's retinue is fully shown in this plaque. The protector of Mongolia is depicted in his usual pose with his various attributes, standing above the copper mountain in a sea of blood. The hilt of his flaming sword of copper is in the shape of a half-*dorje,* instead of the scorpion. To his right is the Red Master of Life (T: Leken Sokdak Marpo; M: Ami-yin eǰen; see cat. nos. 85 and 89), riding his wolf and brandishing his spear and lasso. To Begtse's left, his sister and consort, Rikpay Lhamo, rides on her bear, holding the sword and *phurba.* Around them are the eight butchers wielding swords. These naked red figures with their hair standing on end are using their copper swords in various ways on the enemies of religion, prostrate beneath their feet.

This votive plaque, or *tsha-tsha* (M: *tsagts burkhan*), was made from a metal mold. *Tsha-tsha* can be made from a variety of materials including clay and papier-mâché, and can be mass-produced inexpensively and quickly. The lamas of Mongolia often distribute these images to their followers.[1] Many gods are represented in these plaques, and the images can often be of high quality if the molds remain in good condition. While small plaques are kept in amulet boxes and worn for protection, larger ones (see cat. no. 69) are framed and worshiped on altars. Like the large clay images in temples and monasteries, these plaques are sometimes painted. This example would have been placed on a family altar. —T.T.B.

1. Tsultem, *Mongolian Sculpture,* p. 13.

88. WOLF

Late 18th–19th century
Gilt copper alloy
H: 21½ (54.6) L: 34¼ (87.0) D: 10¼ (26.0)
Choijin-Lama Temple Museum

Wolves were a fact of everyday life in Mongolia, even in Urga, where as late as the turn of the century Aleksei Pozdneyev observed "wolves in large numbers" in the markets of Maimaicheng (whether dead or alive, he does not say).[1] Wolves, jackals, and wild dogs also play a symbolic role in tantric Buddhism as denizens of cemeteries, where they contribute to the horror of the scene by rending corpses limb from limb. They are a special part of the retinue of Begtse, the god of war who Mongols believed tried to bar the Third Dalai Lama from visiting Mongolia in 1575, but was eventually won over to the Buddhist cause to become the protector of both the Dalai Lamas and the Bogdo Gegens of Urga. A huge wolf is the mount of Begtse's right-hand man, the Red Master of Life (T: Leken Sokdak Marpo), also known as the "Red Officer," "the great officer," and "the atrocious life-master."[2] (Begtse's raincloud-colored, corpse-chewing sister and consort, to his left, rides a black bear, oddly depicted in cat. no. 85). Wolves can also be seen with corpses in their mouths running from the flaming aura surrounding Dorje Dordan (cat. no. 86), a protector René de Nebesky-Wojkowitz suggested is an emanation of Begtse.[3]

This sleek gilt repoussé wolf, its fangs bared to reveal bloody jaws, probably originally served as a mount for the Red Master of Life in a sculptural ensemble focusing on Begtse. A hole in his back, which has been clumsily repaired, was a mortise intended to hold the Red Master's tenon. Parts of such grand sculptural montages, which also included painted backdrops, can still be seen fragmented in the monasteries that survive in Ulaanbaatar.　　　　—P.B.

Published: Béguin et al., *Trésors de Mongolie*, cat. no. 19

1. Pozdneyev, *Mongolia and the Mongols*, p. 79.

2. Nebesky-Wojkowitz, *Oracles and Demons of Tibet*, p. 89.

3. Ibid., pp. 125–26.

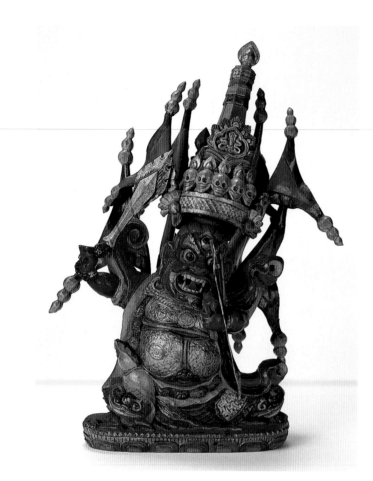

89. BEGTSE SHRINE

Süren
Early 20th century
Painted wood
H: 15⅜ (39.2) W: 9½ (24.0) D: 7⅛ (18.1)
Choijin-Lama Temple Museum

This fantastic creation showing Begtse and his retinue inside a skeleton shrine is the work of Süren, a famous sculptor of the early twentieth century.

The fierce protector of Mongolia brandishes his flaming copper sword with a scorpion tail, while his left hand, armed with a bow and arrow, lifts the heart of an enemy of religion to his mouth. He steps on the corpses of a man and a horse, above the lotus, which is inserted into his copper mountain abode. The mountain in turn rises above the sea of blood enclosed by peaks painted on the rectangular pedestal. His tall crown almost equals him in height. Shaped like a tiered cake, the golden base supports five grinning skulls, a sword emblem with flaming gems, and a tall canopy surmounted by a jewel. Begtse is adorned with three standards and four flags. These flags are also the attributes of military gods such as Pehar and are part of the regalia of the Oracle of Nechung, the official oracle of the Dalai Lama. Generals in Chinese operas wear such flags as well.

Begtse is accompanied by the Red Master of Life on his wolf and his sister Rikpay Lhamo, riding a lion who crouches above a prostrate man.[1] Dancing around them are the eight acolytes (one missing), red in color, with flaming hair ornamented by a single skull. They are the *tritok shenpa gye,* "the eight butchers who wield swords," who devour the flesh, blood, and the "life-breath" of enemies.[2] They are leaping,

jumping, and running with great vigor, while wearing fierce scowls on their faces.

Four pillars, each stacked with nine skulls, support a canopy ingeniously put together with skeletons of humans and *makara.* A seated skeleton holding aloft a human heart (Begtse's attribute) surmounts the square top, together with two legless skeletons and owls. Two larger owls (one missing) and women wrapped in flayed human skins guard the four cornices. The shrine, with its predominance of white, stands in stark contrast to the mass of red figures below.

Begtse and his shrine of skeletons are sometimes seen in thangkas.[3] This superbly carved wooden shrine is the only three-dimensional example known to us. —T.T.B.

Published: Tsultem, *Mongolian Sculpture,* no. 246

1. Rikpay Lhamo riding on a lion instead of a bear as shown in the appliqué of cat. no. 85 is in accordance with the writings of the Panchen Lama Tenpai Nyima; see Tucci, *Tibetan Painted Scrolls,* vol. 2, pp. 594–96.

2. Nebesky-Wojkowitz, *Oracles and Demons of Tibet,* p. 92.

3. Fisher, *Mystics and Mandalas,* cat. no. 28; Copeland, *Tankas from the Koelz Collection,* fig. 54; Essen and Thingo, *Die Götter des Himalaya,* cat. no. 140.

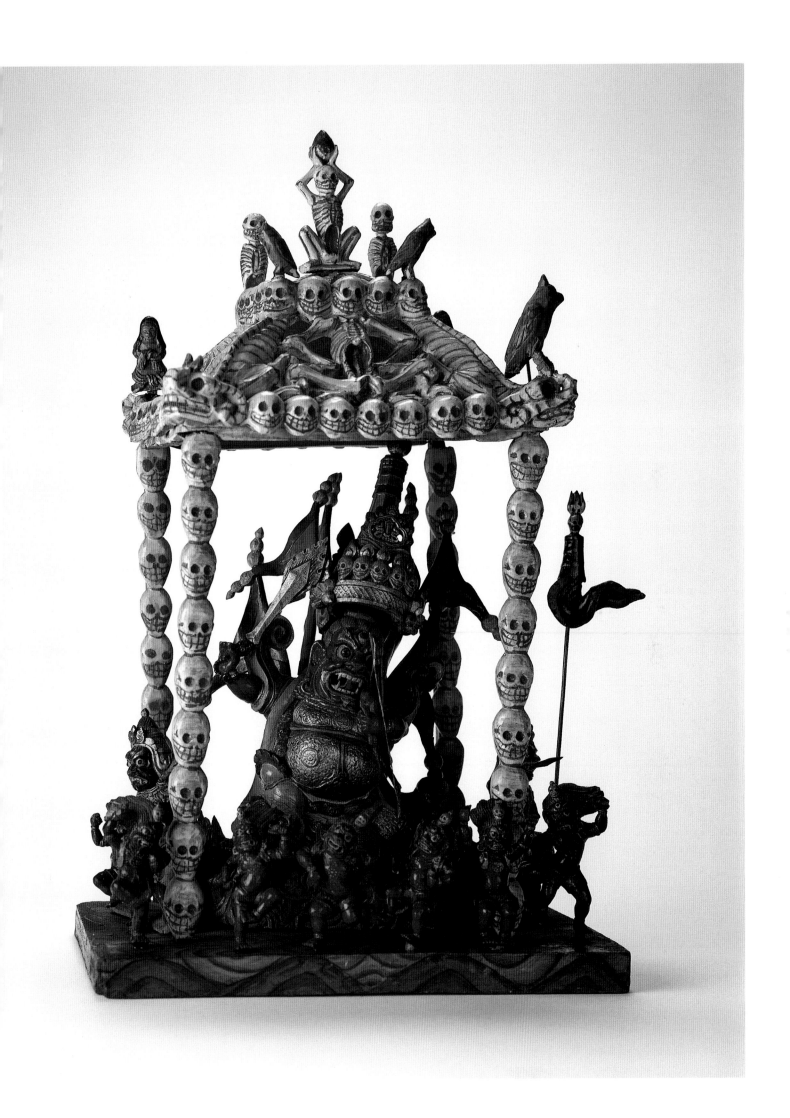

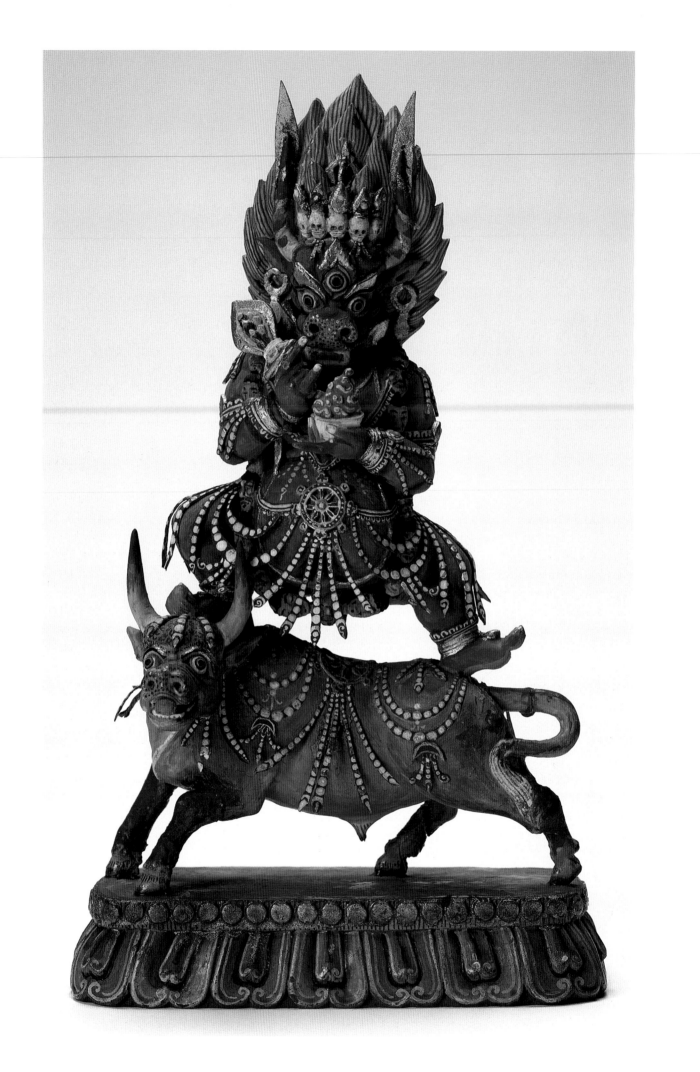

90. YAMA, LORD OF DEATH (M: CHOIJIL)

19th century
Wood with colors, gilt, and leather
H: 9½ (24.3) W: 5½ (14.0) D: 2½ (6.5)
Bogdo Khan Palace Museum

Yama's name comes from the Sanskrit word for "twin," and in Hindu belief Yama was a twin of his sister Yami. Together, the two were the primordial couple, the father and mother of humankind. In Buddhism, however, Yama occupies a position of meaningful ambivalence, for he is both Lord of Death and *Dharmapala,* a sworn protector of the Buddhist law.

As Lord of Death, Yama also had a special relationship to Tsongkhapa, the founder of the Gelugpa, and hence to the order as a whole, for which he served as protector. The origins of this relationship can be found in the tantric mythos surrounding Yama and his subduer, Manjushri, the Bodhisattva of Wisdom incarnate in Tsongkhapa.

The bull-headed Yama was an egocentric deity who presided over hell and cut short human lives, arbitrarily abbreviating the precious and unique opportunity for enlightenment that human birth provided. His rampages were so brutal that Manjushri decided to intervene. Manjushri transformed himself into a shape Yama could appreciate, giving himself a bull's head and eight other faces to symbolize his extraordinary powers. In this form he is Yamantaka, the terminator *(antaka)* of Yama. Yamantaka then traveled to hell, where his perfect selflessness forced Yama to see an infinite series of reflections of himself, an experience so horrifying that Yama was subdued and converted to a more benevolent Buddhist point of view.

Tsongkhapa even wrote a poem of praise to Yama (without whom there would have been no need for his revered Yamantaka), lovingly describing his bullish form.[1] Yama and Yamantaka, so central to the Gelugpa founder's own practice, were equally important in Mongolia. Yamantaka was the subject of a special missionizing effort in the late seventeenth century by the Inner Mongolian Neyiči Toyin lama (1557–1653), whose prayers and rituals to this terrible form of Manjushri, designed as substitutes for shamanist exorcisms, were ultimately suppressed for their unorthodoxy.[2] Nonetheless, Yamantaka continued to be a major object of veneration for the Urga Bogdo Gegens; the meditation thangka of the eighth and last incarnation (cat. no. 18) features him as the central deity. Yama himself played a primary role in the Mongolian Erleg Khan *tsam,* where he was the exorcist and destroyer of illusions and obstacles to enlightenment (cat. no. 40).

Yama's several forms, outer, inner, and secret, each represented by different colors and attributes, are aimed at eliminating different types of obstacles. In his outer, blue form, he wipes out practical problems, such as sickness and famine. In his inner form, he eliminates obstacles to enlightenment in the mind of the devotee. In his red, secret form, shown here, he is capable of generating profound energies from the depths of the devotee's mind.

This exquisitely rendered Yama has a power that belies its minute scale. Poised with his right foot forward on the back of a red bull, Yama holds a skull cup *(kapala)* filled with blood in his left hand and a chopper with a handle in the form of the *chintamani* in his right, symbolizing his additional role as a god of wealth. Yama and his bull are both carved of wood, but their bodies are draped with delicately fashioned, thin leather ornaments. Yama's terrible bullish head, with its upswept horns and flamelike hair, is crowned by five skulls and a demon-dispelling *dorje* (S: *vajra*), symbol of his adoptive lineage within the tantric system of five Buddha families. The *vajra* family was also profoundly important to the lineage of the Bogdo Gegens, for Zanabazar's first initiation at the hands of the Fifth Dalai Lama was into the mysteries of Vajrapani or Vajradhara, and he and his seven rebirths hold the attributes of Vajrasattva, whose identity is often merged with Vajradhara's.　　　—P.B.

Published: Tsultem, *Mongolian Sculpture,* pl. 247

1. Rhie and Thurman, *Wisdom and Compassion,* p. 290, Thurman trans.
2. Heissig, "A Mongolian Source to the Lamaist Suppression of Shamanism in the Seventeenth Century," p. 16.

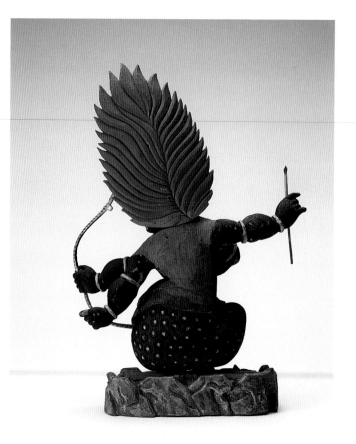

91. RAHU, THE PLANET

Da Khüree style
Early 20th century
Wood with polychrome and string
H: 12⅜ (31.5) W: 9⅛ (23.3) D: 3⅛ (8.0)
Bogdo Khan Palace Museum

Rahu, the Planet, is one of many deities who entered the Buddhist pantheon in Tibet and Mongolia via tantric Hinduism and whose nature is wildly paradoxical.[1] As ruler of all the greater and lesser planets, he holds a particularly important place in the pantheon of the Tibetan Nyingmapa and is generally viewed as a protector of the faith in Tibet and Mongolia, but he is also a demonic figure, the bearer of illness and the swallower of the sun or moon during eclipses. In traditional Mongolia people generally made noise, and dogs barked to chase away the demonic Rahu.

This diminutive but powerful wood carving of Rahu, by an unknown, early-twentieth-century Da Khüree sculptor, depicts him with precision. Rahu has a snake's body with a large, gaping mouth in his belly, which emits an effluvium of illness. His torso and four arms are covered with eyes (one thousand is the number given in texts). His nine stacked,

horrible heads are crowned with flaming hair and the head of a raven, who guards religious teachings and whose shadow was believed to cause apoplexy. Rahu leans back to draw his bow and shoot an arrow into the heart of anyone who breaks his religious vows. His now-empty left hand may have held a banner decorated with a crocodilian *makara*. He sits on a base (not original to him) in a river of blood that flows through a tiny, rocky landscape. This Rahu was one of the deities displayed in the Eighth Bogdo Gegen's monastery in Da Khüree in the early part of this century. —P.B.

Published: Tsultem, *Mongolian Sculpture,* pl. 248

1. Huntington, "Iconography of Evil Deities from Tibet," p. 63; Nebesky-Wojkowitz, *Oracles and Demons of Tibet,* pp. 259–61.

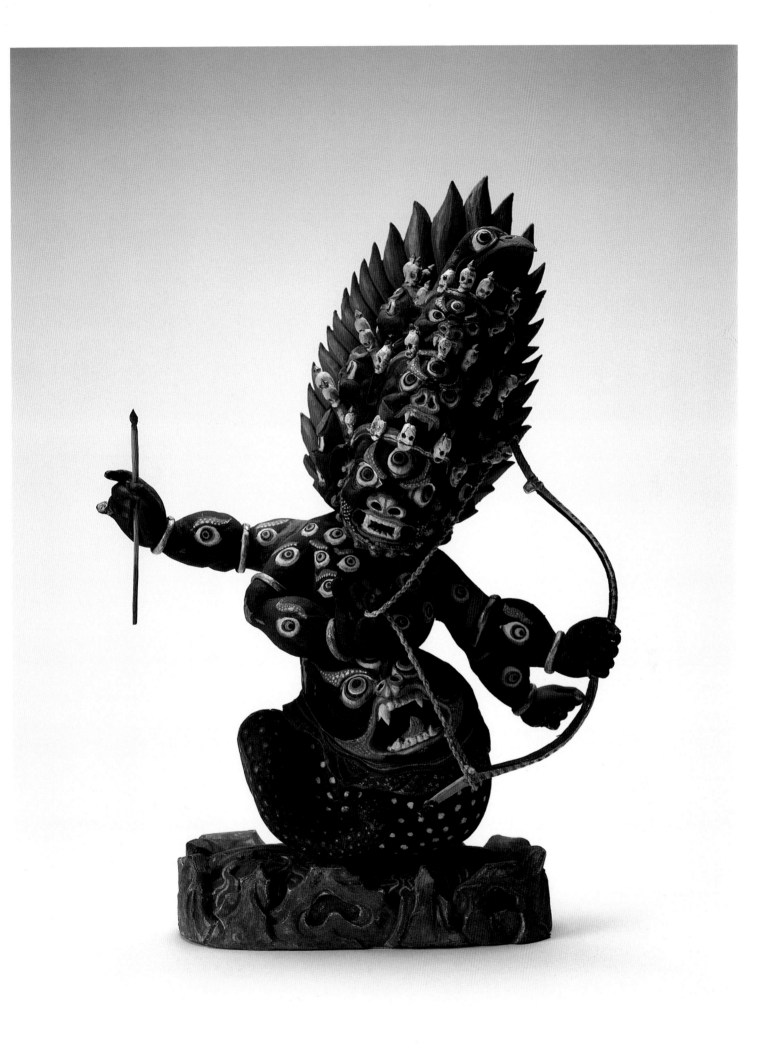

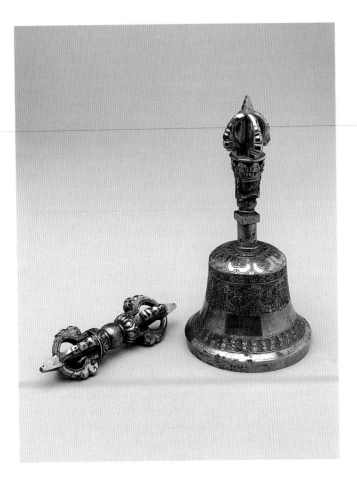

92. SET OF TWELVE RITUAL INSTRUMENTS: BELL AND *DORJE*

19th century
Steel
Bell H: 6⅞ (17.4) D: 3 (7.7)
Dorje L: 4⅝ (11.7) D: 1⅛ (3.0)
Museum of Fine Arts

Although the twelve instruments are shown as a set (cat. nos. 92–94), stylistically, they seem to fall into three groups. All these instruments were once used during Buddhist rituals, and every temple would have owned at least one set. The *dorje* and bell *(dilbu)* are the most important ritual objects of Tibetan Buddhism. They are a necessary part of prayers and rituals and every monk is equipped with a pair. The *dorje* and bell are the attributes of the Adi-Buddha Vajradhara, who holds them with his hands crossed in the *vajrahumkara mudra,* or gesture of highest energy. Vajrasattva (cat. no. 99) and Zanabazar (cat. no. 95) also hold these two instruments.

The *dorje* represents the male aspect of skillful means, and the bell represents wisdom or supreme knowledge, a feminine aspect. Together, the pair symbolizes the union of these aspects, which leads to liberation and enlightenment. During prayers and rituals, the practitioner holds the *dorje* in his right hand and the bell in his left.

The *dorje* consists of four curved prongs around a center post, also considered a prong. The grip has two rows of lotus petals, pointing in opposite directions. The bell handle has a half-*dorje* on top, followed by the head of the goddess Prajna, the personification of transcendent wisdom, below which is the vase of plenty. The top of the bell has eight petals incised with eight Sanskrit syllables, symbolizing the goddesses who attend Prajna. The band below has a design of alternating blossoms and *dorje* against a ring-punched background, below which is a beautifully chased band of *kala* heads spilling forth strands of jewels, forming a valance around the bell. Another band of *dorje* below completes the design. —T.T.B.

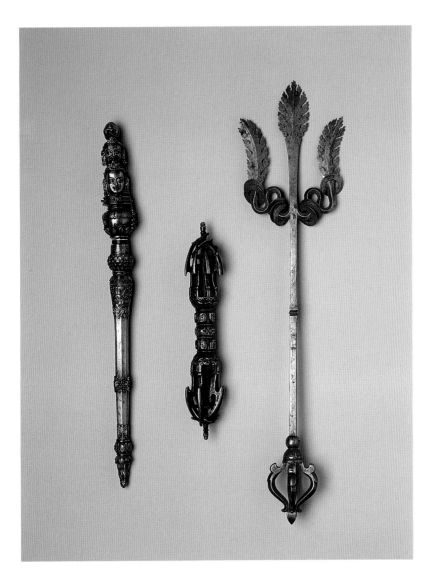

93. SET OF TWELVE RITUAL INSTRUMENTS:
LARGE TRIDENT, LARGE *DORJE*, AND
KHATVANGA

19th century
Steel
Trident L: 21½ (54.5) W: 5¼ (13.4)
Museum of Fine Arts

The trident with its serrated blade is fancier than the example in catalogue number 94. Attached to it are a number of thin circular disks, which make a noise when the instrument is being used. Its three prongs stand for the suppression of passion, aggression, and stupidity.[1]

Unlike the more standard example in the previous entry, this *dorje* is most unusual, with its two rows of human faces in place of the customary two rows of lotus petals. Its fancy prongs are of the type usually attributed to the fourteenth century.

The *khatvanga* is the staff carried by Padmasambhava, *dakini,* and other gods. Starting from the top, it should have a trident or half-*dorje;* followed by three heads in three different stages: skeletal, putrid, and freshly severed, symbolizing conquest of the three poisons of lust, hate, and delusion; the vase of plenty; and a double *dorje.* In this example, the top element and the double *dorje* below the vase are missing.

—T.T.B.

1. Trungpa, *Visual Dharma,* p. 112.

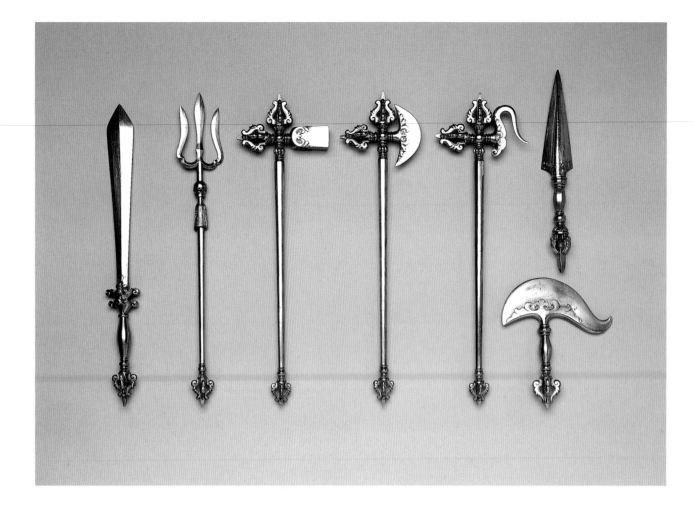

94. SET OF TWELVE RITUAL INSTRUMENTS:
SWORD, TRIDENT, HAMMER, AXE, HOOK,
PHURBA, AND CHOPPER

19th century
Steel
Trident L: 12½ (31.8) W: 1⅞ (4.7) D: 1 (2.6)
Museum of Fine Arts

Within the set of twelve ritual instruments, these seven seem to form a set by themselves because they share a similar half-*dorje* design. They are used by monks in various ceremonies, but they are also the attributes of deities of Tibetan Buddhism.

The sword is the type depicted in the rack of weapons in catalogue numbers 81 and 82. It is the attribute of many deities, among them Begtse, Mahakala, and Manjushri. The sword of Manjushri and Tsongkhapa is sometimes edged with flames, for it is the sword of wisdom that cleaves the clouds of ignorance. The trident is one of Mahakala's weapons. Its three prongs destroy passion, aggression, and stupidity.[1] The hammer is the attribute of Dorje Legpa, one of the *damchen*, those who had taken an oath to serve Buddhism.

Triangular pegs, known as *phurba*, are used by exorcists to stab demons in the air. They are often carried by practitioners of the Nyingma order. The Fifth Dalai Lama, who also practiced Nyingmapa teachings, is depicted with a *phurba* in his sash. The axe and the hook are the attributes both of many of the Guardians of the Law and also of Ganesha (cat. no. 75).

The chopper is a curved blade with a *dorje* haft and is used for slicing the aortas of enemies of religion. Like the *dorje,* it is the symbol for skillful means or compassion. It is paired with the skull cup, which, similar to the bell, represents transcendental knowledge or wisdom. When shown together, they unite the two principles of wisdom and compassion. The chopper and skull cup are the attributes of many wrathful deities, including Mahakala and the *dakini.*

—T.T.B.

1. Trungpa, *Visual Dharma,* p. 112.

Zanabazar

(1635–1723)

PATRICIA BERGER

"Being a Buddha is meditation, being rich is fate, being virtuous is generosity, being clever is wisdom."[1]

The seventeenth and eighteenth centuries were a period of cultural reinvention in Inner and East Asia, much of it inspired by Mongol ideas. China watched the death of the Ming dynasty, only to be overrun by the Manchu Qing. The Qing, in turn, emulated the Mongol emperors of the Yuan to the point of claiming themselves to be reincarnations of the greatest of them, Khubilai Khan. Tibet shed its royal families with the help of the Mongol Güshri Khan, and reorganized under the Dalai Lamas, themselves Mongol creations. The Dalai Lamas proceeded to cooperate with the Manchus, who in turn gave official and personal support to Tibetan Buddhism after being recognized, like Khubilai, as incarnations of Manjushri, China's own Bodhisattva of Wisdom.

In Mongolia the potent national myth of the world conqueror, Chinggis Khan, was expressed much more directly, through descent and inheritance, but it was also embellished through an overarching process that transcended its protagonists. For the Khalkhas of Outer Mongolia, Zanabazar, the first incarnate Bogdo Gegen of Urga, became the mirror of his people's cultural aspirations (fig. 1). As the son of the Tüsheet Khan Gombodorji, the great-grandson of Abadai Khan, and the direct descendant of Chinggis, Zanabazar came into the world armed with a pedigree whose legitimacy could not be impugned.

In histories written as little as a century after his death in 1723, Zanabazar's persona was enhanced to superhuman size by the miracles that surrounded every part of his life.[2] Thus his arrival on earth was first foretold when his great-grandfather Abadai went to Tibet in search of a Buddha-image and a lama for Erdeni Zuu. The Buddha was installed at Erdeni Zuu, and the lama was Zanabazar, who was not to be born for fifty years. Many years later, Zanabazar's father, Gombodorji, met a lama worshiping the earth, who vanished suddenly. In his place a rainbow appeared, a portent, it turned out, of Zanabazar's conception. At the same time, Setsen Khan sent a letter to Gombodorji predicting the birth of a "fine boy of the golden family of Chinggis

Fig. 1. Zanabazar, late 19th century. Woodblock print on paper. Museum of Fine Arts, Ulaanbaatar. From Tsultem, *The Eminent Mongolian Sculptor—G. Zanabazar*, pl. 104.

Khan," who would be the new Mongol leader. The Khansha Khangdajamts went to give birth at the site where Gombodorji had seen the lama and rainbow, a place where a white bitch had had a litter of pups. Despite all these auspicious signs, when Zanabazar was born, the Khansha had no milk, though it poured bountifully from the breasts of her embarrassed servant.

Zanabazar fulfilled all the hopes that had been lodged in him. Setsen Khan called him "Brilliant Child" and rocked him in a jeweled cradle, for the child bore all the signs of the Buddha on his body. He had oblong eyes, the black and white portions of them of equal size (a very auspicious mark), and the first words from his mouth were mantras and *dharani* (charms and spells). He played at being a monk and at building temples, a harbinger of his artistic talents. Consecrated in 1638 at the age of three, he went to Tibet in 1649, when he was just fourteen. There, the Fifth Dalai Lama granted him a second lineage through reincarnation, declaring him the rebirth of the Jonangpa historian Taranatha (1575–1634). He also named him Jebtsundamba Khutuktu (M: Bogdo Gegen) and sent him back to Khalkha to missionize for the Gelugpa.

The miraculous aura that surrounded Zanabazar's birth and earliest years continued throughout his life, according to the legends and tales that grew up around him. They credit him with all types of superhuman acts—his seven-day flight to Tibet in 1655 to visit the Panchen Lama at Tashilunpo, whom he found already dead but revived with a mandala-offering repeated three times; his magical unmasking of the tricks of the Kangxi emperor's courtiers, who hid sacred objects beneath his mat to humiliate him if he should sit on them unaware; his ease in lifting the massive bell and *dorje* that Kangxi prepared for him to use in a ritual of long life; his appearance before the emperor as Vajradhara. Even his art took on a supramundane quality, so that when he carved a ruby into images of Shakyamuni, sixteen arhats, and four heavenly kings, each the size of the tip of a thumb, the Kangxi emperor compared him to Vishvakarman, the architect and artist of the gods.

It is difficult to extract the day-to-day facts of Zanabazar's life from the magical hagiographies written about him. His pious people believed he was divinely endowed, but, even with all the embellishments stripped away, he emerges from his legend as a multitalented genius who concerned himself with every aspect of politics, diplomacy, and Buddhist practice. He was first and foremost a truly devout monk, who spent years in serious study and retreat as a young man, but he also understood that converting his people would require more than piety. It fell to Zanabazar literally to create a context for Mongolian Buddhism in Khalkha, and so he became a theologian and scholar, a linguist who invented a new Mongolian script, an architect, a sculptor, and a painter. Seeing no detail as too small or insignifi-

cant, he busied himself with all the minutiae of ritual; he asked the Panchen Lama's advice on music, introduced and solicited new prayers and ceremonies, and even designed costumes for his monks, down to the buttons on their hats.

None of the many notices that survive of Zanabazar's work clarify how he was formed as an artist, or where he learned his prodigious technique. The pieces that are generally accepted as his today are all masterworks, suggesting he was never anything but a mature master (or mastermind, for it is also impossible to say whether he actually fabricated anything himself). Yet written histories show that he was always visually acute, even as a young child, and that he was able through the course of his long life to reconceive Buddhism in a purely Mongolian form, creating a literal renaissance of Buddhist art and culture.

Zanabazar's biographies record events from several distinct planes of perception. Thus, his everyday activities are interspersed with his initiations and consecrations, his dreams and visions of deities, his diplomatic and political efforts, and his work to build the Mongolian church. Notices of his artistic projects are also frequent, escalating rapidly after his childhood play at temple building.[3] In 1647, at the age of twelve, legend has it that he designed Baruun Khüree, a monastery about twelve miles southeast of Erdeni Zuu. The main assembly hall had a distinctively Mongolian, single-roof structure, an indigenous style of architecture credited to him. Later, as an adult, he returned to Baruun Khüree and cast its main image, a Mahakala, since lost. From 1649 to 1651, Zanabazar traveled in Tibet, via Kumbum. While there, he collected texts and images (of Tara, Maitreya, and Avalokiteshvara) and visited Taranatha's recently refurbished monastery, Puntsagling. When he returned to Mongolia, he was accompanied at the Dalai Lama's order by a huge entourage of monks, many of whom were artisans (and some of whom were most likely Newari, given the Nepalese flavor of Zanabazar's own works in bronze). This crowd of skilled craftsmen probably provided Zanabazar with an education in the technology of architecture and bronze casting, for shortly after his return, as a first order of business, he cast a reliquary to hold Taranatha's remains (1652),[4] built a monastery to Vajradhara, began construction of his main monastery, Urga (Da Khüree), and in 1653 built a retreat complete with a sculpture forge near Erdeni Zuu, called Shibeetü-uula.

Only two years later, in 1655, Zanabazar was already producing cast and painted images of fine enough quality to send to the Manchu court in Beijing. That year he spent in retreat at Shibeetü-uula but suddenly left to make his mysterious journey to the Panchen Lama. In 1657 Zanabazar was back at his forge, making three large gilt statues for the Manchu Shunzhi emperor, along with a painting of the Full Perception; while at Erdeni Zuu, he staged the first Mongo-

lian celebration of the Maitreya Festival in a form he had borrowed from Tashilunpo. (He restaged the same ceremony there in 1681.) Tashilunpo would remain his model for ritual form over the next decades.

The 1660s, as the Kangxi emperor succeeded his father in China and unrest among the Mongol tribes was rife, mark a hiatus in records of Zanabazar's work, but by the 1670s he was apparently once again deeply engaged in religion and art. In 1671 he ordered a Kanjur from Tibet and copied it himself, and over the next few years he made many cast, painted, and carved Buddhist images (including mandalas) and undertook the study of medicine and astronomy.

The 1680s were Zanabazar's most prolific period as an artist. The history of Erdeni Zuu records that in 1683 he cast some of his most famous and enduring sculptures—his Vajradhara, now the main icon at Gandantegchinlin Monastery in Ulaanbaatar (see cat. no. 99, fig. 1), his Five Transcendent Buddhas, originally cast for his own monastery at Urga (see cat. no. 97), as well as eight silver *suburgan* (stupa-reliquaries). The same year, he carved a figure for a monastery in Amdo, gifted the Kangxi emperor with three temples, and gave sacred images, prayers, and other texts to an envoy of the Zunghar leader, Galdan. In 1686 he consecrated the images at Urga, but two years after the consecration the entire complex, including Zanabazar's own residence, was destroyed in the fighting with Galdan.

The troubles brought on by the Zunghar invasion led Zanabazar into his most dramatic political act, the transfer in 1691 of sovereignty over Khalkha into Manchu hands. That year found him in Beijing, where he carved the famed ruby into twenty-one images and cast a Vajradhara for the Kangxi emperor, his new friend and ally. Back in Urga later that year, he worked to improve the Khalkha capital, building new temples in a Mongolian style, making new images, and designing new rituals, music, and monastic costumes. In 1706 he was finally able to rebuild Urga, but, on the advice of the Fifth Dalai Lama, he moved it to a place called Čečeglig-ün erdeni tolughai (Jeweled Head of the Garden), and rededicated the entire monastery to Tara. Prayers were written to Tara upon its consecration, both by Zanabazar and by Zaya Pandita of the Khalkhas (1642–1715), and it was in the new Tara Temple that his great Green Tara and her twenty-one forms were originally placed (cat. nos. 103–106).

The second decade of the eighteenth century saw Zanabazar building several new monasteries, one of them, Zuu (eastern) Khüree, not just designed by him but also built by him (he was now seventy-six). But by 1723 he was back in Beijing to pay homage to the Kangxi emperor, who had just died. There he took sick and quickly died at the Yellow Monastery (Huang si). His body was embalmed, and an elaborate jeweled reliquary was made for it, in which it was carried back to Urga. In 1778 Zanabazar's reliquary was moved once again, this time to Amarbayasgalant Monastery, which had been built especially to house it at the expense of the Yongzheng emperor (r. 1723–35).

Zanabazar's long and prolific career exemplifies a cultural movement that swept over Mongolia, Tibet, and the Manchu court of China. The insoluble issue of which works are his and which works are not is almost irrelevant, because his symbolic persona grew so large in the centuries after his death that it encompassed the age. The naturalistic, Nepalese-derived style he practiced was both difficult and expensive; its truest heirs are to be found in sculptures the Manchu emperors had made for their own devotions in Beijing and Jehol. Ironically, the Chinese-made, repoussé metalwork of the Inner Mongolian city of Dolonnor (old Shangdu or Xanadu) was what came to fill Outer Mongolian monasteries in the centuries after the master's death.

1. Bawden, *The Jebtsundamba Khutukhtus of Urga*, p. 91, with some changes in punctuation. Bawden points out that the first three phrases of Mongolian form an acrostic with three words across and three lines down, which can be read horizontally, vertically, and diagonally. For another, more complex acrostic, see James Bosson's translation and explanation of "The Secret Biography of the Eighth Bogdo Gegen," cat. no. 18.

2. These tales can be found in Bawden, *The Jebtsundamba Khutukhtus of Urga*, in which Bawden translates a text that dates to 1859. Bawden says the manuscript for his translation was found in Köke qota and was probably known to Aleksei Pozdneyev when he wrote his *Mongolia and the Mongols* after his expedition of 1891. Pozdneyev based his retelling of Zanabazar's life mostly on the *Erdeni-yin erike kemegsen teüke* (Rosary of Jewel's History), also written in 1859 by the Taiji Galdan for the edification of the then Bogdo Gegen.

3. Both Bawden, *The Jebtsundamba Khutukhtus of Urga*, and Pozdneyev, *Mongolia and the Mongols*, pp. 324–38, are excellent sources for these tales. A less embellished version of Zanabazar's life has been partially translated by Hans-Rainer Kämpfe, "Sayin Qubitan-u Süsüg-ün Terge." Small bits of information about his career as an artist also crop up in Dharmatāla, *Rosary of White Lotuses*.

4. Taranatha died in Mongolia, but his remains were enshrined at a site about sixty-five miles east of Lhasa. Taranatha, *The Origin of the Tara Tantra*, p. 7.

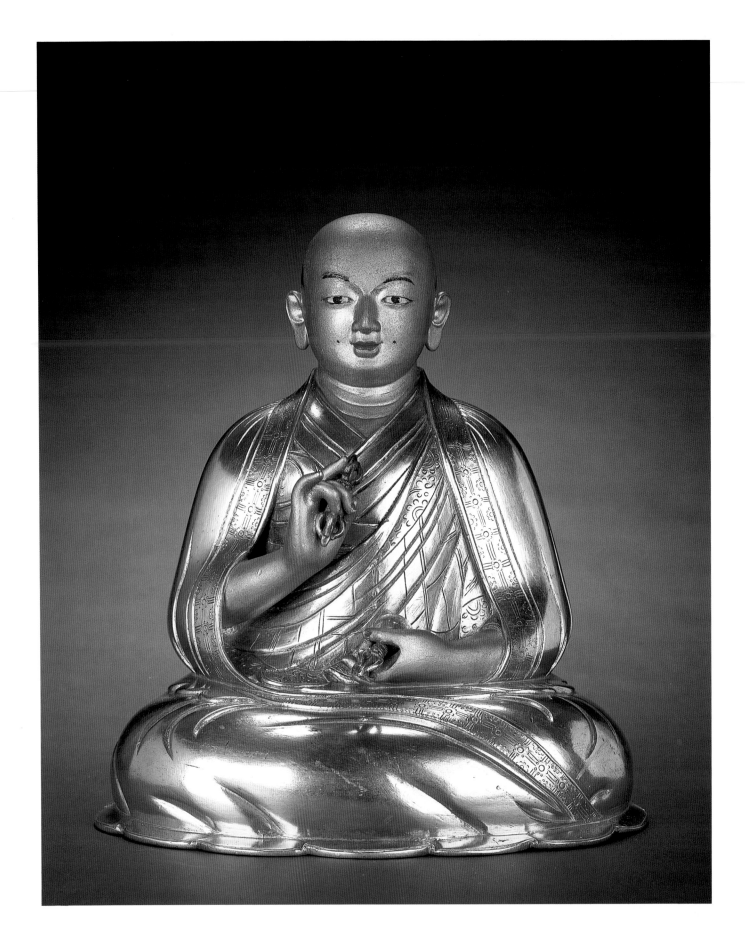

95. PORTRAIT OF ZANABAZAR

School of Zanabazar
Late 17th–early 18th century (or later)
Gilt bronze with silk cushions and cloak
Figure H: 26½ (67.3) W: 17 (43.2) D: 13½ (34.3)
Choijin-Lama Temple Museum

Some of the earliest images of Buddhist masters can be dated to eighth-century China, when portraits of Chan patriarchs were painted to memorialize the oral transfer of the Dharma from one master to the next. These portraits were set up in patriarch halls and used in rituals that resembled Confucian ceremonies to honor the dead. For the Chinese, such lineages also established the political legitimacy of certain masters over others, and their right to control the growing wealth of the Chan monastic community, much as an imperial dynasty derived its authority from inheritance.[1]

Tantric Buddhists also emphasize the importance of lineage, because they believe the only sure introduction to tantric methods is with the help of a guru, whose experience is needed to guide the initiate along a spiritually dangerous path. Thus consecrations are passed from guru to disciple, creating lines of revelation that are spun back into antiquity, to the time of Shakyamuni himself.[2] These lineages of spiritual descent were reinforced in Tibet when the concept of reincarnation was first introduced in the fourteenth century. Incarnate-lamas not only possessed the authority gained by studying with established adepts, but they also embodied the idea that the Buddha's doctrine was passed on even without instruction, transcending death.

Tibetan Buddhists also memorialized their masters in painted and sculpted form from a very early period. Some of the first images of this genre are from Kharakhoto, the Tangut, Tibetan-inspired site in modern Ningxia province (China) that was overrun by Chinggis Khan in 1227.[3] The genre of portraiture continued to occupy some of Tibet's artists in ways that the making of icons could not; the best Tibetan portraits are psychologically insightful, seemingly true to life, and convey a strong sense of the presence of the master.[4]

As the first and greatest incarnation of Outer Mongolia, Zanabazar was the subject of many portraits, in media rang-

ing from the humble woodblock print to sumptuous gilt bronze (see also cat. no. 16). This gilt bronze image of him is one of several major representations still surviving in Ulaanbaatar (others are in the Bogdo Khan Palace Museum, see Rossabi, "Mongolia: From Chinggis Khan to Independence," fig. 9, and at Gandantegchinlin), and a mold to make smaller scale, but similar sculptures of him (cat. no. 114) suggests that his image was widely proliferated.

Here the First Bogdo Gegen sits in his elegant monk's robes, with his legs folded beneath them. He holds the two attributes he inherited from his immediate preincarnation, Taranatha (fig. 1), raising the *dorje* up to his chest with his

Fig. 1. Portrait of Taranatha, from the *Astasahasrika Pantheon*, 20th century. From Chandra, *Buddhist Iconography*, no. 2096.

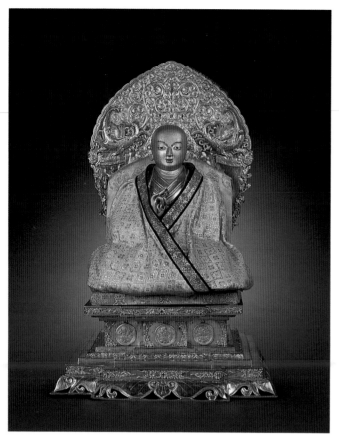

Zanabazar clothed.

Back of Zanabazar.

right hand, and pointing the *dorje*-handled bell in his left hand toward his stomach. His wonderful, round head fits the description attributed to the Kangxi emperor's mother when she first glimpsed him through a glass window and said, "This Blessed One of yours is a beautiful lama, like the full moon."[5]

Though intended to be seen only from the front and then only when clothed in a Tibetan-style *nab-sa* (mantle), Zanabazar's back is beautifully sculpted into a fan of regular, rounded folds. He presently sits ensconced on a square dais, backed by an aureole decorated with a pair of upswept crocodilian *makara*.

Zanabazar's flat cushion and backrest are like the stacks of pillows high lamas sit on while presiding over religious ceremonies, suggesting that this portrait of him was taken from life. (In fact, both this figure and other similar ones have been called self-portraits, probably mistakenly.) Aleksei Pozdneyev writes, however, that the first portrait of Zanabazar was not made until 1798, when the Fourth Bogdo Gegen visited Amarbayasgalant Monastery, which had been built by the Yongzheng emperor (r. 1723–35) specifically to house Zanabazar's remains. There the Fourth Bogdo Gegen had the *suburgan* (reliquary) housing his predecessor's embalmed body opened and ordered his best artists to paint a portrait of the corpse. This portrait served as the basis for a cast im-

age, which was funded by offerings from all four *aimag* of Khalkha.[6] Whether or not this posthumous portrait was indeed the first to be made of Zanabazar, or whether it bears any relation to the example seen here, remains a mystery.

—P.B.

Published: Béguin et al., *Trésors de Mongolie*, cat. no. 1

1. See Weidner et al., *Latter Days of the Law*, especially the section on patriarchs by Amy McNair, pp. 288–93.

2. Many of these lines of inheritance are preserved in the *parampara* (spiritual lineages) illustrated in the *Astasahasrika Pantheon*, reprinted in Chandra, *Buddhist Iconography*, especially nos. 1192ff.

3. See, e.g., Rhie and Thurman, *Wisdom and Compassion*, cat. no. 91.

4. Ibid., cat. nos. 88, 89, 98, and 100.

5. Bawden, *The Jebtsundamba Khutukhtus of Urga*, p. 52.

6. Pozdneyev, *Mongolia and the Mongols*, p. 355.

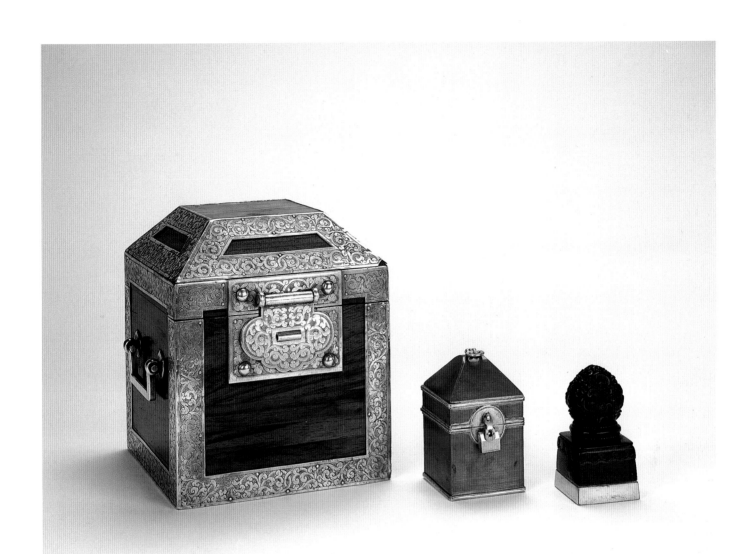

96. THE SEAL OF THE FIRST BOGDO GEGEN

17th century
Wood and silver
H: 8½ (21.5) W: 7 (17.7) D: 7 (17.7)
Bogdo Khan Palace Museum

A silver and bronze seal together with its sandalwood case, which in turn is put in a silver and hardwood case, constitute the official seal of the First Bogdo Gegen, but neither the imprint of the seal nor its interpretation and translation has ever before been published.

No date is indicated on the seal or in its text, but it cannot reasonably predate 1650, when the Bogdo Gegen lineage was recognized and established. This First Bogdo Gegen carried a religious name, *Jñānavajra* in Sanskrit, but pronounced *Dzanabadzar* (Zanabazar) in Mongolian. He was also known under his popular title, Öndür Gegen, meaning the "High Enlightened One." He had a noble Mongolian background, being the son of the Tüsheet Khan, a leading ruler in the

Khalkha confederation and a member of the Borjigid clan; he was thus a direct descendant of Chinggis Khan.

The text of the seal is written both in the vertical Phagspa script (see Bosson, "Scripts and Literacy," fig. 4) and in the Tibetan language. Although Phagspa Lama devised the script on the basis of the Tibetan *u-chen* script, this new script of his is cumbersome and ill-adapted for writing Tibetan. In fact, in Tibetan it is always referred to as *hor-yig,* "Mongolian script." Not surprisingly, there are no known extensive Tibetan documents written in the Phagspa script, but it has been widely used in ornamental inscriptions in temples and, particularly, in the inscriptions on official seals until the most recent times.

Fig. 1. View of base of the Great Seal.

The surface of the text, framed in double lines, reads from left to right in three perpendicular lines (fig. 1):

1. *rdo-rje 'dzin-pa*
2. *dznya'a na ba dzra*
3. *gyi tham ka rgyal*[1]

"Vajradhara Jñānavajra's seal Victory."

Here we are faced with some extremely interesting and important features!

The Dalai Lama possessed two silver seals that were used on official documents (figs. 2a–b). In official circles these seals were referred to as *gser-gyi-rgyal-po* (Serki Gyalto), "the Golden King," and, as it turns out, this was not merely a fanciful name for the seals but referred to the fact that the Third Dalai Lama (who was, after all, the first Dalai Lama to whom the title was given) was presented with these seals by Altan Khan of the Tümed, who also conferred on him the title Dalai Lama. In Mongolian *Altan Khan* means "Golden Khan," hence the name of the seals.

These seals also contain three vertical lines of Tibetan in *hor-yig*:

1. *rdo-rje-'chang*
2. *ta la'i bla ma*[2]
3. *yi tham ka rgyal*

"Vajradhara Dalai Lama's seal Victory."[3]

The wording and arrangement in these seals are almost identical. In addition, the first title in both cases translates as *Vajradhara* in Sanskrit, whereas, in fact, *rdo-rje-'chang* (Dorje Chang) and *rdo-rje 'dzin-pa* (Dorje Dzinba) refer to two different religious antecedents. Both the Dalai Lama and the Bogdo Gegen were frequently called *Vajradhara*.

The Bogdo Gegen's seal obviously could not have been presented by Altan Khan, who died in 1583, yet there can be no doubt that it was deliberately modeled on the Dalai Lama's seal. A likely date and place of the conferment of the seal is 1691, when the Bogdo Gegen met with the Kangxi

Figs. 2a–b. Impressions (left) and reconstructions (right) of the Third Dalai Lama's two "Golden King" seals (*gser-gyi-rgyal-po;* Serki Gyalto). From Schuh, *Grundlagen tibetischer Siegelkunde,* p. 6.

emperor at Dolonnor, when the Khalkhas submitted to the Qing empire. To my knowledge, no document recording the conferment of the seal has yet been found.

One cannot but assume that the similarity of the seals was intentional. And there are historical and political reasons for such an assumption. On the political level, the initiation of the Bogdo Gegen lineage was, with little doubt, intended to appease and calm the Mongols. Upon finding that the Dalai Lamaship was reverting to Tibet after the Third Dalai Lama's reincarnation had been recognized in the person of a Mongolian nobleman, the Mongolian leaders became embittered. The establishment of the Bogdo Gegen lineage was—apart from the spiritual plane—a political move to supply the Mongols with a high religious authority that would remain in Northern Mongolia. Thus we have here an important artifact of Mongolian history, an artifact that was previously almost unknown.

Although the seal carries the personal name of Jñāna-vajra (Zanabazar), which was not inherited by his subsequent reincarnations, it seems likely that the same seal was used also by the following Bogdo Gegens. With the exception of the one mentioned here, no other seal is known to have been used by the Bogdo Gegens. The only other seal known in this context is the seal of the Eighth Bogdo Gegen, which he received when he was enthroned as the temporal khan of Mongolia in 1911 under the reign title *Olan-a ergüg-degsen,* "Raised by the Populace—the Many" (fig. 3).

Two versions of the seal exist, one in jade and one in silver. Both bear the same legend in three scripts: the Soyombo script (see Bosson, "Scripts and Literacy," fig. 7b), the traditional vertical Mongolian script, and the Phagspa script. The text in the Mongolian script reads: "Seal of the Sunlit Bogdo Khan, who holds double sway over Religion and State."[4] The Soyombo text presents the same in a Sanskrit translation, and the Phagspa version presents it in Tibetan.

It is also of interest that the Bogdo Khan's consort, now his queen, had an official seal reading: "Seal of the Mother Dakini of the Nation, who causes Religion and State to flourish in conjunction" (fig. 4).[5] —J.B.

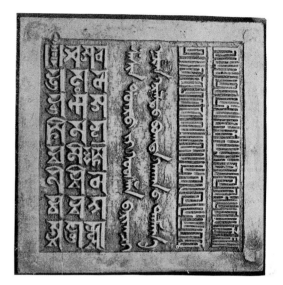

Fig. 3. Seal of the Eighth Bogdo Gegen. From Rintchen, "A propos de la sigillographie mongole," p. 30.

Fig. 4. The queen's seal. From Rintchen, "A propos de la sigillographie mongole," p. 31.

1. The genetive suffix *-gyi* is here incorrectly used with the preceding final vowel. However, if the Mongolian pronunciation is used *(vide supra)* resulting in a final *-r*, it becomes correct.

2. In the seal, the second line ends with a pseudographeme, used merely to fill out the line. The second *gser-gyi-rgyal-po* seal has some slight differences, but they are of no importance in the present context.

3. These two seals are studied and reproduced in the outstanding work of the German scholar Dieter Schuh, *Grundlagen tibetischer Siegelkunde,* pp. 5–7.

4. Here is another parallel with the position of the Dalai Lama.

5. Rintchen, "A propos de la sigillographie mongole," pp. 25–32.

97. AMITABHA (M: ČAGHLASI ÜGEI GERELTÜ), ONE OF FIVE TRANSCENDENT BUDDHAS

Zanabazar (1635–1723)
Ca. 1683
Gilt bronze
H: 28⅛ (71.4) Diam.: 17½ (44.5)
Museum of Fine Arts

The *History of Erdeni Zuu* says that in the black pig year (1683), the activities at the monastery included the casting (by Zanabazar) of a Vajradhara, eight silver stupas, and a group of Transcendent Buddhas.¹ As the Mongolian art historian N. Tsultem has said, the 1680s found Zanabazar in his mid-forties and at the height of his artistic powers; his Five Transcendent Buddhas and his Vajradhara, which has also survived, are among his finest works.

Four of Zanabazar's Five Transcendent Buddhas are now housed in the Museum of Fine Arts in Ulaanbaatar; the fifth, Amoghasiddhi, remains in the Hall of Eternal Tranquility of the Choijin-Lama Temple Museum, where the entire group was kept earlier in this century (fig. 1). Zanabazar conceived the five as a unified set. Among them, only Vairochana, the Buddha of the Center, stands out because of his slightly more elaborate, but closely related, jewelry and lotus pedestal (fig. 2). The other four—Akshobhya, Ratnasambhava, Amitabha, and Amoghasiddhi—are all remarkably similar, except for their hand gestures and the subtlest differences in facial expression and pedestal design.

Zanabazar's Amitabha, the Buddha of the West shown here, is a heavily cast bronze, cold gilt so that his skin is more matte than his jewels, a treatment typical of most of Zanabazar's figural sculpture. He is remarkably beautiful, his face simultaneously soft and strong, his lips bee-stung, his curved eyebrows meeting above the sharp ridge of his nose, with elegantly curved eyes downcast in meditation. His body is proportioned according to the demanding standards of Tibetan iconometry, without sacrificing a sense of naturalness and life. He sits on a full-blown lotus pedestal, holding his hands in his lap in the meditation gesture *(dhyana mudra),* and his diaphanous *dhoti* only makes itself apparent in the subtle patterning on his calves and the perfect fan of pleats on the pedestal between his folded legs. Half of his long blue hair is caught up in a chignon and half is left free, in flattened curls, on his shoulder. Although he is a consecrated Buddha, Amitabha wears the thirteen ornaments of a princely bodhisattva—the five-pointed crown, heavy earrings, multiple necklaces, arm bands, bracelets, Brahmanic thread, belt, and anklets. Zanabazar's taste for the Nepalese style of the twelfth century (first purveyed among the Mon-

gols by Anige, the Nepalese artist who came to Khubilai Khan's court, and later popularized by Newari artists working in Tibet in the seventeenth century) is nowhere more apparent than in this kind of delicate detailing.

Amitabha, whose name means "Boundless Light," is one of Buddhism's oldest deities. He was worshiped for his own sake long before the systematic classifications of the tantric Vajrayana placed him at the head of one of the Buddha families in his role as a Transcendent Buddha. Many writers have speculated that Amitabha appeared as a response to Western ideas current in the Kushan state (located in northwestern India and modern Pakistan) during the first centuries of our era, where the Zoroastrian Ahura Mazda, supreme god of light, was well known. Kushan images of the Buddha with his shoulders aflame, an attribute copied in some of the earliest Chinese Buddha-images of the late fourth and fifth centuries,² may represent Amitabha and not the historic Buddha, Shakyamuni. This Westernized Buddha became the Buddha of the Western Paradise, a luxurious, jewel-like heaven called Sukhavati. Sukhavati was already described in the *Sukhavati-vyuha,* translated into Chinese as early as the third century. A devotional cult focusing on the hope for rebirth in Amitabha's Pure Land continues to be a dominant strain in East Asian Buddhism.

One of the earliest tantras, the *Manjushrimula-kalpa,* already sketches out a system of organizing Buddhist figures into three families—Buddha, Lotus, and *Vajra.*³ Amitabha is the head of the Lotus Family, a position he kept even after the system was expanded into five not always consistent groups, each one headed by a Transcendent Buddha or Tathagata ("so-come" or "one who has entered into suchness"). This transformation, though gradual, is already apparent in the *Guhyasamaja Tantra,* parts of which were written as early as the fifth century, parts as late as the seventh or eighth.

The five Buddhas it describes, sometimes called *dhyani,* or meditation Buddhas, by Western writers, are the mystical counterparts of human Buddhas; each one embodies one of the five *skandha,* or cosmic elements, and each one has attributes that symbolize this equivalence. In the full-blown system current in Zanabazar's day, the first Buddha is Vairochana (Resplendent), who represents the Center. He is

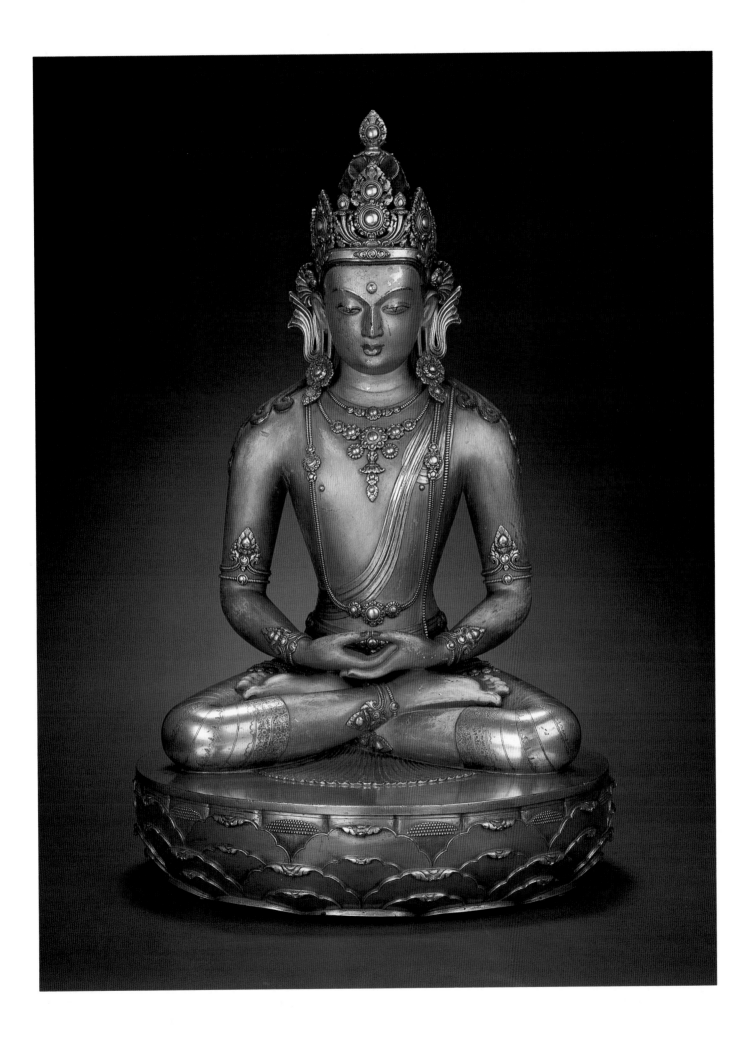

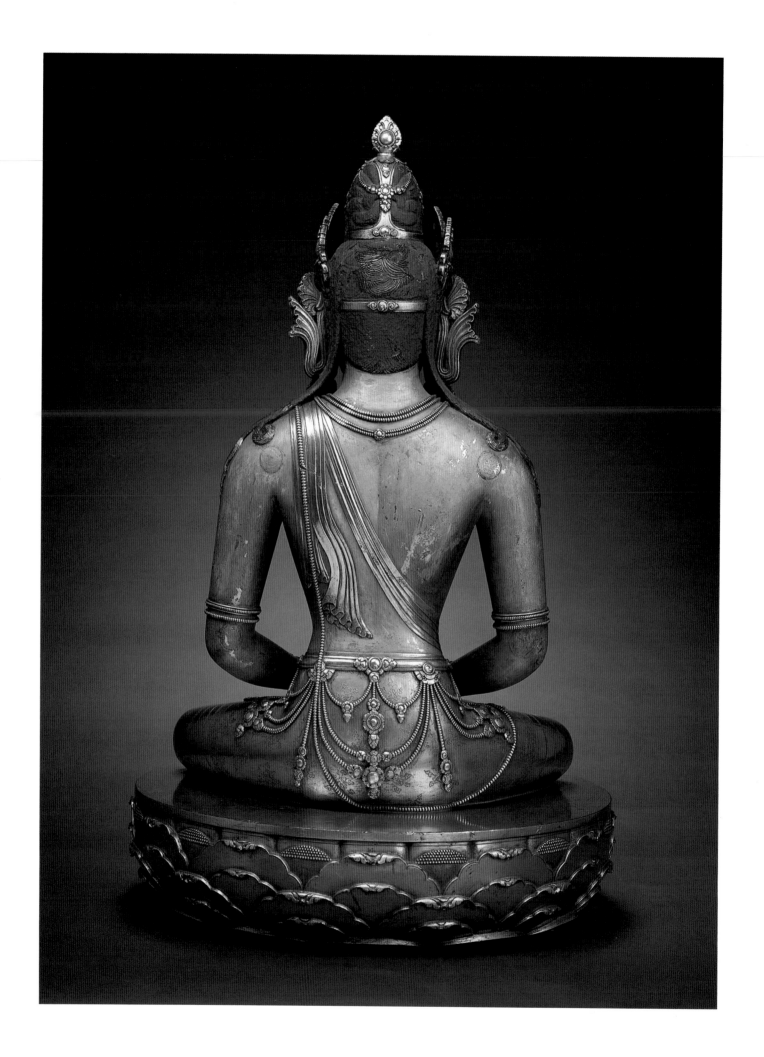

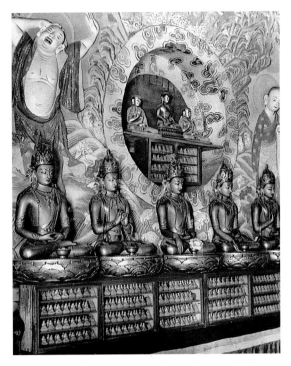

Fig. 1. The Five Transcendent Buddhas in situ in the Hall of Eternal Tranquility, Choijin-Lama Temple Museum, Ulaanbaatar. From Jisl, *Mongolian Journey*, pl. 72.

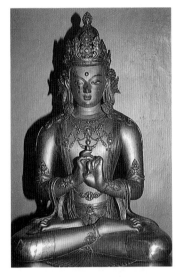

Fig. 2. Vairochana, from Zanabazar's set of the Five Transcendent Buddhas. Gilt bronze. Museum of Fine Arts, Ulaanbaatar. From Tsultem, *The Eminent Mongolian Sculptor—G. Zanabazar*, pl. 16.

white, symbolizing transcendental wisdom, and makes the gesture of turning the Wheel of the Law *(dharmachakra mudra)*. The second is Akshobhya (Immovable), the Buddha of the East. He is blue, symbolizing his ability to destroy the enemies of enlightenment, and makes the earth-touching gesture *(bhumisparsha mudra)*, calling the earth to witness in a way that recalls Shakyamuni's enlightenment. The third, Ratnasambhava (Jewel-Born), who represents the South, is yellow, which symbolizes bliss, and his hand is outstretched in charity *(varada mudra)*. The fourth is Amitabha, Buddha

of the West, red (for meditation), and shown with his hands folded in contemplation *(dhyana mudra)*. Amoghasiddhi (Infallible Power) is the fifth. He is the Buddha of the North, green (for active divine energy), and his hand is raised in the "fear not" gesture *(abhaya mudra)*. Each of these Buddhas also has a bodhisattva-associate. Amitabha's is Avalokiteshvara, who holds the lotus of his spiritual father's family and whose compassion is universal.[4]

Amitabha's prominent role among East Asian Pure Land Buddhists was not duplicated in Tibet and Mongolia, but he did hold a special meaning for them nonetheless, because he manifested himself in a number of significant figures in Tibetan Buddhist history. The first of these was Padmasambhava (Lotus-Born), the late-eighth-century sage who helped convert Tibet to Buddhism and who battled Tibet's indigenous spirits, converting them as well. Padmasambhava is often called the Second Buddha; he was born from a lotus that had been struck by a meteor emanating from Amitabha's tongue and is usually depicted holding the vase of immortality, to signify that he is infinite light (Amitabha) and life (Amitayus, Amitabha's inseparable life-giving nature).

Later Tibetan Buddhists found Amitabha equally attractive. The Great Fifth Dalai Lama (1617–1682), who studied the tantra with Losang Chökyi Gyaltsen (1569–1662), had a dream in which his teacher had merged with Amitabha. After having this vision, the Dalai Lama enthroned his beloved guru at Tashilunpo, naming him the First Panchen Lama. (It was this Panchen Lama who gave Zanabazar some of his first consecrations in 1649, and whom the young Bogdo Gegen visited again in 1655.) Since the seventeenth century, the Panchen Lamas have remained at Tashilunpo and have been considered emanations of Amitabha, symbolizing their spiritual nurturing of the Dalai Lamas, who are manifestations of Avalokiteshvara and, like him, the active advocates of Amitabha's compassion. —P.B.

Published: Tsultem, *The Eminent Mongolian Sculptor—G. Zanabazar*, pls. 26–30

1. Tsultem, *The Eminent Mongolian Sculptor—G. Zanabazar*, p. 7.

2. Even the earliest Chinese images, which are contemporary with similar Kushan pieces, have this trait. A stone engraving of the Buddha with what appear to be wings, but are probably flames, appears in an Eastern Han tomb at Yinan, in Shandong province. It can be dated to the last few decades of the second century. See Zeng Zhaoyu et al., *Yinan gu huaxiang shimu fajue baogao*, pl. 67.

3. See Snellgrove, *Indo-Tibetan Buddhism*, pp. 189–98.

4. See, e.g., Getty, *The Gods of Northern Buddhism*, pp. 28–48.

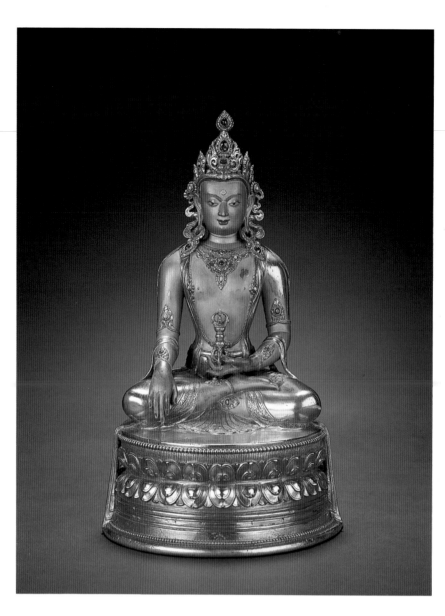

98. AKSHOBHYA (M: ÜLÜ KÖDELÜGČI, MINTUGWA)

Zanabazar (or his school)
Late 17th–early 18th century
Gilt bronze inlaid with jewels
H: 13⅞ (35.2) Diam.: 8 (20.3)
Choijin-Lama Temple Museum

Akshobhya, Imperturbable, is the second of the Five Transcendent Buddhas and the blue representative of the East. Like Amitabha, Buddha of the Western Paradise, Akshobhya reigns over a Pure Land, Abhirati, which is located in the eastern regions. He and Amitabha are the only two of the five who had an independent existence in early texts; as early as the first century B.C., Akshobhya appears in a vision of Shakyamuni described in the *Astasahasrika Prajnaparamita*.

According to David Snellgrove, Akshobhya's eastern paradise, Abhirati, may have been constructed from the Westernized vantage point of Gandhara, whose mixed culture had already given rise to the western Buddha, Amita-

bha. The center of Akshobhya's cult was to the east in Bodhgaya, the place where Shakyamuni was enlightened, and this connection is symbolized in the gesture of his right hand, the *bhumisparsha mudra* borrowed from Shakyamuni at the moment of his enlightenment, when he reaches down to call the earth to witness his triumph over the wrathful demon Mara. Akshobhya's tantras also first appeared around Bodhgaya; he is described in early texts that begin to organize the growing pantheon of Buddhist deities as the head of the *Vajra* family. Wrath is the evil his family is devoted to transforming into supreme wisdom, just as Shakyamuni subdued the wrath of Mara. His most well known fierce form is Achala,

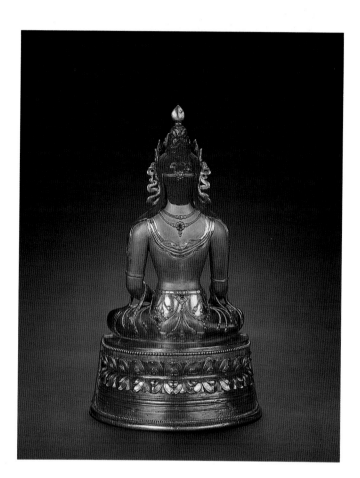

whose name like his means "Imperturbable." (The identification is complete in Mongolian, and Chinese, where their names are identical.)[1]

Akshobhya is subservient to Vairochana in the *yoga* tantras but comes into his own in the supreme *yoga* tantras, which focus on him. Thus in Tibet, he arrives at the center, while Vairochana is moved eastward. These tantras, with their horrific range of deities, were never fully accepted in most of Central Asia or China, but in central Tibet and Mongolia they represented the apogee of tantric study. There Akshobhya's horrific forms were emphasized, and when he takes over the center of a mandala, it is in the terrible guise of Hevajra, Guhyasamaja, or Chakrasamvara, all of whom emanate from him.[2]

This small and delicately wrought Akshobhya, by Zanabazar or his immediate school, shows the deity in his peaceful form, calling the earth to witness with his right hand and holding a *dorje* in his left. As in most of the figures attributed to Zanabazar's hand, the use of matte and glossy gilt subtly heightens the distinction between flesh, fabric, and jewelry. In comparison to Zanabazar's large Akshobhya, part of his set of the Five Transcendent Buddhas, this piece is like the work of a jeweler, detailed at the finest possible scale, and was probably intended for private devotion.

This figure incorporates a number of characteristics that give a hint of when it might have been cast. Akshobhya's double-lotus pedestal, for example, is almost identical to the type chosen to hold the Medicine Buddhas (cat. no. 107), almost certainly works of Zanabazar's school rather than of his own hand. The use of inlaid precious and semiprecious stones also suggests a slightly later date, for this opulent style reached its height of popularity in the eighteenth century, during the reign of the Qing Qianlong emperor (1736–95). Even more significant is the similarity this figure bears to the Akshobhya included in the illustrated version of the Mongolian Kanjur, which was printed at the command of the Qing Kangxi emperor between 1717 and 1720 (fig. 1). The Mongolian Kanjur, based in part on the translations done under Ligdan Khan from 1628 to 1629, was put together by lamas from all the Banners of Mongolia, who were called to work on the project in Dolonnor, the Inner Mongolian seat of the Beijing Jangjya Khutuktu. The wide distribution of this Kanjur makes it likely that it was known to Zanabazar in the last years of his life, and certainly to the school of lama-sculptors who followed him in the eighteenth century.

—P.B.

Fig. 1. Akshobhya, from the Mongolian Kanjur, 1717–20. From Chandra, *Buddhist Iconography*, no. 110.

Published: Tsultem, *The Eminent Mongolian Sculptor—G. Zanabazar,* pls. 79–81; Béguin et al., *Trésors de Mongolie,* cat. no. 5

1. Snellgrove, *Indo-Tibetan Buddhism,* pp. 56, 156.
2. Ibid., p. 204.

99. VAJRASATTVA (M: OČIR-SEDKILTÜ, DORJ-SEMBE)

Zanabazar (1635–1723)
Late 17th–early 18th century
Gilt bronze with colors
H: 62⅜ (158.5) W: 39¾ (101.0) D: 21 (53.2)
Choijin-Lama Temple Museum

Zanabazar's relationship to the supreme being who some-times appears as Vajrasattva, Vajrapani, or Vajradhara, was long-standing and deep. His great-grandfather Abadai Khan, who brought Buddhism back to Khalkha and built Erdeni Zuu, was believed to be Vajrapani-incarnate, and, after his own early consecrations in Mongolia, Zanabazar traveled at the age of fourteen to Tibet, where he received the empow-erment of Vajrapani (or, in other versions of the same story, Vajradhara) from the Fifth Dalai Lama. Back in Mongolia, in 1683 he built a temple to Vajradhara¹ and at the same time cast the large image of Vajradhara, now kept at Gandanteg-chinlin Monastery, Ulaanbaatar (fig. 1).

On a later visit to Beijing in the 1690s, Zanabazar gave the Kangxi emperor (r. 1662–1722) the consecration of Sang-dui (a multiarmed form of Vajradhara), whereupon he him-self appeared before the emperor as Vajradhara. All of this led to friendship and goodwill between the two, so Zanaba-zar cast another "great statue of Vajradhara and installed Sangdui before it."² Later, Zanabazar, busying himself with the details of monkish dress, designed a winter hat that sym-bolized Vajradhara's many forms, "as a sign of finally com-ing to [his] blessedness."³ Zanabazar's continued devotion to Vajradhara and Vajrasattva is recalled in the complex, picto-rial record of his meditations from the Bogdo Khan Palace Museum (cat. no. 18), where he is shown holding an image of blue Vajradhara and meditating on the deity's transcen-dent body (scene 5); and again (scene 21), where he or one of his later incarnations is protected by white Vajrasattva and his consort. These repeated memories of Zanabazar's iden-tification with this multiform deity are also expressed in the attributes he carries in some of his portraits, the dorje (S: vajra) and bell, the attributes of Vajrasattva.

Zanabazar's Vajrasattva and Vajradhara, while probably cast at different points in the artist's career, nonetheless are strikingly similar, many of their differences attributable to a slight movement of the arms. Vajrasattva is one of Zana-bazar's largest extant works, only a centimeter shorter than his Green Tara (see Berger, "After Xanadu," fig. 5). His orna-ments are even more elaborate than the jewels worn by the artist's Five Transcendent Buddhas (cat. no. 97), his neck-laces much more richly hung with tiers and pendants to cre-ate a veil of jewels over his chest. His five-pointed crown bears the sound-syllables of each of the Five Transcendent Buddhas, suggesting his original role may have been to pre-side over a group of them. (A similar detail is described in the *Nishpannayogavali,* where Vajrasattva wears images of the five in his crown, but it is Zanabazar's Vajradhara who has Buddha images in his crown.)

Vajrasattva holds his definitive *vajra* in his right hand, which is raised up to his chest, and the bell in his left hand, held just above his thigh. These two attributes represent a duality that the deity resolves within himself. The *vajra* or thunderbolt, the Tibetan *dorje* (Lord of Stones), represents the active, male principle, which is the compassionate means to enlightenment. The bell is the Perfection of Wisdom sym-bolized in the void *(shunyata)* of its empty yet productive form. The shapes of the *vajra* and bell also found analogies in the male and female sexual organs, the union of which creates the supreme bliss Vajrasattva himself embodies.

Zanabazar's Vajrasattva is currently kept at the Choijin-Lama Temple, where he sits on an enameled and gilt base, backed by an elaborate aureole, surrounded by a mass of unrelated figures. Gilles Béguin suggests that Vajrasattva's present base, which is identical to the base used for Zana-bazar's large figure of Amitayus (fig. 2), is probably not origi-nal to it. (He dates it to the eighteenth century, noting its

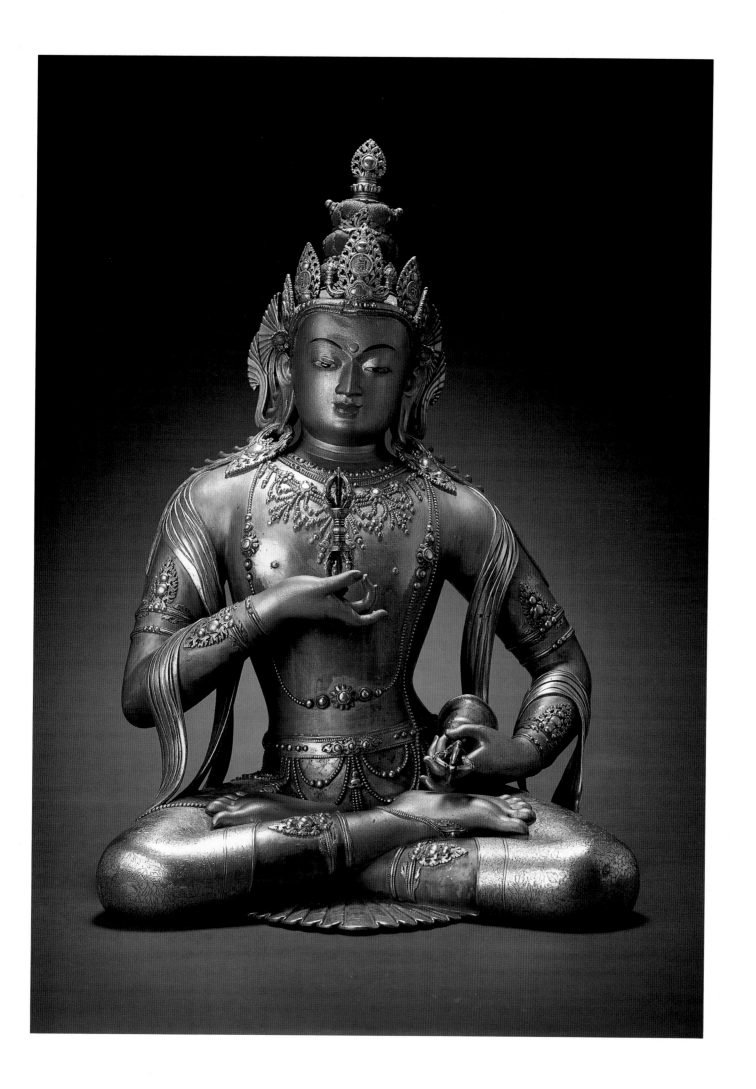

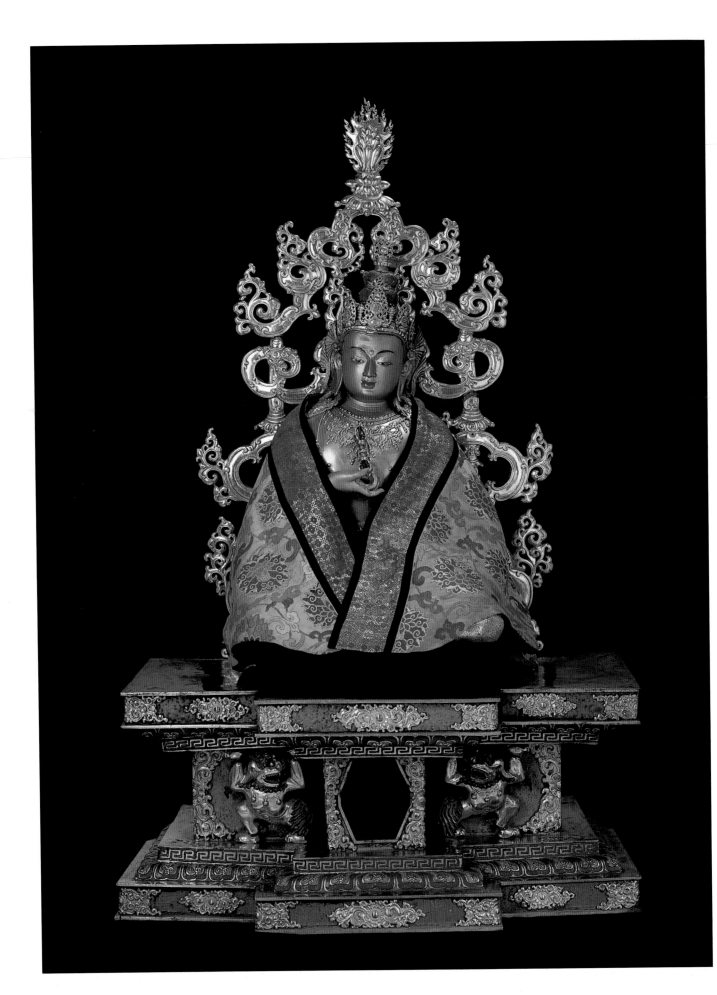

similarity to Tibeto-Chinese work of the period, and cites also a photograph by L. Jisl, taken in 1960, that shows the Vajrasattva without it.)[4]

The aureole, however, is much more likely to be contemporary with the piece itself, because its creative interpolation of Nepalese and Chinese elements of design is so characteristic of Zanabazar's own sensibility. The upright posts of the *torana*, a classic feature of Nepalese aureoles, are almost obscured by the Chinese dragons that twist around it and touch to form an arch above Vajrasattva's head. Another aureole, probably made around the same time in Mongolia though purely Nepalese in feeling, is part of a melange of image, base, and backdrop that was later assembled to make a setting for a single Buddha much like other Buddhas attributed to Zanabazar's school (cat. no. 107; see also Bartholomew, "An Introduction to the Art of Mongolia," fig. 7). This aureole is much more sculptural than Vajrasattva's, creating a literal canopy over the figure seated beneath it. The seemingly casual reuse of parts recombined into innovative montages is typical of the way sacred images are rearranged even today in Mongolia.

For all of its grandeur, Zanabazar's Vajrasattva appears to represent a different stage in the artist's career than the heights of creativity he reached in the mid-1680s, when he probably cast his Five Transcendent Buddhas. The Gandantegchinlin Monastery Vajradhara, with his slimmer jaw and proportionately smaller head, resembles the artist's five Buddhas, which date to this productive period, even more than he does Vajrasattva. Vajradhara's single lotus pedestal is also similar to those of the Five Transcendent Buddhas, falling halfway between Vairochana's, which is more elaborate, and the other four. In the end, the differences between Zanabazar's Vajrasattva and his Vajradhara are much more ineffable, however, with Vajradhara belonging to the part of Zanabazar's life when his work effortlessly expressed Buddhism's mysteries.　　　　　　　　　　　　　—P.B.

Published: Tsultem, *The Eminent Mongolian Sculptor—G. Zanabazar*, pls. 38–39; Béguin et al., *Trésors de Mongolie*, cat. no. 4

1. Pozdneyev, *Mongolia and the Mongols*, p. 331.

2. Bawden, *The Jebtsundamba Khutukhtus of Urga*, p. 57.

3. Ibid., p. 62.

4. Béguin et al., *Trésors de Mongolie*, p. 116. The Choijin-Lama Temple itself was not built until 1903–6, however, so Jisl's 1960 photograph does not tell us how Zanabazar intended his Vajrasattva to be seen.

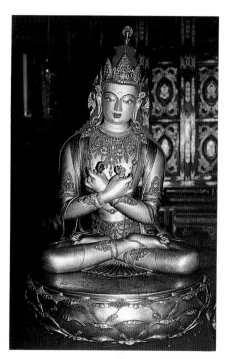

Fig. 1. Zanabazar, Vajradhara. Gilt bronze. Gandantegchinlin Monastery, Ulaanbaatar. From Tsultem, *The Eminent Mongolian Sculptor— G. Zanabazar*, pl. 7.

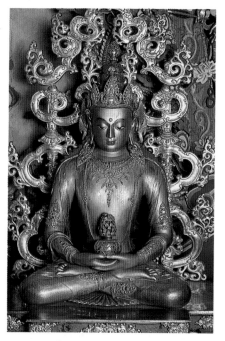

Fig. 2. Zanabazar, Amitayus. Gilt bronze. Choijin-Lama Temple Museum, Ulaanbaatar. From Tsultem, *Mongolian Sculpture*, fig. 84.

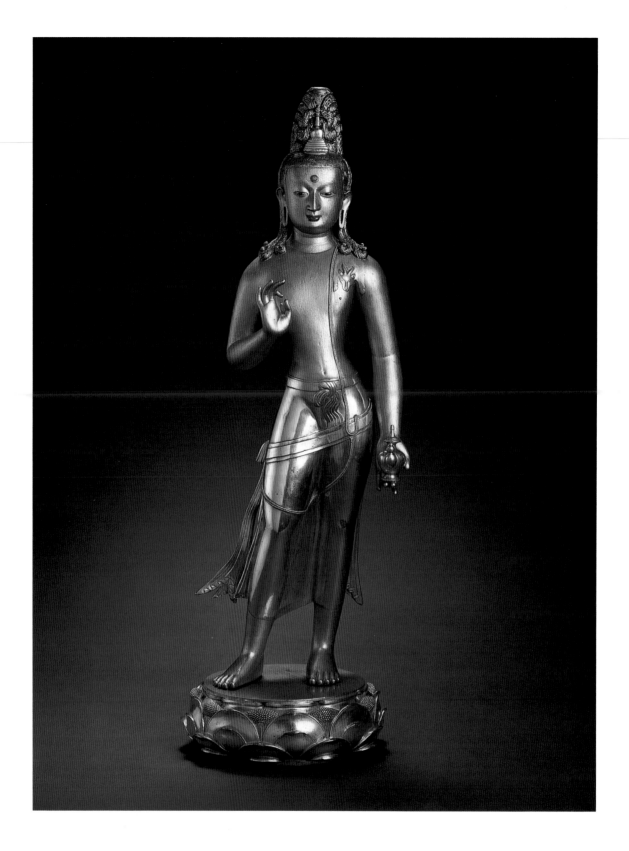

100. STANDING MAITREYA (M: ASARALTU, MAIDAR, MAIDARI)

Zanabazar (1635–1723)
Late 17th–early 18th century
Gilt bronze with traces of colors
H: 28¾ (73.0) W: 9¾ (24.8) D: 9¼ (23.5)
Choijin-Lama Temple Museum

Maitreya, the Buddha of the Future, is the harbinger of a new age, who awaits his final rebirth as Buddha in his Tushita Heaven of Joy. His role was especially celebrated in the pantheon and rituals of the reformed Gelug order as the next Buddha as well as the source of a significant group of tantras. Tsongkhapa named his first monastery Ganden, after Maitreya's heaven, and he and his followers "went to Ganden"

when they died. Maitreya fulfilled many needs, both spiritual and political. He was the anointed heir apparent to Shakyamuni and the model for kings and emperors who saw themselves as enlightened Chakravartin world-rulers. Tibetan and Mongolian monasteries usually housed Maitreya images, which were used in the annual Maitreya Festival instituted by Tsongkhapa in 1409 and promulgated in Mongolia by Zanabazar after his miraculous, fateful visit with the Panchen Lama in 1655.

Held at the New Year in Da Khüree (Urga), the Maitreya Festival had great appeal to Buddhists in Tibet and Mongolia yearning for stability after years of political uncertainty. Zanabazar must have understood the complex ramifications of his devotion to Maitreya; he is known to have focused on him in his own prayers and practice. He also cast images of the Future Buddha, several of which survive.

At least two representations of Maitreya attributed to Zanabazar's hand follow a classic, Nepalese-inspired model, best seen in a Tibetan Maitreya from Narthang, dated to 1190 (fig. 1). One is now kept at Gandantegchinlin Monastery in Ulaanbaatar (fig. 2) and the second and larger of the two, seen here, was the very Maitreya used in the annual festival held at Da Khüree, Zanabazar's monastic encampment. Yet another, strikingly similar image, which bears all the earmarks of Zanabazar's own work, has a double-lobed aureole and a square pedestal (see Bartholomew, "An Introduction to the Art of Mongolia," fig. 4).

In all these works, the Future Buddha is shown as a young bodhisattva. His hair, once washed blue, is piled high in a Brahmanic style that repeats the form of the stupa-reliquary resting above his brow. He holds in his left hand a *kundika* bottle filled with the elixir of immortality and raises his right hand in the *vitarka mudra,* the gesture of argumentation. His nearly evanescent *dhoti* is ringed by two sashes and crossed with a Brahmanic thread. A flayed antelope skin covers his left shoulder. The lotus pedestal that supports his smooth, flat, nearly ankleless feet is radically simplified into a form Zanabazar often used, with two rows of upturned petals interspersed with round-tipped stamens. —P.B.

Published: Tsultem, *Mongolian Sculpture,* fig. 78; Béguin et al., *Trésors de Mongolie,* cat. no. 6

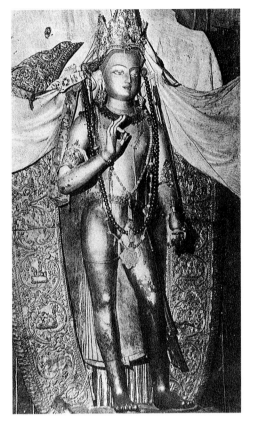

Fig. 1. Maitreya from Narthang Monastery, central Tibet, 1190. From Liu I-se, ed., *Xizang fojiao yishu* (Beijing: Wenwu Press, 1957), fig. 65.

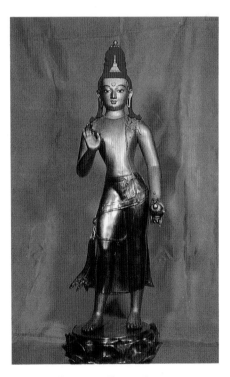

Fig. 2. Zanabazar's smaller Standing Maitreya. Gilt bronze. Gandantegchinlin Monastery, Ulaanbaatar. From Tsultem, *The Eminent Mongolian Sculptor—G. Zanabazar,* fig. 44.

101. SITASAMVARA WITH HIS CONSORT (WHITE SAMVARA, M: ČAGHAN DEMČIG)

Zanabazar (1635–1723)
Late 17th century
Gilt bronze with colors
H: 21½ (54.5) Diam.: 13¼ (33.8)
Choijin-Lama Temple Museum

Samvara, whose name in Sanskrit means "obligation" or "vow," is one of the great tutelary or patron deities *(yidam)* of Tibeto-Mongolian Buddhism. He is usually depicted in his fierce *(heruka)* form, with twelve arms and four heads, together with his equally angry consort, Vajravarahi (Diamond Sow).[1] In this combination, Samvara is called Paramasukha Chakrasamvara—Supreme Bliss Samvara, joined to the Wheel of the Law. *Yidam* deities like Samvara have no physical form but are composed in the visions of tantric adepts of an amalgam of symbolic elements. Thus the union of Samvara with Vajravarahi is a metaphor for the desired result of tantric meditation, the bliss-inducing fusion of the two components of liberation—male means (active compassion) and female wisdom.

In tantric practice, the devotee takes his patron deity as a model of the Buddha he hopes to become. Samvara had this role for followers of several of Tibet's Buddhist orders, the Sakya, the Kagyu, and the Gelug, and descriptions of him appear especially in literature devoted to developing the clear-light, a way of perceiving the ground of being beyond words and ordinary experience. But in Samvara's most well known *sadhana* and texts, such as the eleventh-century *Nishpannayogavali*, which describes his mandala, he appears in a form very different from the benevolent version of the deity Zanabazar chooses here,[2] as a wild Hindu Shaivite yogin with matted hair, a crescent moon in his hair, wearing the elephant skin of ignorance and a garland of skulls, and carrying a trident. One form of Samvara's name, Shamba, like Shiva's, means "fortunate or blessed," translated into Tibetan and Chinese as Supreme Bliss.[3]

Sitasamvara, the White Samvara Zanabazar represents, may be a later, Tibetan creation, for he is included in many of the iconographic works of the eighteenth and nineteenth centuries, if not in earlier texts. Both of the most comprehensive pantheons of eighteenth-century Beijing, the Jangjya Khutuktu's *Three Hundred Icons* and the *Zhufo pusa shengxiang zan*,[4] as well as the Baoxiang Lou bronze pantheon made for the Qianlong emperor's mother (fig. 1), include versions of White Samvara. He and his consort appear in these works in the same form Zanabazar gives them, if not with Zanabazar's sensitivity and insight.

Zanabazar's Sitasamvara is beyond comparison. The god sits on the single lotus pedestal the artist used for most of his large-scale works (here it has only a single tier of petals), with his legs locked in the *vajra* position. Samvara's tiny consort rests in his lap, embraced by the god's arms, which are crossed in the diamond *hum*-sound gesture, right arm over left, a pose she gracefully mimics behind his neck. He holds two ambrosial jars, and she holds a single skull cup *(kapala)* in her right hand and may have originally held another (or perhaps a chopper) in her left. Behind his back, meeting in perfect symmetry, her toes touch and curl in playful ecstasy and precisely frame the center of the *chakra* (Wheel of the Law) at his waist.

Both deities are beautifully crowned, coiffed, and bejeweled, and their surfaces are intricately detailed with patterns both cast in and etched. This sense of complex design is carried over into their tightly entwined, self-contained, and completely unified form, which, ironically, represents a miracle of multipart casting. (Samvara's lotus and his folded legs were cast separately, and his torso and consort either together or separately. All of their attributes were also cast separately.) Without for a second sacrificing his characteristic precision, Zanabazar also pays homage to the nature of flesh as he shows the breasts of Samvara's consort flattened against the god's chest. Likewise, his treatment of the deity's

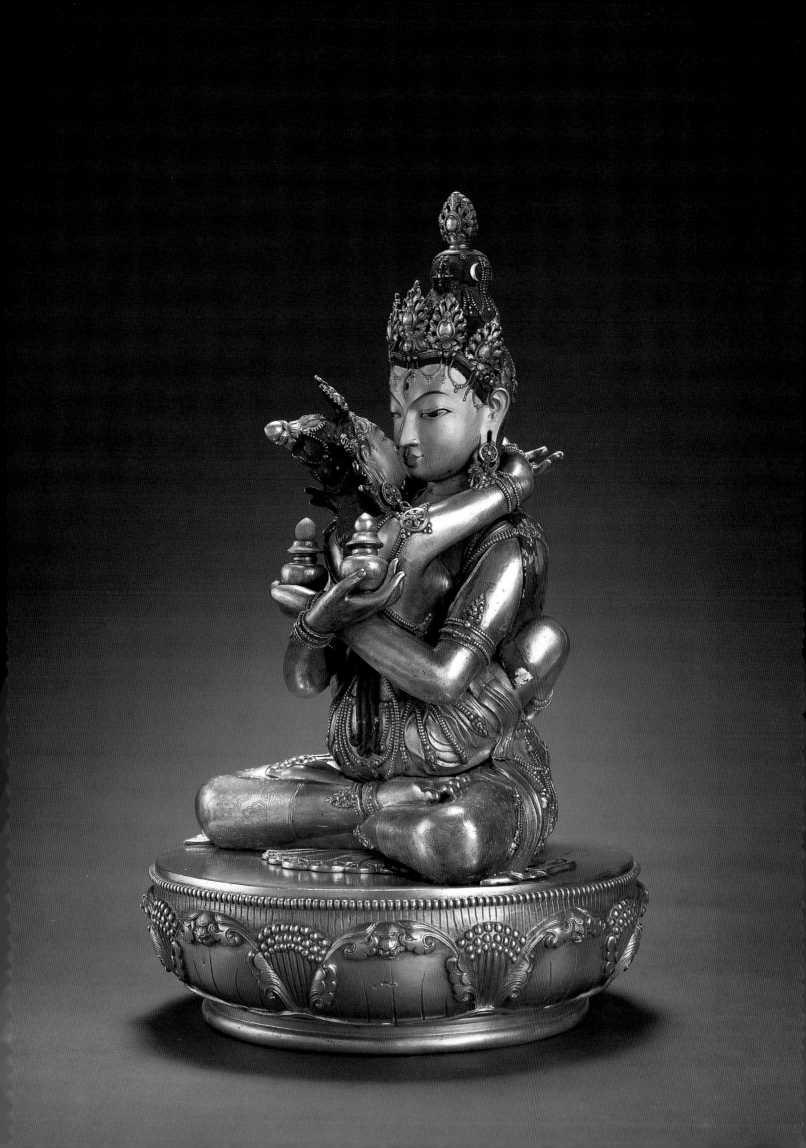

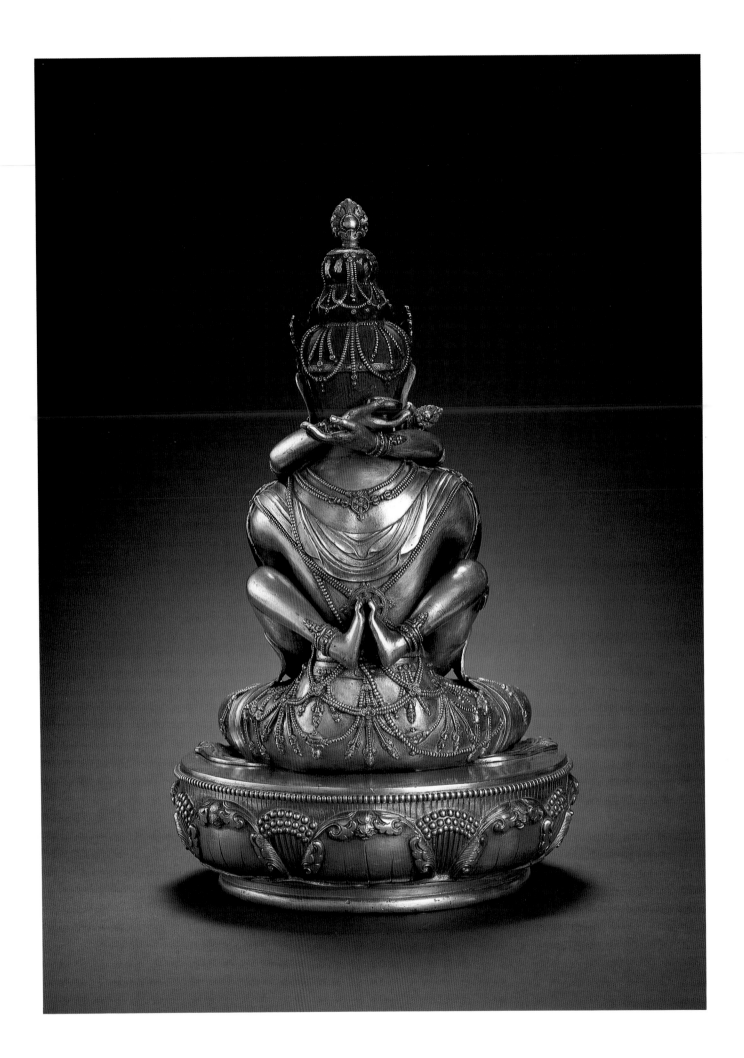

Fig. 1. Sitasamvara and consort, from the set of icons made for the Qianlong emperor's mother and kept in the third section of the Baoxiang Lou, Forbidden City, Beijing. From Clark, *Two Lamaistic Pantheons*, p. 81.

Fig. 2. Zanabazar's other divine couple, identified as Vajradhara, is possibly a different form of Samvara. Gandantegchinlin Monastery, Ulaanbaatar. From Tsultem, *Mongolian Sculpture*, pl. 62.

upper robe conveys a wonderful sense of cloth, especially beautiful as it folds in a rich, formalized pattern over his middle back just above his consort's toes. Zanabazar borrowed this detail from artists working in a Tibetan style at the late Ming and early Qing Chinese courts, while much of the rest of his inspiration must have come from the Nepalese tradition he learned in Tibet and brought back home.

The symmetry, formal restraint, and focused concentration of Zanabazar's composition powerfully, but quietly, express the abstract, mystical ideas of union and unsurpassed bliss that underlie Samvara's meaning. The artist has no need for the pyrotechnics that energize fierce representations of this god; he relies instead on his own capacity for subtlety to communicate insight into a most profound mystery.

One other extant work by Zanabazar represents a divine couple, an image identified as the supreme Adi-Buddha Vajradhara and his consort, which is still kept in worship at Gandantegchinlin Monastery in Ulaanbaatar (fig. 2). Gilles Béguin has pointed out that this deity wears a diadem of human heads, which would be unusual, to say the least, for an Adi-Buddha, and he suggests that it could possibly have been intended to be another, more typically fierce aspect of Samvara.[5] Yet another couple, this time definitely Vajradhara and his consort, Prajnaparamita, is in the Ferenc Hopp Mu-

seum in Budapest.[6] They are much smaller in scale than Zanabazar's magnificent Sitasamvara and consort, but they repeat his most characteristic details. This could well be Zanabazar's own work, or the work of his immediate school.

—P.B.

Published: Tsultem, *The Eminent Mongolian Sculptor—G. Zanabazar*, pls. 42–43; Béguin et al., *Trésors de Mongolie*, cat. no. 11

1. See, e.g., Rhie and Thurman, *Wisdom and Compassion*, cat. nos. 69, 70, and 102. Cat. no. 102 is a Tibeto-Chinese gilt bronze of the seventeenth century in the collection of the Asian Art Museum, San Francisco, and it is shockingly different in tone from Zanabazar's vision.

2. Dawa-Samdup, ed., *Shrīchakrasambhara Tantra*, pp. 10–12.

3. Snellgrove, *Indo-Tibetan Buddhism*, pp. 153, 155–56.

4. See Chandra, *Buddhist Iconography*, no. 2276 (73). Clark, *Two Lamaistic Pantheons*, p. 234.

5. Béguin et al., *Trésors de Mongolie*, p. 142.

6. Ferenczy, "Ādi-Buddha Vajradhara."

102. SITATARA (WHITE TARA, M: ČAGHAN DARA EKE)

Zanabazar (1635–1723)
Late 17th–early 18th century
Gilt bronze
H: 27⅛ (68.9) Diam.: 17⅝ (44.8)
Museum of Fine Arts

While he was living in retreat, Gedündrup (1391–1475), the First Dalai Lama and Tsongkhapa's most eminent disciple, wrote a prayer of praise to White Tara, "A Gem to Increase Life and Wisdom." Its opening verses may well have been the inspiration for Zanabazar's image of White Tara, the goddess who, above all others, filled the hearts of Tibetan and Mongolian Buddhists with her compassion and with the hope of long life:

> Homage to White Tara, a Female Buddha exquisite
> with youth.
> Radiant as the eternal snows in all their glory,
> She sits on a white lotus and a silvery moon
> Indicating fully developed compassion and knowledge.
>
> Homage to the Youthful One with full breasts,
> One face and two arms. Sitting in vajra position,
> She regally displays both grace and calm
> And is filled with great bliss.[1]

Gedündrup came into his Gelugpa title, Dalai Lama, only posthumously, but his love for the goddess Tara was nurtured during his childhood, which he spent in a Kadampa monastery. The Kadam order ("Bound to the Proclamation") was founded by the Indian sage Atisha (982–1054), who was "preserved by Tara, the patron deity of his former lives."[2] Tsongkhapa too was inspired by Atisha's teachings; his reformed Gelugpa was styled the "New Kadam," and his teachings recognize Tara as the mother of all Buddhas, past, present, and future; transcendent, yet capable of intercession and compassionate action.

Atisha was one of several Indian pundits who were invited to Tibet to help restore the Dharma after the bitter persecutions of the apostate king Langdarma (r. 838–42). Trained at the great monasteries of India and Indonesia, Atisha was a tantric adept and a devotee of Tara. His life was "filled with visions of the goddess,"[3] and it was she who encouraged him to make the journey to Tibet, warning him in a dream that it would shorten his life but go far in reestablishing the faith. Atisha's teaching of the tantric Buddhism current in India was severely censored by Tibet's neo-orthodox religious hierarchy, however, who feared that the tantras, with their sexual imagery, would have an adverse effect on Tibetan morals. This stance determined Tara's (and Atisha's) career in Tibet, for her primary texts were tantras, not sutras, and therefore were not, at first, translated or taught.[4]

By Atisha's day, Tara was an established goddess in India. Even very early texts, such as the *Manjushrimula-kalpa* and the *Mahavairochana Sutra,* place her near Avalokiteshvara, the Bodhisattva of Compassion, and the earliest known Indian images of her show her as a celibate consort of Avalokiteshvara, whose active role in compassionate work she eventually assumed.[5] By the ninth century, however, she had already appeared in the Buddhist cave-temples at Ellora as an independent savioress, who, like Avalokiteshvara, rescued those who prayed to her from both physical and psychological dangers. This role is implied by her name, which means both "star" and "savior," a reading that derives from the Sanskrit root *tar,* "to cross over," and, in the Buddhist context, means "to cross over the ocean of rebirths to enlightenment." Her eight different forms as Green Tara, each one efficacious against a different peril, and her twenty-one

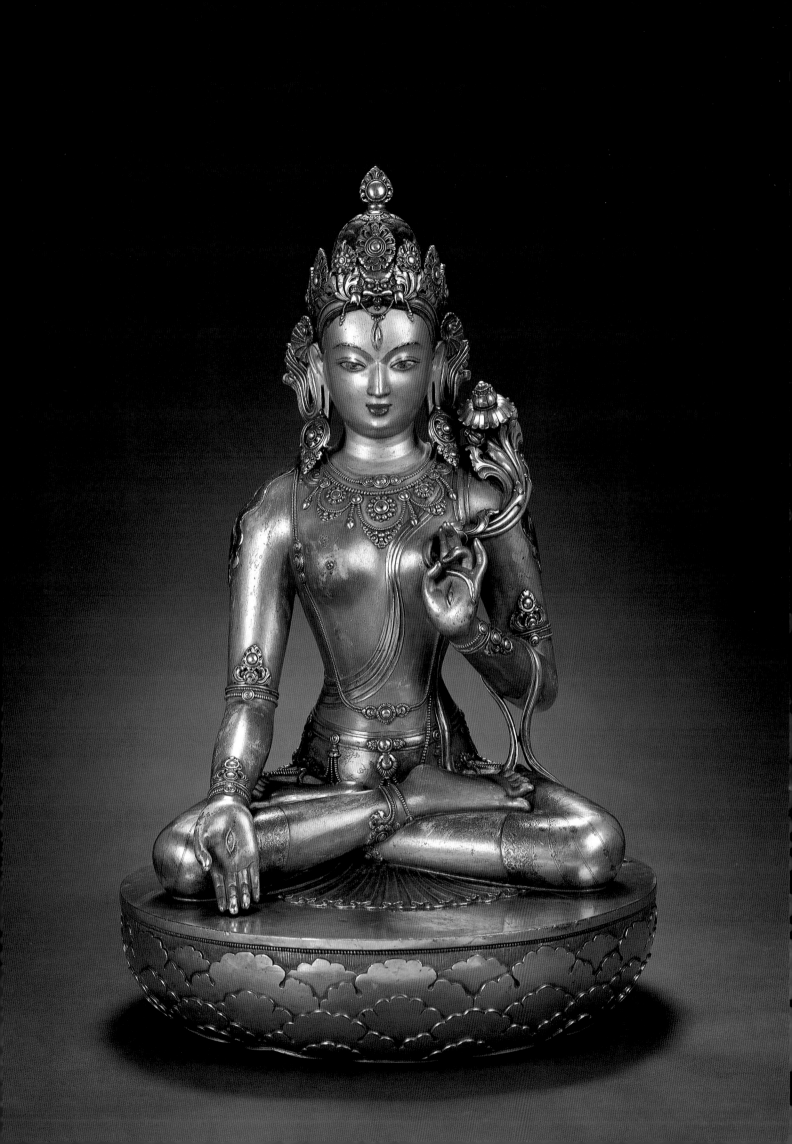

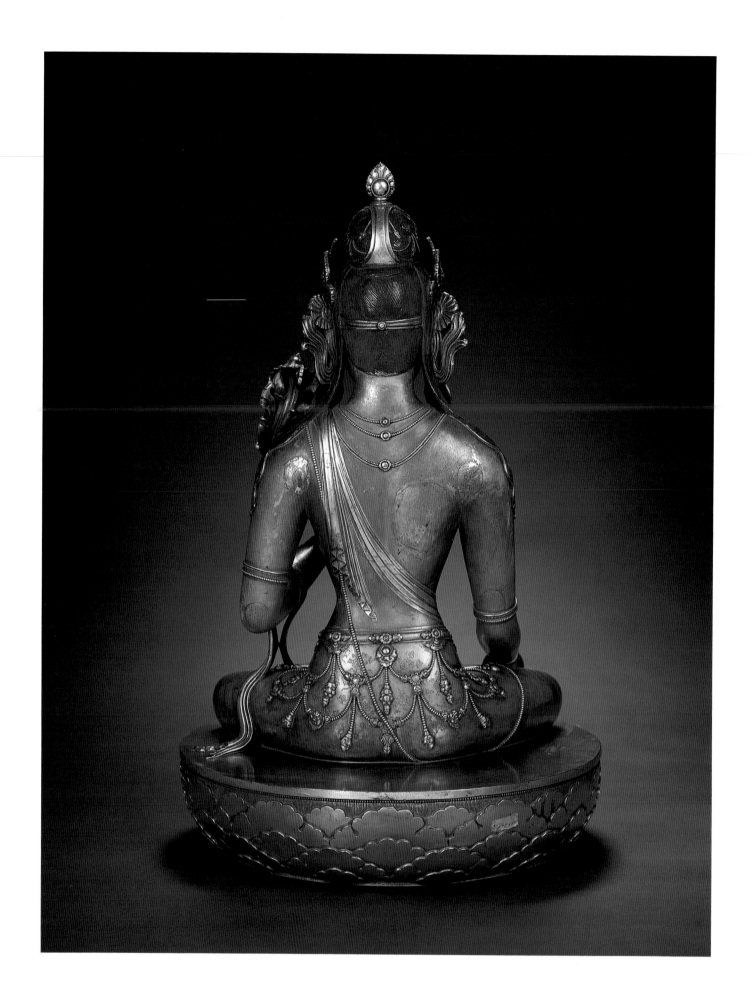

forms, described in the *Praise in Twenty-one Homages,* were all well known to Atisha (see cat. nos. 103–106).

Atisha's visions of Tara were inspired by the tantras, *sadhana* (visualization texts), and prayers that described her in her green, or active form, but also by the potent, personal revelations of her contemplative white form granted to the Indian Vagishvarakirti (ninth–tenth century), who first conceived of her specialized function of "cheating death" and bestowing long life.[6] Atisha wrote an evocation of Vagishvarakirti's White Tara and another of Green Tara. White Tara, however, was more acceptable to the neo-orthodox hierarchy of eleventh-century Tibet, because she was the product of a personal vision, rather than a figure whose authority came through the tantras. During Atisha's brief sojourn in Tibet, it was his own abiding devotion to the goddess more than anything else that fueled the growth of her cult in a way that ignored sectarian lines.

The Mongolian Bogdo Gegen, Zanabazar, received his own devotion to Tara through two transmissions of Atisha's teachings, the first (as outlined above) via the Gelugpa adoption of Kadampa precepts, and the second inherently, by way of his immediate preincarnation, Taranatha (1575–1634). Taranatha belonged to the Jonangpa, an offshoot of the Sakyapa (whose lamas also wholeheartedly shared Atisha's reverence for Tara), and was one of the greatest of Tibet's religious historians. His *Origin of the Tara Tantra,* written in 1604, deals with the source of the tantra and its promulgation, and he is credited with the diffusion and promotion of the cult of Green Tara, and with fashioning its mature form.[7]

There are a few scattered records that document Zanabazar's relationship to Tara; certainly images he made of her in her many forms dominate his extant works (see also cat. nos. 103–106). In 1649, when he went as a fourteen-year-old boy to Tibet to receive consecrations from the Panchen and Dalai Lamas, he was also recognized as Taranatha's rebirth. Before returning to Mongolia, he traveled to monasteries where he had spent his earlier lives, collecting, among other things, the goddess's texts and images.[8] Legend also has it that Zanabazar had a beautiful consort, the Girl Prince, who was as deft a sculptor as he. She died at the age of eighteen and her ashes were used for printing scriptures. Zanabazar is said to have modeled his Taras on her: the White Tara shows her as a young virgin, and the large Green Tara, in her last year, as a physically mature, voluptuous woman. (Several of his Twenty-one Taras are echoes of this central figure; see Berger, "After Xanadu," fig. 5.)

Zanabazar's White Tara was originally kept at the monastery at Erdeni Zuu, and in scale, style, and detail she approximates his extraordinary group of the Five Transcendent Buddhas (see cat. no. 97). His Tara is a pubescent girl, exquisite in form and with an expression of focused, serious compassion. She appears just as the First Dalai Lama, Ge-

dündrup, describes her in his poem, where she is revealed as the "Spiritual Mother" of the Buddhas, as the "Refuge of the World," and as she "whose head is adorned with Amitayus, Buddha of Boundless Life."[9] White Tara sits on a moon-disk placed on top of a single lotus pedestal, erect and alert, and without any of the activating *déhanchement* usually seen in images of her. Nonetheless, her posture and even her flesh appear remarkably natural; Zanabazar's abstractions take the subtler form of perfectly exquisite surface and proportion. Tara lowers her right hand in a gesture of supreme giving *(varada mudra)* and holds a white lotus in her left. Her hands and feet are inset with eyes; she also has a third eye in her forehead, but even these extraordinary attributes seem natural. Her "sapphire tresses" are half-knotted and half-free, and she wears a five-pointed crown that transforms itself into a *kirtimukha* (a protective, terrifying halo-face) at the front. Elaborate earrings and fluttering, flattened scarves surround her elongated ears, and her body is adorned with the spare, elegant jewelry of a bodhisattva, typical of Zanabazar's Nepalese-inspired sensibility.

The First Dalai Lama's poem (as well as his invocation to the goddess) specifically appeals to her for long life, but it also prays for protection from danger and access to enlightenment, hopes that are inextricably intertwined. This vision of Tara as the source of long life is based on Vagishvarakirti's revelations, which saw Tara as a sixteen-year-old girl, in every way the antithesis of death, and his dream of the goddess is perfectly captured by Zanabazar's calm yet energized image. In the most basic sense, Buddhists in Tibet and Mongolia saw the offerings, praises, and prayers they offered to Tara as an "initiation into life,"[10] and as a way of extending and prolonging the unique opportunity for enlightenment that only human life presented. —P.B.

Published: Tsultem, *The Eminent Mongolian Sculptor—G. Zanabazar,* pls. 49–52

1. Mullin, *Selected Works of the Dalai Lama I,* pp. 194–97.

2. Beyer, *The Cult of Tārā,* p. 11.

3. Ibid.

4. Ibid., pp. 11–13.

5. Ghosh, *Development of Buddhist Iconography in Eastern India,* pp. 6–31; Willson, *In Praise of Tara,* pp. 39–43.

6. Beyer, *The Cult of Tārā,* p. 363.

7. Taranatha, *The Origin of the Tara Tantra;* Willson, *In Praise of Tara,* pp. 33–36, 169–206.

8. See, e.g., Bawden, *The Jebtsundamba Khutkhtus of Urga,* p. 45.

9. Mullin, *Selected Works of the Dalai Lama I,* p. 195.

10. Beyer, *The Cult of Tārā,* pp. 363–467.

103–106. FOUR TARAS FROM A SET OF TWENTY-ONE

Zanabazar (1635–1723)
Late 17th–early 18th century
Gilt bronze
103 H: 16¾ (42.5) W: 10⅝ (27.0) D: 7⅛ (18.1)
104 H: 16½ (41.9) W: 10¼ (26.0) D: 6½ (16.5)
105 H: 16¼ (41.3) W: 9⅞ (25.1) D: 6½ (16.5)
106 H: 16½ (41.9) W: 10¼ (26.0) D: 6⅝ (16.8)
Bogdo Khan Palace Museum

Legend has it that Zanabazar created his series of Green Tara (S: Shyamatara; M: Noghughan dara eke) and her twenty-one manifestations for a monastery he built in 1706 in her honor at Čečeglig-ün erdeni tolughai,[1] and that his inspiration for the goddess's sublime form was his brilliant and beautiful consort, the Girl Prince (see Berger, "After Xanadu," fig. 5). But his sources were probably much more complex than that, for by the seventeenth and eighteenth centuries, Green Tara's iconography was well developed and multilayered.

Green Tara's color represents the active principle and ties her to Amoghasiddhi (Infallible Power), the fifth Transcendent Buddha, who is also green. Another interpretation, offered by Buddhagupta, suggests that her green color comes from mixing white, yellow, and blue, thus combining the functions these colors symbolize of pacifying, increasing, and destroying.[2] Her active compassion and willingness to engage in acts of mercy, saving her devotees from perils both physical and psychological, speeded her acceptance among the faithful.

In India Green Tara rapidly evolved into numerous forms. Her eight most basic manifestations, not all of them green, each specifically attend to a particular type of danger, many of them borrowed from the list assigned to Avalokiteshvara in the *Lotus Sutra* (wild animals, swarming bees, fire, serpents, robbers, captivity, high seas, and even vampires);[3] these eight are usually arrayed around a central, all-encompassing image of Green Tara, though some of them also function as independent goddesses. Her most beloved multiple forms are described in the *Praise in Twenty-one Homages,* the third chapter of the *Tara Tantra,* which was probably translated into Tibetan by the late eleventh century. (It was already known in a Tangut translation in Amdo and along the Chinese Gansu corridor leading into Central Asia by the early thirteenth century.) All Tibetan and Mongolian Buddhists knew this prayer of praise to the goddess and depended on it and her mantra, *Om Tare tuttare ture svaha,* for their salvation.[4]

Green Tara's evolution in Tibet took a different course from that of White Tara. Both were well known and beloved by Atisha, the Indian sage who went to Tibet in 1042 to help reestablish the faith, and his charismatic devotion to the goddess, more than anything else, generated great interest in her. However, White Tara, whose cult was based on the personal visions of the ninth–tenth-century Indian pundit Vagishvarakirti (see cat. no. 102), was palatable to Tibet's orthodox and antitantric religious hierarchy, while Green Tara, whose authority came from her tantras, was not. Atisha thus continued his own unfaltering devotion to Tara privately, even though he wrote little about her. It was only as orthodox influence waned over the course of the century following Atisha's death that Green Tara's texts were slowly translated and absorbed into Tibetan belief. This process was completed through the efforts of the First Dalai Lama (1391–1475), for whom Tara was the prime object of devotion, and by Taranatha (1575–1634), who actively promoted faith in the goddess and wrote a history of the *Tara Tantra.*[5]

At the same time, Tara's primacy in Tibet was sustained by her integration into the Tibetan national myth. Stephan Beyer has shown that by the fourteenth century, Tara was equated with the primordial rock ogress, who mated with a monkey king (Avalokiteshvara) to produce the first simian Tibetans.[6] Her universal motherhood was also enshrined, again probably no earlier than the fourteenth century, in the symbolism of Tibet's earliest Buddhist king, Songtsen Gampo (617–650), whose Chinese and Nepalese wives were manifestations of Green Tara and the goddess Bhrkuti.

By Zanabazar's time all obstacles to Green Tara's worship had been removed, and her twenty-one forms were roughly organized into three major iconographic traditions. (There were also numerous separate *sadhana* and iconographies that detailed Tara's eight forms.) The first of these, attributed to Suryagupta (mid-ninth century), gives each of the Twenty-one Taras a different posture, mood, and attribute. Suryagupta's vision was integrated into the Narthang Pantheon, which is based on the work of, among others, the

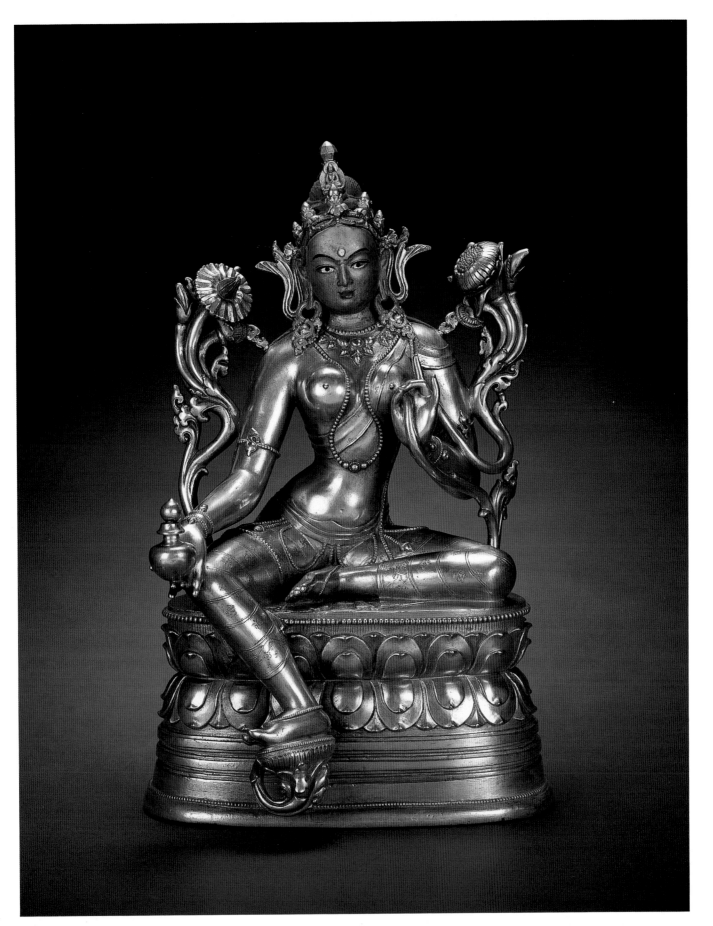

103.

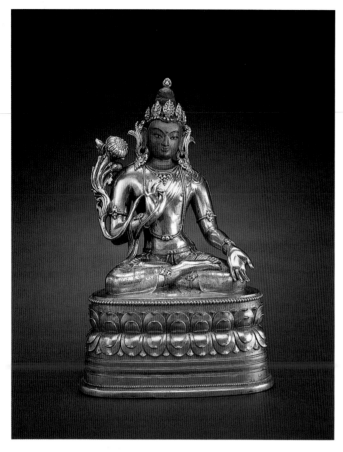

104.

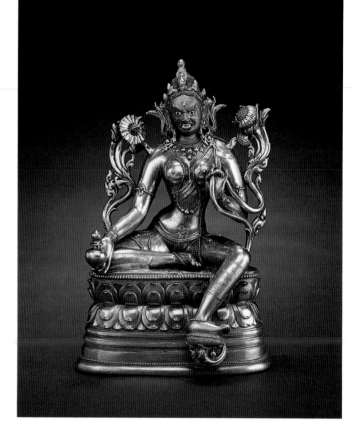

105.

Fourth Panchen Lama (1781–1852), Taranatha, and the Mongolian Ching süsügtü Nomyn Khan, a disciple of Zanabazar.[7] Suryagupta's group also reappears in the Jangjya Khutuktu Rolpay Dorje's iconography, *Zhufo pusa shengxiang zan*.[8] The second tradition is Nagarjuna's, brought to Tibet by Atisha, which envisions all Twenty-one Taras in the identical posture and mood but differentiates them by color and by the color of the flask each holds in her right hand.[9] A third tradition, held by the Nyingmapa, the old school of Tibetan Buddhism, dates back to the fourteenth century and has twenty-one similar Taras, each holding a different attribute aloft on a lotus.

Zanabazar's Taras do not follow any of these systems with complete faithfulness; none was actually published in the form of iconographic drawings until after Zanabazar's time, even though numerous *sadhana* and prayers describing her were available.[10] (It was the eighteenth century that saw a flurry of interest in iconographic accuracy, spurred on by the Qianlong emperor.) Moreover, Zanabazar was himself a great adept and devotee of Tara, and he may well have followed his own inner experience of the goddess (as tradition relates) in giving form to his sculptures of her. The early *sadhana* and the later iconographic drawings based on them to which he may or may not have had access were, after all, built on "the shifting sands of the personal revelations, the unique dreams and visions of the different masters and their disciples."[11]

Nonetheless, there are correspondences between Zanabazar's Taras and those of Suryagupta and Atisha. The majority, like Atisha's, are similar, with either benign or ferocious faces, holding lotuses and flasks (fig. 1). Others have completely different postures, moods, and attributes, like Suryagupta's (although they do not correspond in detail to his list; see, e.g., cat. no. 106). The only key to their identity comes from the traditional names still attached to them in Ulaanbaatar, which govern the order in which they are now displayed.

Thus a fierce-faced Tara in the style of Atisha (cat. no. 105) has an inscription in Tibetan on her base that reads, "the seventh Green Tara," and is locally identified as "Suppressor of the Magic Power of Others," an epithet resembling the seventh Tara as she appears in the *Twenty-one Homages*, who is "the crusher of foes' magic diagrams."[12] (In Atisha's list, she "defeats others, [and] averts the magic mantras of others."[13]) Another terrific Tara (cat. no. 106) goes by the traditional epithet Black Tara[14] or Ekajati (She of the Single Chignon), usually part of a triad with Green Tara and Marichi, goddess of the dawn. She holds Ekajati's attributes as they are described by Suryagupta, a chopper with a *dorje*-shaped handle and a skull cup, and she is draped in the flayed hide of a tiger (fig. 2). A Tara whose function and form resemble Ekajati's (but does not carry her name), "Tara with frowning brows, who destroys hindering demons, her body colored black,"[15] is fourteenth on Atisha's list. (There are

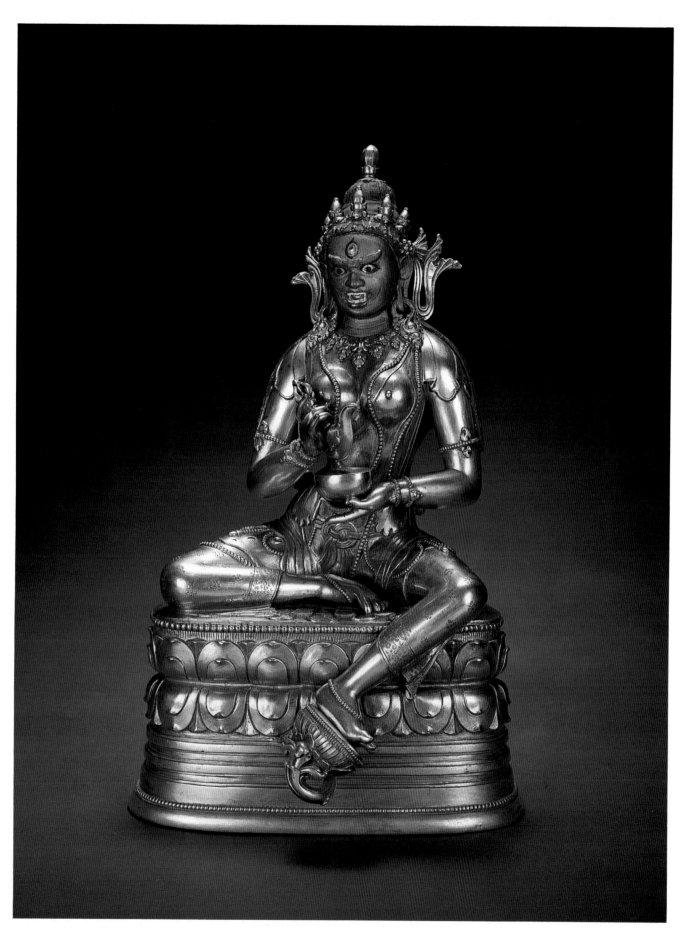

106.

Fig. 1. Zanabazar, four Taras in the style of Atisha, from his group of twenty-one. Gilt bronze. Bogdo Khan Palace Museum, Ulaanbaatar. From Tsultem, *The Eminent Mongolian Sculptor—G. Zanabazar*, pl. 64.

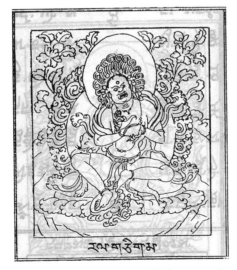

Fig. 2. Ekajati with chopper and skull cup, one of the Twenty-one Taras according to Suryagupta. Illustrated in the *Narthang Pantheon*. From Chandra, *Buddhist Iconography*, no. 792.

discrepancies here with other lists—"Tara with frowning brows" is often identified with Bhrkuti, who is yellow, but can be blue; Ekajati is described as blue or black, two colors often confounded in tantric iconography.)

The two benign Taras shown here are more difficult to identify; most of the twenty-one goddesses closely resemble Atisha's Taras (e.g., cat. no. 103), who hold a flask in the right hand, a lotus stem in the left, and sit with right leg pendant in an elegant, relaxed posture. This type of Tara wears a small image of Amitabha in her five-pointed crown (just as Avalokiteshvara does), and her full, sensual body is draped with a one-shouldered wrap and heavy bodhisattva ornaments. Gilles Béguin notes that a nearly identical figure from the group (exhibited in *Trésors de Mongolie* at the Musée Guimet in 1993) is now called Marichi in Mongolia, but, if so, there is nothing that separates her from several of her sisters.[16] The second benign figure (cat. no. 104), whom N. Tsultem identifies as Yellow Tara,[17] is notably masculine in appearance, with a lower brow and lacking the prominent breasts of her (or his) companions. This Tara carries only a twisting lotus stem and sits with legs folded in the lotus position, to all appearances the image of Avalokiteshvara, Tara's equally beloved male counterpart. —P.B.

Published: Tsultem, *The Eminent Mongolian Sculptor—G. Zanabazar*, pp. 72–82

1. This monastery was built to replace an earlier version of Urga, which Galdan destroyed in 1688. Prayers to Tara were written for its consecration. See Kämpfe, *"Sayin Qubitan-u Süsüg-ün Terge,"* 15 (1981), p. 336.

2. Beyer, *The Cult of Tārā*, p. 279.

3. Ibid., pp. 229–30. These terrors are described in, among other places, a poem by the Indian sage Chandragomin, one of Tara's greatest devotees.

4. Willson, *In Praise of Tara*, pp. 105–66.

5. Ibid., pp. 33–36, 169–206.

6. Beyer, *The Cult of Tārā*, p. 4.

7. Chandra, *Buddhist Iconography*, pp. 22–41 and nos. 784–805.

8. Clark, *Two Lamaistic Pantheons*, pp. 276–83.

9. Beyer, *The Cult of Tārā*, pp. 333–35, provides the list.

10. Willson, *In Praise of Tara*, translates numerous early poems, prayers, invocations, and *sadhana* by great devotees, such as the Indian masters, Matrcheta, Chandragomin, Suryagupta, Atisha, and the First Dalai Lama, among others, pp. 207–350.

11. Beyer, *The Cult of Tārā*, p. xiii.

12. Willson, *In Praise of Tara*, p. 114.

13. Beyer, *The Cult of Tārā*, p. 334.

14. Tsultem, *The Eminent Mongolian Sculptor—G. Zanabazar*, pl. 54, pp. 72–73.

15. Beyer, *The Cult of Tārā*, p. 335.

16. Béguin et al., *Trésors de Mongolie*, cat. no. 9.

17. Tsultem, *The Eminent Mongolian Sculptor—G. Zanabazar*, pl. 55, pp. 74–75.

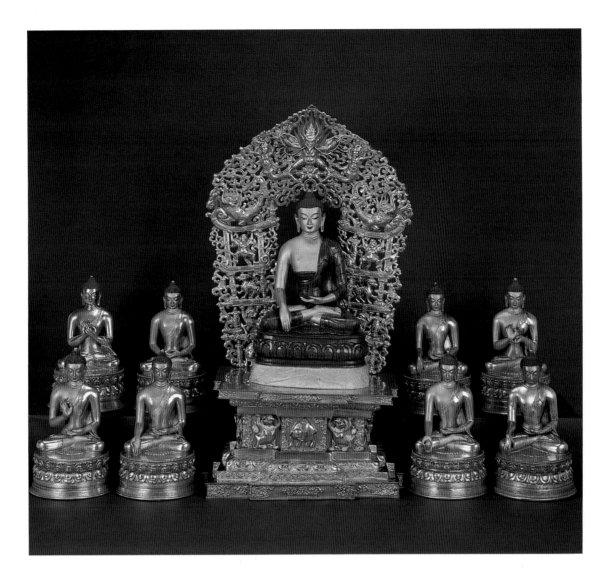

107. SHAKYAMUNI AND EIGHT MEDICINE BUDDHAS (M: OTAČI)

School of Zanabazar
18th century
Gilt bronze
Shrine H: 33⅜ (84.7) W: 17¾ (45.0) D: 15½ (39.5)
Individual figures H: 11⅜–11⅞ (28.8–30.3)
Diam.: 7¼–8⅛ (18.4–20.5)
Bogdo Khan Palace Museum

Buddhists have always held the art of medicine in high regard, seeing it (along with clothing, lodging, and food) as a necessity of life. The practice of medicine has also consistently been an important part of a monk's work. Even the *vinaya*, which contains the Buddha's own rules for monastic life, contains an extensive *materia medica*, for in the practice of medicine monks could play out their compassionate role in a satisfying, visible way. But aside from the practical benefits the medical arts provided, healing was also a metaphor for the process of spiritual awakening. The benighted state of all sentient beings was believed, in the Buddhist view, to

be akin to disease, which might or might not manifest itself in the form of physical illness.[1]

In very early texts, such as the *Questions of Milanda,* Shakyamuni Buddha is cast in the role of Supreme Physician, whose "medicine bazaar" contains prescriptions for liberation from suffering.[2] With the development of the Mahayana concept of the abstract Buddha-principle, Shakyamuni's ability to heal the diseased spirit and body was symbolized in the form of another Buddha, Bhaishajyaguru, whose Lapis-Lazuli Paradise was located far to the east, ten times "beyond as many Buddha-realms as there are grains of sand in the Ganges."[3] This Pure Land is described in the *Bhaishajyaguru Sutra,* which was translated into Chinese several times, most notably in the Tang dynasty (618–906) by the pilgrim Xuanzang and, at the imperial order of Zhongzong (who had survived the tortures of his mother, the Empress Wu Zetian), by Yijing. This sutra describes seven healing Buddhas, Bhaishajyaguru and his six Buddha-brothers, all of them able to provide cures to specific illnesses, whether physical or spiritual. The rites prescribed for Bhaishajyaguru continually play on the number seven and multiples of seven embodied

in this group, based on the belief that forty-nine days must elapse before the dead soul can be reborn in paradise.

The *Bhaishajyaguru Sutra* was translated several times into Tibetan. In Tibetan representations, however, the original group of seven Buddha-brothers was joined by the Supreme Physician Shakyamuni. This later group also subsequently grew to nine members, with Shakyamuni at the center, surrounded by Bhaishajyaguru and his (now seven) brothers. This is the arrangement reproduced in most Mongolian examples.

The set of nine gilt bronzes seen here is one of two extant sets cast by Zanabazar's school; it was originally kept in Gungachoilin *aimag,* an administrative division of Gandantegchinlin Monastery in Urga. (The other group is now in the Museum of Fine Arts, Ulaanbaatar; see fig. 1.) In this set, Shakyamuni is given prominence by his size and by the darker color of his robe, while Bhaishajyaguru and his brothers are all identical except for their hand gestures (and one Buddha, sitting in the back left, who appears to be a more recent replacement).[4] Their gestures should, in theory, allow each of the Buddhas to be matched to their individual names and descriptions, but this cannot be done without knowing their characteristic colors, since some gestures are shared by two Buddha-brothers (see, however, cat. no. 65, an embroidered image of the group of nine).[5] There are several other Buddha-images, also products of Zanabazar's school, that repeat the elegant formula of these Medicine Buddhas. One, at least, found its way to Beijing, where it was obtained by an English officer in the nineteenth century (see Bartholomew, "An Introduction to the Art of Mongolia," fig. 5); another is a Shakyamuni in the Museum of Fine Arts, Ulaanbaatar, whose lotus pedestal is noticeably closer to Zanabazar's own characteristically flatter design.[6]

In his unpublished notes, Ferdinand Lessing wrote that devotion to Bhaishajyaguru probably came to Mongolia with the first conversion to Buddhism of the thirteenth and fourteenth centuries, because Mongolian versions of his sutra use the word *otači* to translate "physician." This term is derived from the Uighur word for medicinal herbs *(ota),* evidence that the earliest Mongol sources for this Buddha were early and Central Asian, and not originally Tibetan.[7] The popularity of the Medicine Buddhas was reestablished with the second conversion in the sixteenth century, when Mongolian lamas were noted for their miraculous ability to cure the sick with herbs and magical incantations. One of the most famous events in Zanabazar's life was when he used mandala-offerings literally to raise the Panchen Lama from the dead in 1655.[8] Sometime in the 1670s, he asked the Fifth Dalai Lama to compose a ritual specifically for the Medicine Buddhas,[9] and later, in 1693, he healed the ailing Kangxi emperor through prayer, a service that resulted in a rapprochement between the two and the beginning of a

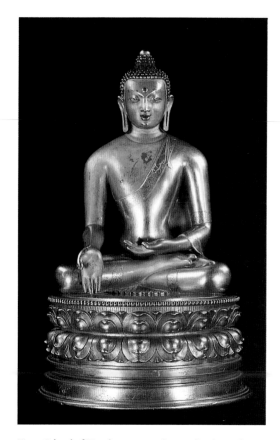

Fig. 1. School of Zanabazar, one of a set of eight Medicine Buddhas, early 18th century. Gilt bronze. Museum of Fine Arts, Ulaanbaatar. From Béguin et al., *Trésors de Mongolie,* cat. no. 15.

close friendship.[10] Zanabazar even received as a gift a Tibetan translation of a sutra dedicated to the Medicine Buddha (among many other things), after he bestowed the Vajradhara consecration upon the Kangxi emperor.[11]

—P.B.

1. Birnbaum, *The Healing Buddha,* is the source for much of the information that follows on Buddhism and healing.

2. Ibid., pp. 16–17.

3. Ibid., p. 71.

4. The larger Buddha also has an inscription in Mongolian script on its base. The legible part reads, "Lord of the Faith." Two of the smaller Buddhas have paper labels on their bases with Tibetan inscriptions which read, "Oh, greatest abundance [being] without suffering, released from misery, such as unhappiness, etc." and "Oh, unsullied good golden [one] completely composed of joy and fortune, such as long life." Translations courtesy of James Bosson.

5. For two such lists, see Birnbaum, *The Healing Buddha,* pp. 93–94 (where a total of seven Buddhas, including Bhaishajyaguru, are given); Liebert, *Iconographic Dictionary of the Indian Religions,* p. 37 (where the list totals nine, excluding Shakyamuni).

6. Béguin et al., *Trésors de Mongolie,* cat. no. 16.

7. Birnbaum, *The Healing Buddha,* p. 60.

8. Bawden, *The Jebtsundamba Khutukhtus of Urga,* pp. 46–47.

9. Kämpfe, "Sayin Qubitan-u Süsüg-ün Terge," 13 (1979), p. 100.

10. Pozdneyev, *Mongolia and the Mongols,* p. 333.

11. Bawden, *The Jebtsundamba Khutukhtus of Urga,* p. 58 n. 3.

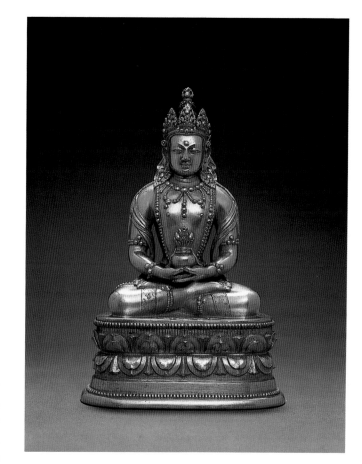

108. AMITAYUS (M: ČAGLASI ÜGEI NASUTU, AYUSI)

School of Zanabazar
First half of the 18th century
Gilt bronze
H: 7¾ (19.7) W: 5⅛ (13.0) D: 3½ (8.9)
Museum of Fine Arts

For Zanabazar, as for most Tibetan, Manchu, and Mongolian Buddhists of the seventeenth and eighteenth centuries, Amitayus, the Buddha of Boundless Life, the inseparable alter ego of Amitabha, Boundless Light (cat. no. 97), was a strongly felt presence. A ritual to importune him for long life was designed by the Fifth Dalai Lama,[1] and his consecrations and blessings were eagerly sought by China's Manchu ruling family throughout their long dynasty (1644–1911).

Once, when Zanabazar was visiting the Kangxi emperor (r. 1662–1722) in Beijing, the emperor asked him to perform a prayer service to Amitayus, as well as a water consecration, both of which he hoped would ensure his (the emperor's) long life.[2] History also records that on at least two separate occasions Zanabazar cast images of Amitayus.[3] One is probably the large, impressive figure, perhaps a mate to his Vajrasattva, that is now in the Choijin-Lama Temple Museum in Ulaanbaatar (cat. no. 99, fig. 2); the location of the second is not known. The small image of the Buddha of Long Life shown here is most probably a work of his immediate school. It re-creates some of the loveliest details of his style, including the soft, Chinese-inspired modeling of the Buddha's shawl, the simplified but rich jewelry, and the overall naturalness of the figure, which radiates potential and life.

The delirium over Amitayus's ability to prolong life had a major effect on artistic production at the Manchu court in Beijing. The Qianlong emperor was a patron-extraordinaire and, in 1751, on the occasion of his mother's sixtieth birthday, he ordered a complete set of Amitayus Buddhas cast for her (how many were in this set is untold). On her seventieth birthday in 1761, the numbers of images she received from him began to approach mythic proportions; according to Walter Eugene Clark, "she was presented with more buddhas: nine sets of Amitayur (Amitayus) Buddhas totaling 900 statues, nine sets of the same totaling 9,000 statues, nine Buddhas, nine Amitayur Buddhas, nine Buddhas, nine Amitayur Buddhas, nine Bodhisattvas, nine *fo-mu* (Buddha mothers—tantric female figures), eighteen *lo-han (arhats),* and nine Buddhas."[4]

Similarly, in 1912, just after he had ascended the newly created Mongolian imperial throne, the Eighth Bogdo Gegen's most ardent supporters commissioned ten thousand figures of Amitayus to be cast in order to prolong his life. Even today in Mongolia, Amitayus's name (Ayusi) is a frequently heard component of personal names, suggesting that faith in his ability to prolong the precious gift of human life has not faded.
 —P.B.

Published: Tsultem, *The Eminent Mongolian Sculptor—G. Zanabazar,* pl. 88, lower right; Béguin et al., *Trésors de Mongolie,* cat. no. 17

1. Béguin et al., *Trésors de Mongolie,* p. 154.

2. Bawden, *The Jebtsundamba Khutukhtus of Urga,* pp. 51–52. This story is retold by Pozdneyev, *Mongolia and the Mongols,* pp. 334–35.

3. Tsultem, *The Eminent Mongolian Sculptor—G. Zanabazar,* p. 7.

4. These repetitive, huge numbers may be a bit deceiving, because Lokesh Chandra reproduces an Amitayus from the Mongolian Kanjur, which he says "stands for Nine Amitayus of the centre and the eight directions," presumably with all these functions subsumed into a single figure. See *Buddhist Iconography,* no. 87. For the details on Qianlong's gifts to his mother, see Clark, *Two Lamaistic Pantheons,* pp. xii–xiii.

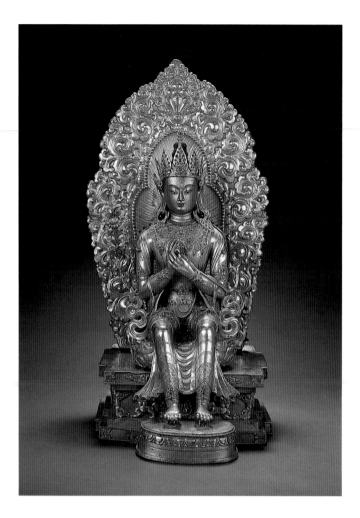

109. SEATED MAITREYA (M: ASRALTU, MAIDARI, MAIDAR)

School of Zanabazar
18th century
Gilt bronze with inset semiprecious stones
H: 27 (68.6) W: 12 (30.5) D: 10⅝ (27.0)
Choijin-Lama Temple Museum

A second, popular form of the Future Buddha Maitreya has him dressed once again as a prince, but with a jeweled crown obscuring his high chignon and characteristic stupa-reliquary and with his legs pendant in the European sitting position. This very ancient form of Maitreya takes him a step further in his career; his hands form the *dharmachakra mudra,* the teaching gesture with which he begins to turn the Wheel of the Law. His crown marks his consecration, a final step in his evolution from bodhisattva (see cat. no. 100) to fully enlightened Buddha. It was this type of Maitreya that was also chosen for the colossal, Dolonnor-style image that presided over the great Maidar Temple built in the Bogdo Gegens' Da Khüree in the 1820s or 1830s,[1] one of several Mongolian colossal Maitreyas. (Others were at Amarbayas-galant, Zanabazar's posthumous retreat, and at the *khüree* of the Ilaghughsan Khutuktu, known for his lavish staging of the Maitreya Festival.)[2]

Maitreya's body is clothed in a thin, almost weightless *dhoti,* which, like his chest, is overlaid with veils of cast beads and inset carnelian and turquoise. He wears bracelets on his wrists and upper arms, anklets, and heavy, ornate, flat earrings. The equally flat, upturning pendants of his five-pointed crown are often seen in Mongolian Buddhist sculpture and may hark back to a style first seen by Zanabazar at Kumbum in Amdo in the mid-seventeenth century.

The pedestal, footrest, and aureole are all later, probably nineteenth-century, additions, perhaps originally made for another image. This almost casual interchange of bases and aureoles, which is typical of the way icons are installed in Mongolian temples, emphasizes the function of the image in religious practice rather than its authorship.　　—P.B.

Published: Tsultem, *The Eminent Mongolian Sculptor—G. Zanabazar,* pl. 91; Tsultem, *Mongolian Sculpture,* pl. 96

1. Pozdneyev, *Mongolia and the Mongols,* pp. 61–62.

2. Ibid., pp. 22–24, where Pozdneyev describes the Amarbayasgalant Maitreya as an incredible "60 armspans" high, and pp. 152–53, 252–53, where he says the Ilaghughsan Khutuktu's Maitreya was 25 cubits high (approx. 37½ ft.).

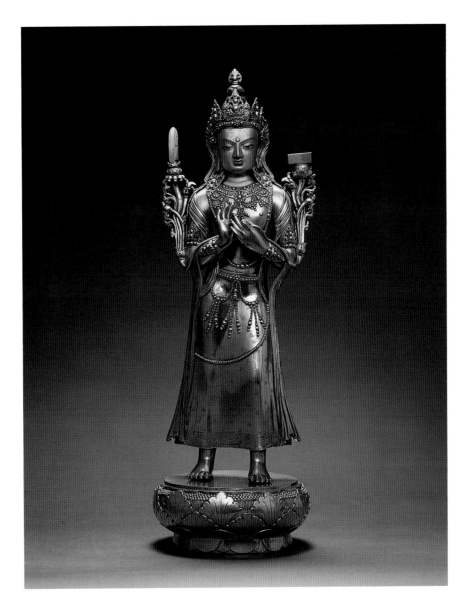

110. MANJUSHRI

Zanabazar or his school
Late 17th–early 18th century
Gilt bronze
H: 22¾ (57.8) W: 7⅞ (20.0) D: 7½ (19.0)
Museum of Fine Arts

Manjushri—Gentle Glory—is a celestial bodhisattva, the denizen of another universe who serves as Shakyamuni's first representative in Mahayana literature. He is the Bodhisattva of Wisdom, who has taken the form of a young prince. He has at his right hand a double-edged sword to cut through the veil of ignorance and delusion. At the same time, he holds the stem of a lotus in his left hand, which blossoms into the *Prajnaparamita Sutra,* one of the most significant of the Perfection of Wisdom texts and the Mother of all Buddhas.

By as early as the second century a much more complex career had been mapped out, in which Manjushri was first described as a Pratyeka Buddha (one who only sought en-

lightenment for himself, forsaking the bodhisattva ideal of working for the salvation of all), but later elevated to the role of an ancient Buddha from another world brought to earth to save all sentient beings. Manjushri's most famous appearance in Mahayana literature is in the *Vimalakirti nirdesha,* a text that describes his visit to the home of the devout householder Vimalakirti. There Manjushri discussed the contradiction inherent in the bodhisattva's path, which required the reconciliation of transcendent wisdom with active engagement in the work of salvation. This could only be accomplished, he argued, through skillful means and pure intention, the primary bodhisattva ideals, for enlightenment could only be found in the chaos and confusion of worldly existence, and not in nirvana.[1]

Manjushri was popular very early in India (although the seventh-century Chinese pilgrim Xuanzang recorded seeing only one shrine devoted to him). He had great appeal to the first tantric Buddhists, and his *Manjushrimula-kalpa* is one of the earliest tantric texts to attempt an organization of the increasingly complex Buddhist pantheon. There he is once

again described as "adorned with the finery of a youngster,"[2] emphasizing that age and experience have little to do with enlightenment and wisdom. By the time of the appearance of the *yoga* tantras, he was elevated to the position of an Adi-Buddha, a symbolic realization of transcendent wisdom.

Manjushri's importance in Tibet is clear from the number of images painted and cast of him, and from the list of great men who were believed to be his incarnations. These include such luminaries as Longchen Rapjam Tsultim Lodrö (1308–1363), the great lama who systematized the path to the Great Perfection, the basis of Nyingmapa study; Tursong Detsen (d. ca. 800), one of Tibet's most ardently Buddhist kings; Sakya Pandita (1182–1251), the head of the Sakyapa who was brought to the court of the Mongol Godan Khan along with his nephew, Phagspa; and Tsongkhapa himself. Tsongkhapa's visions of Manjushri in his terrific form as Yamantaka moved the great reformer to write brilliant verse in the bodhisattva's honor and to place Manjushri and Yamantaka at the center of Gelugpa ritual and practice (see cat. no. 90).

The Mongols also had a special relationship with Manjushri that was older than the lineage they inherited from Tsongkhapa. As early as the Tang dynasty, China, specifically Mount Wutai in modern Shanxi province, was considered by Buddhists as far away as India to be Manjushri's home on earth, a Pure Land where he manifested himself to believers in the form of radiant displays of light (C: *foguang*, "Buddha-radiance") and where all Mongol Buddhists hoped to be buried.[3] Resistance to the Mongol takeover of China in the Yuan dynasty was justified symbolically when Khubilai Khan was posthumously proclaimed to be China's own bodhisattva, Manjushri-incarnate, in the inscriptions on the Juyong Gate, which was built in 1345 north of the Mongol capital, Dadu. Altan Khan was similarly graced with this inheritance in his exchange of titles with Sonam Gyatsho, when the first was called Khubilai-incarnate (and by extension, Manjushri-incarnate) and the second the Dalai Lama. In Zanabazar's lifetime, this politically potent Mongol lineage was transferred to the Manchus, whose emperors the Fifth Dalai Lama and the First Panchen Lama were the first to recognize as Manjushri-incarnate.

Manjushri continued to have a multivalent meaning for the Mongols even in the last years of the nineteenth century. On the one hand, he symbolized transcendent wisdom, on the other, Mongol submission to the Manchus. A potent example is the annual celebration held at the Manjushri Temple in Uliasutai, the Manchu administrative center in Khalkha, on the occasion of the birthday of the bodhisattva's incarnation on earth, the Manchu emperor of China.[4]

The standing Manjushri attributed to Zanabazar or his immediate school represents the form the bodhisattva takes when he is part of the Eight Great Bodhisattva entourage of Amitabha, Buddha of Boundless Light. However, he seems inspired by the lithe, youthful grace of Zanabazar's standing Maitreyas (cat. no. 100), though his pose is more tentative and static, and lacks Maitreya's exuberant sway. He carries his attributes aloft on two twining lotuses, the double-edged sword to his right and the *Prajnaparamita* to his left, in the manner prescribed for standing figures. The Eight Great Bodhisattvas also appear in the Mongolian Kanjur, printed between 1717 and 1720 (fig. 1). There the entire group follows an Indian model, while Zanabazar's prototype is distinctly Nepalese. —P.B.

Published: Tsultem, *The Eminent Mongolian Sculptor—G. Zanabazar,* pl. 83

1. Lamotte, *The Teaching of Vimalakirti,* pp. 176–79.

2. Snellgrove, *Indo-Tibetan Buddhism,* p. 194.

3. See, e.g., Birnbaum, *The Mysteries of Mañjuśrī.*

4. Pozdneyev, *Mongolia and the Mongols,* pp. 165–66.

Fig. 1. Manjushri as one of the Eight Great Bodhisattvas, from the Mongolian Kanjur, 1717–20. From Chandra, *Buddhist Iconography,* no. 88.

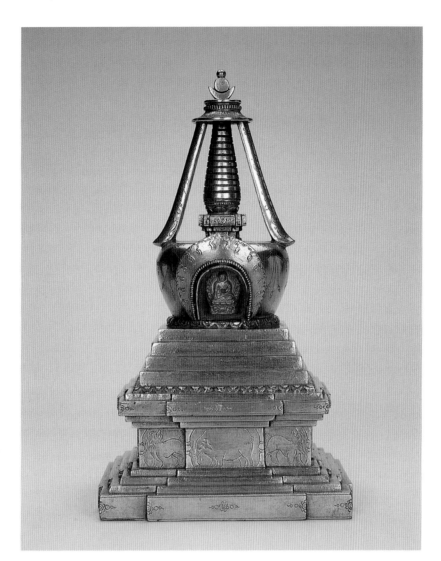

III. STUPA (M: *SUBURGAN*)

School of Zanabazar
Late 17th–early 18th century
Gilt bronze
H: 10⅛ (25.7) W: 5⅝ (14.3) D: 5⅝ (14.3)
Bogdo Khan Palace Museum

The first Buddhists saw Shakyamuni Buddha as a sage-teacher, who opened the path to liberation for all his followers through his own enlightenment. After his death and *parinirvana* (release from the cycle of rebirth), his remains were cremated and, according to legend, divided up among eight townships. (The vessel that held them and the ashes from the fire went to two more.) These relics were the focus of Buddhism's earliest devotional cult, because they symbolized Buddha's passage into the indescribable, supramundane state of nirvana. To house them each of the lucky townships built *chaitya* (stupas), hemispherical tumuli modeled on royal burials, where they were protected beneath multitiered umbrellas.

The Buddha's relics seemed to increase in volume as the

centuries passed, and, by the time the Chinese pilgrim Xuanzang traveled to India in the seventh century, he could report that portions of them were kept at many of the major monasteries he visited. Similarly, the spots marking great moments in Shakyamuni's past and present lives, the relics of other sages, and even sacred texts were treated with veneration and also housed in stupas. India had thousands of these shrines; the great Buddhist king Ashoka alone is said to have commanded the construction of 84,000 of them in the third century B.C.

The idea that the actual bodily remains of the sainted Buddha should be an object of devotion infused early Buddhism. During this aniconic period, which lasted into the current era, reliquary-stupas and symbols of the historic

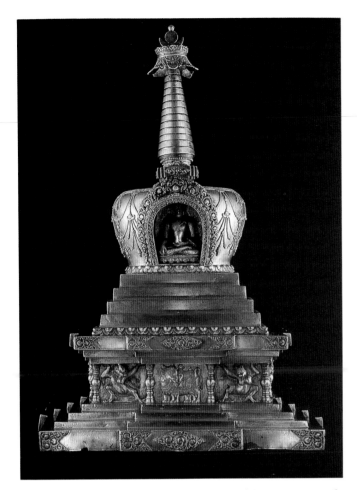

Fig. 1. Zanabazar, stupa with figure of Akshobhya. Gilt bronze. Museum of Fine Arts, Ulaanbaatar. From Béguin et al., *Trésors de Mongolie,* cat. no. 7.

Buddha's presence, such as images of his footprints, pervaded Buddhist imagery. Only with the development of the concept of the Three Bodies of the Buddha, which manifest themselves on different planes of reality, did artists begin to depict the Buddha's image.

The stupa lent itself to extremes of architectural interpretation in the different cultures that Buddhism came to influence. Thus in India it was a hemisphere surmounted by a set of umbrellas, while in China and Japan the umbrellas were emphasized, becoming literally the whole structure elongated into a multistory pagoda. In the Himalayan world, the stupa (T: *chörten*) took on a bulbous form, which could be used to house an image of a Buddha.

The structure chosen for this work of Zanabazar's school follows a model that developed in Tibet, Mongolia, and Manchuria under Mongol patronage. One of the earliest examples of this type of stupa was the Baita (White Pagoda) of the Miaoying Monastery in Beijing, designed by the Nepalese artist Anige and dedicated in 1271. Anige's talent as an architect was first demonstrated to the Mongols when he designed and built a golden stupa in Amdo (now Qinghai province).

The *History of Erdeni Zuu* records that Zanabazar cast

eight silver *suburgan* (stupas) in 1683, the same year he cast his Five Transcendent Buddhas. The number eight is not accidental but refers to the traditional group of eight built to mark the most important events in Shakyamuni's life.[1] One gilt stupa that lives up to the expectations of Zanabazar's exacting standards still remains in Mongolia (fig. 1), although it is impossible to say if it was originally part of the 1683 group.[2] This jewel-like reliquary houses a lovely image of Akshobhya. He faces east above a multileveled platform, each side of which is marked by the animal vehicle of the Buddha of each of the four quarters (Akshobhya's elephant, Amitabha's peacock, Ratnasambhava's horse, and Amoghasiddi's *garuda*). The school work seen here has all of these same characteristics, although it is built on a much smaller scale (and to a lower standard). Where Zanabazar's designs are cast into his stupa with opulent and fine detail, the present piece is much less delicately designed and it is simply engraved. The Buddha that originally occupied the niche (also Akshobhya, judging from its location) has been lost and replaced by a simple clay figure. This stupa was originally kept at Gandantegchinlin Monastery's Gungachoilin *aimag* (an administrative division of the monastery), until it was moved to the Bogdo Khan Palace Museum. At least two other similar stupas still exist, perhaps part of an original group of eight. One, with the bell-shaped body of the stupa commemorating Shakyamuni's nirvana,[3] is in the Choijin-Lama Temple; the other, with the familiar bulb-shaped body, is in the private collection of N. Tsultem.[4]

The stupa form that Anige developed for the Baita in 1271 had tremendous influence on the stupas of seventeenth- and eighteenth-century Mongolia, Manchuria, and Manchu-occupied China. Even the almost room-sized cloisonné stupas made for the imperial palace in Qianlong's day copy its distinctive profile, though without Zanabazar's energy.

—P.B.

1. Chandra, *Buddhist Iconography,* reproduces all eight from the *Bhadrakalpika Sutra Pantheon,* nos. 1074–81.

2. This stupa was included in the 1993–94 exhibition at the Musée Guimet, Paris. See Béguin et al., *Trésors de Mongolie,* cat. no. 7.

3. Chandra, *Buddhist Iconography,* no. 1081.

4. Tsultem, *The Eminent Mongolian Sculptor—G. Zanabazar,* pls. 72–73.

112. ZANABAZAR'S ANVIL

Late 17th–early 18th century
Iron with gilt fittings
H: 3¾ (9.6) W: 7⅜ (18.6) D: 6½ (16.5)
Museum of Mongolian History

All of Zanabazar's extant works are cast bronze sculptures (or, rarely, paintings), which suggests that among the artisans who accompanied him at the Fifth Dalai Lama's order when he returned from Tibet to Mongolia in 1651 were specialists in casting. This anvil is evidence that Zanabazar's output also originally included pieces in wrought metal, a technique where soft metal is hammered into sheets and then beaten into relief from the reverse side, usually with the help of a mold (repoussé). If the supposition that some of the artisans in Zanabazar's entourage were Nepalese Newaris is correct, then they were probably multitalented, skilled in several different metalworking traditions from casting to repoussé.

In fact, large-scale cast works like Zanabazar's, with their extravagant use of metal, are rare in the context of later Mongolian sculpture. By the nineteenth century, most sculpture made for the monasteries of Outer Mongolia came from Dolonnor, the Inner Mongolian seat of the Jangjya Khu-

tuktu, where many of the metalworkers were acculturated Chinese.[1] In Dolonnor most larger pieces were made of wrought copper alloys, built in sections of large, relatively thin sheets of metal (see, e.g., cat. nos. 83 and 84).

None of Zanabazar's wrought works have survived into the twentieth century (at least none have survived with an attribution to him intact), but a number of his cast pieces have contemporaneous repoussé aureoles done in a Nepalese- or Chinese-influenced style (e.g., cat. no. 99). His iron anvil, which is one of the few of his personal possessions to survive into modern times, has been enshrined like a relic in a gilt repoussé frame decorated with Chinese-inspired twining foliage and flames, lappets, and a *ruyi* (as-you-wish) border at the edge. —P.B.

1. See Bartholomew, "An Introduction to the Art of Mongolia";
Pozdneyev, *Mongolia and the Mongols*, p. 69.

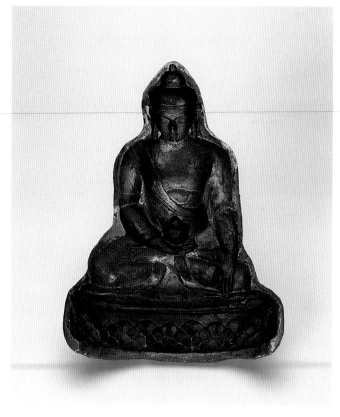

113.

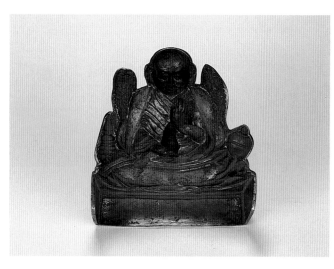

114.

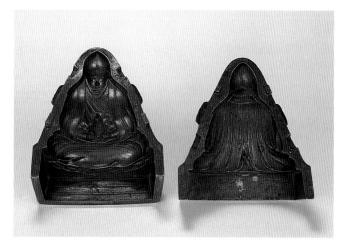

115.

19th century
Bronze
Buddha H: 9 (23.0) W: 7 (17.7) D: 4⅛ (10.5)
Zanabazar H: 5¾ (14.5) W: 6 (15.2) D: 2⅜ (6.0)
Lama H: 5¾ (14.5) W: 5 (12.6) D: 4⅜ (11.0)
Museum of Mongolian History (molds for
Zanabazar and lama)
Bogdo Khan Palace Museum (mold for Buddha)

Buddhists have long believed that by proliferating sacred images or texts they gain merit and improve their chances for a good rebirth. This belief was probably a significant impetus behind the invention of woodblock printing in China; the earliest known printed book is a copy of the *Diamond Sutra* dated 868, which was found at the Buddhist cave-temples of Dunhuang. Printing, and its allied technique, molding, allowed sacred images to be produced so inexpensively that even the humblest believer could own one.

In the world of Tibeto-Mongolian Buddhism, molding became one of the most popular ways of mass-producing religious imagery. Clay *tsha-tsha* (flat votive plaques) could be molded as simply as cookies and left simply to air-dry. Similarly, sophisticated metal figures were also produced in multiples using molds, but of a more complex sort that required a process involving several steps. These three bronze molds for images of Shakyamuni, Zanabazar, and another lama wearing the pointed hat of the Gelugpa were probably made in the nineteenth century to facilitate mass-production lost-wax casting, the technique Zanabazar himself favored for his large-scale sculpture.

This type of bronze mold was not used in the direct casting of molten bronze but to stamp out multiple wax models that melted away in the lost-wax casting process. (The surface of the mold of Shakyamuni still bears traces of a greasy material, perhaps mutton fat, which probably kept the wax from sticking to the bronze mold.) Once the wax models were molded, they were packed with clay, leaving channels in and out for the pouring in of the molten bronze and the release of the melted wax. These processes can still be observed among the Newari artists of Nepal's Kathmandu Valley, heirs to the same tradition Zanabazar imported to Mongolia in the mid-seventeenth century.[1] —P.B.

Published: Béguin et al., *Trésors de Mongolie,* cat. nos. 13 and 14 (molds for the lama and figure of Zanabazar)

1. Schroeder, *Indo-Tibetan Bronzes,* pp. 36–37.

Appendix 1

THE BOGDO GEGENS OF URGA AND THEIR CONTEMPORARIES

(Classical Tibetan forms of names follow the pronounced form.)

	LIFE DATES

BOGDO GEGENS

1. Zanabazar (S: Jñānavajra; M: Öndür Gegen) (Losang Tenbey Gyaltsen [Blo bzang bstan pa'i rgyal mtshan])	*1635–1723*
2. Losang Tenbey Drönmey (Blo bzang bstan pa'i srgon me)	*1724–1757*
3. Yeshe Tenbey Nyima (Ye shes bstan pa'i nyi ma)	*1758–1773*
4. Losang Tupten Wongchuk (Blo bzang thub bstan dbang phyug)	*1775–1813*
5. Losang Tsultrim Jikmey (Blo bzang tshul khrim 'jigs med)	*1815–1842*
6. Losang Palden Tenpa (Blo bzang dpal ldan bstan pa)	*1842–1849*
7. Ngawang Chökyi Wongchuk Trinley Gyatsho (Ngag dbang chos kyi dbang phyug 'phrin las rgya mtsho)	*1850–1868*
8. Ngawang Losang Chökyi Nyima Tenzin Wongchuk (Ngag dbang blo bzang chos kyi nyi ma bstan 'dzin dbang-phyug)	*1870–1924*

DALAI LAMAS

1. Gedündrup (Dge 'dun grub)	*1391–1475*
2. Gedün Gyatsho (Dge 'dun rgya mtsho)	*1475–1542*
3. Sonam Gyatsho (Bsod nams rgya mtsho)	*1543–1588*
4. Yonten Gyatsho (Yon tan rgya mtsho)	*1589–1617*
5. Ngawang Losang Gyatsho (Blo bzang rgya mtsho)	*1617–1682*
6. Tsangyang Gyatsho (Tshangs dbyangs rgya mtsho)	*1683–1746; deposed 1706*
7. Kelzang Gyatsho (Bskal bzan rgya mtsho)	*1708–1757*
8. Jampel Gyatsho ('Jam dpal rgya mtsho)	*1758–1804*
9. Lungton Gyatsho (Lung ston rgya mtsho)	*1806–1815*
10. Tsultrim Gyatsho (Chul khrims rgya mtsho)	*1816–1837*
11. Khedrup Gyatsho (Mkhas grub rgya mtsho)	*1838–1856*
12. Trinley Gyatsho (Phrin las rgya mtsho)	*1856–1875*
13. Thubten Gyatsho (Thub bstan rgya mtsho)	*1876–1933*
14. Tenzing Gyatsho (Bstan 'dzin rgya mtsho)	*b. 1935*

PANCHEN LAMAS ———————————————————————————————————

(The Chinese and Tibetan systems number the Panchen Lamas differently; both systems are used in this book.)

		LIFE DATES
1.	Khedrub Je (Mkhas grub)	*1385–1438*
2.	Sonam Choklang (Bsod Nams phyogs glang)	*1438–1505*
3.	Losang Döndrup (Blo bzang don grub)	*1505–1568*
4.	Losang Chökyi Gyaltsen (Blo bzang chos kyi rgyal mtshan)	*1569–1662*
5.	Losang Yeshe (Blo bzang ye shes)	*1663–1737*
6.	Losang Palden Yeshe (Blo bzang dpal ldan ye shes)	*1737–1780*
7.	Tenpai Nyima (Bstan pa'i nyi ma)	*1781–1852*
8.	Palden Chökyi Drakpa (Dpal ldan chos kyi grags pa)	*1853–1882*
9.	Gelek Namgyal (Dge legs rnam rgyal)	*1883–1937*
10.	Losang Chökyi Gyaltsen (Blo bzang phrin las lhun grub chos kyi rgyal mtshan)	*1938–ca. 1970*

REIGN DATES

QING EMPERORS ———————————————————————————————————

	REIGN DATES
Shunzhi	*1644–61*
Kangxi	*1662–1722*
Yongzheng	*1723–35*
Qianlong	*1736–95*
Jiaqing	*1796–1820*
Daoguang	*1821–50*
Xianfong	*1851–61*
Tungzhi	*1862–74*
Kuangxu	*1875–1908*
Xuantung	*1909–11*
Republic of China	*1911–49*
People's Republic of China	*1949–*

Appendix 2

TIBETAN TEXT OF "THE SECRET BIOGRAPHY OF THE EIGHTH BOGDO GEGEN"

na mo gu ru wi/phun tshogs bde legs 'byung gnas dus gsum gyi/rtsa brgyud bla ma yi dam dkon mchog gsum/dpa' bo mkha' 'gro chos skyong bsrung tshogs bcas/thugs rje'i dbang gis 'dir gshegs brtan par bzhugs/dza: hu bo ho: dam tshig pa dang gnyis su med par gyur/padma ka ma la sṭa/sangs rgyas thams cad 'dus pa'i sku/rdo rje 'dzin pa'i ngo bo nyid/dkon mchogs gsum gyi rtsa ba ste/bla ma rnams la phyag 'tshal lo/

(1)
rgyal ba gnyis pa **blo bzang** grags pa yi/**bstan pa'i rgyal mtshan** 'dzin pa'i mchog gyur ba/mtha' yas 'gro ba'i 'dren pa bla na med/rje btsun bla ma'i zhabs la phyag 'tshal lo/

(2)
blo gter ngur smrig gar rol tsong kha ba'i/lugs **bzang bstan pa'i sgron me** legs bzung nas/gdul bya'i yid kyi ma rig mun sel pa'i/yongs 'dzin dge ba'i bshes la phyag 'tshal lo/

(3)
ye shes lnga yi 'od zer bye ba rgyas/phyogs bcur 'phro zhing 'jig rten mun sel pa'i/**bstan pa'i nyi ma** byang phyogs 'gro ba'i mgon/rje btsun dam ba'i zhabs la phyag 'tshal lo/

(4)
rje btsun bla ma dam pa 'gro ba'i mgon/**blo** chen skal **bzang** rnam 'dren **thub** mchog gi/**bstan pa'i dbang phyug** 'jigs med rgya mtsho'i ste/skyabs kun ngo bor gyur la phyag 'tshal lo/

(5)
'dren mchog **blo bzang** grags pa'i chos **tshul** kun/thub bstan **khrims** gnyis mkha' la legs shar te/**'jigs med** bstan pa'i rgyal mtshan 'dzin mkhas pa/rje btsun bla ma zhabs la phyag 'tshal lo/

(6)
blo gros **bzang** po **dpal ldan** thub dbang gi/mdo sngags **bstan** pa'i ring lugs ma lus 'dzin/bdud dpung kun bcom chos kyi rgyal mtshan bsgreng/rje btsun bla ma'i zhabs la phyag 'tshal lo/

(7)
zhva ser mdo sngags bstan pa'i gsal byed kyi/mkhas btsun **ngag dbang chos kyi dbang phyug** mchog/gzhan phan **'phrin las rgya mtsho** lhun grub pa'i/skyabs gnas kun 'dus ngo bor phyag 'tshal lo/

(8)
ngag dbang blo gros **bzang** po'i mkha' dbyings su/**chos kyi**

nyi ma gcig gi gzi byin gyis/**bstan** pa'i pad tshal **'dzin** cing spel gsum gnyin/rje btsun **dbang phyug** chen por phyag 'tshal lo/

dpal ldan ye shes ma 'ongs ka la ba'i/nor bu'i khri la zhabs song 'god pa'i tshe/sa yi bdag po'i bka' bzhin sgrub mdzad pa'i/dmag dpon dpa' bo rol par gsol pa 'debs/dpung tshogs yan lag bzhi yi kla klo'i tshogs/bcom ste sa chen dum bu bcu gnyis la/dbang bsgyur 'khor los bsgyur rgyal drag po yi/'dus pa dang po'i 'khor du skye bar shog/gzhan yang skye phreng kun tu dal 'byor rten/thob cing zhva ser bstan dang mjal pa dang/mgon po mchog gi zlos gar dge ba'i bshes/mtshan nyid ldan pas 'bral med rjes 'dzin shog/tshe 'di'i phun tshogs sgyu ma'i zlos gar dang/'khor ba'i dpal 'byor chu shing ltar mthong nas/byams dang snying rjes brgyan pa'i sems bskyed kyis/slabs chen rgyal sras spyod la 'jug par shog/dbang bzhi'i chu bos sgo gsum sgrib spyangs te/dngos grub rtsa ba dam tshig sdom pa rnams/srog las gces par bsrung ste rim gnyis kyi/lam bzang mthar phyin zung 'jug myur thob shog/bsod nams zhing gi mchog gyur rje bla ma'i/sgyu 'phrul tshogs la gus pas gsol btab mthus/zhing der nad mug 'khrug rtsod la sogs pa/mi mthun rgud pa'i tshogs rnams zhi bar shog/char chu dus phebs lo phyugs rtag legs shing/rgyal po 'bangs bcas dge bcu'i lam la gnas/bstan dang bstan 'dzin zhabs pad brtan pa sogso/legs tshogs dbyar mtsho lta bur 'phel gyur cig/skye ba kun tu yongs dag bla ma dang/'bral med chos kyi dpal la longs spyod cing/sa dang lam gyi yon tan rab rdzogs nas/rdo rje 'chang gi go 'phang myur thob shog/rmad 'byung rnam thar gtsang ma'i khrims dang ldan/rlabs chen rgyal sras spyod pa'i snying stobs che/bde stong mchog gi rim gnyis rnal 'byor spyod/blo bzang rgyal ba'i bstan dang mjal bar shog/

Byin rlabs mchog stsol rtsa brgyud bla ma dang/dngos grub char 'bebs yi dam zhi khro'i lha/bar gcod kun sel mkha' 'gro chos bsrung la/sgo gsum gus pa chen po phyag 'tshal lo/dngos bshams yid kyis sprul pa'i mchog pa'i tshogs/nam mkha' khyab srid yongs su bkang ste 'bul/thog med nas bsags sdig ltung bshags shing sdom/skye 'phags ji snyed dge la rjes yi rang/zab rgyas chos kyi 'khor lo bskor bar bskul/'khor mtha' srid du brtan bzhugs gsol ba 'debs/'dis mtshon ma lus dge ba'i phung po rnams/dus gsum sras bcas rgyal bas yongs smon bzhin/'gro kun ma rig mun pa kun bsang ste/kun mkhyen ye shes snang ba rgyas phyir bsngo/cher snyigs mun chen lhag par gtibs pa yi/bdag cag dus ngan 'gro la thugs rjes skyobs/las ngan nyon mongs 'bras bu dus smin pa'i/sna thsogs sdug bsngal me chen kun zhi nas/yun tshun khon bral byams brtses

307

yid mthun pa'i/bde legs phun thsogs rgyas par mdzad du
gsol/skyobs shig bde legs phun thsogs rgyas par mdzad du
gsol/skyobs shig skyobs shig bslu ba med pa'i mgon/gzigs shig
gzigs shig tshad med thugs rje'i gter/ma g.yel ma g.yel ston
gyi thugs dam gnyan/dgongs shing dgongs te myur ba nyid
du skyobs/rgyal bstan nyi 'od phyogs bcur rgyas pa dang/'gro
kun bde skyed dpal la rtag spyod cing/sgrib byar tshogs rdzogs
kun mkhyen go 'phang la/myur zhing myur ba nyid du rig
gyur cig/bla ma mchog gsum bden pa'i byin rlabs dang/chos
dbyings 'gyur med rten 'brel bslu med mthu/bdag sogs mos
pa chos bsrung 'phrin las kyis/re 'bras mtha' dag yid bzhin
'grub par shog/skyabs kun 'dus pa bla ma'i byin rlabs kyis/
gnas skabs mthar thug rkud pa kun zhi nas/srid dang zhi ba'i
legs tshogs lhun grub pa'i/phun tshogs dpal la rol pa'i bkra
shis shog/

na mo manyju shrī gho shā ya/dkon mchog gsum la phyag
'tshal lo/thugs rje'i bdag nyid bla ma dang/dkon mchog gsum
dang yi dam lha/lha yi drang srong mngon shes can/lhag pa'i
smon lam 'grub par shog/mir gyur yul dbus skye ba dang/
dbang po tshang zhing gnas la dad/de bzhin las mtha' ma log
pa'i rang 'byor lnga dang ldan par shog/sangs rgyas byon
dang dam chos gsungs/bstan pa gnas dang der rjes 'jug/gzhan
phyir rtag tu snying brtse ba'i/gzhan 'byor lnga dang ldan par
shog/dmyal ba yi dvags dud 'gro dang/tshe ring kla klo log lta
dang/sangs rgyas kyis stong lkugs pa ste/mi khom brgyad las
thar bar shog/dad pa dang ni gtong ba dang/thos dang tshul
khrims shes rab dang/khrel yod ngo tsha shes pa dang/'phags
nor bdun dang ldan par shog/tshe ring nad med bde skyid la/
gzugs dang skal pa bzang dang rigs/nor dang shes rab dag
dang bdun/yon tan bdun dang ldan par shog/sde snod gsum
dang rgyud sde bzhi/'chad rtsol 'khrul pa mi mnga' ba'i/thugs
rje'i rgyun chad med pa yi/bla ma rnams dang 'jal bar shog/
des gsungs so thar byang sems dang/rig 'dzin sngags kyi bslab
bya rnams/ji ltar mnos bzhin bsrung ba dang/gong nas gong
nus phel bar shog/gsal stong dbyer med rtogs pa dang/snang
stong zung du 'jug pa dang/bde stong bla na med pa yis/sgrib
gnyis bad chags dag par shog/'dod pa chud zhing chog shes
dang/byang chub sems dang ldan pa yi/log pa'i 'tsho ba kun
spangs nas/chos kyi 'tsho bas 'tsho bar shog/gang zhig dgra
bcom pha ma gsod/mthun pa'i dge 'dun dbyen byed cing/de
bzhin gshegs pa'i sku khrag 'byin/mtshams med lnga las thar
par shog/mchod rten bsheg dang byang sems gsod/dge slong
ma rnams sun 'byin dang/slob pa gsod cing chos nor brku/
nye ba lnga las thar par shog/gsod rku brdzun dang 'dod log
spyor/phra ma tshig rtsub ngag 'khyal smra/brnab sems gnod
sems log par lta/mi dge bcu las thar par shog/mnar med rab
tsha tsha ba dang/ngu 'bod che dang ngu 'bod chung/bsdus
'joms thig nag g.yang sos te/tsha dmyal brgyad las thar par
shog/chu bur can dang chu bur rdol/so tham a chu kyi hud
dang/u tpal padma cher gas te/grang dmyal brgyal las thar par
shog/nye che nye 'khor ro myags 'dam/mi gtsang mdam dang
me mur 'obs/chu bo rabs med shal ma ri/de dag gnas las thar
par shog/phyi sgrib can dang nang sgrib can/zas skom gnyis
ka'i sgrib pa can/me lce'i 'khor lo can la sogs/yi dvags gnas las
thar par shog/bying na gnas dang kha 'thor dang/glin lkugs
gcig la gcig za dang/gsod gcod bkol 'rdung byed pa ste/dud
'gro'i gnas las thar par shog/lha la 'pho dang lhung ba dang/
lha ma yin la 'thab rtsod dang/mi la skye rgan 'chi sogs/sdug
bsngal kun las thar par shog/'jam pa'i dbyangs kyi shes rab
dang/spyan ras gzigs kyi thugs rje dang/phyag na rdo rje'i
mthu stobs kyi/bde ba can du skye bar shog/shā ri'i bu yi
bslab pa dang/mo'u gal bu yi rdzu 'phrul dang/kun dga' bo'i
thos pa yis/bde ba can du skye bar shog/klu sgrub snying po'i
mkhyen pa dang/sa ra ha pa'i rtags pa dang/shā w'ai yi nus
mthu yis/bde ba can du skye bar shog/dkon mchog gsum gyi
bden pa dang/sangs rgyas byang sems byin rlabs dang/tshogs

gnyis yongs rdzogs mda' thang dang/chos nyid bden pas 'grub
par shog/dge ba'i rta la rab zhon nas/smon lam srab kyis kha
lo bsgyur/brtson 'grus lcags kyis myur bskul nas/thar ba'i
gling du bgrod par shog/spangs rtogs mthar phyin sangs rgyas
dang/lung dang rtogs pa'i dam pa'i chos/sa bcu'i byang sems
dge 'dun ste/dkon mchog gsum gyi bkra shis shog/phun
tshogs sku gsum go 'phang mchog brnyes kyang/bsam bzhin
blo bzang rgyal ba gnyis pa yis/bstan pa'i rgyal mtshan 'dzin
pa'i mchog 'gyur ba/rje btsun bla ma'i zhabs la phyag 'tshal
lo/bdag gsogs mar gyur 'gro ba ma lus pa/rnam dag dge ba'i
las la brtson pa'i mthus/ring por mi thogs byang phyogs
shambha lar/skyes nas rgyal sras spyod pa mthar phyin shog/
ha nu manta drag po'i tshul bzung nas/dam nyams dgra bgegs
snying la mtshon gzer ba'i/dus 'dir bdag kyang khyod kyis
'khor nyid du/skye nas mgon khyod mnyes pa byed par shog/
'di ltar smon lam btab pa'i 'gro ba kun/drin can bla mar 'bral
med rjes 'dzin cing/sgrib gnyis sa bon myur du spang nas ni/
don gnyis mthar phyin rdzogs gsangs myur thob shog/

rgyal ba ma lus skyed pa'i yab gyur kyang/
rgyal sras tshul gyis zhing khams rab 'byams su/
rgyal ba'i chos 'dzin thugs bskyed bden pa'i mthus/
blo bzang rgyal ba'i bstan pa rgyas gyur cig/

sngon tshe dbang po'i tog gi spyan snga ru/
dam bcas tshe na snying stobs chen po zhes/
sras bcas rgyal bas bsngags brjod bden pa'i mthus/
blo bzang rgyal ba'i bstan pa rgyas gyur cig/

lta spyod gtsang ma'i brgyud pa spel ba'i phyir/
thub pa'i drung du shel dkar phreng ba phul/
chos dung gnang zhing lung bstan bden pa'i mthus/
blo bzang rgyal ba'i bstan pa rgyas gyur cig/

lta ba rnam dag rtag chad mtha' las grol/
sgom pa rnam dag bying rmugs mun pa gsangs/
spyod pa rnam dag rgyal ba'i bka' bzhin bsgrubs/
blo bzang rgyal ba'i bstan pa rgyas gyur cig/

mang du thos pa rgya cher btsal bas mkhas/
thos don ji bzhin rgyud la spyar bas btsun/
kun kyang bstan 'gro'i don du bsngo bas bzang/
blo bzang rgyal ba'i bstan pa rgyas gyur cig/

drang des gsang rab ma lus 'gal med du/
gang zag gcig gi nyams len gdams pa ru/
nges pa rnyed pas nyes spyod mtha' dag 'gags/
blo bzang rgyal ba'i bstan pa rgyas gyur cig/

lung chos sde snod gsum gyi 'chad nyan dang/
rtogs pa'i bstan pa bslab gsum nyams len te/
mkhas shing grub pa'i rnam thar rmad du byung/
blo bzang rgyal ba'i bstan pa rgyas gyur cig/

phyi ru nyan thos spyod pas zhi zhing dul/
nang du rim gnyis rnal 'byor gdengs dangs ldan/
mdo sngags lam bzang 'gal med grogs su 'khyer/
blo bzang rgyal ba'i bstan pa rgyas gyur cig/

rgyu yi thig par bshad pa'i stong pa nyid/
'bras bu'i thabs kyis sgrub pa'i bde chen dang/
mnyam spyod chos phung brgyad khri'i snying po'i bcud/
blo bzang rgyal ba'i bstan pa rgyas gyur cig/

skyes bu'i gsum gyi lam gyi srung ma'i gtso/
myur mdzad mgon dang rnam sras las gshin sogs/
bstan srung dam can rgya mtsho'i mthu stobs kyis/
blo bzang rgyal ba'i bstan pa rgyas gyur cig/

mdor na dpal ldan bla ma'i sku tshe brtan/
mkhas btsun bstan 'dzin dam pas sa steng gang/

bstan pa'i sbyin bdag mnga' thang dar pa yis/
blo bzang rgyal ba'i bstan pa rgyas gyur cig/

na mo gu ru bya: skyabs mgon blo bstan pa'i nyi ma dang/drin
can blo bzang bstan 'dzin rgya mthso'i mchog/dbyer med bla
ma rdo rje 'jigs byed la/sgo gsum rtse gcig gus pa gsol ba
'debs/'di phyi par do'i gnas skabs thams cad du/skyed rung
sdug rung gnas skabs cir 'gyur kyang/re sa gzhan na med do
thugs rjes gzigs/'bral ba med par rjes su bzung du gsol/khyad
par kā la pa yi ljongs bzang du/drag po 'khor los gdul bya
spyod pa'i tshe/'khor gyi thog ma nyid du bdag gyur nas/
zung 'jug rdo rje 'chang dbang thob par shog////gnas skab su
yang tshe ring nad med cing/rnam dkar dge tshogs yar zla'i/
rjes song ste/bde skyid dpal 'byor rgyas pa'i dga' ston la/ci
dkar spyod pa'i dge mtshan 'bar bar shog/

skyabs gsum kun 'dus bla ma rdo rje 'chang/snod rung gdul
byar bshes gnyen skur bstan nas/mdo sngags zab mo'i gnang
rnams stsol mdzad pa'i/drin can bla ma rnams la gsol ba
'debs/bdag sogs mar gyur 'gro ba ma lus pa/rnam dag dge
ba'i las la brtson pa'i mthus/ring por mi thogs byang phyogs
shambha lar/skyes nas rgyal sras spyod pa mthar phyin shog/
'di ltar cung zad smon pa'i dge ba'i mthus/bslu med dkon
mchog gsum po skyabs bzung nas/sgrib gnyis sa bon myur du
spangs nas ni/don gnyis mthar phyin rdzogs sangs myur thob
shog/

phun tshogs sku gsum go 'phang mchog brnyes kyang/bsams
bzhin blo bzang rgyal ba gnyis pa yis/bstan pa'i rgyal mtshan
'dzin pa'i mchog 'gyur ba/rje btsun bla ma'i zhabs la phyag
'tshal lo/bdag sogs mar gyur 'gro ba ma lus pa/rnam dag dge
ba'i las la brtson pa'i mthus/rim por mi thogs byang phyogs
shambha lar/skyes nas rgyal sras spyod pa mthar phyin shog/
ha nu manta drag po'i tshul bzung nas/dam nyams dgra bgegs
snying la mtshan gzer ba'i/dus 'dir bdag kyang khod kyis 'khor
nyid du/skye nas mgon khyod mnyes pa byed par shog/'di ltar
smon lam btab pa'i 'gro ba kun/drin can bla mar 'bral med
rjes 'dzin cing/sgrib gnyis sa bon myur du spangs nas ni/don
gnyis mthar phyin rdzogs sangs myur thob shog/phun gsum
tshogs pa mnga' ba gser gyi ri bo 'dra/'jig rten gsum gyi mgon
po dri ma gsum spangs pa/sangs rgyas padma 'dab ma rgyas
'dra'i spyan mnga' ba/'di ni 'jig rten dge ba'i bkra shis dang
po'o/de yi nye bar dam pa'i mchog rab mi g.yo ba/'jig rten
gsum grags shing hla dang mis mchod pa/chos kyi dam pa
skye dgu kun la zhi byed pa/'di ni 'jig rten dge ba'i bkra shis
gnyis pa'o/dge 'dun dam pa'i chos ldan thos pa'i bkra shis
phyug/mi dang lha dang hla ma yin gyi mchod pa'i gnas/
tshogs kyi tshogs rab ngo tsha shes dang dpal gyi gzhi/'di ni
'jig rten dge ba'i bkra shis gsum pa'o//tatya thā/om paltsa gīla
a bo dha ni svā hā//

rje btsun dam pa sku 'phreng brgyad pa rje btsun ngag dbang
blo bzang chos kyi nyi ma bstan 'dzin dbang phyug dpal bzang
po'i dag snang gsang ba'i rnam thar zhes bya ba bzhugs so/'di
ni bshin tu gsang ba yin no/

Chronology

CHINA

THE WEST

1127	Song dynasty forced south by invading Jin Tartars
1215	Beijing falls to the Mongols
1271	Anige's Baitai (White Pagoda) dedicated in Dadu
1272	Khubilai Khan proclaims Yuan dynasty in China
1279	Mongols destroy Southern Song
1294	Khubilai Khan dies
ca. 1300	Mongol emperors subsidize printing of Tripitaka
1340s	Yellow River floods
1345	Juyong Gate dedicated north of Beijing
1368	Yuan falls to Zhu Yuanzhang; last Yuan emperor, Toghon Temür, flees to Inner Mongolia
	Zhu Yuanzhang founds Ming dynasty (1368–1644)
1407	Tibetan Fifth Karmapa invited to Nanjing to perform funeral services for parents of Yongle emperor (r. 1403–24)
1409	Ming attacks Eastern Mongols
1449	Ming war with Esen; emperor is kidnapped by Mongols

1130–44	Abbé Suger builds first true Gothic church at St. Denis
1202–4	Fourth Crusade launched
1210	St. Francis of Assisi founds Franciscan Order (Friars Minor)
1215	Magna Carta signed in England
1237–42	Mongol armies conquer southern and central Russia and campaign in Eastern Europe
1246	Giovanni dal Piano del Carpine carries papal letters to Mongols importuning peace
1248	St. Louis, king of France, sends embassy to Mongols
1271	Marco Polo leaves Venice for the East
1291	Fall of Acre to forces of Sultan al-Ashraf al-Khalil
1304–12	Giotto paints the Arena Chapel in Padua
1313–21	Dante writes *The Divine Comedy*
1338–1453	The Hundred Years War
1348–49	The Black Death kills millions in Europe
1431	Jeanne d'Arc martyred
1453	Fall of Constantinople to the Turks
1480	Ivan III founds "Third Rome" in Moscow
1480–1502	Golden Horde destroyed in Russia
1492	Columbus journeys to America

1522–66	Buddhist persecutions under Ming Jiajing emperor
1582	Jesuit missionary Matteo Ricci arrives in Macau; Wanli emperor (r. 1573–1621) invites Dalai Lama Sonam Gyatsho to visit Chinese court

1508–12	Michelangelo paints the Sistine Chapel ceiling
1517	Martin Luther posts his 95 Theses and begins Protestant Reformation
1519–21	Magellan completes first circumnavigation of globe
1534	Jesuit order founded by Ignatius Loyola
1543	Copernicus publishes *De revolutionibus orbium coelestium*
1546–63	St. Peter's is built in Rome
1549	The Jesuit St. Francis Xavier arrives in Japan
1558–1603	Elizabeth I reigns in England
1590–1613	Shakespeare writes his plays

MONGOLIA		TIBET	
1600s			
1616	Nurhaci proclaims Later Jin dynasty	1601	Fourth Dalai Lama, grandson of Altan Khan, is enthroned
1628–29	Ligdan Khan of the Chahar supports translation of Tibetan Buddhist canon into Mongolian	1617	Fourth Dalai Lama dies; Fifth is born; Mongol Güshri Khan comes to Dalai Lama's aid against king of Tsang and Karmapa
1634	The Manchu Huang Taiji drives Ligdan out of Chahar to the west; Ligdan dies of smallpox	1617–18	Jonang Taranatha restores Puntsagling
1635	Öndür Gegen (Zanabazar) is born in Khalkha	1634	Taranatha dies
1639	Zanabazar selected head of Mongolian Buddhist church in Khalkha	1641–42	Güshri Khan imprisons king of Tsang and installs Fifth Dalai Lama as leader of Tibet
1649	Zanabazar departs for Tibet, where he is named Jebtsundamba Khutuktu (Bogdo Gegen)	1645	Potala Palace founded
1650–52	Zaya Pandita of the Oirats translates Buddhist canon into Western Mongolian	1650–51	Zanabazar visits the Panchen and Dalai Lamas and is recognized as reincarnation of Taranatha
1652	Zanabazar constructs his monastery at Urga	1653	Fifth Dalai Lama visits Beijing
1655	Zanabazar once again leaves for Tibet	1655	Zanabazar returns to Tashilunpo to visit Panchen Lama
1656	Zanabazar returns to Khalkha	1682	Fifth Dalai Lama dies; his death is kept secret
1683	Zanabazar casts his Vajradhara, Five Transcendent Buddhas, and eight silver *suburgan*	1695	Potala Palace completed
1688	Galdan destroys Urga monasteries		
1691	Zanabazar seeks Manchu protection against Galdan		
1696	Galdan is annihilated by the Manchus		
1700s			
1706	Zanabazar rebuilds Urga at Čečeglig-ün erdeni tolughai	1707	Italian Capuchin monks arrive in Tibet
1717	The Jangjya Khutuktu Rolpay Dorje is born in Amdo	1716	Jesuit Ippolito Desideri arrives in Lhasa
1723	Zanabazar dies at Yellow Monastery in Beijing	1717–20	Zunghar Mongols occupy and sack Lhasa
1737	Amarbayasgalant established as imperial Manchu monastery and repository of Zanabazar's relics	1751	Qing Qianlong emperor recognizes Dalai Lama as ruler of Tibet, under supervision of Manchu *amban*
1756–57	Mongols rebel against Manchu Qing	1774–75	George Bogle mission to Tibet establishes relations with Panchen Lama
1757	Manchus declare Bogdo Gegens must be Tibetan	1780	Panchen Lama visits Jehol and Beijing
1800s			
1809	Fourth Bogdo Gegen builds Gandantegchinlin at Urga	1854–56	Conflict with Nepal
1811	First *tsam* held in Khalkha	1876	Birth of Thirteenth Dalai Lama
1820–36	Maidar Temple built in Urga		
1870	Eighth Bogdo Gegen born		
1890s	The Russian Aleksei Pozdneyev travels in Mongolia		
1900s			
1911	Fall of Qing; Mongolian independence; Eighth Bogdo Gegen enthroned as emperor of Mongolia	1904	British envoy Younghusband forces his way into Lhasa; Dalai Lama flees to Mongolia
1915	Tripartite Treaty of Khiakhta returns Khalkha to Chinese suzerainty	1909	Dalai Lama returns to Tibet
1921	Mongolian Communist Revolution	1910	Restoration of Chinese control over Eastern Tibet
1924	Eighth Bogdo Gegen dies; Mongolian People's Republic established	1911	Uprising against Chinese
1930s	Buddhist purges	1920–21	Growth of Dalai Lama's power; Panchen Lama flees to China
1932	Rebellion of monks	1933	Thirteenth Dalai Lama dies
1937	Government policy of no tolerance toward Buddhism; monasteries destroyed	1934	Reting appointed regent
		1935	Fourteenth Dalai Lama born
		1949	Tibet annexed after Chinese Revolution

	CHINA			THE WEST
1636	Manchus change their dynastic name from Jin to Qing		1602	Dutch East India Company founded to control trade with the East
1644	Manchus topple Ming dynasty and become emperors of China		1611	St. James Bible published
1653	Fifth Dalai Lama visits Beijing		1617	Samuel Purchas publishes *Purchas His Pilgrimages,* describing Khubilai Khan's pleasure dome in Xanadu
1662–1722	Kangxi emperor reigns, sympathetic to Tibetan Buddhism; invites European Jesuits to court		1632	Galileo publishes *Dialogue on the Two Great World Systems*
1691	Khalkhas submit to Manchu authority; Zanabazar swears allegiance to Kangxi at Dolonnor		1682	Louis XIV moves French court to Versailles
1696	Kangxi pacifies Zunghar threat			

	CHINA			THE WEST
1717–20	Mongolian Buddhist canon published by order of Kangxi		1726	Jonathan Swift publishes *Gulliver's Travels*
1736	Qianlong emperor assumes throne		1767	Catherine the Great promulgates her *Instructions for Radical Social Reform*
1742–49	Tanjur translated into Chinese at imperial command		1789	Storming of the Paris Bastille
1744	Yonghegong in Beijing rededicated as an imperial monastery of Tibetan Buddhism		1793	Execution of Louis XVI
1755–80	Monasteries at Jehol (Chengde) built		1797	Samuel Taylor Coleridge writes "Kubla Khan"
1780	Qianlong hosts Panchen Lama at Jehol and Beijing			
1795	Qianlong abdicates in favor of his son			

	CHINA			THE WEST
1839–40	Opium Wars		1804	Napoleon crowned emperor of France
1851–64	Taiping Rebellion		1812	Napoleon invades Russia
1894–95	Sino-Japanese War		1815	The Battle of Waterloo
			1845	Irish famine and the Great Migration
			1859	Charles Darwin publishes *The Origin of Species*
			1877	Queen Victoria of England crowned empress of India

	CHINA			THE WEST
1900	Boxer Rebellion; international force captures Beijing		1900	Sigmund Freud publishes his *Interpretation of Dreams*
1908	The Empress Dowager Cixi dies		1904	Russo-Japanese War
1911	Qing dynasty falls; Republic of China established		1917	The October Revolution ends tsarist rule of Russia
1915	Yuan Shikai reigns briefly as Hongxian emperor		1914–19	World War I
1924	Kuomingtang holds first National Congress in Canton		1922	James Joyce's *Ulysses* published
1934–36	Mao Zedong leads Communists on the Long March to Yenan		1938	The *Anschluss*
1935	Japanese seize parts of Manchuria Inner Mongolia		1939	Germans invade Poland
1937–45	Sino-Japanese War—World War II			
1945–49	Civil War between Kuomingtang and Communists			
1949	People's Republic of China founded			

Glossary

acharya (S): an Indian teacher or spiritual guide.

aimag (M): any of the districts in Mongolia.

airag (M): fermented mare's or cow's milk, the national drink of Mongolia.

Akshobhya (S): "Unshakable," one of the Five Transcendent Buddhas, the Buddha of the East.

Altan Khan (1507–1582): a descendant of Chinggis Khan; the Mongolian ruler who instigated the Mongol renaissance in the sixteenth century. He gave Sonam Gyatsho the title of Dalai Lama in 1578, thereby formalizing religious and political interdependence between Mongolia and Tibet.

Amarbayasgalant (M): a monastery north of Urga commissioned by the Yongzheng emperor (r. 1723–35) to hold the relics of Zanabazar.

amban (C): Chinese imperial envoys and administrators in Mongolia and Tibet.

Amitabha (S): "Boundless Light," one of the Five Transcendent Buddhas, the Buddha of the West and also of the Western Paradise (Sukhavati) or Pure Land. He is associated with the Buddha Amitayus (Infinite Life) and is considered the spiritual father of the bodhisattva Avalokiteshvara.

anda (M): Mongolian blood brothers sworn to loyalty.

Anige: an esteemed Nepalese artist brought to Khubilai's court in the thirteenth century on Phagspa's recommendation; originator of the Sino-Tibetan style.

arhat (S; C: *luohan*): "the worthy one," one of the disciples of the historic Buddha Shakyamuni; a spiritual practitioner who has achieved a high degree of release from passions and attachments.

Aru Mongghol (M): Outer Mongolia or Khalkha ("Northern [or back] Mongolia"), a sovereign nation until recently under jurisdiction of the Soviet Union. So-called because it lay outside the northern border of the Qing empire.

Astasahasrika Prajnaparamita (S): "The Perfection of Wisdom in Eight Thousand Lines," an important Mahayana sutra.

Avalokiteshvara (S): the Bodhisattva of Compassion, one of the most popular and important Buddhist deities.

Barga (M): a tribe living in the easternmost areas of Outer Mongolia, near Manchuria.

Bayan Jirüke (M): one of the four northern Mongolian mountains whose spirit was worshiped; represented in the Mongolian *tsam* as a yellow-faced prince.

Begtse (T; M: Jamsaran): one of the Eight Guardians of the Law and chief protector of Mongolia; protective deity of the Dalai Lamas and the Bogdo Gegens.

bodhisattva (S): a being destined for enlightenment; a deity who delays his own attainment of nirvana in order to minister compassionately to other sentient beings.

Bogdo Gegen (M): "Resplendent Saint," another name for the Jebtsundamba Khutuktu, the highest incarnation and prime prelate of the Buddhist clergy of Outer Mongolia.

Bogdo Khan (M): the title given to the Eighth Bogdo Gegen (1870–1924), the last of his line.

Bogdo Ula (M): the sacred mountain south of Ulaanbaatar whose spirit was worshiped in shamanist tradition; represented in the Mongolian *tsam* as a Garuda bird with a snake in its beak.

Bön (T): the indigenous pre-Buddhist religion of Tibet.

Buddha (S): an epithet for a perfectly enlightened being. Sometimes refers specifically to the historic Buddha Shakyamuni (Siddartha Gautama, c. 563–483 B.C.).

Buriat (M): a tribe living traditionally in a northern area of Outer Mongolia (today within Russian borders), to the west, east, and south of Lake Baikal.

Čaghan ebügen (M): the White Old Man, a comic and symbolic figure in the Mongolian *tsam*, is a shamanist folk figure who was incorporated into the Buddhist pantheon by the early seventeenth century.

Čenggeltü (M): a mountain spirit worshiped in the shamanist tradition; one of the Lords of the Four Mountains who appeared as characters in the *tsam*.

Chahar (M): a people of eastern Inner Mongolia.

Chakravartin (S): universal monarch; ideal ruler.

chörten (T): *See* stupa.

Da Khüree (M): "Great Circle" (also Yikh Khüree, Daküriyen, Yeke küriyen, Neyislel küriyen), name for historic city of Urga, seat of the Bogdo Gegens; modern Ulaanbaatar. *See also* Urga.

Dalai Lama (T; M): *Dalai* (M) means "ocean," and *lama* (T), "spiritual master." In 1578 Sonam Gyatsho, an incarnate-lama at Drepung Monastery in Tibet, received this honorific title from the Mongol Altan Khan. The Great Fifth Dalai Lama, Losang Gyatsho, was invested with secular and spiritual authority over Tibet, and the Dalai Lama ruled in this capacity until 1959, when the Fourteenth Dalai Lama fled Chinese occupation. He heads the Tibetan government-in-exile in Dharamsala, India.

darkhan (M): a blacksmith or silversmith.

del (M): the Mongolian national dress.

dharani (S): a group of syllables believed by Buddhists to generate power, used as a charm or prayer.

Dharma (S): "the law," a Sanskrit word often used as a name for the Buddhist religion and its principles.

Dharmapala (S): fierce deities who are protectors of Buddhism usually after having been converted to the faith. Well known among these are Mahakala, Palden Lhamo, Begtse, and Dorje Dordan.

Dolonnor (M): a city in Inner Mongolia with two important Buddhist monasteries.

dorje (T): "Lord of Stones." The most important symbol in Tibetan Buddhism, the *dorje* stands for diamondlike and thunderbolt, and is based on the Indian *vajra*, symbol of the Indian pre-Buddhist god Indra. The *dorje* is a male symbol representing skillful means. The pairing of the *dorje* with the bell stands for the union of wisdom and compassion, which leads ultimately to enlightenment.

Drepung: the largest monastery in Tibet, founded in 1416 by the Gelug order.

Ekh Dagin (M): "Mother Dakini," title given to Dondogdulam, wife of the Eighth Bogdo Gegen.

Erdeni-yin tobči (M): a history of Mongolia written in the mid-seventeenth century by Saghang Sečen.

Erdeni Zuu (M): the largest monastery in Outer Mongolia, constructed in 1586 by Abadai Khan near the early Mongol capital of Kharakhorum.

Gandantegchinlin: a large monastery in Ulaanbaatar bearing the same name as Ganden in Tibet.

Ganden (T): Ganden is Tibetan for Tushita, the heavenly paradise of the bodhisattva Maitreya. Ganden Monastery, east of Lhasa, was founded by Tsongkhapa in 1409.

Ganesha: a Hindu deity associated with prosperity, auspiciousness, beginnings; also called the Lord of Obstacles. He has a human body and an elephant's head.

ga'u (T): a reliquary box worn by men and women of Tibet.

Gelug (T): a reform Buddhist order founded by the intellectual visionary Tsongkhapa in the fourteenth century. *Gelugpa* refers to a person, text, monastery, idea, etc., belonging to the Gelug order.

ger (M): a Mongolian felt tent; also called "yurt," a term derived from Turkic languages. The primary Mongolian architectural form, it is a mobile nomadic dwelling that endures throughout Mongolia today.

Geser of Ling (T): a mythical Tibetan messianic hero whose cult was encouraged in Mongolia by the Manchus.

Hayagriva (S): one of the Great Protectors and one of the most popular *yidam* among the Gelugpa. Considered in Buddhism to be a manifestation of Avalokiteshvara, his imagery combines the Hindu god Vishnu and the savior horse Balaha.

Hevajra (S): a *yidam* of lightning *(vajra)* considered to represent the eternal. In tantric Buddhism, the fearful aspect of Vajrasattva.

Jangjya Khutuktu (T; M): the title of successive incarnate-lamas who ruled from Beijing and Dolonnor and propagated Tibetan Buddhism during the Qing dynasty. Best known in the lineage is Rolpay Dorje (1717–1786), who instigated the publication of a new edition of the Kanjur and Tanjur, and who authored Buddhist dictionaries and iconographic albums.

jasag (M): a Banner prince.

Jebtsundamba Khutuktu (T): *See* Bogdo Gegen.

jud (M): lack of forage, which leads to loss of livestock.

Jula-yin bayar (M; T: Ganden Namcho): Festival of Lights held to commemorate the death of Tsongkhapa.

Kadam (T): a Tibetan Buddhist order, founded by Atisha, that developed into the Gelug order. *Kadampa* refers to a person or thing associated with the order.

Kagyu (T): a Tibetan Buddhist order founded by Marpa, Milarepa, and Gampopa, tracing its origins to the Indian Great Adepts Tilopa and Naropa. *Kagyupa* refers to a person or thing associated with the order.

kala (S): a monster mask used as an auspicious symbol to protect the devotee and to ward off evil.

Kalachakra (S): "Wheel of Time," a unique tantra containing a complex cosmology, including an apocalyptic theory of history involving a great war at the end of time and eventual triumph in Shambhala.

Kanjur (T): the major section of the Tibetan Buddhist canon containing the words of the Buddha Shakyamuni. The 108 volumes were translated from Sanskrit.

kapala (S): a human skull cup made into a container. It is the attribute of fierce deities and is often accompanied by a curved chopper.

Karmapa (T): a suborder of the Kagyu order of Tibetan Buddhism and the title of the incarnate-lama who heads it.

kesi (C): "slit silk," a very high quality silk tapestry woven with several colors of thread in a distinctive weave. It reached its high point of development in Central Asia and China between the twelfth and fourteenth centuries.

keyid (M): a monastic hermitage.

Khalkha (M): the principal tribe of Outer Mongolia, comprising about 80 percent of its population. The Khalkha dialect is the basis of the official language of the Mongolian Republic.

khan (M): "king."

khatak (T): a white scarf used for ceremonial purposes. Many of the silk *khatak* were woven in China. A *khatak* always accompanies the gift exchange between the high lamas and the emperor of China.

khatvanga (S): the ceremonial staff of Padmasambhava and other tantric deities. Starting from the top, it bears either a trident or a half-*dorje*, followed by three heads (skeletal, putrefied, and freshly severed); the vase of plenty; and a double *dorje*.

khubilgan (M): an incarnate-lama of Mongolia.

khural (M): a general assembly of monks; bicameral legislature; daily prayer meeting.

khüree (M): a circle of *ger*.

khuriltai (M): an assemblage of Mongol nobility.

khutuktu (M): an incarnate-lama of Mongolia.

Köke qota (M): "Blue Fort," city in Inner Mongolia; Altan Khan's capital and center of Mongolian lamaism.

luohan (C): *See* arhat.

Mahakala (S): the fierce, intelligent protector diety and tutelary genius of the Sakyapa, one of the Eight *Dharmapala* or Guardians of the Law; protector of Mongolia.

mahasiddha (S): "great realized one," "great adept," one who has achieved enlightenment in his lifetime through tantric practices; often refers to eighty-four important teachers from India.

Maitreya (S): the Buddha of the Future and one of the most popular bodhisattvas. He resides in Ganden (a heavenly paradise) until his incarnation. Especially popular in Mongolia and worshiped in major annual festivals, he was also associated with a new age of Mongol rule.

Manjushri (S): the Bodhisattva of Wisdom, whose attributes are the sword that cleaves ignorance and the book of wisdom, the *Prajnaparamita Sutra*. He was thought to reside on China's Mount Wutai.

mantra (S): a mystical verse, incantation; a series of syllables understood as a deity's aural form. In tantric Buddhism, repetition of mantras is practiced as a form of meditation.

marthang (T): Buddhist scroll painting done on a red ground.

Monlam or **Monlam chenmo** (T): the great prayer ceremony instituted by Tsongkhapa which took place at the Jokhang of Lhasa during the New Year, and throughout the Tibetan Buddhist world.

mudra (S): a hand gesture, usually referring to a class of hand gestures having specific iconographic meaning. Among these are *abhaya mudra*, gesture of reassurance or "fear-not" gesture; *bhumisparsha mudra*, earth-touching gesture; *dharmachakra mudra*, gesture of teaching; *dhyana mudra*, gesture of meditation; *vitarka mudra*, gesture of argument.

Naadam (M): the People's Revolution Day and the Mongols' traditional summer holiday, celebrated on 11–12 July every year. The main Naadam events are wrestling, archery, and horse racing.

nakthang (T): Buddhist scroll painting done on a black ground, the subject matter being wrathful deities.

oboo (pl. *obugha*; M): shamanist sacred rock pile, created as an offering to nature spirits; an outdoor shrine eventually converted to Buddhist use.

Öbür Mongghol (M): Inner Mongolia ("Southern [or front] Mongolia"). So-called because it lay within the borders of the Qing empire.

Oirat (M): a tribe living in far western Outer Mongolia.

ongod (M): shamanist ancestral and nature spirits; some were converted to Buddhism and appeared as characters in the *tsam*.

Panchen Lama (T): the title of successive incarnations of Sakya Pandita who reside in Tashilunpo. The Panchen Lamas were the teachers of the Dalai Lamas and were considered to be incarnations of Amitabha.

Phagspa (T): Tibetan lama named Imperial Preceptor by Khubilai Khan in 1270; inventor of the Phagspa script and author of a Mongol syllabary.

phurba (T): a ritual dagger with triangular blade used in exorcising and taming demons. It is often carried by the Nyingmapa.

pipa (C): Chinese four-stringed instrument introduced from Central Asia. It is the attribute of Dhritarashtra, Guardian of the East, and Sarasvati, goddess of wisdom and music.

sadhana (S): a class of ritual-iconographic handbooks that aid meditators in visualizing deities; a kind of tantric invocation and practice.

Sakya (T): the sect in southern Tibet that rose to power in the thirteenth century; Phagspa is perhaps the best-known Sakyapa. Sakya is also the name of a Tibetan monastery founded in 1073.

Setsen Khan *aimag* (M): the easternmost of the four major khanates of Outer Mongolia.

Shambhala (T): a mythical mountainous region in the north, said to be the birthplace of the Kalachakra doctrine.

shastra (S): sacred texts, especially Sanskrit religious texts.

Songgina (M): one of Outer Mongolia's greatest and most sacred peaks. The spirit of Songgina was represented in the Mongolian *tsam* as a dark-skinned old man with tousled hair and a bitter expression. The Dark Old Man was a powerful shaman who after fierce struggle was converted to Buddhism; he thus embodied the memory and imagery of pre-Buddhist Mongolia.

Soyombo (M): a symbol invented by Zanabazar in the seventeenth century, along with his Soyombo script. Today the national symbol of Mongolia, it includes a variety of elements: the three-tongued flame represents past, present, and future prosperity; sun and crescent, ancient clan totems; downward spear tips, victory; rectangles, uprightness and honesty; *yinyang*, the unity of pairs of natural elements; and vertical lines, friendship and staunchness. A five-pointed star was added to the top of the Soyombo symbol in 1924 to mark the People's Revolution.

stupa (S; T: *chörten*; M: *suburgan*): originally a funerary mound housing relics of the Buddha, the stupa eventually became a primary Buddhist monument, symbolizing the Buddha's transcendence and enlightenment.

suburgan (M): *See* stupa.

süme (M): temple.

Tanjur (T): part of the Tibetan canon, comprising about 225 volumes of commentaries on the Kanjur and related Buddhist literature translated from the Sanskrit.

tantra (S): "treatise," an esoteric group of texts and religious practices whose goal is the immediate enlightenment of the practitioner. First appearing in the sixth century, by the seventh century the *shakti*, or female energy of the gods, became important to tantric practice, resulting in gods being depicted in *yab-yum* form.

Tara (S): the Savioress; female counterpart of Avalokiteshvara, god of mercy.

thangka (T): a painting that is rolled up; a portable icon usually painted on cotton.

tngri (M): a heavenly being, spirit; the name for deities of shamanist origin.

Torghut (M): a tribe living in western Inner Mongolia.

torma (T): an effigy of flour and/or yak's butter used in ceremonies as a substitute for real objects.

Tsaghan sara (M): "White Month," the beginning of the new year whose celebrations included ceremonies paying homage to Buddhist and shamanist deities, culminating in the Maitreya Festival.

tsam (M): Buddhist ritual dance dramas performed at monasteries, whose general goals are the exorcism of evil spirits and the destruction of forces that obstruct enlightenment.

tsanid (M): monastic curriculum for the study of advanced theology.

tsha-tsha (T): ex-votos and pious images made in molded clay or papier-mâché and sometimes painted.

Tsongkhapa (1357–1419): one of the greatest lamas of Tibet; founder of the Gelug order.

Tüsheet Khan (M): "Pillar King," a title used by Abadai Khan (1554–1588), who founded the Tüsheet Khalkha khanate, and also by Gombodorji (1594–1655), who established his son Zanabazar as the First Bogdo Gegen. The Tüsheet khanate was one of the four major khanates of Outer Mongolia; its territory included the capital Urga.

Urga (M): the historic name for Mongolia's capital, renamed Ulaanbaatar in 1924. Residence of the Bogdo Gegens from 1664 to 1924 and location of Gandantegchinlin Monastery. *See also* Da Khüree.

Uzemchin (M): a tribe living in eastern Outer Mongolia.

vajra (S): *See dorje.*

yab-yum (T): "father-mother," in tantric Buddhism, a common name for depictions of male gods in sexual union with their female counterparts; a metaphor for enlightenment.

yidam (T): a divine spiritual guide or tutelary deity.

Zanabazar (1635–1723): also called Öndür Gegen; the First Bogdo Gegen and Mongolia's greatest artist.

Zasagt Khan *aimag* (M): the westernmost of the four major khanates of Outer Mongolia.

Zunghar (M): a tribe living in southwestern Outer Mongolia, whose territory extends into Inner Mongolia and Central Asia.

Selected Bibliography

Aalto, P. "A Second Fragment of the Mongolian *Subhāsitaratnanidhi* in Mongolian Quadratic Script." *Journal de la Société Fenno-Ougrienne* 57 (1955).

Academy of Sciences, People's Republic of Mongolia. *Information Mongolia*. Oxford and New York: Pergamon Press, 1990.

Ahmad, Zahiruddin. *Sino-Tibetan Relations in the Seventeenth Century*. Rome: Istituto Italiano per il Medio ed Estremo Oriente, 1970.

Akiner, Shirin, ed. *Mongolia Today*. London: Kegan Paul International and Central Asia Research Forum, 1991.

Alexandre, Egly. "Erdeni-zuu, un monastère du XVIe siècle en Mongolie." *Etudes Mongoles* 10 (1979), 7–33.

Alinge, Curt. *Mongolische Gesetze*. Leipzig: T. Weicher Verlag, 1934.

Allen, Thomas B. "Time Catches Up with Mongolia." *National Geographic*, February 1985, 242–69.

Allsen, Thomas T. *The Mongols in East Asia, Twelfth–Fourteenth Centuries: A Preliminary Bibliography of Books and Articles in Western Languages*. Philadelphia: Sung Studies Newsletter, 1976.

———. *Mongol Imperialism: The Politics of the Grand Qan Möngke in China, Russia, and the Islamic Lands, 1251–1259*. Berkeley: University of California Press, 1987.

———. "Mongolian Princes and Their Merchant Partners, 1200–1260." *Asia Major* 2, no. 2 (1989), 83–126.

Alonso, Mary E., ed. *China's Inner Asian Frontier*. Historical text by Joseph Fletcher. Cambridge, Mass.: Peabody Museum, 1979.

Amagaev, N., Alamzhi-Mergen. *Novyi buriatskii alfavit* (The New Buriat Alphabet). St. Petersburg: Narang, 1910.

Andreev, A. J. *Buddiiskaia sviatynia Petrograda* (The Buddhist Shrine of Petrograd). Ulan-Ude: Agentstvo EkoArt, 1992.

Andrews, Roy C. "Explorations in the Gobi Desert." *National Geographic*, June 1933, 653–716.

Anthony, David W., and Dorcas R. Brown. "The Origins of Horseback Riding." *Antiquity* 65 (1991).

Arlington, L. C., and William Lewisohn. *In Search of Old Peking*. Peking: Henry Vetch, The French Bookstore, 1935.

The Art of Korea (Chosen), Manchuria (Manchukuo), Mongolia, and Tibet. Toledo: Toledo Museum of Art, 1942.

Atwood, Christopher. "Review Article: Mongolian Art." *Mongolian Studies* 12 (1989), 113–24.

Badamkhatan, S., ed. *Khalkhyn ugsaatny züi* (Khalkha Ethnography of the Nineteenth–Twentieth Centuries). Ulaanbaatar, 1987.

Baddeley, John F. *Russia, Mongolia, China*. 2 vols. London, 1919.

Bannerjea, J. N. *The Development of Hindu Iconography*. 4th ed. Delhi: Munshiram Manoharlal, 1985.

Baradin, B. B. *The Buddhist Monasteries*. Translated by P. Koluda. Verkhneudinsk, 1926.

Barfield, Thomas J. *The Perilous Frontier*. Oxford: Blackwell Publishers, 1989.

Barthold, V. V. "The Burial Rites of the Turks and the Mongols." Translated by J. M. Rogers. *Central Asiatic Journal* 14, nos. 1–3 (1970), 195–227.

Bartholomew, Terese Tse. "Sino-Tibetan Art of the Qianlong Period from the Asian Art Museum of San Francisco." *Orientations* 22, no. 6 (June 1991), 34–45.

———. "Three Thangkas from Chengde." In *Tibetan Studies*. Proceedings of the 5th Seminar of the International Association for Tibetan Studies, pp. 353–60. Narita: Naritasan Shinshoji, 1992.

Basilov, Vladimir N., ed. *Nomads of Eurasia*. Los Angeles: Natural History Museum of Los Angeles County; Seattle: University of Washington Press, 1989.

Bauer, W., ed. *Studia Mongolica: Festschrift für Herbert Franke*. Wiesbaden: Franz Steiner, 1979.

Bawden, Charles R. *The Mongol Chronicle Altan Tobči*. Asiatische Forschungen, Band 5. Wiesbaden: Otto Harrassowitz, 1955.

———. *The Jebtsundamba Khutukhtus of Urga*. Asiatische Forschungen, Band 9. Wiesbaden: Otto Harrassowitz, 1961.

———. *The Modern History of Mongolia*. London: Weidenfeld & Nicolson, 1968.

———. "The Mongol Rebellion of 1756–1757." *Journal of Asian History* 2, no. 1 (1968), 1–31.

———. "Some Portraits of the First Jebtsumdamba Qutuqtu." *Zentral Asiatche Studien* 4 (1970), 183–201.

———. *Eight North Mongolian Epic Poems*. Asiatische Forschungen, Band 75, Mongolische Epen X. Wiesbaden: Otto Harrassowitz, 1982.

Bazin, Jacques. "Recherches sur les parlers T'o-pa." *T'oung Pao* 39 (1950), 228–339.

Bazin, Louis. "Un texte proto-turc du IVe siècle: Le distique du Hiong-nou 'Tsou-chou.'" *Oriens* 1 (1948), 208–19.

Beall, Cynthia, and Melvyn Goldstein. "Past Becomes Future for Mongolian Nomads." *National Geographic*, May 1993, 126–38.

Béguin, Gilles. *Dieux et démons de l'Himālaya*. Paris: Editions de la Réunion des musées nationaux, 1977.

———. *L'art bouddhique tibétain.* Paris: Librairie You-Feng, 1989.

———. *Art ésotérique de l'Himalaya: La donation Lionel Fournier.* Paris: Editions de la Réunion des musées nationaux, 1990.

Béguin, Gilles, et al. *Trésors de Mongolie, XVIIe–XIXe siècles.* Paris: Editions de la Réunion des musées nationaux, 1993.

Bell, Sir Charles. *Tibet Past and Present.* Oxford: Clarendon Press, 1924.

———. *The Religion of Tibet.* 1931. Oxford: Clarendon Press, 1968.

Bell, John. *Travels from St. Petersburg in Russia to Diverse Parts of Asia.* 2 vols. Glasgow, 1763.

Berger, Patricia. "Preserving the Nation: The Political Uses of Tantric Art in China." In *Latter Days of the Law: Images of Later Chinese Buddhism, 850–1850,* edited by Marsha Weidner et al. Lawrence: Spencer Museum of Art, University of Kansas; Honolulu: University of Hawaii Press, 1994.

Bergholz, Fred W. *The Partition of the Steppe.* New York: Peter Lang, 1993.

Bernbaum, Edwin. *The Way to Shambhala.* Garden City, N.Y.: Anchor Press, 1980.

Bethlenfalvy, Géza, et al., eds. *Altaic Religious Beliefs and Practices.* Proceedings of the 33d Meeting of the Permanent International Altaistic Conference, Budapest, 24–29 June 1990. Budapest: Research Group for Altaic Studies, Hungarian Academy of Sciences, 1992.

Beurdeley, Cécile, and Michel Beurdeley. *Giuseppe Castiglione: A Jesuit Painter at the Court of the Chinese Emperors.* Rutland, Vt., and Tokyo: Charles E. Tuttle Publishers, 1971.

Beyer, Stephan. *The Cult of Tārā: Magic and Ritual in Tibet.* Berkeley: University of California Press, 1973.

Bhattacharya, Benoytosh. *The Indian Buddhist Iconography.* Calcutta: Firma K. L. Mukhopadhyay, 1958.

Birnbaum, Raoul. *The Healing Buddha.* Boulder, Colo.: Shambala, 1979.

———. *The Mysteries of Mañjuśrī: A Group of East Asian Maṇḍalas and Their Traditional Symbolism.* Society for the Study of Chinese Religions, Monograph 2. Boulder, Colo.: Society for the Study of Chinese Religions, 1983.

Blake, Robert F., and Richard Frye, trans. and ed. "History of the Nation of the Archers (The Mongols) by Grigor of Akanc." *Harvard Journal of Asiatic Studies* 12, nos. 3–4 (December 1949), 269–399.

Bleichsteiner, Robert. *Die gelbe Kirche: Mysterien der buddhistischen Klöster in Indien, Tibet, Mongolei und China.* Vienna: Josef Belf, 1937. Translated by Jacques Marty as *L'église jaune.* Paris: Payot, 1937.

Blochet, E. *Introduction à l'histoire des Mongols de Fadl Allāh Rashīd Ed-Dīn.* Leiden: E. J. Brill, 1910.

Bonaparte, Roland. *Documents sur l'époque mongole des XIIIe et XIVe siècles.* Paris, 1895.

Bosson, James E. "A Rediscovered Xylograph Fragment from the Mongolian 'Phags-pa Version of the *Subhāṣitaratnanidhi.*" *Central Asiatic Journal* 6, no. 2 (1961), 85–102.

———. *A Treasury of Aphoristic Jewels: The Subhāṣitarananidhi of Sa Skya Paṇḍita in Tibetan and Mongolian.* Bloomington: Indiana University Press, 1969.

———. *A Modest Proposal: The Etymology of Mongghol.* Köke qota, 1990.

Bouvat, Lucien. *L'empire Mongol (2e phase).* Paris, 1927.

Boyer, Martha. *Mongol Jewelry.* Copenhagen: I Kommission Hos Gyldendalske Boghandel, Nordisk Forlag, 1952.

Boyle, John A. "The Thirteenth-Century Mongols' Conception of the After Life: The Evidence of Their Funerary Practices." *Mongolian Studies* 1 (1974), 5–14.

———. *The Mongol World Empire, 1206–1370.* London: Variorum Reprints, 1977.

———, ed. *The Cambridge History of Iran: The Saljuq and Mongol Periods.* Cambridge: Cambridge University Press, 1968.

———, trans. *The Successors of Genghis Khan.* Translation of text by Rašīd ad-Dīn Raḍallāh. New York: Columbia University Press, 1971.

Brent, Peter. *Genghis Khan: The Rise, Authority, and Decline of Mongol Power.* New York: McGraw-Hill, 1976.

Brown, William, and Urgunge Onon, trans. *The History of the Mongolian People's Republic.* Cambridge, Mass.: Harvard University Press, 1976.

Buddhism in Mongolia. Ulaanbaatar: Center of Gandantegchinlin Studies, 1981.

Budge, E. A. Wallis, trans. *The Monks of Kūblāi Khān, Emperor of China.* London: Religious Tract Society, 1928.

Buell, Paul. "Pleasing the Palate of the Qan: Changing Foodways of the Imperial Mongols." *Mongolian Studies* 13 (1990), 57–81.

Cammann, Schuyler. *The Land of the Camel: Tents and Temples of Inner Mongolia.* New York, 1951.

Campi, Alicia. "The Rise of Nationalism in the Mongolian People's Republic." *Central and Inner Asian Studies* 6 (1992), 46–58.

Chabros, K. "Mongol Examples of Proto-Weaving." *Central Asiatic Journal* 37, nos. 1–2 (1993), 20–32.

Chambers, James. *The Devil's Horsemen: The Mongol Invasion of Europe.* London: Cassell Publishers, 1988.

Chandra, Lokesh. "Buddhism in Mongolia." *Indo-Asian Culture* 8 (1960), 266–75.

———. *Eminent Tibetan Polymaths of Mongolia.* Śatapiṭaka Series, vol. 16. New Delhi: International Academy of Indian Culture, 1961.

———. *Sādhana-māla of the Panchen Lama.* Śatapiṭaka Series, vol. 210. New Delhi: International Academy of Indian Culture, 1974.

———. *Life and Works of Jibcundampa I.* Śatapiṭaka Series, vol. 294. New Delhi: International Academy of Indian Culture, 1982.

———. *Buddhist Iconography.* New Delhi: International Academy of Indian Culture and Aditya Prakashan, 1991.

———. *Cultural Horizons of India.* Śatapiṭaka Series, vol. 361. 3 vols. New Delhi: International Academy of Indian Culture and Aditya Prakashan, 1993.

Chan Hok-lam. "A Mongolian Legend of the Building of Peking." *Asia Major* 3d ser., 3, no. 2 (1990), 63–93.

———. "Siting by Bowshot: A Mongolian Custom and Its Sociopolitical and Cultural Implications." *Asia Major* 3d ser., 4, no. 2 (1991), 53–78.

Chapman, F. Spencer. *Lhasa: The Holy City.* London: Readers Union Ltd., 1940.

Chapman, Walker [pseud.]. *Kublai Khan: Lord of Xanadu.* Indianapolis: Bobbs-Merrill Co., 1966.

Chayet, Anne. *Les temples de Jehol et leurs modèles tibétains.* Paris: Editions Recherches sur les civilisations, 1985.

Chayet, Anne, and Corneille Gest. "Le monastère de la Félicité tranquille, fondation impériale en Mongolie." *Arts Asiatiques* 46 (1991), 72–81.

Chen Do and Shi Zonghua, eds. *Xinbian Zhongguo dili* (New Chinese Atlas). N.p., n.d.

Cheney, George A. *The Pre-Revolutionary Culture of Outer Mongolia.* Bloomington, Ind.: The Mongolia Society, 1968.

Chibetto. Kyoto: Zhongguo renmin meishu Press and Binobi, 1981.

Ch'i-yü. "Who Were the Oirats?" *The Yenching Journal of Social Studies* 3, no. 2 (August 1941), 174–219.

Chö-yang. Year of Tibet edition. Dharamsala: Council for Religious and Cultural Affairs of H. H. the Dalai Lama, 1991.

Chugoku Sekkutsu: Tonkō Mokōkutsu. 5 vols. Tokyo: Heibonsha, 1980–82.

Clark, Walter Eugene. *Two Lamaistic Pantheons*. 2 vols. Cambridge, Mass.: Harvard University Press, 1937. Reprint (2 vols. in 1). New York: Paragon Books, 1965.

Clauson, Gerard. "The hP'ags-pa Alphabet." *Bulletin of the School of Oriental and African Studies, London University* 22 (1959), 300–23.

Cleaves, Francis Woodman, trans. *The Secret History of the Mongols*. Cambridge, Mass.: Harvard University Press, 1982.

Commeaux, C. *La vie quotidienne chez les Mongols de la conquête (XIIIe siècle)*. Paris: Librairie Hachette, 1972.

Consten, Hermann. *Weideplätze der Mongolen*. 2 vols. Berlin: Dietrich Reimer, 1920.

———. "Denominations of Monasteries in Outer and Inner Mongolia." *Collectanea Commissionis Synodalis* 12 (1939), 11–19.

Copeland, Carolyn. *Tankas from the Koelz Collection, Museum of Anthropology, University of Michigan*. Ann Arbor: University of Michigan Center for South and Southeast Asian Studies, 1980.

Crowe, Yolanda. "Late-Thirteenth-Century Persian Tilework and Chinese Textiles." *Bulletin of the Asia Institute* 5 (1991), 153–61.

Cultural Relics of Tibetan Buddhism Collected in the Qing Palace (Qinggong Zangchuan fojiao wenwu). Palace Museum, Beijing. Beijing: Forbidden City Press, The Woods Publishing Company, 1992.

Dababdorj, N. *Erdene-Zuu sum muzei*. Ulaanbaatar, 1982.

Dagyab Rinpoche, Loden Sherap. *Tibetan Religious Art*. 2 vols. Asiatische Forschungen, Band 52. Wiesbaden: Otto Harrassowitz, 1977.

———. *Buddhistische Glückssymbole im tibetischen Kulturraum*. Munich: Eugen Diederichs Verlag, 1992.

d'Argencé, René-Yvon Lefebvre, et al. *Chinese, Korean, and Japanese Sculpture in the Avery Brundage Collection*. San Francisco: Asian Art Museum of San Francisco; Tokyo: Kodansha, 1974.

Dars, Sarah. "L'architecture mongole ancienne." *Etudes Mongoles* 3 (1972), 159–223.

Dashbaldan, Dorjin. *Zanabazar (1635–1725), the Great Saint*. Ulaanbaatar: Ochirbatyn Dashbalbar, 1991. In Mongolian.

David-Neel, Alexandra, and Lama Yongden. *The Superhuman Life of Gesar of Ling*. Boston and London: Shambhala, 1987.

Dawa-Samdup, Kazi, ed. *Shrīchakrasambhara Tantra: A Buddhist Tantra*. New Delhi: Aditya Prakashan, 1987.

Dawson, Christopher. *The Mongol Mission: Narratives and Letters of the Franciscan Missionaries in Mongolia and China in the Thirteenth and Fourteenth Centuries*. New York: Sheed and Ward, 1955.

DeWeese, Devin. "The Influence of the Mongols on the Religious Consciousness of Thirteenth-Century Europe." *Mongolian Studies* 5 (1977–78), 41–78.

Dharmatāla, Damcho Gyatsho. *Rosary of White Lotuses, Being the Clear Account of How the Precious Teaching of Buddha Appeared and Spread in the Great Hor Country*. Translated by Piotr Klafkowski. Wiesbaden: Otto Harrassowitz, 1987.

Dickinson, Gary, and Linda Wrigglesworth. *Imperial Wardrobe*. London: Bamboo Publishing, 1990.

Ding Fubao, ed. *Foxue da cidian* (Buddhist Dictionary). Taipei, 1961.

Doboom Tulku. *Sixteen Arhats*. Delhi: Tibet House, n.d.

Dobu. *Uyighurjin mongghol üsüg-ün durasqaltu bičig-üd* (Monuments of the Uighur-Mongol Script). Beijing: Ündüsüten-ü keblel-ün qoriya (Nationalities Publishing House), 1983.

Douglas, William O. "Journey to Outer Mongolia." *National Geographic*, March 1962, 289–345.

Dowman, Keith. *The Power-Places of Central Tibet: The Pilgrim's Guide*. London and New York: Routledge and Kegan Paul, 1988.

Dreyer, Edward L. *Early Ming China: A Political History, 1355–1435*. Stanford, Calif.: Stanford University Press, 1982.

Drouin, Edmond. "Notices sur les monnaies mongoles." *Journal Asiatique* ser. 9, 7 (1896), 486–544.

Eberhard, Wolfram. *Das Topa-Reich Nordchinas*. Leiden: E. J. Brill, 1949.

Enkhe, L. "Monumental Art in Our Country." *Mongolia Today* 11, nos. 7–8 (1969), 7–10.

Essen, Gerd-Wolfgang, and Tsering Tashi Thingo. *Die Götter des Himalaya*. Munich: Prestel-Verlag, 1989.

Ettinghausen, Richard. "On Some Mongol Miniatures." *Kunst des Orients* 3 (1959), 44–65.

Even, Marie-Dominique. "Chants de chamans mongols." *Etudes mongoles et sibériennes* 19–20 (1988–89).

Fairbank, John K., ed. *The Chinese World Order*. Cambridge, Mass.: Harvard University Press, 1968.

———. *The Cambridge History of China: Late Ch'ing, 1800–1911, Part I*. Cambridge: Cambridge University Press, 1978.

Farmer Edward L. *Early Ming Government: The Evolution of Dual Capitals*. Cambridge, Mass.: Harvard University Press, 1976.

Farquhar, David. "Oirat-Chinese Tribute Relations, 1408–1446." In *Studia Altaïca: Festschrift für Nikolaus Poppe*, pp. 60–68. Wiesbaden: Otto Harrassowitz, 1957.

———. "The Origins of the Manchus' Mongolian Policy." In *The Chinese World Order*, edited by John K. Fairbank, pp. 198–205. Cambridge, Mass.: Harvard University Press, 1968.

———. "Emperor as Bodhisattva in the Governance of the Ch'ing Empire." *Harvard Journal of Asiatic Studies* 38, no. 1 (June 1978), 5–35.

———. *The Government of China under Mongolian Rule: A Reference Guide*. Münchener Ostasiatische Studien, Band 53. Stuttgart: Franz Steiner Verlag, 1990.

Feddersen, Martin. "Kunst und Kunstgewerbe Ostasiens in den europäischen Reiseberichten der Mongolenzeit." *Ostasiatische Zeitschrift* 17, no. 27 (1941), 4–31.

Ferenczy, László. "Ādi-Buddha Vajradhara." *Orientations* 21, no. 2 (February 1990), 43–45.

Filchner, W. *Kumbum Dschamba Ling*. Leipzig, 1933.

———. *Kumbum: Lamaismus in Lehre und Leben*. Mit Original-legenden (tibetisch, mongolisch, chinesisch) und 7 Bildtafeln nach Originalaufnahmen des Verfassers. Zurich: Rascher, 1954.

Fine Arts in Contemporary Mongolia. Ulaanbaatar, 1971.

Fisher, Robert E. *Mystics and Mandalas: Bronzes and Paintings of Tibet and Nepal*. Redlands, Calif.: University of Redlands, 1974.

Fletcher, Joseph. "China and Central Asia, 1368–1884." In *The Chinese World Order*, edited by John K. Fairbank. Cambridge, Mass.: Harvard University Press, 1968.

———. "Qing Inner Asia, c. 1800." In *The Cambridge History of China: Late Ch'ing, 1800–1911, Part I*, edited by John K. Fairbank. Cambridge: Cambridge University Press, 1978.

———. "The Mongols: Ecological and Social Perspectives." *Harvard Journal of Asiatic Studies* 46, no. 1 (June 1986), 11–50.

Forman, Werner, and Bjamba Rintchen. *Lamaistische Tanzmasken: Der Erlik-Tsam in der Mongolei*. Leipzig: Koehler & Amelang, 1967.

Franck, Irene M., and David M. Brownstone. *The Silk Road: A History*. New York: Facts on File Publications, 1986.

Franke, Herbert. *Geld und Wirtschaft in China unter der Mongolenherrschaft*. Leipzig: Otto Harrassowitz, 1949.

———. *From Tribal Chieftain to Universal Emperor and God: The Legitimation of the Yuan Dynasty*. Munich: Verlag der Bayerischen Akademie der Wissenschaften, 1978.

Gabain, A von. *Alttürkische Grammatik*. Leipzig: Otto Harrassowitz, 1950.

Getty, Alice. *The Gods of Northern Buddhism*. Oxford: Clarendon Press, 1914. Reprint. Tokyo: Charles E. Tuttle Co., 1962.

Ghosh, Mallar. *Development of Buddhist Iconography in Eastern India: A Study of Tārā, Prajñās of Five Tathāgatas, and Bhrikutī*. New Delhi: Minchiram Manoharlal, 1980.

Goldstein, Melvyn G., and Cynthia Beall. *The Changing World of Mongolia's Nomads*. Berkeley: University of California Press, 1994.

Goodrich, L. C., and Chaoying Fang, eds. *Dictionary of Ming Biography*. 2 vols. New York: Columbia University Press, 1976.

Gray, Basil. "Art under the Mongol Dynasties of China and Persia." *Oriental Art* 1 (Winter 1955), 159–67.

Grekov, B., and A. Iakoubovski. *La horde d'or*. Translated by Françoise Thuret. Paris: Payot, 1939.

Grousset, René. *L'empire des steppes*. Paris: Payot, 1939. Translated by Naomi Walford as *The Empire of the Steppes: A History of Central Asia*. New Brunswick, N.J.: Rutgers University Press, 1970.

———. *L'empire mongol (1ère phase)*. Paris: E. de Boccard, 1941.

———. *Conqueror of the World: The Life of Chingis Khan*. Translated by Marian McKellar and Denis Sinor. New York: Viking Press, 1972.

Grünwedel, Albert. *Mythologie des Buddhismus in Tibet und der Mongolei: Führer durch die lamaistische Sammlung des Fürsten E. Uchtomskij*. Leipzig, 1900.

———, trans. *Das Pantheon des Tschangtscha Hutuktu*. In *Veröffentlichungen aus dem königlichen Museum für Völkerkunde in Berlin* 1, fasc. 2–3 (1890).

Grupper, Samuel. "The Manchu Imperial Cult of the Early Ch'ing Dynasty: Texts and Studies on the Tantric Sanctuary of Mahākāla at Mukden." Ph.D. diss., Indiana University, 1979.

Guignes, Joseph de. *Histoire générale des Huns, des Turcs, des Mongols, et des autres Tartares occidentaux*. 4 vols. Paris: Desaint & Saillant, 1756–58.

Gulik, R. H. van. *Hayagriva: The Mantrayanic Aspect of Horse-Cult in China and Japan*. Internationales Archiv für Ethnographie. Leiden: E. J. Brill, 1935.

Gumilev, L. N. *Searches for an Imaginary Kingdom: The Legend of the Kingdom of Prester John*. Translated by R. E. F. Smith. Cambridge: Cambridge University Press, 1987.

Guy, John, ed. *Palm-Leaf and Paper: Illustrated Manuscripts of India and Southeast Asia*. Melbourne: National Gallery of Victoria, 1982.

Guzman, Gregory G. "Simon of Saint-Quentin and the Dominican Mission of the Mongol Baiju: A Reappraisal." *Speculum* 46, no. 2 (April 1971), 232–49.

———. "Simon of Saint-Quentin as Historian of the Mongols and the Seljuk Turks." *Medievalia et Humanistica*, n.s., 3 (1972), 155–78.

———. "The Encyclopedist Vincent of Beauvais and His Mongol Extracts from John of Plano Carpini and Simon of Saint-Quentin." *Speculum* 49, no. 2 (April 1974), 287–307.

Halperin, Charles J. "Russia in the Mongol Empire in Historical Perspective." *Harvard Journal of Asiatic Studies* 43, no. 1 (June 1983), 239–61.

———. *Russia and the Golden Horde*. Bloomington: Indiana University Press, 1985.

Hambis, Louis. *Documents sur l'histoire des Mongols à l'époque des Ming*. Paris: Presses Universitaires de France, 1969.

Hangin, Gombojab, et al. *A Modern Mongolian-English Dictionary*. Indiana Uralic and Altaic Series, vol. 150. Bloomington: Indiana University Press, 1986.

Hangin, John, trans. *Köke Sudur (The Blue Chronicle): A Study of the First Mongolian Historical Novel by Injannasi*. Wiesbaden: Otto Harrassowitz, 1973.

Hangin, John, and Urgunge Onon. *Analecta Mongolica*. The Mongolia Society Occasional Papers, no. 8. Bloomington: The Mongolia Society, 1972.

Hansen, Henny Harald. *Mongol Costumes: Researches on the Garments Collected by the First and Second Danish Central Asian Expeditions under the Leadership of Henning Haslund-Christensen, 1936–37 and 1938–39*. Reprint. London: Thames and Hudson, 1993.

Härtel, Herbert, and Marianne Yaldiz. *Along the Ancient Silk Routes: Central Asian Art from the West Berlin State Museums*. New York: The Metropolitan Museum of Art, 1982.

Haslund, Henning. *Tents in Mongolia (Yabonah): Adventures and Experiences among the Nomads of Central Asia*. Translated by Elizabeth Sprigge and Claude Napier. New York: E. P. Dutton, 1934.

———. *Men and Gods in Mongolia*. Translated by Elizabeth Sprigge and Claude Napier. London: Kegan Paul, 1935. Reprint. Stelle, Ill.: Adventures Unlimited Press, 1992.

Hedin, Sven. *Jehol: City of Emperors*. New York: E. P. Dutton, 1933.

———. *History of the Expedition in Asia, 1927–1935*. Stockholm and Göteborg: Elanders Boktryckeri Aktiebolag, 1943.

Heer, Ph. de. *The Care-Taker Emperor*. Leiden: E. J. Brill, 1986.

Heissig, Walther. "A Mongolian Source to the Lamaist Suppression of Shamanism in the Seventeenth Century." *Anthropos* 48, nos. 1–2 (1953), 1–29; nos. 3–4, 493–536.

———. *Die Pekinger lamaistischen Blockdrucke in mongolischer Sprache*. Asiatische Forschungen, Band 2. Wiesbaden: Otto Harrassowitz, 1954.

———. "Zur Entstehungsgeschichte der Mogolischen Kandjur-Redaktion der Ligdan Khan-Zeit (1628–1629)." In *Studia Altaïca: Festschrift für Nikolaus Poppe*, pp. 71–87. Wiesbaden: Otto Harrassowitz, 1957.

———. *A Lost Civilization: The Mongols Rediscovered*. Translated by D. J. S. Thomson. London: Thames and Hudson, 1966.

———. *Catalogue of Mongol Books, Manuscripts, and Xylographs*. Copenhagen: The Royal Library, 1971.

———. *Geschichte der mongolischen Literatur*. 2 vols. Wiesbaden: Otto Harrassowitz, 1972.

———. *The Religions of Mongolia*. Translated by Geoffrey Samuel. Berkeley: University of California Press, 1980.

———. *Les Mongols: Un peuple à la recherche de son histoire*. Translated by M. P. Mathieu and Jean-Claude Lattès. Düsseldorf and Vienna: Econ Verlag, 1979. Reprint. Paris, 1982.

Heissig, Walther, and Claudius Müller. *Die Mongolen*. 2 vols. Innsbruck: Pinguin-Verlag, 1989.

Heller, Amy. "Remarques préliminaires sur les divinités protectrices *Srung-ma dmar-nag* du Potala." In *Tibet: Civilisation et société*. Paris: Fondation Singer-Polignac / Maison des Sciences de l'Homme, 1990

———. "Historic and Iconographic Aspects of the Protective Deities *Srung-ma dmar-nag*." In *Tibetan Studies*, vol. 1, edited by Ihara and Yamaguchi. Narita: Naritasan Shinshoji, 1989.

Henmi, Baiei. *Man-Mō ramakyō bijutsu zuhan* (Illustrated Lamaist Art of Manchuria and Mongolia). Tokyo: Shiryo-hen, 1975. Reprinted as *Manmeng lamajiao meishu tuban*. Taipei: Hsin wen-feng, 1979.

Hōbōgirin: Dictionnaire encyclopédique du bouddhisme d'après les sources chinoises et japonaises. 2d ed. Paris: Librairie d'Amérique et d'Orient, A. Maisonneuve; Tokyo: Maison Franco-Japonaise, 1978.

Holmgren, Jennifer. "Observations on Marriage and Inheritance Practices in Early Mongol and Yuan Society." *Journal of Asian History* 20, no. 2 (1986), 127–92.

Hoog, Constance, trans. *Prince Jin-gim's Textbook of Tibetan Buddhism*. Leiden: E. J. Brill, 1983.

Hopkirk, Peter. *The Great Game: The Struggle for Empire in Central Asia*. New York and Tokyo: Kodansha, 1992.

Howorth, H. H. *History of the Mongols from the Ninth to the Nineteenth Century.* Vol. 1, *The Mongols Proper and the Kalmuks;* vol. 2, 2 pts., *The So-called Tartars of Russia and Central Asia;* vol. 3, *The Mongols of Persia;* vol. 4, *Supplement and Indices.* London, 1876–1927. Reprint. 1970.

Huc, Abbé E. R. *Recollections of a Journey through Tartary, Thibet, and China during the Years 1844, 1845, and 1846.* 2 vols. New York: D. Appleton and Co., 1852.

Hung, William. "The Transmission of the Book Known as *The Secret History of the Mongols.*" *Harvard Journal of Asiatic Studies* 14 (1951), 433–92.

Huntington, John C. *The Styles and Stylistic Sources of Tibetan Painting.* Ann Arbor, Mich.: University Microfilms Inc., 1969.

———. "Iconography of Evil Deities from Tibet." *Studies in Indo-Asian Art* 3 (1973), 55–75.

Huth, G., trans. *Geschichte des Buddhismus in der Mongolei.* Translation of Gushrī Tshemphel, *Hor Chos-'byung.* 2 vols. Strasbourg, 1892, 1896.

Hyer, Paul. "An Historical Sketch of Köke-Khota City, Mongolia." *Central Asia Journal* 26, nos. 1–2 (1982), 56–77.

Hyer, Paul, and Sechin Jagchid. *A Mongolian Living Buddha: Biography of the Kanjurwa Khutughtu.* Albany: State University of New York Press, 1983.

Inner Mongolia Museum. *Mongolia Cultural Relics.* Hohhot: Inner Mongolia People's Art Publishing House, 1987. In Mongolian and Chinese, with preface and contents in English.

Ipşiroğlu, M. S. "Mongolische Miniaturen." *Pantheon* 22 (1964), 288–301.

———. *Painting and Culture of the Mongols.* Translated by E. D. Phillips. New York: Harry N. Abrams; London: Thames and Hudson, 1967.

Ishihama, Yumiko. "On the Dissemination of the Belief in the Dalai Lama as a Manifestation of the Bodhisattva Avalokiteśvara." *Acta Asiatica* 64 (1993), 38–56.

Jackson, Peter. "The Dissolution of the Mongol Empire." *Central Asiatic Journal* 22, nos. 3–4 (1978), 186–244.

———. "The Crusade against the Mongols." *Journal of Ecclesiastical History* 42 (1991), 1–18.

Jackson, Peter, and David Morgan. *The Mission of Friar William of Rubruck.* London: Hakluyt Society, 1990.

Jagchid, Sechin. "Buddhism in Mongolia after the Collapse of the Yuan Dynasty." In *Traditions réligieuses des peuples altaïques,* pp. 4–58. Paris: Presses Universitaires de France, 1972.

———. *Essays in Mongolian Studies.* Provo, Utah: Brigham Young University, 1988.

Jagchid, Sechin, and Paul Hyer. *Mongolia's Culture and Society.* Boulder, Colo.: Westview Press, 1979.

Jagchid, Sechin, and Van Jay Symons. *Peace, War, and Trade along the Great Wall.* Bloomington: Indiana University Press, 1989.

Jay, Jennifer W. *A Change in Dynasties.* Bellingham: Western Washington University, 1991.

Jenkins, Gareth. "A Note on Climatic Cycles and the Rise of Chinggis Khan." *Central Asiatic Journal* 18 (1974), 217–26.

Jettmar, Karl. *Art of the Steppes.* New York: Crown Publishers, 1967.

Jiacuo et al. "Lasa xiancang de liangbu yongleban 'ganzhuer'" (The Two Yongle Versions of the Kanjur in Lhasa). *Wenwu,* no. 9 (1985), 85–94.

Jing, Anning. "The Portraits of Khubilai Khan and Chabi by Anige (1245–1306), a Nepali Artist at the Yuan Court." *Artibus Asiae* 54, nos. 1–2 (1994), 40–86.

Jisl, Lumir. *Mongolian Journey.* London: Batchworth Press, 1960.

Juvainī, 'Ala' al-Dīn 'Atā-Malik. *The History of the World Conqueror.* Translated by John Andrew Boyle. 2 vols. Manchester: Manchester University Press, 1958.

Kabzińska-Stawarz, Ivona. *Games of Mongolian Shepherds.* Warsaw: Institute of the History of Material Culture, Polish Academy of Sciences, 1991.

Kahn, Paul. *The Secret History of the Mongols: The Origin of Chingis Khan. An Adaptation of the "Yuan Ch'ao Pi Shih," Based Primarily on the English Translation by Francis Woodman Cleaves.* San Francisco: North Point Press, 1984.

Kämpfe, Hans-Rainer. *Ni ma'i 'od zer/Naran-u gerel: Die Biographie des 2. Pekinger Lcan skya-Qutuqtu Rol pa'i rdo rje (1717–1786).* Monumenta Tibetica Historica, Abt. 2, Band 1. Sankt Augustin: Wissenschaftsverlag, 1976.

———. "*Sayin Qubitan-u Süsüg-ün Terge,* Biographie des 1. rJe bcun dam pa-Qutuqtu Öndür gegen (1635–1723), verfasst von Nag gi dban po 1839." *Zentralasiatische Studien* 13 (1979), 93–146; 15 (1981), 331–82.

———. *Das Asarayči Nertü-yin Teüke, eine mongolische Chronik des 17. Jahrhunderts.* Asiatische Forschungen, Band 81. Wiesbaden: Otto Harrassowitz, 1983.

Kara, D. *Knigi mongol'skikh kochevnikov* (Books of the Mongol Nomads). Moscow: Nauka, 1972.

Karmay, Heather. [See also Stoddard, Heather.] *Early Sino-Tibetan Art.* Warminster: Aris and Phillips, 1975.

Karmay, Samten. *Secret Visions of the Fifth Dalai Lama.* London: Serindia Publications, 1988.

Kessler, Adam T. *Empires beyond the Great Wall: The Heritage of Genghis Khan.* Los Angeles: Natural History Museum of Los Angeles County, 1993.

Khazanov, Anatoly. *Nomads and the Outside World.* Cambridge and New York: Cambridge University Press, 1984.

Khenpo Könchog Gyaltsen, trans. *The Great Kagyu Masters.* Ithaca, N.Y.: Snow Lion Publications, 1990.

Khodarkovsky, M. *Where Two Worlds Met: The Russian State and the Kalmyk Nomads, 1600–1771.* Ithaca, N.Y.: Cornell University Press, 1992.

Kiggell, Ralph, ed. and trans. *Buddhist Art of the Tibetan Plateau.* Compiled and photographed by Liu Lizhong. San Francisco: China Books and Periodicals, 1988.

Kiselev, S. V., ed. *Drevnie mongolskie goroda* (Ancient Mongolian Cities). Moscow: Nauka, 1965.

Kohn, Richard. "Mani Rimdu: Text and Tradition in a Tibetan Ritual." Ph.D. diss., University of Wisconsin, 1988.

Korostovetz, Iwan J. *Von Cinggis Khan zur Sowjetrepublik.* Berlin and Leipzig: Walter de Gruyter and Co., 1926.

Kotwicz, W. "Les Mongols, promoteurs de l'idée de paix universelle au début du XIIIe siècle." *Rocznik Orjentalistyczny* 16 (1950), 428–34. Originally published in *La Pologne au VIe Congrès International des Sciences Historiques* 1, pp. 199–204, Warsaw, 1933.

Krueger, John R. "Toward Greater Utilization of the Ch'ien-lung Pentaglot: The Mongolian Index." *Ural-Altaische Jahrbücher* 35 (1963), 228–40.

———. "Chronology and Bibliography of the *Secret History of the Mongols.*" *Mongolia Society Bulletin* 5 (1966–67), 25–31.

Krueger, John R., and György Kara, eds. *Mongolian Studies, Index and Reviews Issue* 16 (1993).

Krueger, John R., and Jan Nattier, trans. "The Black Faith, or Shamanism among the Mongols by Dorji Banzarov." *Mongolian Studies* 7 (n.d.), 53–91.

Kuijp, Leonard W. J. van der. "A Note to the Development of Buddhism in Mongolia." *Canada-Mongolia Review* 1, no. 1 (1975), 67–94.

———. "Shambhala: An Imperial Envoy to Tibet during the Late Yuan." *Journal of the American Oriental Society* 113, no. 4 (October–December 1993), 529–38.

Lamaistic Art. Brussels: Société Générale de Banque de Bruxelles, 1975.

Lamotte, Etienne. *L'enseignement de Vimalakirti*. Louvain, 1962. Translated by Sara Boin as *The Teaching of Vimalakirti*. London, 1976.

Lancaster, Lewis, ed. *Prajñāpāramitā and Related Systems*. Berkeley, Calif.: Berkeley Buddhist Studies Series, 1977.

Lange, Kristina. "Maidari-Fest im Ivolginsker Kloster." *Jahrbuch des Museums für Völkerkunde* 27 (1970), 90–98.

Lattimore, Owen. *Inner Asian Frontiers of China*. New York: American Geographical Society, 1940.

———. *Mongol Journeys*. New York: Doubleday, Doran, and Co., 1941.

———. *Nationalism and Revolution in Mongolia*. New York and London: Oxford University Press, 1955.

———. "The Social History of Mongol Nomadism." In *Proceedings of the Conference on Asian Historiography*, pp. 328–43. London: University of London, 1957.

———. *Nomads and Commissars: Mongolia Revisited*. New York and London: Oxford University Press, 1962.

Lattimore, Owen, and Fujiko Isono. *The Diluv Khutagt: Memoirs and Autobiography of a Mongol Buddhist Reincarnation in Religion and Revolution*. Asiatische Forschungen, Band 74. Wiesbaden: Otto Harrassowitz, 1982.

Lauf, Detlef Ingo. *Secret Revelation of Tibetan Thangkas: The John Gilmore Ford Collection*. Fribourg-en-Brisgau: Aurum Verlag, 1976.

Lee, Sherman E., and Wai-Kam Ho. *Chinese Art under the Mongols: The Yüan dynasty (1279–1368)*. Cleveland: The Cleveland Museum of Art, 1968.

Legrand, Jacques. *L'administration dans la domination sino-mandchoue en Mongolie Qalq-a* (Mongolian Version of Lifan Yuan Zeli). Paris: Collège de France, Institut des Hautes Etudes Chinoise, 1976.

Lessing, Ferdinand. *Mongolen: Hirten, Priester und Dämonen*. Berlin: Klinkhardt & Bierman, 1935.

———. *Yung-ho-kung: An Iconography of the Lamaist Temple in Peking*. Stockholm and Göteborg: Elanders Boktryckeri Aktiebolag, 1942.

———. "Bodhisattva Confucius." In *Ritual and Symbol: Collected Essays on Lamaism and Chinese Symbolism*. Asian Folklore and Social Life, Monograph 91, pp. 91–94. Taipei: Chinese Association for Folklore, 1976.

Lessing, F. D., and A. Wayman. *Introduction to the Buddhist Tantric Systems*. New York: Samuel Weiser; Delhi: Motilal Banarsidass, 1980.

Levitskaia. L. S., ed. *Etimologicheskii slovar' tiurkskikhi azykov: j, zh, y* (Etymological Dictionary of the Turkic Languages). Moscow, 1989.

Lhundub Sopa, Geshe, et al. *The Wheel of Time: The Kalachakra in Context*. Ithaca, N.Y.: Snow Lion Publications, 1985.

Liebert, Gösta. *Iconographic Dictionary of the Indian Religions*. Delhi: Sri Satguru Publications, 1976.

Ligeti, L. "A kitaj nép és nyelv" (The Khitan People and Language). *Magyar Nyelv* 23 (1927), 301–10.

Ligeti, Louis, ed. *Mongolian Studies*. Amsterdam: Verlag B. R. Grüner, 1970.

———. *Monuments en écriture 'Phagspa: Pièces de chancellerie en transcription chinoise*. Budapest: Akadémiai Kiadó, 1972.

Liu, Cary. "The Yuan Dynasty Capital, Ta-tu: Imperial Building Program and Bureaucracy." *T'oung Pao* 78 (1992), 264–301.

Liu, I-se, ed. *Xizang fojiao yishu* (The Buddhist Art of Tibet). Beijing: Wenwu Press, 1957.

Liu Lizhong. *L'art bouddhique tibétain*. Paris: Librairie You-Feng, 1989.

Lomakina, Inesa. *Marzan Sharav*. Moscow: Izobrazitchnoe Iskusstvo, 1974.

Maenchen-Helfen, Otto J. *The World of the Huns*. Berkeley: University of California Press, 1973.

Magyar, G. J. "A Visit to the Last Living God in Mongolia." *China Journal* 34 (1941), 17–25.

Maidar, Dandijalin. *Arkhitektura i gradostroitelstvo mongolii*. Moscow: Ocherki po istorii, 1970.

———. *Mongoliin arkhitektur ba xot baigulalt*. Ulaanbaatar, 1972.

———. *Pamiatniki istorii i kul'turi mongolii*. Moscow: M.I.S.L., 1981.

Maidar, Dandijalin, and L. Darsuren. *Ger*. Ulaanbaatar: State Publishing House, 1976.

Maidar, Dandijalin, and Djangar Badmaievic Piurveev. *Ot Kochevoi do mobilskoi arkhitektur* (From a Nomadic to a Mobile Architecture). Moscow, 1980.

Maiskii, J. M. *Mongoliia nakanune revoliutsii* (Mongolia on the Eve of the Revolution). 2d ed. Moscow, 1959.

"The Maitreya Procession." *Chö-yang* 1, no. 2 (1987), 94–95.

Mallmann, Marie-Thérèse de. *Introduction à l'iconographie du tântrisme bouddhique*. Vol. 1 of *Bibliothèque du Centre de recherches sur l'Asie Centrale et la Haute-Asie*. Paris: Adrien Maisonneuve, 1975.

Mancall, Mark. *Russia and China: Their Diplomatic Relations to 1728*. Cambridge, Mass.: Harvard University Press, 1971.

Marek, J., and H. Knížková. *The Jenghiz Khan Miniatures from the Court of Akbar the Great*. Translated by Olga Kuthanová. London: Spring Book, 1963.

Markov, Gennadii Evgen'evich. *Kochevniki Azii* (The Nomads of Asia). Moscow, 1976.

Martin, H. D. *The Rise of Chingis Khan and His Conquest of North China*. Baltimore: The Johns Hopkins University Press, 1950.

Maslennikov, V. A. *Contemporary Mongolia*. Translated by David C. Montgomery. Bloomington, Ind.: The Mongolia Society, 1964.

Masterpieces of Chinese Portrait Painting in the National Palace Museum. Taipei: National Palace Museum, 1971.

Masterpieces of Chinese Tibetan Buddhist Altar Fittings in the National Palace Museum. Taipei: National Palace Museum, 1971.

Merge, Salvatore. "Mongol Lamaseries." *East and West* 4, no. 1 (April 1953), 50–51.

Miller, Robert James. *Monasteries and Culture in Inner Mongolia*. Wiesbaden: Otto Harrassowitz, 1959.

Miyawaki, Junko. "The Qalqa Mongols and the Oyirad in the Seventeenth Century." *Journal of Asian History* 18, no. 2 (1984), 136–73.

———. "Tibeto-Mongol Relations at the Time of the First Rje btsun dam pa Qutukhtu." *Tibetan Studies*. Proceedings of the 5th Seminar of the International Association for Tibetan Studies. Vol. 2, *Language, History and Culture*, pp. 599–604. Narita: Naritasan Shinshoji, 1992.

Mizuno, Kogen. *Buddhist Sutras: Origin, Development, Transmission*. Tokyo: Kosei Publishing Company, 1982.

"Modern Painters of Mongolia." *Mongolia Today* 6 (1964), 27–31.

Moffett, Samuel. *A History of Christianity in Asia*. Vol. 1. New York: HarperCollins, 1992.

Mongol Ard Ulsyn ugsatny sudlal, khelnii shinjleliin atlas (Ethnographic and Linguistic Atlas of the People's Republic of Mongolia). 2 vols. Ulaanbaatar: B. Rinchen, 1979.

Mongolica: Pamiati akademika Borisa Iakovlevicha Vladimirtsova, 1884–1931. Moscow: Nauka, 1986.

"Monlam Chemo: The Great Prayer Festival." *Chö-yang* 1, no. 2 (1987), 83–95.

Morgan, David. "Trois documents mongols des Archives secrètes vaticanes." *Harvard Journal of Asiatic Studies* 15 (1952), 419–506.

———. *The Mongols*. New York: Basil Blackwell, 1986.

———. "The Mongols and the Eastern Mediterranean." *Mediterranean Historical Review* 4, no. 1 (June 1989), 198–211.

Moses, Larry W. *The Political Role of Mongol Buddhism*. Indiana University Uralic and Altaic Series, vol. 133. Bloomington: Asian Studies Research Institute, Indiana University, 1977.

Moses, Larry, and Stephen Halkovic. *Introduction to Mongolian History and Culture*. Bloomington: Indiana University Press, 1985.

Mostaert, Antoine. "Note sur le culte du Vieillard blanc chez les Ordos." In *Studia Altaïca: Festschrift für Nikolaus Poppe*, pp. 108–17. Wiesbaden: Otto Harrassowitz, 1957.

Mote, Frederick. "The T'u-mu Incident of 1449." In *Chinese Ways in Warfare*, edited by Frank A. Kierman and John K. Fairbank, pp. 251–58. Cambridge, Mass.: Harvard University Press, 1974.

Moule, A. C., and Paul Pelliot. *Marco Polo: The Description of the World*. 2 vols. London: George Routledge & Sons, 1938.

Mullin, Glenn H. *Selected Works of the Dalai Lama I: Bridging the Sutras and Tantras*. Ithaca, N.Y.: Snow Lion Publications, 1981.

———. *The Practice of Kalachakra*. Ithaca, N.Y.: Snow Lion Publications, 1991.

Munkuev, N. Ts. *Kitaiskii istochnik o pervykh mongol'skikh khanakh* (A Chinese Source on the First Mongol Khans). Moscow: Nauka, 1965.

Nagao, Gadjin. *Moko ramabyo-ki* (Note on Mongolian Lamaseries). Kyoto, 1947.

Natsagdorj, Sh. "The Economic Basis of Feudalism in Mongolia." Translated by Owen Lattimore. *Modern Asian Studies* 1, no. 3 (1967), 265–81.

———. "The Introduction of Buddhism into Mongolia." Translated by John R. Krueger. *Mongolia Society Bulletin* 7 (1968), 1–12.

Nebesky-Wojkowitz, René de. *Oracles and Demons of Tibet*. The Hague: Mouton, 1956.

———. *Tibetan Religious Dances: Text and Translation of the 'Chams-yig*. The Hague and Paris: Mouton, 1976.

Nei Menggu minzu wenwu (Cultural Relics of the People of Inner Mongolia). Beijing: Renmin Meishu Press, 1987.

Niambu, Kh. *Övöögiin ögüülsen tüükh* (History Told by Grandfather). Ulaanbaatar, 1990.

Ning Chia. "The Lifanyuan and the Inner Asian Rituals in the Early Qing (1644–1795)." *Late Imperial China* 14, no. 1 (June 1993), 60–92.

Novgorodova, Eleonora. *Alte Kunst der Mongolei*. Leipzig: E. A. Seeman Verlag, 1980.

Okada, Hidehiro. "Life of Dayan Qayan." *Acta Asiatica* 11 (1966), 46–55.

———. "The Third Dalai Lama and Altan Khan of the Tumed." In *Tibetan Studies*. Proceedings of the 5th Seminar of the International Association for Tibetan Studies, Narita, 1989. Vol. 2, *Language, History and Culture*, pp. 645–52. Narita: Naritasan Shinshoji, 1992.

———. "The Yuan Seal in Manchu Hands: The Source of the Ch'ing Legitimacy." In *Altaic Religious Beliefs and Practices*. Proceedings of the 33d Meeting of the Permanent International Altaistic Conference, Budapest, 24–29 June 1990. Budapest: Research Group for Altaic Studies, Hungarian Academy of Sciences, 1992.

Oledzki, Jacek. "Native and Folk Elements in Contemporary Mongolian National Art." *Poland at the Eighth International Congress* (1968), 224–37.

Olschak, Blanche C. *Ancient Bhutan: A Study of Early Buddhism in the Himalāyas*. Zurich: Swiss Foundation for Alpine Research, 1979.

Olschak, Blanche Christine, and Geshé Thupten Wangyal. *Mystic Art of Ancient Tibet*. London: George Allen and Unwin, 1973.

Olschki, Leonardo. *Guillaume Boucher: A French Artist at the Court of the Khans*. Baltimore: The Johns Hopkins University Press, 1946.

———. *The Myth of Felt*. Berkeley: University of California Press, 1949.

Onon, Urgunge. *Mongolian Heroes of the Twentieth Century*. New York: A. M. S. Press, 1976.

———, trans. *The History and the Life of Chinggis Khan (The Secret History of the Mongols)*. Leiden: E. J. Brill, 1990.

Onon, Urgunge, and D. Pritchatt. *Asia's First Modern Revolution: Mongolia Proclaims Its Independence in 1911*. Leiden: E. J. Brill, 1989.

Overmyer, Daniel L. "Les systèmes d'écriture en usage chez les anciens Mongols." *Asia Major*, o.s., 2, no. 2 (1925), 284–89.

Pal, Pratapaditya. *The Art of Tibet*. New York: The Asia Society, 1969.

———. *The Arts of Nepal, Part I, Sculpture*. Leiden: E. J. Brill, 1974.

———. *The Arts of Nepal, Part II, Painting*. Leiden: E. J. Brill, 1978.

———. *Tibetan Paintings*. London: Sotheby Publications, 1984.

Pal, Pratapaditya, and Julia Meeck-Pekarik. *Buddhist Book Illuminations*. New York: Ravi Kumar, 1988.

Pander, Eugen. "Das Pantheon des Tschangtscha Hutuktu." *Veröffentlichungen aus dem Königlichen Museum für Völkerkunde* 1, fasc. 2, 3 (1890).

Patkanov, K. P. *Istoria mongolov po armianskim istochnikam* (Mongolian History Based on Armenian Sources). St. Petersburg, 1873.

Pelliot, Paul. *Les Mongols et la papauté*. Paris: Librairie August Picard, 1923.

———, trans. *Histoire secrète des Mongols*. Paris: Adrien Maisonneuve, 1949.

Pelliot, Paul, and Louis Hambis, trans. and annotators. *Histoire des campagnes de Gengis Khan: Cheng-wou ts'in-tcheng lou*. Leiden: E. J. Brill, 1951.

Petech, Luciano. *China and Tibet in the Early Eighteenth Century*. Leiden: E. J. Brill, 1972.

———. *Mediaeval History of Nepal*. Rome: Istituto Italiano per il Medio ed Estremo Oriente, 1984.

———. *Central Tibet and the Mongols: The Yuan-Sa-skya Period of Tibetan History*. Rome: Istituto Italiano per il Medio ed Estremo Oriente, 1990.

Plan Carpin, Jean de. *Histoire des Mongols*. Translated and annotated by Dom Jean Becquet and Louis Hambis. Paris: Adrien Maisonneuve, 1965.

Pokotilov, Dmitrii. "History of the Eastern Mongols during the Ming Dynasty from 1368 to 1634." Translated by R. Löwenthal. *Studia Serica*, ser. A, no. 1 (1947), 25–30.

Poppe, Nikolaus [Nikolai]. *Mongol'skii slovar' Mukaddimat Al-Alab* (The Mongolian Dictionary Mukaddimat Al-Alab). Moscow and Leningrad, 1938.

———. *Introduction to Mongolian Comparative Studies*. Helsinki: Fenno-Ugric Society, 1955.

———. *Mongolische Volksdichtung*. Wiesbaden: Otto Harrassowitz, 1955.

———. *The Mongolian Monuments in ḤP'ags-pa Script*. Translated and edited by John R. Krueger. Wiesbaden: Otto Harrassowitz, 1957.

———. *Vergleichende Grammatik der altaischen Sprachen*. Wiesbaden: Otto Harrassowitz, 1960.

———. "Ein altmongolischer Hochzeitsgebrauch." In *Studia Sino-Altaïca*, pp. 159–64. Wiesbaden: Franz Steiner, 1961.

———. *The Twelve Deeds of Buddha: A Mongolian Version of the Lalitavistara. Mongolian Text, Notes, and English Translation*. Asiatische Forschungen, Band 23. Wiesbaden: Otto Harrassowitz, 1967.

———. *Grammar of Written Mongolian*. Wiesbaden: Otto Harassowitz, 1974.

———. *The Heroic Epic of the Khalkha Mongols*. Translated by John R. Krueger et al. Mongolia Society Occasional Papers, no. 11. Bloomington, Ind.: The Mongolia Society, 1979.

Pott, P. H. *Introduction to the Tibetan Collection of the National Museum of Ethnology, Leiden*. Leiden, 1951.

Poucha, Pavel. *Die geheime Geschichte der Mongolen als Geschichtsquelle und Literaturdenkmal*. Prague: Verlag der Tschechoslowakischen Akademie der Wissenschaften, 1956.

Pozdneyev, Aleksei M. *Mongolia and the Mongols.* Translated by John Roger Shaw and Dale Plank. Uralic and Altaic Series, vol. 61. Bloomington: Indiana University Publications, 1971.

———. *Religion and Ritual in Society: Lamaist Buddhism in Late Nineteenth-Century Mongolia.* Translated by Alo Raun and Linda Raun. The Mongolia Society Occasional Papers, no. 10. Bloomington, Ind.: The Mongolia Society, 1978.

Pritsak, Omeljan. "Der Titel Attila." In *Festschrift für Max Vasner zum 70. Geburtstag,* edited by M. Woltner, pp. 404–19. Veröffentlichungen der Abteilung für Slavische Sprachen und Literaturen des Osteuropa-Instituts, Band 9. Wiesbaden: Otto Harrassowitz, 1956.

"Qing gongting huajia Lang Shining nianpu" (Chronology of the Qing Court Painter Giuseppe Castiglione). *Gugong Bowuynan Yuankan* 2 (1988), 62.

Qinggertai et al. *Qidan xiaozi yanjiu* (Studies on the Small Khitan Script). Beijing: Social Science Publishers, 1985.

Ramstedt, G. J. "Ein Fragment mongolischen Quadratschrift." *Journal de la Société Fenno-Ougrienne* 27 (1912).

Ratchnevsky, Paul. *Genghis Khan: His Life and Legacy.* Translated by Thomas Haining. Oxford: Blackwell Publishers, 1991.

Regmi, D. R. *Ancient Nepal.* Calcutta: Firma K. L. Mukhopadhyay, 1960.

Reynolds, Valrae, et al. *Catalogue of the Newark Museum Tibetan Collection.* 3 vols. Newark, N.J.: The Newark Museum, 1986.

Rhie, Marylin, and Robert A. F. Thurman. *Wisdom and Compassion: The Sacred Art of Tibet.* San Francisco: Asian Art Museum of San Francisco; New York: Tibet House and Harry N. Abrams, 1991.

Richardson, Hugh E. "The Karma-pa Sect: A Historical Note." *Journal of the Royal Asiatic Society* (October 1958), 139–64; (April 1959), 1–18.

———. *Ceremonies of the Lhasa Year.* London: Serindia Publications, 1993.

Rinchen, Y. *Gandan Tekchenling Monastery.* New Delhi, 1961.

Rintchen, B. [also spelled Rinchen, Rintschen]. "Zwei unbekannte mongolische Alphabete aus dem XVII. Jahrhundert." *Acta Orientalia* 2 (1952), 63–71.

———. "A propos de la sigillographie mongole: Le grand sceau de jaspe et le petit sceau d'argent du qaγan *olan-a ergügdegsen.*" *Acta Orientalia* 3 (1953), 25–31.

———. "Schamanistische Geister der Gebirge: Dörben aγula-yin eǰed in Urgaer Pantomimen." *Acta Ethnographica Academiae Scientarium Hungaricae* 6 (1958), 444–48.

———. *Les matériaux pour l'étude du chamanisme mongol:* "Sources litteraires." *Asiatische Forschungen* 3, no. 1 (1959); "Textes chamanistes bouriates," 8, no. 2 (1961); "Textes chamanistes mongols," 40, no. 3 (1975).

———. *Folklore Mongol.* Asiatische Forschungen, Band 7. Wiesbaden: Otto Harrassowitz, 1960.

———. *Mongol bičgiin xelnii züi: Udirtgal* (Grammar of Literary Mongolian: Introduction). Ulaanbaatar: Shinjlex Uxaany Akademiin Xevlex Üildver, 1964.

———. "The Smile of the Goddess Tara." *Mongolia Society Bulletin* 11, no. 1 (1989), 113–24.

Rockhill, William W., trans. *The Journey of William of Rubruck to the Eastern Parts of the World.* London: Hakluyt Society, 1900.

Róna-Tas, Andras. "Felt-Making in Mongolia." *Acta Orientalia Hungarica* 16 (1963), 199–215.

Rossabi, Morris. "Notes on Esen's Pride and Ming China's Prejudice." *Mongolia Society Bulletin* 9, no. 2 (Fall 1970), 31–39.

———. *China and Inner Asia from 1368 to the Present Day.* London: Thames and Hudson, 1975.

———. "Khubilai Khan and the Women in His Family." In *Studia Sino-Mongolica: Festschrift für Herbert Franke,* edited by Wolfgang Bauer, pp. 153–80. Wiesbaden: Franz Steiner Verlag, 1979.

———. *The Jurchens in the Yüan and Ming.* Ithaca, N.Y.: China-Japan Program, Cornell University, 1982.

———. "Genghis Khan." In vol. 1 of *Encyclopedia of Asian History,* edited by A. Embree, pp. 496–98. New York: Charles Scribner's Sons, 1988.

———. *Khubilai Khan: His Life and Times.* Berkeley: University of California Press, 1988.

———. "Mongolia: A New Opening?" *Current History* 91, no. 566 (September 1992), 278–83.

———. *Voyager from Xanadu: Rabban Sauma and the First Journey from China to the West.* New York: Kodansha, 1992.

———. "The Ch'ing Conquest of Inner Asia." In *Cambridge History of China: Early Ch'ing,* edited by Denis Twitchett. Cambridge: Cambridge University Press, forthcoming.

———. "Ming China and Inner Asia." In *Cambridge History of China: Ming II,* edited by Denis Twitchett. Cambridge: Cambridge University Press, forthcoming.

Roux, Jean-Paul. *Histoire de l'empire mongol.* Paris: Fayard, 1993.

Rowland, Benjamin. *The Art of Central Asia.* New York: Crown Publishers, 1970.

Rupen, Robert A. "The City of Urga in the Manchu Period." In *Studia Altaïca: Festschrift für Nikolaus Poppe.* Wiesbaden: Otto Harrassowitz, 1957.

———. *The Mongols of the Twentieth Century.* Uralic and Altaic Series, vol. 37, nos. 1–2. 2 vols. Bloomington: Indiana University Press, 1964.

Saar, John. "Japanese Divers Discover Wreckage of Mongol Fleet." *Smithsonian Magazine,* December 1981, 118–29.

Samuel, Geoffrey. *Civilized Shamans: Buddhism in Tibetan Societies.* Washington and London: Smithsonian Institution Press, 1993.

Sanders, Alan J. K. *The People's Republic of Mongolia: A General Reference Guide.* London: Oxford University Press, 1968.

Sanjdorj, M. *Manchu Chinese Colonial Rule in Northern Mongolia.* Translated by Urgunge Onon. New York: St. Martin's Press, 1980.

Sárközi, Alice. *Political Prophecies in Mongolia in the Seventeenth–Twentieth Centuries.* Bibliotheca Orientalis Hungarica, vol. 38; Asiatische Forschungen, Band 116. Budapest: Akadémiai Kiadó, 1992.

Saunders, E. Dale. *Mudrā.* New York: Pantheon, 1960.

Sazykin, Aleksei Georgievich. *Katalog mongol'skikh rukopisei i ksilografov Instituta Vostokovedeniia Akademii Nauk SSSR* (A Catalogue of the Mongolian Manuscripts and Xylographs of the Institute of Oriental Studies of the Academy of Sciences of the USSR). Moscow: Nauka, 1988.

Schmid, Toni. *Saviours of Mankind: Dalai Lamas and Former Incarnations of Avalokiteśvara.* The Sino-Swedish Expedition Publication, no. 45. Stockholm: Statens Etnografiska Museum, 1961.

———. *Saviours of Mankind II: Panchen Lamas and Former Incarnations of Amitāyus.* The Sino-Swedish Expedition Publication, no. 46. Stockholm: Statens Etnografiska Museum, 1964.

Schmidt, Elena Tasseva. "Revival of Buddhism in Mongolia." *Arts of Asia* 23, no. 4 (July–August 1993), 59–63.

Schmidt, I. J. *Geschichte der Ost-Mongolen und ihres Fürstenhauses verfasst von Ssanang Ssetsen Chungtaidschi der Ordos.* St. Petersburg, 1829.

Schroeder, Ulrich von. *Indo-Tibetan Bronzes.* Hong Kong: Visual Dharma Publications, 1981.

Schuh, Dieter. *Grundlagen tibetischer Siegelkunde: Eine Untersuchung über tibetische Siegelaufschriften in 'Phags-pa-Schrift.* Monumenta Tibetica Historica, Band 3, Nr. 5 (1981), 5–7.

Schulemann, G. *Geschichte der Dalai-Lamas.* 2d ed. Leipzig: Otto Harrassowitz, 1958.

Schurmann, H. F. *The Mongols in Afghanistan: An Ethnography of the Moghuls and Related Peoples of Afghanistan.* Leiden: Mouton, 1962.

Schwarz, Henry G. *Bibliotheca Mongolica. Part I: Works in English, French, and German*. Bellingham: Western Washington University Press, 1978.

———. *Studies on Mongolia: Proceedings of the First North American Conference on Mongolian Studies*. Bellingham: Western Washington University Center for East Asian Studies, 1979.

Seaman, Gary, ed. *Ecology and Empire: Nomads in the Cultural Evolution of the Old World*. Los Angeles: Ethnographics/University of Southern California, 1989.

———. *Foundations of Empire: Archaeology and Art of the Eurasian Steppes*. Los Angeles: Ethnographics/University of Southern California, 1992.

Seaman, Gary, and Daniel Marks, eds. *Rulers from the Steppe: State Formation on the Eurasian Periphery*. Los Angeles: Ethnographics/University of Southern California, 1991.

Serruys, Henry. "Notes on a Few Mongolian Rulers of the Fifteenth Century." *Journal of the American Oriental Society* 76 (1956).

———. *Genealogical Tables of the Descendants of Dayan-qan*. The Hague: Mouton, 1958.

———. "Were the Ming against the Mongols Settling in North China?" *Oriens Extremus* 6, no. 2 (December 1959), 131–59.

———. "Four Documents Relating to the Sino-Mongol Peace of 1570–1571." *Monumenta Serica* 19 (1960), 1–66.

———. "Three Mongol Documents from 1635 in the Russian Archives." *Central Asiatic Journal* 7, no. 1 (March 1962), 1–41.

———. "Early Lamaism in Mongolia." *Oriens Extremus* 10, no. 2 (October 1963), 181–216.

———. "Additional Note on the Origin of Lamaism in Mongolia." *Oriens Extremus* 13 (1966), 165–73.

———. "The Mongols in China, 1400–1450." *Monumenta Serica* 27 (1968), 233–305.

———. "Remarks on the Introduction of Lamaism into Mongolia." *Mongolia Society Bulletin* 7 (1968), 62–65.

———. "A Manuscript Version of the Legend of the Mongol Ancestry of the Yung-lo Emperor." *Analecta Mongolica*. The Mongolia Society Occasional Papers, no. 8. Bloomington, Ind.: The Mongolia Society, 1972.

———. *The Mongols and Ming China: Customs and History*. London: Variorum Reprints, 1987.

Shagdasüren, Ts. *Mongol üseg züi: Tergüün Devter (Ert üyees 1921 on xürtel)* (Mongol Scriptology: From Ancient Times until 1921). Ulaanbaatar: Shinjlex Uxaany Akademi, 1981.

Shakabpa, Tsepon W. D. *Tibet: A Political History*. New Haven, Conn.: Yale University Press, 1967.

Shchelpetil'nikov, Nicolaï M. *Arkhitektura mongolii* (Mongolian Architecture). Moscow: Gostroizdata, 1960.

Shirnen, G., ed. *Bügd Nairamdakh Mongol Ard Ulsyn malchdyn nüüdel* (The Transhumance of the Herdsmen of the Mongolian People's Republic). Ulaanbaatar, 1989.

Siklos, B. "Mongolia Buddhism: A Defensive Account." In *Mongolia Today*, edited by Akiner Shirin, pp. 155–182. London: Kegan Paul and Central Asia Research Forum, 1991.

Slessarev, Vsevolod. *Prester John: The Letters and the Legend*. Minneapolis: University of Minnesota Press, 1959.

Snellgrove, David. *Indo-Tibetan Buddhism: Indian Buddhists and Their Tibetan Successors*. Vol. 1, London: Serindia Publications; vol. 2, Boston: Shambhala, 1987.

Snellgrove, David, and Hugh Richardson. *A Cultural History of Tibet*. London: Weidenfeld & Nicolson, 1968.

Soothill, William Edward, and Lewis Hodous. *A Dictionary of Chinese Buddhist Terms*. Taipei: Chengwen Publishing Company, 1968.

Sosor, O. "Mongol Zurag Painting: Revival of Traditions." *Mongolia* 2 (1989), 24.

Sponberg, Alan, and Helen Hardacre. *Maitreya, the Future Buddha*. Cambridge: Cambridge University Press, 1988.

Spuler, Bertold. *Les Mongols dans l'histoire*. Paris: Payot, 1961.

———. *Die Goldene Horde: Die Mongolen in Russland, 1233–1502*. Wiesbaden: Otto Harrassowitz, 1965.

———. *History of the Mongols Based on Eastern and Western Accounts of the Thirteenth and Fourteenth Centuries*. Translated by Helga Drummond and Stuart Drummond. Berkeley: University of California Press, 1972.

Stein, Rolf A. "Le *Linga* des danses masquées lamaïques et la théorie des âmes." *Liebenthal Festschrift, Sino-Indian Studies* 5, pts. 3–4 (May 1957), 200–234.

———. "Les danseuses masquées ('cham)." *Annuaire* (Ecole Pratique des Hautes Etudes, IVe section) 82, fasc. 3 (1973–74), 50–51.

Steinhardt, Nancy S. "The Plan of Khubilai Khan's Imperial City." *Artibus Asiae* 44, nos. 2–3 (1983), 137–58.

———. "Imperial Architecture along the Mongolian Road to Dadu." *Ars Orientalis* 18 (1988), 59–92.

Stoddard, Heather. [See also Heather Karmay.] "A Stone Sculpture of mGur mGon-po, Mahākāla of the Tent, Dated 1292." *Oriental Art*, n.s., 31, no. 3 (Autumn 1985), 278–82.

Taranatha, Jo-nan. *The Origin of the Tara Tantra*. Edited and translated by David Templeman. Dharamsala: Library of Tibetan Works and Archives, 1981.

Thévenet, Jacqueline. *Les Mongols de Gengis-khan et d'aujourd'hui*. Paris: Armand Colin, 1986

Thinley, Karma. *The History of the Sixteen Karmapas of Tibet*. Boulder, Colo.: Prajñā Press, 1980.

This Is Mongolia. Ulaanbaatar, 1991.

Thurman, Robert A. F. *The Central Philosophy of Tibet*. Princeton, N.J.: Princeton University Press, 1984.

Tkatchev, Valentin. *Istoria mongol'skogo arkhitektura* (History of Mongolian Architecture). Moscow, 1988.

Trungpa, Chögyam. *Visual Dharma: The Buddhist Art of Tibet*. Berkeley and London: Shambhala, 1975.

Tsevel, Ja. *Mongol khelnii tovch tailbar tol'* (Explanatory Dictionary of Mongolian). Ulaanbaatar, 1966.

Tsultem, N. *The Eminent Mongolian Sculptor—G. Zanabazar*. Ulaanbaatar: State Publishing House, 1982.

———. *Development of the Mongolian National Style Painting "Mongol Zurag" in Brief*. Ulaanbaatar: State Publishing House, 1986.

———. *Mongolian Arts and Crafts*. Ulaanbaatar: State Publishing House, 1987.

———. *Mongolian Architecture*. Ulaanbaatar: State Publishing House, 1988.

———. *Mongolian Sculpture*. Ulaanbaatar: State Publishing House, 1989.

Tucci, Giuseppe. *Tibetan Painted Scrolls*. Rome: La Librairio del Stato, 1949.

———. *The Religions of Tibet*. Translated by Geoffrey Samuel. Berkeley: University of California Press, 1980.

Tuguan Luosang Queji Nima, Chen Qingying, and Ma Lianlong. *Zhangjia guoshi Ruobi Duoji chuan* (The Biography of the National Preceptor the Jangjya Rolpay Dorje). Beijing: Minzu Press, 1988.

Turnbull, S. R., and Angus McBride. *The Mongols*. London: Osprey Publishing, 1980.

Undrah, D. *Bogdo Khaany ordon-muzei* (Bogdo Khan Palace Museum). Ulaanbaatar, 1972.

Veit, Veronika. *Die vier Qane von Qalqa: Ein Beitrag zur Kenntnis der politischen Bedeutung der nordmongolischen Aristokratie in den Regierugsperioden K'ang-hsi bis Ch'ien-lung (1661–1796)*. 2 vols. Wiesbaden: Otto Harrassowitz, 1990.

Vinkovics, Judit. "Two Mongol Sculptures from the Ferenc Hopp Museum of Eastern Asiatic Art." *Ars Decorative—Iparmüvészet* 10 (1991), 99–113.

Vira, Raghu, and Lokesh Chandra. *A New Tibeto-Mongol Pantheon.* 2 vols. New Delhi: International Academy of Indian Culture, 1961–72.

Visser, M. W. de. *The Arhats in China and Japan.* Berlin: Oesterheld and Co., 1923.

Vladimirtsov, Boris Ia. *Obshchestvennyi stroi mongolov* (Social Structure of the Mongols). Leningrad: Izdatel'stvo Akademii Nauk SSSR, 1934.

———. *La régime social des Mongols: Le féodalisme nomade.* Translated by Michel Carsow. Paris: Adrien Maisonneuve, 1948.

———. *The Life of Chingis Khan.* Translated by D. S. Mirsky. Reprint. New York: Benjamin Blom, 1969.

Vreeland, Herbert Harold, III. *Mongol Community and Kinship Structure.* New Haven, Conn.: Human Relations Area Files, 1953.

Wada, Masami. "A Study of Dayan Khan." *Memoires of the Research Department of the Toyo Bunko* 19 (1960), 1–42.

Waddell, L. Austine. *The Buddhism of Tibet or Lamaism.* London, 1895. Reprint. Cambridge: W. Heffer & Sons, 1967.

Wakeman, Frederic, Jr. *The Great Enterprise.* 2 vols. Berkeley: University of California Press, 1985.

Waldron, Arthur. *The Great Wall of China.* Cambridge: Cambridge University Press, 1990.

Waley, Arthur, trans. *The Travels of an Alchemist.* London: Routledge & Kegan Paul, 1931.

———. *The Secret History of the Mongols and Other Pieces.* London: Allen and Unwin, 1963.

Wan Yi, Wang Shuqing, and Liu Lu. *Qingdai gongting shi* (History of the Qing Palace). Shengyang: Liaoning renmin Press, 1990.

Wang Yarong. *Chinese Folk Embroidery.* London: Thames and Hudson, 1987.

Wangjil, Borjigidai B. *Köke jula* (The Blue Lamp). Külün Büir Aimag, 1990.

Wardwell, Anne E. "*Panni Tartaricus:* Eastern Islamic Silks Woven with Gold and Silver, Thirteenth and Fourteenth Centuries." *Islamic Art* 3 (1988–89), 95–173.

———. "Two Silk and Gold Textiles of the Early Mongol Period." *Bulletin of the Cleveland Museum of Art* 79, no. 10 (December 1992), 354–78.

Warwick, Adam. "The People of the Wilderness: The Mongols, Once the Terror of All Christendom, Now a Primitive, Harmless Nomad Race." *National Geographic,* January–June 1921, 506–51.

Watt, James C. Y., and Barbara Brennan Ford. *East Asian Lacquer: The Florence and Herbert Irving Collection.* New York: The Metropolitan Museum of Art, 1991.

Weidner, Marsha. "Painting and Patronage at the Mongol Court of China." Ph.D. diss., University of California, Berkeley, 1982.

———. "Yuan Dynasty Court Collections of Chinese Paintings." *Central and Inner Asian Studies* 2 (1988), 1–40; "Appendixes to Yuan Dynasty Court Collections of Chinese Paintings," 3 (1989), 83–104.

———. "Aspects of Painting and Patronage at the Mongol Court, 1260–1368." In *Artists and Patrons: Some Social and Economic Aspects of Chinese Art,* edited by Chu-tsing Li, pp. 37–59. Seattle: University of Washington Press, 1989.

Weidner, Marsha, et al. *Latter Days of the Law: Images of Chinese Buddhism, 850–1850.* Lawrence: Spencer Museum, University of Kansas; Honolulu: University of Hawaii Press, 1994.

West, Elizabeth Endicott. *Mongolian Rule in China: Local Administration in the Yuan Dynasty.* Cambridge, Mass.: Harvard University Press, 1989.

Widmer, Eric. *The Russian Ecclesiastical Mission in Peking during the Eighteenth Century.* Cambridge, Mass.: Harvard University Press, 1976.

Willson, Martin. *In Praise of Tara: Songs to the Saviouress.* London: Wisdom Publications, 1986.

Wittfogel, Karl A., and Chia-sheng Fêng. *History of Chinese Society: Liao (907–1125).* Philadelphia: The American Philosophical Society, 1949.

Worden, Robert L., and Andrea M. Savada. *Mongolia: A Country Study.* Washington, D.C.: Library of Congress, Federal Research Division, 1989.

Wylie, Turrel V. "Reincarnation: A Political Innovation in Tibetan Buddhism." *Bibliotheca Orientalis Hungarica* 23. Proceedings of the Cosma de Körös Memorial Symposium, 24–30 September 1976, edited by Louis Ligeti. Budapest: Akadémiai Kiadó, 1978.

Yang Boda. *Qingdai Yuanhua* (Qing Dynasty Court Painting). Beijing: Forbidden City Press, 1993.

Yang Qingxi. *Taersi* (Taer Monastery). Xining: Qinghai Nationalities Press, 1984.

———. *Taersi gaikuang* (Overview of Taer Monastery). Xining: Qinghai People's Press, 1987.

Yang Shuwen, et al. *The Biographical Paintings of 'Phags-Pa.* Beijing: New World Press; Lhasa: People's Publishing House of Tibet, 1987.

Yeshey, Paldan. *Erdeni-yin Erike: Mongolische Chronik der lamaistischen Klosterbauten der Mongolei von Isibaldan.* 1835. Edited by Walther Heissig. Copenhagen: Einar Munksgaard, 1961.

Yuanshi (History of the Yuan). Ershiwushi edition. Taipei: Kaiming Bookstore, 1969.

Yuanshi (History of the Yuan). Beijing: Zhonghua Shuji, 1976.

Zeng Zhaoyu et al. *Yinan gu huaxiang shimu fajue baogao* (Report on the Excavation of an Ancient Decorated Stone Tomb at Yinan). Nanjing: Nanjing Museum, 1956.

Zhang Yuxin. *Qing zhengfu yu lama jiao* (The Qing Government and Lamaism). Beijing: People's Publishing House of Tibet, 1988.

———. *Qingdai sida huofo* (The Four Living Buddhas of the Qing Dynasty). Beijing: Zhongguo Renmin Daxue Press, 1989.

Zhukovskaya, Nataliya. *Category and Symbol in Traditional Mongolian Culture.* Moscow, 1988. In Russian.

Zlatkin, Il'ia Iakovlevich. *Istoriia dzhungarskogo khanstva, 1635–1758* (A History of the Jungharian Khanate). Moscow: Nauka, 1964.

Zwalf, Wladimir. *Heritage of Tibet.* London: The British Museum Publications, 1981.

Zwilling, Leonard. "Mongolian Xylographs in the University of Wisconsin (Madison) Libraries." *Mongolian Studies* 9 (1985–86), 5–11.

Index

Page numbers in roman refer to the text; page numbers in *italic* refer to illustrations; and page numbers in **boldface** refer to color plates of the objects in the exhibition. Spellings in classical Tibetan are given for selected names.

incantation by, 100
legacy of, 28
and literacy in Mongolia, 28, 89–90
and the Mongol empire, 25–29
myth of, 5, 261
portrait of, 26
relics of, 50, 55, 55, 72 n. 2
religion and, 27, 28
succession to, 28–29
U.S.S.R.'s demonization of, 46
Ching süsügtü Nomyn Khan, 292
Choijil. See Yama
Chongqin empress, 189
chopper, ritual, 260, **260**
Christianity, Nestorian, 29, 33
Citipati (deity; Lord of the Funeral Pile, 41, 64
Citipati, Lord of the Funeral Pile (Choijin-
Lama Temple Museum), 154, **155**
Clark, Walter E., 297, 297 n. 4
clothing
for sculptures, 266, 266, 278
see also dress
Coleridge, Samuel Taylor, 5, 31
color
manuscript in, 202, **202**
and points of the compass, 9, 162, 191
symbolism of, 164, 168, 174, 273, 274, 290,
294
Communism in Mongolia, and Buddhism, 4,
45–47, 72, 181
confederations, Mongol society as, 8, 24 n. 2,
25
Confucius, in the Buddhist pantheon, 70
copperplate. See printing block
craftsmen
Chinese, in Mongolia, 39
Chinggis Khan and, 28
encouragement of, by Khubilai Khan, 31–32
in the monasteries, 45
under Altan Khan, 38
Čültem Čoyinpel, 192

D

Dachin-kalbain süme (temple), 81, 181
Dadu, 31, 31, 51, 120
Dagwa (scribe), 204
Dakba Dorje (abbot), 53
Dakdan Puntsagling. See monastery,
Puntsagling
Dalai Lama
list of, 305
seals of, 268, 268
symbolism of name, Ocean, of, 39, 52
First. See Gedundrüp
Second, 212, 244
Third. See Sonam Gyatsho
Fourth. See Yonten Gyatsho
Fifth (the Great). See Losang Gyatsho
Sixth, 62, 174
Seventh, 68
Thirteenth, 158, 177, 178, 246
Da lha (Dgra lha; a spirit of destiny), 228, **229**
dal Piano del Carpine, Giovanni. See Carpine,
Giovanni dal Piano del

Damdinsüren, 175
Damtsik Dorje (Dam tshig rdo rje), 186
dance, ritual, 150
Black Hat. See Black Hats
manual for, 150, 151, 154, 162
of spirits, 177, 178
see also tsam
Da Qingchao shilu (text), 54
Dark Old Man, 64, 151, 212
Spirit of Songgina (mask; Choijin-Lama
Temple Museum), 161, **161**
Dashatala (system of iconometry), 224
Dayan Khan. See Batu Möngke
deer, as decoration, 218, 218
Deer with a Single Antler (Choijin-Lama
Temple Museum), 218, **218**
del. See dress, Mongolian national
Deshinshekpa (Fifth Black Hat Karmapa), 210
Dharmatala (arhat), 156
Dharmatala (historian), 5, 62, 123, 174
Die Mongolen (exhibition), 5
Diluv Khutagt, 119 n. 10
Ding Guanpeng (painter), 69
Dolonnor
sculpture from, 80–82, 219–20, **219**, 232,
243–**45**, 263, 303
style of, 221, 225, 232
see also monastery, Dolonnor
Dondogdulam (Ekh Dagin, Mother Dakini;
wife of Bogdo Khan)
as an oracle, 146
portrait of (Sharav; Museum of Fine Arts),
86, 146, **146**
regalia of (Bogdo Khan Palace Museum),
45, 71, 140, 147–48, **147–48**
seal of, 269, 269
dorje (rdo rje; ritual object), 140, 141 n. 2, 258,
258, 259, **259**
large (Bogdo Khan Palace Museum), 142,
142
symbol of
on base plates, 21, 77–79, 78, **121**, 233, 233
on book covers, 192, 193, 203, **203**
Dorje Dordan (Rdo rje grags ldan; Perenlay;
Museum of Fine Arts), 84, **248**, 249, 251
see also Begtse
Dorje Shukden (Rdo rje shugs ldan; protec-
tor), Gelugpa and, 211
Dorj, G., 174
Dorjieff (lama), 181
Dorj-sembe. See Vajrasattva
dough
image (lingka), 64, 150, 168, 170
sacrifice (baling), 244
dress
ceremonial, 71, 138–41, **138–41**, 147–48,
147–48
Mongolian national, 84, 99, 106
tsam, 64, 170, **170–71**
drum, hand (Bogdo Khan Palace Museum),
86, 143, **143**
Dunhuang, Thousand Buddha Caves of, 208
cave no. 465, 208, 208
Duolin. See Dolonnor
Durteddagva. See Citipati

dynasty
Jin, 39, 55
Manchu. See dynasty, Qing
Ming, 261
the Mongols under, 35, 36, 39, 51
Pala (India), 186
Qing (Manchu; 1644–1911), 261
and the Bogdo Gegen succession, 118
ceremonial dress and, 138
khatak and, 142
languages of, 185
the Mongols under, 12, 42–45, 56–57
and the printing of texts, 186
records of, and Mongolian art, 5
territory of, 9
Southern Song, 29, 31 (map)
Tang, 300
Yuan
art in, 4, 120
decline of, 33–34, 36, 51
founding of, 29
literacy during, 89
see also Northern Yuan

E

Early Sino-Tibetan Art (Stoddard), 4
eating set, 84, 99, 106, **107**, **148**
Eight Dharmapala (sculpture), 82
Eighth Bogdo Gegen (Bogdo Khan Palace
Museum), **46**
Ekajati. See Tara, Black
embroidery
Mongol, 83–84, 86, 86
Qing, 216, **217**
on silk appliqués, 236, **237**, **239**, 240, 241, 242,
246
Empires beyond the Great Wall: The Heritage of
Genghis Khan (exhibition), 4
Enthronement of Arghun Khan (Uzbek Academy
of Sciences), 35
Epi Khalkha süme (temple), sculpture from,
82
Erbekei. See Citipati
Erdene Bandid Khutagt. See Lamyn Gegeen
Erdeni Nomyn Khan (Rolpay Dorje's spiritual
teacher), 69
Erdeni-yin tobči (text), 5, 54, 72 n. 9, 73 n. 22
Erleg Khan, 150, 154, 168
see also Yama
Erleg Khan (Yama) tsam, 64, 64, 150, 151, 255
Europe
Mongols in, 29
trade with the Mongols and, 32
Europeans, in Mongolia, 32–33
ewer, double-spouted (Museum of Fine Arts),
104, **104**
exorcism
ritual for, 255
see also tsam

F

Feilaifeng caves, tantric sculpture at, 209, 209
felt, making, 22, 23

Outer Mongolia (*Aru Mongghol;* Khalkha), 1, 9–10
 sculpture of, 77–80
 tradition of *Gobiin lha* in, 228

P

Padmasambhava (Indian sage), 53, 208, 228, 273
page
 from sutra, 195, **195**
 manuscript, in Mongolian script (State Central Library), 90, 200–202, **200–202**
painting, 126, 127
 at Jehol, 68
 attributed to Zanabazar, **122**, 123–24
 Mongolian Buddhist, 83
 on book covers, 196–97, **196**
 see also thangka
Paizi [passport or safe-conduct pass] with Phagspa Script (The Metropolitan Museum of Art), *32*
Palden Lhamo (Dpal ldan lha mo; Choijin-Lama Temple Museum), 82, 225, 232, 243, **243**, 302
Palden Lhamo (protectress), 228
 Gelugpa and, 211, 243
 see also Lhamo; Offerings to Palden Lhamo; Rikpay Lhamo
Palden Maksor Remati (a form of Lhamo), 228
Panchen Lama
 establishment of, 118
 list of, 306
 Shambhala and, 181
 First. *See* Losang Chökyi Gyaltsen
 Third. *See* Losang Palden Yeshe
 Fourth, 306
 Narthang Pantheon and, 77, 230, 292
pantheon, Buddhist
 in art, 3, 207–60
 Baoxiang Lou, 211
 extraneous introductions into, 65, 70, 74 n. 78
 Mongolian Kanjur and, 77
 Narthang. *See Narthang Pantheon*
 origins of, 207–8
 Tara in, 251, 290, 292
 Tibetan, in Mongolia, 207–60, 226
 see also Astasahasrika; Zhufo pusa
paper, for canonic texts, 187
passport or safe-conduct pass (*paizi*), 32, *32*
pedestal, for sculpture, 77, 244, 256, 275, 276, 281
Pehar (pre-Buddhist deity), 212, 249
pen, use of, by Central Asian scribes, 187
Perenlay (artist), 248, **248**
Persia, Mongol influence on arts in, 36
Phagspa ('Phags pa; lama), 117
 biography of, 69
 and the Buddhist state, 33, 50–51, 120, 209
 career of, 120
 and conversion of Mongols to Buddhism, 207, 209
 Khubilai Khan and, 53, 54
 Makahala of, 4, 54, 55, 73 n. 27, 236

prophecy of, 50
 script of. *See* script, Phagspa
Phagspa Lama (Namsarai; Museum of Fine Arts), 120, **120**
phurba (phur ba; ritual instrument), 260, **260**
plaque, votive *(tsha-tsha)*, 222, **222–23**, 250, **250**
pole-lasso, 15, 16–17, *17, 18*
Polo, Marco, 5, 11, 32–33
Portrait of Chabi, Wife of Khubilai Khan (National Palace Museum, Taiwan), *34*
Portrait of Chinggis Khan (National Palace Museum, Taiwan), *26*
Portrait of Ekh Dagin Dondogdulam (Sharav; Museum of Fine Arts), 71, 86, 146, **146**
Portrait of Khubilai Khan (National Palace Museum, Taiwan), *30*
Portrait of Taranatha (Astasahasrika Pantheon), 265
Portrait of Zanabazar
 (Bogdo Khan Palace Museum), *40*
 (N. Tsultem collection), *125*
 (school of Zanabazar; Choijin-Lama Temple Museum), 57, 70, 259, **264**, 265–66, **266**
 (Zanabazar; Museum of Fine Arts), 57, 67, 70, **122**, 123–24, 232, 238, 266
portraiture, as memorialization, 123–24, 265
Potala Palace, Lhasa, 56, 177, **177**
Pott, P. H., 78
pouch, Barga, 114, **115**
 see also snuff bottle(s)
Pozdneyev, Aleksei M., 5, 64, 81, 118, 123, 125, 140, 151, 154, 164, 174, 221, 246, 251, 263 n. 2, 266, 298 n.
Praise in Twenty-one Homages (text), 289, 290
Pratimalakshana (text), 224
prayer
 invocation, **126**, 127
 Tibetan, 234
 to White Tara, 286
 see also Monlam
prayer flag, *14*
prayer service, in *tsam,* 64, 65
preincarnation, 118
Prester John, 32
printing, of canonic texts, 185, 186
printing block, and print (State Central Library), 199, **199**

Q

Qalqa. *See* Khalkha
Qianlong emperor (r. 1736–95)
 Bogdo Gegen and, 118–19, 142
 gifts for, 220
 Mongolian art and, 76, 83
 translation of canonic texts by, 187
Questions of Milanda (text), 295

R

Rahu, the Planet (Bogdo Khan Palace Museum), 256, **257**
Raktayamari (tantric *yidam*), Gelugpa and, 211
Rashid al-Dīn, *28*, 36
Ratnasambhava (Zanabazar; Museum of Fine Arts), 270, 273

Red Master of Life, 246, 250, 251, 252
 see also Begtse, **247**, **250**, **253**
regalia. *See* dress, ceremonial
reincarnation, 117, 119 n. 2
 and Mongol art, 3, 117–48
 politics and, 117–18, 125
relics
 of Chinggis Khan, 50, 55, **55**, 72 n. 2
 of Shakyamuni Buddha, 301
 stored in Mongolian images, 77
reliquary
 box. *See ga'u*
 Zanabazar's, 263, 266
 see also stupa
renaissance, Mongol, 50–75
Resplendent Saint. *See* Bogdo Gegen
Rhie, Marylin, 82
Richardson, Hugh, 177
Rikpay Lhamo (Rig pa'i lha mo gdong dmar ma), 243, **243**, 244, 246, 250, 252, 252 n. 1
 see also Palden Lhamo, **247**, **250**, **253**
Rintchen, B., 100, 150
ritual
 instruments for, 241, 258–60, **258–60**
 recitation of canonic texts in, 186
 Zanabazar's reform of, 61–62
 see also Maitreya Festival; *tsam*
robe
 Ekh Dagin Dondogdulam's, 147–48, **147**
 tsam, 170, **170**
 see also jifu
Rolpay Dorje (Rol pa'i rdo rje; Jangjya Khutuktu)
 and art in Inner Mongolia, 5, 82–83
 biography of, 75 n. 95
 iconography and, 69, 234
 Mongolian Buddhism and, 53, 69–70
 pantheons of
 Three Hundred Icons, 77, 282
 Zhufo pusa. See Zhufo pusa
 portrait of, 70
 prayer for Guandi written by, 65
 sutras and, 185, 203
 Tara and, 292
 translation of canonic texts by, 187
Rosary of White Lotuses (Dharmatala), 5
Roublev, Andrei, 36
Rudrachakrin (Drakpo Korlojen [Drag po 'khor lo can]; last king of Shambhala), 180
Ruru jataka (text), 218
Russia
 Buddhism in, 212
 expansionism of, in Central Asia, 41–42
 Golden Horde in, 35
 Mongolia and, 36, 71, 73 n. 25
 Mongols in, 73 n. 25
 as Shambhala, 181
 Tibetan monastery in, 93
 see also U.S.S.R.

S

sacrifice, *baling,* 244
saddle, 16, 99
 Buriat (Museum of Mongolian History), 100, 102, **103**

for a high lama (Museum of Mongolian
History), 100, 102, **102**
Khalkha (Museum of Mongolian History),
100, **101**
Saghang Sečen (historian), 5
Sakyapa (Sa skya pa; order of Buddhism), 33,
51, 52, 150, 300
and Buddhism in the Mongol empire, 209
Erdeni Zuu and, 53
Great Fifth Dalai Lama and, 57–58
Mahakala and, 55, 163
Samvara and, 282
Tara and, 287
Tibet under, 117
tsam and, 154
Sakya Pandita (uncle of Phagspa), 120, 207,
208, *208*, 300
Samvara (deity), 282
see also Sitasamvara with His Consort
Sanduin jüd, 84, 204, 205
Sanguozhi (Romance of the Three Kingdoms),
65
Sarasvati (bodhisattva), 60, *61*
Sarba Khutuktu (lama), 54, 55
Sayin nigürtü eke. See Tingi Shalsangma
scarf, ceremonial. See *khatak*
scraper, for horses, 16, *17*
script
Arabic, Mongolian in, 91
clear. See script, Todo
in colors, 202, **202**
Cyrillic, use of, in Mongolia, 46, 93, 94, *94*
dialects and, 10
earliest. See script, Tuoba / Tavghach
Khitan, 88–89, *89*
Lantsha, 185, 189, 190, 192, *193*
Latin, use of, in Mongolia, 93–94
Mongolian (*hor-yig*), 200–201, **200–201**
classical, 10, 90, *90*
evolution of, 3, 88–97
Phagspa script as, 267, 268, *268*, 269, *269*,
269 n. 2
Mongol. See script, Uighur
Phagspa (square), 33, 90–91, *91*, 120, 185, 199,
199, 269, *269*
uses of, 267
recumbent square, 91–92
Sogdian, 89
Soyombo, 92, *92*, 93, 185, 199, **199**
on the Eighth Bogdo Gegen's seal, 269,
269
Zanabazar and, 40
square. See script, Phagspa
Tibetan, on book covers, **188**, 189, 196, **197**,
198, 199, **199**, 205, **205**
Todo (clear), 92–93, *93*
Tuoba / Tavghach, 88
u-chen, 133, 267
Uighur (Uighur-Mongol; Mongol), 28,
89–90, *90*, 91, 185
modern, *90, 94*
restoration of, 47
Vagindra (Buriat alphabet), 93, 94
sculpture
amalgamation of several, 80, 279, **296**
at Jehol, 68, 69

base plates of. *See* base plates
bronze, 61, 77
consecration of, 77
molds for, 304, **304**
Mongolian religious, 77–83
multipart casting, 282
Newari, *60*
repoussé, 82, 83, 218, **218**, 243, **243**, 251, **251**,
263, 303
wax, 77, 304, **304**
models for, 77
Zanabazar's school of, 213, **213**
seal
of the Bogdo Khan's consort, 269, *269*
of the Dalai Lama, 268, *268*
of the First Bogdo Gegen (Bogdo Khan
Palace Museum), 267–69, **267**, *268*
of the Eighth Bogdo Gegen, 269, *269*
"Golden King," 268, *268*
of Güyük Khan, *90*
of the Mongolian People's Republic, 14, *14*
script for, *90*, 91
Yuan imperial, 55, 56, 73 n. 25
Seated Maitreya
(school of Zanabazar; Choijin-Lama
Temple Museum), 150, 298, **298**
(State Hermitage, St. Petersburg), 220, *220*
Secret Biography of the Eighth Bogdo Gegen,
The, 132, 133–37, **133**, 263 n. 1
Secret History of the Mongols, The, 11, 20, 89, 91,
92
Selmeči. *See* Sword Bearer
Sengge (brother of Galdan), 41
Sengge (great-granddaughter of Khubilai
Khan), 36
Set of Twelve Ritual Instruments (Museum of
Fine Arts), 258–60, **258–60**
Setsen Khan, on Zanabazar, 262
Setsen Khan Artased (shaman), 71
Shakyamuni Buddha
on a book cover, 196–97, **196**, 198, **198**
historic, 53
mold for sculpture of (Bogdo Khan Palace
Museum), 304, **304**
relics of, 301
as the Supreme Physician, 295, 296
as a teacher, 208, 218
Zanabazar as reincarnation of, 40
Shakyamuni and Eight Medicine Buddhas
(school of Zanabazar; Bogdo Khan Palace
Museum), 77, **78**, 275, 295–96, **295**
(school of Zanabazar; Museum of Fine
Arts), 296, *296*
Shakyamuni Buddha
enthroned (school of Zanabazar; Asian Art
Museum of San Francisco), 80, *81*
in Shrine (Bogdo Khan Palace Museum),
213, **213**
(school of Zanabazar; Asian Art Museum
of San Francisco), 79, *80*, 296
(from *Zhufo pusa*; Musée Guimet), *211*
shamanism, 33, 39, 47, 71, 100, 228
in Buddhist ritual, 149, 158, 161
14th-century resurgence of, 51, 149
suppression of, 38, 52, 68–69, 149
syncretization of, with Buddhism, 3, 52,
149, 211–12, 244

Chinggis Khan and, 27
spirits in, 61, 69, 158, 160, 161, 162, 166,
168, 211
in the *tsam*, 64–65, 150, *151*
trance and, 150
Shambhala, 63, 212
in Communist propaganda, 63–64, 72
kings of, 63, **182**, 183–84, *184*
political influence of, 181
and Tibetan belief, 181
Shambhala (thangka; Museum of Fine Arts),
63, 180–81, **180**
shanag (zhva nag). See Black Hats
Shangdu (Xanadu), 31, 69, 81
see also Dolonnor
Sharav, B., *13, 23, 71*, 146, **146**, *176, 178*
Shibeetü-uula (Zanabazar's retreat), 123, 262
Shigi Qutuqu (adopted brother of Chinggis
Khan), 89
Shoulao (Daoist deity), 65
shrine, 213, **213**, 225, **225**
skeleton, 252, *253*
Shyamatara. *See* Tara, Green
Sickelpart, Ignatius (Ai Qimeng), 68, *68*
silk
for appliqués, 84
for book covers, 190, **190**, 205, **205**
patchwork, 234, *235*
for temple hangings, 84, *85*
silver, statue of, **219**, 220, *220*
Siregetü Guosi Dharma (historian), 54
Sitasamvara with His Consort
(from the Baoxiang Lou), 285, *285*
(Zanabazar; Choijin-Lama Temple
Museum), 58, 230, 282–85, **283–84**
Sitatara (Zanabazar; Museum of Fine Arts),
58, 59, 77, 286–89, **287**–88, 290
Six-Armed Mahakala (silk appliqué; Bogdo
Khan Palace Museum), 54, 230, 236, **237**
smith (*darkhan*), skills of, 99, 105
Snellgrove, David, 274
"snouts, the five," 14, *14*, 87, 99, 104, 236, 241
snuff, custom of using, 144
snuff bottle(s)
agate, with embroidered pouch (Bogdo
Khan Palace Museum), 144, **144**
coral, with embroidered pouch (Museum
of Fine Arts), 86, 145, **145**
embroidery on pouches for, 86, *86*
and pouch (Bogdo Khan Palace Museum),
86
socks, Dondogdulam's, 147–48, **147–48**
Sogdians, deities of, 212
Sonam Gyatsho (Bsod nams rgya mtsho;
Third Dalai Lama), 38, 52, 61, 161
and Abadai Khan, 118
Begtse and, 244
and the conversion of Altan Khan, 1, 38,
51–52, 72 n. 9, 118, 121, 211, 244, 300
Mahakala and, 211, 236, 238
seals of, 268, *268*
syncretization of shamanism and Bud-
dhism by, 160, 161, 166
Songgina Mountain, 161
Songtsen Gampo (Srong btsan sgam po), 65

Sorghaghtani Beki (daughter-in-law of
 Chinggis Khan), 29
Southeast Asia, defeat of Mongols in, 33
Soyombo (symbol), 92, *92*, *93*
 see also script, Soyombo
Spirit of Bayan Jirüke, The (Choijin-Lama
 Temple Museum), 162, **162**
staff, ritual. *See khatvanga*
Standing Maitreya
 (Zanabazar; Choijin-Lama Temple
 Museum), 58, 62, 150, 174, 280–81, **280**,
 298, 300
 (Zanabazar; Gandantegchinlin Monastery),
 281, *281*
Stoddard, Heather [Karmay], 4
Stone of Chinggis (State Hermitage,
 St. Petersburg), 89, *89*
stupa *(suburgan)*
 silver, by Zanabazar, 263, 302
 (Zanabazar; Museum of Fine Arts), 302, *302*
 (Zanabazar or his school; Bogdo Khan
 Palace Museum), 301–2, **301–2**
 for Zanabazar's relics, 67, 70
suburgan. See stupa
Suchandra, first king of Shambhala, 63, 181
Sükhbaatar, 181
Süren (sculptor), 252, **252**
Suryagupta, 290, 292
sutra
 covers for, 190, **190**, 191, **191**, 203, **203**
 (Yim collection), 188, **189**
 "Great Khan of the Tantra Called the
 Secret Collection, The," 204, **204**
 Mahayana, 186
 with painted textblock and wooden covers
 (State Central Library), 192, **192**
 palm-leaf, 202
 translation of, 190, 191
 Vajra (Long Life), 191
 see also Khan Sudra
sword, ritual, 260, **260**
Sword Bearer (Choijin-Lama Temple
 Museum), 166, **167**
symbol
 Kalachakra (namchu wongden), 183, 190, 192,
 194
 rank and, 138, 140, 141 n. 2
 Soyombo, 199, **199**
 yinyang, 78–79, 86, 196, **196**, 204, **204**

T

Taiji Galdan, 263 n. 2
Tales of King Vikramaditya (text), 64
Tamerlane (Temür), 35
Tanguts, deities of, 212
Tanjur (Bstan 'gyur; commentarial texts on
 the Kanjur), 186, 187
 translation of, into Mongolian, 69, 84, 90
tantra
 Guhyasamaja, 234, 270
 Hevajra, 54
 Kalachakra (Wheel of Time), 63, 71, 181, 183
 Gelugpa and, 181, 183, 212
 Manjushrimula-kalpa, 270

Tara, 290
yoga-
 Akshobhya in, 275
 texts of, 234
Tara
 Bhrkuti as, 292, 294
 Black (Ekajati), 292, **293**, 294, *294*
 as a deity, 211, 286–87, 290, 294 n. 10
 Green, 129, 286
 iconography of, 290, 292
 seventh, 292, **292**
 Taranatha and, 289
 Green (Zanabazar; Bogdo Khan Palace
 Museum), 59, *59*, 77, 263, 287, 290,
 290–94, **291–93**
 incarnations of, 146
 Lamanteri as a form of, 225
 Set of Twenty-one. *See* Four Taras from a
 Set of Twenty-one; Green Tara
 White, 129, 290
 see also Sitatara
 Yellow, **292**, 294
Taranatha (Jonangpa historian), 263 n. 4, 290,
 292
 portrait of, *265*
 Shambhala and, 181
 Zanabazar and, 57, 59, 73 n. 43, 118, 125, 212,
 262, 289
Tara Temple, Zanabazar and, 263
Tatatunga (scribe), 89
Tavghach. *See* script Tuoba/Tavghach
temple-*ger*, 21
 Abadai (Baruun örgöö), 66
Temüjin. *See* Chinggis Khan
Tenfold Virtuous White Chronicle of the Faith,
 The (Khung Taiji), 52
text, canonic, 186–87
textblock, painted, 192, **192**
thangka *(thang kha)*, 126, 127, 142
 appliquéd, 84
 of Buddha Shakyamuni, 214, **215**
 of Ganesha, 96, 230, **231**
 inscription on reverse, 132–37, *133*, 307–9
 Lamanteri in, 225
 painted, 83
 of the pantheon, 211, **223**
 Shambhala, 180–81, **180**, *182*, 183–84
 of Yamantaka, 209, *210*
theocracy
 in Mongolia, 33, 38–41 passim, 50–52, 57–58,
 117–18, 146, 208–9
 in Tibet, 41, 56, 120, 261
The Polo Brothers, Including the Young Marco . . .
 (Bodleian Library, Oxford), *32*
Three Hundred Icons (text), 77, 234, 282
Tibet
 Dalai Lamas in, 261
 Maitreya in, 63, 74 n. 65
 Manjushri in, 300
 Medicine Buddhas in, 296
 Mongolian religious art and, 76, 82–83, 87
 records of monasteries in, and Mongolian
 art, 5
 reincarnation lineages in, 266
 Tara in, 290, 292
 theocracy in, 41, 56, 120, 261
 tsam held in, 158

under Mongol jurisdiction, 29, 44, 120
 see also Buddhism, Tibetan
Tibetan language, on seal, 267
tinder pouch (flint and steel set), 84, 106, **107**
Tingi Shalsangma (Mthing gi zhal bzang ma;
 one of the Five Sisters of Long Life), 228
Toghon Temür (last Mongol emperor), 51, 117,
 209
Togh Temür, 209, *210*
Tolui (son of Chinggis Khan), 29
trade
 Chinggis Khan and, 28
 Khubilai Khan and, 32–33
trance, use of, in ritual dance, 150
transhumance. *See* nomadism
translation
 of canonic texts, 186
 see also Bosson, James
travelers, information about Mongolian art
 from early, 5, 32–33
Treaty of Nerchinsk, 42
Tree of Life, 211
 (papier-mâché; Bogdo Khan Palace
 Museum), 211, 223, **223**, 250
 (terracotta; Museum of Fine Arts), 211, 222,
 223
Trésors de Mongolie (exhibition, Musée
 Guimet), 5
trident (ritual instrument), 259, **259**, 260, **260**
tsam (ritual dance-theater), 64–65, *64*, 150,
 151–69, *151*, *152*, *153*, **155**, **157**, **159**, **160**, **161**,
 162, **163**, **165**, **167**, **169**, **170–71**, 255
 Erleg Khan (Yama), 154, 164
 Maitreya Festival and, 62
 masks for. *See* masks
 original, 150
 regalia for, 170, **170–71**
 sacred textiles for, 234, 235
 shamanism and, 150, 151, 158, 160–68
 passim, 212, 255
 as theater, 74 n. 75
 in Tibet, 177
tsanid (theological curriculum), 66, 71
Tsend, T., 234–35, **235**
Tserendug. *See* White Old Man
Tseringma, Mo lha and, 228
Tsewang Rabtan (nephew of Galdan), 42
tsha-tsha. See plaque, votive
Tsogdogmarav. *See* Ganesha
Tsongkhapa (Tsong kha pa; lama)
 career of, 121, 129
 and Jula-yin bayar, 150
 and the *Kalachakra*, 181, 183, 184
 Maitreya and, 280
 and the Maitreya Festival, 62, 149, 174
 Manjushri and, 300
 and the Monlam Chenmo, 179
 pantheon and, 211, 255
 portraits of, 121, **121**, 204, **204**, 246, **247**, **248**,
 249
 reincarnated, 118
 theocracy and, 223
 Tree of Life and, **222–23**
 and the Yongle emperor, 51, 211
Tsongkhapa (school of Zanabazar; Museum
 of Fine Arts), 121, **121**